3D GAME ENGINE ARCHITECTURE

*Engineering Real-Time
Applications with Wild Magic*

THE MORGAN KAUFMANN SERIES IN INTERACTIVE 3D TECHNOLOGY

SERIES EDITOR: DAVID H. EBERLY, MAGIC SOFTWARE, INC.

The game industry is a powerful and driving force in the evolution of computer technology. As the capabilities of personal computers, peripheral hardware, and game consoles have grown, so has the demand for quality information about the algorithms, tools, and descriptions needed to take advantage of this new technology. To satisfy this demand and establish a new level of professional reference for the game developer, we created the **Morgan Kaufmann Series in Interactive 3D Technology.** Books in the series are written for developers by leading industry professionals and academic researchers, and cover the state of the art in real-time 3D. The series emphasizes practical, working solutions and solid software-engineering principles. The goal is for the developer to be able to implement real systems from the fundamental ideas, whether it be for games or other applications.

3D Game Engine Architecture: Engineering Real-Time Applications with Wild Magic
David H. Eberly

Real-Time Collision Detection
Christer Ericson

Physically Based Rendering: From Theory to Implementation
Matt Pharr and Gregg Humphreys

Essential Mathematics for Game and Interactive Applications: A Programmer's Guide
James M. Van Verth and Lars M. Bishop

Game Physics
David H. Eberly

Collision Detection in Interactive 3D Environments
Gino van den Bergen

3D Game Engine Design: A Practical Approach to Real-Time Computer Graphics
David H. Eberly

Forthcoming

Artificial Intelligence for Computer Games
Ian Millington

Visualizing Quaternions
Andrew J. Hanson

3D GAME ENGINE ARCHITECTURE

Engineering Real-Time Applications with Wild Magic

DAVID H. EBERLY

Magic Software, Inc.

AMSTERDAM · BOSTON · HEIDELBERG · LONDON
NEW YORK · OXFORD · PARIS · SAN DIEGO
SAN FRANCISCO · SINGAPORE · SYDNEY · TOKYO

Morgan Kaufmann is an imprint of Elsevier

MORGAN KAUFMANN PUBLISHERS

Senior Editor Tim Cox
Publishing Services Manager Simon Crump
Project Editor Justin Palmeiro
Project Management Elisabeth Beller
Assistant Editor Rick Camp
Cover Design Chen Design Associates, San Francisco
Text Design Rebecca Evans
Composition Windfall Software, using ZzTEX
Technical Illustration Dartmouth Publishing
Copyeditor Ken DellaPenta
Proofreader Jennifer McClain
Indexer Steve Rath
Interior Printer The Maple-Vail Book Manufacturing Group
Cover Printer Phoenix Color Corporation

Morgan Kaufmann Publishers is an imprint of Elsevier.
500 Sansome Street, Suite 400, San Francisco, CA 94111

This book is printed on acid-free paper.

Library of Congress Cataloguing-in-Publication: applied for

ISBN: 978-0-12-229064-0

For information on all Morgan Kaufmann publications,
visit our Web site at *www.mkp.com*.

Printed and bound by CPI Group (UK) Ltd, Croydon, CR0 4YY
Transferred to Digital Print 2012

ABOUT THE AUTHOR

Dave Eberly is the president of Magic Software, Inc. (*www.magic-software.com*), a company that specializes in software development for computer graphics, image analysis, and numerical methods. Previously, he was the director of engineering at Numerical Design Ltd., the company responsible for the real-time 3D game engine, NetImmerse. His background includes a BA degree in mathematics from Bloomsburg University, MS and PhD degrees in mathematics from the University of Colorado at Boulder, and MS and PhD degrees in computer science from the University of North Carolina at Chapel Hill. He is the author of *Game Physics* (2004) and *3D Game Engine Design* (2001) and coauthor with Philip Schneider of *Geometric Tools for Computer Graphics* (2003), all published by Morgan Kaufmann.

As a mathematician, Dave did research in the mathematics of combustion, signal and image processing, and length-biased distributions in statistics. He was an associate professor at the University of Texas at San Antonio with an adjunct appointment in radiology at the U.T. Health Science Center at San Antonio. In 1991 he gave up his tenured position to re-train in computer science at the University of North Carolina. After graduating in 1994, he remained for one year as a research associate professor in computer science with a joint appointment in the Department of Neurosurgery, working in medical image analysis. His next stop was the SAS Institute, working for a year on SAS/Insight, a statistical graphics package. Finally, deciding that computer graphics and geometry were his real calling, Dave went to work for Numerical Design Ltd., then later to Magic Software, Inc. Dave's participation in the newsgroup *comp.graphics.algorithms* and his desire to make 3D graphics technology available to all are what has led to the creation of his company's Web site and this book.

CONTENTS

CHAPTER

8

APPLICATIONS 601

For additional reference material please visit:
http://www.elsevierdirect.com/companion.jsp?ISBN=9780122290640

PREFACE

My book *3D Game Engine Design* appeared in print in September 2000. It described many of the algorithms that are used in the development of the graphics and physics portions of game engines and shipped with a CD-ROM that contained the source code for version 0.1 of the Wild Magic engine. Although the algorithms have not changed over the years, the engine has evolved significantly. The original version was written for the Microsoft Windows platform using an OpenGL-based renderer, and not all of the book algorithms were implemented in that version. The last version before the one shipping with this book, version 2.3, runs on Linux machines and on Macintosh machines with OS X. A number of users have been successful in porting the code (with relatively minor changes) to run on SGI machines with IRIX, on HP machines with HP-UX, and on Sun machines with Solaris. On the Microsoft Windows platform, the engine has renderers for OpenGL and Direct3D. Many more algorithms had been implemented in version 2.3, and the engine was extended to support shader programs. As a result of my book *Game Physics,* more physics support was added, including particle systems, mass-spring systems, and rigid body dynamics. Specialized applications were added to illustrate physical simulations that are based on the equations of motion derived from Lagrangian dynamics.

Some of the systems in Wild Magic were implemented by contractors. Unfortunately, I did not have any documents written up about the design and architecture of the engine, so the contractors had to do their best to add new features into the framework without guidance from such documents. The primary goal was to add new features into the engine's framework, and the contractors delivered exactly what I had hoped for. A user's guide and reference manual would have been helpful to these folks.

Users of the engine asked me frequently about the availability of a user's guide and reference manual and sometimes about the design and architecture of the engine. Embarassingly enough, I had to tell the users that no such document existed and that I did not have the time to write one.

The pressures from users and the needs of the contractors finally increased enough that I decided it was time to write a document describing how I had designed and architected the engine. Any library that evolves so much over a few years is a prime candidate for a rewrite—Wild Magic is no exception. Instead of writing a book about Wild Magic version 2, I decided that the engine rewrite should occur first to incorporate ideas that I believed would make the engine better, and to redesign and rebuild the components that contractors had provided. This book, *3D Game Engine Architecture,* is the result of those efforts, and Wild Magic version 3 is the brand-new and much-improved engine that the book describes. I have attempted to convey my

thoughts as much as possible on the software engineering and computer science aspects of the engine. The focus on mathematics is as minimal as I could make it (and there was much rejoicing!), but there is still some mathematics—enough to motivate why I built the interfaces for those classes that provide mathematical support for the engine.

The engine source code, applications, and some of the tools are of my own doing. However, the 3DS importer and Maya exporter are the contributions of Nolan Walker, a contractor who has helped me with various engine components over the years. His was a more formidable task than mine—figuring out how to convert the data from modeling packages to the scene graph format of Wild Magic. This is a nontrivial task, especially when the information on data layout for various packages is difficult to locate. My thanks go to him for producing these tools. I wish to thank Jeremiah Washburn, an NDL artist, who created much of the fine artwork that you will see on the companion website. You can visit his personal website, *www.bloodyart.com,* for other samples of his artwork. Finally, I can retire a lot of the cheesy-looking engineer's artwork that I have been using in my books. I also wish to thank Chris Moak, an artist who constructed the castle data set that you will see in one of the sample applications. He built the data set in 2001; I have only now gotten around to making it available. You can visit his website, *home.nc.rr.com/krynshaw/index.html,* for other samples of his artwork.

My long-term relationship with Morgan Kaufmann Publishers (MKP), now spanning four books and a series editorship, has been a fruitful one. A book project always begins with an editor prodding a potential author to write a book and then continues with more prodding to keep the author writing. My friend and senior editor, Tim Cox, has been quite good at this! When he is busy on other projects, his editorial assistant, Rick Camp, assumes the role and reminds me to deliver various book-related materials. Both Tim and Rick have the uncanny ability to prod at just the right time—when I have a dozen other items to attend to. Once the project begins, my job is simple: Write the book and deliver a draft with supporting figures and screen-captured images. Once delivered, the hard part of the process commences— the actual book production. Fortunately, all of my books published through MKP have had the same project manager, Elisabeth Beller. Her superb abilities to schedule the workload and keep a team of people on track are amazing. I consider it a modern miracle that she and her team can take my crude drafts and produce from them such fine-quality books! My thanks go to the talented people at MKP for producing yet again another of my works.

On a final note: In case you were wondering about why I chose the name Wild Magic, here is a quote from the release notes that shipped with version 0.1 of the engine:

> I am not a fan of fancy names, but I guess it is about time to do some branding. So I have given the engine a name. That name, Wild Magic, while sharing part of the company name, is also a reference to the Thomas Covenant novels written by Stephen R. Donaldson. In my opinion he is the best fantasy writer ever. I have

lost count of the number of times I have read the Covenant series. My hope is that someday he will write another trilogy in that series. Or that there will be a movie about the current books. Or that there will be a 3D game based on the series

Ironically, the first book of a new series, *The Last Chronicles of Thomas Covenant*, is scheduled to appear in print about the time this book does. If my future books are delayed, let it be known that I was spending my hours reading, not writing! Now, Mr. Donaldson, about that movie and 3D game

CHAPTER 1

INTRODUCTION

My book *3D Game Engine Design* (*3DGED*) was written to explain the high-level details that arose in the development of the real-time 3D game engine NetImmerse. The expression "game engine" was used because, at the time of the development of NetImmerse, that was what such large libraries were called. *3DGED* is partly about the computer graphics issues for a real-time engine. It discusses the *graphics pipeline*—taking an object, positioning and orienting it in the world, and drawing it (if necessary). Some discussion was included of rendering effects, the topic of interest to most budding game programmers, but the book covered in more detail the aspects of scene graph management. This is the "front-end" data management system that provides potentially visible data to the "back-end" rendering system. Part of scene graph management is about abstract systems. An appendix (which should have been a chapter) was provided on object-oriented design, including topics such as run-time type information, sharing via reference counting, and streaming (memory, disk, networks). Other abstract systems included spatial organization via trees, a rendering layer to hide graphics APIs, controllers, and so on.

3DGED covered a number of topics of interest—for example, animation, level of detail, sorting, terrain, and so on. But all these were discussed at a fairly high level, a "design level" so to speak.

Much to the dismay of some readers, the book contained a lot of mathematics, required to implement the concepts. Reader feedback indicated that what many folks want are the *architectural details* of how you actually build a game engine, with less focus on the mathematical algorithms. Such a need has led to this book, *3D Game Engine Architecture* (*3DGEA*).

3DGED included a basic scene graph management system and rendering system, called Wild Magic. The original code ran on Windows with OpenGL, but over the

1

years it has been ported to run on PCs with Direct3D, on PCs with Linux, on Macintoshes with OS X, and on Unix workstations that have OpenGL support. The engine has evolved to include many more features, namely, high-level rendering effects and shaders. I have received innumerable emails asking how to use the engine, how to extend the engine, and how to write tools for the engine. Naturally, to understand the answers to these questions you must understand how the engine is architected. This book is about the Wild Magic architecture, a case study for understanding the issues of constructing an engine that you would see in a commercial environment.

The issues are many, each relatively easy to understand in isolation from the others. However, putting all the pieces together is a formidable task to get right. But what does "right" mean? An engine is a large library and is subject to the software engineering principles that govern how such a large package evolves. Certainly you (or your customers) will want to customize the engine to support new features. But unfortunately, simplicity of maintenance does not come trivially. The various abstract subsystems of the library must be architected so that they integrate easily among themselves, and, as many customers of middleware have found out, they must integrate easily with packages provided by others. Talk to any game company that has had to combine a graphics engine, a physics engine, a networking engine, and an AI engine together into a single game—you will hear the war stories about the difficulties of making that happen. The promise of this book is not that you will architect a system that will just simply plug into everyone else's system, but rather that you will learn how to minimize the pain of doing so. You need to ask a lot of questions about your architecture and many times decide on various trade-offs. Sometimes you will make a decision and go with it, only to find out later that you have to redesign and rebuild. This is a natural part of the process for any large library construction, but your goal is to anticipate where the problems will occur and design to facilitate solving those problems without having to rewrite from scratch.

The next three sections present a couple of complete applications that compile and run. The idea is to show you what systems come into play to get a working application. The last section is a discussion of encapsulation of abstract systems whose implementations depend on the platform (operating system, windowing system, renderer creation, and use). More complicated applications show that you also need to identify systems that allow you to factor code for reusability. Although some games are written as throwaway code, from a company's perspective it is better to write libraries that can be reused in other similar games. The last section also provides brief descriptions of the remaining chapters in the book.

1.1 DRAWING A TRIANGLE

In this section I discuss the graphics equivalent of the "Hello, world" introductory programming assignment—drawing a single triangle on the screen. The triangle vertices are assigned colors, and the graphics system will interpolate these to create colors

for pixels that are inside the triangle. When certain keys are pressed, you can rotate the triangle about a center point and translate the center point itself. Something as simple as drawing a triangle requires a large amount of code. The sample application runs on a PC with Microsoft Windows, but please be aware that the quantity of code is not a consequence of this particular platform. Similar applications may be written for other platforms and will be as large as the current example. The source code can be found on the companion website, in the file

```
GeometricTools/WildMagic3/BookFigures/DrawTriangle/DrawTriangle.cpp
```

I will explain it a piece at a time.

Four header files are included:

```
#include <windows.h>
#include <GL/gl.h>
#include <GL/glu.h>
#include <cmath>
```

The first accesses the Win32 API for windowed applications. The second exposes the OpenGL API, and the third exposes various utility functions that were built for OpenGL. The fourth is used to access sine and cosine functions for constructing rotation matrices for the triangle.

The window in which you render must be created. The width and height of the window are specified by the first two variables in this block:

```
static int gs_iWidth = 640;
static int gs_iHeight = 480;
static HDC gs_hWindowDC = (HDC)0;
```

The last variable is a device context that is associated with the window. I have made it global so that it may be accessed by the triangle drawing routine. It is initialized to the null handle, but the main program will set it to the correct device context.

For perspective projection, you need to specify a view frustum. The left, right, bottom, top, near, and far values are

```
static double gs_fLFrustum = -0.5500;
static double gs_fRFrustum = +0.5500;
static double gs_fBFrustum = -0.4125;
static double gs_fTFrustum = +0.4125;
static double gs_fNFrustum = +1.0;
static double gs_fFFrustum = +100.0;
```

You also need to specify a viewport (a rectangular portion of the screen) in which the drawing will occur. In this application, the viewport is the entire screen:

```
static int gs_iXPort = 0;
static int gs_iYPort = 0;
static int gs_iWPort = gs_iWidth;
static int gs_iHPort = gs_iHeight;
```

The first two values are the location of the upper-right corner of the viewport. The last two values are the dimensions of the viewport.

The camera must be positioned somewhere in the world, and it must be assigned a set of coordinate axes:

```
static double gs_adEye[3] = { 0.0, 0.0, 4.0 };
static double gs_adDir[3] = { 0.0, 0.0, -1.0 };
static double gs_adUp[3] = { 0.0, 1.0, 0.0 };
static double gs_adRight[3] = { 1.0, 0.0, 0.0 };
```

The camera location, sometimes called the eye point of the observer, is specified in the first array in world coordinates. The second array is a unit-length vector that is the direction of view. The third array is a unit-length vector that indicates which direction is up to the observer. The fourth array is a unit-length vector that is the cross product of the direction vector and the up vector.

The triangle vertices and associated colors are

```
static float gs_afVertex0[3] = { 1.0f, 0.0f, 0.0f };
static float gs_afVertex1[3] = { -1.0f, 1.0f, 0.0f };
static float gs_afVertex2[3] = { -1.0f, -1.0f, 0.0f };
static float gs_afColor0[3] = { 1.0f, 0.0f, 0.0f };  // red
static float gs_afColor1[3] = { 0.0f, 1.0f, 0.0f };  // green
static float gs_afColor2[3] = { 0.0f, 0.0f, 1.0f };  // blue
```

Notice that the vertices have been chosen in the plane $z = 0$ and that the observer is looking at this plane from 4 units away. The triangle should be visible initially.

I will allow the triangle to be rotated about a center point $(0, 0, 0)$. The center point may be translated, but the rotation is always about the center point no matter where it is located. Rather than modifying the vertex locations and risking a gradual introduction of numerical round-off errors, I instead maintain a rotation matrix and translation vector that are used to construct a transformation that maps the initial vertex (model data) to their actual locations (world data). The translation and rotation are stored as

```
// translation vector for triangle
static float gs_afTranslate[3] =
{
    0.0f, 0.0f, 0.0f
};
```

```
// rotation matrix for triangle
static float gs_aafRotate[3][3] =
{
    {1.0f, 0.0f, 0.0f},
    {0.0f, 1.0f, 0.0f},
    {0.0f, 0.0f, 1.0f}
};
```

The rotation matrix is initially the identity matrix. I prefer to tell OpenGL all at once what the model-to-world transformation is. The way to do this is through a 4×4 homogeneous matrix:

```
// transformation matrix for triangle (in OpenGL format)
static float gs_afMatrix[16] =
{
    1.0f, 0.0f, 0.0f, 0.0f,
    0.0f, 1.0f, 0.0f, 0.0f,
    0.0f, 0.0f, 1.0f, 0.0f,
    0.0f, 0.0f, 0.0f, 1.0f
};
```

The layout of the matrix may be inferred from the assignments in the WinProc function. The translation is updated by incremental changes in the world coordinate axis directions, and the rotation is updated by incremental rotations about the world coordinate axis directions. The minimal information to allow the increments is

```
// for incremental translations
static float gs_fDPosition = 0.1f;
```

```
// for incremental rotations
static float gs_afAngle = 0.1f;
static float gs_fCos = cosf(gs_afAngle);
static float gs_fSin = sinf(gs_afAngle);
```

The camera is also allowed to move based on keystrokes. You may translate the camera in the direction of view or rotate it about its own coordinate axes.

The entry point into a Microsoft Windows Win32 application is the function WinMain. The first block of code in that function is

```
// register the window class
static char s_acWindowClass[] = "Wild Magic Application";
WNDCLASS wc;
wc.style        = CS_HREDRAW | CS_VREDRAW | CS_OWNDC;
wc.lpfnWndProc  = WinProc;
```

```
wc.cbClsExtra    = 0;
wc.cbWndExtra    = 0;
wc.hInstance     = hInstance;
wc.hIcon         = LoadIcon(NULL,IDI_APPLICATION);
wc.hCursor       = LoadCursor(NULL,IDC_ARROW);
wc.hbrBackground = (HBRUSH)GetStockObject(WHITE_BRUSH);
wc.lpszClassName = s_acWindowClass;
wc.lpszMenuName  = NULL;
RegisterClass(&wc);
```

This block of code defines a class of windows that the application can create. I only create one window here, but more sophisticated applications may create many windows (and might have more than one class of windows). Standard objects are associated with the window (icon, cursor, brush), but no menus. The first two parameters of the style field specify that the window is to be redrawn if a move or size operation changes the width or height. The last parameter guarantees that each window in the class gets its own device context, which is important for windows in which OpenGL is used for rendering. The wc.lpfnWndProc assignment tells the window class to use the function WinProc as the event handler for the window. Messages such as keystrokes and mouse clicks are dispatched to that function for processing (if necessary).

The client area of window dimensions is set by

```
// require the window to have the specified client area
RECT kRect = { 0, 0, gs_iWidth-1, gs_iHeight-1 };
AdjustWindowRect(&kRect,WS_OVERLAPPEDWINDOW,false);
```

The vertices of the rectangle correspond to those of the client area. However, the window will have various "decorations" such as a title bar and borders that are a few pixels thick, so the actual window must be larger than the client area. The function AdjustWindowRect computes how large it must be.

The last step in the window setup is window creation:

```
// create the application window
static char s_acWindowTitle[] = "Draw Triangle";
int iXPos = 0, iYPos = 0;
int iWidth = kRect.right - kRect.left + 1;
int iHeight = kRect.bottom - kRect.top + 1;
HWND hWnd = CreateWindow(s_acWindowClass,s_acWindowTitle,
    WS_OVERLAPPEDWINDOW,iXPos,iYPos,iWidth,iHeight,(HWND)0,
    (HMENU)0,hInstance,NULL);

// create a window for rendering
gs_hWindowDC = GetDC(hWnd);
```

The window title is displayed in the title bar. I have requested that the upper-left corner of the window be (0, 0) on the desktop. The width and height are for the window plus its decorations. The call to GetDC obtains a device context associated with the window handle.

The next few blocks of code will allocate the hardware resources needed to support drawing to the window. These are all specific to Microsoft Windows, but other platforms have similar setups. First, you need to choose a format for the buffers to be allocated:

```
// select format for drawing surface
PIXELFORMATDESCRIPTOR kPFD;
memset(&kPFD,0,sizeof(PIXELFORMATDESCRIPTOR));
kPFD.nSize = sizeof(PIXELFORMATDESCRIPTOR);
kPFD.nVersion = 1;
kPFD.dwFlags =
    PFD_DRAW_TO_WINDOW |
    PFD_SUPPORT_OPENGL |
    PFD_GENERIC_ACCELERATED |
    PFD_DOUBLEBUFFER;
kPFD.iPixelType = PFD_TYPE_RGBA;
kPFD.cColorBits = 24;  // 24-bit colors for front/back buffers
kPFD.cDepthBits = 16;  // 16-bit depth buffer
kPFD.cStencilBits = 8; // 8-bit stencil buffer
```

The request is for hardware-accelerated, double-buffered drawing using OpenGL. The drawing was the back buffer. Once done, you have to call a function to have the back buffer copied (or swapped) into the front buffer. The front and back buffers are 24 bits each, and the depth buffer is 16 bits. Consumer graphics cards have enough memory so that you should be able to use 24 or 32 bits for the depth. The stencil buffer only has 8 bits, so if you have fancy features that require more bits for the stencil buffer, you will need to change the number (assuming the graphics drivers you have support a greater number of bits).

The block of code

```
int iPixelFormat = ChoosePixelFormat(gs_hWindowDC,&kPFD);
if ( iPixelFormat == 0 )
{
    ReleaseDC(hWnd,gs_hWindowDC);
    return -1;
}
```

is a request to see if the graphics system can support the pixel format you requested. If it cannot, the return value of ChoosePixelFormat is zero, in which case you have no choice but to terminate the application. A commercial application would attempt less

aggressive formats instead of aborting. Assuming the format is acceptable, the block of code

```
BOOL bSuccess = SetPixelFormat(gs_hWindowDC,iPixelFormat,&kPFD);
if ( !bSuccess )
{
    ReleaseDC(hWnd,gs_hWindowDC);
    return -2;
}
```

will configure the device context as needed.

A resource context corresponding to the device context is created through

```
// create an OpenGL context
HGLRC hWindowRC = wglCreateContext(gs_hWindowDC);
if ( !hWindowRC )
{
    ReleaseDC(hWnd,gs_hWindowDC);
    return -3;
}

bSuccess = wglMakeCurrent(gs_hWindowDC,hWindowRC);
if ( !bSuccess )
{
    wglDeleteContext(hWindowRC);
    ReleaseDC(hWnd,gs_hWindowDC);
    return -4;
}
```

The second block of code takes the resource context and makes it the active one for the application. Assuming all these steps have been successful, we are *finally* ready to make calls to the OpenGL graphics system.

The first OpenGL call sets the color that is used to clear the back buffer. The default value is black, but I prefer something less bold:

```
// background color is gray
glClearColor(0.75f,0.75f,0.75f,1.0f);
```

The view frustum for the perspective projection is enabled with

```
// set up for perspective projection
glMatrixMode(GL_PROJECTION);
glLoadIdentity();
glFrustum(gs_fLFrustum,gs_fRFrustum,gs_fBFrustum,gs_fTFrustum,
    gs_fNFrustum,gs_fFFrustum);
```

The frustum settings affect how a model is transformed to screen space. That is why `glMatrixMode` and `glLoadIdentity` show up in the code. The `glFrustum` call creates that portion of the transformation that is controlled by the perspective projection. The viewport is the entire screen:

```
// set the viewport so that the entire screen is drawn to
glViewport(gs_iXPort,gs_iYPort,gs_iWPort,gs_iHPort);
```

We have to tell OpenGL about the camera eye point and coordinate axis directions. This happens via

```
double adLookAt[3] =
{
    gs_adEye[0]+gs_adDir[0],
    gs_adEye[1]+gs_adDir[1],
    gs_adEye[2]+gs_adDir[2]
};
glMatrixMode(GL_MODELVIEW);
glLoadIdentity();
gluLookAt(gs_adEye[0],gs_adEye[1],gs_adEye[2],adLookAt[0],adLookAt[1],
    adLookAt[2],gs_adUp[0],gs_adUp[1],gs_adUp[2]);
```

Just as setting the frustum involved matrix manipulation, so does setting the camera coordinate system. The `gluLookAt` call creates that portion of the transformation that maps world coordinates into the coordinate system of the camera. Internally, the `gluLookAt` function re-creates the view direction vector from the eye point and the look-at point; then the view direction and up vector are used to generate the right vector in the camera coordinate system.

At this point in the `WinMain` execution, we are ready to draw the triangle. Some more Windows infrastructure code is necessary. Up till now, the window exists, but has not been displayed on the screen. To do this, use

```
// display the window
ShowWindow(hWnd,SW_SHOW);
UpdateWindow(hWnd);
```

A Microsoft Windows program is event driven. A loop is started, called the message pump:

```
// start the message pump
MSG kMsg;
while ( TRUE )
{
    if ( PeekMessage(&kMsg,(HWND)0,0,0,PM_REMOVE) )
```

```
    {
        if ( kMsg.message == WM_QUIT )
            break;

        HACCEL hAccel = (HACCEL)0;
        if ( !TranslateAccelerator(hWnd,hAccel,&kMsg) )
        {
            TranslateMessage(&kMsg);
            DispatchMessage(&kMsg);  .
        }
    }
    else
    {
        // idle loop
        DrawIt();
    }
}
```

The function PeekMessage looks for a message generated by some event. If there is one, a check is made to see if the application has requested termination, for example, if the combined keystrokes ALT and F4 are pressed. The loop is exited if the message is to quit. Otherwise, the message is dispatched so that windows created by the application may receive the events. In the current example, the message is received by an internal call to the WinProc function. In the event that PeekMessage determines that no message is pending, the else clause is executed. This is what I call the *idle loop;* that is, any code in this clause is executed when the application has idle time because it is not processing messages. The idle loop is where you need to place your rendering code in order to obtain real-time frame rates. Trying to render at a fixed rate through a system timer is typically not sufficient because the timers tend to be of limited resolution. For example, the WM_TIMER message is generated about 18 times per second, so you cannot use this message to drive your application at 30 frames or 60 frames per second.

Once the message pump terminates, you should clean up by freeing resources and deallocating memory. In the current example,

```
// clean up
wglDeleteContext(hWindowRC);
ReleaseDC(hWnd,gs_hWindowDC);
```

I did not explicitly allocate memory from the heap, so there is nothing to deallocate. However, resources on the graphics card were committed to the application when a resource context was created. These need to be released, which is what the wglDelete-Context call does. The final call releases the window device context associated with the window handle.

Now onto what the application does during idle time and what events it chooses to handle. The application function DrawIt uses OpenGL to draw the triangle:

```
static void DrawIt ()
{
    // set the entire window to the background color
    glClear(GL_COLOR_BUFFER_BIT);

    // double-sided triangles
    glDisable(GL_CULL_FACE);

    // set the model-to-world transformation
    glMatrixMode(GL_MODELVIEW);
    glPushMatrix();
    glMultMatrixf(gs_afMatrix);

    // draw the triangle
    glBegin(GL_POLYGON);
    glColor3f(gs_afColor0[0],gs_afColor0[1],gs_afColor0[2]);
    glVertex3f(gs_afVertex0[0],gs_afVertex0[1],gs_afVertex0[2]);
    glColor3f(gs_afColor1[0],gs_afColor1[1],gs_afColor1[2]);
    glVertex3f(gs_afVertex1[0],gs_afVertex1[1],gs_afVertex1[2]);
    glColor3f(gs_afColor2[0],gs_afColor2[1],gs_afColor2[2]);
    glVertex3f(gs_afVertex2[0],gs_afVertex2[1],gs_afVertex2[2]);
    glEnd();

    // restore the previous transformation
    glMatrixMode(GL_MODELVIEW);
    glPopMatrix();

    // copy the back buffer into the front buffer
    SwapBuffers(gs_hWindowDC);
}
```

The call glClear takes a parameter that specifies which buffer to clear. In this case, I have asked that the pixels in the back buffer be set to the clear color, something we set to gray at program initialization with a call to glClearColor. The call glDisable is made with a parameter that tells OpenGL not to cull back-facing triangles; that is, the triangles are considered to be double sided. I wanted this behavior so that when you rotate the triangle, it will not disappear once you have rotated it more than 90 degrees about any of the rotation axes.

The triangle vertices, which were specified in model space, need to be transformed into world coordinates. The block of code that does this is

```
// set the model-to-world transformation
glMatrixMode(GL_MODELVIEW);
glPushMatrix();
glMultMatrixf(gs_afMatrix);
```

Recall that when the camera coordinate system was specified, the matrix mode was also GL_MODELVIEW. At that time we set the first matrix to be the identity matrix by calling glLoadIdentity. The function glLookAt multiplies the identity by the matrix that transforms world coordinates to camera coordinates. The product is considered to be the top matrix on a stack of matrices. The glPushMatrix call makes a copy of the top matrix and makes it the new top matrix. The glMultMatrixf call then multiplies the top matrix by its argument and stores it in place. In this case the argument is the model-to-world transformation. The resulting top matrix on the stack represents a transformation that maps vertices in model coordinates to vertices in camera coordinates.

The next block of code tells OpenGL about the vertex colors and locations:

```
// draw the triangle
glBegin(GL_POLYGON);
glColor3f(gs_afColor0[0],gs_afColor0[1],gs_afColor0[2]);
glVertex3f(gs_afVertex0[0],gs_afVertex0[1],gs_afVertex0[2]);
glColor3f(gs_afColor1[0],gs_afColor1[1],gs_afColor1[2]);
glVertex3f(gs_afVertex1[0],gs_afVertex1[1],gs_afVertex1[2]);
glColor3f(gs_afColor2[0],gs_afColor2[1],gs_afColor2[2]);
glVertex3f(gs_afVertex2[0],gs_afVertex2[1],gs_afVertex2[2]);
glEnd();
```

The call glBegin has an input parameter that tells OpenGL we will be giving it an ordered list of vertices and attributes, one group at a time. The vertices are assumed to be those of a convex polygon. In the example, only vertex colors are used. Each group consists of a color specification, via glColor3f, and a location specification, via glVertex3f. In OpenGL, when you call glVertex3f, the vertex attributes currently set are bound to that vertex. For example, if all the vertices are to be the color red, you could use

```
glColor3f(1.0f,0.0f,0.0f);
glVertex3f(gs_afVertex0[0],gs_afVertex0[1],gs_afVertex0[2]);
glVertex3f(gs_afVertex1[0],gs_afVertex1[1],gs_afVertex1[2]);
glVertex3f(gs_afVertex2[0],gs_afVertex2[1],gs_afVertex2[2]);
```

The call glEnd tells OpenGL that you are done specifying the vertices. At this time the object is drawn into the back buffer. The call to SwapBuffers causes the back buffer to be copied into the frame buffer (or swapped in the sense that internally a pointer is

modified to point from one buffer to the other buffer, with the current buffer pointed to becoming the front buffer).

Because I tend to call SwapBuffers at the end of the pipeline, before doing so I restore the state of the transformation system by

```
// restore the previous transformation
glMatrixMode(GL_MODELVIEW);
glPopMatrix();
```

Before these calls, the top of the model-view matrix stack contains the concatenation of the model-to-world transformation (which we set in the DrawIt function) and the world-to-camera transformation (which we set by the gluLookAt function). The matrix immediately below the top matrix was the world-to-camera transformation. The function glPopMatrix pops the top matrix off the stack, making the one below it the new top. Thus, we have restored the world-to-camera transformation to the top of the stack, allowing us to draw other objects by pushing and popping their model-to-world transformations. Why go to this effort? If you were to maintain a single matrix for the model-view system, the push operation amounts to directly modifying the current matrix by multiplying by some transformation. The pop operation must undo this by multiplying the current matrix by the *inverse transformation*, but a general matrix inversion takes quite a few computational cycles. With an eye toward real-time performance, the matrix stack is a space-time trade-off: We reduce computation time by increasing memory usage. Instead of inverting and multiplying with a single-matrix storage, we copy and multiply (push) or copy (pop) using a stack of matrices.

The event handler is the function WinProc, which is indirectly called through the dispatch functions mentioned previously. A windowing system provides a large number of messages. In the current example, the only messages that the event handler processes are keystrokes that occur from pressing text keys (WM_CHAR); keystrokes that occur from pressing some special keys including arrow keys, home/end keys, and page up/page down keys (WM_KEYDOWN); and a message generated when a user closes the window (WM_DESTROY). The WM_CHAR event handler responds to each of six pressed keys and rotates the triangle accordingly. For example, if the r key is pressed, the triangle is rotated about the x-axis in the world space:

```
for (i = 0; i < 3; i++)
{
    fTmp0 =
        gs_fCos*gs_aafRotate[1][i] +
        gs_fSin*gs_aafRotate[2][i];
    fTmp1 =
        gs_fCos*gs_aafRotate[2][i] -
        gs_fSin*gs_aafRotate[1][i];
```

```
        gs_aafRotate[1][i] = fTmp0;
        gs_aafRotate[2][i] = fTmp1;
}
```

The implied update of the rotation matrix is

$$
R' = \begin{bmatrix} r'_{00} & r'_{01} & r'_{02} \\ r'_{10} & r'_{11} & r'_{12} \\ r'_{20} & r'_{21} & r'_{22} \end{bmatrix}
$$

$$
= \begin{bmatrix} r_{00} & r_{01} & r_{02} \\ r_{10}\cos\theta + r_{20}\sin\theta & r_{11}\cos\theta + r_{21}\sin\theta & r_{12}\cos\theta + r_{22}\sin\theta \\ -r_{10}\sin\theta + r_{20}\cos\theta & -r_{11}\sin\theta + r_{21}\cos\theta & -r_{12}\sin\theta + r_{22}\cos\theta \end{bmatrix}
$$

$$
= \begin{bmatrix} 1 & 0 & 0 \\ 0 & \cos(\theta) & \sin(\theta) \\ 0 & -\sin(\theta) & \cos(\theta) \end{bmatrix} \begin{bmatrix} r_{00} & r_{01} & r_{02} \\ r_{10} & r_{11} & r_{12} \\ r_{20} & r_{21} & r_{22} \end{bmatrix}
$$

$$
= QR,
$$

where R is the old rotation matrix, Q is the incremental rotation about the x-axis by θ radians, and R' is the new rotation matrix. My convention for matrices is that they multiply vectors on the right. If \mathbf{V} is a 3×1 vector, then the result of rotating it by a matrix R is $R\mathbf{V}$. It is important to understand this convention, and others, when dealing with a graphics API. OpenGL, for example, uses the opposite convention: \mathbf{V} would be considered to be 1×3 and would be multiplied on the right by a matrix, $\mathbf{V}M$. After the new rotation matrix is computed, the 4×4 matrix (stored as a linear array of 16 numbers) must be reassigned in order for the DrawIt function to correctly set the transformation. The OpenGL convention already exposes itself here. Usually an $n \times m$ array is stored in linear memory using *row-major order*—the first row of the matrix occurs in the first n slots of memory, the second row following it, and so on. In the source code you will notice that the first *column* of the new rotation R' is stored in the first slots in memory.

The translation updates are simple enough. For example, if the x key is pressed, the x-component of the translation is decremented by a small amount. The transformation to be fed to OpenGL is updated, and the next call to DrawIt will use that transformation before drawing the triangle.

The WM_KEYDOWN event handler is designed to move the camera. Let the eye point be \mathbf{E}, the view direction be \mathbf{D}, the up vector be \mathbf{U}, and the right vector be $\mathbf{R} = \mathbf{D} \times \mathbf{U}$. If the key pressed is the up arrow (code VK_UP), the camera is translated a small amount in its direction of view. The update is

$$
\mathbf{E} \leftarrow \mathbf{E} + \Delta\mathbf{D}.
$$

where $\Delta > 0$ is a small scalar. The down arrow (code VK_DOWN) causes the camera to be translated a small amount in the opposite direction of view. The update is

$$\mathbf{E} \leftarrow \mathbf{E} - \Delta \mathbf{D}.$$

The observer may look to the left by turning his head to the left. The camera must be rotated about its own up axis by a small angle θ. The direction and right vectors must rotate, but the up axis remains the same. The update is

$$\mathbf{D}' \leftarrow \cos\theta\mathbf{R} + \sin\theta\mathbf{D}$$

$$\mathbf{R}' \leftarrow -\sin\theta\mathbf{R} + \cos\theta\mathbf{D}$$

$$\mathbf{D} \leftarrow \mathbf{D}'$$

$$\mathbf{R} \leftarrow \mathbf{R}'.$$

The temporary vectors \mathbf{D}' and \mathbf{R}' are necessary. If you were to assign the right-hand side of the first statement directly to \mathbf{D}, the next statement would use the updated \mathbf{D} rather than the original one. The code for implementing this is

```
for (i = 0; i < 3; i++)
{
    adTmp0[i] = gs_fCos*gs_adRight[i] + gs_fSin*gs_adDir[i];
    adTmp1[i] = gs_fCos*gs_adDir[i] - gs_fSin*gs_adRight[i];
}
for (i = 0; i < 3; i++)
{
    gs_adRight[i] = adTmp0[i];
    gs_adDir[i] = adTmp1[i];
}
```

Rotation to the right about the up axis is

$$\mathbf{D}' \leftarrow \cos\theta\mathbf{R} - \sin\theta\mathbf{D}$$

$$\mathbf{R}' \leftarrow \sin\theta\mathbf{R} + \cos\theta\mathbf{D}$$

$$\mathbf{D} \leftarrow \mathbf{D}'$$

$$\mathbf{R} \leftarrow \mathbf{R}'.$$

The only difference is a change of two signs, thought of as replacing θ by $-\theta$ in the assignment statements. Rotations about the right axis are

$$\mathbf{D}' \leftarrow \cos\theta\mathbf{D} \pm \sin\theta\mathbf{U}$$

$$\mathbf{U}' \leftarrow \mp\sin\theta\mathbf{D} + \cos\theta\mathbf{U}$$

$$\mathbf{D} \leftarrow \mathbf{D}'$$

$$\mathbf{U} \leftarrow \mathbf{U}'.$$

Rotations about the view direction are

$$\mathbf{R}' \leftarrow \cos\theta\mathbf{R} \pm \sin\theta\mathbf{U}$$

$$\mathbf{U}' \leftarrow \mp\sin\theta\mathbf{R} + \cos\theta\mathbf{U}$$

$$\mathbf{R} \leftarrow \mathbf{R}'$$

$$\mathbf{U} \leftarrow \mathbf{U}'.$$

Each of the previously mentioned rotations is performed by pressing the correct key. Once the camera axis directions are updated, OpenGL must be told that the camera coordinate system has changed. This is accomplished using the same function described previously, gluLookAt.

Let me remind you why I went to great pains to construct, and describe, an application that (1) draws a single triangle using vertex colors, (2) allows the triangle to move, and (3) allows the camera to move. Your first thought might have been "This should be a straightforward application to write." As you likely have observed, the application is quite complicated and long. This example should already convince you of the necessity to think of a graphics application as a collection of systems that should not be hard-coded into a single application source file. We created a window, created a graphics context to associate resources with the window, initialized the graphics system for drawing, started a loop to receive and dispatch events, implemented a drawing function that uses the current state of the graphics system, and wrote an event handler so that we could update the state of the graphics system for triangle motion and for camera motion.

If you have in mind creating similar applications for other platforms such as the Macintosh or a PC running Linux, you will have to understand how the application coding is done on those platforms. You also have to know how to create the graphics context and deal with events. Moreover, if you want Direct3D instead of OpenGL for the Microsoft Windows application, you have to replace all the OpenGL calls by (hopefully) equivalent Direct3D calls. To support *all* of this in a game/graphics engine is a monumental effort! The only way you can accomplish this is to apply the principles of software engineering and factor your engine into (1) systems that encapsulate the platform dependencies and (2) systems that are platform independent.

Figure 1.1 shows a pair of screen shots from the sample application.

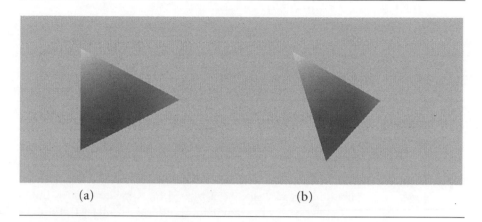

<center>(a) (b)</center>

Figure 1.1 Two screen shots from the sample application for drawing a vertex-colored triangle. (a) The triangle in its initial configuration. (b) The triangle after some rotations about its center. (See also Color Plate 1.1.)

1.2 DRAWING A TRIANGLE MESH

The example from the previous section on drawing a triangle can be modified to handle a mesh of triangles. In this section I discuss the application that does this. The mesh consists of a rectangular grid of vertices with a regular triangulation applied to it. You may think of the resulting mesh as a height field. Rather than using vertex colors, I apply one or two textures to the mesh. The first texture image gives the mesh the appearance of a mountainous terrain, and the second texture image gives the illusion that the mountain is covered with patches of fog. Figure 1.2 shows a pair of screen shots from the sample application.

The source code is found on the companion website, in the file

```
GeometricTools/WildMagic3/BookFigures/DrawMesh/DrawMesh.cpp
```

Much of the code is duplicated from the previous example of drawing a single triangle. I will explain only the differences here.

The OpenGL API that ships with Microsoft Windows is only version 1.1, but later versions are available. In order to access features from later versions, you have to use the OpenGL extension mechanism. A lot of open source packages exist that handle these details for you. Wild Magic version 3 uses one called GLEW, the OpenGL Extension Wrangler Libary [IM04]. In the sample application, I have included only the necessary code to access what is needed to support the multitexture operations in the application:

(a) (b)

Figure 1.2 Two screen shots from the sample application for drawing a multitextured triangle
mesh. The mesh has been rotated the same amount in the two images. (a) The
mesh with only the mountain texture (the primary texture). (b) The mesh with the
mountain texture as the primary texture and with the fog texture as the secondary
texture. (See also Color Plate 1.2.)

```
// support for multitexturing
#define GL_TEXTURE0_ARB 0x84C0
#define GL_TEXTURE1_ARB 0x84C1
#define GL_COMBINE 0x8570
#define GL_COMBINE_RGB 0x8571
#define GL_COMBINE_ALPHA 0x8572
#define GL_RGB_SCALE 0x8573
#define GL_INTERPOLATE 0x8575
#define GL_CONSTANT 0x8576
#define GL_PRIMARY_COLOR 0x8577
#define GL_PREVIOUS 0x8578
#define GL_SOURCE0_RGB 0x8580
#define GL_SOURCE1_RGB 0x8581
#define GL_SOURCE2_RGB 0x8582
#define GL_SOURCE0_ALPHA 0x8588
#define GL_SOURCE1_ALPHA 0x8589
#define GL_SOURCE2_ALPHA 0x858A
#define GL_OPERAND0_RGB 0x8590
#define GL_OPERAND1_RGB 0x8591
#define GL_OPERAND2_RGB 0x8592
#define GL_OPERAND0_ALPHA 0x8598
#define GL_OPERAND1_ALPHA 0x8599
#define GL_OPERAND2_ALPHA 0x859A
typedef void (__stdcall *PFNGLCLIENTACTIVETEXTUREARBPROC)(GLenum);
PFNGLCLIENTACTIVETEXTUREARBPROC glClientActiveTextureARB = NULL;
typedef void (__stdcall *PFNGLACTIVETEXTUREARBPROC)(GLenum);
PFNGLACTIVETEXTUREARBPROC glActiveTextureARB = NULL;
```

The two functions I need access to are `glClientActiveTextureARB` and `glActiveTextureARB`. The types of these are specific to the operating system platform. GLEW hides these details for you so that you have a portable mechanism for accessing the function pointers. In the body of `WinMain`, you will see

```
glClientActiveTextureARB = (PFNGLCLIENTACTIVETEXTUREARBPROC)
    wglGetProcAddress("glClientActiveTextureARB");
assert( glClientActiveTextureARB );

glActiveTextureARB = (PFNGLACTIVETEXTUREARBPROC)
    wglGetProcAddress("glActiveTextureARB");
assert( glActiveTextureARB );
```

This code calls a Windows-specific function, `wglGetProcAddress`, to load the function pointers from the graphics driver.

The triangle vertex positions and colors are replaced by the following:

```
// number of vertices and vertex array
static int gs_iVQuantity = 0;
static float* gs_afVertex = NULL;

// shared texture coordinates
static float* gs_afUV = NULL;

// primary image (RGB), width and height
static int gs_iImageW0 = 0;
static int gs_iImageH0 = 0;
static unsigned char* gs_aucImage0 = NULL;

// binding id for graphics card
static unsigned int gs_uiID0 = 0;

// secondary image (RGB), width and height
static int gs_iImageW1 = 0;
static int gs_iImageH1 = 0;
static unsigned char* gs_aucImage1 = NULL;

// binding id for graphics card
static unsigned int gs_uiID1 = 0;

// number of indices and index array (triple of int)
static int gs_iIQuantity = 0;
static int* gs_aiIndex = NULL;

// toggle secondary texture
static bool gs_bUseSecondaryTexture = false;
```

The comments are self-explanatory for most of the data. The binding identifiers are used to get a handle on texture images that are uploaded to the graphics card. The images are transferred to the video memory on the first drawing pass, and on subsequent drawing passes, the images are accessed directly from video memory. The last data value in the list is a Boolean variable that lets you toggle the secondary texture. If set to true, the primary and secondary textures are appropriately combined onto the mesh. If set to false, only the primary texture is drawn. You may toggle this value with the *s* or *S* keys; see the modified WinProc for the simple details.

The texture images are stored as 24-bit Windows BMP files. The loader for these is

```
static bool LoadBmp24 (const char* acFilename, int& riWidth,
    int& riHeight, unsigned char*& raucData)
{
    HBITMAP hImage = (HBITMAP) LoadImage(NULL,acFilename,
        IMAGE_BITMAP,0,0, LR_LOADFROMFILE | LR_CREATEDIBSECTION);
    if ( !hImage )
        return false;

    DIBSECTION dibSection;
    GetObject(hImage,sizeof(DIBSECTION),&dibSection);

    riWidth = dibSection.dsBm.bmWidth;
    riHeight = dibSection.dsBm.bmHeight;
    int iQuantity =
        dibSection.dsBm.bmWidth*dibSection.dsBm.bmHeight;
    if ( dibSection.dsBm.bmBitsPixel != 24 )
        return false;

    // Windows BMP stores BGR, need to invert to RGB.
    unsigned char* aucSrc =
        (unsigned char*) dibSection.dsBm.bmBits;
    raucData = new unsigned char[3*iQuantity];
    for (int i = 0, i0 = 0, i1 = 1, i2 = 2; i < iQuantity; i++)
    {
        raucData[i0] = aucSrc[i2];
        raucData[i1] = aucSrc[i1];
        raucData[i2] = aucSrc[i0];
        i0 += 3;
        i1 += 3;
        i2 += 3;
    }
    return true;
}
```

The images are loaded into arrays of unsigned characters. The order of the color channels for Windows is the reverse of what OpenGL prefers, so the loader reorders the data.

The triangle mesh is created by the function

```
static void CreateModel ()
{
    // generate vertices and texture coordinates
    int iDim = 32;
    gs_iVQuantity = iDim*iDim;
    gs_afVertex = new float[3*gs_iVQuantity];
    gs_afUV = new float[2*gs_iVQuantity];
    float* pfVertex = gs_afVertex;
    float* pfUV = gs_afUV;
    for (int iY = 0, i = 0; iY < iDim; iY++)
    {
        float fY = iY/(float)(iDim-1);
        for (int iX = 0; iX < iDim; iX++)
        {
            float fX = iX/(float)(iDim-1);

            *pfVertex++ = 2.0f*fX-1.0f;
            *pfVertex++ = 2.0f*fY-1.0f;
            *pfVertex++ = 0.1f*rand()/(float)(RAND_MAX);
            *pfUV++ = fX;
            *pfUV++ = fY;
        }
    }

    // generate connectivity
    gs_iIQuantity = 6*(iDim-1)*(iDim-1);
    gs_aiIndex = new int[gs_iIQuantity];
    for (int i1 = 0, i = 0; i1 < iDim - 1; i1++)
    {
        for (int i0 = 0; i0 < iDim - 1; i0++)
        {
            int iV0 = i0 + iDim * i1;
            int iV1 = iV0 + 1;
            int iV2 = iV1 + iDim;
            int iV3 = iV0 + iDim;
            gs_aiIndex[i++] = iV0;
            gs_aiIndex[i++] = iV1;
            gs_aiIndex[i++] = iV2;
            gs_aiIndex[i++] = iV0;
```

```
            gs_aiIndex[i++] = iV2;
            gs_aiIndex[i++] = iV3;
        }
    }

    // primary texture image
    bool bLoaded = LoadBmp24("mountain.bmp",gs_iImageW0,
        gs_iImageH0,gs_aucImage0);
    assert( bLoaded );

    // secondary texture image
    bLoaded = LoadBmp24("fog.bmp",gs_iImageW1,gs_iImageH1,
        gs_aucImage1);
    assert( bLoaded );
}
```

The mesh is a 32×32 array of vertices uniformly spaced in the xy-plane in the square $[-1, 1]^2$. The z-values (the heights) are randomly generated. The texture coordinates are uniformly spaced in the square $[0, 1]$. The primary and secondary images share the same array of texture coordinates, although in general you may specify different arrays for the different images. The triangles are formed two at a time by connecting four vertices:

$$\langle (x, y), (x + 1, y), (x + 1, y + 1) \rangle, \ \langle (x, y), (x + 1, y + 1), (x, y + 1) \rangle$$

The two texture images are loaded during model creation. The creation function is called in WinMain.

The model data must be deallocated before the program terminates. The function for destroying the mesh is

```
static void DestroyModel ()
{
    delete[] gs_afVertex;
    delete[] gs_afUV;
    delete[] gs_aucImage0;
    delete[] gs_aucImage1;
    delete[] gs_aiIndex;
}
```

All the arrays allocated in CreateModel are deallocated. This function is called in WinMain after the message pump is exited and just before the final return statement that terminates the program.

The drawing function is still named DrawIt, but it is much more complex than the one used for drawing a single triangle. Because the mesh is not a convex object, it is possible that some portions of it occlude other portions depending on the orientation

of the mesh relative to the observer. In order to guarantee correct, sorted drawing, a depth buffer is used:

```
// enable depth buffer reads and writes
glEnable(GL_DEPTH_TEST);
glDepthFunc(GL_LEQUAL);
glDepthMask(GL_TRUE);

// set the background color, set depth buffer to infinity
glClear(GL_COLOR_BUFFER_BIT | GL_DEPTH_BUFFER_BIT);

// double-sided triangles
glDisable(GL_CULL_FACE);
```

In addition to clearing the back buffer using the background color, we also need to initialize the depth buffer. The glClear call handles both. Back-face culling is disabled since the mesh does not form a closed object.

The drawing uses *vertex arrays* rather than the mechanism used in the single triangle drawing that sets the attributes for a vertex at a time. The array manipulation should lead to much better performance on current graphics hardware. The vertex locations are set via

```
// enable vertex arrays
glEnableClientState(GL_VERTEX_ARRAY);
glVertexPointer(3,GL_FLOAT,0,gs_afVertex);
```

The function glVertexPointer tells OpenGL that the array consists of triples (first parameter 3) of 32-bit floating-point numbers (second parameter GL_FLOAT) that are packed together (third parameter 0). The disabling occurs after the drawing via

```
// disable vertex arrays
glDisableClientState(GL_VERTEX_ARRAY);
```

The matrix handling is the same as in the single triangle drawing. However, vertex arrays require you to specifically tell OpenGL to draw the mesh. The glBegin/glEnd mechanism automatically calls the drawing routine. The function for drawing is

```
// draw the mesh
glDrawElements(GL_TRIANGLES,gs_iIQuantity,GL_UNSIGNED_INT,
    gs_aiIndex);
```

The first parameter indicates that a triangle mesh is to be drawn. If the number of triangles is T, the number of indices is $3T$, the number stored by the second parameter, gs_iIQuantity. The third parameter tells OpenGL to treat the indices

as 4-byte unsigned integers, and the fourth parameter is the array of indices. My index array contains signed integers, but the graphics drivers are limited in how many triangles may be drawn at one time. The mismatch of types is not a problem. (OpenGL does not support a third parameter that is a signed integer type.)

The most complicated part of DrawIt is the enabling of texture units. Texture unit 0 is assigned to the primary texture and is enabled by

```
// enable texture unit 0
glClientActiveTextureARB(GL_TEXTURE0_ARB);
glEnableClientState(GL_TEXTURE_COORD_ARRAY);
glTexCoordPointer(2,GL_FLOAT,0,gs_afUV);
glActiveTextureARB(GL_TEXTURE0_ARB);
glEnable(GL_TEXTURE_2D);
if ( gs_uiID0 != 0 )
{
    glBindTexture(GL_TEXTURE_2D,gs_uiID0);
}
else
{
    glGenTextures(1,&gs_uiID0);
    glBindTexture(GL_TEXTURE_2D,gs_uiID0);
    glTexImage2D(GL_TEXTURE_2D,0,GL_RGB8,gs_iImageW0,gs_iImageH0,
        0,GL_RGB,GL_UNSIGNED_BYTE,gs_aucImage0);
    glTexParameteri(GL_TEXTURE_2D,GL_TEXTURE_WRAP_S,GL_REPEAT);
    glTexParameteri(GL_TEXTURE_2D,GL_TEXTURE_WRAP_T,GL_REPEAT);
    glTexParameteri(GL_TEXTURE_2D,GL_TEXTURE_MAG_FILTER,
        GL_LINEAR);
    glTexParameteri(GL_TEXTURE_2D,GL_TEXTURE_MIN_FILTER,
        GL_NEAREST);
}
glTexEnvi(GL_TEXTURE_ENV,GL_TEXTURE_ENV_MODE,GL_REPLACE);
```

The first five lines activate the texture unit, pass the array of texture coordinates to the graphics driver, and enable texturing. On the first drawing pass, the value of gs_uiID0 is zero. That gets you into the else clause. The first three lines in that clause ask OpenGL to upload the texture image to the graphics card and return a positive value in gs_uiID0 as a handle you can use for drawing on subsequent passes. On other passes, notice that only glBindTexture is called. The graphics driver looks at the input identifier and uses the data for that texture already loaded in video memory.

The last four lines in the else clause specify some information about the texture. The first two glTexParameteri calls specify that the texture coordinates are wrapped to always be in the interval [0, 1]. The third glTexParameteri call tells OpenGL to use bilinear interpolation on the image to produce a smooth visual effect when the

mesh is close to the eye point. The last call tells OpenGL to use nearest-neighbor interpolation on the image when the mesh is far from the eye point.

The last call is to glTexEnvi. This function tells OpenGL to replace the pixel colors by the texture image colors for those pixels covered by the transformed and perspectively projected mesh. In the current example, this means that the background colors are replaced by the texture image colors.

When the secondary texture is allowed, texture unit 1 is assigned to it. The enabling code is

```
// enable texture unit 1
glClientActiveTextureARB(GL_TEXTURE1_ARB);
glEnableClientState(GL_TEXTURE_COORD_ARRAY);
glTexCoordPointer(2,GL_FLOAT,0,gs_afUV);
glActiveTextureARB(GL_TEXTURE1_ARB);
glEnable(GL_TEXTURE_2D);
if ( gs_uiID1 != 0 )
{
    glBindTexture(GL_TEXTURE_2D,gs_uiID1);
}
else
{
    glGenTextures(1,&gs_uiID1);
    glBindTexture(GL_TEXTURE_2D,gs_uiID1);
    glTexImage2D(GL_TEXTURE_2D,0,GL_RGB8,gs_iImageW1,gs_iImageH1,
        0,GL_RGB,GL_UNSIGNED_BYTE,gs_aucImage1);
    glTexParameteri(GL_TEXTURE_2D,GL_TEXTURE_WRAP_S,GL_REPEAT);
    glTexParameteri(GL_TEXTURE_2D,GL_TEXTURE_WRAP_T,GL_REPEAT);
    glTexParameteri(GL_TEXTURE_2D,GL_TEXTURE_MAG_FILTER,
        GL_LINEAR);
    glTexParameteri(GL_TEXTURE_2D,GL_TEXTURE_MIN_FILTER,
        GL_NEAREST);
}
static float s_afWhite[4] = { 1.0f, 1.0f, 1.0f, 1.0f };
glTexEnvfv(GL_TEXTURE_ENV,GL_TEXTURE_ENV_COLOR,s_afWhite);
glTexEnvi(GL_TEXTURE_ENV,GL_TEXTURE_ENV_MODE,GL_COMBINE);
glTexEnvi(GL_TEXTURE_ENV,GL_COMBINE_RGB,GL_INTERPOLATE);
glTexEnvi(GL_TEXTURE_ENV,GL_COMBINE_ALPHA,GL_INTERPOLATE);
glTexEnvi(GL_TEXTURE_ENV,GL_SOURCE0_RGB,GL_CONSTANT);
glTexEnvi(GL_TEXTURE_ENV,GL_SOURCE0_ALPHA,GL_REPLACE);
glTexEnvi(GL_TEXTURE_ENV,GL_OPERAND0_RGB,GL_SRC_COLOR);
glTexEnvi(GL_TEXTURE_ENV,GL_OPERAND0_ALPHA,GL_SRC_COLOR);
glTexEnvi(GL_TEXTURE_ENV,GL_SOURCE1_RGB,GL_PREVIOUS);
glTexEnvi(GL_TEXTURE_ENV,GL_SOURCE1_ALPHA,GL_REPLACE);
glTexEnvi(GL_TEXTURE_ENV,GL_OPERAND1_RGB,GL_SRC_COLOR);
```

```
glTexEnvi(GL_TEXTURE_ENV,GL_OPERAND1_ALPHA,GL_SRC_COLOR);
glTexEnvi(GL_TEXTURE_ENV,GL_SOURCE2_RGB,GL_TEXTURE);
glTexEnvi(GL_TEXTURE_ENV,GL_SOURCE2_ALPHA,GL_REPLACE);
glTexEnvi(GL_TEXTURE_ENV,GL_OPERAND2_RGB,GL_SRC_COLOR);
glTexEnvi(GL_TEXTURE_ENV,GL_OPERAND2_ALPHA,GL_SRC_COLOR);
glTexEnvi(GL_TEXTURE_ENV,GL_RGB_SCALE,1);
glTexEnvi(GL_TEXTURE_ENV,GL_ALPHA_SCALE,1);
```

The first part of the code through the if-then-else statement is essentially the same as for the primary texture. To somehow blend the secondary texture with the primary one, we certainly do not want to use the replace mode GL_REPLACE as we did in texture unit 0. The long list of parameters here tells OpenGL exactly how to do the blending, using the GL_COMBINE mode. The explanation for this occurs later in the book (see Section 3.4.4).

The disabling of texture units is

```
if ( gs_bUseSecondaryTexture )
{
    // disable texture unit 1
    glActiveTextureARB(GL_TEXTURE1_ARB);
    glDisable(GL_TEXTURE_2D);
    glClientActiveTextureARB(GL_TEXTURE1_ARB);
    glDisableClientState(GL_TEXTURE_COORD_ARRAY);
}

// disable texture unit 0
glActiveTextureARB(GL_TEXTURE0_ARB);
glDisable(GL_TEXTURE_2D);
glClientActiveTextureARB(GL_TEXTURE0_ARB);
glDisableClientState(GL_TEXTURE_COORD_ARRAY);
```

Not much work to do here.

One last item to take care of has to do with the binding that we did to upload the texture images to the graphics card. You need to tell the graphics driver to free up the video memory before the application terminates. This is done in WinMain by

```
if ( gs_uiID0 > 0 )
    glDeleteTextures((GLsizei)1,(GLuint*)&gs_uiID0);
if ( gs_uiID1 > 0 )
    glDeleteTextures((GLsizei)1,(GLuint*)&gs_uiID1);
```

As you can see, quite a bit of programming goes into displaying something as simple as a single mesh with multiple textures.

1.3 DRAWING A COMPLICATED SCENE

The next example is the drawing of a complicated scene. The scene is an indoor level with 100 rooms, each intricately designed and·textured. The indoor level is managed on a server machine. The scene has 1000 characters, each an animated biped. Each character is controlled by a player who is running his application on a client machine. The characters can shoot at each other and can destroy various objects in the scene. The scene is large enough that the client machines do not have the processing power to draw all of it, so only the visible portions of the scene should be drawn. The sample uses full collision detection and a physics system to obtain realistic behavior of the objects in the world. Quite a few sound emitters exist in the scene and need to be rendered with 3D sound. Finally, the client software runs on PCs, on Linux machines, and on Macintosh machines. The next couple of pages will describe all the work necessary to produce such a sample.

Well, maybe not. The fact is, such a scene and sample application is what many games are about. It takes much more than just a few pages to describe how to build an application of this magnitude. In fact, it takes more than a few books to describe how to do this. The graphics system itself must be quite large to handle this; so must be the physics system. Networking, 3D sound, and cross-platform capabilities are yet a few more systems you need, each requiring a superhuman effort to build them all, but certainly within reach of a team of people per system. The rest of the book focuses on the management of data in a scene and the underlying graphics and physics engines that support it.

1.4 ABSTRACTION OF SYSTEMS

The previous three sections of this chapter should convince you of one thing: Writing a monolithic program for a sophisticated graphics application is just not the way to architect an application. We have seen a few systems in action in the illustrative samples:

- *An application layer.* This is dependent on the platform and operating system and includes window creation, graphics system initialization, and event handling. In commercial applications, you have to deal with graphical user interfaces and their associated controls.

- *Use of a graphics API.* In a sense, this is also dependent on platform. On the PC platform, you have a choice of OpenGL or Direct3D. On Linux and Unix platforms, most likely you will use OpenGL. Game consoles have their own special needs.

- *Data management.*

The last item is the focus of this book. My engine, Wild Magic, is a large library that is designed to provide platform-independent data management or *scene graph management*. It is designed to be efficient in order to support real-time graphics. And it is what I call *graphics API agnostic*. An abstract rendering interface is used by the scene graph management system to communicate with the rendering system. The renderer implementation is effectively irrelevant. It makes no difference if the implementation is based on OpenGL, Direct3D, or even a software renderer (although in the latter case you do not get the real-time performance).

Chapter 2 discusses the core systems that are used by the engine. Section 2.1 describes a low-level system that includes basic data structures, encapsulates any platform dependencies, handles byte order issues (endianness), handles files, and provides convenience functions for memory management. Section 2.2 describes another core system, a mathematics library for supporting standard mathematical functions, vector and matrix algebra, quaternions (for rotations), and basic geometric objects. The most important core system is described in Section 2.3—the object system that provides object-oriented services that are essential to large library design.

The heart of the book is scene graph management. The fundamental ideas and architecture of Wild Magic are discussed in Chapter 3. Section 3.1 describes the four important core classes in scene graph management: Spatial, Node, Geometry, and Renderer. Geometric state management, including transformations and bounding volumes, is the topic of Section 3.2. All important is the mechanism for updating the scene graph whenever some of the geometric quantities in it have changed. Section 3.3 is a description of the standard geometric primitives you find in a graphics system, including points, polylines, and triangle meshes. The section also introduces particles, which can be thought of as points with size; the particles are represented as small squares that always face the observer.

Section 3.4 is a lengthy discussion about render state, the quantities that are used to display geometric objects. The four main classes of state are global state, lights, textures, and effects. Global state is information that is effectively independent of specific geometric data and includes information such as depth buffer parameters, culling status, alpha blending parameters, and material properties. Light state has to do with the lights in the scene and how they dynamically light the geometric objects. To make the geometric objects have a realistic appearance, texturing is essential. (Multitexturing is also discussed.) This section also covers yet another important update mechanism—one that is necessary whenever render state is attached to, or detached from, a scene.

The final section of the chapter, Section 3.5, talks about the camera model for perspective projection and the fundamentals of the rendering system. An important aspect of scene graph management is using an abstract class for rendering in order to hide the details that are specific to certain platforms. This layer allows you to manipulate and display scene graphs without caring if the renderer is implemented using OpenGL or Direct3D, or if the application is running on a PC with Windows, a PC with Linux, or a Macintosh with OS X. This section also covers a few other

complex topics, such as how to cache data on the graphics card and how to support both single-pass and multipass drawing operations.

Chapter 4 takes us into advanced scene graph management. Core scene graph management is simply about choosing good data structures and using object-oriented principles, but the advanced topics have more of an algorithmic flavor. Many of these algorithms are explained in detail in [Ebe00]. Section 4.1 discusses level of detail. The simplest level of detail used is billboards, where textured rectangles are used to represent three-dimensional objects, and the rectangles are always required to face the observer. Particles in Wild Magic are implemented as billboards for visual purposes. The engine also supports the notion of an object always facing the observer, whether it is a flat rectangle or a solid three-dimensional object. Level of detail for a solid object is usually categorized in one of three ways: discrete (change one object at a time), continuous (change a couple of triangles at a time), and infinite (subdivision of surfaces to an arbitrary level of tessellation).

The topic of Section 4.2 is sorting, which comes in two flavors. You can sort objects based on geometric attributes, or you can sort them based on render state. In both instances, the sorting is an attempt to produce a correct drawing of a scene with minimum render state changes. Such changes can be expensive, so it is good to avoid them if possible. The topic of binary space partitiong trees is covered, but only for coarse-level sorting of a scene, not for partitioning of triangles for completely correct sorted drawing. Sorting by render state is accomplished in the engine by deferred drawing. A list of objects is accumulated during the drawing pass, but not drawn, then sorted by selected render states. At that time the objects are sent to the renderer. A hierarchical scene allows you the possibility of sorting the children of a node. One of the physics applications makes use of this to display a gelatinous blob that is semitransparent. This section also covers the topic of portals in which sorting is used for occlusion culling rather than minimizing render state changes.

Curves and surfaces are discussed in Section 4.3. The focus is on the data structure support in the engine so that you can easily add new types of curves or surfaces without having to change the infrastructure of the engine. Some of you will breathe a sigh of relief when I say that no mathematics was harmed in the making of that section.

Section 4.4 looks at constructing terrain objects as a collection of square or rectangular pages of data. The pages may be meshes built as height fields stored as rectangular arrays of heights, as irregular triangulations of the plane with height data specified at the vertices, or as meshes generated from smooth surfaces. Continuous level of detail for height fields is one of the topics. Probably the most important subsection is the one on terrain pages and memory management. Regardless of the page representation, your outdoor environment will no doubt be so large that you cannot keep all the data in memory. This requires you to build a virtual memory management system for terrain.

The last section of the chapter, Section 4.5, discusses how the controller system of the engine is used to support animation of various quantities in the engine. The

illustrative examples are keyframes to control transformations (forward kinematics in a sense), inverse kinematics to control transformations, morphing to control vertex locations, particle systems, and skin and bones for smooth animation.

The companion to advanced scene graph management is advanced rendering, the subject of Chapter 5. Various special effects are supported by the engine and easily used in applications. The chapter has two halves. The first half, Section 5.1, describes the implementation of some special effects using the *fixed-function pipeline*—the standard support in graphics APIs before the introduction of programmable graphics hardware. Section 5.2 describes obtaining special effects using *shaders*—user-written code that programs the graphics hardware. I do not focus on shader writing, although a few sample applications are provided. Instead the emphasis is on how a scene graph management system can support shaders.

Wild Magic has some support for collision detection and physics. Chapter 6 introduces some of the simpler algorithms for collision detection. Line-object intersection, sometimes referred to as *picking,* is discussed in Section 6.1. Object-object intersection is also covered (in Section 6.2), but keep in mind that a fully featured collision detection library with a nearly infinite supply of intersection functions for every object you can imagine is the stuff of commercial physics engines. I promise to touch only the surface of the topic. Likewise, Chapter 7 is a reasonable discussion of how you can add some physics support to an engine, but fully featured physics engines, especially ones of the black-box form (you specify objects, the engine handles everything else for you), are quite difficult to build and take a lot of time. The topics I briefly cover are numerical methods for solving ordinary differential equations (Section 7.1), particle physics (Section 7.2), mass-spring systems (Section 7.3), deformable bodies (Section 7.4), and rigid bodies (Section 7.5). The coverage of these topics is designed to show you how I built the sample applications in my game physics book [Ebe03a]. The emphasis in this book is on implementation, not on the theory.

Chapter 8 is a moderate discussion of how I built an application layer for all the samples. Once again an abstract API is used in order to hide the implementation details on the various platforms. The layer is not a general one that supports GUI construction on any platform. It has simple support for my 3D applications. The chapter has a brief discussion of some graphics and physics applications that appear on the companion website. The goal is to let you know what I was thinking when I built the applications. The application infrastructure is also used for many of my tools, which I also discuss in this chapter.

The final material is an appendix on my coding conventions and on the class hierarchy of Wild Magic version 3. Coding conventions always generate philosophical debates—mine certainly have! However, I have chosen my conventions and I stick to them (well, almost always). Consistency is an important part of a commercial product, more than you might think.

CHAPTER 2

CORE SYSTEMS

2.1 THE LOW-LEVEL SYSTEM

At the lowest level of any library lies a collection of routines that are used frequently enough that their interfaces may be exposed through a single header file in order to save the programmer time by not constantly having to `#include` various files repeatedly. In Wild Magic, this header file is `Wm3System.h` and exposes the interfaces for most of the standard C/C++ libraries. The system header has the block

```
#include <cassert>
#include <cctype>
#include <cfloat>
#include <cmath>
#include <cstddef>
#include <cstdio>
#include <cstdlib>
#include <cstring>
```

The Standard Template Library (STL) is not exposed here. Although STL is a convenient implementation of a lot of commonly used items, many of the container classes are designed to be efficient in time in the asymptotic sense. For example, the STL set class stores the elements of the set in ascending order, which allows a logarithmic-time binary search to determine existence of an element. The ordering also supports logarithmic-time insertion and deletion. Unfortunately, real-time engines sometimes have performance penalties because of the overhead of STL, both in time and memory.

31

For example, a triangle mesh class from an earlier version of the engine was implemented to store vertex, edge, and triangle adjacency information using STL maps. The mesh class had a nested class to represent a mesh vertex. Each vertex needs to know which edges and triangle shared it. A partial code listing is

```
class VertexAttribute
{
public:
    VertexAttribute ();
    void* m_pvData;             // user-defined per-vertex data
    set<Edge> m_kESet;          // adjacent edges
    set<Triangle> m_kTSet;      // adjacent triangles
};
```

The mesh class was used to build the adjacency information for a level surface extracted from a 3D voxel image. The surface was a collection of 825 KB vertices, 2.5 MB edges, and 1.6 MB triangles. The memory used by the program that built the adjacency information was 980 MB.

However, for a typical mesh the average number of edges sharing a vertex is six, and the average number of triangles sharing a vertex is six. The average number of triangles sharing an edge is two. Since the sets of adjacent objects are small, a template class representing a "small set" is more appropriate. That class stores elements in an unordered array and reallocates when necessary. The initial array size defaulted to eight, and each reallocation added eight more items. The expected number of reallocations is zero. Searching a set of up to eight items is fairly fast, so the overhead of maintaining a sorted array was avoided. The insertion always occurs at the end of the array. On deletion of an element, the largest-indexed element of the array is moved to the position of the deleted element, thus maintaining a contiguous set of elements. The nested class became

```
class VertexAttribute
{
public:
    VertexAttribute ();
    void* m_pvData;
    SmallSet<Edge> m_kESet;
    SmallSet<Triangle> m_kTSet;
};
```

For the same application the memory usage was 503 MB, nearly a 50 percent reduction from the version using the STL set. The execution time itself was faster for the SmallSet version.

Real-time applications are of such a nature that the designer/architect of the system has a lot of knowledge about memory usage patterns, but a generic set of template containers do not have the benefit of this knowledge. In this setting, there is some justification for reinventing the wheel! Section 2.1.1 discusses the basic data structures that replicate some of the functionality of STL, but just the minimum necessary to support the engine.

Keep in mind that new hardware (such as game consoles) might not immediately have libraries that support STL. Since consoles tend to have much less memory than desktop computers, the presence of STL might actually be a curse because of the memory overhead.

Also at the lowest level, a library that intends to be portable must encapsulate platform-specific concepts. These concepts include, but are not limited to, reading the system or real-time clock, file handling operations, byte order for data types (endianness), and any basic low-level services common to most operating systems. Encapsulation also may be used to hide optimized versions of common services, for example, memory management. These issues are discussed in Sections 2.1.2 through 2.1.6.

2.1.1 BASIC DATA STRUCTURES

The basic data structures that are implemented are arrays, hash tables, hash sets, lists, sets, and stacks—all template container classes. A simple wrapper for strings is also implemented. All of the template classes are not intended to be derived from, so the destructors are nonvirtual and the class data members are private. The data structures certainly will evolve as needed when the engine is endowed with new features, and other classes will also be added on demand.

The template classes all have comments indicating what the template parameter class must support in its own interface. The requirements are mentioned in the following sections.

Arrays

The array template class encapsulates dynamically resizable, contiguous storage of objects. The template parameter class need only implement the default constructor, the copy constructor, and the assignment operator.

The array constructor allows you to specify the initial quantity of elements in the array (default 1) and the number of elements to grow by when the array size is dynamically increased (default 1). The initial quantity is also the maximum quantity allowed, but dynamic resizing can cause the two numbers to differ. It is guaranteed that the current quantity is less than or equal to the maximum quantity.

Member access is provided by

```
int GetQuantity () const;
T* GetArray ();
const T* GetArray () const;
T& operator[] (int i);
const T& operator[] (int i) const;
```

The members GetQuantity and GetArray perform the obvious operations. The operator[] accessor allows you to read and write elements in the array. The assert-repair paradigm is used in these methods. Range checking is performed to make sure the input i is valid. If it is not, in debug builds an assertion is fired. In release mode, the input is clamped to the valid range. If the input is negative, the item at index 0 is accessed. If the input is larger than or equal to the current quantity Q, the item at index $Q - 1$ is accessed.

The operator[] members never cause automatic growth if the input index is out of range. However, the array class supports automatic growth through

```
void Append (const T& rtElement);
void SetElement (int i, const T& rtElement);
```

The Append method inserts the input element at index Q, where Q is the current quantity. After the insertion, Q is incremented by 1. The SetElement method allows you to insert a new element at any index larger than Q. After insertion, the current quantity is incremented so that the array is just large enough to include the new object. If the input index is already in the current range of valid indices, no resizing is necessary and the current element at that index is overwritten.

Array elements can also be removed through

```
void Remove (int i);
void RemoveAll ();
```

The Remove method deletes the ith element by shifting the elements at larger indices to fill the vacant slots. That is, the element at index $i + 1$ is copied to the location i, the element at index $i + 2$ is copied to the location $i + 1$, and so forth. If Q is the current quantity before the removal, the element at index $Q - 1$ is copied to the location $Q - 2$. Because construction and destruction can have side effects, the default constructor is used to generate a dummy object that is stored at location $Q - 1$, even though the current quantity will be decremented so as not to include the vacated slot. For example, if the template parameter class is a graphics engine Object that holds onto other objects or has dynamically allocated memory, this last step allows the object to free up its resources. The method RemoveAll sets all objects in the valid index range to default constructed objects, and then sets the current quantity to zero.

Dynamic growth may be explicitly controlled via

```
void SetMaxQuantity (int iNewMaxQuantity, bool bCopy);
int GetMaxQuantity () const;
void SetGrowBy (int iGrowBy);
int GetGrowBy () const;
```

The suggestive names make it clear what the behaviors are. In the method Set-MaxQuantity, an assert-and-repair operation checks for nonnegativity of the input. If the input is zero, the array is deallocated and the quantity set to zero. If the input quantity is equal to the current maximum quantity, nothing needs to be done and the function just returns. If the input quantity is different than the current maximum quantity, the array is reallocated. In the event the array grows, the Boolean bCopy input specifies whether or not the old array items should be copied to the new array.

Hash Tables

The hash table template class encapsulates a collection of key-value pairs. The objects are stored in a fixed-size array, where each array element stores a singly linked list of key-value pairs. The data structure for hashing is one of the simplest you will see in a standard computer science textbook. A hash table requires a hash function that computes an array index from a key. If two keys map to the same index, a *collision* is said to have occurred. The colliding key-value pairs are stored in the linked list at the computed array index. This process is called *chaining*. In the hash map template, the hash function uses a multiplicative scheme and is an implementation of equation (4) in [Knu73, Volume 3, Section 6.4]. Should you use a hash table in your application code, it is your responsibility to select a table size that is sufficiently large to help minimize the number of hash collisions.

An important issue for hash tables is the time required for insertion, deletion, and searching. A good discussion of the asymptotic analyses for these are in [CLR90, Section 12.2]. For a chaining with singly linked lists, the worst-case asymptotic behavior for insertion, deletion, or searching is $O(1 + \alpha)$, where α is the *load factor*—the average number of list items in a chain, given by the ratio of the number of objects in the table divided by the total number of table slots. As long as you have a large enough table so that only a few collisions occur, the deletion and searching are quite fast. If you choose the table size way too small, then the computational time may be an issue in your applications.

The hash table class is named THashTable and involves two template parameter classes: TKEY for the keys and TVALUE for the values. The THashMap class has a nested class, HashItem, that represents the singly linked list node. This class stores the key, value, and a pointer to the next node in a list. Both TKEY and TVALUE need to implement their default constructors, since creation of a HashItem object implicitly creates a default key and a default value. They both must implement the assignment operator, since after a HashItem object is created, it is assigned a key and a value. The TKEY

class must additionally implement the comparisons `operator==` and `operator!=` since these are used by the insertion, deletion, and search operations to decide if two keys are equal or different.

As mentioned earlier, the default hash function is multiplicative. However, a user may provide an alternate hash function. Since the template classes are not intended for derivation, the alternate hash function must be provided as a function pointer, a public data member `int (*UserHashFunction)(const TKEY&)`. By default, this pointer is null. If it is set to some function, the internal hashing detects this and uses it instead of the default hash function.

Insertion of a key-value pair into the hash table is accomplished by the member function

```
bool Insert (const TKEY& rtKey, const TVALUE& rtValue);
```

The hash function is evaluated at the input key to locate the table index corresponding to the key. The linked list at that location is searched for the key. If the key does not exist in the list, a new list node is added to the front of the list, and this node is assigned the input key and input value. The insertion function returns `true` to indicate that, in fact, the key-value pair was inserted. If the key does exist in the list, the insertion function returns `false`. Be aware that if you insert a key-value pair, later change the value, and then attempt to insert again, the new value does not replace the old one. If you need support for modifying the value of an existing key-value pair, use the `Find` function, described later in this section.

Removal of a key-value pair from the hash table is accomplished by the member function

```
bool Remove (const TKEY& rtKey);
```

The hash function is evaluated at the input key to locate the table index corresponding to the key. The linked list at that location is searched for the key. If the key does not exist in the list, the removal function returns `false`. If the key does exist in the list, the list node is removed from the list and deleted, and then the removal function returns `true`. No access is given to the value for the key-value pair that is removed. If you need this value, you must perform a search using the `Find` member function to access it, and then call the `Remove` function. The member function

```
void RemoveAll ();
```

iterates through the table and deletes the linked lists.

Searching for a key-value pair is performed by calling the member function

```
TVALUE* Find (const TKEY& rtKey) const;
```

The hash function is evaluated at the input key to locate the table index corresponding to the key. The linked list at that location is searched for the key. If the key does

not exist in the list, the Find function returns NULL. If the key does exist in the list, the Find function returns a pointer to the value associated with the key. The pointer is to the list node's copy of the value. You may modify the value if you so choose; this does not affect where in the table a key-value pair is hashed.

In many situations, it is desirable to iterate through the elements of a hash table for processing. For example, the streaming system in Wild Magic makes use of this. The member functions supporting the iteration are

```
TVALUE* GetFirst (TKEY* ptKey) const;
TVALUE* GetNext (TKEY* ptKey) const;
```

Each of these functions returns a pointer to the hash table's copy of the key-value pair. The functions also assign a *copy* of the key in the key-value pair to the input key (provided by address). The syntax for the iteration is

```
THashTable<SomeKey,SomeValue> kTable = <some hash table>;

// start the iteration
SomeKey kKey;
SomeValue* pkValue = kTable.GetFirst(&kKey);
while ( pkValue )
{
    // ...process kKey and pkValue here...

    // continue the iteration
    pkValue = kTable.GetNext(&kKey);
}
```

To support this mechanism, the hash table must remember where the iteration was on the previous call to GetNext in order to fetch the next key-value pair in the current call to GetNext. Two pieces of information are essential to remember: the current table index and the current list node. The data members m_iIndex and m_pkItem store this information.

The call to GetFirst loops through the table to locate the first nonempty list. When it finds that list, m_iIndex is the table index for it, and m_pkItem is the pointer to the first node in the list. The key and value for this list node are returned by the GetFirst function. On the call to GetNext, the pointer m_pkItem is set to the next node in the list, if any. In the event there is, GetNext simply returns the key and value for that node. If there is no next node, m_iIndex is incremented and the next nonempty list is sought. If one is found, m_pkItem is set to the first node in the list, and the iteration continues. Once all hash table items have been visited, GetNext returns a null pointer, indicating that the iteration has terminated.

Hash Sets

Sets of keys are supported by the THashSet template class. The class is nearly identical in structure to THashTable and uses the TKEY template parameter for set objects, but it does not include the values through a TVALUE template parameter. Although removing the TVALUE dependency in THashTable leads to a perfectly reasonable container class for sets, I have introduced features that allow you to use hash sets in place of hash tables. The main modification is that the TKEY class has members that are used for key comparison *and* has any additional data that normally would be stored by the TVALUE class.

To insert an element into the hash set, use member function

```
TKEY* Insert (const TKEY& rtKey);
```

The hash function is evaluated at the input key to locate the table index corresponding to the key. The linked list at that location is searched for the key. If the key is found, the insertion function returns a pointer to the hash set's version of the key. In this sense, the insertion acts like a find operation. If the key does not exist in the list, a new node is added to the front of the list, the input key is assigned to the node, and a pointer to the hash set's version of the key is returned. In most cases, the assignment operator for TKEY performs a deep copy so that the hash set has an identical copy of the input. In other cases, more complicated semantics may be used. The members of TKEY that are used for key comparisons must be copied, but the other members can be handled as needed. For example, you might have a data member that is a pointer to an array of items. The pointer can be copied to the hash set's version of the key, a shallow copy.

The removal functions

```
bool Remove (const TKEY& rtKey);
void RemoveAll ();
```

behave exactly as those for hash tables.

Searching for a key is performed by calling the member function

```
TKEY* Get (const TKEY& rtKey) const;
```

The hash function is evaluated at the input key to locate the table index corresponding to the key. The linked list at that location is searched for the key. If the key is found, the insertion function returns a pointer to the hash set's version of the key. You may change any values associated with the key. If the key does not exist in the list, the function returns NULL.

Iteration through the elements of the hash set is similar to that for hash tables. The functions that support this are

```
TKEY* GetFirst () const;
TKEY* GetNext () const;
```

The structure of the iteration is

```
THashSet<SomeKey> kSet = <some hash set>;

// start the iteration
SomeKey* pkKey = kSet.GetFirst();
while ( pkKey )
{
    // ...process pkKey here...

    // continue the iteration
    pkKey = kSet.GetNext();
}
```

Lists

The engine has a need for lists, but typically these do not have a lot of nodes. A simply linked list class, TList, suffices. The template parameter class need only implement the default constructor, the copy constructor, and the assignment operator.

The TList class is not very sophisticated. It manages an item from the template parameter class and has a pointer that links to the next list node, if it exists, or is the null pointer if the node is at the end of the list. The member accessors are

```
void SetItem (const T& rtItem);
T& Item ();
const T& GetItem () const;
void SetNext (TList* pkNext);
TList*& Next ();
const TList* GetNext () const;
```

The first three members allow you to set or get the item managed by the node. The last three members support construction of the list itself. The constructor

```
TList (const T& rtItem, TList* pkNext);
```

also supports list construction in the manner shown by the following example:

```
// create the first list node
int i0 = <some integer>;
TList<int>* pkList0 = new TList<int>(i0,NULL);
```

```
// add a node to the front of the list
int i1 = <some integer>;
TList<int>* pkList1 = new TList<int>(i1,pkList0);
```

The TList class does not implement a recursive destructor that deletes the front node of the list and then asks the rest of the list to delete itself. A recursive destructor is problematic for very long lists because you can overflow the program stack. The user is responsible for destroying the list. In the previous example, the list is destroyed by

```
while ( pkList1 )
{
    TList<int>* pkFront = pkList1;
    pkList1 = pkList1->Next();
    delete pkFront;
}
```

My convention is to always dynamically allocate list nodes, but nothing stops you from having nodes on the program stack. The user must manually manage any dynamic allocations and deallocations. For example,

```
// create a circular list, no deallocation necessary
int iQuantity = <number of list items>;
TList<int> kList[iQuantity];
for (int i = 0; i < iQuantity; i++)
{
    kList[i].SetItem(i);
    kList[i].SetNext(&kList[(i+1) % iQuantity]);
    }

// create a list, some destruction required
int i0 = <some integer>;
TList<int>* pkList0 = new TList<int>(i0,NULL);
int i1 = <some integer>;
TList<int> kList1(i1,pkList0);

// destroy the list, kList1 is on the program stack--do not deallocate
delete pkList0;
```

The TList class does not maintain a count of the number of nodes in the list. The member function

```
int GetQuantity () const;
```

iterates through the list and counts the nodes, returning the quantity.

Removal of the front node of a list is simple:

```
TList<int>* pkList = <some list, all dynamically allocated nodes>;
TList<int>* pkFront = pkList;
pkList = pkList->Next();
delete pkFront;
```

Removing any other node requires more work. This operation is usually in conjunction with a search: find a node with a specified item and remove it from the list. Two pointers must be maintained: one pointing to the current node in the search and the other pointing to the previous node. This is necessary so that you can tell the previous node to relink itself to the successor of the current node.

```
TList<T>* pkList = pkYourList;
TList<T>* pkPrev = NULL;
for (/**/; pkList; pkPrev = pkList, pkList = pkList->Next())
{
    if ( pkList->Item() == specified_item )
    {
        // process specified_item before deletion (if necessary)

        // remove the item
        if ( pkPrev )
        {
            // item not at front of list
            pkPrev->Next() = pkList->Next();
        }
        else
        {
            // item at front of list
            pkYourList = pkList->Next();
        }
        pkList->Next() = NULL;
        delete pkList;
    }
}
```

Insertion of a node before or after a node with a specified item has a similar syntax.

Sets

The template class TSet is intended for sets with a small number of elements. The STL class set has a large memory overhead for sets with a large number of elements. In much of the engine code, the set sizes are small, so the sets may be implemented to use less memory. Unlike the STL sets, TSet is unordered. The idea is that if the sets

are small, a linear search is inexpensive. If you have no intent for searching a large set and you know that the elements you will be adding are unique, then TSet is also an ideal class. It has a member function for insertion that does not search to see if the element is already in the set.

The template parameter class must implement the default constructor, the copy constructor, and the assignment operator. The set storage is an array that is managed similarly to the array in TArray. The TSet class has a default constructor, a copy constructor, and an assigment operator. The copy constructor and assignment make deep copies of the input set. The other constructor is

```
TSet (int iMaxQuantity, int iGrowBy);
```

and allows you to specify the initial maximum quantity of elements in the set and an amount to grow by if an insertion requires it. A data member separate from the maximum quantity keeps track of the actual quantity of elements.

Member access is straightforward:

```
int GetMaxQuantity () const;
int GetGrowBy () const;
int GetQuantity () const;
T* GetElements ();
const T* GetElements () const;
T& operator[] (int i);
const T& operator[] (int i) const;
```

The GetElements functions return a pointer to the array storage. You may iterate over the elements of the set, as the following example shows:

```
TSet<T> kSet = <some set>;
const T* akElement = kSet.GetElements();
for (int i = 0; i < kSet.GetQuantity(); i++)
{
    // ... process element akElement[i] ...
}
```

If you want to change any elements during the iteration, you need to use the nonconstant GetElements. The operator[] methods allow you to access an element as shown:

```
TSet<int> kSet = <some set>;
int iElement = kSet[17];
kSet[3] = -5;
```

An assert-and-repair paradigm is used, just like TArray does. In debug mode, an assertion is fired if the input index to the operator is out of range. In release mode,

the input index is clamped to the valid range of indices, $0 \le i \le Q - 1$, where Q is the current quantity of elements in the set.

Insertion of elements into the set is supported by

```
bool Insert (const T& rkElement);
void InsertNoCheck (const T& rkElement);
```

The first function iterates over the current set and tests to see if the input element is already in the set. If it is, the insertion function returns `false`. If it is not, the element is appended to the end of the array storage. A reallocation of the array is performed first, if necessary. The second function does not check for the existence of the input element. It simply appends the input to the end of the array, reallocating the array if necessary. This function is useful if you know that your set will have unique elements, thereby avoiding the cost of searching the set.

The set may be searched to see if it contains a specific element:

```
bool Exists (const T& rkElement);
```

The return value is `true` if and only if the input element is in the set.

Three member functions support removal of elements from a set:

```
bool Remove (const T& rkElement);
void Clear ();
void Clear (int iMaxQuantity, int iGrowBy);
```

The `Remove` method searches the set for the input element. If it does not exist, the function returns `false`. If it does exist, the element is removed from the array by shifting all the later elements, just as was done in the `Remove` method for `TArray`. The last vacated slot is then assigned an element created by the default constructor to induce side effects for cleaning up any complex objects stored by the set. The `Clear` methods assign zero to the quantity, indicating the set is empty. The method with no parameters retains the current maximum quantity and array storage. The array slots that had actual elements are assigned elements created by the default constructor, again to induce side effects for cleaning up complex objects. The `Clear` method with parameters allows you to re-create the set with new maximum quantity and growth parameters. The current array is deallocated, and a new one allocated.

Stacks

The class `TStack` represents a nonresizable stack. In all the engine code, the ability to dynamically resize is never needed. The constructor for the class requires you to specify the maximum number of items that can be pushed on the stack, and an array of that size is allocated for the stack storage. The template parameter class only

needs to implement the default constructor, the copy constructor, and the assignment operator.

The basic stack operations are

```
bool IsEmpty () const;
bool IsFull () const;
void Push (const T& rkItem);
void Pop (T& rkItem);
void Clear ();
bool GetTop (T& rkItem) const;
```

An integer index is used to track the top of the stack. Initially the index is -1, indicating the stack is empty. Method IsEmpty reports this condition. The stack is considered to be full if the index is one less than the maximum quantity, a condition reported by method IsFull. A Push operation places the input item on top of the stack. The top index is incremented first, then the item is copied. A Pop operation copies the item on top of the stack, returns it through the function parameter, and then decrements the top index. The Clear method sets the top index to -1, creating an empty stack. The method GetTop reads the top item on the stack, but does not pop it. The return value is true as long as the stack is not empty, indicating that indeed the top item was read.

Support is provided for iterating over the stack as if it were an array. The methods are shown next along with a typical iteration:

```
int GetQuantity () const;
const T* GetData () const;

TStack<T> kStack = <some stack>;
T* akArray = kStack.GetData();
for (int i = 0; i < kStack.GetQuantity(); i++)
{
    // ... process item akArray[i] ...
}
```

Strings

The String class is not extremely powerful as most string implementations go. It was created for two purposes. First, the class supports streaming of character strings. Character manipulation functions in the standard library prefer null-terminated strings. The String class wraps such strings. Unfortunately, when reading a string that has been written to disk, having to read a character at a time and searching for the null terminator is inefficient, so the class also stores a string length. When a string

is written to disk, the length is written first, followed by the string characters but not the null terminator. To read the string from disk, the length is read first, then the block of characters of that length is read—a much more efficient mechanism. The member functions

```
int GetMemoryUsed () const;
int GetDiskUsed () const;
```

are used by the streaming system, as discussed in Section 2.3.5.

Second, loading of objects from disk requires the loader to know what type of object is being loaded. Knowing this, the loader can create an object and then read data from disk and fill in the object. The type identification is string based. The loader reads the type string from disk and must look up the associated factory function for that object. The type string is used as a key in a hash table; the factory function is used as a value. Thus, the String class implements the member functions required by the TKEY template parameter class in THashTable:

```
String& operator= (const String& rkString);
bool operator== (const String& rkString) const;
bool operator!= (const String& rkString) const;
operator unsigned int () const;
```

2.1.2 ENCAPSULATING PLATFORM-SPECIFIC CONCEPTS

The encapsulation amounts to providing an abstract set of functions that correspond to the platform services, where the specific details are hidden from the user. Each platform must implement the functions exposed through the abstraction. We are *not* using the inheritance mechanism of an object-oriented language. Inheritance is the process of deriving a class from a base class and implementing any of the virtual functions that are in the base class. Think of this as adding a class *on top of the abstract layer* defined by the base class. Implementing an abstract layer for specific platforms is quite the opposite. The implementation is *behind the abstract layer,* and the abstract layer need not have virtual functions. The abstract interface is common to all platforms, but the source files for a platform are compiled only on that platform. The abstract system layer in Wild Magic is the class System, found in the files Wm3System.(h,inl,cpp).

It is nearly impossible not to expose a small amount of platform-specific information to the engine and applications. The system header file contains the block

```
#if defined(WIN32)
#include "Wm3WinSystem.h"
#elif defined(__MACOS__)
#include "Wm3MacSystem.h"
```

```
#else
#include "Wm3LnxSystem.h"
#endif
```

to expose such details. On a given platform, the appropriate preprocessor symbol is defined to give access to a platform-specific header file. Currently those include a PC with Microsoft Windows 2000/XP (Wm3WinSystem.h), a Macintosh running Mac OS X (Wm3MacSystem.h), and a PC with some variant of Linux (Wm3LnxSystem.h). A source file of the same name, but with the cpp extension, is provided for each platform and contains any implementations that are needed on the platform.

An example that shows a need to expose details is the following. Sometimes compilers that are noncompliant with ANSI standards require conditional compilation for various syntactic issues. This was particularly true for *nearly all* compilers regarding explicit instantiation of template classes that have static data members. The static data members must use specialized instantiation on most platforms, but some platforms want the specialization to occur before the explicit class instantiation, while others want it after. Yet other compilers have issues regarding the syntax on how global scope template operators are instantiated. When these problems show up in the engine source code, you will see conditional compilation involving the symbols WIN32, __MACOS__, or other symbols that identify a certain compiler being used (for example, CodeWarrior Metrowerks and its symbol __MWERKS__).

Another example is on a Microsoft Windows machine when you want to create dynamic link libraries. The classes in the engine require qualification by either __declspec(dllexport) or __declspec(dllimport). The symbol WM3_ITEM hides these qualifiers. What the symbol expands to on each platform is governed by the symbol's implementation in the platform-specific header files.

2.1.3 ENDIANNESS

One major function of the encapsulation is to hide byte order, or *endianness*, when reading or writing files. A PC running Microsoft Windows or Linux uses *little endian* order, but a Macintosh uses *big endian* order—the bytes for a multibyte quantity are stored in memory in the opposite order of those on the PC. The streaming system in the graphics engine stores all native quantities in little endian order. To read or write files on a Macintosh requires reversing the order of the bytes. The System functions supporting this are

```
class System
{
public:
    static void SwapBytes (int iSize, void* pvValue);
    static void SwapBytes (int iSize, int iQuantity,
        void* pvValue);
```

```
static void EndianCopy (int iSize, const void* pvSrc,
    void* pvDst);
static void EndianCopy (int iSize, int iQuantity,
    const void* pvSrc, void* pvDst);
}
```

The first function swaps iSize bytes in the memory pointed to by pvValue. The second function swaps iSize bytes in each of the iQuantity elements of the array pvValue. The last two functions copy with swapping, but the swap occurs only if necessary. The third function copies iSize bytes from the source pvSrc to the destination pvDst, but swaps the bytes along the way. The fourth function has similar behavior applied to an array of items.

The Wild Magic streaming system makes calls to EndianCopy. Since the graphics engine stores all native quantities in little endian order, the Microsoft Windows platform EndianCopy functions just reduce to a memcpy call. However, on the Macintosh, the swapping is implemented during the copying phase.

2.1.4 SYSTEM TIME

Many applications need to keep track of time, whether for sequencing purposes or for simulation. Although the standard programming libraries provide functions to manage a 32-bit clock, the number of bits is not enough and the resolution too coarse to satisfy the needs of real-time applications. Operating systems and main processors likely have support for a 64-bit clock, but direct access to this clock cannot be done in a platform-independent manner. The details must be encapsulated to hide the dependencies from the application layer. The System member function to support this is

```
class System
{
public:
    static double GetTime ();
};
```

The returned double-precision number is 64 bits. Although this is a floating-point value, if the need arises the return value can be bit manipulated as if it were a 64-bit integer. The application must necessarily understand that the time is bit manipulated and parse it accordingly.

As an example, on a 32-bit Microsoft Windows system, GetTime is implemented in the file Wm3WinSystem.cpp and uses the operating system type LARGE_INTEGER that represents a 64-bit integer. The platform-dependent functions QueryPerformanceFrequency and QueryPerformanceCounter are used to create a 64-bit value representing the current time.

2.1.5 FILE HANDLING

The streaming system for scene graph saving to disk or loading to memory requires basic file handling. Specifically, files must be opened and closed. Data is either read, written, or appended. Although file operations of these types are supported in C and C++ in a platform-independent manner, it is convenient to encapsulate the operations in the System class. The member functions are

```
class System
{
public:
    static bool Load (const char* acFilename, char*& racBuffer,
        int& riSize);
    static bool Save (const char* acFilename,
        const char* acBuffer, int iSize);
    static bool Append (const char* acFilename, char* acBuffer,
        int iSize);
};
```

The specified files are assumed to contain binary data. Some operating systems prefer to distinguish text files from binary files in order to apply conversions regarding end-of-line and end-of-file characters. The choice of dealing with only binary files is to avoid portability problems whereby implicit conversions occur.

The Load operation determines how many bytes are in the file and returns the amount in riSize. A character buffer racBuffer is allocated to contain that number of bytes. The returned Boolean value is true if the load is successful, in which case the outputs racBuffer and riSize are valid. If the returned value is false, one of the following conditions has occurred: The file does not exist, the file cannot be opened for reading (the file attributes might not allow this), or the number of bytes read is different than what the operating system reported for the file. The latter condition is not expected to occur, so a developmental assertion is triggered in the slim chance the condition fails.

The Save operation writes the input buffer to disk. The buffer pointer acBuffer is required to be nonnull and the iSize value is required to be positive. The function cannot determine if the buffer has the correct number of bytes; the caller has the responsibility of ensuring it does. The returned Boolean value is true if the save is successful. If the returned value is false, one of the following conditions has occurred: The input buffer is null or the size is nonpositive, the file cannot be opened for writing (the file might exist and be set to read-only), or the number of bytes written is different than what was requested. The invalidity of the inputs is trapped with a developmental assertion. The incorrect number of bytes written is not expected to occur, so a developmental assertion is triggered in the slim chance the condition fails.

The Append operation is identical in structure to Save, except that the file is opened for appending. The input buffer is written at the end of an already existing file. If the file does not exist, it is created and the buffer is written.

The main client of the System file operations is class Stream. However, the file operations are simple to use in other situations as they arise.

2.1.6 MEMORY ALLOCATION AND DEALLOCATION

This is probably not a topic you would expect to see regarding encapsulation of platform-dependent code. Both the C and C++ languages provide basic memory management functions. In C we have malloc and free; in C++ we have new and delete. All of these functions are portable; however, portability is not the important issue in this section.

Consider implementing a graphics engine on a device less powerful than a desktop computer. The current-day example is an embedded device that contains an ARM processor—cell phones, handheld devices, and portable data assistants. The costs of memory allocation and deallocation can become noticeable if the number of allocations and deallocations is large.

Two-Dimensional Arrays

The prototypical case is allocation and deallocation of a two-dimensional array. The standard mechanism for doing this is illustrated next for a two-dimensional array of integers. Moreover, we wish to zero the memory values.

```
// allocation
int iNumRows = <number of rows>;
int iNumCols = <number of columns>;
int* aaiArray = new Type[iNumRows];
for (iRow = 0; iRow < iNumRows; iRow++)
{
    aaiArray[iRow] = new int[iNumCols];
    memset(aaiArray[iRow],0,iNumCols*sizeof(int));
}

// deallocation
for (iRow = 0; iRow < iNumRows; iRow++)
{
    delete[] aaiArray[iRow];
}
delete[] aaiArray;
```

The code is straightforward, but a closer look is in order. If R is the number of rows in the array, an allocation makes $R + 1$ calls to new, and a deallocation makes $R + 1$ calls to delete. On a device with limited computational power, the excessive number of calls can be a performance problem because of the overhead costs associated with a memory manager. Additionally, R calls to memset are made.

Consider now an alternative for allocation and deallocation and memory initialization. The array elements are stored in a one-dimensional array in row-major order. If the two-dimensional array A has R rows and C columns, the element A[y][x] is stored in the one-dimensional array B as B[x+C*y]:

```
// allocation
int iNumRows = <number of rows>;
int iNumCols = <number of columns>;
int iNumElements = iNumRows * iNumCols;
int* aaiArray = new int*[iNumRows];
aaiArray[0] = new int[iNumElements];
memset(aaiArray,0,iNumElements*sizeof(int));
for (iRow = 1; iRow < iNumRows; iRow++)
{
    aaiArray[iRow] = &aaiArray[0][iNumCols*iRow];
}

// deallocation
delete[] aaiArray[0];
delete[] aaiArray;
```

The number of calls to new is two, to delete is two, and to memset is one, *regardless of the number of rows R*. This is quite a savings in computational time because of the low overhead costs for the memory manager. Moreover, the array is stored in a single block of contiguous memory, so chances are that the memset will be cache friendly.

The latter method is superior to the former. To avoid replicating the allocation and deallocation code throughout an engine and applications, these are encapsulated in the System class as template member functions:

```
class System
{
public:
    template <class T> static void Allocate (int iCols, int iRows,
        T**& raatArray);
    template <class T> static void Deallocate (T**& raatArray);
};
```

The allocated array is returned through a parameter in the function signature rather than as the function return value. This is a requirement for the compiler to

correctly expand the template function; the type T must occur somewhere in the function signature. The deallocation function sets the array pointer to NULL after deletion, which helps trap bugs due to dangling pointers.

Three-Dimensional Arrays

A similar analysis applies to allocation and deallocation of a three-dimensional array, with optional initialization. The standard mechanism is

```
// allocation
int iNumSlices = <number of slices>;
int iNumRows = <number of rows>;
int iNumCols = <number of columns>;
int* aaaiArray = new int**[iNumSlices];
for (iSlice = 0; iSlice < iNumSlices; iSlice++)
{
    aaaiArray[iSlice] = new int*[iNumRows];
    for (iRow = 0; iRow < iNumRows; iRow++)
    {
        aaaiArray[iSlice][iRow] = new int[iNumCols];
        memset(aaaiArray[iSlice][iRow],0,iNumCols*sizeof(int));
    }
}

// deallocation
for (iSlice = 0; iSlice < iNumSlices; iSlice++)
{
    for (iRow = 0; iRow < iNumRows; iRow++)
    {
        delete[] aaaiArray[iSlice][iRow];
    }
    delete[] aaaiArray[iSlice];
}
delete[] aaaiArray;
```

If S is the number of slices and R is the number of rows, then allocation requires $S(R + 1)$ calls to new and SR calls to memset. Deallocation requires $S(R + 1)$ calls to delete.

The alternative stores the three-dimensional array elements in a one-dimensional array in lexicographical order. If the three-dimensional array A has S slices, R rows, and C columns, and if B is the one-dimensional array, the element A[z][y][x] is stored as B[x+C*(y+R*z)]:

```
// allocation
int iNumSlices = <number of slices>;
int iNumRows = <number of rows>;
int iNumCols = <number of columns>;
int iNumElements = iNumSlices * iNumRows * iNumCols;
int* aaaiArray = new int**[iNumSlices];
aaaiArray[0] = new int*[iNumSlices*iNumRows];
aaaiArray[0][0] = new int[iNumElements];
memset(aaaiArray[0][0],0,iNumElements*sizeof(int));
for (iSlice = 0; iSlice < iNumSlices; iSlice++)
{
    aaaiArray[iSlice] = &aaaiArray[0][iNumRows*iSlice];
    for (iRow = 0; iRow < iNumRows; iRow++)
    {
        aaaiArray[iSlice][iRow] = &aaaiArray[0][0][
            iNumCols*(iRow+iNumRows*iSlice)];
    }
}

// deallocation
delete[] aaaiArray[0][0];
delete[] aaaiArray[0];
delete[] aaaiArray;
```

The number of calls to new is three, to delete is three, and to memset is one, regardless of the array dimensions. Once again this is a savings in computational time because of the low overhead costs for the memory manager, and the array is stored in a single block of contiguous memory, a cache-friendly situation.

To avoid replicating the allocation and deallocation code throughout an engine and applications, these are encapsulated in the System class as template member functions:

```
class System
{
public:
    template <class T> static void Allocate (int iCols, int iRows,
        int iSlices, T***& raaatArray);

    template <class T> static void Deallocate (T***& raaatArray);
};
```

The allocated array is returned through a parameter in the function signature rather than as the function return value. This is a requirement for the compiler to

correctly expand the template function; the type T must occur somewhere in the function signature. The deallocation function sets the array pointer to NULL after deletion, which helps trap bugs due to dangling pointers.

2.2 THE MATHEMATICS SYSTEM

Any engine that deals with computer graphics and geometry must necessarily have a subsystem for mathematics, vector algebra, and matrix algebra. At the most basic level, C/C++ has a standard mathematics library to support common functions such as sin, cos, sqrt, and so on. Usually graphics engines rely on the single-precision float data type, so mathematics functions for this type suffice. However, physics engines sometimes need double precision for accurate results. Mathematics functions for 8-byte double are also necessary. The mathematics subsystem should provide for both, as discussed in Section 2.2.1.

For real-time engines, there is also a need for implementations of standard mathematics functions other than the ones provided in the standard mathematics library for C/C++. The alternatives are designed for fast execution at the expense of accuracy. The advent of modern processors with extended instructions to speed up common mathematics alleviates the need for some of these, such as a fast inverse square root, but Wild Magic includes implementations anyway for platforms whose processors do not have such power. Section 2.2.2 provides a summary of a few such fast functions.

Sections 2.2.3, 2.2.4, and 2.2.5 are on the basic mathematics library that all game programmers are fond of building. Classes are provided for dimensions 2, 3, and 4. Dimension 4 is mainly available to support homogeneous points, vectors, and matrices. The geometry of vectors and matrices is not complete without a discussion of lines and planes; see Section 2.2.6.

The last topic, Section 2.2.7, is the implementations for colors, both RGB (red-green-blue) and RGBA (red-green-blue-alpha). The classes are simple, treat all color channels as floating-point values between 0 and 1, and have some support for clamping and scaling (useful for software rendering).

2.2.1 BASIC MATHEMATICS FUNCTIONS

Support is provided for the basic mathematics functions found in the standard C/C++ library, both for float and double. Rather than duplicate code, templates are used where the template parameter is the type of floating-point number. Unlike the usual construction of templates, where the implementations are exposed to the application, the implementations are hidden from the engine. The main library is compiled so that the templates for float and double are *explicitly instantiated*. The manner in which templates are explicitly instantiated is part of the ANSI standards

for compilers, but unfortunately not all compilers agree on the correct syntax for the code. Neither do they agree on how to specialize the instantiations for static template data members nor on the syntax for global scope operator functions. More on this issue later in the section.

The Math template class encapsulates many of the standard functions. A partial listing of the class definition is the following:

```
template <class Real>
class Math
{
public:
    static Real ACos (Real fValue);
    static Real ASin (Real fValue);
    static Real ATan (Real fValue);
    static Real ATan2 (Real fY, Real fX);
    static Real Ceil (Real fValue);
    static Real Cos (Real fValue);
    static Real Exp (Real fValue);
    static Real FAbs (Real fValue);
    static Real Floor (Real fValue);
    static Real FMod (Real fX, Real fY);
    static Real InvSqrt (Real fValue);
    static Real Log (Real fValue);
    static Real Pow (Real fBase, Real fExponent);
    static Real Sin (Real fValue);
    static Real Sqr (Real fValue);
    static Real Sqrt (Real fValue);
    static Real Tan (Real fValue);
};
```

The InvSqrt function is not standard, but normalization of a vector (division by the length) is common enough that a wrapper is convenient. In this case the implementation is just InvSqrt(x) = 1/Sqrt(x). The Sqr function is also a convenience for Sqr(x) = x*x.

The standard mathematics libraries tend to supply us with two forms of each function. For example, the sine function has the prototype

```
double sin (double dAngle);
```

To use this in an environment based on float, the following is required:

```
float fAngle = <some angle in radians>;
float fResult = (float)sin((float)fAngle);
```

To avoid the verbosity of the expression, the libraries provide alternate versions. In the case of the sine function,

```
float fResult = sinf(fAngle);
```

Unfortunately, sometimes the alternate versions are not provided on a platform. For example, g++ 3.x on Sun Solaris does not have the alternate versions, requiring us to avoid using these functions. The use of encapsulation of the mathematics functions in a template class has the added benefit of allowing us to provide, in effect, the alternate versions. For example, the implementation of the sine function is

```
template <class Real>
Real Math<Real>::Sin (Real fValue)
{
    return (Real)sin((double)fValue);
}
```

A handful of common constants are also wrapped into the template.

```
template <class Real>
class Math
{
public:
    static const float EPSILON;
    static const float MAX_REAL;
    static const float PI;
    static const float TWO_PI;
    static const float HALF_PI;
    static const float INV_PI;
    static const float INV_TWO_PI;
    static const float DEG_TO_RAD;
    static const float RAD_TO_DEG;
};
```

The value EPSILON is for convenience only and is set to the smallest floating-point value for which 1 + EPSILON == 1, either FLT_EPSILON or DBL_EPSILON. Similarly, MAX_REAL is set to the largest floating-point number, either FLT_MAX or DBL_MAX.

Mathematical Constants

The constants involving PI are computed during program initialization. For example, in Wm3Math.cpp,

```
template<> const float Math<float>::PI = (float)(4.0*atan(1.0));
template<> const double Math<double>::PI = 4.0*atan(1.0);
```

The reason for doing this is to try to maintain as much precision as possible for the numbers and to maintain consistency of the values across files. As an example of inconsistency, I have seen code distributions with one file containing

```
#define PI 3.141259
```

and another file containing

```
#define PI 3.14126
```

Rather than trying to remain consistent manually with defined quantities throughout the code base, a single value generated by a mathematics function call automates the process. The warning, though, is that the calculation of Math<Real>::PI occurs *before* main executes. If you have another function that executes before main does, and that function tries to use the value Math<Real>::PI before it is initialized, the value is zero (the case for static data in general). Be careful about accessing any quantity that is initialized before main executes.

The constant DEG_TO_RAD is a multiplier that converts radians to degrees. The constant RAD_TO_DEG converts from degrees to radians. Be careful in code that uses trigonometric functions. The inputs are assumed to be in radians, not degrees!

The template wrappers also allow us to protect against some unwanted side effects. For example, the inverse cosine function acos takes a floating-point input that should be in the interval $[-1, 1]$. If an input is outside the interval, the function silently returns NaN (Not a Number). This can occur more frequently than you would like. Numerical round-off errors can cause calculations of the input value to be just slightly larger than 1 or just slightly smaller than -1. The wrapper can clamp the input to avoid generating a silent NaN. For example,

```cpp
template <class Real>
Real Math<Real>::ACos (Real fValue)
{
    if ( -(Real)1.0 < fValue )
    {
        if ( fValue < (Real)1.0 )
            return (Real)acos((double)fValue);
        else
            return (Real)0.0;
    }
    else
    {
        return PI;
    }
}
```

The implementation clamps the input value to make sure acos is passed a value in the interval $[-1, 1]$.

A few convenience functions are provided by class Math:

```
template <class Real>
class Math
{
public:
    static int Sign (int iValue);
    static Real Sign (Real fValue);
    static Real UnitRandom (unsigned int uiSeed = 0);
    static Real SymmetricRandom (unsigned int uiSeed = 0);
    static Real IntervalRandom (Real fMin, Real fMax,
        unsigned int uiSeed = 0);
};
```

The Sign functions return $+1$ if the input is positive, 0 if the input is 0, or -1 if the input is negative. The other three functions involve uniform random number generation using srand (for seeding) and rand. UnitRandom returns a random number in the interval $[0, 1)$ (0 is inclusive, 1 is excluded). SymmetricRandom returns a random number in the interval $[-1, 1)$. IntervalRandom returns a random number in the interval [min, max). The seeding with srand occurs only when the input seed is positive.

2.2.2 FAST FUNCTIONS

Trigonometric functions are common in graphics and physics applications. If there is a need for speed, calls to the standard mathematics library functions can be substituted with calls to faster functions that exchange accuracy for speed:

```
template <class Real>
class Math
{
public:
    static float FastSin0 (float fAngle);
    static float FastSin1 (float fAngle);
    static float FastCos0 (float fAngle);
    static float FastCos1 (float fAngle);
    static float FastTan0 (float fAngle);
    static float FastTan1 (float fAngle);
    static float FastInvSin0 (float fValue);
    static float FastInvSin1 (float fValue);
    static float FastInvCos0 (float fValue);
```

```
      static float FastInvCos1 (float fValue);
      static float FastInvTan0 (float fValue);
      static float FastInvTan1 (float fValue);
      static float FastInvSqrt (float fValue);
};
```

The fast trigonometric and inverse trigonometric functions are all based on approximations that appear in [AS65]. The item numbers from the reference are provided for convenient lookup. The approximations are stated here without proof (as is the case in the reference). Some of the error bounds were verified numerically, with a slight bit more precision reported here than in the reference.

The experimental results reported herein are using float functions on a PC with an AMD 2.0 GHz processor running a project in release mode. See the test application TestFastMath.

Fast approximations to the sine function are implemented by Math::FastSin0 and Math::FastSin1. The function FastSin0(x) is based on the approximation 4.3.96, which requires the input to satisfy $x \in [0, \pi/2]$,

$$\frac{\sin(x)}{x} = 1 - 0.16605\,x^2 + 0.00761\,x^4 + \epsilon(x). \tag{2.1}$$

The error term is bounded by $|\epsilon(x)| \leq 1.7 \times 10^{-4}$. The speedup over sin is 4.0.

The function FastSin1(x) is based on the approximation 4.3.97, which requires the input to satisfy $x \in [0, \pi/2]$,

$$\frac{\sin(x)}{x} = 1 - 0.1666666664\,x^2 + 0.0083333315\,x^4 - 0.0001984090\,x^6$$

$$+ 0.0000027526\,x^8 - 0.0000000239\,x^{10} + \epsilon(x). \tag{2.2}$$

The error term is bounded by $|\epsilon(x)| \leq 1.9 \times 10^{-8}$. The speedup over sin is about 2.8.

Fast approximations to the cosine function are implemented by Math::FastCos0 and Math::FastCos1. The function FastCos0(x) is based on the approximation 4.3.98, which requires the input to satisfy $x \in [0, \pi/2]$,

$$\cos(x) = 1 - 0.49670\,x^2 + 0.03705\,x^4 + \epsilon(x). \tag{2.3}$$

The error term is bounded by $|\epsilon(x)| \leq 1.2 \times 10^{-3}$. The speedup over cos is about 4.5.

The function FastCos1(x) is based on the approximation 4.3.99, which requires the input to satisfy $x \in [0, \pi/2]$,

$$\cos(x) = 1 - 0.4999999963\,x^2 + 0.0416666418\,x^4 - 0.0013888397\,x^6$$

$$+ 0.0000247609\,x^8 - 0.0000002605\,x^{10} + \epsilon(x). \tag{2.4}$$

The error term is bounded by $|\epsilon(x)| \leq 6.5 \times 10^{-9}$. The speedup over cos is about 2.8.

Fast approximations to the tangent function are implemented by `Math::FastTan0` and `Math::FastTan1`. The function `FastTan0(x)` is based on the approximation 4.3.100, which requires the input to satisfy $x \in [0, \pi/4]$,

$$\frac{\tan(x)}{x} = 1 + 0.31755\, x^2 + 0.20330\, x^4 + \epsilon(x). \qquad (2.5)$$

The error term is bounded by $|\epsilon(x)| \leq 8.1 \times 10^{-4}$. The speedup over tan is about 5.7.

The function `FastTan1(x)` is based on the approximation 4.3.101, which requires the input to satisfy $x \in [0, \pi/2]$,

$$\frac{\tan(x)}{x} = 1 + 0.3333314036\, x^2 + 0.1333923995\, x^4 + 0.0533740603\, x^6$$

$$+ 0.0245650893\, x^8 + 0.0029005250\, x^{10}$$

$$+ 0.0095168091\, x^{12} + \epsilon(x). \qquad (2.6)$$

The error term is bounded by $|\epsilon(x)| \leq 1.9 \times 10^{-8}$. The speedup over tan is about 3.3.

Fast approximations to the inverse sine function are implemented by `Math::FastInvSin0` and `Math::FastInvSin1`. The function `FastInvSin0(x)` is based on the approximation 4.4.45, which requires the input to satisfy $x \in [0, 1]$,

$$\arcsin(x) = \frac{\pi}{2} - \sqrt{1 - x}\, (1.5707288 - 0.2121144\, x$$

$$+ 0.0742610\, x^2 - 0.0187293\, x^3) + \epsilon(x). \qquad (2.7)$$

The error term is bounded by $|\epsilon(x)| \leq 6.8 \times 10^{-5}$. The speedup over asin is about 7.5.

The function `FastInvSin1(x)` is based on the approximation 4.4.46, which requires the input to satisfy $x \in [0, 1]$,

$$\arcsin(x) = \frac{\pi}{2} - \sqrt{1 - x}\, (1.5707963050 - 0.2145988016\, x + 0.0889789874\, x^2$$

$$- 0.0501743046\, x^3 + 0.0308918810\, x^4 - 0.01708812556\, x^5$$

$$+ 0.0066700901\, x^6 - 0.0012624911\, x^7) + \epsilon(x). \qquad (2.8)$$

The error term is bounded by $|\epsilon(x)| \leq 1.4 \times 10^{-7}$. The speedup over asin is about 5.6.

Fast approximations to the inverse cosine function are implemented by `Math::FastInvCos0` and `Math::FastInvCos1`. The function `FastInvCos0(x)` uses the identity $\arccos(x) = \pi/2 - \arcsin(x)$ and uses the approximation `FastInvSin0(x)` for $\arcsin(x)$. The error term is bounded by $|\epsilon(x)| \leq 6.8 \times 10^{-5}$. The speedup over acos is about 8.0.

The function `FastInvCos1(x)` uses the identity $\arccos(x) = \pi/2 - \arcsin(x)$ and uses the approximation `FastInvSin1(x)` for $\arcsin(x)$. The error term is bounded by $|\epsilon(x)| \leq 1.3 \times 10^{-7}$. The speedup over `acos` is about 5.8.

Fast approximations to the inverse tangent function are implemented by `Math::FastInvTan0` and `Math::FastInvTan1`. The function `FastInvTan0(x)` is based on the approximation 4.4.47, which requires the input to satisfy $x \in [-1, 1]$,

$$\arctan(x) = 0.9998660\,x - 0.3302995\,x^3 + 0.1801410\,x^5 - 0.0851330\,x^7$$

$$+ 0.0208351\,x^9 + \epsilon(x). \tag{2.9}$$

The error term is bounded by $|\epsilon(x)| \leq 1.2 \times 10^{-5}$. The speedup over `atan` is about 2.8.

The function `FastInvTan1(x)` is based on the approximation 4.4.49, which requires the input to satisfy $x \in [-1, 1]$,

$$\frac{\arctan(x)}{x} = 1 - 0.3333314528\,x^2 + 0.1999355085\,x^4 - 0.1420889944\,x^6$$

$$+ 0.1065626393\,x^8 - 0.0752896400\,x^{10} + 0.0429096138\,x^{12}$$

$$- 0.0161657367\,x^{14} + 0.0028662257\,x^{16} + \epsilon(x). \tag{2.10}$$

The error term is bounded by $|\epsilon(x)| \leq 2.3 \times 10^{-8}$. The speedup over `atan` is about 1.8.

The function `Math::FastInvSqrt` implements the fast computation of an inverse square root by formulating the calculation as a root-finding problem, and then using one iterate (or more) of Newton's method. Specifically, given $x > 0$, compute $y = 1/\sqrt{x}$. Rewrite this equation as

$$F(y) = \frac{1}{y^2} - x = 0.$$

Given an initial guess y_0, Newton's iterates are

$$y_{n+1} = y_n - \frac{F(y_n)}{F'(y_n)} = y_n(1.5 - 0.5xy_n^2), \qquad n \geq 0.$$

The technical challenge is to select a good initial guess y_0, as is true for any problem using Newton's method.

An interesting hack for this was posted to Usenet and has an undetermined history. No explanation for the hack was provided in the post, so I tried to reverse-engineer the code and produce the algorithm. This process is described in [Ebe02] and applies to the `float` function. Another online document, [Lom03], provides more detail about the choice of a particular magic constant, but the details are quite mathematical. This document does provide a magic constant for the `double` function. The implementations are

```
float Mathf::FastInvSqrt (float fValue)
{
    float fHalf = 0.5f*fValue;
    int i    = *(int*)&fValue;
    i = 0x5f3759df - (i >> 1);
    fValue = *(float*)&i;
    fValue = fValue*(1.5f - fHalf*fValue*fValue);
    return fValue;
}

double Mathd::FastInvSqrt (double dValue)
{
    double dHalf = 0.5*dValue;
    long long i  = *(long long*)&dValue;
    i = 0x5fe6ec85e7de30da - (i >> 1);
    dValue = *(double*)&i;
    dValue = dValue*(1.5 - dHalf*dValue*dValue);
    return dValue;
}
```

The aforementioned documents describe how the magic constants in the third lines of the functions come about. The fourth lines provide the initial guess y_0. The fifth lines are for one iteration of Newton's method to produce y_1, the value that approximates the inverse square root.

2.2.3 VECTORS

The engine has classes for vectors in 2, 3, and 4 dimensions, named Vector2, Vector3, and Vector4, respectively. Two main goals must be achieved in designing these classes. One of these goals is clearly having support for the algebraic and geometric operations that are associated with vectors. These operations may be easily implemented regardless of the two standard class data member layouts for vector coordinates: a separate data member per coordinate or an array containing all coordinates. However, the data member layout itself is an important issue in light of the discussion in Section 1.2 about how to provide the vertices and attributes to the graphics APIs, so I will discuss this issue first.

Memory Layout

Consider the class for vectors in two dimensions. A choice must be made between two data member layouts:

```
class Vector2a
{
public:
    float x, y;

    operator float* () { return (float*)this; }
};

class Vector2b
{
public:
    float& X() { return m_afTuple[0]; }
    float& Y() { return m_afTuple[1]; }

    operator float* () { return (float*)this; }

private:
    float m_afTuple[2];
};
```

Vector2a makes its members public for convenience since there are no side effects for reading or writing the members. Vector2b makes its members private to avoid accidental use of out-of-range indices into the tuple array.

Both classes have an implicit conversion to a float* pointer. Such conversions are generally dangerous, so you need to be careful in providing them. The main issue is about the memory layout that the compiler generates for the classes. In C++, any class that has virtual functions must have, as part of an object's memory layout, a pointer to a *virtual function table*. The table supports derivation and the possibility that a derived class implements a virtual function from the base class. The entries in the table are the virtual function pointers specific to the class. The table is used at run time to determine the correct function to call when the object is accessed polymorphically. For example,

```
class Base
{
public:
    Base (int iFQ)
    {
        m_iFQ = iFQ;
        m_afFArray = new float[m_iFQ];
    }

    virtual ~Base ()
```

```
        {
            delete[] m_pfFArray;
        }

        virtual void SetToZero ()
        {
            memset(m_afFArray,0,m_iFQ*sizeof(float));
        }

        virtual void DoSomethingSilly () const
        {
            m_afFValue[0] += 1.0f;
        }

protected:
    int m_iFQ;
    float* m_afFArray;
};

class Derived : public Base
{
public:
    Derived (int iFQ, int iIQ)
        :
        Base(iFQ)
    {
        m_iIQ = iIQ;
        m_piIValue = new int[m_iIQ];
    }

    virtual ~Derived ()
    {
        delete[] m_piIValue;
    }

    virtual void SetToZero ()
    {
        Base::SetToZero();
        memset(m_piIArray,0,m_iIQ*sizeof(int));
    }

    virtual

protected:
```

```
    int m_iIQ;
    int* m_piIArray;
};
```

The base class has a virtual function table with three entries:

```
Base::VFT[3] =
{
    &~Base(),
    &Base::SetToZero,
    &Base::DoSomethingSilly
};
```

The table may be thought of as static class data (a single instance) and is accessible by all Base objects.

The memory layout for a single object of the Base class is

```
Base::VFT*
int
int*
```

The derived class has a virtual function table, also with three entries:

```
Derived::VFT[3] =
{
    &~Derived(),
    &Derived::SetToZero,
    &Base::DoSomethingSilly
};
```

The last table entry is the same as in the Base class since the Derived class does not override with its own implementation. The memory layout for a single object of the Derived class is

```
Derived::VFT*
int
float*
int
int*
```

The following code block creates a Derived object, but keeps hold on it by a Base class pointer:

```
Base* pkObject = new Derived(17,10);
pkObject->SetToZero();        // calls Derived::SetToZero
pkObject->DoSomethingSilly(); // calls Base::DoSomethingSilly
delete pkObject;              // calls ~Derived
```

Even though pkObject is a pointer of type Base*, the compiler generates code to look up in the object's virtual function table Derived::VFT the correct SetToZero to call. In order for this to happen, the object itself must provide a way to access the correct table—thus the need to store a pointer to the table. On a 32-bit system, the following numbers are reported:

```
int iBSize = sizeof(Base);    // iBSize is 12
int iDSize = sizeof(Derived); // iDSize is 20
```

The Base class requires 4 bytes for m_iFQ, 4 bytes for m_afFArray, and 4 bytes for the pointer to the virtual function table. The Derived class requires an additional 4 bytes for m_iIQ and 4 bytes for m_aiIArray.

How does this relate back to Vector2a and Vector2b? If you chose to have virtual functions in these classes with the intent of deriving classes from them, the memory layout contains the virtual function table in addition to the floating-point coordinates. If you had a virtual function table and you tried something like

```
class Vector2a
{
public:
    virtual ~Vector2a ();  // virtual destructor for derivation
    float x, y;
    operator float* () { return (float*)this; }
};

void ProcessThisVector (float* afCoordinates)
{
    float fX = afCoordinates[0];
    float fY = afCoordinates[1];
    // do something with fX, fY, ...
};

// The memory layout of Vector2a causes this not to work correctly.
Vector2a kV = <some vector>;
ProcessThisVector(kV);
```

you will not get the results you want. The implicit conversion from kV to a float* is executed, so the address of kV is what is passed as afCoordinates. The dereference

afCoordinates[0] will actually fetch the first 4 bytes of the virtual function table (a function pointer) and interpret it as a floating-point number. Therefore, fX effectively stores garbage, and the value fY stores kV.x. The example might seem contrived, but in fact when you provide an array of float to the graphics API as an attempt to reinterpret a collection of vertices as a contiguous collection of floating-point values, you need to worry about the memory layout and unintended consequences.

You might consider different implementations of the implicit conversion:

```
class Vector2a
{
public:
    virtual ~Vector2a ();  // virtual destructor for derivation
    float x, y;
    operator float* () { return &x; }
};

// The conversion bypasses the 'this' pointer and behaves as you
// expect (maybe).
Vector2a kV = <some vector>;
ProcessThisVector(kV);

void ProcessThisVectorArray (int iNumVertices,
    float* afCoordinates)
{
    for (int i = 0; i < iNumVertices; i++)
    {
        float fX = afCoordinates[2*i];
        float fY = afCoordinates[2*i+1];
        // do something with fX, fY, ...
    }
};

// This assumes akArray has (x[0],y[0],x[1],y[1],...),
// which it does not.
Vector2a* akArray = <some array of vectors>;
ProcessThisVectorArray((float*)akArray);
```

In the array processing, because Vector2a has a virtual function (the class destructor), an object's memory layout has a pointer to the virtual function table followed by two floating-point values: vft*, float, float. The dereferencing of afCoordinates in ProcessThisVectorArray fails, just as it did in the earlier example. The design choice that classes Vector2a and Vector2b have no virtual functions is solely intended (1) to allow a single object to be safely typecast via an implicit conversion to a pointer to an array of two float values and (2) to allow an array of objects to be safely typecast to

a pointer to an array of float values whose number of entries is twice the number of objects. Various other classes in Wild Magic also make this choice, namely, matrices, quaternions, and colors. These all have implicit operator conversions to pointers to float.

A long story, but it is still not complete. In the previous example for Vector2a, where the conversion operator returned the address of member x, the comment before the call to ProcessThisVector indicates that the conversion "behaves as you expect (maybe)." In fact, this is true on a 32-bit system with a standard compiler setting to align data on 32-bit boundaries. That is, the x and y values are each 32 bits and contiguous in memory. However, on a 64-bit system where a compiler is configured to align data on 64-bit boundaries, x and y will not be contiguous in memory; there will be a 32-bit gap between the two. Once again the implicit conversion is incorrect!

Even on a 32-bit system, alignment issues should be of concern. Recall that the C language does not guarantee how members of a struct are aligned. Similarly, C++ does not guarantee how members of a class are aligned. For example, standard compiler settings for

```
class MyClass1 { public: int i; char c; float f; };
```

will cause the value of sizeof(MyClass1) on a 32-bit system to be 12. Even though i and f each require 4 bytes of storage and c requires 1 byte of storage, a compiler will store c in a 32-bit quantity for alignment. Consider now

```
class MyClass2 { public: int i; char c1; float f; char c2; };
class MyClass3 { public: int i; float f; char c1; char c2; };
```

Using standard alignment on a 32-bit system, sizeof(MyClass2) has value 16 and sizeof(MyClass3) has value 12. If you have a lot of objects of these types, it is better to use the layout in MyClass3 to minimize memory use.

Regarding the memory layout for vectors with float components, if you wish for your engine to run on both 32- and 64-bit systems, and you intend to support implicit operator conversions to pointers to float, the layout of the type Vector2a is not safe. You must use the layout of the type Vector2b because the C and C++ languages do guarantee that an array of a native type such as float has contiguous values. Wild Magic 1.x used the Vector2a layout. When I changed it to the layout of Vector2b, a few engine users complained about the verbosity of accessing members with X() and Y(). Yes, the use of the classes is slightly more verbose, but the trade-off is that the code now safely runs on both 32- and 64-bit systems. The older version would have problems on a 64-bit system.

Vector Templates and Basic Operations

The vector classes are template based with type Real replaced either by float or double. For every dimension, the classes have default constructors that initialize the data

members to zero. The classes also have copy constructors and assignment operators. The only other constructors are those that allow you to pass in the individual components to initialize the vectors.

The classes all have static constant vectors, namely, the zero vector and the standard basis vectors. In Vector2, the member ZERO represents the zero vector (0, 0), the member UNIT_X represents the basis vector (1, 0), and the member UNIT_Y represents the basis vector (0, 1). Static data members in template classes are always problematic. If the template class body is exposed to an application that uses two (or more) execution modules, a dynamic-link library (DLL) and the executable (EXE) itself, for example, it is possible that two copies of the static member are generated, one in each execution module. This ambiguity can be fatal to applications. In fact, this was a classic problem with the Standard Template Library that shipped with Microsoft's Visual C++, version 6. The xtree template class that encapsulated red-black trees had a static member that represented a nil node in the tree. Any application using STL and a dynamic-link library was susceptible to crashes because the application code would traverse an STL structure that was created in the DLL, but with comparisons made to the nil node generated in the EXE.[1] The multiple instantiation of template static data members is not of concern if the data members are intended to be constant, as is the zero vector and the basis vectors. The multiple instantiations all have the same value, so which one is accessed is not of concern (unless you try comparing to the *address* of the members). Even so, Wild Magic 2.x and 3.x instantiate the static, constant class members in the library source files and do not expose the template body, thereby avoiding an unintended instantiation elsewhere.

Member Access

All classes provided the facilities for implicit operator conversion, as discussed earlier, and for member access by array brackets. For example,

```
template <class Real>
class Vector3
{
public:
    operator const Real* () const;
    operator Real* ();
    Real operator[] (int i) const;
    Real& operator[] (int i);
};
```

1. Microsoft was not to blame. The STL was a third-party package from Dinkumware that, due to legal reasons between Dinkumware and another company, could not be updated in Microsoft-supplied service packs until the legal issues were resolved. A fix was available at Dinkumware's Web site. Visual C++ versions 7.x (the .NET versions) no longer have this problem.

```
Vector3<float> kU = <some vector>, kV;
kV[0] = 1.0f;
kV[1] = 2.0f * kU[1] - 0.5f* kU[2];
kV[2] = kU[0];
```

All classes provide named member access. For example,

```
template <class Real>
class Vector3
{
public:
    Real X () const;
    Real& X ();
    Real Y () const;
    Real& Y ();
    Real Z () const;
    Real& Z ();
};
```

```
Vector3<float> kU = <some vector>, kV;
kV.X() = 1.0f;
kV.Y() = 2.0f * kU.Y() - 0.5f* kU.Z();
kV.Z() = kU.X();
```

Comparison Operators

The classes have comparison operators to support sorting:

```
template <class Real>
class Vector3
{
public:
    bool operator== (const Vector3& rkV) const;
    bool operator!= (const Vector3& rkV) const;
    bool operator<  (const Vector3& rkV) const;
    bool operator<= (const Vector3& rkV) const;
    bool operator>  (const Vector3& rkV) const;
    bool operator>= (const Vector3& rkV) const;
};
```

The comparison treats the member data as a contiguous array of unsigned integers representing a nonnegative binary number. Comparisons between binary numbers are straightforward. For example, these are useful when building hash tables of vertices in order to identify vertices that are (nearly) the same.

Algebraic Operations

All classes have implemented algebraic operations. These functions are the ones most programmers tend to focus on since the classes are about vectors, which naturally have an algebraic flavor. The N in the class name is either 2, 3, or 4.

```
template <class Real>
class VectorN
{
public:
    VectorN operator+ (const VectorN& rkV) const;
    VectorN operator- (const VectorN& rkV) const;
    VectorN operator* (Real fScalar) const;
    VectorN operator/ (Real fScalar) const;
    VectorN operator- () const;
    VectorN& operator+= (const VectorN& rkV);
    VectorN& operator-= (const VectorN& rkV);
    VectorN& operator*= (Real fScalar);
    VectorN& operator/= (Real fScalar);
};

// The member function operator*(Real) supports
// ''VectorN * Real''.  This function supports
// ''Real * VectorN''.
template <class Real>
VectorN<Real> operator* (Real fScalar, const VectorN<Real>& rkV);
```

The implementations of all the operators are straightforward.

Geometric Operations

All classes have implemented standard geometric operations that are common to all dimensions:

```
template <class Real>
class VectorN
{
public:
    Real Length () const;
    Real SquaredLength () const;
    Real Dot (const VectorN& rkV) const;
    Real Normalize ();
};
```

If $\mathbf{U} = (u_0, \ldots, u_{N-1})$ and $\mathbf{V} = (v_0, \ldots, v_{N-1})$ are two N-tuples, then the length of \mathbf{U} is

$$|\mathbf{U}| = \sqrt{u_0^2 + \cdots + u_{N-1}^2},$$

the squared length is

$$|\mathbf{U}|^2 = u_0^2 + \cdots + u_{N-1}^2,$$

and the dot product of the two vectors is

$$\mathbf{U} \cdot \mathbf{V} = u_0 v_0 + \cdots + u_{N-1} v_{N-1}.$$

The normalized vector for $\mathbf{V} \neq \mathbf{0}$ is the unit-length vector

$$\mathbf{U} = \frac{\mathbf{V}}{|\mathbf{V}|} = \frac{(v_0, \ldots, v_{N-1})}{\sqrt{v_0^2 + \cdots + v_{N-1}^2}}.$$

The class function `Normalize` returns the length of \mathbf{V} that was computed during normalization, just in case the application needs to know this information. For numerical robustness, in the event the original vector is nearly zero, the normalized vector is set to zero and the returned length is zero.

The remaining geometric operations are specific to the dimension of the class. In two dimensions, we have

```
template <class Real>
class Vector2
{
public:
    Vector2 Perp () const;
    Vector2 UnitPerp () const;
    Real Kross (const Vector2& rkV) const;
    static void Orthonormalize (Vector2& rkU, Vector2& rkV);
    static void GenerateOrthonormalBasis (Vector2& rkU,
        Vector2& rkV, bool bUnitLengthV);
};
```

Given a vector (x, y), it is sometimes convenient to choose a vector perpendicular to it. The simplest way to do this is to swap components and change the sign of one of them, $(x, y)^\perp = (y, -x)$. This is called the *perp operation* and is implemented in `Vector2::Perp`. In a sense, this is the natural specialization of the three-dimensional cross product to two dimensions. In three dimensions, if $\imath = (1, 0, 0)$, $\jmath = (0, 1, 0)$, and $k = (0, 0, 1)$, then the cross product of (x_0, y_0, z_0) and (x_1, y_1, z_1) is written as a

formal determinant

$$(x_0, y_0, z_0) \times (x_1, y_1, z_1) = \det \begin{bmatrix} \imath & \jmath & k \\ x_0 & y_0 & z_0 \\ x_1 & y_1 & z_1 \end{bmatrix}$$

$$= \imath(y_0 z_1 - y_1 z_0) - \jmath(x_0 z_1 - x_1 z_0) + k(x_0 y_1 - x_1 y_0)$$

$$= (y_0 z_1 - y_1 z_0, x_1 z_0 - x_0 z_1, x_0 y_1 - x_1 y_0).$$

The determinant is evaluated by a cofactor expansion across the first row. The cross product is a vector perpendicular to its two input vectors. In two dimensions, we may similarly formulate the perp vector as

$$(x, y)^{\perp} = \det \begin{bmatrix} \imath & \jmath \\ x & y \end{bmatrix} = \imath(y) - \jmath(x) = (y, -x),$$

where $\imath = (1, 0)$ and $\jmath = (0, 1)$. The perp vector is perpendicular to its only input vector. The function `Vector2::Perp` computes the perp vector. The function `Vector2::UnitPerp` computes the perp vector and then normalizes it to unit length (or zero if the original vector is zero).

A related operation is called the *dot perp operation*, implemented by `Vector2::DotPerp`. Given two vectors (x_0, y_0) and (x_1, y_1), the dot perp is the scalar

$$(x_0, y_0) \cdot (x_1, y_1)^{\perp} = (x_0, y_0) \cdot (y_1, -x_1) = x_0 y_1 - x_1 y_0 = \det \begin{bmatrix} x_0 & y_0 \\ x_1 & y_1 \end{bmatrix}.$$

The operation is analogous to the triple scalar product in three dimensions:

$$(x_0, y_0, z_0) \cdot (x_1, y_1, z_1) \times (x_2, y_2, z_2) = \det \begin{bmatrix} x_0 & y_0 & z_0 \\ x_1 & y_1 & z_1 \\ x_2 & y_2 & z_2 \end{bmatrix}$$

$$= x_0(y_1 z_2 - y_2 z_1) - y_0(x_1 z_2 - x_2 z_1) + z_0(x_1 y_2 - x_2 y_1).$$

The operation may also be thought of in terms of 3D cross products

$$(x_0, y_0, 0) \times (x_1, y_1, 0) = (0, 0, x_0 y_1 - x_1 y_0),$$

so the dot perp is the z-component of the cross product of the two input vectors when considered as vectors in the $z = 0$ plane. The function `Vector2::DotPerp` computes the dot perp operation.

Given two nonparallel vectors $\mathbf{V}_0 = (x_0, y_0)$ and $\mathbf{V}_1 = (x_1, y_1)$, there are times when we want to compute two unit-length and perpendicular vectors from these, call them \mathbf{U}_0 and \mathbf{U}_1. The process is called *Gram-Schmidt orthonormalization* and is

implemented by `Vector2::Orthonormalize`. The first vector is obtained from \mathbf{V}_0 by normalization:

$$\mathbf{U}_0 = \frac{\mathbf{V}_0}{|\mathbf{V}_0|}.$$

The second vector is obtained by projecting out of \mathbf{V}_1 the component in the \mathbf{U}_0 direction, then normalizing the result:

$$\mathbf{U}_1 = \frac{\mathbf{V}_1 - (\mathbf{U}_0 \cdot \mathbf{V}_1)\mathbf{U}_0}{|\mathbf{V}_1 - (\mathbf{U}_0 \cdot \mathbf{V}_1)\mathbf{U}_0|}.$$

\mathbf{U}_0 and \mathbf{U}_1 were obtained by normalization, so they are unit length. Also,

$$\mathbf{U}_0 \cdot (\mathbf{V}_1 - (\mathbf{U}_0 \cdot \mathbf{V}_1)\mathbf{U}_0) = (\mathbf{U}_0 \cdot \mathbf{V}_1) - (\mathbf{U}_0 \cdot \mathbf{V}_1)(\mathbf{U}_0 \cdot \mathbf{U}_0)$$
$$= (\mathbf{U}_0 \cdot \mathbf{V}_1) - (\mathbf{U}_0 \cdot \mathbf{V}_1) = 0,$$

so \mathbf{U}_0 and \mathbf{U}_1 are perpendicular.

Given a nonzero vector \mathbf{V}, the function `Vector2::GenerateOrthonormalBasis` computes in place a pair of unit-length and perpendicular vectors. One of these is $\mathbf{U}_0 = \mathbf{V}/|\mathbf{V}|$; the other is $\mathbf{U}_1 = \mathbf{U}_0^{\perp}$. If it is already known that \mathbf{V} is unit length, the function `GenerateOrthonormalBasis` has a Boolean parameter to provide that hint, in which case the function does not have to normalize \mathbf{V}.

In three dimensions, the extra geometric operations are

```
template <class Real>
class Vector3
{
public:
    Vector3 Cross (const Vector3& rkV) const;
    Vector3 UnitCross (const Vector3& rkV) const;
    static void Orthonormalize (Vector3& rkU, Vector3& rkV,
        Vector3& rkW);
    static void Orthonormalize (Vector3* akV);
    static void GenerateOrthonormalBasis (Vector3& rkU,
        Vector3& rkV, Vector3& rkW, bool bUnitLengthW);
};
```

If \mathbf{V}_0 is the vector for the calling object and \mathbf{V}_1 is the input vector to the function `Vector3::Cross`, then the returned vector is

$$\mathbf{V}_0 \times \mathbf{V}_1$$

The function `Vector3::UnitCross` computes the cross product, then normalizes and returns it:

$$\frac{\mathbf{V}_0 \times \mathbf{V}_1}{|\mathbf{V}_0 \times \mathbf{V}_1|}.$$

The function `Vector3::Orthonormalize` uses Gram-Schmidt orthonormalization applied to the three input vectors and stores in place three unit-length and mutually perpendicular vectors. If \mathbf{V}_i, $0 \leq i \leq 2$, are the three input vectors, and if \mathbf{U}_i are the output orthonormal vectors, then

$$\mathbf{U}_0 = \frac{\mathbf{V}_0}{|\mathbf{V}_0|}.$$

The second vector is obtained by projecting out of \mathbf{V}_1 the component in the \mathbf{U}_0 direction and normalizing, just like we did in two dimensions:

$$\mathbf{U}_1 = \frac{\mathbf{V}_1 - (\mathbf{U}_0 \cdot \mathbf{V}_1)\mathbf{U}_0}{|\mathbf{V}_1 - (\mathbf{U}_0 \cdot \mathbf{V}_1)\mathbf{U}_0|}.$$

The fact that we projected out \mathbf{U}_0 makes \mathbf{U}_1 and \mathbf{U}_0 perpendicular. The third vector is obtained by projecting out of \mathbf{V}_2 the components in the \mathbf{U}_0 and \mathbf{U}_1 directions and normalizing:

$$\mathbf{U}_2 = \frac{\mathbf{V}_2 - (\mathbf{U}_0 \cdot \mathbf{V}_2)\mathbf{U}_0 - (\mathbf{U}_1 \cdot \mathbf{V}_2)\mathbf{U}_1}{|\mathbf{V}_2 - (\mathbf{U}_0 \cdot \mathbf{V}_2)\mathbf{U}_0 - (\mathbf{U}_1 \cdot \mathbf{V}_2)\mathbf{U}_1|}.$$

The resulting vector is necessarily perpendicular to \mathbf{U}_0 and \mathbf{U}_1.

Given a nonzero vector \mathbf{W}, the function `Vector3::GenerateOrthonormalBasis` computes in place a triple of unit-length and perpendicular vectors. One of these is $\mathbf{U}_0 = \mathbf{W}/|\mathbf{W}|$. There are infinitely many pairs of orthonormal vectors perpendicular to \mathbf{U}_0. To obtain a vector \mathbf{U}_1, two components of \mathbf{U}_0 are swapped and one of those components has its sign changed. The remaining component is set to zero. In order to be numerically robust, the swap occurs with the component of largest absolute magnitude.

```
U0 = W/Length(W);
if ( |W.x| >= |W.y| )
{
    // W.x or W.z is the largest-magnitude component, swap them
    U1.x = -W.z;
    U1.y = 0;
    U1.z = +W.x;
}
```

```
else
{
    // W.y or W.z is the larges-magnitude component, swap them
    U1.x = 0;
    U1.y = +W.z;
    U1.z = -W.y;
}
U1 /= Length(U1);
U2 = Cross(U0,U1);
```

As in the two-dimensional case, if **W** is unit length, the function `GenerateOrthonormalBasis` has a Boolean parameter to provide that hint, in which case the function does not have to normalize **W**.

2.2.4 MATRICES

The engine has classes for square matrices in 2, 3, and 4 dimensions, named `Matrix2`, `Matrix3`, and `Matrix4`, respectively. The goals for memory layout are the same as for vectors. The matrix classes have no virtual functions, and the matrix elements are stored in a one-dimensional array of floating-point numbers; these two conditions guarantee that you can safely (1) typecast a matrix as a pointer `float*` or `double*` and (2) typecast an array of matrices as a pointer `float*` or `double*`. The general layout is the following, where `N` is either 2, 3, or 4 and `Real` is `float` or `double`:

```
template <class Real>
class MatrixN
{
public:
    operator const Real* () const;
    operator Real* ();
private:
    Real* m_afTuple[N*N];
};
```

For memory organization it might seem natural to choose `Real[N][N]` for the matrix storage, but this can be a problem on a platform that chooses to store the data in column-major rather than row-major format. To avoid potential portability problems, the matrix is stored as `Real[N*N]` and organized in row-major order; that is, the entry of the matrix in row r, with $0 \le r < N$, and column c, with $0 \le c < N$, is stored at index $i = c + Nr$, with $0 \le i < N^2$.

Matrix Conventions

Layout is one thing, but interpretation of matrix-matrix and matrix-vector operations is another. One of the biggest sources of pain in architecting an engine is having

to deal with matrix conventions, say, from a graphics API, that are different than your own. The chances are that you already had a lot of matrix and vector code in place. Reimplementing these to conform to someone else's conventions can be a time sink. Whether you do or do not, it is important to understand *what* the conventions are of any systems you use. And it is important to let users of your engine know what conventions *you have chosen*. Here are the conventions used in Wild Magic.

Matrix operations are applied on the left. For example, given a matrix M and a vector \mathbf{V}, matrix times vector is $M\mathbf{V}$; that is, \mathbf{V} is treated as a column vector. Some graphics APIs use $\mathbf{V}M$, where \mathbf{V} is treated as a row vector. In this context the matrix M is really a transpose of the one represented in Wild Magic. Similarly, to apply two matrix operations M_0 and M_1, in that order, you compute M_1M_0 so that the transform of a column vector is

$$(M_1M_0)\mathbf{V} = M_1(M_0\mathbf{V}).$$

Some graphics APIs use M_0M_1, but again these matrices are the transpose of those as represented in Wild Magic. You must therefore be careful about how you interface the transformation code with graphics APIs. For example, OpenGL uses the convention $\mathbf{V}M$ for matrix times a vector. In the renderer function `OpenGLRenderer::SetWorldMatrix`, the Wild Magic world matrix for the to-be-drawn object is computed from its local components and copied into a one-dimensional array that corresponds to the representation OpenGL uses, a transpose of the Wild Magic matrix.

Another convention to be aware of is what rotation matrices mean. In two dimensions, Wild Magic represents a rotation matrix by

$$R = \begin{bmatrix} \cos\theta & -\sin\theta \\ \sin\theta & \cos\theta \end{bmatrix} = I + (\sin\theta)S + (1 - \cos\theta)S^2, \tag{2.11}$$

where I is the identity matrix and S is the skew-symmetric matrix, as shown:

$$I = \begin{bmatrix} 1 & 0 \\ 0 & 1 \end{bmatrix}, \qquad S = \begin{bmatrix} 0 & -1 \\ 1 & 0 \end{bmatrix}.$$

For a positive angle θ, $R\mathbf{V}$ rotates the 2×1 vector \mathbf{V} *counterclockwise* about the origin (see Figure 2.1).

Some rotation systems might associate a positive angle with a clockwise rotation about the origin. If you use such a system with Wild Magic, you must be careful how you present a Wild Magic matrix to it.

In three dimensions, consider a rotation about an axis through the origin with unit-length direction $\mathbf{W} = (w_0, w_1, w_2)$ and angle θ. Wild Magic represents a rotation matrix by

$$R = I + (\sin\theta)S + (1 - \cos\theta)S^2, \tag{2.12}$$

Figure 2.1 A positive angle corresponds to a counterclockwise rotation.

Figure 2.2 A positive angle corresponds to a counterclockwise rotation when looking in the negative direction, $-\mathbf{W}$, of the axis of rotation. The vectors \mathbf{U} and \mathbf{V} are unit length, perpendicular, and in the plane perpendicular to \mathbf{W}.

where I is the identity matrix and S is a skew-symmetric matrix, as shown:

$$I = \begin{bmatrix} 1 & 0 & 0 \\ 0 & 1 & 0 \\ 0 & 0 & 1 \end{bmatrix}, \qquad S = \begin{bmatrix} 0 & -w_2 & w_1 \\ w_2 & 0 & -w_0 \\ -w_1 & w_0 & 0 \end{bmatrix}.$$

The rotation is in the plane perpendicular to \mathbf{W} and containing the origin. If you are an observer looking along the axis of rotation in the direction $-\mathbf{W}$, a positive angle θ corresponds to a counterclockwise rotation in the observed plane (see Figure 2.2). The rotation matrix for rotation about the x-axis is

$$R_x(\theta) = \begin{bmatrix} 1 & 0 & 0 \\ 0 & \cos(\theta) & -\sin(\theta) \\ 0 & \sin(\theta) & \cos(\theta) \end{bmatrix}. \tag{2.13}$$

The rotation matrix for rotation about the y-axis is

$$R_y(\theta) = \begin{bmatrix} \cos(\theta) & 0 & \sin(\theta) \\ 0 & 1 & 0 \\ -\sin(\theta) & 0 & \cos(\theta) \end{bmatrix}. \tag{2.14}$$

The rotation matrix for rotation about the z-axis is

$$R_z(\theta) = \begin{bmatrix} \cos(\theta) & -\sin(\theta) & 0 \\ \sin(\theta) & \cos(\theta) & 0 \\ 0 & 0 & 1 \end{bmatrix}. \tag{2.15}$$

You may think of the 2D rotation as a special case where the rotation axis has direction $\mathbf{W} = (0, 0, 1)$. When you look in the direction $(0, 0, -1)$, you see the xy-plane ($z = 0$), and a positive angle corresponds to a counterclockwise rotation in that plane.

Common Operations

As was the case for the vector classes, the matrix classes have a lot of common operations, including default constructors, copy constructors, assignment, comparisons for use in sorting, implicit conversions to pointers, member access, and matrix algebra. Also included are somewhat higher-level operations. A summary of methods that are common to all the classes is listed next, where N is either 2, 3, or 4.

```
template <class Real>
class MatrixN
{
public:
    // construction
    MatrixN ();
    MatrixN (const Matrix3& rkM);
    MatrixN (bool bZero);
    MatrixN (const Real afEntry[N*N], bool bRowMajor);

    void MakeZero ();
    void MakeIdentity ();

    // member access
    operator const Real* () const;
    operator Real* ();
    const Real* operator[] (int iRow) const;
    Real* operator[] (int iRow);
    Real operator() (int iRow, int iCol) const;
    Real& operator() (int iRow, int iCol);
```

```
    void SetRow (int iRow, const VectorN<Real>& rkV);
    VectorN<Real> GetRow (int iRow) const;
    void SetColumn (int iCol, const VectorN<Real>& rkV);
    VectorN<Real> GetColumn (int iCol) const;
    void GetColumnMajor (Real* afCMajor) const;

    // assignment
    MatrixN& operator= (const MatrixN& rkM);

    // comparison
    bool operator== (const MatrixN& rkM) const;
    bool operator!= (const MatrixN& rkM) const;
    bool operator<  (const MatrixN& rkM) const;
    bool operator<= (const MatrixN& rkM) const;
    bool operator>  (const MatrixN& rkM) const;
    bool operator>= (const MatrixN& rkM) const;

    // arithmetic operations
    MatrixN operator+ (const MatrixN& rkM) const;
    MatrixN operator- (const MatrixN& rkM) const;
    MatrixN operator* (const MatrixN& rkM) const;
    MatrixN operator* (Real fScalar) const;
    MatrixN operator/ (Real fScalar) const;
    MatrixN operator- () const;

    // arithmetic updates
    MatrixN& operator+= (const MatrixN& rkM);
    MatrixN& operator-= (const MatrixN& rkM);
    MatrixN& operator*= (Real fScalar);
    MatrixN& operator/= (Real fScalar);

    // matrix times vector
    VectorN<Real> operator* (const VectorN<Real>& rkV) const;

    // other operations
    MatrixN Transpose () const;
    MatrixN TransposeTimes (const MatrixN& rkM) const;
    MatrixN TimesTranspose (const MatrixN& rkM) const;
    MatrixN Inverse () const;
    MatrixN Adjoint () const;
    Real Determinant () const;
    Real QForm (const Vector4<Real>& rkU,
        const Vector4<Real>& rkV) const;
};
```

```
// c*M where c is a scalar, M a matrix
template <class Real>
MatrixN<Real> operator* (Real fScalar, const MatrixN<Real>& rkM);

// vector times matrix, v^T * M
template <class Real>
VectorN<Real> operator* (const VectorN<Real>& rkV,
    const MatrixN<Real>& rkM);
```

Constructors and Assignment

The classes have default constructors, copy constructors, and assignment operators. The default constructor initializes the matrix to zero. The constructor MatrixN(bool) creates a zero matrix if the input Boolean parameter is true; otherwise, it creates the identity matrix. The constructor MatrixN(const Real[], bool) creates a matrix and copies the input $N \times N$ matrix to it. If the Boolean parameter is true, the input matrix is copied directly to the created matrix (in row-major order). If the Boolean parameter is false, the transpose of the input matrix is copied to the created matrix.

Member Access

The members MatrixN::operator const Real* and MatrixN::operator Real* are for implicit conversion of the matrix to a pointer to an array of floating-point numbers. The matrix is stored in row-major order in a one-dimensional array.

The members const Real* MatrixN::operator[] and Real* MatrixN::operator[] allow you to access the rows of a MatrixN object using the same syntax that applies to a stack-based 2D array:

```
Matrix2f kM = <some matrix of float values>;
float* afRow0 = kM[0];
float* afRow1 = kM[1];
float afEntry01 = kM[0][1];
```

These operators provide one method for accessing matrix entries. Another mechanism is provided by the member Real MatrixN::operator()(int,int) const for read-only access and by the member Real& MatrixN::operator(int,int) for read-write access:

```
Matrix3f kM = <some matrix of float values>;
kM(0,1) = 1.0f;
kM(2,1) = kM(1,2);
```

In some cases you might want to access an entire row or column of a matrix. The members `MatrixN::SetRow`, `MatrixN::GetRow`, `MatrixN::SetColumn`, and `MatrixN::GetColumn` are used to this end.

Finally, for transferring matrix data to systems that store matrices in column-major order in a one-dimensional array, the member function `MatrixN::GetColumnMajor` fills in a user-supplied one-dimensional array with the correct entries.

Comparisons

The comparisons are similar to those for vectors. The member data is treated as a contiguous array of unsigned integers representing a nonnegative binary number. Comparisons between binary numbers are straightforward. For example, these are useful when building hash tables of vertices in order to identify vertices that are (nearly) the same.

Arithmetic Operations

The arithmetic operations are for matrix-matrix algebra, including addition and subtraction of matrices, multiplication and division of a matrix by a scalar, and matrix-matrix products. The latter operation is always well defined since both matrices are square and of the same size. One of the most common operations in the engine is matrix times vector. Given a matrix M and a column vector \mathbf{V}, the member function `MatrixN::operator*(const VectorN<Real>&)` computes $M\mathbf{V}$. The global function `MatrixN::operator*(const VectorN<Real>&, const MatrixN<Real>&)` computes $\mathbf{V}^{\mathrm{T}}M$, which is considered after the fact to be a column vector (the algebraic quantity is a row vector). This is a convenience to avoid the cost of computing the transpose of M followed by $M^{\mathrm{T}}\mathbf{V}$.

Other Operations

The remaining common operations are found frequently in applications.

Given a square matrix M, its transpose M^{T} is obtained by swapping rows and columns. If $M = [m_{rc}]$, where m_{rc} is the entry in row r and column c, then $M^{\mathrm{T}} = [m'_{rc}]$, where $m'_{rc} = m_{cr}$. The entry m'_{rc} is in row r and column c of the transpose; it is the entry in row c and column r of the original matrix. The function `MatrixN::Transpose` computes M^{T} and returns it.

Two convenient matrix products are $M_0^{\mathrm{T}} M_1$, computed by the member function `MatrixN::TransposeTimes`, and $M_0 M_1^{\mathrm{T}}$, computed by the member function `MatrixN::TimesTranspose`. Code samples are

```
MatrixN kM0 = <some N-by-N matrix>;
MatrixN kM1 = <another N-by-N matrix>;
MatrixN kM0M1 = kM0 * kM1;  // = kM0.operator*(kM1)
MatrixN kM0TrnM1 = kM0.TransposeTimes(kM1);  // M0^T * M1
MatrixN kM0M1Trn = kM0.TimesTranspose(kM1);  // M0 * M1^T
```

Given a square matrix M, its inverse (if it exists) is denoted M^{-1} and has the properties $MM^{-1} = M^{-1}M = I$, where I is the identity. Not all matrices have inverses (the zero matrix, for example), but in most cases matrices are used in the engine for mapping data between coordinate systems. These matrices are invertible. The member function MatrixN::Inverse attempts to compute the inverse matrix. If it exists, that matrix is returned by the function. If it does not, the zero matrix is returned as a way of communicating to the caller that the matrix is not invertible. The implementations construct the inverses by the identity

$$M^{-1} = \frac{1}{\det(M)} M^{\text{adj}},$$

where $\det(M)$ is the determinant of the matrix, necessarily nonzero for the inverse to exist, and M^{adj} is the *adjoint matrix*, which is the transpose of the matrix of cofactors of M. The construction for 4×4 matrices is not the standard one that uses cofactors from 3×3 submatrices. In fact, it uses 2×2 submatrices and greatly reduces the operation count compared to the standard method. The expansion of this form is known as the *Laplace expansion theorem*; see [Pea85, Section 16.2.3]. The adjoint matrix may be computed by itself via the member function MatrixN::Adjoint. The determinant is computed by the member function MatrixN::Determinant. This construction also uses the cofactor expansion.

The final common operation is a *quadratic form*. Given column vectors \mathbf{U} and \mathbf{V} and a matrix M, the form is $\mathbf{U}^T M \mathbf{V}$, a scalar.[2] The member function MatrixN::QForm computes the quadratic form.

Operations Specific to 2D

Specific operations for 2D are

```
template <class Real>
class Matrix2
{
public:
```

2. The term *quadratic form* is usually associated with $\mathbf{V}^T M \mathbf{V}$, where the left and right vectors are the same. My use of the term to cover the more general case $\mathbf{U}^T M \mathbf{V}$ might be viewed as an abuse of the mathematical definition.

```
    void ToAngle (Real& rfAngle) const;
    void Orthonormalize ();
    void EigenDecomposition (Matrix2& rkRot,
        Matrix2& rkDiag) const;
};
```

The method `Matrix2::ToAngle` requires the matrix to be a rotation and extracts an angle of rotation. The angle is

$$\theta = \text{atan } 2(\sin \theta, \cos \theta) = \text{atan } 2(r_{00}, r_{10}).$$

The method `Matrix2::Orthonormalize` requires the matrix to be a rotation and applies Gram-Schmidt orthonormalization to its columns. The first column is normalized, and the second column is adjusted by subtracting out its projection onto the normalized first column. This operation is useful when the rotation is updated frequently through concatenation with other matrices. Over time, the numerical round-off errors can accumulate, and the matrix strays from having the properties of a rotation. An adjustment such as Gram-Schmidt orthonormalization restores the matrix to a rotation.

A matrix M is said to have an *eigenvalue* λ and a corresponding *eigenvector* \mathbf{V}, a nonzero vector, whenever $M\mathbf{V} = \lambda\mathbf{V}$. If M and \mathbf{V} have only real-valued components and if λ is a real number, geometrically the vector \mathbf{V} is transformed only in that its length is scaled by λ. A symmetric, real-valued matrix M is guaranteed to have only real-valued eigenvalues and a set of eigenvectors that are mutually perpendicular. The method `Matrix2::EigenDecomposition` requires the matrix to be symmetric. It computes the eigenvalues of the matrix and stores them as the diagonal entries of a diagonal matrix D. It also computes corresponding eigenvectors and stores them as the columns of a rotation matrix R. Column i of the rotation matrix is an eigenvector for diagonal entry i of the diagonal matrix. The matrices are part of the *eigendecomposition* of M, a factorization $M = RDR^{\text{T}}$. The methodology for an eigendecomposition of a symmetric matrix applies in any dimension, in particular, three dimensions.

This topic is much more mathematical than what you normally encounter in computer graphics, but it is quite useful in a number of circumstances. A real-time rendering system relies on drawing only what is visible, or potentially visible if the exact visibility is unknown. Looking at this a different way, if an object is known not to be visible (i.e., not in the view frustum), then the renderer should not be asked to draw it. A classical approach to testing for nonvisibility is to associate with the object an enclosing bounding volume and use *culling*. If the bounding volume is outside the view frustum, then the object is outside and the object is culled from the list of objects to be rendered. The goal is to choose a class of bounding volumes whose tests for being outside the frustum are inexpensive. The simplest bounding volume is a sphere, but it is not always a good fit to the complex objects in the scene. An oriented bounding box (OBB) may be used instead to obtain a better fit, but the

Figure 2.3 A polygon enclosed by an OBB whose center **C** is the average of the polygon vertices and whose axes are the eigenvectors of the covariance matrix of the polygon vertices.

trade-off is that the test for being outside the frustum is slightly more expensive than for a sphere. For a single culling test, the sphere requires less time to process than the OBB. However, if the sphere partially overlaps the frustum but the contained object is outside the frustum, the renderer is told to draw the object only to find out that none of it is visible. Given the object in the same position and orientation, if the OBB is outside the frustum, then despite the fact that you spent more time determining this (compared to the sphere), you have not attempted to draw the object. The total time of culling and rendering is smaller for the box bounding volume than for the sphere bounding volume. The important information is a comparison of the costs of culling versus the costs of rendering a nonvisible object *for the entire set of objects*, not just for a single object. An amortized analysis is called for to determine which class of bounding volume is more suited for your applications.

So where does eigendecomposition come into play? You have to construct an OBB that contains an object. Assuming the object is represented by a triangle mesh with a collection of vertices \mathbf{V}_i, $0 \le i < n$, the problem is to compute a tight-fitting box that contains the vertices. The minimum volume OBB is certainly an ideal candidate, but its construction is a nontrivial process that has roots in computational geometry. A less optimal candidate is normally used. The OBB center is chosen to be the average of the mesh vertices. The OBB axes are selected based on the distribution of the vertices. Specifically, the covariance matrix of the vertices is computed, and the eigenvectors of this matrix are used as the box axes. Figure 2.3 illustrates the concept in 2D. The mesh in this case is a polygon. An OBB enclosing the polygon is shown, with center equal to the average of the polygon vertices and axes based on the vertex distribution.

A similar type of construction is used to construct a bounding volume hierarchy of OBBs to represent a triangle mesh for the purposes of collision detection. More information on both topics is in Section 6.4.2.

Operations Specific to 3D

Specific operations for 3D are

```
template <class Real>
class Matrix3
{
public:
    void ToAxisAngle (Vector3<Real>& rkAxis,
        Real& rfAngle) const;
    void Orthonormalize ();
    void EigenDecomposition (Matrix3& rkRot,
        Matrix3& rkDiag) const;

    void FromEulerAnglesXYZ (Real fYAngle, Real fPAngle,
        Real fRAngle);
    void FromEulerAnglesXZY (Real fYAngle, Real fPAngle,
        Real fRAngle);
    void FromEulerAnglesYXZ (Real fYAngle, Real fPAngle,
        Real fRAngle);
    void FromEulerAnglesYZX (Real fYAngle, Real fPAngle,
        Real fRAngle);
    void FromEulerAnglesZXY (Real fYAngle, Real fPAngle,
        Real fRAngle);
    void FromEulerAnglesZYX (Real fYAngle, Real fPAngle,
        Real fRAngle);
    bool ToEulerAnglesXYZ (Real& rfYAngle, Real& rfPAngle,
        Real& rfRAngle) const;
    bool ToEulerAnglesXZY (Real& rfYAngle, Real& rfPAngle,
        Real& rfRAngle) const;
    bool ToEulerAnglesYXZ (Real& rfYAngle, Real& rfPAngle,
        Real& rfRAngle) const;
    bool ToEulerAnglesYZX (Real& rfYAngle, Real& rfPAngle,
        Real& rfRAngle) const;
    bool ToEulerAnglesZXY (Real& rfYAngle, Real& rfPAngle,
        Real& rfRAngle) const;
    bool ToEulerAnglesZYX (Real& rfYAngle, Real& rfPAngle,
        Real& rfRAngle) const;

    static Matrix3 Slerp (Real fT, const Matrix3& rkR0,
        const Matrix3& rkR1);
};
```

The method `Matrix3::ToAxisAngle` requires the matrix to be a rotation and extracts an axis and angle of rotation. The axis direction is unit length. The extraction is based on Equation (2.12). Some algebra will show that $\cos(\theta) = (\text{Trace}(R) - 1)/2$, where $\text{Trace}(R)$ is the *trace* of the matrix R, the sum of the diagonal entries of R. This allows us to obtain the rotation angle

$$\theta = \arccos((\text{Trace}(R) - 1)/2).$$

Also, $R - R^{\text{T}} = 2\sin(\theta)S$, where S is formed from the rotation axis components (w_0, w_1, w_2). As long as θ is not a multiple of π, we may solve for

$$w_0 = \frac{r_{21} - r_{12}}{2\sin(\theta)}, \qquad w_1 = \frac{r_{02} - r_{20}}{2\sin(\theta)}, \qquad w_2 = \frac{r_{10} - r_{01}}{2\sin(\theta)},$$

where $R = [r_{ij}]$. If $\theta = 0$, the rotation matrix is the identity, and any choice of axis will do. My choice is $(1, 0, 0)$. If $\theta = \pi$, $R - R^{\text{T}} = 0$, which prevents us from extracting the axis through S. Observe that $R = I + 2S^2$, so $S^2 = (R - I)/2$. The diagonal entries of S^2 are $w_0^2 - 1$, $w_1^2 - 1$, and $w_2^2 - 1$. We can solve these for the axis direction (w_0, w_1, w_2). Because the angle is π, it does not matter which sign you choose on the square roots.

The method `Matrix3::Orthonormalize` requires the matrix to be a rotation and applies Gram-Schmidt orthonormalization to its columns. See the discussion earlier regarding this operation applied to 2D rotation matrices and to vectors in 3D.

The discussion of eigendecomposition for 2×2 symmetric matrices also covers 3×3 symmetric matrices and $N \times N$ matrices in general. The function `Matrix3::EigenDecomposition` does the decomposition for 3×3 matrices.

The next discussion is about the methods `Matrix3::FromEulerAnglesUVW` and `Matrix3::ToEulerAnglesUVW`. A popular topic for representations of rotation matrices is *Euler angles*. The idea is to represent a rotation matrix as a product of rotation matrices corresponding to the coordinate axes. For example,

$$R = R_x(\alpha)R_y(\beta)R_z(\gamma)$$

is a rotation obtained by rotating γ radians about the z-axis, then rotating β radians about the y-axis, then rotating α radians about the x-axis. Other combinations are possible, including using the same axis twice ($R = R_x(\alpha)R_y(\beta)R_x(\gamma)$). The attraction of Euler angles is that it is easy to think about rotations a "channel at a time," and most modeling packages support Euler angles for this reason. The disadvantages of Euler angles are many. Contrary to the previous statement about understanding rotations a channel at a time, I find it not so easy to think this way. All three rotations are specified relative to a fixed coordinate system ("world" coordinates). After rotating about one coordinate axis, you have to imagine the rotated object in its new orientation, then rotate again. And again. I find it easier to assign a coordinate system that remains rigid relative to the object ("body" coordinates). Once a rotation is applied to one body axis, I find it easier to think of how the next rotation occurs for

another body axis. Better yet, I prefer thinking in the following terms. Imagine the to-be-rotated vector as a rigid rod. One end point remains fixed to the origin. The other end point may be positioned on a sphere whose radius is the length of the rod. You have two degrees of freedom to position the rod (the angles from spherical coordinates). Once positioned, rotate about the axis of the rod, thus consuming the third degree of freedom. Of course, you may imagine the operations applied in the other order—rotate about the axis of the rod first, then position the rod on the sphere.

Another disadvantage of Euler angles is that the factorization of a specified rotation matrix into a product of three coordinate axis rotations (all axes specified) is not always unique. This is related to a problem called *gimbal lock*. Regardless of my opinion and the nonunique factorization, `Matrix3` class provides the ability to compose a rotation as a product of coordinate rotations and the ability to factor a rotation into some product of coordinate rotations. The prototype for composition is

```
void FromEulerAnglesUVW (Real fYAngle, Real fPAngle,
    Real fRAngle);
```

where UVW is either XYZ, XZY, YXZ, YZX, ZXY, or ZYX. The parameters in the function signature have variable names including `Angle`. The preceding letter is Y for *yaw*, P for *pitch*, or R for *roll*. The prototype for factorization is

```
bool ToEulerAnglesUVW (Real& rfYAngle, Real& rfPAngle,
    Real& rfRAngle) const;
```

where UVW is chosen from one of the six possibilities mentioned earlier. The matrix class does not have support for combinations with a repeated axis such as XYX. The return value on the factorization is `true` if the factorization is unique, `false` otherwise. In the latter case, one of the infinitely many factorizations is returned.

A problem that arises in keyframed animation is how to interpolate two rotation matrices for in-betweening. A common misconception is that you have to resort to quaternions to do this. In fact, you do not need quaternions; matrix operations will suffice. However, the computational costs for interpolating using only matrices is much greater than that for quaternions. Class `Matrix3` provides a *slerp* (spherical linear interpolation) for two matrices,

```
static Matrix3 Slerp (Real fT, const Matrix3& rkR0,
    const Matrix3& rkR1);
```

but the keyframe system in the engine uses a quaternion and its associated slerp function to achieve as much speed as it can. The rotational slerp of two rotation matrices R_0 and R_1 for time $t \in [0, 1]$ is

$$R(t) = R_0(R_0^T R_1)^t,$$

where we must make sense of the power operation on a matrix M. Assuming such an operation exists and has properties you would expect, namely, $M^0 = I$ (the identity matrix) and $M^1 = M$, we have $R(0) = R_0$ and $R(1) = R_1$. Generally, it is impossible to define M^t ($0 < t < 1$) for all matrices M. However, for rotation matrices R, where the axis of rotation has unit-length direction \mathbf{W} and angle of rotation θ, we can define R^t to be a rotation about the same axis, but with an angle that is a fraction of the rotation angle, $t\theta$. A value of $t = 0$ means no rotation is applied. A value of $t = 1$ means the full rotation is applied. The method `Matrix3::Slerp` must compute the product $R_0^{\mathrm{T}} R_1$, extract its axis and angle of rotation, multiply the angle by t, compute the rotation for the same axis but new angle of rotation, and then finally multiply that by R_0, all to obtain the interpolated $R(t)$.

Operations Specific to 4D

The `Matrix4` classes are used by the engine mainly to store homogeneous matrices. The operations specific to 4D are useful for the rendering system, and in particular for planar projected shadows and for planar reflections.

First, let's consider the method `Matrix4::MakeObliqueProjection`. The projection plane is $\mathbf{N} \cdot (\mathbf{X} - \mathbf{P}) = 0$, where \mathbf{N} is a unit-length normal vector and \mathbf{P} is a point on the plane. The projection is oblique to the plane, in the direction of a unit-length vector \mathbf{D}. Necessarily $\mathbf{N} \cdot \mathbf{D} \neq 0$ for the projection to be defined. Given a point \mathbf{U}, the projection onto the plane is obtained by computing the intersection of the line $\mathbf{U} + t\mathbf{D}$ with the plane. Replacing this equation into the plane equation and solving for t yields

$$t = \frac{-\mathbf{N} \cdot (\mathbf{U} - \mathbf{P})}{\mathbf{N} \cdot \mathbf{D}}.$$

The intersection point is

$$\mathbf{V} = \mathbf{P} + \left(I - \frac{\mathbf{D}\mathbf{N}^{\mathrm{T}}}{\mathbf{N} \cdot \mathbf{D}} \right) (\mathbf{U} - \mathbf{P}),$$

where I is the 3×3 identity matrix. A 4×4 homogeneous transformation representing the projection, written in block-matrix form, is

$$\begin{bmatrix} \mathbf{V} \\ \hline 1 \end{bmatrix} \sim \begin{bmatrix} \mathbf{V}' \\ \hline w \end{bmatrix} = M \begin{bmatrix} \mathbf{U} \\ \hline 1 \end{bmatrix} = \begin{bmatrix} \mathbf{D}\mathbf{N}^{\mathrm{T}} - (\mathbf{N} \cdot \mathbf{D})I & -(\mathbf{N} \cdot \mathbf{P})\mathbf{D} \\ \hline \mathbf{0}^{\mathrm{T}} & -\mathbf{N} \cdot \mathbf{D} \end{bmatrix} \begin{bmatrix} \mathbf{U} \\ \hline 1 \end{bmatrix},$$

where the equivalency symbol means $\mathbf{V} = \mathbf{V}'/w$. The matrix $M = [m_{ij}]$, $0 \leq i \leq 3$ and $0 \leq j \leq 3$, is chosen so that $m_{33} > 0$ whenever $\mathbf{N} \cdot \mathbf{D} < 0$; the projection is on the "positive side" of the plane, so to speak. The method `Matrix4::MakeObliqueProjection` takes as input \mathbf{N}, \mathbf{P}, and \mathbf{D}.

Now let's look at the method `Matrix4::MakePerspectiveProjection`. The projection plane is $N \cdot (X - P) = 0$, where N is a unit-length normal vector and P is a point on the plane. The eye point for the projection is E and is assumed not to be on the plane. Given a point U, the perspective projection onto the plane is the intersection of the ray $E + t(U - E)$ for some $t > 0$. Substituting this in the plane equation and solving for t yields

$$t = -\frac{N \cdot (E - P)}{N \cdot (U - E)}.$$

The point of intersection is

$$V = E - \frac{N \cdot (E - P)}{N \cdot (U - E)}(U - E)$$

$$= \frac{(N \cdot (U - E))E - (N \cdot (E - P))(U - E)}{N \cdot (U - E)}$$

$$= \frac{[EN^T - (N \cdot (E - P))\, I\,](U - E)}{N \cdot (U - E)}.$$

A 4×4 homogeneous transformation representing the projection, written in block-matrix form, is

$$\left[\frac{V}{1}\right] \sim \left[\frac{V'}{w}\right] = M\left[\frac{U}{1}\right]$$

$$= \left[\begin{array}{c|c} (N \cdot (E - P))I - EN^T & -[(N \cdot (E - P))I - EN^T]E \\ \hline -N^T & N \cdot E \end{array}\right]\left[\frac{U}{1}\right],$$

where the equivalency symbol means $V = V'/w$. The method `Matrix4::MakePerspectiveProjection` takes as input N, P, and E.

Finally, let's consider `Matrix4::MakeReflection`. The reflection plane is $N \cdot (X - P) = 0$, where N is a unit-length normal vector and P is a point on the plane. Given a point U, the reflection through the plane is obtained by removing the normal component of $U - P$, which produces a vector in the plane, and then subtracting the normal component again. That is, twice the normal component is subtracted from the vector. The resulting point V is defined by

$$V - P = (U - P) - 2(N \cdot (U - P))N$$

or

$$V = (I - 2NN^T)U + 2(N \cdot P)N.$$

A 4×4 homogeneous transformation representing the reflection, written in block-matrix form, is

$$
\left[\frac{\mathbf{V}}{1} \right] \sim \left[\frac{\mathbf{V}'}{w} \right] = M \left[\frac{\mathbf{U}}{1} \right] = \left[\begin{array}{c|c} I - 2\mathbf{N}\mathbf{N}^{\mathrm{T}} & 2(\mathbf{N} \cdot \mathbf{P})\mathbf{N} \\ \hline \mathbf{0}^{\mathrm{T}} & 1 \end{array} \right] \left[\frac{\mathbf{U}}{1} \right].
$$

where the equivalency symbol means $\mathbf{V} = \mathbf{V}'/w$. The `Matrix4::MakeReflection` method takes as input \mathbf{N} and \mathbf{P}.

2.2.5 QUATERNIONS

I am not going to provide in-depth mathematical derivations for quaternions and their properties. You may find these instead in my other books [Ebe00, Ebe03a] or in many online documents. This section contains the bare minimum background to understand what the methods are in the template class `Quaternion`. The main thing to understand is that a unit-length quaternion is used to represent a rotation. Compared to rotation matrices, quaternions require less memory to store, are faster to multiply for the purposes of composition of rotations, and are faster to interpolate for the purposes of keyframed animations.

From a data structures perspective, a quaternion is a 4-tuple of numbers (w, x, y, z). The class representation has the same philosophy as the vector and matrix classes. The data is stored in an array of four elements to allow safe typecasting to a pointer of type `float*` or `double*`. The index 0 corresponds to w, 1 corresponds to x, 2 corresponds to y, and 3 corresponds to z. The standard constructors and assignment are

```
Quaternion ();
Quaternion (Real fW, Real fX, Real fY, Real fZ);
Quaternion (const Quaternion& rkQ);
Quaternion& operator= (const Quaternion& rkQ);
```

The default constructor does not initialize the data members. Member access methods follow, where `Real` is the template parameter class, either `float` or `double`:

```
operator const Real* () const;
operator Real* ();
Real operator[] (int i) const;
Real& operator[] (int i);
Real W () const;
Real& W ();
Real X () const;
Real& X ();
Real Y () const;
```

```
Real& Y ();
Real Z () const;
Real& Z ();
```

The first two methods are for safe typecasting as mentioned earlier. The operator[] methods access the components of the quaternion using the array indices. As always, the methods use the assert-and-repair paradigm. If the input index is out of range, an assertion is fired in debug mode, but a clamp to the valid index range occurs in release mode. The remaining accessors allow you to read or write the quaternion components by name.

For purposes of sorting and hashing, a full set of comparison functions is provided by the class. As with all other classes using the array storage, the comparison is based on reinterpreting the array of floating-point numbers as an array of unsigned integers, with the entire array thought of as a large unsigned integer.

Algebraic Properties

An algebraic system is associated with quaternions. The symbolic representation is

$$q = w + xi + yj + zk,$$

where i, j, and k may be thought of as placekeepers for now. Two quaternions, $q_0 = w_0 + x_0 i + y_0 j + z_0 k$ and $q_1 = w_1 + x_1 i + y_1 j + z_1 k$, are added or subtracted componentwise:

$$q_0 + q_1 = (w_0 + w_1) + (x_0 + x_1)i + (y_0 + y_1)j + (z_0 + z_1)k$$

$$q_0 - q_1 = (w_0 - w_1) + (x_0 - x_1)i + (y_0 - y_1)j + (z_0 - z_1)k.$$

The class methods supporting addition and subtraction are

```
Quaternion operator+ (const Quaternion& rkQ) const;
Quaternion operator- (const Quaternion& rkQ) const;
Quaternion& operator+= (const Quaternion& rkQ);
Quaternion& operator-= (const Quaternion& rkQ);
```

Quaternion addition is commutative and associative; that is,

$$q_0 + q_1 = q_1 + q_0$$

$$q_0 + (q_1 + q_2) = (q_0 + q_1) + q_2.$$

Quaternions may also be multiplied by scalars. If c is a scalar and $q = w + xi + yj + zk$ is a quaternion, then

$$cq = (cw) + (cx)i + (cy)j + (cz)k = qc.$$

The class methods supporting scalar multiplication (and scalar division) are

```
Quaternion operator* (Real fScalar) const;
Quaternion operator/ (Real fScalar) const;
Quaternion& operator*= (Real fScalar);
Quaternion& operator/= (Real fScalar);
Quaternion operator- () const;
```

The last function in this list changes signs on the components of the quaternion, which is a multiplication of the quaternion by the scalar -1. Scalar multiplication has the following associative and distributive properties:

$$(c_0 c_1)q = c_0(c_1 q)$$

$$(c_0 + c_1)q = c_0 q + c_1 q$$

$$c(q_0 + q_1) = c q_0 + c q_1.$$

Products of quaternions are defined, but not by componentwise multiplication. The definition is unintuitive and based on multiplicative properties assigned to the placekeeper symbols i, j, and k: $i^2 = -1$, $j^2 = -1$, $k^2 = -1$, $ij = k$, $ji = -k$, $ik = -j$, $ki = j$, $jk = i$, and $kj = -i$. The first three definitions give quaternions the flavor of complex numbers. The other definitions imply that quaternion multiplication is *not commutative*. If you reverse the order of two numbers in a product, you might not get the same result. (In some special cases, the results can be the same.) The product of quaternions $q_0 = w_0 + x_0 i + y_0 j + z_0 k$ and $q_1 = w_1 + x_1 i + y_1 j + z_1 k$ is obtained from the products of the placekeepers by requiring the distributive and associative laws to apply, and by using the distributive and associative laws for quaternion addition and scalar multiplication:

$$\begin{aligned}
q_0 q_1 &= (w_0 + x_0 i + y_0 j + z_0 k)(w_1 + x_1 i + y_1 j + z_1 k) \\
&= (w_0 w_1 - x_0 x_1 - y_0 y_1 - z_0 z_1) \\
&\quad + (w_0 x_1 + w_1 x_0 + y_0 z_1 - z_0 y_1)i \\
&\quad + (w_0 y_1 + w_1 y_0 + z_0 x_1 - x_0 z_1)j \\
&\quad + (w_0 z_1 + w_1 z_0 + x_0 y_1 - y_0 x_1)k.
\end{aligned} \tag{2.16}$$

The member function that implements quaternion multiplication is

```
Quaternion operator* (const Quaternion& rkQ) const;
```

To emphasize that quaternion multiplication is not commutative, the product in the reversed order is

$$q_1 q_0 = (w_1 + x_1 i + y_1 j + z_1 k)(w_0 + x_0 i + y_0 j + z_0 k)$$

$$= (w_0 w_1 - x_0 x_1 - y_0 y_1 - z_0 z_1)$$

$$+ (w_0 x_1 + w_1 x_0 + y_1 z_0 - y_0 z_1)i \qquad (2.17)$$

$$+ (w_0 y_1 + w_1 y_0 + z_1 x_0 - z_0 x_1)j$$

$$+ (w_0 z_1 + w_1 z_0 + x_1 y_0 - x_0 y_1)k.$$

The w-components of $q_0 q_1$ and $q_1 q_0$ are the same. On the other hand, the last two terms of each of the i-, j-, and k-components in the second line of (2.17) are opposite in sign to their counterparts in the second line of (2.16). Those terms should remind you of the components of a cross product. Symbolically, Equations (2.16) and (2.17) are different, but it is possible for *some* quaternions (but not all) that $q_0 q_1 = q_1 q_0$. For this to happen we need

$$(x_0, y_0, z_0) \times (x_1, y_1, z_1) = (y_0 z_1 - y_1 z_0, z_0 x_1 - z_1 x_0, x_0 y_1 - y_0 x_1)$$

$$= (y_1 z_0 - y_0 z_1, z_1 x_0 - z_0 x_1, x_1 y_0 - x_0 y_1)$$

$$= (x_1, y_1, z_1) \times (x_0, y_0, z_0).$$

The only way the two cross products can be the same for a pair of vectors is if they are parallel. In summary, $q_0 q_1 = q_1 q_0$ if and only if $(x_1, y_1, z_1) = t(x_0, y_0, z_0)$ for some real-valued scalar t.

Notice that the quaternion class does not implement `operator*=` with a quaternion input. This is to avoid confusion about which order in the product is intended—an important point since quaternion multiplication is not commutative. For the same reasons, the division operators `operator/` and `operator/=` with quaternion inputs are not implemented.

Rotations

The utility of quaternions in computer graphics is that the unit-length ones are related to rotations. If $q = w + xi + yj + zk$, then q is unit length if $w^2 + x^2 + y^2 + z^2 = 1$. Such a quaternion may be written as

$$q = \cos(\theta/2) + \sin(\theta/2)(u_0 i + u_1 j + u_2 k) = \cos(\theta/2) + \sin(\theta/2)\hat{u},$$

where $u_0^2 + u_1^2 + u_2^2 = 1$. The last equality defines \hat{u}, which is itself a unit-length quaternion, but has no w-component. The quaternion corresponds to a rotation matrix R whose axis of rotation has a unit-length direction $\mathbf{u} = (u_0, u_1, u_2)$ and whose angle of rotation is θ. The rotation matrix may be applied to a vector $\mathbf{v} = (v_0, v_1, v_2)$ to obtain the rotated vector \mathbf{v}':

$$\mathbf{v}' = R\mathbf{v}.$$

In terms of quaternions, let $\hat{v} = v_0 i + v_1 j + v_2 k$. The rotation is computed using quaternions by

$$\hat{v}' = q\hat{v}q^*,$$

where $q^* = w - xi - yj - zk = \cos(\theta/2) - \sin(\theta/2)\hat{u}$ is called the *conjugate* of q. The result $\hat{v}' = v_0'i + v_1'j + v_2'k$ has no w-component and represents the rotated vector $\mathbf{v}' = (v_0', v_1', v_2')$. That said, the operation count for rotating a vector is smaller when instead the quaternion is converted to a rotation matrix and the vector is multiplied directly. The member function to rotate a vector is

```
Vector3<Real> Rotate (const Vector3<Real>& rkVector) const;
```

```
Quaternion<Real> q = <some unit-length quaternion>;
Vector3<Real> v = <some vector>;
Vector3<Real> rotated_v = q.Rotate(v);
```

The usage is clear. The conjugate operation is supported by

```
Quaternion Conjugate () const;
```

If you wanted to use only quaternion algebra, the rotation operation, which uses a constructor that takes a vector and converts it to a quaternion with a w-component that is zero, is the following:

```
Quaternion<Real> q = <some unit-length quaternion>;
Vector3<Real> v = <some vector>;
Vector3<Real> rotated_v = q * Quaternion(v) * q.Conjugate();
```

Related to the conjugate is the multiplicative *inverse* of a nonzero quaternion q, namely, q^{-1}. The inverse has the property $qq^{-1} = q^{-1}q = 1 = 1 + 0i + 0j + 0k$. Moreover,

$$q^{-1} = \frac{q^*}{|q|},$$

where $|q|$ is the length of q when considered a 4-tuple. The member function for inversion is

```
Quaternion Inverse () const;
```

Invariably an application requires conversion between unit-length quaternions and rotation matrices. Constructors supporting conversion of rotations are

```
Quaternion (const Matrix3<Real>& rkRot);
```

```
Quaternion (const Vector3<Real> akRotColumn[3]);
Quaternion (const Vector3<Real>& rkAxis, Real fAngle);
```

The first two constructors convert the rotation matrix directly. The third constructor creates a quaternion from an axis-angle representation of the rotation. Other member functions supporting conversion are

```
Quaternion& FromRotationMatrix (const Matrix3<Real>& rkRot);
void ToRotationMatrix (Matrix3<Real>& rkRot) const;
Quaternion& FromRotationMatrix (
    const Vector3<Real> akRotColumn[3]);
void ToRotationMatrix (Vector3<Real> akRotColumn[3]) const;
Quaternion& FromAxisAngle (const Vector3<Real>& rkAxis,
    Real fAngle);
void ToAxisAngle (Vector3<Real>& rkAxis, Real& rfAngle) const;
```

The names make it clear how the functions are used. The `From` methods return a reference to the object to allow side effects such as

```
Matrix3<Real> rot = <some rotation matrix>;
Quaternion<Real> p = <some quaternion>, q;
Quaternion<Real> product = p * q.FromRotationMatrix(rot);
```

Interpolation

One of the primary benefits of quaternions is ease of interpolation of rotation and orientation data. Given two unit-length quaternions q_0 and q_1, the *spherical linear interpolation* of the quaternions is the unit-length quaternion

$$\text{slerp}(t; q_0, q_1) = \frac{\sin((1-t)\theta)q_0 + \sin(t\theta)q_1}{\sin\theta},$$

where θ is the angle between q_0 and q_1. The value t is in the interval $[0, 1]$. The formula requires that $\sin\theta \neq 0$. If q_0 and q_1 are the same quaternion, then $\theta = 0$. But in this case, you may choose $q(t) = q_0$ for all t. If $q_1 = -q_0$, then $\theta = \pi$. Although the 4-tuples are different, they represent the same rotation. Despite this, you can choose a unit-length 4-tuple p that is perpendicular to q_0 (there are infinitely many of these), then interpolate from q_0 to p for $t \in [0, 1/2]$ and from p to q_1 for $t \in [1/2, 1]$. Specifically,

$$\text{slerp}(t; q_0, q_1) = \begin{cases} \sin(\pi(1/2 - t))q_0 + \sin(\pi t)p, & t \in [0, 1/2] \\ \sin(\pi(1-t))p + \sin(\pi(t - 1/2))q_1, & t \in [1/2, 1]. \end{cases}$$

The angle θ may be obtained from the dot product of 4-tuples, $q_0 \cdot q_1 = \cos(\theta)$, or $\theta = \arccos(q_0 \cdot q_1)$. The dot product is implemented by the member function

```
Real Dot (const Quaternion& rkQ) const;
```

The spherical linear interpolation has the acronym *slerp*. The method that implements this is

```
Quaternion& Slerp (Real fT, const Quaternion& rkQ0,
    const Quaternion& rkQ1);
```

Because of the observation that q and $-q$ represent the same rotation, it is better to preprocess a sequence of quaternions so that consecutive pairs form acute angles. For such a sequence, you need only trap the case when θ is (nearly) zero. The preprocessing is

```
Quaternion<Real> q[n] = <sequence of n quaternions>;
for (int i = 0; i < n-1; i++)
{
    if ( q[i].Dot(q[i+1]) < (Real)0.0 )
        q[i+1] = -q[i+1];
}
```

The Slerp function assumes that the two input quaternions form an acute angle (their dot product is nonnegative).

The slerp function is a parameterization of the shortest arc that connects q_0 to q_1 on the four-dimensional unit hypersphere. If you extend that path to completely cover the great circle starting at q_0, passing through q_1, eventually passing through q_0 again, then terminating at q_1, the resulting interpolations produce rotation matrices that have interesting properties. If those rotations are applied to an object, the object obtains *extra spins*. A brief discussion is in the article "Quaternion interpolation with extra spins" in [Kir92]. The modified slerp equation is

$$\text{SlerpExtraSpins}(t; q_0, q_1, k) = \frac{\sin((1-t)\theta - k\pi t)q_0 + \sin(t\theta + k\pi t)q_1}{\sin\theta},$$

where k is the number of extra spins (or the number of times the path on the hypersphere returns through q_0). The standard slerp equation occurs when $k = 0$. The method implementing slerp with extra spins is

```
Quaternion& SlerpExtraSpins (Real fT, const Quaternion& rkQ0,
    const Quaternion& rkQ1, int iExtraSpins);
```

A higher-order interpolation is provided by *spherical quadrangle interpolation* or, in short, *squad*. Whereas slerp is a form of linear interpolation, squad is a form of

cubic interpolation. Recall from the study of cubic polynomial curves that four pieces of information are needed to determine the four coefficients of the curve. If \mathbf{P}_0 and \mathbf{P}_1 are the end points of the curve segment with corresponding tangent vectors \mathbf{T}_0 and \mathbf{T}_1, a cubic polynomial curve containing the end points is

$$\mathbf{X}(t) = \mathbf{A}_0 + \mathbf{A}_1 t + \mathbf{A}_2 t^2 + \mathbf{A}_3 t^3,$$

where $t \in [0, 1]$. The derivative is

$$\mathbf{X}'(t) = \mathbf{A}_1 + 2\mathbf{A}_2 t + 3\mathbf{A}_3 t^2$$

and represents the velocity of a particle traveling along the curve. To satisfy the constraints we need

$$\mathbf{P}_0 = \mathbf{X}(0) = \mathbf{A}_0$$

$$\mathbf{P}_1 = \mathbf{X}(1) = \mathbf{A}_0 + \mathbf{A}_1 + \mathbf{A}_2 + \mathbf{A}_3$$

$$\mathbf{T}_0 = \mathbf{X}'(0) = \mathbf{A}_1$$

$$\mathbf{T}_1 = \mathbf{X}'(1) = \mathbf{A}_1 + 2\mathbf{A}_2 + 3\mathbf{A}_3.$$

This is a linear system of four equations in four unknown vectors. The solution is

$$\mathbf{A}_0 = \mathbf{A}_1$$

$$\mathbf{A}_1 = \mathbf{T}_0$$

$$\mathbf{A}_2 = 3(\mathbf{P}_1 - \mathbf{P}_0) - 2\mathbf{T}_0 - \mathbf{T}_1$$

$$\mathbf{A}_3 = -2(\mathbf{P}_1 - \mathbf{P}_0) + \mathbf{T}_0 + \mathbf{T}_1.$$

If you are interpolating a sequence of points $\{\mathbf{P}_n\}_{n=0}^{N-1}$ with no specified tangents, you may estimate the tangent \mathbf{P}_n using only this point and its immediate neighbors \mathbf{P}_{n-1} and \mathbf{P}_{n+1}. The one-sided tangent generated from the previous point is $\mathbf{P}_n - \mathbf{P}_{n-1}$. The other one-sided tangent is $\mathbf{P}_{n+1} - \mathbf{P}_n$. A reasonable estimate for the tangent is the average of these:

$$\mathbf{T}_n = \frac{(\mathbf{P}_n - \mathbf{P}_{n-1}) + (\mathbf{P}_{n+1} - \mathbf{P}_n)}{2} = \frac{\mathbf{P}_{n+1} - \mathbf{P}_{n-1}}{2}.$$

The tangent vector is the direction of the line segment connecting the two neighboring points.

The analogy to this construction produces squad from two unit-length quaternions q_0 and q_1, but as in the case of a cubic curve, we need two additional pieces of information. As discussed in [Sho87], the squad of four quaternions q_0, a_0, b_1, and q_1 is

$$\text{squad}(t; q_0, a_0, b_1, q_1) = \text{slerp}(2t(1-t); \text{slerp}(t; q_0, q_1), \text{slerp}(t; a_0, b_1)),$$

for $t \in [0, 1]$. A natural selection for a_0 and b_1 is motivated by the use of tangent vectors for cubic polynomial curves. The concept of a tangent in the quaternion realm is quite mathematical, despite its ties to geometric ideas. As it turns out, you need the concept of a *logarithmic function* and its inverse, an *exponential function*. The quaternions have such functions. A unit-length quaternion $\cos(\theta/2) + \sin(\theta/2)\hat{u}$ has the logarithm

$$\log(\cos(\theta/2) + \sin(\theta/2)\hat{u}) = (\theta/2)\hat{u}.$$

The exponential function is the inverse of this operation,

$$\exp((\theta/2)\hat{u}) = \cos(\theta/2) + \sin(\theta/2)\hat{u},$$

where \hat{u} is a unit-length quaternion whose w-component is zero.

To continue the analogy with cubic polynomial curves generated from a sequence of positions, let $\{q_n\}_{n=0}^{N-1}$ be a sequence of unit-length quaternions where $N \geq 3$. The one-sided tangent at q_n corresponding to q_{n-1} is $\log(q_{n-1}^{-1}q_n)$. The one-sided tangent at q_n corresponding to q_n is $\log(q_n^{-1}q_{n+1})$. A reasonable tangent to select for q_n is an average of the one-sided tangents:

$$T_n = \frac{\log(q_{n-1}^{-1}q_n) + \log(q_n^{-1}q_{n+1})}{2}.$$

Consider the problem of interpolating a sequence of unit-length quaternions, where $N \geq 3$. Specifically, let

$$S_n(t) = \text{squad}(t; q_n, a_n, b_{n+1}, q_{n+1})$$

for some to-be-determined quaternions a_n and b_{n+1}. To obtain continuity of the interpolation across shared end points, we need

$$S_{n-1}(1) = q_n = S_n(0).$$

To obtain derivative continuity, we need

$$S'_{n-1}(t) = q_n T_n = S'_n(0),$$

where T_n is a tangent quaternion at q_n. These produce two equations in the two unknowns a_n and b_n. An application of the rules of quaternion algebra leads to

$$a_n = b_n = q_n \exp\left(-\frac{\log(q_n^{-1}q_{n-1}) + \log(q_n^{-1}q_{n+1})}{4}\right).$$

Each a_n and b_n depends on three quaternions: $q_{n-1}, q_n,$ and q_{n+1}, just as the estimated tangent for a sequence of positions depended on three consecutive positions.

The methods in class Quaternion that support logarithms, exponentials, estimation of the intermediate a_n, and squad are

```
Quaternion Log () const;
Quaternion Exp () const;

Quaternion& Intermediate (const Quaternion& rkQ0,
    const Quaternion& rkQ1, const Quaternion& rkQ2);

Quaternion& Squad (Real fT, const Quaternion& rkQ0,
    const Quaternion& rkA0, const Quaternion& rkA1,
    const Quaternion& rkQ1);
```

The GetIntermediate function is used to compute the a_n. Observe that the estimation of tangent vectors for the cubic polynomial curve requires the two immediate neighbors of the given point. The first point \mathbf{P}_0 and \mathbf{P}_{N-1} do not have two neighbors, so artificial ones should be used just for the purposes of the estimation. The same issue occurs for quaternion sequences. My choice is to use q_0 itself as one of its neighbors. The following pseudocode shows how I choose to preprocess a quaternion sequence for the purposes of interpolation:

```
Quaternion<Real> q[n] = <sequence of n quaternions>;
Quaternion<Real> a[n] = <intermediate quaternions, to be computed>;

// arrange for all acute angles between consecutive quaternions
for (i = 0; i < n-1; i++)
{
    if ( q[i].Dot(q[i+1]) < (Real)0.0 )
        q[i+1] = -q[i+1];
}

// compute the intermediate quaternions for squad
a[0].Intermediate(q[0],q[0],q[1]);
for (i = 1; i <= n-2; i++)
{
    a[i].Intermediate(q[i-1],q[i],q[i+1]);
}
a[n-1].Intermediate(q[n-2],q[n-1],q[n-1]);

// example:  interpolate at t = 1/2 for all segments
Quaternion<Real> interp;
Real t = 0.5;
for (i = 0; i < n-1; i++)
    interp.Squad(t,q[i],a[i],a[i+1],q[i+1]);
```

Three member functions are provided to support animation of joints in characters:

```
Quaternion& Align (const Vector3<Real>& rkV1,
    const Vector3<Real>& rkV2);

void DecomposeTwistTimesSwing (const Vector3<Real>& rkV1,
    Quaternion& rkTwist, Quaternion& rkSwing);

void DecomposeSwingTimesTwist (const Vector3<Real>& rkV1,
    Quaternion& rkSwing, Quaternion& rkTwist);
```

Function `Align` computes a quaternion that rotates the unit-length vector \mathbf{V}_1 to a unit-length vector \mathbf{V}_2. There are infinitely many rotations that can do this. If the two vectors are not parallel, the axis of rotation is the unit-length vector

$$\mathbf{U} = \frac{\mathbf{V}_1 \times \mathbf{V}_2}{|\mathbf{V}_1 \times \mathbf{V}_2|}.$$

The angle of rotation θ is the angle between the two vectors. The quaternion for the rotation is

$$q = \cos(\theta/2) + \sin(\theta/2)(u_0 i + u_1 j + u_2 k),$$

where $\mathbf{U} = (u_0, u_1, u_2)$. Rather than extracting $\theta = \arccos(\mathbf{V}_1 \cdot \mathbf{V}_2)$, multiplying by $1/2$, then computing $\sin(\theta/2)$ and $\cos(\theta/2)$, we reduce the computational costs by computing the bisector $\mathbf{B} = (\mathbf{V}_1 + \mathbf{V}_2)/|\mathbf{V}_1 + \mathbf{V}_2|$, so $\cos(\theta/2) = \mathbf{V}_1 \cdot \mathbf{B}$. The rotation axis is $\mathbf{U} = (\mathbf{V}_1 \times \mathbf{B})/|\mathbf{V}_1 \times \mathbf{B}|$, but

$$|\mathbf{V}_1 \times \mathbf{B}| = |\mathbf{V}_1||\mathbf{B}| \sin(\theta/2) = \sin(\theta/2),$$

in which case

$$\sin(\theta/2)(u_0 i + u_1 j + u_2 k) = (c_0 i + c_1 j + c_2 k),$$

where $\mathbf{C} = \mathbf{V}_1 \times \mathbf{B}$.

If \mathbf{V}_1 and \mathbf{V}_2 are parallel, or nearly parallel as far as the floating-point calculations are concerned, the calculation of \mathbf{B} will produce the zero vector since `Vector3::Normalize` checks for closeness to zero and returns the zero vector accordingly. Thus, we test for parallelism by checking if $\cos(\theta/2)$ is zero. The test for exactly zero is usually not recommended for floating-point arithmetic, but the implementation of `Vector3::Normalize` guarantees the comparison is robust. The axis of rotation for the parallel case can be any axis. If $\mathbf{V}_2 = (a, b, c)$, the axis I choose is the permutation (c, b, a).

The decomposition functions are similar to the Euler angle decompositions for matrices. Given a unit-length quaternion q and a vector \mathbf{V}_1, let \mathbf{V}_2 be the rotation of \mathbf{V}_1 via the quaternion. We may think of q as having two rotational components. The first component is rotation about the axis perpendicular to \mathbf{V}_1 and \mathbf{V}_2 and is represented by the quaternion q_{swing}. The term *swing* is suggestive of the motion of \mathbf{V}_1 toward \mathbf{V}_2 about the hinge perpendicular to the plane of those vectors. The second component is the remaining rotation needed to complete the full rotation implied by q and is represented by the quaternion q_{twist}. The term *twist* is used because this rotation is effectively about the axis with direction \mathbf{V}_1. Two decompositions are possible:

$$q = q_{\text{swing}}\, q_{\text{twist}},$$

which is implemented in `DecomposeSwingTimesTwist`, or

$$q = q_{\text{twist}}\, q_{\text{swing}},$$

which is implemented in `DecomposeTwistTimesSwing`. The order you choose is, of course, related to how your joint animations are implemented in the applications.

Physics

You might have asked the question: Why support addition, subtraction, and scalar multiplication of quaternions when they are used only to represent rotations? The rotational aspects require us only to work with quaternion multiplication. The answer is that numerical methods for physical simulation require all the algebraic operations when the simulation uses quaternions to represent rotation matrices. For example, the equations of motion for an unconstrained rigid body of mass m with applied force \mathbf{F} and applied torque $\boldsymbol{\tau}$ are

$$\dot{\mathbf{x}} = \mathbf{p}/m$$
$$\dot{q} = \omega q /2$$
$$\dot{\mathbf{p}} = \mathbf{F}$$
$$\dot{\mathbf{L}} = \boldsymbol{\tau},$$

where \mathbf{x} is the location of the center of mass for the body, \mathbf{p} is the linear momentum ($\mathbf{p} = m\mathbf{v}$, where \mathbf{v} is the linear velocity), q is the quaternion that represents the orientation of the rigid body, ω is the quaternion that represents the angular velocity (this quaternion has w-component equal to zero), and \mathbf{L} is the angular momentum. If you were to numerically solve this with Euler's method, the algorithm is

$$\mathbf{x}(t + h) = \mathbf{x}(t) + h\mathbf{p}(t)/m$$

$$q(t + h) = q(t) + h\omega(t)q(t)/2$$

$$\mathbf{p}(t + h) = \mathbf{p}(t) + h\mathbf{F}(t)$$

$$\mathbf{L}(t + h) = \mathbf{L}(t) + h\boldsymbol{\tau}(t),$$

where the right-hand side depends on current time t, the time step $h > 0$, and the state of the system at time t. The left-hand side is the state of the system at time $t + h$. The right-hand side of the quaternion equation requires scalar multiplication and quaternion addition. The left-hand side is generally not unit length because of the approximation, so a numerical solver will normalize $\mathbf{q}(t + h)$ to make it unit length. Of course you will most likely use more sophisticated numerical solvers, such as the Runge-Kutta methods. These also use quaternion addition and scalar multiplication.

2.2.6 LINES AND PLANES

Lines and planes are two basic geometric objects in any 3D system. Minimal support is provided for these.

Lines

The template class `Line3` represents a parametric line $\mathbf{P} + t\mathbf{D}$ for $t \in \mathbb{R}$. The point \mathbf{P} is on the line and is considered to be the origin for the line. The unit-length vector \mathbf{D} is a direction for the line. The user is responsible for ensuring that the direction is unit length. The class interface is self-explanatory. The data members for the origin and direction are public since reading or writing them has no side effects. The most complicated member function is

```
Real DistanceTo (const Vector3<Real>& rkQ) const;
```

which computes the distance from the input point to the line. The distance d from point \mathbf{Q} to the line is given by the equation

$$d = |\mathbf{D} \times (\mathbf{Q} - \mathbf{P})|.$$

This equation represents the length of $\mathbf{Q} - \mathbf{P}$ with the component in the direction \mathbf{D} projected out.

Planes

The template class `Plane3` represents a plane of the form $\mathbf{N} \cdot \mathbf{X} = c$. The unit-length vector \mathbf{N} is normal to the plane, and the value c is called the plane constant. If

P is any point on the plane, then $c = \mathbf{N} \cdot \mathbf{P}$. An equivalent representation of the plane is $\mathbf{N} \cdot (\mathbf{X} - \mathbf{P}) = 0$. The user is responsible for ensuring that the normal is unit length. The class interface is also self-explanatory. The data members for the normal and constant are public since reading or writing them has no side effects. Three constructors of interest are

```
Plane3 (const Vector3<Real>& rkNormal, Real fConstant);
Plane3 (const Vector3<Real>& rkNormal, const Vector3<Real>& rkP);
Plane3 (const Vector3<Real>& rkP0, const Vector3<Real>& rkP1,
    const Vector3<Real>& rkP2);
```

The first allows you to specify the normal and constant, the second allows you to specify the normal and a point on the plane, and the third generates the normal from three points on the plane.

Two utility functions are provided. The first is

```
int WhichSide (const Vector3<Real>& rkP) const;
```

The *positive side* of the plane is defined to be the half space to which the plane normal points. The *negative side* is the other half space. The function returns 1 if the input point is on the positive side of the plane, -1 if the point is on the negative side of the plane, and 0 if the point is on the plane. The second utility function is

```
Real DistanceTo (const Vector3<Real>& rkQ) const;
```

It computes the *signed distance* from the point **Q** to the plane. This quantity is

$$d = \mathbf{N} \cdot \mathbf{Q} - c.$$

The sign of d is positive if the point is on the positive side of the plane, negative if the point is on the negative side, and zero if the point is on the plane. The value $|d|$ is the true distance and is the length of the projection of $\mathbf{Q} - \mathbf{P}$ onto a normal line to the plane, where **P** is any point on the plane.

2.2.7 COLORS

The engine has two color classes, ColorRGB and ColorRGBA. Both classes are intended to store color channels that are floating-point numbers in the interval [0, 1]. Extreme precision for colors is not required, so only float is implemented (the classes are not templates). Class ColorRGB stores a red-green-blue color in an array of three elements. Class ColorRGBA stores a red-green-blue-alpha color in an array of four elements. The classes are nearly identical in structure to Vector3 and Vector4, respectively. The array storage is used to allow safe typecasting of an object to a float* pointer, regardless of whether the engine is running on a 32- or 64-bit platform.

ColorRGB

The constructors other than the default and copy constructors are

```
ColorRGB (float fR, float fG, float fB);
ColorRGB (float afTuple[3]);
```

When using an array for colors, index 0 maps to red, index 1 maps to green, and index 2 maps to blue.

Member accessors are

```
operator const float* () const;
operator float* ();
float operator[] (int i) const;
float& operator[] (int i);
float R () const;
float& R ();
float G () const;
float& G ();
float B () const;
float& B ();
```

The first two members are for safe typecasting to `float*` pointers. The `operator[]` members use the assert-and-repair paradigm. If the index is out of range, an assertion is fired in debug mode, but in release mode the index is clamped to the valid range. The remaining members are for access by name: `R` for the red channel, `G` for the green channel, and `B` for the blue channel.

The comparison operators are useful for sorting and hashing. Such operations might occur when attempting to generate a small subset of colors from a given set (color quantization).

All the arithmetic operations and updates are performed on a per-channel basis. This is true even for the multiplication operators, whereby the colors are said to be *modulated*. When performing arithmetic on colors, it is possible that the final results have color channels outside the interval [0, 1]. Two methods are provided to transform the channels back to the interval [0, 1]. The Clamp method sets a negative value to zero and a value larger than one to one. The ScaleByMax method assumes that the color channels are nonnegative. The maximum channel is found and all channels are divided by it.

ColorRGBA

The class `ColorRGBA` stores its color channels in an array of four elements. The only difference between this class and `ColorRGB` is the addition of a channel to store alpha

values for color blending. The discussion of ColorRGB applies directly to ColorRGBA, with one exception. The ScaleByMax method finds the maximum of the RGB channels and divides the RGB channels by that amount. The alpha channel is handled differently: it is clamped to the interval [0, 1].

2.3 The Object System

A graphics engine is sufficiently large and complex that it is subject to the rules of large library design using object-oriented programming. The engine has enough objects to manage that it is essential to have a core set of automatic services that the application writers can rely on. This section discusses the support in Wild Magic for object management.

2.3.1 Run-Time Type Information

Polymorphism provides abstraction of functionality. A polymorphic function call can be made regardless of the true type of the calling object. But there are times when you need to know the type of the polymorphic object or to determine if the object's type is derived from a specified type—for example, to safely typecase a base class pointer to a derived class pointer, a process called *dynamic typecasting*. *Run-time type information* (RTTI) provides a way to determine this information while the program is executing.

Single-Inheritance Class Trees

A *single-inheritance object-oriented system* consists of a collection of directed trees where the tree nodes represent classes and the tree arcs represent inheritance. The arcs are directed in the sense that if C_0 is a base class and C_1 is a derived class, the tree has a directed arc from C_1 to C_0. The directed edges indicate an *is-a* relationshiop. A root node of the tree represents the common base class of all the classes in that tree. Although a single-inheritance system can have multiple trees, it is standard to implement a single tree. The root class provides basic services for any derived classes. Wild Magic is architected with a single tree whose root class is Object. Figure 2.4 shows a simple single-inheritance hierarchy. The root of the tree is Polygon. Rectangle is a Polygon, and Square is a Rectangle. Moreover, Square is a Polygon indirectly. Triangle is a Polygon, EquilateralTriangle is a Triangle, and RightTriangle is a Triangle. However, Square is not a Triangle, and RightTriangle is not an EquilateralTriangle.

An RTTI system is an implementation of the directed trees. The basic RTTI data type stores any class-specific information an application requires at run time. It also stores a link to the base class (if any) to allow an application to determine if a class is inherited from another class. The simplest representation stores no class information

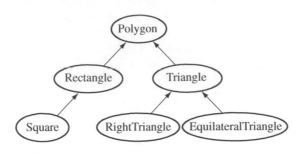

Figure 2.4 Single-inheritance hierarchy.

and only the link to the base class. However, it is useful to store a string encoding the name of the class. In particular, the string will be used in the streaming system that is described later. The string may also be useful for debugging purposes in quickly identifying the class type.

```
class Rtti
{
public:
    Rtti (const String& rkName, const Rtti* pkBaseType);
    ~Rtti ();

    const String& GetName () const;

    bool IsExactly (const Rtti& rkType) const;
    bool IsDerived (const Rtti& rkType) const;

private:
    String m_kName;
    const Rtti* m_pkBaseType;
};
```

In order to support the namespace of Wild Magic version 3, Wm3, and other namespaces defined by applications using the engine (including Wml, used for Wild Magic version 2), the string used for the class should contain the namespace as well. In Wild Magic, a class Foo uses the name "Wm3.Foo". The member function GetName is a simple accessor of the name.

The member function IsExactly checks to see if the caller RTTI object and the input RTTI object are the same. The string names uniquely identify the RTTI objects and may be compared to determine if the objects are the same. This is an expensive test, though, and instead I take advantage of the fact that the RTTI objects persist

throughout the application execution time. As such, the addresses of the objects are themselves unique identifiers. The function is simply implemented as

```
bool Rtti::IsExactly (const Rtti& rkType) const
{
    return &rkType == this;
}
```

The member function `IsDerived` checks to see if the caller RTTI object has the same type of the input RTTI object *or* if a class derived from that of the caller RTTI object has the same type of the input RTTI object. This function implements a search of the linear list starting at the directed tree node corresponding to the class for the caller RTTI object and terminates either when a visited tree node matches the input RTTI object (the function returns `true`) or when the root node of the directed tree is reached without a match (the function returns `false`).

```
bool Rtti::IsDerived (const Rtti& rkType) const
{
    const Rtti* pkSearch = this;
    while ( pkSearch )
    {
        if ( pkSearch == &rkType )
            return true;
        pkSearch = pkSearch->m_pkBaseType;
    }
    return false;
}
```

The class in a single-inheritance tree must contain basic support for the RTTI system:

```
class MyClass
{
public:
    static const Rtti TYPE;
    virtual const Rtti& GetType () const { return TYPE; }
};
```

The RTTI object is static since that information is specific to the entire class. The member is public since it needs to be used in RTTI queries. Because the name `TYPE` of the static member is the same in each class, the derived class member hides the base class member. The virtual function `GetType` allows you to access the correct type when an object is available polymorphically through a base class pointer or reference. The source file for each class must construct the static member:

```
// in source file of root ''class Object''
const Rtti Object::TYPE("Wm3.Object",NULL);

// in source file of ''class DerivedClass : public BaseClass''
const Rtti DerivedClass::TYPE("Wm3.DerivedClass",&BaseClass::TYPE);
```

The constructor adds each new class to the single-inheritance tree of RTTI objects
and adds the tree arc from the derived class to the base class.

Because of the name hiding of TYPE, you should beware of incorrectly accessing
the type. For example,

```
DerivedClass* pkDerived = <some DerivedClass object>;
String kName0 = pkDerived->TYPE.GetName();
    // kName0 = "Wm3.DerivedClass"
String kName1 = pkDerived->GetType().GetName();
    // kName1 = "Wm3.DerivedClass"

BaseClass* pkBase = pkDerived;
String kName2 = pkBase->TYPE.GetName();
    // kName2 = "Wm3.BaseClass"
String kName3 = pkBase->GetType().GetName();
    // kName3 = "Wm3.DerivedClass"

Object* pkRoot = pkDerived;
String kName4 = pkRoot->TYPE.GetName();
    // kName4 = "Wm3.Object"
String kName5 = pkRoot->GetType().GetName();
    // kName5 = "Wm3.DerivedClass"
```

To be safe, you should always use the GetType member function when accessing the
RTTI name via the object itself. If you want to access the class RTTI name directly,
you can use MyClass::TYPE to access the static member of MyClass.

The root class Object has been given four helper functions to make RTTI queries
a bit simpler to use:

```
class Object
{
public:
    bool IsExactly (const Rtti& rkType) const;
    bool IsDerived (const Rtti& rkType) const;
    bool IsExactlyTypeOf (const Object* pkObj) const;
    bool IsDerivedTypeOf (const Object* pkObj) const;
};
```

```
// sample usage
DerivedClass* pkDerived = <some DerivedClass object>;
bool bResult0 = pkDerived->IsExactly(DerivedClass::TYPE);
  // bResult0 = true
bool bResult1 = pkDerived->IsExactly(BaseClass::TYPE);
  // bResult1 = false
bool bResult2 = pkDerived->IsDerived(BaseClass::TYPE);
  // bResult2 = true

BaseClass* pkBase = <some BaseClass object>;
bool bResult3 = pkDerived->IsExactlyTypeOf(pkBase);
  // bResult3 = false
bool bResult4 = pkDerived->IsDerivedTypeOf(pkBase);
  // bResult4 = true
bool bResult5 = pkBase->IsExactlyTypeOf(pkDerived);
  // bResult5 = false
bool bResult6 = pkBase->IsDerivedTypeOf(pkDerived);
  // bResult6 = false
```

The implementations of the helper functions are quite simple and just transfer the calls to the RTTI objects for processing:

```
bool Object::IsExactly (const Rtti& rkType) const
{
    return GetType().IsExactly(rkType);
}

bool Object::IsDerived (const Rtti& rkType) const
{
    return GetType().IsDerived(rkType);
}

bool Object::IsExactlyTypeOf (const Object* pkObj) const
{
    return pkObj && GetType().IsExactly(pkObj->GetType());
}

bool Object::IsDerivedTypeOf (const Object* pkObj) const
{
    return pkObj && GetType().IsDerived(pkObj->GetType());
}
```

Static and Dynamic Typecasting

If you have a base class pointer to an object, yet at compile time know that the object is from a derived class of the base class, you can use a static typecast to manipulate that object:

```
DerivedClass* pkDerived0 = <some DerivedClass object>;
pkDerived0->SomeDerivedClassFunction();  // okay

BaseClass* pkBase = pkDerived0;
pkBase->SomeDerivedClassFunction();  // will not compile

// typecast is safe since *pkBase is a DerivedClass object
DerivedClass* pkDerived1 = (DerivedClass*) pkBase;
pkDerived1->SomeDerivedClassFunction();  // okay
```

There are times, though, when you want to manipulate a polymorphic object only when it is from a specific class or derived from a specific class. Such information might not be deduced at compile time and can only be determined at run time. The static typecast is not safe because the object may very well not be in the class to which you cast. The answer is to use a *dynamic cast*. The RTTI system allows you to determine if the object is in the specified class. If it is, you can then safely typecast. If it is not, you ignore the object and continue.

The root class Object provides services for static and dynamic typecasting. A static typecast can be performed in a C-style as shown earlier, but to be consistent with coding style and to support smart pointers, discussed in Section 2.3.3, wrappers are provided for this. The support in both cases is via templates.

```
template <class T> T* StaticCast (Object* pkObj)
{
    return (T*)pkObj;
}

template <class T> const T* StaticCast (const Object* pkObj)
{
    return (const T*)pkObj;
}

template <class T> T* DynamicCast (Object* pkObj)
{
    return pkObj
        && pkObj->IsDerived(T::TYPE) ? (T*)pkObj : NULL;
}
```

```
template <class T> const T* DynamicCast (const Object* pkObj)
{
    return pkObj
        && pkObj->IsDerived(T::TYPE) ? (const T*)pkObj : NULL;
}
```

The static casts just wrap the C-style cast. The support for smart pointers occurs because of an implicit conversion allowed from a smart pointer object to an Object pointer of the object managed by the smart pointer. The dynamic cast checks to make sure the input object can be cast to the desired derived class. If it can, the object pointer is returned. If it cannot, a null pointer is returned. The caller of the dynamic cast must check the returned pointer to distinguish between the two cases. For example,

```
class MyClass1 : public Object {...};
class MyClass2 : public Object {...};

bool PerformClass1Action (Object* pkObj)
{
    MyClass1* pkCast = DynamicCast<MyClass1>(pkObj);
    if ( pkCast )
    {
        // perform action
        return true;
    }

    // object not from MyClass1
    return false;
}

MyClass1* pkObj1 = <some MyClass1 object>;
bool bResult1 = PerformClass1Action(pkObj1);  // bResult1 = true

MyClass2* pkObj2 = <some MyClass2 object>;
bool bResult2 = PerformClass1Action(pkObj2);  // bResult1 = false
```

The typecasting mechanisms absolutely depend on the input objects being pointers to objects in the Object single-inheritance tree. You must not pass pointers to objects not in the system. The only alternative that can handle any objects is to have compiler support where the RTTI is created and maintained implicitly, but compiler support is typically a nonportable solution. Moreover, the compiler support must handle multiple inheritance, so the RTTI system can be slower than one designed specifically for single inheritance. I prefer portability and avoid multiple inheritance; the RTTI system in Wild Magic reflects these preferences.

2.3.2 NAMES AND UNIQUE IDENTIFIERS

Searching for specific objects at run time is useful. The graphics engine supports searching based on a character string name and on a unique integer-valued identifier.

Name String

An application might require finding objects in the system during run time. To facilitate this, each object has a character string member. The string can be something as simple as a human-readable name, but it could also contain additional information that is useful to the application. For example, the root node of a model of a table could be assigned the name string "Table 17" to identify that the model is in fact a table, with the number indicating that other tables (or types of tables) exist in the scene. It might be important for the application to know what room contains the table. The name string can contain such information, for example, "Table 17 : Room 23".

To support name strings, the `Object` class provides the following API:

```
public:
    void SetName (const String& rkName);
    const String& GetName () const;
    virtual Object* GetObjectByName (const String& rkName);
    virtual void GetAllObjectsByName (const String& rkName,
        TArray<Object*>& rkObjects);
private:
    String m_kName;
```

The member functions `SetName` and `GetName` are standard accessors to the name string. The member function `GetObjectByName` is a search facility that returns a pointer to an object with the specified name. If the caller object has the specified name, the object just returns a pointer to itself. If it does not have the input name, a search is applied to member objects. The method of search depends on the `Object`-derived class itself. Class `Object` compares the input name to the name of the object itself. If found, the object pointer is returned. If not, a search is made over all the controllers attached to the object, and if found, the controller pointer is returned. Otherwise, a null pointer is returned indicating that an object with the specified name was not found in the current object. A derived class implementation must call the base class function before checking its own object members.

The name string is not necessarily unique. If two objects have the same name, `GetObjectByName` will find one of them and return a pointer to it. The other object is not found. The other name string member function handles multiple occurrences of a name string. A call to `GetAllObjectsByName` will search for all objects with the input name. The method of search depends on the `Object`-derived class itself.

Unique Identification

Although names are readable and of use to a human, another form of identification may be used to track objects in the system. At first glance you might choose to use the memory address of the object as a unique identifier since, at a single instant in time, the address is unique. Over time, however, you can run into problems with this scheme. If the memory address of an object is stored by the application to be processed at a later time, it is possible that the object is deleted at some intermediate time. At deletion time the application then has a dangling pointer since the object no longer exists. Worse, other memory allocations can occur with the chance that an entirely new object has the same memory address as the old one that is now defunct. The application no longer has a dangling pointer, but that pointer does not point to the object the application thinks it is. The likelihood of such an occurrence is higher than you think, especially when the memory manager is asked to allocate and deallocate a collection of homogeneous objects, all objects of constant size in memory.

To avoid such problems, each object stores a unique identifier. Wild Magic currently uses a 32-bit unsigned integer. The Object class has a static unsigned integer member that stores the next available identifier. Each time an object is created, the current static member value is assigned to the nonstatic object member; the static member is then incremented. Hopefully, 32 bits is large enough to provide unique identifiers for all objects over the lifetime of the application. If you have an application that requires more than 2^{32} objects, either you can allow the wraparound that will occur when incrementing the static member, or you can implement a "counter" class that allows for more bits and provides the simple services of storing a static "next available" counter and of incrementing a counter.

To support unique identifiers, the Object class provides the following API:

```
public:
    unsigned int GetID () const;
    static unsigned int GetNextID ();
    virtual Object* GetObjectByID (unsigned int uiID);
private:
    unsigned int m_uiID;
    static unsigned int ms_uiNextID;
```

The static member is initialized (pre-main) to zero. Each constructor for the class has the line of code

```
m_uiID = ms_uiNextID++;
```

This is a simple system that is not designed to reuse an old identifier when an object is deleted. A more sophisticated system could allow reuse, but I believe the additional run-time costs are not warranted.

The member function GetObjectByID is similar in structure to the function Get-ObjectByName, except that identifiers are compared rather than name strings. Since the identifiers are unique, there is no need for a function GetAllObjectsByID. As with the other search functions, the method of search in an Object-derived class is specific to that class.

2.3.3 SHARING AND SMART POINTERS

One of the most important concepts in a large library is the ability to share objects. Geometric models with a lot of data can have the data shared to minimize memory use. Because texture images can take a lot of space, if two objects are to be textured with the same image, you might as well share the texture object in order to minimize memory use. It is unlikely that the application programmers can manually manage shared objects without losing some (object leaking) or destroying some while others are using them (premature destruction). An automated system can assist in the object management. The method I use is to include a reference counter in the Object class that counts how many objects have a pointer to the current one. Each time an object is referenced by another, the reference count is incremented. Each time another object decides not to reference the current one, the current's reference count is decremented. Once the reference counter decreases to zero, the object is no longer referenced in the system and it is automatically deleted.

The programmer may be given the ability to increment or decrement the reference counts himself, but this once again assumes the programmer will properly manage the objects. I prefer to hide the details of the sharing mechanism using a *smart pointer* system. The Object class provides the following interface in support of sharing:

```
class Object
{
public:
    void IncrementReferences ();
    void DecrementReferences ();
    int GetReferences () const;
    static THashTable<unsigned int,Object*> InUse;
    static void PrintInUse (const char* acFilename,
        const char* acMessage);
private:
    int m_iReferences;
};
```

The data member m_iReferences stores the number of references to the object. The Object constructor sets this value to zero. You may query an object to find out how many references it has using the member function GetReferences. The function

IncrementReferences does exactly what its name says: it increments the reference counter. It is intended for use by the smart pointer system, but if programmers have a compelling argument to call it explicitly, they may. I hope that they will also call DecrementReferences at the appropriate time to balance out the increments and decrements. The decrement function is

```
void Object::DecrementReferences ()
{
    if ( --m_iReferences == 0 )
        delete this;
}
```

The reference counter is decremented. As promised, if the counter becomes zero, the object is deleted. I cannot stress the following point enough: The standard library delete is called. The only time you should call this is when the object is *dynamically allocated*. That means that *all* Objects in the system must be dynamically allocated.

The static hash table InUse and the static member function PrintInUse in the reference counting system are for debugging purposes. Each time an object is created, the Object constructor adds to the hash table the pair consisting of the unique identifier (the key) and a pointer to the object (the value). Each time an object is destroyed, the Object destructor removes the key-value pair from the hash table. At any time during the application run time, you can print out the list of objects that currently exist using PrintInUse. The main reason I have these static values is to support looking for object leaks. The details are provided in Section 2.3.8.

The smart pointer system is a template class that is designed to correctly manipulate the reference counter in the Object class. The interface is

```
template <class T> class Pointer
{
public:
    // construction and destruction
    Pointer (T* pkObject = NULL);
    Pointer (const Pointer& rkPointer);
    ~Pointer ();

    // implicit conversions
    operator T* () const;
    T& operator* () const;
    T* operator-> () const;

    // assignment
    Pointer& operator= (T* pkObject);
    Pointer& operator= (const Pointer& rkReference);
```

```
    // comparisons
    bool operator== (T* pkObject) const;
    bool operator!= (T* pkObject) const;
    bool operator== (const Pointer& rkReference) const;
    bool operator!= (const Pointer& rkReference) const;

protected:
    // the shared object
    T* m_pkObject;
};
```

You will see a typedef per class of the form

```
typedef Pointer<MyClass> MyClassPtr;
```

This is a convenient alias for smart pointers. I always create the name to be the concatenation of the class name and the suffix Ptr (for "pointer").

The implicit conversions and comparisons in the class have trivial implementations—no need to discuss them here. The constructors and destructor are

```
template <class T> Pointer<T>::Pointer (T* pkObject)
{
    m_pkObject = pkObject;
    if ( m_pkObject )
        m_pkObject->IncrementReferences();
}

template <class T> Pointer<T>::Pointer (const Pointer& rkPointer)
{
    m_pkObject = rkPointer.m_pkObject;
    if ( m_pkObject )
        m_pkObject->IncrementReferences();
}

template <class T> Pointer<T>::~Pointer ()
{
    if ( m_pkObject )
        m_pkObject->DecrementReferences();
}
```

The constructors store the input pointer in m_pkObject and then increment that object's reference counter to indicate that we have just added a reference to the object. The destructor decrements the reference counter to indicate that we have just lost a reference to the object. If the object's reference counter decreases to zero, the object is automatically deleted.

The only warning when implementing smart pointers is how to properly handle assignments. The first assignment operator is

```
template <class T> Pointer<T>& Pointer<T>::operator= (T* pkObject)
{
    if ( m_pkObject != pkObject )
    {
        if ( pkObject )
            pkObject->IncrementReferences();

        if ( m_pkObject )
            m_pkObject->DecrementReferences();

        m_pkObject = pkObject;
    }
    return *this;
}
```

The first conditional guards against an assigment of a smart pointer object to itself, for example,

```
MyClass* pkMC = new MyClass;  // pkMC references = 0
MyClassPtr spkMC = pkMC;      // pkMC references = 1
spkMC = pkMC;                 // pkMC references = 1
```

The assignment statement effectively does nothing. I believe it is safe to skip the first conditional, but there is no point in executing more statements than you have to.

That said, the order of incrementing and decrementing *is important*. In [Ebe00] I listed the original code for smart pointers, which included the assignment with DecrementReferences first and IncrementReferences second. This is actually an error in logic because the decrement can have the side effect of destroying the object that is currently being assigned! For example,

```
class A : public Object { ... };
typedef Pointer<A> APtr;
class B : public Object { public: APtr MemberObject; };
typedef Pointer<B> BPtr;

A* pkAObject = new A;                 // pkAObject references = 0
B* pkBObject = new B;                 // pkBObject references = 0
pkBObject.MemberObject = pkAObject;   // pkAObject references = 1
ObjectPtr spkObject = pkBObject;      // pkBObject references = 1
spkObject = pkAObject;                // oops!
```

If you were to first decrement the reference count for the right-hand side spkObject, the object affected is pkBObject. That is, the reference count on pkBObject is decremented from 1 to 0. This causes pkBObject to be deleted. In the process of destruction, the MemberObject smart pointer goes out of scope and its destructor is called. In that destructor, the function DecrementReferences is called on the object m_pkObject points to, which in this case is what pkAObject points to. Therefore, the reference count on pkAObject is decremented from 1 to 0, causing the object to be automatically deleted. When this happens, pkAObject is a dangling pointer. The assignment operator now attempts to call IncrementReferences on pkAObject, which is an error.

The rest of the material in this section on smart pointers is nearly the same as in [Ebe00], but with modifications for the notation of Wild Magic version 3. My apologies for repeating this, but the examples are important in understanding what you can and cannot do with smart pointers.

There might be a need to typecast a smart pointer to a pointer or smart pointer. For example, class Node, the internal node representation for scene graphs, is derived from Spatial, the leaf node representation for scene graphs. Polymorphism allows the assignment

```
Node* pkNode = <some node in scene graph>;
Spatial* pkObject = pkNode;
```

Abstractly, a smart pointer of type NodePtr is derived from SpatialPtr, but the C++ language does not support this. The use of implicit operator conversions in the smart pointer class guarantees a side effect that makes it appear as if the derivation really does occur. For example,

```
// This code is valid.
NodePtr spkNode = <some node in scene graph>;
SpatialPtr spkObject = spkNode;

// This code is not valid when class A is not derived from class B.
APtr spkAObject = new A;
BPtr spkBObject = spkAObject;
```

The implicit conversions also support comparison of smart pointers to null, just like regular pointers:

```
NodePtr spkNode = <some node in scene graph>;
SpatialPtr spkChild = spkNode->GetChildAt(2);
if ( spkChild )
{
    <do something with spkChild>;
}
```

A simple example illustrating the use and cleanup of smart pointers is the following. The class `Node` stores an array of smart pointers for its children.

```
NodePtr spNode = <some node in scene graph>;
Node* pkNode = new Node;         // pkNode references = 0
NodePtr spkChild = new Node;     // pkNode references = 1
spkNode->AttachChild(spkChild);  // pkNode references = 2
spkNode->DetachChild(spkChild);  // pkNode references = 1
spkChild = NULL;                 // pkNode references = 0,
                                 //     destroy it
```

This illustrates how to properly terminate use of a smart pointer. In this code the call `delete spkChild` would work just fine. However, if the object that `spkChild` points to has a positive reference count, explicitly calling the destructor forces the deletion, and the other objects that were pointing to the same object now have dangling pointers. If instead the smart pointer is assigned `NULL`, the reference count is decremented, and the object pointed to is not destroyed if there are other objects referencing it. Thus, code like the following is safe:

```
NodePtr spkNode = <some node in scene graph>;
Node* pkNode = new Node;         // pkNode references = 0
NodePtr spkChild = new Node;     // pkNode references = 1
spkNode->AttachChild(spkChild);  // pkNode references = 2
spkChild = NULL;                 // pkNode references = 1,
                                 //     no destruction
```

Also note that if the assignment of `NULL` to the smart pointer is omitted in this code, the destructor for the smart pointer is called, and the reference count for `pkNode` still is decremented to 1.

Some other guidelines that must be adhered to when using smart pointers are the following. Smart pointers apply only to dynamically allocated objects, not to objects on the stack. For example,

```
void MyFunction ()
{
    Node kNode;                  // kNode references = 0
    NodePtr spkNode = &kNode;    // kNode references = 1
    spkNode = NULL;              // kNode references = 0,
                                 //     kNode is deleted
}
```

is doomed to failure. Since `kNode` is on the stack, the deletion implied in the last statement will attempt to deallocate stack memory, not heap memory.

Using smart pointers as function parameters or returning them as the result of a function call also has its pitfalls. The following example illustrates the dangers:

```
void MyFunction (NodePtr spkNode)
{
    <do nothing>;
}

Node* pkNode = new Node;
MyFunction(pkNode);
// pkNode now points to invalid memory
```

On allocation pkNode has zero references. The call to MyFunction creates an instance of NodePtr on the stack via the copy constructor for that class. That call increments the reference count of pkNode to one. On return from the function, the instance of NodePtr is destroyed, and in the process, pkNode has zero references and it too is destroyed. However, the following code is safe:

```
Node* pkNode = new Node;    // pkNode references = 0
NodePtr spkNode = pkNode;   // pkNode references = 1;
MyFunction(spkNode);        // pkNode references increase to 2,
                            //      then decrease to 1
// pkNode references = 1 at this point
```

A related problem is the following:

```
NodePtr MyFunction ()
{
    Node* pkReturnNode = new Node;   // references = 0;
    return pkReturnNode;
}

Node* pkNode = MyFunction();
// pkNode now points to invalid memory
```

A temporary instance of NodePtr is implicitly generated by the compiler for the return value of the function. The copy constructor is called to generate that instance, so the reference count on pkNode is one. The temporary instance is no longer needed and is implicitly destroyed, and in the process, pkNode has zero references and it too is destroyed. The following code is safe:

```
NodePtr spkNode = MyFunction();
// spkNode.m_pkObject has one reference
```

The temporary instance increases the reference count of pkReturnNode to one. The copy constructor is used to create spkNode, so the reference count increases to two. The temporary instance is destroyed, and the reference count decreases to one.

2.3.4 CONTROLLERS

Animation in the classic sense refers to the motion of articulated characters and objects in the scene. If a character is represented hierarchically, each node might represent a joint (neck, shoulder, elbow, wrist, knee, etc.) whose local transformations change over time. Moreover, the values of the transformations are usually controlled by procedural means as compared to the application manually adjusting the transforms. This can be accomplished by allowing each node to store *controllers*, with each controller managing some quantity that changes over time. In the case of classic animation, a controller might represent the local transform as a matrix function of time. For each specified time in the application, the local transform is computed by the controller, and the world transform is computed using this matrix.

It is possible to allow any quantity at a node to change over time. For example, a node might be tagged to indicate that fogging is to be used in its subtree. The fog depth can be made to vary with time. A controller can be used to procedurally compute the depth based on current time. In this way animation is a concept that refers to controlling any time-varying quantity in a scene graph.

The abstract base class that supports time-varying quantities is `Controller`. The class will be discussed in detail in Section 4.5, including a presentation of the `Controller`-derived classes in the engine. Here I will mention only the support in the base class `Object` for controllers.

```
class Object
{
public:
    void SetController (Controller* pkController);
    int GetControllerQuantity () const;
    Controller* GetController (int i) const;
    void RemoveController (Controller* pkController);
    void RemoveAllControllers ();
    bool UpdateControllers (double dAppTime);
private:
    // controllers (Pointer used directly to avoid circular headers)
    TList<Pointer<Controller> >* m_pkControllerList;
}
```

Each controller can manage a single object. To guarantee this, the controllers can be attached or detached only through the object intended to be managed. If a controller is attached to an object, any previous object managed by the controller is replaced by the new object. The replacement is handled internally by the object using the controller's `SetObject` member function. Support for attach and detach is in the `Object` class. However, an object can have many controllers attached to it, with each controller modifying a portion of the object's state over time.

2.3.5 STREAMING

Persistence of storage is a requirement for a game engine. Game content is typically generated by a modeling tool and must be exported to a format that the game application can import. The game application itself might have a need to save its data so that it can be reloaded at a later time. *Streaming* of data refers to the process of mapping data between two media, typically disk storage and memory. In this section, we will discuss transfers between disk and memory, but the ideas directly apply to transfers between memory blocks (which supports transfers across a network).

A scene graph is considered to be an abstract directed graph of objects (of base type `Object`). The nodes of the graph are the objects, and the arcs of the graph are pointers between objects. Each object has nonobject members, in particular, any members of a native data type (integer, float, string, etc.). The abstract graph must be saved to disk so that it can be re-created later. This means that both the graph nodes and graph arcs must be saved in some reasonable form. Moreover, each graph node should be saved exactly once. The process of saving a scene graph to disk is therefore equivalent to creating a list of the unique objects in the graph, saving them to disk, and in the process saving any connections between them. If the graph has multiple connected components, then each component must be traversed and saved. Support for saving multiple abstract objects is easy to implement. The class `Stream` provides the ability to assemble a list of *top-level* objects to save. Typically these are the roots of scene graphs, but they can be other objects whose state needs to be saved. To support loading the file and obtaining the same list of top-level objects, an identifying piece of information must be written to disk before each abstract graph corresponding to a top-level object. A simple choice is to write a string to disk.

The Stream API

The class that exists to manage the streaming process is `Stream`. The relevant public portion of the interface is

```
class Stream
{
public:
    // construction and destruction
    Stream ();
    ~Stream ();

    // The objects to process, each object representing an entry
    // into a connected component of the abstract graph.
    bool Insert (Object* pkObject);
    bool Remove (Object* pkObject);
```

```
    void RemoveAll ();
    int GetObjectCount ();
    Object* GetObjectAt (int i) const;
    bool IsTopLevel (Object* pkObject);

    // Memory loads and saves.  Stream does not assume
    // responsibility for the char arrays.  The application must
    // manage the input acBuffer for the call to Load and delete
    // the output racBuffer for the call to Save.
    bool Load (char* acBuffer, int iSize);
    bool Save (char*& racBuffer, int& riSize);

    // file loads and saves
    bool Load (const char* acFilename);
    bool Save (const char* acFilename);

    // support for memory and disk usage
    int GetMemoryUsed () const;
    int GetDiskUsed () const;
};
```

A Stream object manages a list of top-level objects. Objects are inserted into the list by Insert and removed from the list by Remove or RemoveAll. The function GetObjectCount returns the number of objects in the top-level list. The function GetObjectAt(int) returns the *i*th object in the list. The function IsTopLevel is mainly used internally by Stream, but may be called by an application as a check for existence of an object in the top-level list.

Streaming to and from disk is supported by the load/save functions that take a filename (character string) as input. The other load/save functions are for streaming to and from a memory block. The return value is true if and only if the function call is successful.

The function call GetDiskUsed computes how much disk space the top-level objects will use, not counting the file header that is used in the Wild Magic scene file format. This function is also used internally by the file Save function to allocate a memory block of the appropriate size, stream the top-level objects to that block, and then write the block with a single call to a low-level file writing function. The intent is to avoid expensive disk operations that might occur if writes are made on a member-by-member basis for each object. The function call GetMemoryUsed reports how much memory is required to store the top-level objects. This is useful to obtain a *memory footprint* of a scene graph for the purposes of designing an application to fit within a budgeted amount of memory. Every class derived from Object must implement both of these functions.

The typical usage for disk streaming is shown in the next code block:

```
// save a list of objects
Stream kOutStream;
kOutStream.Insert(pkObject1);
:
kOutStream.Insert(pkObjectN);
kOutStream.Save("myfile.mgc");

// load a list of objects
Stream kInStream;
bool bLoaded = kInStream.Load("myfile.mgc");
if ( bLoaded )
{
    for (int i = 0; i < kInStream.GetObjectCount(); i++)
    {
        ObjectPtr spkObject = kInStream.GetObjectAt(i);
        // Use prior knowledge of the file contents and statically
        // cast the objects for further use by the application,
        // ...or...
        // Get the run-time type information and process the
        // objects accordingly.
    }
}
```

A pseudocode example of how the memory streaming might be used in a networking application follows:

```
// Server code:
Stream kOutStream;
// ...insert objects into kOutStream...
int iSize;
char* acBuffer;
kOutStream.Save(acBuffer,iSize);
create begin_stream packet [send iSize];
send packet;
while ( not done sending bytes from acBuffer )
{
    create a packet of bytes from acBuffer;
    send packet;
}
create end_stream packet;
send packet;
delete[] acBuffer;
```

```
// Client code (in idle loop):
if ( received begin_stream packet )
{
    int iSize;
    get iSize from packet;
    char* acBuffer = new char[iSize];
    while ( not end_stream packet )
    {
        get packet;
        extract bytes into acBuffer;
    }
    Stream kInStream;
    kInStream.Load(acBuffer,iSize);
    delete[] acBuffer;
    // ...get objects from kInStream and process...
}
```

The Object API

The class Object has the following API to support streaming:

```
typedef Object* (*FactoryFunction)(Stream&);

class Object
{
public:
    enum { FACTORY_MAP_SIZE = 256 };
    static THashTable<String,FactoryFunction>* ms_pkFactory;
    static bool RegisterFactory ();
    static void InitializeFactory ();
    static void TerminateFactory ();
    static Object* Factory (Stream& rkStream);
    virtual void Load (Stream& rkStream, Stream::Link* pkLink);
    virtual void Link (Stream& rkStream, Stream::Link* pkLink);
    virtual bool Register (Stream& rkStream) const;
    virtual void Save (Stream& rkStream) const;
    virtual int GetMemoryUsed () const;
    virtual int GetDiskUsed () const;
};
```

The factory hash table stores class-static functions that are used to load an object from disk. The key of the hash item is the RTTI string. The value is the factory function for the class. For example, class Object has the factory function Object*

Factory (Stream&). The factory hash table must be created and the factory functions must be added to it during the initialization phase of the application (see Section 2.3.8). The functions RegisterFactory and InitializeFactory are built to do this. On termination of the application, the factory hash table must be destroyed. The function TerminateFactory does this. The functions Register, Save, and GetDiskUsed are used for saving objects. The functions Factory, Load, and Link are used for loading objects. The function GetMemoryUsed is not used for streaming, but does provide a measure of memory usage, which can differ from disk usage. Each derived class has the same API minus the static hash table and the TerminateFactory function. The streaming functions are described in detail here.

Saving a Scene Graph

To save a scene graph, a unique list of objects must be created first. This list is built by a depth-first traversal of the scene. Each Object that is visited is told to *register* itself if it has not already done so. The virtual function that supports this is Register. The base class registration function is

```
bool Object::Register (Stream& rkStream) const
{
    Object* pkThis = (Object*)this;  // conceptual constness
    if ( rkStream.InsertInMap(pkThis,NULL) )
    {
        // Used to ensure the objects are saved in the order
        // corresponding to a depth-first traversal of the scene.
        rkStream.InsertInOrdered(pkThis);

        TList<ControllerPtr>* pkList = m_pkControllerList;
        for (/**/; pkList; pkList = pkList->Next())
        {
            Controller* pkController = pkList->Item();
            if ( pkController )
                pkController->Register(rkStream);
        }

        return true;
    }

    return false;
}
```

The stream maintains a hash table of registered objects. The base class `Object` implements this function to ask the stream if the object has been registered. If so, the function returns `false`. If not, the stream adds the object to the hash map, and the object tells the stream to register its only `Object*` members, a list of `Controller` objects. The function then returns `true`. Each derived class implements this function. The base class function is called. If the registration is successful, this object is visited for the first time, and it tells each `Object*` member to register itself. The generic structure is

```
bool DerivedClass::Register (Stream& rkStream) const
{
    if ( !BaseClass::Register(rkStream) )
        return false;

    if ( m_spkObjectMember1 )
        m_spkObjectMember1->Register(rkStream);

    // ... other object member registration ...

    if ( m_spkObjectMemberN )
        m_spkObjectMemberN->Register(rkStream);

    return true;
}
```

After the registration phase, the stream has a list of unique `Objects`. An iteration is made through the list, and each object is told to save itself. The base class virtual function that supports this is

```
void Object::Save (Stream& rkStream) const
{
    WM3_BEGIN_DEBUG_STREAM_SAVE;

    // RTTI name for factory lookup on Load
    rkStream.Write(GetType().GetName());

    // address of object for unique ID on Load/Link
    rkStream.Write(this);

    // name of object
    rkStream.Write(m_kName);
```

```
    // link data
    int iQuantity = 0;
    TList<ControllerPtr>* pkList = m_pkControllerList;
    for (/**/; pkList; pkList = pkList->Next())
        iQuantity++;

    rkStream.Write(iQuantity);

    pkList = m_pkControllerList;
    for (/**/; pkList; pkList = pkList->Next())
        rkStream.Write(pkList->Item());

    WM3_END_DEBUG_STREAM_SAVE(Object);
}
```

The RTTI (run-time type information) name is a string specific to the class. The string for class Object is "Wm3.Object", but Object is an abstract base class, so you will not see this name in a scene file. The class Spatial is also abstract and has the name "Wm3.Spatial", but objects of class Node can be instantiated, so you will see "Wm3.Node" in the scene files. The RTTI name is used by the stream loader to locate the correct factory function to create an object of that class. The address of the object is written to disk to be used as a unique identifier when loading. That address will not be a valid memory address when loading, so the stream loader has to resolve these addresses with a linking phase. Each object may have a character string name. Such strings are written to disk by saving the length of the string first followed by the characters of the string. The null terminator is not written. The controller pointers are also memory addresses that are written to disk for unique identification of the objects. When the controllers themselves are written to disk, those same addresses are the ones that occur immediately after the RTTI names are written.

Each derived class implements Save. The base class Save is called first. Non-Object data is written to disk first, followed by any Object* addresses.

```
void DerivedClass::Save (Stream& rkStream) const
{
    WM3_BEGIN_DEBUG_STREAM_SAVE;

    BaseClass::Save(rkStream);
    write non-object data;   // ''native'' data
    write Object* pointers;   // ''link'' data

    WM3_END_DEBUG_STREAM_SAVE(DerivedClass);
}
```

Not all native data needs to be saved. Some data members are *derivable* from other data and are reproduced once the data is fully loaded from disk. Some data members are set by other run-time processes and need not be saved. For example, Spatial has an Object* member, the pointer to a parent node. When the scene graph is reconstructed during stream loading, that parent pointer is initialized when the spatial object is attached to a parent by a call to an appropriate Node member function. Therefore, the parent pointer is not saved to disk. Some native data may be aggregate data in the form of a class—for example, the class Vector3. Various template functions are provided in the streaming source files to save such classes based on memory size. The implication is that any such class cannot have virtual functions; otherwise, the memory size includes the size of the nonstatic class members as well as the size of the implicit virtual function table pointer.

Although a single scene graph is typically written to disk, the stream object allows multiple objects to be written. For example, you might save a scene graph, a set of camera objects, and a set of light objects. The root node of the scene is what you tell the stream object to save. This node is an example of a *top-level object*. Other objects that are contained in the scene graph are automatically saved, but they are not top-level objects. When you load a scene file that contains multiple top-level objects, you need a way of loading the scene and recapturing these objects. Before a top-level object is saved to disk, the string "Top Level" is written first. This allows the loader to easily identify top-level objects.

A brief explanation is in order for the couple of code samples previously shown. You saw the macros WM3_BEGIN_DEBUG_STREAM_SAVE and WM3_END_DEBUG_STREAM_SAVE (classname). I introduced these to help debug the streaming code for new classes that are added to Wild Magic. Each Object-derived class implements a function called GetDiskUsed. The function returns the number of bytes that the object will require for storage on disk. The Stream class saves a scene graph to a memory block first, then writes the memory block to disk. In order to have a large enough memory block, the Stream queries all the unique objects to be streamed by calling GetDiskUsed per object. The sum of the numbers is exactly the number of bytes required for the disk operation. During the streaming to the memory block, Stream maintains an index to the location in the memory block where the next write should occur. The "begin" macro saves the index before any writes occur, and the "end" macro saves the index after all writes occur. The difference should be exactly the amount reported by GetDiskUsed for that object. If the difference is in error, an assertion is fired. The problem is either that you are incorrectly saving the object to disk or that GetDiskUsed itself is incorrectly implemented. The firing of the assertion has been enough for me to track down which of the two is the problem.

Loading a Scene Graph

Loading is a more complicated process than saving. Since the pointer values on disk are invalid, each object must be created in memory first and then filled in

with data loaded from disk. Links between objects such as parent-child relationships must be established later. Despite the invalidity of the disk pointer values, they do store information about the abstract graph that is being loaded. The address of each object in memory is associated with a disk pointer value, so the same hash table that was used for storing the unique objects for saving can be reused for tracking the correspondence between the disk pointer values, called *link IDs*, and the actual memory address of the object. Once all objects are in memory and the hash table is complete with the correspondences, the table is iterated as if it were a list, and the link IDs in each object are replaced by the actual memory addresses. This is exactly the concept of resolving addresses that a linker uses when combining object files created by a compiler.

An object is loaded as follows. The stream object knows that the first thing to expect is either the string "Top Level" or an RTTI string. If "Top Level" is read, the loaded object is stored in a set of top-level objects for the application to access. If an RTTI string is read, the stream knows that it needs to create an object of that type from the file data that follows the RTTI string. The RTTI string is used as a key in a hash map that was created pre-main at program initialization. The value of a hash map entry is a static class function called Factory. This function starts the loading process by creating an object of the desired type and then filling in its member values by reading the appropriate data from the file. The factory function for instantiable classes is structured as

```
classname* classname::Factory (Stream& rkStream)
{
    classname* pkObject = new classname;
    Stream::Link* pkLink = new Stream::Link(pkObject);
    pkObject->Load(rkStream,pkLink);
    return pkObject;
}
```

The scene file contains a list of unique objects, each storing a link ID. This identifier was the address of the object when it was saved to disk. Any Object* members in an object are themselves old addresses, but are now link IDs that refer to objects that are in the scene file. When loading an object, all link IDs must be stored persistently so that they may be resolved later in a linking phase. The second line of the Factory function creates an object to store these links. The link object itself is stored as the value in a hash map entry whose key is the input object to the constructor. The call to Load allows the object to read its native data and Object* links from disk. The link object is passed down from derived classes to base classes to allow each base class to add any links it loads.

The Load function for the base class Object does the work of telling the stream to add the link-object pair to the stream's hash map. After that, the object's native data and links are loaded. The function is

```
void Object::Load (Stream& rkStream, Stream::Link* pkLink)
{
    WM3_BEGIN_DEBUG_STREAM_LOAD;

    // get old address of object, save it for linking phase
    Object* pkLinkID;
    rkStream.Read(pkLinkID);
    rkStream.InsertInMap(pkLinkID,pkLink);

    // name of object
    rkStream.Read(m_kName);

    // link data
    int iQuantity;
    rkStream.Read(iQuantity);
    m_pkControllerList = NULL;
    for (int i = 0; i < iQuantity; i++)
    {
        Controller* pkController;
        rkStream.Read(pkController);
        pkLink->Add(pkController);

        // build pkController list, to be filled in by Link
        TList<ControllerPtr>* pkList = new TList<ControllerPtr>;
        pkList->Item() = NULL;
        pkList->Next() = m_pkControllerList;
        m_pkControllerList = pkList;
    }

    WM3_END_DEBUG_STREAM_LOAD(Object);
}
```

Notice how the function loads the controller pointers. At the time the object was saved to disk, this value was the memory address for the controller. Now at load time it can only be used as a unique identifier. That value is stored in the link object for the linking phase that occurs after loading.

Derived classes implement the Load function by calling the base class Load first and then reading native data followed by link data. This is done in the same order that Save processed the data.

```
void DerivedClass::Load (Stream& rkStream, Stream::Link* pkLink)
{
    WM3_BEGIN_DEBUG_STREAM_LOAD;
```

```
    BaseClass::Load(rkStream,pkLink);
    read non-object data;   // ''native'' data
    read Object* pointers;  // ''link'' data
    add Object* pointers to pkLink;  // for later linking phase

    WM3_END_DEBUG_STREAM_LOAD(DerivedClass);
}
```

Once all objects are loaded from disk, the linking phase is initiated. An iteration is made over the list of loaded objects, and the link function is called for each object. The base class linking function is

```
void Object::Link (Stream& rkStream, Stream::Link* pkLink)
{
    TList<ControllerPtr>* pkList = m_pkControllerList;
    for (/**/; pkList; pkList = pkList->Next())
    {
        Object* pkLinkID = pkLink->GetLinkID();
        pkList->Item() = (Controller*)rkStream.GetFromMap(pkLinkID);
    }
}
```

The generic structure of the linking function is

```
void classname::Link (Stream& rkStream, Stream::Link* pkLink)
{
    Object* pkLinkID;

    // link member 1
    pkLinkID = GetLinkID();
    m_spkObjectMember1 =
        (ObjectMember1Class*)rkStream.GetFromMap(pkLinkID);

    // ... other object member linking ...

    // link member N
    pkLinkID = GetLinkID();
    m_spkObjectMemberN =
        (ObjectMemberNClass*)rkStream.GetFromMap(pkLinkID);

    // post-link semantics, if any, go here...
}
```

The function GetLinkID accesses a link ID and internally increments a counter so that the next call accesses the next link ID. The objects *must* be linked in the order in which they were saved to disk (which is the same order they were loaded from disk).

A brief explanation is in order for the couple of code samples previously shown. You saw the macros WM3_BEGIN_DEBUG_STREAM_LOAD and WM3_END_DEBUG_STREAM_LOAD (classname). These are analogous to the macros used for saving a scene. They allow you to track down any implementation errors in streaming when adding new classes to Wild Magic. The Stream class loads a scene graph to a memory block first and then writes the memory block to a scene in memory. In order to have a large enough memory block, the Stream queries all the unique objects to be streamed by calling GetDiskUsed per object. The sum of the numbers is exactly the number of bytes required for the disk operation. During the streaming to the memory block, Stream maintains an index to the location in the memory block where the next read should occur. The "begin" macro saves the index before any reads occur, and the "end" macro saves the index after all reads occur. The difference should be exactly the amount reported by GetDiskUsed for that object. If the difference is in error, an assertion is fired. The problem is either that you are incorrectly loading the object from disk or that GetDiskUsed itself is incorrectly implemented.

2.3.6 CLONING

Wild Magic version 2 did not formally have a system for copying an object. As it turns out, a side effect of the streaming system is that you can create a copy—a *deep copy* in the sense that an entire object is duplicated (no subobject is shared). The interface for this is

```
class Object
{
public:
    Pointer<Object> Copy () const;
    static char NameAppend;
};
```

The idea is straightforward. The object to be copied can be streamed to a memory block, and the memory block is immediately streamed back to a new object that happens to be a copy of the old one. The code is

```
ObjectPtr Object::Copy () const
{
    // save the object to a memory buffer
    Stream kSaveStream;
    kSaveStream.Insert((Object*)this);
    char* acBuffer = NULL;
```

```
int iBufferSize = 0;
bool bSuccessful = kSaveStream.Save(acBuffer,iBufferSize);
assert( bSuccessful );
if ( !bSuccessful )
    return NULL;

// load the object from the memory buffer
Stream kLoadStream;
bSuccessful = kLoadStream.Load(acBuffer,iBufferSize);
assert( bSuccessful );
if ( !bSuccessful )
    return NULL;
delete[] acBuffer;

// generate unique names
for (int i = 0; i < kLoadStream.GetOrderedQuantity(); i++)
{
    Object* pkObject = kLoadStream.GetOrderedObject(i);
    assert( pkObject );
    const String& rkName = pkObject->GetName();
    int iLength = rkName.GetLength();
    if ( iLength > 0 )
    {
        // Object has a name, append a character to make
        // it unique.
        const char* acName = (const char*)rkName;
        char* acNewName = new char[iLength+2];
        strcpy(acNewName,acName);
        acNewName[iLength] = NameAppend;
        acNewName[iLength+1] = 0;
        pkObject->SetName(String(acNewName));
    }
}

return kLoadStream.GetObjectAt(0);
}
```

Keep in mind that *everything* is a copy. This includes any string names that have been attached to objects. If the duplicated object is to be placed in a scene graph with the original, you then have two identically named objects. In most cases the duplicate object is intended to be an object that has its own name. To automatically support this, I have an extra block of code in the Copy function. New names are generated from the old names by appending a special character, NameAppend. The special character is a

static class member that you may set to whatever you want. The default is the pound character (#).

A consequence of copying is that an object that consumes a lot of memory will be duplicated to an object that consumes just as much memory. For example, if the original object is a texture with a very large image, the copy has its own texture with a duplicate of the very large image. What I had hoped to include in Wild Magic version 3 is what I call a *cloning* system—a system that copies some of the objects, but shares others. After much experimentation and mental debate, I decided not to include a cloning system at this time. The problem has to do with the semantics of what to copy and what to share. To give all users the flexibility to copy or share what they want, the system would have to be very complex.

What I thought would work is to have each class in the Object hierarchy maintain a static bit field and a set of enumerated values. Each enumerated value corresponds to an Object* data member of the class and to a bit in the field. For example,

```
class Derived : public Object
{
public:
    enum
    {
        COPY_OBJECT_A = 1,
        COPY_OBJECT_B = 2,
        COPY_OBJECT_C = 4
    };
    static int CloneControl;

protected:
    Object* m_pkObjectA;
    Object* m_pkObjectB;
    Object* m_pkObjectC;
    // ... other non-Object data ...
};

// decide that A and C are copied, B is shared
Derived::CloneControl =
    Derived::COPY_OBJECT_A | Derived::COPY_OBJECT_C;

// clone an object through an Object::Clone() member function
DerivedPtr spkDerived = <some Derived object>;
ObjectPtr spkClone = spkDerived->Clone();
```

The default clone controls would be reasonably chosen, but users of the engine could adjust as needed for their own applications.

The problem, though, is that it is not always possible to grant the requests that each class makes through its clone control. That makes the clone control enumerations *hints only*, which can lead to unexpected behavior. I choose not to have unpredictable side effects. To illustrate the problem, consider the graph in Figure 2.5. The classes are

```
class A : public Object
{
public:
    enum
    {
        COPY_OBJECT_B = 1,
        COPY_OBJECT_C = 2
    };
    static int CloneControl;   // = COPY_OBJECT_B

protected:
    BPtr m_spkObjectB;
    CPtr m_spkObjectC;
};

class B : public Object
{
public:
    enum
    {
        COPY_OBJECT_D = 1
    };
    static int CloneControl;   // = COPY_OBJECT_D

protected:
    DPtr m_spkObjectD;
};

class C : public Object
{
public:
    enum
    {
        COPY_OBJECT_D = 1
    };
    static int CloneControl;   // = COPY_OBJECT_D
```

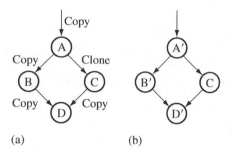

Figure 2.5 A simple `Object` graph. (a) The nodes are labeled with their class types. The arcs are labeled with the class's requests for clone control. (b) The cloned object. The prime superscripts indicate that those objects were copied.

```
protected:
    DPtr m_spkObjectD;
};

class D : public Object
{
public:
    // no object members, so no clone control
};
```

The initial clone controls are set up so that class A wants to copy `m_spkObjectB`, but share `m_spkObjectC`. Class B and Class C both want to copy their `m_spkObjectD` members (which point to the same object of class D). Figure 2.5(b) shows the result of the cloning operation. The expectation was that the copied object A′ would share the subgraph that was rooted at the class C member. The side effect is that the subgraph at the class C member has had portions replaced by copies. Effectively, A′ does not have the subgraph that was intended by the cloning operation. In fact, the problems can be worse. Consider if class B wants its `m_spkObjectD` copied, but class C wants its `m_spkObjectD` shared. To satisfy this, the topology of the original graph must change (B has a new child D′, but C retains its child D).

For a cloning operation to produce what you expect, it appears that if an object in the graph is required to be copied, then any predecessors in the graph must also be copied, even if their class's clone control specifies they should be shared.

As I mentioned, the semantics are quite complicated. My recommendation is to make copies and then replace objects in the copy by substituting the smart pointers from the original as needed.

2.3.7 STRING TREES

The Stream class provides the ability to save scene graphs to disk, but in a binary format. A human-readable form of the data is sometimes desirable. The StringTree class encapsulates the process of converting raw data to strings. When applied to a scene graph, the end result is a tree of strings that corresponds to the scene graph. The construction is not memory efficient, since the strings corresponding to a shared object are not shared themselves. Because I only intended the human-readable format for debugging purposes and for exploring output from exporters and other packages that generate Wild Magic scenes, my design choice was to keep the construction as simple as possible. The two tools that use string trees are the ScenePrinter tool and the SceneTree tool. The first tool prints the strings to an ASCII text file and is portable across platforms. The second tool is specific to the Microsoft Windows platform. A Windows tree control is built to represent a scene graph. The tool launches a simple window with the tree control and lots of readable data. In fact, the source code for SceneTree was constructed so that, on a Microsoft Windows platform, you can include the tree control code and launch a window during your application run. This provides a more readable version of a scene than do the standard watch windows in a compiler/development environment.

The essential portion of StringTree is

```
class StringTree
{
public:
    // construction and destruction
    StringTree (int iStringQuantity, int iChildQuantity);
    ~StringTree ();

    // strings
    int GetStringQuantity () const;
    void SetString (int i, char* acString);
    char* GetString (int i);

    // children
    int GetChildQuantity () const;
    void SetChild (int i, StringTree* pkChild);
    StringTree* GetChild (int i);

private:
    TArray<char*> m_kStrings;
    TArray<StringTree*> m_kChildren;
};
```

This is a simple tree structure. Each node of the tree has an array of strings and an array of pointers to child nodes. The other member functions not listed here are for formatting the raw data into strings and for recursively saving the tree.

Each `Object`-derived class is required to implement a member function

```
virtual StringTree* DerivedClass::SaveStrings (const char* acTitle);
```

The input is an optional string that is used in the `StringTree` tool to give a label on array data or other conglomerate data. The class creates whatever strings it chooses to make its native data human-readable. Any `Object`-based data members are asked to create their own string trees to be attached as children to the current tree node. In this manner the construction is recursive.

2.3.8 Initialization and Termination

A class in the object system might declare one or more static members. These members are initialized in the source file for the class. If a static member is itself a class object, the initialization is in the form of a constructor call. This call occurs before the application's main function starts (pre-main). The destructor is called after the application's main function terminates (post-main). The C++ compiler automatically generates the code for these function calls.

Potential Problems

The pre-main and post-main mechanism has a few potential pitfalls. One problem is that the order in which the function calls occurs is unpredictable and is dependent on the compiler. Obtaining a specific order requires some additional coding to force it to occur. Without the forced ordering, one pre-main initialization might try to use a static object that has not yet been initialized. For example,

```
// contents of Matrix2.h
class Matrix2
{
public:
    Matrix2 (float fE00, float fE01, float fE10, float fE11);
    Matrix2 operator* (float fScalar);
    static Matrix2 IDENTITY;
protected:
    float m_aafE[2][2];
};
```

```
// contents of Matrix2.cpp
Matrix2 Matrix2::IDENTITY(1.0f,0.0f,0.0f,1.0f);
Matrix2::Matrix2 (float fE00, float fE01, float fE10, float fE11)
{
    m_aafE[0][0] = fE00;  m_aafE[0][1] = fE01;
    m_aafE[1][0] = fE10;  m_aafE[1][1] = fE11;
}
// ... other member functions here ...

// contents of MyClass.h
class MyClass
{
public:
    static Matrix2 TWICE_IDENTITY;
};

// contents of MyClass.cpp
Matrix2 Matrix2::TWICE_IDENTITY = Matrix2::IDENTITY*2.0f;
```

If the static matrix of MyClass is initialized first, the static matrix of Matrix2 has all zero entries since the storage is reserved already by the compiler, but is set to zero values as is all static data.

Problems can occur with file-static data. If a file-static pointer is required to allocate memory, this occurs before the main application is launched. However, since such an initialization is C-style and not part of class semantics, code is not generated to deallocate the memory. For example,

```
int* g_aiData = new int[17];
int main ()
{
    memset(g_aiData,0,17*sizeof(int));
    return 0;
}
```

The global variable g_aiData is allocated pre-main, but no deallocation occurs, thus creating a memory leak. One mechanism to handle this is the atexit function provided by C or C++ run-time libraries. The input to atexit is a function that takes no parameters and returns void. The functions are executed before the main application exits, but before any global static data is processed post-main. There is an order in this scheme, which is LIFO (last in, first out). The previous block of code can be modified to use this:

```
int* g_aiData = new int[17];
void DeleteData () { delete[] g_aiData; }
```

```
int main ()
{
    atexit(DeleteData);
    memset(g_aiData,0,17*sizeof(int));
    return 0;
}
```

Of course in this example the global array is allocated in the same file that has main, so a delete statement may instead be used before the return from the function. However, if the global array occurs in a different file, then some function in that file has the responsibility for calling atexit with the appropriate deletion function as input. That function will be called before main returns.

Another problem with file-static data may occur, but it depends on the compiler you use. In order to initialize some part of the system, it might be desirable to force a C-style function to be called pre-main. The following code in a source file has that effect:

```
bool g_bInitialized = SomeInitialization();
static bool SomeInitialization ()
{
    // do the initialization
    return true;
}
```

The initialization function is static because its only purpose is to force something to happen specifically to items in that file. The fact that g_bInitialized is global requires the compiler to make the symbol externally accessible by adding the appropriate label to the compiled code in the object file. The compiler should then add the call of the initialization function to its list of such functions to be called pre-main.

A drawback with this mechanism is that, in fact, the variable g_bInitialized is externally accessible. As such, you might have name clashes with symbols in other files. One solution is to create a name for the dummy variable that has a large probability of not clashing with other names. Another solution is to make the dummy variable file-static.

```
static bool gs_bInitialized = SomeInitialization();
static bool SomeInitialization ()
{
    // do the initialization
    return true;
}
```

The problem, though, is that an optimizing compiler or a smart linker might try to be too smart. Noticing that gs_bInitialized is never referenced anywhere else

in the file, and noticing that it is in fact static, the compiler or linker might very well discard the symbol and never add the initialization function to its list of pre-main initializers to call. Yes, this has happened in my experience, and it is a difficult problem to diagnose. A compiler might provide a macro that lets you prevent the static variable from being discarded, but then again it might not. A more robust solution to prevent the discard is

```
static bool gs_bInitialized = SomeInitialization();
static bool SomeInitialization ()
{
    // do the initialization
    gs_bInitialized = true;
    return gs_bInitialized;
}
```

Hopefully, the compiler or linker will not try to be really smart and simply notice that the static variable is used somewhere in the file and not discard it. If for some strange reason the compiler or linker does figure this one out and discards the variable, a more sophisticated body can be used.

To handle order dependencies in the generic solution for classes, discussed in the next subsection, it is necessary to guard against multiple initializations. The following will do this:

```
static bool gs_bInitialized = SomeInitialization();
static bool SomeInitialization ()
{
    if ( !gs_bInitialized )
    {
        // do the initialization
        gs_bInitialized = true;
    }
    return gs_bInitialized;
}
```

The C++ language guarantees that the static data gs_bInitialized is zero (false) before any dynamic initialization occurs (the call to SomeInitialization), so this code will work as planned to initialize once and only once.

A Generic Solution for Classes

Here is a system that allows a form of pre-main initialization and post-main termination that takes care of order dependencies. The idea is to register a set of initialization functions and a set of termination functions, all registered pre-main using the file-static mechanism discussed previously. The initialization and termination functions

themselves are called in the main application and bound a call to a function that an application is required to implement.

The class Main provides the ability to add initialization and termination functions. The class has a member function that executes all the initializers and a member function that executes all the terminators. The initializers and terminators, if any, are called only once. The class structure is

```
class Main
{
public:
    typedef void (*Initializer)(void);
    typedef TArray<Initializer> InitializerArray;
    static void AddInitializer (Initializer oInitialize);
    static void Initialize ();

    typedef void (*Terminator)(void);
    typedef TArray<Terminator> TerminatorArray;
    static void AddTerminator (Terminator oTerminate);
    static void Terminate ();

private:
    enum { IT_MAXQUANTITY = 256, IT_GROWBY = 256 };
    static InitializerArray* ms_pkInitializers;
    static TerminatorArray* ms_pkTerminators;

    static int ms_iStartObjects, ms_iFinalObjects;
};
```

The arrays of function pointers are initialized to NULL. The static data members ms_iStartObjects and ms_iFinalObjects are used to trap object leaks in the program execution. The function to add an initializer is

```
void Main::AddInitializer (Initializer oInitialize)
{
    if ( !ms_pkInitializers )
    {
        ms_pkInitializers = new InitializerArray(IT_MAXQUANTITY,
            IT_GROWBY);
    }

    ms_pkInitializers->Append(oInitialize);
}
```

The initializer array is allocated only if there is at least one initializer. Once all initializers are added to the array, the function `Initialize` is called. Its implementation is shown in the following. Notice the code blocks that are used for detecting object leaks.

```
void Main::Initialize ()
{
    // objects should not be created pre-initialize
    ms_iStartObjects = Object::InUse.GetQuantity();
    if ( ms_iStartObjects != 0 )
    {
        assert( ms_iStartObjects == 0 );
        Object::PrintInUse("AppLog.txt",
            "Objects were created before pre-main initialization");
    }

    if ( ms_pkInitializers )
    {
        for (int i = 0; i < ms_pkInitializers->GetQuantity(); i++)
            (*ms_pkInitializers)[i]();
    }

    delete ms_pkInitializers;
    ms_pkInitializers = NULL;

    // number of objects created during initialization
    ms_iStartObjects = Object::InUse.GetQuantity();
}
```

The first time the function is called, the initializers are executed. Afterwards, the array of functions is deallocated so that no work must be done in a post-main fashion to free up the memory used by the array. The termination system is identical in structure:

```
void Main::AddTerminator (Terminator oTerminate)
{
    if ( !ms_pkTerminators )
    {
        ms_pkTerminators = new TerminatorArray(IT_MAXQUANTITY,
            IT_GROWBY);
    }

    ms_pkTerminators->Append(oTerminate);
}
```

```
void Main::Terminate ()
{
    // all objects created during the application should be deleted by now
    ms_iFinalObjects = Object::InUse.GetQuantity();
    if ( ms_iStartObjects != ms_iFinalObjects )
    {
        assert( ms_iStartObjects == ms_iFinalObjects );
        Object::PrintInUse("AppLog.txt",
            "Not all objects were deleted before"
            "post-main termination");
    }

    if ( ms_pkTerminators )
    {
        for (int i = 0; i < ms_pkTerminators->GetQuantity(); i++)
            (*ms_pkTerminators)[i]();
    }

    delete ms_pkTerminators;
    ms_pkTerminators = NULL;

    // objects should not be deleted post-terminate
    ms_iFinalObjects = Object::InUse.GetQuantity();
    if ( ms_iFinalObjects != 0 )
    {
        assert( ms_iFinalObjects == 0 );
        Object::PrintInUse("AppLog.txt",
            "Objects were deleted after post-main termination");
    }
}
```

Once again I have added code blocks to detect object leaks. If you reach one of the assert statements, you can ignore it and continue the program execution. This will result in an ASCII file written to disk that contains a list of the objects that should have been deleted, but were not. The list includes the unique identifiers stored in the Object class and the object types. This allows you to set break points in the next run to determine why the objects are not deleted. You will find in most cases that the application termination function (see Chapter 8) did not set various smart pointers to null.

For a 2D or 3D graphics application, you will use the Application interface described in Chapter 8. The application library provides the following code block:

```
int main (int iQuantity, char** apcArgument)
{
    Main::Initialize();
```

```
    int iExitCode = Application::Run(iQuantity,apcArgument);
    Main::Terminate();
    return iExitCode;
}
```

The details of how you hook your application into Application::Run will be discussed in Chapter 8.

Each class requiring initialization services must contain the following in the class definition in the header file:

```
class MyClass
{
public:
    static bool RegisterInitialize ();
    static void Initialize ();
private:
    static bool ms_bInitializeRegistered;
};
```

The source file contains

```
bool MyClass::ms_bInitializeRegistered = false;
bool MyClass::RegisterInitialize ()
{
    if ( !ms_bInitializeRegistered )
    {
        Main::AddInitializer(classname::Initialize);
        ms_bInitializeRegistered = true;
    }
    return ms_bInitializeRegistered;
}
```

```
void MyClass::Initialize () { <initializations go here> }
```

The registration uses the file-static pre-main initialization scheme discussed previously. Similar constructs are used if the class requires termination services.

I have provided macros for the previously mentioned code blocks:

```
WM3_DECLARE_INITIALIZE
WM3_IMPLEMENT_INITIALIZE(classname)
```

The macros are defined in Wm3Main.mcr. They may be used if no order dependencies exist for the initialization. If there are dependencies, here is an example of how to handle them. Suppose that class A initializes some static data and class B needs that

data in order to initialize its own static data. The initializer for A must be called before the initializer for B. The registration function for B is

```
bool B::RegisterInitialize ()
{
    if ( !ms_bInitializeRegistered )
    {
        A::RegisterInitialize();
        Main::AddInitializer(B::Initialize);
        ms_bInitializeRegistered = true;
    }
    return ms_bInitializeRegistered;
}
```

This guarantees that the initializer for A occurs in the array of functions *before* the initializer for B. Since the array of functions is executed in the order stored, the correct order of initialization is obtained.

SCENE GRAPHS AND REN-DERERS

A t its lowest level, a graphics engine has the responsibility to draw the objects that are visible to an observer. An engine programmer typically uses a graphics API such as OpenGL or Direct3D to implement a renderer whose job it is to correctly draw the objects. On some platforms if no hardware acceleration exists or a standard API is unavailable, the programmer might even write the entire graphics system to run on the CPU; the result is called a software renderer. Although current consumer graphics hardware has a lot of power and obviates the need for writing software renderers on systems with this hardware, the ability to write software renderers is still important—for example, on embedded systems with graphics capabilities such as cell phones and handheld devices. That said, this book does not cover the topic of writing a fully featured software renderer. Rather, the focus is on writing a renderer using an existing graphics API, but hidden by an abstract rendering layer to allow applications not to worry about whether the API is standard or user-written. Wild Magic has renderers for OpenGL, for Direct3D, and even one to illustrate how you might write a software renderer. The examples in the book refer to the OpenGL renderer, but the ideas apply equally as well to Direct3D.

Building a renderer to draw primitives such as points, polylines, triangle meshes, and triangle strips using basic visual effects such as textures, materials, and lighting is a straightforward process that is well understood. The process is sometimes referred to as the *fixed-function pipeline*. The graphics API limits you to calling functions supported only by that API. Recent generations of graphics hardware, though, now provide the ability to program the hardware. The programs are called *shaders* and come in two flavors, *vertex shaders* and *pixel shaders*. Vertex shaders allow you to

control drawing based on vertex attributes such as positions, normals, and colors. A simple vertex shader might draw a triangle mesh where the user supplies vertex positions and colors. Pixel shaders allow you to control drawing through image-based attributes. A simple pixel shader might draw a triangle mesh where the user supplies vertex positions, texture coordinates, and a texture image to be interpolated to fill in the final pixels that correspond to the drawn object. Writing shaders can be more challenging than using the fixed-function pipeline.

A large portion of Usenet postings to groups related to computer graphics and rendering are of the form "How do I do *X* with my graphics API?" The answers tend to be compact and concise with supporting code samples on the order of a few lines of API code. An abundant supply of Web sites may be found that provide tutorials and code samples to help novice programmers with their ventures into writing renderers for OpenGL or Direct3D. These are useful learning tools for understanding what it takes to do low-level drawing. But in my opinion they lack insight into how you architect a graphics system that supports complex applications such as games. In particular:

1. How do you provide data efficiently to the renderer to support applications that must run in real time?

2. How does an application interface with the renderer?

3. How do you make it easy for the application programmer to use the engine?

4. How can you help minimize the changes to the system when new features must be added to support the latest creations from your artists?

Although other questions may be asked, the four mentioned are the most relevant to a game application—my conclusion based on interacting with game companies that used NetImmerse as their game engine.

The first question is clear. The demands for a 3D game are that it run at real-time rates. Asking the renderer to draw every possible object in the game's world is clearly not going to support real time. The clipping and depth buffering mechanisms in the graphics API will eliminate those objects that are not visible, but these mechanisms use computation time. Moreover, they have no high-level knowledge of the game logic or data organization. As an engine programmer, you have that knowledge and can guide the renderer accordingly. The game's world is referred to as the *scene*. The objects in the world are part of the scene. When you toss in the interrelationships between the objects and their various attributes, visual or physical, you have what is called a *scene graph*. If you can limit the objects sent to the renderer to be only those that are visible or potentially visible, the workload of the renderer is greatly reduced. This type of data handling is called *scene graph management*. Visibility determination is one aspect of the management, but there are others, many of which are discussed later in the book.

Scene graph management is a higher-level system than the rendering system and may be viewed as a front end to the renderer, one constructed to efficiently feed it. The

design of the interface between the two systems is important to get right, especially when the graphics engines evolve as rapidly as they do for game applications. This is the essence of the second question asked earlier. As new requirements are introduced during game development, the last thing you want to do is change the interface between data management and drawing. Such changes require maintenance of both the scene graph and rendering systems and can adversely affect a shipping schedule. Although some change is inevitable, a carefully thought-out abstract rendering layer will minimize the impact of those changes to other subsystems of the engine.

The third question is quite important, especially when your plan is to market your graphics engine as a middleware tool to other companies, or even to internal clients within your own company. A scene graph management system helps isolate the application programmer from the low-level details of rendering. However, it must expose the capabilities of the rendering system in a high-level and easy-to-use manner. I believe this aspect of Wild Magic to be the one that has attracted the majority of users. Application programmers can focus on the high-level details and semantics of how their objects must look and interact in the application. The low-level rendering details essentially become irrelevant at this stage!

The fourth question is, perhaps, the most important one. Anyone who has worked on a game project knows that the requirements change frequently—sometimes even on a daily or weekly basis. This aspect of frequent change is what makes software engineering for a game somewhat different than that for other areas of application. Knowing that change will occur as often as it does, you need to carefully architect the scene graph management system so that the impact of a change is minimal and confined to a small portion of the engine. In my experience, the worst type of requirement change is one of adding new visual effects or new geometric object types to the system. Yet these are exactly what you expect to occur most often during game development! Your favorite artist is hard at work creating a brand-new feature: environment-mapped, bump-mapped, iridescent (EMBMI) clouds. The cloud geometry is a mixture of points, polylines, and triangle meshes. The lead artist approves the feature, and the programming staff is asked to support it as soon as possible. After the usual fracas between the artists and programmers, with each side complaining about how the other side does not understand its side, the game producer intervenes and says, "Just do it."[1] Now you must create a new set of classes in the scene graph management system to support EMBMI clouds. The rendering system might (or might not) have to be modified to support the visual aspects of the clouds. The streaming system for persistent storage of the game assets must be modified to handle the new type. Finally, you must modify the exporter for the artist's modeling

1. Okay, I made this one up, but it is illustrative of what you might encounter. About the producer's decision: Let's face it. A good story, good game play, and fantastic artwork are essential. No consumer will notice that fancy hack you made to reduce an intersection test from 7 cycles to 6 cycles. Relish the fact that your name will be on the credits, hope that the consumer will actually read the credits, and look forward to the next Game Developer's Conference where your friends *will* congratulate you on that amazing hack!

package to export EMBMI clouds to the engine's file format. If any of these tasks requires you to significantly rewrite the scene graph manager or the renderer, there is a good chance that the original architectures were not designed carefully enough to anticipate such changes.[2]

This chapter is about the basic ideas that Wild Magic uses for scene graph management and for abstracting the renderer layer. I explain my design choices, but keep in mind that there may be other equally valid choices. My goal is not to compare with as many competing ideas as possible. Rather, it is to make it clear *what* motivated me to make my choices. The necessity to solve various problems that arise in data management might very well lead someone else to different choices, but the problems to solve are certainly the same.

Section 3.1 is a discussion of the subsystems I chose for the basic services provided by the scene graph management. These include the classes `Spatial`, `Node`, `Geometry`, and `Renderer`, which correspond to spatial decomposition, transformation, grouping of related data, representation of geometric data, and drawing of the data.

Sections 3.2 and 3.3 describe the geometric state and geometric types of the `Spatial` and `Geometry` classes. Topics include transformations and coordinate systems, bounding volumes, updating geometric state, and specialized geometric types.

Section 3.4 is about render state and effects, which is the information that controls how objects are drawn. I discuss an important distinction between the architecture of Wild Magic version 3 and older versions of the engine: *global state* and *local state*. Global state affects all objects in a specified portion of the scene (depth buffering, alpha blending, wire frame, etc.), whereas local state affects a single, specified object in the scene (texture coordinates, vertex colors, etc.).

Section 3.5 is a discussion about camera models and the renderer architecture. Also discussed are issues regarding caching of data on the graphics card and multipass rendering, not from a performance perspective, but from the perspective of how a scene graph management system can support them in a manner independent of the underlying graphics API.

3.1 THE CORE CLASSES

The most important subsystems of scene graph management are encapsulated in the classes `Spatial`, `Node`, `Geometry`, and the abstract renderer layer `Renderer`. The first three are designed to support feeding data to the last in an efficient manner. Figure 3.1 is the most important figure you will see in this book. The schematic diagram shows how the four classes are interrelated.

2. Be aware that major rewrites in the middle of a game development cycle can severely affect the value of your stock options!

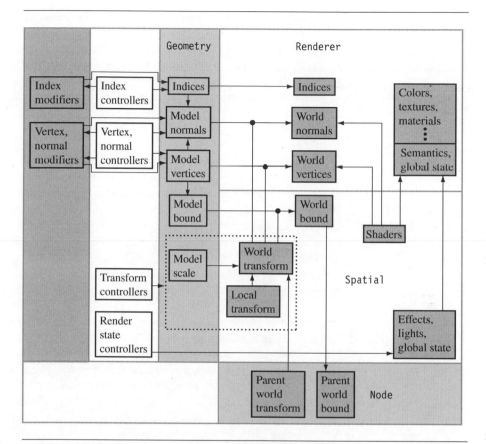

Figure 3.1 The interrelationships among classes Spatial, Node, Geometry, and Renderer.

The discussions in this section are all about why the various boxed items in the diagram are encapsulated as shown. The arrows in the diagram imply a loose form of dependency: An object at the arrowhead depends in some form on the object at the origin of the arrow.

3.1.1 MOTIVATION FOR THE CLASSES

Before you can draw objects using a renderer, you actually need objects to draw! Of course, this is the role of artists in the game development process. Using a modeling package, an artist will create geometric data, usually in the form of points, polylines,

and triangle meshes, and assign various visual attributes, including textures, materials, and lighting. Additional information is also created by the artists. For example, keyframe data may be added to a biped structure for the purposes of animation of the character. Complicated models such as a biped are typically implemented by the modeling package using a scene graph hierarchy itself! For illustration, though, consider a simple, inanimate object such as a model of a wooden table.

Geometry

The table consists of geometric information in the form of a collection of *model vertices*. For convenience, suppose they are stored in an array $V[i]$ for $0 \le i < n$. Most likely the table is modeled as a triangle mesh. The triangles are defined as triples of vertices, ordered in a consistent manner that allows you to say which side of the triangle is outward facing from a display perspective, and which side is inward facing. A classical choice for outward-facing triangles is to use counterclockwise ordering: If an observer is viewing the plane of the triangle and that plane has a normal vector pointing to the side of the plane on which the observer is located, the triangle vertices are seen in a counterclockwise order in that plane. The triangle information is usually stored as a collection of triples of *indices* into the vertex array. Thus, a triple $(i0,i1,i2)$ refers to a triangle whose vertices are $(V[i0],V[i1],V[i2])$. If dynamic lighting of the table is desired, an artist might additionally create vertex *model normals*, although in many cases it is sufficient to generate the normals procedurally. Finally, the model units are possibly of a different size than the units used in the game's world, or the model is intended to be drawn in a different size than what the modeling package does. A *model scale* may be applied by the artist to accommodate these. This does allow for nonuniform scaling, where each spatial dimension may be scaled independently of the others. The region of space that the model occupies is represented by a *model bound*, typically a sphere that encloses all the vertices, but this information can always be generated procedurally and does not require the artist's input. The model bound is useful for identifying whether or not the model is currently visible to an observer. All the model information created by the artist, or procedurally generated from what the artist produces, is encapsulated by the class Geometry, as shown in Figure 3.1.

Spatial

Suppose that the artist was responsible for creating both a table and a room in which the table is placed. The table and room will most likely be created in separate modeling sessions. When working with the room model, it would be convenient to load the already-created table model and place it in the room. The technical problem is that the table and room were created in their own, independent *coordinate systems*. To place the table, it must be translated, oriented, and possibly scaled. The resulting

local transformation is a necessary feature of the final scene for the game. I use the adjective *local* to indicate that the transformation is applied to the table relative to the coordinate system of the room. That is, the table is *located* in the room, and the relationship between the room and table may be thought of as a *parent-child* relationship. You start with the room (the parent) and place the table (the child) in the room using the coordinate system of the room. The room itself may be situated relative to another object—for example, a house—requiring a local transformation of the room into the coordinate system of the house. Assuming the coordinate system of the house is used for the game's world coordinate system, there is an implied *world transformation* from each object's model space to the world space. It is intuitive that the model bound for an object in model space has a counterpart in world space, a *world bound*, which is obtained by applying the world transformation to the model bound. The local and world transformations and the world bound are encapsulated by the class Spatial, as shown in Figure 3.1. The (nonuniform) model scale of the Geometry class and the transformations of the Spatial class are surrounded by a dotted-line box to indicate that both participate in transformations, even though the data is contained in their respective classes.

Node

The example of a house, room, and table has another issue that is partially related to the local and world transformations. The objects are ordered in a natural hierarchy. To make the example more illustrative, consider a house with two rooms, with a table and chair in one room, and a plate, fork, and knife placed on the table. The hierarchy for the objects is shown in Figure 3.2. Each object is represented by a node in the hierarchy.

The objects are all created separately. The hierarchy represents parent-child relationships regarding how a child object is placed relative to its parent object. The Plate,

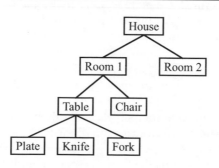

Figure 3.2 A hierarchy to represent a collection of related objects.

Knife, and Fork are assigned local transformations relative to the Table. The Table and Chair are assigned local transformations relative to Room 1. Room 1 and Room 2 are assigned local transformations relative to the House. Each object has world transformations to place it directly in the world. If L_{object} is the local transformation that places the object in the coordinate system of its parent and W_{object} is the world transformation of the object, the hierarchy implies the following matrix compositions. The order of application to vectors (the vertices) is from right to left according to the conventions used in Wild Magic

$$W_{\text{House}} = L_{\text{House}}$$

$$W_{\text{Room1}} = W_{\text{House}} \, L_{\text{Room1}} = L_{\text{House}} \, L_{\text{Room1}}$$

$$W_{\text{Room2}} = W_{\text{House}} \, L_{\text{Room2}} = L_{\text{House}} \, L_{\text{Room2}}$$

$$W_{\text{Table}} = W_{\text{Room1}} \, L_{\text{Table}} \quad = L_{\text{House}} \, L_{\text{Room1}} \, L_{\text{Table}}$$

$$W_{\text{Chair}} = W_{\text{Room1}} \, L_{\text{Chair}} \quad = L_{\text{House}} \, L_{\text{Room1}} \, L_{\text{Chair}}$$

$$W_{\text{Plate}} = W_{\text{Table}} \, L_{\text{Plate}} \quad = L_{\text{House}} \, L_{\text{Room1}} \, L_{\text{Table}} \, L_{\text{Plate}}$$

$$W_{\text{Knife}} = W_{\text{Table}} \, L_{\text{Knife}} \quad = L_{\text{House}} \, L_{\text{Room1}} \, L_{\text{Table}} \, L_{\text{Knife}}$$

$$W_{\text{Fork}} = W_{\text{Table}} \, L_{\text{Fork}} \quad = L_{\text{House}} \, L_{\text{Room1}} \, L_{\text{Table}} \, L_{\text{Fork}}.$$

The first equation says that the house is placed in the world directly. The local and world transformations are the same. The second equation says that Room 1 is transformed first into the coordinate system of the House, then is transformed to the world by the House's world transformation. The other equations have similar interpretations. The last one says that the Fork is transformed into the coordinate system of the Table, then transformed to the coordinate system of Room 1, then transformed to the coordinate system of the House, then transformed to the world coordinates. A path through the tree of parent-child relationships has a corresponding sequence of local transformations that are composited. Although each local transformation may be applied one at a time, it is more efficient to use the world transformation of the parent (already calculated by the parent) and the local transformation of the child to perform a single matrix product that is the world transformation of the child.

The grouping together of objects in a hierarchy is the role of the Node class. The compositing of transformations is accomplished through a depth-first traversal of the parent-child tree. Each parent node provides its world transformation to its child nodes in order for the children to compute their world transformations, naturally a recursive process. The transformations are propagated *down the hierarchy* (from root node to leaf nodes).

Each geometry object has a model bound associated with it. A node does not have a model bound per se, given that it only groups together objects, but it can be

assigned a world bound. The world bound indicates that portion of space containing the collection of objects represented by the node. Keep in mind that the bound is a coarse measurement of occupation, and that not all of the space contained in the bound is occupied by the object. A natural choice for the world bound of a node is any bound that contains the world bounds of its children. However, it is not necessary that the world bound contain the child bounds. All that matters is that the *objects* represented by the child nodes are contained in the world bound. Once a world bound is assigned to a node, it is possible to define a model bound—the one obtained by applying the inverse world transformation to the world bound. A model bound for a node is rarely used, so the Node class does not have a data member to store this information. If needed, it can be computed on the fly from other data.

Each time local transformations are modified at a node in the scene, the world transformations must be recalculated by a traversal of the subtree rooted at that node. But a change in world transformations also implies a change in the world bounds. After the transformations are propagated down the hierarchy, new world bounds must be recomputed at the child nodes and propagated *up the hierarchy* (from leaf nodes to root node) to parent nodes so that they may also recompute their world bounds.

Figure 3.1 shows the relationship between transformations and bounds. A connection is shown between the world transformation (in Spatial) and the link between the model bound (in Geometry) and the world bound (in Spatial). Together these indicate that the model bound is transformed to the world bound by the world transformation. The world transformation at a child node depends on its parent's world transformation. The relationship is shown in the figure by an arrow. The composition of the transformations occurs during the downward pass through the hierarchy. The parent's world bound depends on the child's world bound. The relationship is also shown in the figure by an arrow. The recalculation of the world bounds occurs during the upward passes through the hierarchy. The downward and upward passes together are referred to as a *geometric update*, whose implementation details will be discussed later.

Renderer

Figure 3.1 has a block representing the rendering layer in the engine. Naturally, the renderer needs to be fed the geometric data such as vertices and normals, and this data must be in its final position and orientation in the world. The renderer needs to know how the vertices are related to each other, say, as a triangle mesh, so the indices must also be provided. Notice that some connections are shown between the world transformations (in Spatial) and the links between the model vertices and normals and the world vertices and normals. These indicate that *someone* must be responsible for applying the transformations to the model data before the renderer draws them. Although the Spatial class can be given the responsibility, most likely performing the

calculations on the central processing unit (CPU), the Renderer class instead takes on the responsibility. A software renderer most likely implements the transformations to be performed on the CPU, but renderers using current graphics hardware will allow the graphics processing unit (GPU) to do the calculations. Because the target processor is not always the CPU, it is natural to hide the transformation of model data inside the renderer layer.

The renderer must also be provided with any vertex attributes, texture maps, shader programs, and anything else needed to properly draw an object. On the renderer side, all this information is shown in the box in that portion of Figure 3.1 corresponding to the Renderer class. The provider of the information is class Spatial. Why Spatial and not Geometry? The choice is not immediately obvious. For simple objects consisting of triangle meshes and basic attributes such as vertex colors, materials, or textures, placing the data in Geometry makes sense. However, more complicated special effects (1) may be applied to the entire collection of geometric objects (at the leaf nodes) contained in a subtree of the hierarchy or (2) may require multiple drawing passes in a subtree. An example of (1) is projected textures, where a texture is projected from a postulated light source onto the surfaces of objects visible to the light. It is natural that a node store such a "global effect" rather than share the effect multiple times at all the geometric objects in the subtree. Shader programs are also stored by the Spatial class for the same reason. A shader can affect multiple objects, all in the same subtree of the hierarchy. An example of (2) is planar, projected shadows, where an object casts shadows onto multiple planes. Each casting of a shadow onto the plane requires its own drawing pass. The hierarchy support in Wild Magic is designed to handle both (1) and (2).

Controllers and Modifiers

The word *animation* tends to be used in the context of motion of characters or objects. I use the word in a more general sense to refer to any time-varying quantity in the scene. The engine has support for animation through *controllers*; the abstract base class is Controller. Figure 3.1 illustrates some standard quantities that are controlled.

The most common are transform controllers—for example, keyframe controllers or inverse kinematic controllers. For keyframe controllers, an artist provides a set of positions and orientations for objects (i.e., for the nodes in the hierarchy that represent the objects). A keyframe controller interpolates the keyframes to provide smooth motion over time. For inverse kinematic controllers, the positions and orientations for objects are determined by constraints that require the object to be in certain configurations. For example, a hand on a character must be translated and rotated to pick up a glass. The controller selects the translations and rotations for the hand according to where the glass is.

Vertex and normal controllers are used for morphing and mesh deformation. Render state controllers are used for animating just about any effect you like. For example, a controller could be used to vary the color of a light source. A texture may

be animated by varying the texture coordinates associated with the texture and the object to which the texture applies. This type of effect is useful for giving the effect that a water surface is in motion.

Index controllers are less common, but are used to dynamically change the topology of a triangle mesh or strip. For example, continuous level of detail algorithms may be implemented using controllers.

Controllers are not limited to those shown in Figure 3.1. Use your creativity to implement as complex an animated effect as you can dream up.

I use the term *modifier* to indicate additional semantics applied to a collection of vertices, normals, and indices. The Geometry class is a container for these items, but is itself an abstract class. The main modifier is class TriMesh, which is derived from Geometry, and this class is used to provide indices to the base class. A similar example is class TriStrip, where the indices are implicitly created by the class and provided to the Geometry base class. In both cases, the derived classes may be viewed as index modifiers of the geometry base class.

Other geometric-based classes may also be viewed as modifiers of Geometry, including points (class Polypoint) and polylines (class Polyline). Both classes may be viewed as vertex modifiers. Particle systems (base class Particles) are derived from class TriMesh. The particles are drawn as rectangular billboards (the triangle mesh stores the rectangles as pairs of triangles), and so may be thought of as index modifiers. However, the physical aspects of particles are tied into only the point locations. In this sense, particle systems are vertex modifiers of the Geometry class.

How one adds the concept of modifiers to an engine is up for debate. The controller system allows you to attach a list of controllers to an object. Each controller manages the animation of some member (or members) of the object. As you add new Controller-derived classes, the basic controller system need not change. This is a good thing since you may extend the behavior of the engine without having to rearchitect the core. Preserving old behavior when adding new features is related to the object-oriented principle called the *open-closed principle*. After building a system that, over time, is demonstrated to function as designed and is robust, you want it to be *closed* to further changes in order to protect its integrity. Yet you also want the system to be *open* to extension with new features. Having a core system such as the controllers that allows you to create new features and support them in the (closed) core is one way in which you can have both open and closed.

The classical manner in which you obtain the open-closed principle, though, is through class derivation. The base class represents the closed portion of the system, whereas a derived class represents the open portion. Regarding modifiers, I decided to use class derivation to define the semantics. Such semantics can be arbitrarily complex—something not easily fitted by a system that allows a list of modifiers to be attached to an object. A derived class allows you to implement whatever interface is necessary to support the modifications. Controllers, on the other hand, have simple semantics. Each represents management of the animation of one or more object members, and each implements an update function that is called by the core system. The controller list-based system is natural for such simple objects.

3.1.2 SPATIAL HIERARCHY DESIGN

The main design goal for class Spatial is to represent a coordinate system in space. Naturally, the class members should include the local and world transformations and the world bounding volume, as discussed previously. The Geometry and Node classes themselves involve transformations and bounding volumes, so it is natural to derive these from Spatial. What is not immediately clear is the choice for having both classes Spatial and Node. In Figure 3.2, the objects Table, Plate, Knife, Fork, and Chair are Geometry objects. They all are built from model data, they all occupy a portion of space, and they are all transformable. The objects House, Room 1, and Room 2 are grouping nodes. We could easily make all these Spatial objects, but not Geometry objects. In this scenario, the Spatial class must contain information to represent the hierarchy of objects. Specifically, each object must have a link to its parent object (if any) and links to its child objects. The links shown in Figure 3.2 represent both the parent and child links.

The concepts of grouping and of representing geometric data are effectively disjoint. If Spatial objects were allowed child objects, then by derivation so would Geometry objects. Thus, Geometry objects would have double duty, as representations of geometric data and as nodes for grouping related objects. The interface for a Geometry class that supports grouping as well as geometric queries will be quite complicated, making it difficult to understand all the behavior that objects from the class can exhibit. I prefer instead a *separation of concerns* regarding these matters. The interfaces associated with Geometry and its derived classes should address only the semantics related to geometric objects, their visual appearances, and physical properties. The grouping responsibilities are delegated instead to a separate class, in this case the class Node. The interfaces associated with Node and its derived classes address only the semantics related to the subtrees associated with the nodes. By separating the responsibilities, it is easier for the engine designer and architect to maintain and extend the separate types of objects (geometry types or node types).

My choice for separation of concerns leads to class Spatial storing the parent link in the hierarchy and to class Node storing the child links in the hierarchy. Class Node derives from Spatial, so in fact the Node objects have both parent and child links. Class Geometry also derives from Spatial, but geometry objects can only occur as leaf nodes in the hierarchy. This is the main consequence of the separation of concerns. The price one pays for having the separation and a clean division of responsibilities is that the hierarchy as shown in Figure 3.2 is not realizable in this scheme. Instead the hierarchy may be structured as shown in Figure 3.3.

Two grouping nodes were added. The Table Group node was added because the Table is a geometric object and cannot be an interior node of the tree. The utensils (Plate, Knife, Fork) were children of the Table. To preserve this structure, the Utensil Group node was added to group the utensils together. To maintain the transformation structure of the original hierarchy, the Table Group is assigned the transformations the Table had, the Table is assigned the identity transformation, and the Utensil Group is assigned the identity transformation. This guarantees that the

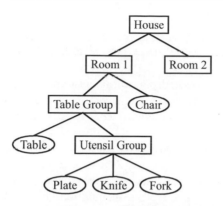

Figure 3.3 The new hierarchy corresponding to the one in Figure 3.2 when geometric objects can be only leaf nodes. Ellipses are used to denote geometric objects. Rectangles are used to denote grouping nodes.

Utensil Group is in the same coordinate system that the Table is in. Consequently, the utensils may be positioned and oriented using the same transformations that were used in the hierarchy of Figure 3.2.

Alternatively, you can avoid the Utensil Group node and just make the utensils siblings of the Table. If you do this, the coordinate system of the utensils is now that of the Table Group. The transformations of the utensils must be changed to ones relative to the coordinate system of the Table Group.

The portion of the interface for class Spatial relevant to the scene hierarchy connections is

```
class Spatial : public Object
{
public:
    virtual ~Spatial ();
    Spatial* GetParent ();

protected:
    Spatial ();
    Spatial* m_pkParent;

// internal use
public:
    void SetParent (Spatial* pkParent);
};
```

The default constructor is protected, making the class an abstract base class. The default constructor is implemented to support the streaming system. The class is derived from the root class Object, as are nearly all the classes in the engine. All of the root services are therefore available to Spatial, including run-time type information, sharing, streaming, and so on.

The parent pointer is protected, but read access is provided by the public interface function GetParent. Write access of the parent pointer is provided by the public interface function SetParent. That block of code is listed at the end of the class. My intention on the organization is that the public interface intended for the application writers is listed first in the class declaration. The public interface at the end of the class is tagged with the comment "internal use." The issue is that SetParent is called by the Node class when a Spatial object is attached as the child of a node. No other class (or application) should call SetParent. If the method were put in the protected section to prevent unintended use, then Node cannot call the function. To circumvent this problem, Node can be made a friend of Spatial, thus allowing it access to SetParent, but disallowing anyone else to access it. In some circumstances, a Node-derived class might also need access to a protected member of Spatial. In the C++ language, friendship is not inherited, so making Node a friend of Spatial will not make the Node-derived class a friend of Spatial. To avoid the somewhat frequent addition of friend declarations to classes to allow restricted access to protected members, I decided to use the system of placing the restricted access members in public scope, but tagging that block with the "internal use" comment to let programmers know that they should *not* use those functions.

The portion of the interface for class Node relevant to the scene hierarchy connections is

```
class Node : public Spatial
{
public:
    Node (int iQuantity = 1, int iGrowBy = 1);
    virtual ~Node ();

    int GetQuantity () const;
    int GetUsed () const;
    int AttachChild (Spatial* pkChild);
    int DetachChild (Spatial* pkChild);
    SpatialPtr DetachChildAt (int i);
    SpatialPtr SetChild (int i, Spatial* pkChild);
    SpatialPtr GetChild (int i);

protected:
    TArray<SpatialPtr> m_kChild;
    int m_iUsed;
};
```

The links to the child nodes are stored as an array of Spatial smart pointers. Clearly, the pointers cannot be Node pointers because the leaf nodes of the hierarchy are Spatial-derived objects (such as Geometry), but not Node-derived objects. The nonnull child pointers do not have to be contiguous in the array, so where the children are placed is up to the programmer. The data member m_iUsed indicates how many of the array slots are occupied by nonnull pointers.

The constructor allows you to specify the initial quantity of children the node will have. The array is dynamic; that is, even if you specify the node to have a certain number of children initially, you may attach more children than that number. The second parameter of the constructor indicates how much storage increase occurs when the array is full and an attempt to attach another child occurs.

The AttachChild function searches the pointer array for the first available empty slot and stores the child pointer in it. If no such slot exists, the child pointer is stored at the end of the array, dynamically resizing the array if necessary. This is an important feature to remember. For whatever reason, if you detach a child from a slot internal to the array and you do not want the next child to be stored in that slot, you must use the SetChild function because it lets you specify the exact location for the new child. The return value of AttachChild is the index into the array where the attached child is stored. The return value of SetChild is the child that was in the ith slot of the array before the new child was stored there. If you choose not to hang onto the return value, it is a smart pointer, in which case the reference count on the object is decremented. If the reference count goes to zero, the child is automatically destroyed.

Function DetachChild lets you specify the child, by pointer, to be detached. The return value is the index of the slot that stored the child. The vacated slot has its pointer set to NULL. Function DetachChildAt lets you specify the child, by index, to be detached. The return value is that child. As with SetChild, if you choose not to hang onto the return value, the reference count on the object is decremented and, if zero, the object is destroyed.

Function GetChild simply returns a smart pointer to the current child in the specified slot. This function is what you use when you iterate over an array of children and process them in some manner—typically something that occurs during a recursive traversal of a scene graph.

3.1.3 INSTANCING

The spatial hierarchy system is a *tree structure*; that is, each tree node has a single parent, except for a root node that has no parent. You may think of the spatial hierarchy as the skeleton for the scene graph. A scene graph really is an abstract graph because the object system supports sharing. If an object is shared by two other objects, effectively there are two *instances* of the first object. The act of sharing the objects is called *instancing*. I do not allow instancing of nodes in a spatial hierarchy, and this

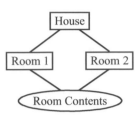

Figure 3.4 A scene graph corresponding to a house and two rooms. The rooms share the same geometric model data, called Room Contents.

is enforced by allowing a `Spatial` object to have only a single parent link. Multiple parents are not possible.[3] One of the questions I am occasionally asked is why I made this choice.

For the sake of argument, suppose that a hierarchy node is allowed to have multiple parents. A simple example is shown in Figure 3.4. The scene graph represents a house with two rooms. The rooms share the same geometric model data. The two rooms may be thought of as instances of the same model data. The implied structure is a directed acyclic graph (DAG). The house node has two directed arcs to the room nodes. Each room node has a directed arc to the room contents leaf node. The room contents are therefore shared. Reasons to share include reducing memory usage for the game application and reducing your artist's workload in having to create distinct models for everything you can imagine in the world. The hope is that the user is not terribly distracted by the repetition of like objects as he navigates through the game world.

What are some of the implications of Figure 3.4? The motivation for a spatial hierarchy was to allow for positioning and orienting of objects via local transformations. The locality is important so that generation of content can be done independently of the final coordinate system of the world (the coordinate system of the root node of the scene). A path through the hierarchy from root to leaf has a corresponding sequence of local transformations whose product is the world transformation for the leaf node. The problem in Figure 3.4 is that the leaf node may be reached via *two paths* through the hierarchy. Each path corresponds to an instance of the leaf object. Realize that the two rooms are placed in different parts of the house. The world transformations applied to the room contents are necessarily different. If you have any plans to make the world transformations persistent, they must be stored *somewhere*. In the tree-based hierarchy, the world transformations are stored directly at the node. To

3. *Predecessors* might be a better term to use here, but I will use the term *parents* and note that the links are directed from parent to child.

store the world transformations for the DAG of Figure 3.4, you can store them either at each node or in a separate location that the node has pointers to. In either case, a dynamic system is required since the number of parents can be any number and change at any time. World bounding volumes must also be maintained, one per instance.

Another implication is that if you want to change the data directly at the shared node, the room contents in our example, it is necessary for you to be able to specify *which instance is to be affected*. This alone creates a complex situation for an application programmer to manage. You may assign a set of names to the shared object, one name per path to the object. The path names can be arbitrarily long, making the use of them a bit overwhelming for the application programmer. Alternatively, you can require that a shared object not be directly accessible. The instances must be managed only through the parent nodes. In our example, to place Room 1 in the house, you set its local transformations accordingly. Room 2 is placed in the world with a different set of local transformations. The Room Contents always have the identity transformation, never to be changed. This decision has the consequence that if you only have a single instance (most likely the common case in a scene), a parent node should be used to indirectly access that instance. If you are not consistent in the manner of accessing the object, your engine logic must distinguish between a single instance of an object and multiple instances of an object, then handle the situations differently. Thus, every geometric object must be manipulated as a node-geometry pair. Worse is that if you plan on instancing a subgraph of nodes, that subgraph must have parent nodes through which you access the instances. Clearly this leads to "node bloat" (for lack of a better term), and the performance of updating such a system is not optimal for real-time needs.

Is this speculation or experience? The latter, for sure. One of the first tasks I was assigned when working on NetImmerse in its infancy was to support instancing in the manner described here. Each node stored a dynamic array of parent links and a dynamic array of child links. A corresponding dynamic array of geometric data was also maintained that stored transformations, bounding volumes, and other relevant information. Instances were manipulated through parent nodes, with some access allowed to the instances themselves. On a downward traversal of the scene by a recursive function, the parent pointer was passed to that function and used as a lookup in the child's parent array to determine which instance the function was to affect. This mechanism addresses the issue discussed earlier, unique names for the paths to the instance. Unfortunately, the system was complicated to build and complicated to maintain (adding new recursive functions for scene traversal was tedious), and the parent pointer lookup was a noticeable time sink, as shown by profiling any applications built on top of the engine. To eliminate the cost of parent pointer lookups, the node class was modified to include an array of instance pointers, one per child of the node. Those pointers were passed through recursive calls, thus avoiding the lookups, and used directly. Of course, this increased the per-node memory requirements and increased the complexity

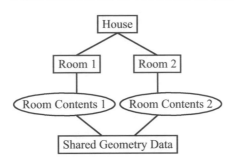

Figure 3.5 The scene graph of Figure 3.4, but with instancing at a low level (geometric data) rather than at a node level.

of the system. In the end we decided that supporting instancing by DAGs was not acceptable.

That said, instancing still needs to be supported in an engine. I mentioned this earlier and mention it again: What is important regarding instancing is that (1) you reduce memory usage and (2) you reduce the artist's workload. The majority of memory consumption has to do with models with *large* amounts of data. For example, a model with 10,000 vertices, multiple 32-bit texture images, each 512 × 512, and corresponding texture coordinates consumes a lot of memory. Instancing such a model will avoid duplication of the large data. The amount of memory that a node or geometry object requires to support core scene graph systems is quite small relative to the actual model data. If a subgraph of nodes is to be instanced, duplication of the nodes requires only a small amount of additional memory. The model data is shared, of course. Wild Magic 3 chooses to share in the manner described here. The sharing is *low level*; that is, instancing of models involves geometric data. If you want to instance an object of a `Geometry`-derived class, you create two unique `Geometry`-derived objects, but ask them to share their vertices, texture coordinates, texture images, and so on. The DAG of Figure 3.4 abstractly becomes the graph shown in Figure 3.5.

The work for creating an instance is more than what a DAG-style system requires, but the run-time performance is much improved and the system complexity is minimal.

3.2 GEOMETRIC STATE

Two basic objects involving geometric state are transformations and bounding volumes.

3.2.1 TRANSFORMATIONS

Wild Magic version 2 supported transformations involving translations \mathbf{T}, rotations R, and uniform scaling $\sigma > 0$. A vector \mathbf{X} is transformed to a vector \mathbf{Y} by

$$\mathbf{Y} = R(\sigma \mathbf{X}) + \mathbf{T}. \tag{3.1}$$

The order of application is scale first, rotation second, and translation third. However, the order of uniform scaling and rotation is irrelevant. The inverse transformation is

$$\mathbf{X} = \frac{1}{\sigma} R^{\mathrm{T}}(\mathbf{Y} - \mathbf{T}). \tag{3.2}$$

Generally, a graphics API allows for any affine transformation, in particular, nonuniform scaling. The natural extension of Equation (3.1) to allow nonuniform scale $S = \mathrm{Diag}(\sigma_0, \sigma_1, \sigma_2)$, $\sigma_i > 0$, for all i, is

$$\mathbf{Y} = RS\mathbf{X} + \mathbf{T}. \tag{3.3}$$

The order of application is scale first, rotation second, and translation third. In this case the order of nonuniform scaling and rotation is relevant. Switching the order produces different results since, in most cases, $RS \neq SR$. The inverse transformation is

$$\mathbf{X} = S^{-1} R^{\mathrm{T}}(\mathbf{Y} - \mathbf{T}), \tag{3.4}$$

where $S^{-1} = \mathrm{Diag}(1/\sigma_0, 1/\sigma_1, 1/\sigma_2)$. The memory requirements to support nonuniform scaling are modest—only two additional floating-point numbers to store.

Wild Magic version 2 disallowed nonuniform scaling because of some undesirable consequences. First, a goal was to minimize the time spent on matrix and vector arithmetic. This was particularly important when an application has a physical simulation that makes heavy use of the transformation system. Using operation counts as a measure of execution time,[4] let μ represent the number of cycles for a multiplication, let α represent the number of cycles for an addition/subtraction, and let δ represent the number of cycles for a division. On an Intel Pentium class processor, μ and α are equal, both 3 cycles. The value δ is 39 cycles. Both Equations (3.1) and (3.3) use $12\mu + 9\alpha$ cycles to transform a single vector. Equation (3.2) uses $12\mu + 9\alpha + \delta$ cycles. The only difference between the inverse transform and the forward transform is the division required to compute the reciprocal of scale. The reciprocal is computed first and then multiplies the three components of the vector. Equation (3.4) uses $9\mu + 9\alpha + 3\delta$ cycles. Compared to the uniform scale inversion, the reciprocals are

4. A warning about operation counting: Current-day processors have other issues now that can make operation counting not an accurate measure of performance. You need to pay attention to memory fetches, cache misses, branch penalties, and other architectural aspects.

not computed first. The three vector components are divided directly by the nonuniform scales, leading to three less multiplications, but two more divisions. This is still a significant increase in cost because of the occurrence of the additional divisions. The divisions may be avoided by instead computing $p = \sigma_0\sigma_1\sigma_2$, $r = 1/p$, and observing that $S^{-1} = r \, \text{Diag}(\sigma_1\sigma_2, \sigma_0\sigma_2, \sigma_0\sigma_1)$. Equation (3.3) then uses $19\mu + 9\alpha + \delta$ cycles, replacing two divisions by 10 multiplications. If the CPU supports a faster but lower-precision division, the increase is not as much of a factor, but you pay in terms of accuracy of the final result. With the advent of specialized hardware such as extended instructions for CPUs, game console hardware, and vector units generally, the performance for nonuniform scaling is not really a concern.

Second, an issue that is mathematical and that hardware cannot eliminate is the requirement to factor transformations to maintain the ability to store at each node the scales, the rotation matrix, and the translation vector. To be precise, if you have a path of nodes in a hierarchy and corresponding local transformations, the world transformation is a composition of the local ones. Let the local transformations be represented as homogeneous matrices in block-matrix form. The transformation $\mathbf{Y} = RS\mathbf{X} + \mathbf{T}$ is represented by

$$\left[\begin{array}{c} \mathbf{Y} \\ \hline 1 \end{array}\right] \left[\begin{array}{c|c} RS & \mathbf{T} \\ \hline \mathbf{0}^{\mathrm{T}} & 1 \end{array}\right] \left[\begin{array}{c} \mathbf{X} \\ \hline 1 \end{array}\right].$$

The composition of two local transformations $\mathbf{Y} = R_1 S_1 \mathbf{X} + \mathbf{T}_1$ and $\mathbf{Z} = R_2 S_2 \mathbf{Y} + \mathbf{T}_2$ is represented by a homogeneous block matrix that is a product of the two homogeneous block matrices representing the individual transformations:

$$\left[\begin{array}{c|c} R_2 S_2 & \mathbf{T}_2 \\ \hline \mathbf{0}^{\mathrm{T}} & 1 \end{array}\right] \left[\begin{array}{c|c} R_1 S_1 & \mathbf{T}_1 \\ \hline \mathbf{0}^{\mathrm{T}} & 1 \end{array}\right] = \left[\begin{array}{c|c} R_2 S_2 R_1 S_1 & R_2 S_2 \mathbf{T}_1 + \mathbf{T}_2 \\ \hline \mathbf{0}^{\mathrm{T}} & 1 \end{array}\right] = \left[\begin{array}{c|c} M & \mathbf{T} \\ \hline \mathbf{0}^{\mathrm{T}} & 1 \end{array}\right],$$

where $M = R_2 S_2 R_1 S_1$ and $\mathbf{T} = R_2 S_2 \mathbf{T}_1 + \mathbf{T}_2$. A standard question that is asked somewhat regularly in the Usenet computer graphics newsgroups is how to factor

$$M = RS,$$

where R is a rotation and S is a diagonal nonuniform scaling matrix. The idea is to have a transformation class that always stores R, S, and \mathbf{T} as individual components, thus allowing direct evaluation of Equations (3.3) and (3.4). Much to the posters' dismay, the unwanted answer is, You cannot always factor M in this way. In fact, it is not always possible to factor $D_1 R_1$ into $R_2 D_2$, where D_1 and D_2 are diagonal matrices and R_1 and R_2 are rotation matrices.

The best you can do is factor M using *polar decomposition* or *singular value decomposition* ([Hec94, Section III.4]). The polar decomposition is

$$M = UA,$$

where U is an orthogonal matrix and A is a symmetric matrix, but not necessarily diagonal. The singular value decomposition is closely related:

$$M = VDW^\mathrm{T},$$

where V and W are orthogonal matrices and D is a diagonal matrix. The two factorizations are related by appealing to the eigendecomposition of a symmetric matrix, $A = WDW^\mathrm{T}$, where W is orthogonal and D is diagonal. The columns of W are linearly independent eigenvectors of A, and the diagonal elements of D are the eigenvalues (ordered to correspond to the columns of W). It follows that $V = UW$. Implementing either factorization is challenging because the required mathematical machinery is more than what you might expect.

Had I chosen to support nonuniform scaling in Wild Magic *and* wanted a consistent representation of local and world transformations, the factorization issue prevents me from storing a transformation as a triple (R, S, \mathbf{T}), where R is a rotation, S is a diagonal matrix of scales, and \mathbf{T} is a translation. One way out of the dilemma is to use a triple for local transformations, but a pair (M, \mathbf{T}) for world transformations. The 3×3 matrix M is the composition of rotations and nonuniform scales through a path in the hierarchy. The memory usage for a world transformation is smaller than for a local one, but only one floating-point number less. The cost for a forward transformation $\mathbf{Y} = M\mathbf{X} + \mathbf{T}$ is $9\mu + 9\alpha$, cheaper than for a local transformation. Less memory usage, faster transformation, but the cost is that you have no scaling or rotational information for the world transformation unless you factor into polar form or use the singular value decomposition. Both factorizations are very expensive to compute. The inverse tranformation $\mathbf{X} = M^{-1}(\mathbf{Y} - \mathbf{T})$ operation count is slightly more complicated to determine. Using a cofactor expansion to compute the inverse matrix,

$$M^{-1} = \frac{1}{\det(M)} M^\mathrm{adj},$$

where $\det(M)$ is the determinant of M and M^adj is the adjoint matrix—the transpose of the matrix of cofactors of M. The adjoint has nine entries, each requiring $2\mu + \alpha$ cycles to compute. The determinant is computed from a row of cofactors, using three more multiplications and two more additions, for a total of $3\mu + 2\alpha$ cycles. The reciprocal of the determinant uses δ cycles. Computing the inverse transformation as

$$\mathbf{X} = \frac{1}{\det(M)} \left(M^\mathrm{adj}(\mathbf{Y} - \mathbf{T}) \right)$$

requires $33\mu + 20\alpha + \delta$ cycles. This is a very significant increase in cost compared to the $19\mu + 9\alpha + \delta$ cycles used for computing $\mathbf{X} = S^{-1}R^\mathrm{T}(\mathbf{Y} - \mathbf{T})$.

To avoid the increase in cost for matrix inversion, you could alternatively choose a consistent representation where the transformations are stored as 4-tuples of the form (L, S, R, \mathbf{T}), where L and R are rotation matrices, S is a diagonal matrix of scales, and \mathbf{T} is a translation. Once a world transformation is computed as a

composition of local transformations to obtain M and \mathbf{T}, you have to factor $M = LDR$ using the singular value decomposition—yet another expensive proposition.

Given the discussion of nonuniform scaling and the performance issues arising from factorization and/or maintaining a consistent representation for transformations, in Wild Magic version 2 I decided to constrain the transformations to use only uniform scaling. I have relaxed the constraint slightly in Wild Magic version 3. The Spatial class stores three scale factors, but only the Geometry class may set these to be nonuniform. But doesn't this introduce all the problems that I just mentioned? Along a path of n nodes, the last node being a geometry leaf node, the world transformation is a composition of $n - 1$ local transformations that have only uniform scale σ_i, $i \geq 2$, and a final local transformation that has nonuniform scales S_1:

$$\left[\begin{array}{c|c} R_n\sigma_n & \mathbf{T}_n \\ \hline \mathbf{0}^\mathrm{T} & 1 \end{array} \right] \cdots \left[\begin{array}{c|c} R_2\sigma_2 & \mathbf{T}_2 \\ \hline \mathbf{0}^\mathrm{T} & 1 \end{array} \right] \left[\begin{array}{c|c} R_1S_1 & \mathbf{T}_1 \\ \hline \mathbf{0}^\mathrm{T} & 1 \end{array} \right]$$

$$= \left[\begin{array}{c|c} R'\sigma' & \mathbf{T}' \\ \hline \mathbf{0}^\mathrm{T} & 1 \end{array} \right] \left[\begin{array}{c|c} R_1S_1 & \mathbf{T}_1 \\ \hline \mathbf{0}^\mathrm{T} & 1 \end{array} \right]$$

$$= \left[\begin{array}{c|c} (R'R_1)(\sigma'S_1) & R'\sigma'\mathbf{T}_1 + \mathbf{T}' \\ \hline \mathbf{0}^\mathrm{T} & 1 \end{array} \right]$$

$$= \left[\begin{array}{c|c} R''S'' & \mathbf{T}'' \\ \hline \mathbf{0}^\mathrm{T} & 1 \end{array} \right].$$

Because of the commutativity of uniform scale and rotation, the product of the first $n - 1$ matrices leads to another matrix of the same form, as shown. The product with the last matrix groups together the rotations and groups together the scales. The final form of the composition is one that does not require a general matrix inverse calculation. I consider the decision to support nonuniform scales only in the Geometry class an acceptable compromise between having only uniform scales or having nonuniform scales available at all nodes.

The class that encapsulates the transformations containing translations, rotations, and nonuniform scales is Transformation. The default constructor, destructor, and data members are shown next in a partial listing of the class:

```
class Transformation
{
public:
    Transformation ();
    ~Transformation ();

    static const Transformation IDENTITY;
```

```
private:
    Matrix3f m_kRotate;
    Vector3f m_kTranslate;
    Vector3f m_kScale;
    bool m_bIsIdentity, m_bIsUniformScale;
};
```

In a moment I will discuss the public interface to the data members. The rotation matrix is stored as a 3 × 3 matrix. The user is responsible for ensuring that the matrix really is a rotation. The three scale factors are stored as a 3-tuple, but they could just as easily have been stored as three separate floating-point numbers. The class has two additional data members, both Boolean variables. These are considered *hints* to allow for more efficient composition of transformations. The default constructor creates the identity transformation, where the rotation is the 3 × 3 identity matrix, the translation is the 3 × 1 zero vector, and the three scales are all one. The m_bIsIdentity and m_bIsUniformScale hints are both set to true. For an application's convenience, the static class member IDENTITY stores the identity transformation.

Part of the public interface to access the members is

```
class Transformation
{
public:
    void SetRotate (const Matrix3f& rkRotate);
    const Matrix3f& GetRotate () const;
    void SetTranslate (const Vector3f& rkTranslate);
    const Vector3f& GetTranslate () const;
    void SetScale (const Vector3f& rkScale);
    const Vector3f& GetScale () const;
    void SetUniformScale (float fScale);
    float GetUniformScale () const;
};
```

The Set functions have side effects in that each function sets the m_bIsIdentity hint to false. The hint is set, even if the final transformation is the identity. For example, calling SetTranslate with the zero vector as input will set the hint to false. I made this choice to avoid having to check if the transformation is really the identity after each component is set. The expected case is that the use of Set functions is to make the transformation something *other* than the identity. Even if we were to test for the identity transformation, the test is problematic when floating-point arithmetic is used. An exact comparison of floating-point values is not robust when some of the values were computed in expressions, the end results of which were produced after a small amount of floating-point round-off error. The SetScale function also has the side effect of setting the m_bIsUniformScale hint to false. As before, the hint is set even if the input scale vector corresponds to uniform scaling. The Get functions have

no side effects and return the requested components. These functions are const, so the components are read-only.

Three other public member access functions are provided:

```
class Transformation
{
public:
    Matrix3f& Rotate ();
    Vector3f& Translate ();
    Vector3f& Scale ();
};
```

My convention is to omit the Set or Get prefixes on member accessors when I intend the accessor to provide read-write access. The displayed member functions are read-write, but also have the side effects of setting the m_bIsIdentity and/or the m_bIsUniformScale hints. Because the accessor cannot determine if it was called for read versus write, the hints are always set. You should avoid this style of accessor if your intent is only to read the member value, in which case you should use the Get version. A typical situation to use the read-write accessor is for updates that require both, for example,

```
Transformation kXFrm = <some transformation>;
kXFrm.Translate() += Vector3f(1.0f,2.0f,3.0f);
```

or for in-place calculations, for example,

```
Transformation kXFrm = <some transformation>;
kXFrm.Rotate().FromAxisAngle(Vector3f::UNIT_Z,Mathf::HALF_PI);
```

In both cases, the members are written, so setting the hints is an appropriate action to take.

Two remaining public accessors are for convenience:

```
class Transformation
{
public:
    float GetMinimumScale () const;
    float GetMaximumScale () const;
};
```

The names are clear. The first returns the smallest scale from the three scaling factors, and the second returns the largest. An example of where I use the maximum scale is in computing a world bounding sphere from a model bounding sphere and a transformation with nonuniform scaling. The exact transformation of the model

bounding sphere is an ellipsoid, but since I really wanted a bounding sphere, I use the maximum scale as a uniform scale factor and apply a uniform scale transformation to the model bounding sphere.

Other convenience functions include the ability to tell a transformation to make itself the identity transformation or to make its scales all one:

```
class Transformation
{
public:
    void MakeIdentity ();
    void MakeUnitScale ();
    bool IsIdentity () const;
    bool IsUniformScale () const;
};
```

The last two functions just return the current values of the hints.

The basic algebraic operations for transformations include application of a transformation to points, application of an inverse transformation to points, and composition of two transformations. The member functions are

```
class Transformation
{
public:
    Vector3f ApplyForward (const Vector3f& rkInput) const;
    void ApplyForward (int iQuantity, const Vector3f* akInput,
        Vector3f* akOutput) const;

    Vector3f ApplyInverse (const Vector3f& rkInput) const;
    void ApplyInverse (int iQuantity, const Vector3f* akInput,
        Vector3f* akOutput) const;

    void Product (const Transformation& rkA,
        const Transformation& rkB,);

    void Inverse (Transformation& rkInverse);
};
```

The first `ApplyForward` and `ApplyInverse` functions apply to single vectors. The second pair of these functions apply to arrays of vectors. If the transformation is $\mathbf{Y} = RS\mathbf{X} + \mathbf{T}$, where R is a rotation matrix, S is a diagonal scale matrix, and \mathbf{T} is a translation, function `ApplyForward` computes \mathbf{Y} from the input vector(s) \mathbf{X}. Function `ApplyInverse` computes $\mathbf{X} = S^{-1}R^{\mathrm{T}}(\mathbf{Y} - \mathbf{T})$ from the input vector(s) \mathbf{Y}.

The composition of two transformations is performed by the member function `Product`. The name refers to a product of matrices when the transformations are viewed as 4×4 homogeneous matrices. For example,

```
Transformation kA = <some transformation>;
Transformation kB = <some transformation>;
Transformation kC;

// compute C = A*B
kC.Product(kA,kB);

// compute C = B*A, generally not the same as A*B
kC.Product(kB,kA);
```

We will also need to apply inverse transformations to vectors. Notice that I earlier used both the term *points* and the term *vectors*. The two are abstractly different, as discussed in the study of *affine algebra*. A point **P** is transformed as

$$\mathbf{P}' = RS\mathbf{P} + \mathbf{T},$$

whereas a vector **V** is transformed as

$$\mathbf{V}' = RS\mathbf{V}.$$

You can think of the latter equation as the difference of the equations for two transformed points **P** and **Q**:

$$\mathbf{V} = \mathbf{P} - \mathbf{Q}$$

$$\mathbf{P}' = RS\mathbf{P} + \mathbf{T}$$

$$\mathbf{Q}' = RS\mathbf{Q} + \mathbf{T}$$

$$\mathbf{V}' = \mathbf{P}' - \mathbf{Q}' = (RS\mathbf{P} + \mathbf{T}) - (RS\mathbf{Q} + \mathbf{T}) = RS(\mathbf{P} - \mathbf{Q}) = RS\mathbf{V}.$$

In terms of homogeneous vectors, the point **P** and vector **V** are represented by

$$\left[\frac{\mathbf{P}}{1} \right] \quad \text{and} \quad \left[\frac{\mathbf{V}}{0} \right].$$

The corresponding homogeneous transformations are

$$\left[\begin{array}{c|c} RS & \mathbf{T} \\ \hline \mathbf{0}^{\mathrm{T}} & 1 \end{array}\right] \left[\begin{array}{c} \mathbf{P} \\ \hline 1 \end{array}\right] = \left[\begin{array}{c} RS\mathbf{P}+\mathbf{T} \\ \hline 1 \end{array}\right] = \left[\begin{array}{c} \mathbf{P}' \\ \hline 1 \end{array}\right]$$

and
$$\left[\begin{array}{c|c} RS & \mathbf{T} \\ \hline \mathbf{0}^{\mathrm{T}} & 1 \end{array}\right] \left[\begin{array}{c} \mathbf{V} \\ \hline 0 \end{array}\right] = \left[\begin{array}{c} RS\mathbf{V} \\ \hline 0 \end{array}\right] = \left[\begin{array}{c} \mathbf{V}' \\ \hline 0 \end{array}\right].$$

The inverse transformation of a vector \mathbf{V}' is

$$\mathbf{V} = S^{-1}R^{\mathrm{T}}\mathbf{V}'.$$

The member function that supports this operation is

```
class Transformation
{
public:
    Vector3f InvertVector (const Vector3f& rkInput) const;
};
```

Finally, the inverse of the transformation is computed by

```
void Inverse (Transformation& rkInverse);
```

The translation, rotation, and scale components are computed. If $\mathbf{Y} = RS\mathbf{X} + \mathbf{T}$, the inverse is $\mathbf{X} = S^{-1}R^{\mathrm{T}}(\mathbf{Y} - \mathbf{T})$. The inverse transformation has scale S^{-1}, rotation R^{T}, and translation $-S^{-1}R^{\mathrm{T}}\mathbf{T}$. A warning is in order, though. The components are stored in the class data members, but the transformation you provide to the function *should not* be used as a regular Transformation. If you were to use it as such, it would represent

$$R^{\mathrm{T}}S^{-1}\mathbf{X} - S^{-1}R^{\mathrm{T}}\mathbf{T}.$$

Only call this function, access the individual components, and then discard the object.

The transformation of a plane from model space to world space is also sometimes necessary. Let the model space plane be

$$\mathbf{N}_0 \cdot \mathbf{X} = c_0,$$

where \mathbf{N}_0 is a unit-length normal vector, c_0 is a constant, and \mathbf{X} is any point on the plane and is specified in model space coordinates. The inverse transformation of the point is $\mathbf{X} = S^{-1}R^{\mathrm{T}}(\mathbf{Y} - \mathbf{T})$, where \mathbf{Y} is the point in world space coordinates. Substituting this in the plane equation leads to

$$\mathbf{N}_1 \cdot \mathbf{Y} = c_1, \qquad \mathbf{N}_1 = \frac{RS^{-1}\mathbf{N}_0}{|RS^{-1}\mathbf{N}_0|}, \qquad c_1 = \frac{c_0}{|RS^{-1}\mathbf{N}_0|} + \mathbf{N}_1 \cdot \mathbf{T}.$$

The member function that supports this operation is

```
class Transformation
{
public:
    Plane3f ApplyForward (const Plane3f& rkInput) const;
};
```

The input plane has normal \mathbf{N}_0 and constant c_0. The output plane has normal \mathbf{N}_1 and constant c_1.

In all the transformation code, I take advantage of the `m_bIsIdentity` and `m_bIsUniformScale` hints. Two prototypical cases are the implementation of `Apply-Forward` that maps $\mathbf{Y} = RS\mathbf{X} + \mathbf{T}$ and the implementation of `ApplyInverse` that maps $\mathbf{X} = S^{-1}R^{\mathrm{T}}(\mathbf{Y} - \mathbf{T})$. The forward transformation implementation is

```
Vector3f Transformation::ApplyForward (
    const Vector3f& rkInput) const
{
    if ( m_bIsIdentity )
        return rkInput;

    Vector3f kOutput = rkInput;
    kOutput.X() *= m_kScale.X();
    kOutput.Y() *= m_kScale.Y();
    kOutput.Z() *= m_kScale.Z();
    kOutput = m_kRotate*kOutput;
    kOutput += m_kTranslate;
    return kOutput;
}
```

If the transformation is the identity, then $\mathbf{Y} = \mathbf{X}$ and the output vector is simply the input vector. A generic implementation might do all the matrix and vector operations anyway, not noticing that the transformation is the identity. The hint flag helps avoid those unnecessary calculations. If the transformation is not the identity, it does not matter whether the scale is uniform or nonuniform since three multiplications by a scale parameter occur in either case.

The inverse transformation implementation is

```
Vector3f Transformation::ApplyInverse (
    const Vector3f& rkInput) const
{
    if ( m_bIsIdentity )
        return rkInput;
```

```
if ( m_bIsUniformScale )
{
    return ((rkInput - m_kTranslate)*m_kRotate) /
        GetUniformScale();
}

Vector3f kOutput = ((rkInput - m_kTranslate)*m_kRotate);
float fSXY = m_kScale.X()*m_kScale.Y();
float fSXZ = m_kScale.X()*m_kScale.Z();
float fSYZ = m_kScale.Y()*m_kScale.Z();
float fInvDet = 1.0f/(fSXY*m_kScale.Z());
kOutput.X() *= fInvDet*fSYZ;
kOutput.Y() *= fInvDet*fSXZ;
kOutput.Z() *= fInvDet*fSXY;
return kOutput;
}
```

If the transformation is the identity, then $\mathbf{X} = \mathbf{Y}$ and there is no reason to waste cycles by applying the transformation components. Unlike ApplyForward, if the transformation is not the identity, then there is a difference in performance between uniform and nonuniform scaling.

For uniform scale, $R^T(\mathbf{Y} - \mathbf{T})$ has all three components divided by scale. The Matrix3 class has an operator function such that a product of a vector (the left operand \mathbf{V}) and a matrix (the right operand M) corresponds to $M^T\mathbf{V}$. The previous displayed code block uses this function. The Vector3 class supports division of a vector by a scalar. Internally, the reciprocal of the divisor is computed and multiplies the three vector components. This avoids the division occurring three times, replacing the operation instead with a single division and three multiplications.

For nonuniform scale, I use the trick described earlier for avoiding three divisions. The displayed code replaces the three divisions by 10 multiplications and one division. For an Intel Pentium that uses 3 cycles per multiplication and 39 cycles per division, the three divisions would cost 78 cycles, but the 10 multiplications and one division costs 69 cycles.

3.2.2 BOUNDING VOLUMES

The term *bounding volume* is quite generic and refers to any object that contains some other object. The simplest bounding volumes that game programmers use tend to be spheres or axis-aligned bounding boxes. Slightly more complicated is an oriented bounding box. Yet more complicated is the convex hull of the contained object, a convex polyhedron. In all cases, the bounding volumes are convex. To be yet more complicated, a bounding volume might be constructed as a union of (convex) bounding volumes.

Culling

One major use for bounding volumes in an engine is for the purposes of *culling* objects. If an object is completely outside the view frustum, there is no reason to tell the renderer to try and draw it because if the renderer made the attempt, it would find that all triangles in the meshes that represent the object are outside the view frustum. Such a determination does take some time—better to avoid wasting cycles on this, if possible. The scene graph management system could itself determine if the mesh triangles are outside the view frustum, testing them one at a time for intersection with, or containment by, the view frustum, but this gains us nothing. In fact, this is potentially slower when the renderer has a specialized GPU to make the determination, but the scene graph system must rely on a general CPU.

A less aggressive approach is to use a convex bounding volume as an approximation to the region of space that the object occupies. If the bounding volume is outside the view frustum, then so is the object and we need not ask the renderer to draw it. The intersection/containment test between bounding volume and view frustum is hopefully a lot less expensive to compute than the intersection/containment tests for all the triangles of the object. If the bounding volume is a sphere, the test for the sphere being outside the view frustum is equivalent to computing the distance from the sphere center to the view frustum and showing that it is larger than the radius of the sphere.

Computing the distance from a point to a view frustum is more complicated than most game programmers care to deal with—hence the replacement of that test with an *inexact* query that is simpler to implement. Specifically, the sphere is tested against each of the six frustum planes. The frustum plane normals are designed to point into the view frustum; that is, the frustum is on the "positive side" of all the planes. If the sphere is outside any of these planes, say, on the "negative side" of a plane, then the sphere is outside the entire frustum and the object is not visible and therefore not sent to the renderer for drawing (it is culled). I call this *plane-at-a-time culling*. The geometry query I refer to as the *which-side-of-plane query*. There are situations when the sphere is not outside one of the planes, but is outside the view frustum; that is why I used earlier the adjective "inexact." Figure 3.6 shows the situation in two dimensions.

The sphere in the upper right of the image is not outside any of the frustum planes, but is outside the view frustum. The plane-at-a-time culling system determines that the sphere is not outside any plane, and the object associated with the bounding volume is sent to the renderer for drawing. The same idea works for convex bounding volumes other than spheres. Pseudocode for the general inexact culling is

```
bool IsCulled (ViewFrustum frustum, BoundingVolume bound)
{
    for each plane of frustum do
    {
        if bound is on the negative side of plane then
```

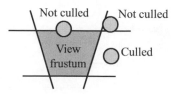

Figure 3.6 A two-dimensional view of various configurations between a bounding sphere and a view frustum.

```
            return true;
    }
    return false;
}
```

Hopefully the occurrence of false positives (bound outside frustum, but not outside all frustum planes) is infrequent.

Even though plane-at-a-time culling is inexact, it may be used to improve efficiency in visibility determination in a scene graph. Consider the scene graph of Figure 3.3, where each node in the tree has a bounding volume associated with it. Suppose that, when testing the bounding volume of the Table Group against the view frustum, you find that the bounding volume is on the positive side of one of the view frustum planes. The collective object represented by Table Group is necessarily on the positive side of that plane. Moreover, the objects represented by the children of Table Group must also be on the positive side of the plane. We may take advantage of this knowledge and pass enough information to the children (during a traversal of the tree for drawing purposes) to let the culling system know not to test the child bounding volumes against that same plane. In our example, the Table and Utensil Group nodes do not have to compare their bounding volumes to that plane of the frustum. The information to be stored is as simple as a bit array, each bit corresponding to a plane. In my implementation, discussed in more detail later in this chapter, the bits are set to 1 if the plane should be compared with the bounding volumes, and 0 otherwise.

An argument I read about somewhat regularly in some Usenet newsgroups is that complicated bounding volumes should be avoided because the which-side-of-plane query for the bounding volume is expensive. The recommendation is to use something as simple as a sphere because the query is very inexpensive to compute compared to, say, an oriented bounding box. Yes, a true statement, but it is taken out of the context of the bigger picture. There is a balance between the complexity of the bounding volume type and the cost of the which-side-of-plane query. As a rule of thumb, the more complex the bounding volume of the object, the better fitting it is to the object, but the query is more expensive to compute. Also as a rule of thumb,

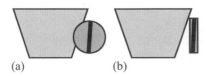

(a) (b)

Figure 3.7 A situation where a better-fitting bounding volume leads to culling, but a worse-fitting one does not. (a) The bounding sphere is not tight enough to induce culling. (b) The bounding box is tight enough to induce culling.

the better fitting the bounding volume, the more likely it is to be culled compared to a worse-fitting bounding volume. Figure 3.7 shows a typical scenario.

Even though the cost for the which-side-of-plane query is more expensive for the box than for the sphere, the combined cost of the query for the sphere *and* the attempt to draw the object, only to find out it is not visible, is *larger* than the cost of the query for the box. The latter object has no rendering cost because it was culled.

On the other hand, if most of the objects are typically inside the frustum, in which case you get the combined cost of the query and drawing, the sphere bounding volumes look more attractive. Whether or not the better-fitting and more expensive bounding volumes are beneficial depends on your specific 3D environment. To be completely certain of which way to go, allow for different bounding volume types and profile your applications for each type to see if there is any savings in time for the better-fitting volumes. The default bounding volume type in Wild Magic is a bounding sphere; however, the system is designed to allow you to easily swap in another type without having to change the engine or the application code. This is accomplished by providing an abstract interface (base class) for bounding volumes. I discuss this a bit later in the section.

Collision Determination

Another major use for bounding volumes is *3D picking*. A picking ray in world coordinates is selected by some mechanism. A list of objects that are intersected by the ray can be assembled. As a coarse-level test, if the ray does not intersect the bounding volume of an object, then it does not intersect the object.

The bounding volumes also support *collision determination*. More precisely, they may be used to determine if two objects are *not intersecting*, much in the same way they are used to determine if an object is not visible. Collision detection for two arbitrary triangle meshes is an expensive endeavor. We use a bounding volume as an approximation to the region of space that the object occupies. If the bounding volumes of two objects do not intersect, then the objects do not intersect. The hope is that the test for intersection of two bounding volumes is much less expensive than the

test for intersection of two triangle meshes. Well, it is, unless the objects themselves are single triangles!

The discussion of how to proceed with picking after you find out that the ray intersects a bounding volume or how you proceed with collision detection after you find out that the bounding volumes intersect is deferred to Section 6.3.3.

The Abstract Bounding Volume Interface

My main goal in having an abstract interface was not to force the engine users to use my default, bounding spheres. I also wanted to make sure that it was very easy to make the change, one that did not require changes to the core engine components or the applications themselves. The abstraction forces one to think about the various geometric queries in object-independent ways. Although abstract interfaces tend not to have data associated with them, experience led me to conclude that a minimal amount of information is needed. At the lowest level, you need to know *where* a bounding volume is located and what its *size* is. The two data members that represent these are a center point and a radius. These values already define a sphere, so you may think of the base class as a representation of a bounding sphere for the bounding volume. The values for an oriented bounding box are naturally the box center and the maximum distance from the center to a vertex. The values for a convex polyhedron may be selected as the average of the vertices and the maximum distance from that average to any vertex. Other types of bounding volumes can define center and radius similarly.

The abstract class is BoundingVolume and has the following initial skeleton:

```
class BoundingVolume : public Object
public:
{
    virtual ~BoundingVolume ();

    Vector3f Center;
    float Radius;

    static BoundingVolume* Create ();

protected:
    BoundingVolume ();
    BoundingVolume (const Vector3f& rkCenter, float fRadius);
};
```

The constructors are protected, making the class abstract. However, most other member functions in the interface are pure virtual, so the class would have to be abstract anyway, despite the access level for the constructors. The center point and radius are

in public scope since setting or getting them has no side effects. The static member function Create is used as a factory to produce objects without having to know what specific type (or types) exist in the engine. A derived class has the responsibility for implementing this function, and only one derived class may do so. In the engine, the Create call occurs during construction of a Spatial object (the world bounding volume) and a Geometry object (the model bounding volume). A couple of additional calls occur in Geometry-derived classes, but only because the construction of the model bounding volume is deferred until the actual model data is known by those classes.

Even though only a single derived class implements Create, you may have multiple BoundingVolume-derived classes in the engine. The ones not implementing Create must be constructed explicitly. Only the core engine components for geometric updates must be ignorant of the type of bounding volume.

Switching to a new BoundingVolume type for the core engine is quite easy. All you need to do is comment out the implementation of BoundingVolume::Create in the default bounding volume class, SphereBV, and implement it in your own derived class. The SphereBV class is

```
BoundingVolume* BoundingVolume::Create ()
{
    return new SphereBV;
}
```

If you were to switch to BoxBV, the oriented bound box volumes, then in Wm3BoxBV.cpp you would place

```
BoundingVolume* BoundingVolume::Create ()
{
    return new BoxBV;
}
```

The remaining interface for BoundingVolume is shown next. All member functions are pure virtual, so the derived classes must implement these.

```
class BoundingVolume : public Object
public:
{
    virtual void ComputeFromData (
        const Vector3fArray* pkVertices) = 0;

    virtual void TransformBy (const Transformation& rkTransform,
        BoundingVolume* pkResult) = 0;

    virtual int WhichSide (const Plane3f& rkPlane) const = 0;
```

```
    virtual bool TestIntersection (const Vector3f& rkOrigin,
        const Vector3f& rkDirection) const = 0;

    virtual bool TestIntersection (
        const BoundingVolume* pkInput) const = 0;

    virtual void CopyFrom (const BoundingVolume* pkInput) = 0;

    virtual void GrowToContain (const BoundingVolume* pkInput) = 0;
};
```

The bounding volume depends, of course, on the vertex data that defines the object. The ComputeFromData method provides the construction of the bounding volume from the vertices.

The transformation of a model space bounding volume to one in world space is supported by the method TransformBy. The first input is the model-to-world transformation, and the second input is the world space bounding volume. That volume is computed by the method and is valid on return from the function. The Geometry class makes use of this function.

The method WhichSide supports the which-side-of-plane query that was discussed for culling of nonvisible objects. The Plane3 class stores unit-length normal vectors, so the BoundingVolume-derived classes may take advantage of that fact to implement the query. If the bounding volume is fully on the positive side of the plane (the side to which the normal points), the function returns $+1$. If it is fully on the negative side, the function returns -1. If it straddles the plane, the function returns 0.

The first TestIntersection method supports 3D picking. The input is the origin and direction vector for a ray that is in the same coordinate system as the bounding volume. The direction vector must be unit length. The return value is true if and only if the ray intersects the bounding volume. The second TestIntersection method supports collision determination. The input bounding volume must be the same type as the calling object, but the engine does not check this constraint, so you must. The bounding volumes are assumed to be stationary. The return value of the function is true if and only if the two bounding volumes are intersecting.

The last two member functions, CopyFrom and GrowToContain, support the upward pass through the scene graph that computes the bounding volume of a parent node from the bounding volumes of the child nodes. In Wild Magic, the parent bounding volume is constructed to contain all the child bounding volumes. The default bounding volume is a sphere, so the parent bounding volume is a sphere that contains all the spheres of the children. The function CopyFrom makes the calling object a copy of the input bounding volume. The function GrowToContain constructs the bounding volume of the calling bounding volume and the input bounding volume. For a node with multiple children, CopyFrom makes a copy of the first child, and GrowToContain creates a bounding volume that contains that copy and the bounding volume of the

second child. The resulting bounding volume is grown further to contain each of the remaining children.

A brief warning about having a bounding volume stored in Spatial through an abstract base class (smart) pointer: Nothing prevents you from setting the bounding volume of one object to be a sphere and another to be a box. However, the BoundingVolume member functions that take a BoundingVolume object as input are designed to manipulate the input as if it is the same type as the calling object. Mixing bounding volume types is therefore an error, and the engine has no prevention mechanism for this. You, the programmer, must enforce the constraint. That said, it is possible to extend the bounding volume system to handle mixed types. The amount of code for n object types can be inordinate. For intersection queries between two bounding volumes, you need a function for each pair of types, a total of $n(n-1)/2$ functions. The semantics of the CopyFrom function must change. How do you copy a bounding sphere to an oriented bounding box? The semantics of GrowToContain must also change. What is the type of bounding volume to be used for a collection of mixed bounding volume types? If you have a sphere and a box, should the containing volume be a sphere or a box? Such a system can be built (NetImmerse had one), but I chose to limit the complexity of Wild Magic by disallowing mixing of bounding volume types.

3.2.3 THE CORE CLASSES AND GEOMETRIC UPDATES

Recall that the scene graph management core classes are Spatial, Geometry, and Node. The Spatial class encapsulates the local and world transformations, the world bounding volume, and the parent pointer in support of the scene hierarchy. The Geometry class encapsulates the model data and the model bounding sphere and may exist only as leaf nodes in the scene hierarchy. The Node class encapsulates grouping and has a list of child pointers. All three classes participate in the *geometric update* of a scene hierarchy—the process of propagating transformations from parents to children (the downward pass) and then merging bounding volumes from children to parents (the upward pass).

The data members of the Spatial interface relevant to geometric updates are shown in the following partial interface listing:

```
class Spatial : public Object
{
public:
    Transformation Local;
    Transformation World;
    bool WorldIsCurrent;

    BoundingVolumePtr WorldBound;
    bool WorldBoundIsCurrent;
};
```

The data members are in public scope. This is a deviation from my choices for Wild Magic version 2, where the data members were protected or private and exposed only through public accessor functions, most of them implemented as inline functions. My choice for version 3 is to reduce the verbosity, so to speak, of the class interface. In earlier versions, you would have a protected or private data member, one or more accessors, and inline implementations of those accessors. For example,

```
// in OldSpatial.h
class OldSpatial : public Object
{
public:
    Transformation& Local ();                    // read-write access
    const Transformation& GetLocal () const;     // read-only access
    void SetLocal (const Transform& rkLocal);    // write-only access
protected:
    Transformation m_kLocal;
};

// in OldSpatial.inl
Transformation& OldSpatial::Local ()
    { return m_kLocal; }
const Transformation& OldSpatial::GetLocal () const
    { return m_kLocal; }
void OldSpatial::SetLocal (const Transformation& rkLocal)
    { m_kLocal = rkLocal; }
```

The object-oriented premise of such an interface is to allow the underlying implementation of the class to change without forcing clients of the class to have to change their code. This is an example of *modular continuity*; see [Mey88, Section 2.1.4], specifically the following paragraph:

> A design method satisfies Modular Continuity if a small change in a problem specification results in a change of just one module, or few modules, in the system obtained from the specification through the method. Such changes should not affect the *architecture* of the system, that is to say the relations between modules.

The interface for OldSpatial is a conservative way to achieve modular continuity. The experiences of two versions of Wild Magic have led me to conclude that exposing some data members in the public interface is acceptable as long as the subsystem involving those data members is stable; that is, the subsystem will not change as the engine evolves. This is a less conservative way to achieve modular continuity because it relies on you not to change the subsystem.

By exposing data members in the public interface, you have another issue of concern. The function interfaces to data members, as shown in OldSpatial, can hide side effects. For example, the function SetLocal has the responsibility of setting the m_kLocal data member of the class. But it could also perform operations on other data

members or call other member functions, thus causing changes to state elsewhere in the system. If set/get function calls require side effects, it is not recommended that you expose the data member in the public interface. For if you were to do so, the engine user would have the responsibility for doing whatever is necessary to make those side effects occur.

In the case of the Spatial class in version 3 of the engine, the Local data member is in public scope. Setting or getting the value has no side effects. The new interface is

```
// in Spatial.h
class Spatial : public Object
{
public:
    Transformation Local;  // read-write access
};
```

and is clearly much reduced from that of OldSpatial. Observe that the prefix convention for variables is now used only for protected or private members. The convention for public data members is not to use prefixes and to capitalize the first letter of the name, just like function names are handled.

In class Spatial the world transformation is also in public scope. Recalling the previous discussion about transformations, the world transformations are compositions of local transformations. In this sense, a world transformation is computed as a (deferred) side effect of setting local transformations. I just mentioned that exposing data members in the public interface is not a good idea when side effects must occur, so why already violate that design goal? The problem has to do with the complexity of the controller system. Some controllers might naturally be constructed to *directly set the world transformations*. Indeed, the engine has a skin-and-bones controller that computes the world transformation for a triangle mesh. In a sense, the controller bypasses the standard mechanism that computes world transformations from local ones. The data members World and WorldIsCurrent are intended for read access by application writers, but may be used for write access by controllers. If a controller sets the World member directly, it should also set the WorldIsCurrent flag to let the geometric update system know that the world transformation for this node should not be computed as a composition of its parent's world transformation and its local transformation.

Similar arguments apply to the data members WorldBound and WorldBoundIsCurrent. In some situations you have a node (and subtree) whose behavior is known to you (by design), and whose world bounding volume may be assigned directly. For example, the node might be a room in a building that never moves. The child nodes correspond to objects in the room; those objects can move within the room, so their world bounding volumes change. However, the room's world bounding volume need not change. You may set the room's world bounding volume, but the geometric up-

date system should be told not to recalculate that bounding volume from the child bounding volumes. The flag WorldBoundIsCurrent should be set to true in this case.

The member functions of Spatial relevant to geometric updates are shown in the following partial interface listing:

```
class Spatial : public Object
{
public:
    void UpdateGS (double dAppTime = -Mathd::MAX_REAL,
        bool bInitiator = true);
    void UpdateBS ();

protected:
    virtual void UpdateWorldData (double dAppTime);
    virtual void UpdateWorldBound () = 0;
    void PropagateBoundToRoot ();
};
```

The public functions UpdateGS ("update geometric state") and UpdateBS ("update bound state") are the entry points to the geometric update system. The function UpdateGS is for both propagation of transformations from parents to children and propagation of world bounding volumes from children to parents. The dAppTime ("application time") is passed so that any animated quantities needing the current time to update their state have access to it. The Boolean parameter will be explained later. The function UpdateBS is for propagation only of world bounding volumes. The protected function UpdateWorldData supports the propagation of transformations in the downward pass. It is virtual to allow derived classes to update any additional world data that is affected by the change in world transformations. The protected functions UpdateWorldBound and PropagateToRoot support the calculation of world bounding volumes in the upward pass. The UpdateWorldBound function is pure virtual to require Geometry and Node to implement it as needed.

The portion of the Geometry interface relevant to geometric updates is

```
class Geometry : public Spatial
{
public:
    Vector3fArrayPtr Vertices;
    Vector3fArrayPtr Normals;
    BoundingVolumePtr ModelBound;
    IntArrayPtr Indices;

    void UpdateMS ();
```

```
protected:
    virtual void UpdateModelBound ();
    virtual void UpdateModelNormals ();
    virtual void UpdateWorldBound ();
};
```

As with the Spatial class, the data members are in public scope because there are no immediate side effects from reading or writing them. But there are side effects that the programmer must ensure, namely, the geometric update itself.

The function UpdateMS (" update model state") is the entry point into the update of the model bound and model normals. The function should be called whenever you change the model vertices. All that UpdateMS does is call the protected functions UpdateModelBound and UpdateModelNormals. The function UpdateModelBound computes a model bounding volume from the collection of vertices. This is accomplished by a call to the BoundingVolume function ComputeFromData. I made the model bound update a virtual function just in case a derived class needs to compute the bound differently. For example, a derived class might have prior knowledge about the model bound and not even have to process the vertices.

The function UpdateModelNormals has an empty body in Geometry since the geometry class is just a container for vertices and normals. Derived classes need to implement UpdateModelNormals for their specific data representations. Not all derived classes have normals (for example, Polypoint and Polyline), so I decided to let them use the empty base class function rather than making the base function pure virtual and then requiring derived classes to implement it with empty functions.

The function UpdateWorldBound is an implementation of the pure virtual function in Spatial. All that it does is compute the world bounding volume from the model bounding volume by applying the current world transformation.

The member functions of Node relevant to geometric updates are shown in the following partial interface listing:

```
class Node : public Spatial
{
protected:
    virtual void UpdateWorldData (double dAppTime);
    virtual void UpdateWorldBound ();
};
```

The function UpdateWorldData is an implementation of the virtual function in the Spatial base class. It has the responsibility to propagate the geometric update to its children. The function UpdateWorldBound is an implementation of the pure virtual function in the Spatial base class. Whereas the Geometry class implements this to calculate a single world bounding volume for its data, the Node class implements this to compute a world bounding volume that contains the world bounding volume of all its children.

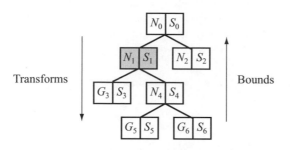

Figure 3.8 A geometric update of a simple scene graph. The light gray shaded node, N_1, is the one at which the UpdateGS call initiates.

Figure 3.8 illustrates the behavior of the update. The symbols are N for Node, S for Spatial, and G for Geometry. The rectangular boxes represent the nodes in the scene hierarchy. The occurrence of both an N and an S at a node stresses the fact the Node is derived from Spatial, so both classes' public and protected interfaces are available to Node. A similar statement is made for Geometry and Spatial.

If the model bounding volumes or the model normals for a Geometry object are not current, that object must call Geometry::UpdateMS() to make them current. In most cases, the model data is current—for example, in rigid triangle meshes; you will not call UpdateMS often for such objects. The other extreme is something like a morph controller that changes the vertex data frequently, and the UpdateMS call occurs after each change.

Assuming the model data is current at all leaf nodes, the shaded gray box in the figure indicates that node N_1 is the one initiating a geometric update because its local transformation was changed (translation, rotation, and/or uniform scale). Its world transformation must be recomputed from its parent's (N_0) world transformation and its newly changed local transformation. The new world transformation is passed to its two children, G_3 and N_4, so that they also may recompute their world transformations. The world bounding volume for G_3 must be recomputed from its model bounding volume. The process is repeated at node N_4. Its world transformation is recomputed from the world transformation of N_1 and its local transformation. The new world transformation is passed to its two children, G_5 and G_6, so that they may recompute their world transformations. Those leaf nodes also recompute their world bounding volumes from their current model bounding volumes and their new world transformations. On return to the parent N_4, that node must recompute its world bounding volume to contain the new world bounding volumes of its children. On return to the node N_1, that node must recompute its world bounding volume to contain the new world bounding volumes for G_3 and N_4. You might think the geometric update terminates at this time, but not yet. The change in world bounding volume at N_1 can cause the world bounding volume of its parent, N_0, to be out of date. N_0 must

be told to update itself. Generally, the change in world bounding volume at the initiator of the update must propagate all the way to the root of the scene hierarchy. Now the geometric update is complete. The sequence of operations is listed as pseudocode in the following. The indentation denotes the level of the recursive call of UpdateGS.

```
double dAppTime = <current application time>;
N1.UpdateGS(appTime,true);
  N1.World = compose(N0.World,N1.Local);
  G3.UpdateGS(appTime,false);
    G3.World = Compose(N1.World,G3.Local);
    G3.WorldBound = Transform(G3.World,G3.ModelBound);
  N4.UpdateGS(appTime,false);
    N4.World = Compose(N1.World,N4.Local);
    G5.UpdateGS(appTime,false);
      G5.World = Compose(N4.World,G5.Local);
      G5.WorldBound = Transform(G5.World,G5.ModelBound);
    G6.UpdateGS(appTime,false);
      G6.World = Compose(N4.World,G6.Local);
      G6.WorldBound = Transform(G6.World,G6.ModelBound);
    N4.WorldBound = BoundContaining(G5.WorldBound,G6.WorldBound);
  N1.WorldBound = BoundContaining(G3.WorldBound,N4.WorldBound);
N0.WorldBound = BoundContaining(N1.WorldBound,N2.WorldBound);
```

The Boolean parameter bInitiator in the function UpdateGS is quite important. In the example, the UpdateGS call initiated at N_1. A depth-first traversal of the subtree rooted at N_4 is performed, and the transformations are propagated downward. Once you reach a leaf node, the new world bounding volume is propagated upward. When the last child of N_1 has been visited, we found we needed to propagate its world bounding volume to its predecessors all the way to the root of the scene, in the example to N_0. The propagation of a world bounding volume from G_5 to N_4 is slightly different than the propagation of a world bounding volume from N_1 to N_0. The depth-first traversal at N_1 guarantees that the world bounding volumes are processed on the upward return. You certainly would not want each node to propagate its world bounding volume all the way to the root whenever that node is visited in the traversal because only the initiator has that responsibility. If you were to have missed that subtlety and not had a Boolean parameter, the previous pseudocode would become

```
double dAppTime = <current application time>;
N1.UpdateGS(appTime);
  N1.World = compose(N0.World,N1.Local);
  G3.UpdateGS(appTime);
    G3.World = Compose(N1.World,G3.Local);
    G3.WorldBound = Transform(G3.World,G3.ModelBound);
```

```
    N1.WorldBound = BoundContaining(G3.WorldBound,N4.WorldBound);
    N0.WorldBound = BoundContaining(N1.WorldBound,N2.WorldBound);
  N4.UpdateGS(appTime);
    N4.World = Compose(N1.World,N4.Local);
    G5.UpdateGS(appTime);
      G5.World = Compose(N4.World,G5.Local);
      G5.WorldBound = Transform(G5.World,G5.ModelBound);
      N4.WorldBound = BoundContaining(G5.WorldBound,G6.WorldBound);
      N1.WorldBound = BoundContaining(G3.WorldBound,N4.WorldBound);
      N0.WorldBound = BoundContaining(N1.WorldBound,N2.WorldBound);
    G6.UpdateGS(appTime);
      G6.World = Compose(N4.World,G6.Local);
      G6.WorldBound = Transform(G6.World,G6.ModelBound);
      N4.WorldBound = BoundContaining(G5.WorldBound,G6.WorldBound);
      N1.WorldBound = BoundContaining(G3.WorldBound,N4.WorldBound);
      N0.WorldBound = BoundContaining(N1.WorldBound,N2.WorldBound);
    N4.WorldBound = BoundContaining(G5.WorldBound,G6.WorldBound);
    N1.WorldBound = BoundContaining(G3.WorldBound,N4.WorldBound);
    N0.WorldBound = BoundContaining(N1.WorldBound,N2.WorldBound);
  N1.WorldBound = BoundContaining(G3.WorldBound,N4.WorldBound);
  N0.WorldBound = BoundContaining(N1.WorldBound,N2.WorldBound);
```

Clearly, this is an inefficient chunk of code. The Boolean parameter is used to prevent subtree nodes from propagating the world bounding volumes to the root.

The actual update code is shown next because I want to make a few comments about it. The entry point for the geometric update is

```
void Spatial::UpdateGS (double dAppTime, bool bInitiator)
{
    UpdateWorldData(dAppTime);
    UpdateWorldBound();
    if ( bInitiator )
        PropagateBoundToRoot();
}
```

If the object is a Node object, the function UpdateWorldData propagates the transformations in the downward pass. If the object is a Geometry object, the function is not implemented in that class, and the Spatial version is used. The two different functions are

```
void Node::UpdateWorldData (double dAppTime)
{
    Spatial::UpdateWorldData(dAppTime);
```

```
    for (int i = 0; i < m_kChild.GetQuantity(); i++)
    {
        Spatial* pkChild = m_kChild[i];
        if ( pkChild )
            pkChild->UpdateGS(dAppTime,false);
    }
}

void Spatial::UpdateWorldData (double dAppTime)
{
    UpdateControllers(dAppTime);

    // NOTE:  Updates on controllers for global state and lights
    // go here.  To be discussed later.

    if ( !WorldIsCurrent )
    {
        if ( m_pkParent )
            World.Product(m_pkParent->World,Local);
        else
            World = Local;
    }
}
```

The Spatial version of the function has the responsibility for computing the composition of the parent's world transformation and the object's local transformation, producing the object's world transformation. At the root of the scene (m_pkParent is NULL), the local and world transformations are the same. If a controller is used to compute the world transformation, then the Boolean flag WorldIsCurrent is true and the composition block is skipped. The Node version of the function allows the base class to compute the world transformation, and then it propagates the call (recursively) to its children. Observe that the bInitiator flag is set to false for the child calls to prevent them from propagating the world bounding volumes to the root node.

The controller updates might or might not affect the transformation system. For example, the point, particles, and morph controllers all modify the model space vertices (and possibly the model space normals). Each of these calls UpdateMS to guarantee the model bounding volume is current. Fortunately this step occurs before our UpdateGS gets to the stage of updating world bounding volumes. Keyframe and inverse kinematics controllers modify local transformations, but they do not set the WorldIsCurrent flag to true because the world transformations must still be updated. The skin controllers modify the world transformations directly and do set the World-IsCurrent flag to true.

In UpdateGS, on return from UpdateWorldData the world bounding volume is updated by UpdateWorldBound. If the object is a Node object, a bound of bounds is com-

puted. If the object is a Geometry object, the newly computed world transformation is used to transform the model bounding volume to the world bounding volume.

```
void Node::UpdateWorldBound ()
{
    if ( !WorldBoundIsCurrent )
    {
        bool bFoundFirstBound = false;
        for (int i = 0; i < m_kChild.GetQuantity(); i++)
        {
            Spatial* pkChild = m_kChild[i];
            if ( pkChild )
            {
                if ( bFoundFirstBound )
                {
                    // Merge current world bound with child
                    // world bound.
                    WorldBound->GrowToContain(pkChild->WorldBound);
                }
                else
                {
                    // Set world bound to first nonnull child
                    // world bound.
                    bFoundFirstBound = true;
                    WorldBound->CopyFrom(pkChild->WorldBound);
                }
            }
        }
    }
}

void Geometry::UpdateWorldBound ()
{
    ModelBound->TransformBy(World,WorldBound);
}
```

If the application has explicitly set the world bounding volume for the node, it should have also set WorldBoundIsCurrent to false, in which case Node::UpdateWorldBound has no work to do. However, if the node must update its world bounding volume, it does so by processing its child bounding volumes one at a time. The bounding volume of the first (nonnull) child is copied. If a second (nonnull) child exists, the current world bounding volume is modified to contain itself and the bound of the child. The growing algorithm continues until all children have been visited.

For bounding spheres, the iterative growing algorithm amounts to computing the smallest volume of two spheres, the current one and that of the next child. This is a greedy algorithm and does not generally produce the smallest volume bounding sphere that contains all the child bounding spheres. The algorithm to compute the smallest volume sphere containing a set of spheres is a very complicated beast [FG03]. The computation time is not amenable to real-time graphics, so instead we use a less exact bound, but one that can be computed quickly.

The last stage of UpdateGS is to propagate the world bounding volume from the initiator to the root. The function that does this is PropagateBoundToRoot. This, too, is a recursive function, just through a linear list of nodes:

```
void Spatial::PropagateBoundToRoot ()
{
    if ( m_pkParent )
    {
        m_pkParent->UpdateWorldBound();
        m_pkParent->PropagateBoundToRoot();
    }
}
```

As mentioned previously, if a local transformation has not changed at a node, but some geometric operations cause the world bounding volume to change, there is no reason to waste time propagating transformations in a downward traversal of the tree. Instead just call UpdateBS to propagate the world bounding volume to the root:

```
void Spatial::UpdateBS ()
{
    UpdateWorldBound();
    PropagateBoundToRoot();
}
```

Table 3.1 is a summary of the updates that must occur when various geometric quantities change in the system. All of the updates may be viewed as side effects to changes in the geometric state of the system. None of the side effects occur automatically because I want application writers to use as much of their knowledge as possible about their environment and not force an inefficient update mechanism to occur behind the scenes.

For example, Figure 3.9 shows a scene hierarchy that needs updating. The light gray shaded nodes in the scene have had their local transformations changed. You could blindly call

```
a.UpdateGS(appTime,true);
b.UpdateGS(appTime,true);
c.UpdateGS(appTime,true);
d.UpdateGS(appTime,true);
```

Table 3.1 Updates that must occur when geometric quantities change.

Changing quantity	Required updates	Top-level function to call
Model data	Model bound, model normals (if any)	`Geometry::UpdateMS`
Model bound	World bound	`Spatial::UpdateGS` or `Spatial::UpdateBS`
World bound	Parent world bound (if any)	`Spatial::UpdateGS` or `Spatial::UpdateBS`
Local transformation	World transformation, child transformations	`Spatial::UpdateGS`
World transformation	World bound	`Spatial::UpdateGS`

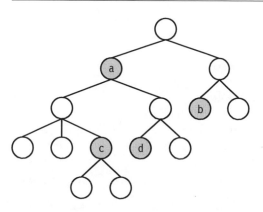

Figure 3.9 A scene hierarchy that needs updating. The light gray shaded nodes have had their local transformations changed.

to perform the updates, but this is not efficient. All that is needed is

```
a.UpdateGS(appTime,true);
b.UpdateGS(appTime,true);
```

Nodes c and d are updated as a side effect of the update at node a. In general, the minimum number of `UpdateGS` calls needed is the number of nodes requiring an update that have no predecessors who also require an update. Node a requires an update, but has no out-of-date predecessors. Node c requires an update, but it has a predecessor, node a, that does. Although it is possible to construct an automated system to determine the minimum number of `UpdateGS` calls, that system will consume too many

cycles. I believe it is better to let the application writers take advantage of knowledge they have about what is out of date and specifically call `UpdateGS` themselves.

3.3 Geometric Types

The basic geometric types supported in the engine are collections of points, collections of line segments, triangle meshes, and particles. Various classes in the core engine implement these types. During the drawing pass through the scene graph, the renderer is provided with such objects and must draw them as their types dictate. Most graphics APIs require the type of object to be specified, usually via a set of enumerated values. To facilitate this, the `Geometry` class has enumerations for the basic types, as shown in the following code snippet:

```
class Geometry : public Spatial
{
    // internal use
    public:
        enum // GeometryType
        {
            GT_POLYPOINT,
            GT_POLYLINE_SEGMENTS,
            GT_POLYLINE_OPEN,
            GT_POLYLINE_CLOSED,
            GT_TRIMESH,
            GT_MAX_QUANTITY
        };

        int GeometryType;
};
```

The type itself is stored in the data member `GeometryType`. It is in public scope because there are no side effects in reading or writing it. However, the block is marked for internal use by the engine. There is no need for an application writer to manipulate the type.

The value `GT_POLYPOINT` indicates the object is a collection of points. The value `GT_TRIMESH` indicates the object is a triangle mesh. The three values with `POLYLINE` as part of their names are used for collections of line segments. `GT_POLYLINE_SEGMENTS` is for a set of line segments with no connections between them. `GT_POLYLINE_OPEN` is for a polyline, a set of line segments where each segment end point is shared by at most two lines. The initial and final segments each have an end point that is not shared by any other line segment; thus the polyline is said to be *open*. Another term for an

open polyline is a *line strip*. If the two end points are actually the same point, then the polyline forms a loop and is said to be *closed*. Another term for a closed polyline is a *line loop*.

If you were to modify the engine to support other types that are native to the graphics APIs, you can add enumerated types to the list. You should add these after GT_TRIMESH, but before GT_MAX_QUANTITY, in order to preserve the numeric values of the current types.

3.3.1 POINTS

A collection of points is represented by the class Polypoint, which is derived from Geometry. The interface is very simple:

```
class Polypoint : public Geometry
{
public:
    Polypoint (Vector3fArrayPtr spkVertices);
    virtual ~Polypoint ();

    void SetActiveQuantity (int iActiveQuantity);
    int GetActiveQuantity () const;

protected:
    Polypoint ();

    int m_iActiveQuantity;
};
```

The points are provided to the constructor. From the application's perspective, the set of points is unordered. However, for the graphics APIs that use vertex arrays, I have chosen to assign indices to the points. The vertices and indices are both used for drawing. The public constructor is

```
Polypoint::Polypoint (Vector3fArrayPtr spkVertices)
    :
    Geometry(spkVertices)
{
    GeometryType = GT_POLYPOINT;

    int iVQuantity = Vertices->GetQuantity();
    m_iActiveQuantity = iVQuantity;

    int* aiIndex = new int[iVQuantity];
```

```
    for (int i = 0; i < iVQuantity; i++)
        aiIndex[i] = i;
    Indices = new IntArray(iVQuantity,aiIndex);
}
```

The assigned indices are the natural ones.

The use of an index array has a pleasant consequence. Normally, all of the points would be drawn by the renderer. In some applications you might want to have storage for a large collection of points, but only have a subset *active* at one time. The class has a data member, m_iActiveQuantity, that indicates how many are active. The active quantity may be zero, but cannot be larger than the total quantity of points. The active set is contiguous in the array, starting at index zero, but if need be, an application can move the points from one vertex array location to another.

The active quantity data member is not in the public interface. The function SetActiveQuantity has the side effect of validating the requested quantity. If the input quantity is invalid, the active quantity is set to the total quantity of points.

The index array Indices is a data member in the base class Geometry. Its type is TSharedArray<int>. This array is used by the renderer for drawing purposes. Part of that process involves querying the array for the number of elements. The shared array class has a member function, GetQuantity, that returns the *total* number of elements in the array. However, we want it to report the active quantity when the object to be drawn is of type Polypoint. To support this, the shared array class has a member function SetActiveQuantity that changes the internally stored total quantity to the requested quantity. The requested quantity must be no larger than the original total quantity. If it is not, no reallocation occurs in the shared array, and any attempt to write elements outside the original array is an access violation.

Rather than adding a new data member to TSharedArray to store an active quantity, allowing the total quantity to be stored at the same time, I made the decision that the caller of SetActiveQuantity must remember the original total quantity, in case the original value must be restored through another call to SetActiveQuantity. My decision is based on the observation that calls to SetActiveQuantity will be infrequent, so I wanted to minimize the memory usage for the data members of TSharedArray.

As in all Object-derived classes, a default constructor is provided for the purposes of streaming. The constructor is protected to prevent the application from creating default objects whose data members have not been initialized with real data.

3.3.2 LINE SEGMENTS

A collection of line segments is represented by the class Polyline, which is derived from Geometry. The interface is

```
class Polyline : public Geometry
{
public:
    Polyline (Vector3fArrayPtr spkVertices, bool bClosed,
        bool bContiguous);
    virtual ~Polyline ();

    void SetActiveQuantity (int iActiveQuantity);
    int GetActiveQuantity () const;
    void SetClosed (bool bClosed);
    bool GetClosed () const;
    void SetContiguous (bool bContiguous);
    bool GetContiguous () const;

protected:
    Polyline ();
    void SetGeometryType ();

    int m_iActiveQuantity;
    bool m_bClosed, m_bContiguous;
};
```

The end points of the line segments are provided to the constructor. The three possible interpretations for the vertices are disjoint segments, open polyline, or closed polyline. The input parameters bClosed and bContiguous determine which interpretation is used. The inputs are stored as class members m_bClosed and m_bContiguous. The actual interpretation is implemented in SetGeometryType:

```
void Polyline::SetGeometryType ()
{
    if ( m_bContiguous )
    {
        if ( m_bClosed )
            GeometryType = GT_POLYLINE_CLOSED;
        else
            GeometryType = GT_POLYLINE_OPEN;
    }
    else
    {
        GeometryType = GT_POLYLINE_SEGMENTS;
    }
}
```

To be a polyline where end points are shared, the contiguous flag must be set to `true`. The closed flag has the obvious interpretation.

Let the points be P_i for $0 \le i < n$. If the contiguous flag is `false`, the object is a collection of disjoint segments. For a properly formed collection, the quantity of vertices n should be even. The $n/2$ segments are

$$\langle P_0, P_1 \rangle, \quad \langle P_2, P_3 \rangle, \quad \ldots, \quad \langle P_{n-2}, P_{n-1} \rangle.$$

If the contiguous flag is `true` and the closed flag is `false`, the points represent an open polyline with $n - 1$ segments:

$$\langle P_0, P_1 \rangle, \quad \langle P_1, P_2 \rangle, \quad \ldots, \quad \langle P_{n-2}, P_{n-1} \rangle.$$

The end point P_0 of the initial segment and the end point P_{n-1} of the final segment are not shared by any other segments. If instead the closed flag is `true`, the points represent a closed polyline with n segments:

$$\langle P_0, P_1 \rangle, \quad \langle P_1, P_2 \rangle, \quad \ldots, \quad \langle P_{n-2}, P_{n-1} \rangle, \quad \langle P_{n-1}, P_0 \rangle.$$

Each point is shared by exactly two segments. Although you might imagine that a closed polyline in the plane is a single loop that is topologically equivalent to a circle, you can obtain more complicated topologies by duplicating points. For example, you can generate a bow tie (two closed loops) in the $z = 0$ plane with $P_0 = (0, 0, 0)$, $P_1 = (1, 0, 0)$, $P_2 = (0, 1, 0)$, $P_3 = (0, 0, 0)$, $P_4 = (0, -1, 0)$, and $P_5 = (-1, 0, 0)$. The contiguous and closed flags are both set to `true`.

The class has the ability to select an active quantity of end points that is smaller or equal to the total number, and the mechanism is exactly the one used in `Polypoint`. If your `Polyline` object represents a collection of disjoint segments, you should also make sure the active quantity is an even number.

3.3.3 Triangle Meshes

The simplest representation for a collection of triangles is as a list of m triples of $3m$ vertices:

$$\langle V_0, V_1, V_2 \rangle, \quad \langle V_3, V_4, V_5 \rangle, \quad \ldots, \quad \langle V_{3m-3}, V_{3m-2}, V_{3m-1} \rangle.$$

The vertices of each triangle are listed in counterclockwise order; that is, the triangle is in a plane with a specified normal vector. An observer on the side of the plane to which the normal is directed sees the vertices of the triangle in a counterclockwise order on that plane. A collection like this is sometimes called a *triangle soup* (more generally, a *polygon soup*). Graphics APIs do support rendering where the triangles are provided this way, but most geometric models built from triangles are not built as a triangle soup. Vertices in the model tend to be part of more than one triangle.

Moreover, if the triangle soup is sent to the renderer, each vertex must be transformed from model space to world space, including running them through the clipping and lighting portions of the system. If a point occurs multiple times in the list of vertices, each one processed by the renderer, we are wasting a lot of cycles.

A more efficient representation for a collection of triangles is to have an array of unique vertices and represent the triangles as a collection of triples of indices into the vertex array. This is called a *triangle mesh*. If \mathbf{V}_i for $0 \leq i < n$ is the array of vertices, an index array I_j for $0 \leq j < 3m$ represents the triangles

$$\langle \mathbf{V}_{I_0}, \mathbf{V}_{I_1}, \mathbf{V}_{I_2} \rangle, \quad \langle \mathbf{V}_{I_3}, \mathbf{V}_{I_4}, \mathbf{V}_{I_5} \rangle, \quad \ldots, \quad \langle \mathbf{V}_{I_{3m-3}}, \mathbf{V}_{I_{3m-2}}, \mathbf{V}_{I_{3m-1}} \rangle.$$

The goal, of course, is that n is a lot smaller than $3m$ because of the avoidance of duplicate vertices in the vertex array. Fewer vertices must be processed by the renderer, leading to faster drawing.

The class that represents triangle meshes is `TriMesh`. A portion of the interface is

```
class TriMesh : public Geometry
{
public:
    TriMesh (Vector3fArrayPtr spkVertices, IntArrayPtr spkIndices,
        bool bGenerateNormals);
    virtual ~TriMesh ();

    int GetTriangleQuantity () const;
    void GenerateNormals ();

protected:
    TriMesh ();
    virtual void UpdateModelNormals ();
};
```

I have omitted the interface that supports the picking system and will discuss that in Section 6.3.3.

The constructor requires you to provide the vertex and index arrays for the triangle mesh. The quantity of elements in the index array should be a multiple of three. The member function `GetTriangleQuantity` returns the quantity of indices divided by three. For the purposes of lighting, the renderer will need to use vertex normals. The third parameter of the constructor determines whether or not the normals should be generated.

The actual construction of the vertex normals is done in the method `UpdateModel-Normals`. The method is protected, so you cannot call it directly. It is called indirectly through the public update function `Geometry::UpdateMS`. Multiple algorithms exist for the construction of vertex normals. The one I implemented is as follows. Let T_1

through T_m be those triangles that share vertex \mathbf{V}. Let \mathbf{N}_1 through \mathbf{N}_m be normal vectors to the triangles, but not necessarily unit-length ones. For a triangle T with vertices \mathbf{V}_0, \mathbf{V}_1, and \mathbf{V}_2, the normal I use is $\mathbf{N} = (\mathbf{V}_1 - \mathbf{V}_0) \times (\mathbf{V}_2 - \mathbf{V}_0)$. The vertex normal is a unit-length vector,

$$\mathbf{N} = \frac{\sum_{i=1}^{m} \mathbf{N}_i}{\left| \sum_{i=1}^{m} \mathbf{N}_i \right|}.$$

The length $|\mathbf{N}_i|$ is twice the area of the triangle to which it is normal. Therefore, large triangles will have a greater effect on the vertex normal than small triangles. I consider this a more reasonable algorithm than one that computes the vertex normal as an average of unit-length normals for the sharing triangles, where all triangles have the same influence on the outcome regardless of their areas.

Should you decide to create a triangle mesh without normals, you can always force the generation by calling the method `GenerateNormals`. This function allocates the normals if they do not already exist and then calls `UpdateModelNormals`.

3.3.4 PARTICLES

A *particle* is considered to be a geometric primitive with a *location* in space and a *size*. The size attribute distinguishes particles from points. A collection of particles is referred to as a *particle system*. Particle systems are quite useful, for interesting visual displays as well as for physical simulations. Both aspects are discussed later, the visual ones in Section 4.1.2 and the physical ones in Section 7.2. In this section I will discuss the geometric aspects and the class `Particles` that represents them.

The portion of the class interface for `Particles` that is relevant to data management is

```
class Particles : public TriMesh
{
public:
    Particles (Vector3fArrayPtr spkLocations,
        FloatArrayPtr spkSizes, bool bWantNormals);
    virtual ~Particles ();

    Vector3fArrayPtr Locations;
    FloatArrayPtr Sizes;
    float SizeAdjust;

    void SetActiveQuantity (int iActiveQuantity);
    int GetActiveQuantity () const;
```

```
protected:
    Particles ();
    void GenerateParticles (const Camera* pkCamera);

    int m_iActiveQuantity;
};
```

The first observation is that the class is derived from TriMesh. The particles are drawn as billboard squares (see Section 4.1.2) that always face the observer. Each square is built of two triangles, and all the triangles are stored in the base class as a triangle mesh. The triangle mesh has four times the number of vertices as it does particle locations, which is why the locations are stored as a separate array.

The constructor accepts inputs for the particle locations and sizes. The third parameter determines whether or not normal vectors are allocated. If they are, the normal vectors are in the opposite direction of view—they are directed toward the observer. Even though the particles are drawn as billboards, they may still be affected by lights in the scene, so the normal vectors are relevant.

The data members Locations, Sizes, and SizeAdjust are in public scope because no side effects must occur when they are read or written. The locations and sizes are as described previously. The data member SizeAdjust is used to uniformly scale the particle sizes, if so desired. The adjustment is a multiplier of the sizes stored in the member array Sizes, not a replacement for those values. The initial value for the size adjustment is one.

The class has the ability to select an active quantity of end points that is smaller or equal to the total number. The mechanism is exactly the one used in Polypoint.

3.4 RENDER STATE

I use the term *render state* to refer to all the information that is associated with the geometric data for the purposes of drawing the objects. Three main categories of render state are *global state*, *lights*, and *effects*.

3.4.1 GLOBAL STATE

Global state refers to information that is essentially independent of any information the objects might provide. The states I have included in the engine are alpha blending, triangle culling, dithering, fog, material, shading, wireframe, and depth buffering. For example, depth buffering does not care how many vertices or triangles an object has. A material has attributes that are applied to the vertices of an object, regardless of how many vertices it has. Alpha blending relies on the texture images of the Geometry object having an alpha channel, but it does not care about what the texture

coordinates are for that object. A global state, when attached to an interior node in a scene hierarchy, affects all leaf nodes in the subtree rooted at the node. This property is why I used the adjective *global*.

The base class is `GlobalState` and has the following interface:

```
class GlobalState : public Object
{
public:
    virtual ~GlobalState ();

    enum // Type
    {
        ALPHA,
        CULL,
        DITHER,
        FOG,
        MATERIAL,
        SHADE,
        WIREFRAME,
        ZBUFFER,
        MAX_STATE
    };

    virtual int GetGlobalStateType () const = 0;

    static Pointer<GlobalState> Default[MAX_STATE];

protected:
    GlobalState ();
};
```

The base class is abstract since the constructor is protected (or since there is a pure virtual function declared). To support fast access of global states in arrays of smart pointers `GlobalStatePtr`, I chose to avoid using the `Object` run-time type information system. The enumerated type of `GlobalState` provides an alternate RTTI system. Each derived class returns its enumerated value through an implementation of `GetGlobal-StateType`. Each derived class is also responsible for creating a default state, stored in the static array `GlobalState::Default[]`. Currently, the enumerated values are a list of all the global states I support. If you were to add another one, you would derive a class `MyNewGlobalState` from `GlobalState`. But you also have to add another enumerated value `MYNEWGLOBALSTATE` to the base class. This violates the open-closed principle of object-oriented programming, but the changes to `GlobalState` are so simple and so infrequent that I felt justified in the violation. None of the classes in Wild Magic

version 3 ever write an array of global state pointers to disk, so adding a new state does not invalidate all of the scenes you had streamed before the change.

The global states are stored in class Spatial. A portion of the interface relative to global state storing and member accessing is

```
class Spatial : public Object
{
public:
    void SetGlobalState (GlobalState* pkState);
    GlobalState* GetGlobalState (int eType) const;
    void RemoveGlobalState (int eType);
    void RemoveAllGlobalStates ();

protected:
    TList<GlobalStatePtr>* m_pkGlobalList;
};
```

The states are stored in a singly linked list of smart pointers. The choice was made to use a list rather than an array, whose indices are the GlobalState enumerated values, to reduce memory usage. A typical scene will have only a small number of nodes with global states attached, so the array representation would generate a lot of wasted memory for all the other nodes. The names of the member functions make it clear how to use the functions. The eType input is intended to be one of the GlobalState enumerated values. For example, the code

```
MaterialState* pkMS = <some material state>;
Spatial* pkSpatial = <some Spatial-derived object>;
pkSpatial->SetGlobalState(pkMS);
pkSpatial->RemoveGlobalState(GlobalState::MATERIAL);
```

attaches a material state to an object, then removes it from the object.

The class Geometry also has storage for global states, but the storage is for all global states encountered along the path in the scene hierarchy from the root node to the geometry leaf node. The storage is assembled during a render state update, a topic discussed later in this section. The portion of the interface of Geometry relevant to storage is

```
class Geometry : public Spatial
{
// internal use
public:
    GlobalStatePtr States[GlobalState::MAX_STATE];
};
```

The array of states is in public scope, but is tagged for internal use only. An application should not manipulate the array or its members.

I will now discuss each of the derived global state classes. These classes have a couple of things in common. First, they must all implement the virtual function GetGlobalStateType. Second, they must all create default objects, something that is done at program initialization. At program termination, the classes should all destroy their default objects. The initialization-termination system discussed in Section 2.3.8 is used to perform these actions. You will see that each derived class uses the macros defined in Wm3Main.mcr and implements void Initialize() and void Terminate(). All the derived classes have a default constructor that is used to create the default objects.

Depth Buffering

In a correctly rendered scene, the pixels drawn in the frame buffer correspond to those visible points closest to the observer. But many points in the (3D) world can be projected to the same pixel on the (2D) screen. The graphics system needs to keep track of the actual depths in the world to determine which of those points is the visible one. This is accomplished through *depth buffering*. A frame buffer stores the pixel colors, and a depth buffer stores the corresponding depth in the world. The depth buffer is sometimes called a *z-buffer*, but in a perspective camera model, the depth is not measured along a direction perpendicular to the screen. It is depth along rays emanating from the camera location (the eye point) into the world.

The standard drawing pass for a system using a depth buffer is

```
FrameBuffer fbuffer = <current RGB values on the screen>;
DepthBuffer zbuffer = <current depth values for fbuffer pixels>;
ColorRGB sourceColor = <color of pixel to be drawn>;
float sourceDepth = <depth of the point in the world>;
int x, y = <location of projected point in the buffers>;

if ( sourceDepth <= zbuffer(x,y) )
{
    fbuffer(x,y) = sourceColor;
    zbuffer(x,y) = sourceDepth;
}
```

Three aspects of a depth buffer are apparent in the code. You need the ability to *read* from the depth buffer, *compare* a value against the read value, and *write* to the depth buffer. The comparison function in the pseudocode is "less than or equal to." You could use "less than" if so desired, but allowing equality provides the ability to draw on top of something already visible when the new object is coincident with the already visible object (think "decal"). For generality, the comparison could be written as

```
if ( ComparesFavorably(sourceDepth,zbuffer(x,y)) )
{
    fbuffer(x,y) = sourceColor;
    zbuffer(x,y) = sourceDepth;
}
```

The function ComparesFavorably(a,b) can be any of the usual ones: $a < b$, $a \le b$, $a > b$, $a \ge b$, $a = b$, or $a \ne b$. Two additional functions are allowed: always or never. In the former, the frame and depth buffers are always updated. In the latter, the frame and depth buffers are never updated.

The class that encapsulates the depth buffering is ZBufferState. Its interface is

```
class ZBufferState : public GlobalState
{
public:
    virtual int GetGlobalStateType () const { return ZBUFFER; }

    ZBufferState ();
    virtual ~ZBufferState ();

    enum // Compare values
    {
        CF_NEVER,
        CF_LESS,
        CF_EQUAL,
        CF_LEQUAL,
        CF_GREATER,
        CF_NOTEQUAL,
        CF_GEQUAL,
        CF_ALWAYS,
        CF_QUANTITY
    };

    bool Enabled;    // default: true
    bool Writable;   // default: true
    int Compare;     // default: CF_LEQUAL
};
```

The data members are in public scope because no side effects must occur when they are read or written. The member Enabled is set to true if you want depth buffering to be enabled. In this case, the buffer is automatically readable. To make the depth buffer writable, set the member Writable to true. The comparison function is controlled by the member Compare. The defaults are the standard ones used when depth buffering is

desired (readable, writable, less than or equal to for the comparison). A simple code block for using standard depth buffering in an entire scene is

```
NodePtr m_spkScene = <the scene graph>;
m_spkScene->SetGlobalState(new ZBufferState);
```

There are situations where you want the depth buffer to be readable, but not writable. One of these occurs in conjunction with alpha blending and semitransparent objects, the topic of the next few paragraphs.

Alpha Blending

Given two RGBA colors, one called the *source color* and one called the *destination color*, the term *alpha blending* refers to the general process of combining the source and destination into yet another RGBA color. The source color is (r_s, g_s, b_s, a_s), and the destination color is (r_d, g_d, b_d, a_d). The blended result is the final color (r_f, g_f, b_f, a_f). All color channel values in this discussion are assumed to be in the interval $[0, 1]$.

The classical method for blending is to use the alpha channel as an opacity factor. If the alpha value is 1, the color is completely opaque. If the alpha value is 0, the color is completely transparent. If the alpha value is strictly between 0 and 1, the colors are semitransparent. The formula for the blend of only the RGB channels is

$$(r_f, g_f, b_f) = (1 - a_s)(r_s, g_s, b_s) + a_s(r_d, g_d, b_d)$$
$$= ((1 - a_s)r_s + a_s r_d, (1 - a_s)g_s + a_s g_d, (1 - a_s)b_s + a_s b_d).$$

The algebraic operations are performed component by component. The assumption is that you have already drawn the destination color into the frame buffer; that is, the frame buffer becomes the destination. The next color you draw is the source. The alpha value of the source color is used to blend the source color with the current contents of the frame buffer.

It is also possible to draw the destination color into an offscreen buffer, blend the source color with it, and then use the offscreen buffer for blending with the current contents of the frame buffer. In this sense we also want to keep track of the alpha value in the offscreen buffer. We need a blending equation for the alpha values themselves. Using the same operations as for the RGB channels, your choice will be

$$a_f = (1 - a_s)a_s + a_s a_d.$$

Combining the four channels into a single equation, the classic alpha blending equation is

$$(r_f, g_f, b_f, a_f) = ((1 - a_s)r_s + a_s r_d, (1 - a_s)g_s$$
$$+ a_s g_d, (1 - a_s)b_s + a_s b_d, (1 - a_s)a_s + a_s a_d). \quad (3.5)$$

If the final colors become the destination for another blending operation, then

$$(r_d, g_d, b_d, a_d) = (r_f, g_f, b_f, a_f)$$

sets the destination to the previous blending results.

Graphics APIs support more general combinations of colors, whether the colors come from vertex attributes or texture images. The general equation is

$$(r_f, g_f, b_f, a_f) = (\sigma_r r_s + \delta_r r_d, \sigma_g g_s + \delta_g g_d, \sigma_b b_s + \delta_b b_d, \sigma_a a_s + \delta_a a_d). \quad (3.6)$$

The blending coefficients are σ_i and δ_i, where the subscripts denote the color channels they affect. The coefficients are assumed to be in the interval [0, 1]. Wild Magic provides the ability for you to select the blending coefficients from a finite set of possibilities. The class that encapsulates this is AlphaState. Since the AlphaState class exists in the scene graph management system, it must provide a graphics-API-independent mechanism for selecting the coefficients. The names I use for the various possibilities are reminiscent of those OpenGL uses, but also map to what Direct3D supports.

The portion of the class interface for AlphaState relevant to the blending equation (3.6) is

```
class AlphaState : public GlobalState
{
public:
    enum // SrcBlend values
    {
        SBF_ZERO,
        SBF_ONE,
        SBF_DST_COLOR,
        SBF_ONE_MINUS_DST_COLOR,
        SBF_SRC_ALPHA,
        SBF_ONE_MINUS_SRC_ALPHA,
        SBF_DST_ALPHA,
        SBF_ONE_MINUS_DST_ALPHA,
        SBF_SRC_ALPHA_SATURATE,
        SBF_CONSTANT_COLOR,
        SBF_ONE_MINUS_CONSTANT_COLOR,
        SBF_CONSTANT_ALPHA,
        SBF_ONE_MINUS_CONSTANT_ALPHA,
        SBF_QUANTITY
    };
```

```
enum // DstBlend values
{
    DBF_ZERO,
    DBF_ONE,
    DBF_SRC_COLOR,
    DBF_ONE_MINUS_SRC_COLOR,
    DBF_SRC_ALPHA,
    DBF_ONE_MINUS_SRC_ALPHA,
    DBF_DST_ALPHA,
    DBF_ONE_MINUS_DST_ALPHA,
    DBF_CONSTANT_COLOR,
    DBF_ONE_MINUS_CONSTANT_COLOR,
    DBF_CONSTANT_ALPHA,
    DBF_ONE_MINUS_CONSTANT_ALPHA,
    DBF_QUANTITY
};

bool BlendEnabled;  // default: false
int SrcBlend;       // default: SBF_SRC_ALPHA
int DstBlend;       // default: DBF_ONE_MINUS_SRC_ALPHA
};
```

The data members are all public since no side effects must occur when reading or writing them. The data member `BlendEnabled` is set to `false` initially, indicating that the default alpha blending state is "no blending." This member should be set to `true` when you do want blending to occur.

The data member `SrcBlend` controls what the source blending coefficients $(\sigma_r, \sigma_g, \sigma_b, \sigma_a)$ are. Similarly, the data member `DstBlend` controls what the destination blending coefficients $(\delta_r, \delta_g, \delta_b, \delta_a)$ are. Table 3.2 lists the possibilities for the source blending coefficients. The constant color, (r_c, g_c, b_c, a_c), is stored in the `Texture` class (member `BlendColor`), as is an RGBA image that is to be blended with a destination buffer.

Table 3.3 lists the possibilities for the destination blending coefficients. Table 3.2 has `DST_COLOR`, `ONE_MINUS_DST_COLOR`, and `SRC_ALPHA_SATURATE`, but Table 3.3 does not. Table 3.3 has `SRC_COLOR` and `ONE_MINUS_SRC_COLOR`, but Table 3.2 does not.

The classic alpha blending equation (3.5) is reproduced by the following code:

```
AlphaState* pkAS = new AlphaState;
pkAS->BlendEnabled = true;
pkAS->SrcBlend = AlphaState::SBF_SRC_ALPHA;
pkAS->DstBlend = AlphaState::DBF_ONE_MINUS_SRC_ALPHA;
Spatial* pkSpatial = <some Spatial-derived object>;
pkSpatial->SetGlobalState(pkAS);
```

Table 3.2 The possible source blending coefficients.

Enumerated value	$(\sigma_r, \sigma_g, \sigma_b, \sigma_a)$
SBF_ZERO	$(0, 0, 0, 0)$
SBF_ONE	$(1, 1, 1, 1)$
SBF_DST_COLOR	(r_d, g_d, b_d, a_d)
SBF_ONE_MINUS_DST_COLOR	$(1 - r_d, 1 - g_d, 1 - b_d, 1 - a_d)$
SBF_SRC_ALPHA	(a_s, a_s, a_s, a_s)
SBF_ONE_MINUS_SRC_ALPHA	$(1 - a_s, 1 - a_s, 1 - a_s, 1 - a_s)$
SBF_DST_ALPHA	(a_d, a_d, a_d, a_d)
SBF_ONE_MINUS_DST_ALPHA	$(1 - a_d, 1 - a_d, 1 - a_d, 1 - a_d)$
SBF_SRC_ALPHA_SATURATE	$(\sigma, \sigma, \sigma, 1), \sigma = \min\{a_s, 1 - a_d\}$
SBF_CONSTANT_COLOR	(r_c, g_c, b_c, a_c)
SBF_ONE_MINUS_CONSTANT_COLOR	$(1 - r_c, 1 - g_c, 1 - b_c, 1 - a_c)$
SBF_CONSTANT_ALPHA	(a_c, a_c, a_c, a_c)
SBF_ONE_MINUS_CONSTANT_ALPHA	$(1 - a_c, 1 - a_c, 1 - a_c, 1 - a_c)$

The default constructor for AlphaState sets SrcBlend and DstBlend, so only setting the BlendEnabled to true is necessary in an actual program. If the alpha state object is attached to a node in a subtree, it will affect the drawing of all the leaf node objects.

A more interesting example is one that does a *soft addition* of two textures. *Hard addition* refers to adding the two colors together and then clamping the result to [0, 1]. This may result in saturation of colors, causing the resulting image to look washed out. The soft addition combines the two colors to avoid the saturation, yet still look like an addition of colors. The formula is

$$(r_f, g_f, b_f, a_f) = ((1 - r_d)r_s, (1 - g_d)g_s, (1 - b_d)b_s, (1 - a_d)a_s)$$

$$+ (r_d, g_d, b_d, a_d). \tag{3.7}$$

The idea is that you start with the destination color and add a fraction of the source color to it. If the destination color is bright (values near 1), then the source blend coefficients are small, so the source color will not cause the result to wash out. Similarly, if the destination color is dark (values near 0), the destination color has little contribution to the result, and the source blend coefficients are large, so the source color dominates and the final result is a brightening of dark regions. The code block to obtain the blend is

Table 3.3 The possible destination blending coefficients.

Enumerated value	$(\delta_r, \delta_g, \delta_b, \delta_a)$
DBF_ZERO	$(0, 0, 0, 0)$
DBF_ONE	$(1, 1, 1, 1)$
DBF_SRC_COLOR	(r_s, g_s, b_s, a_s)
DBF_ONE_MINUS_SRC_COLOR	$(1 - r_s, 1 - g_s, 1 - b_s, 1 - a_s)$
DBF_SRC_ALPHA	(a_s, a_s, a_s, a_s)
DBF_ONE_MINUS_SRC_ALPHA	$(1 - a_s, 1 - a_s, 1 - a_s, 1 - a_s)$
DBF_DST_ALPHA	(a_d, a_d, a_d, a_d)
DBF_ONE_MINUS_DST_ALPHA	$(1 - a_d, 1 - a_d, 1 - a_d, 1 - a_d)$
DBF_CONSTANT_COLOR	(r_c, g_c, b_c, a_c)
DBF_ONE_MINUS_CONSTANT_COLOR	$(1 - r_c, 1 - g_c, 1 - b_c, 1 - a_c)$
DBF_CONSTANT_ALPHA	(a_c, a_c, a_c, a_c)
DBF_ONE_MINUS_CONSTANT_ALPHA	$(1 - a_c, 1 - a_c, 1 - a_c, 1 - a_c)$

```
AlphaState* pkAS = new AlphaState;
pkAS->BlendEnabled = true;
pkAS->SrcBlend = AlphaState::SBF_ONE_MINUS_DST_COLOR;
pkAS->DstBlend = AlphaState::DBF_ONE;
Spatial* pkSpatial = <some Spatial-derived object>;
pkSpatial->SetGlobalState(pkAS);
```

The `AlphaState` class also encapsulates what is referred to as *alpha testing*. The idea is that an RGBA source color will only be combined with the RGBA destination color as long as the source alpha value compares favorably with a specified *reference* value. Pseudocode for alpha testing is

```
source = (Rs,Gs,Bs,As);
destination = (Rd,Gd,Bd,Ad);
reference = Aref;
if ( ComparesFavorably(As,Aref) )
    result = BlendTogether(source,destination);
```

The `ComparesFavorably(x,y)` function is a standard comparison between two numbers: $x < y$, $x \leq y$, $x > y$, $x \geq y$, $x = y$, or $x \neq y$. Two additional functions are allowed: always or never. In the former, the blending always occurs. This is the default behavior of an alpha blending system. In the latter, blending never occurs.

The portion of the interface of AlphaState relevant to alpha testing is

```
class AlphaState : public GlobalState
{
public:
    enum // Test values
    {
        TF_NEVER,
        TF_LESS,
        TF_EQUAL,
        TF_LEQUAL,
        TF_GREATER,
        TF_NOTEQUAL,
        TF_GEQUAL,
        TF_ALWAYS,
        TF_QUANTITY
    };

    bool TestEnabled;    // default: false;
    int Test;            // default: TF_ALWAYS
    float Reference;     // default: 0, always in [0,1]
};
```

By default, alpha testing is turned off. To turn it on, set TestEnabled to true. The Reference value is a floating-point number in the interval [0, 1]. The Test function may be set to any of the first eight enumerated values prefixed with TF_. The value TF_QUANTITY is just a marker that stores the current number of enumerated values and is used by the renderers to declare arrays of that size.

In order to correctly draw a scene that has some semitransparent objects (alpha values smaller than 1), the rule is to draw your opaque objects first, then draw your semitransparent objects sorted from back to front in the view direction. The leaf nodes in a scene hierarchy can be organized so that those corresponding to opaque objects occur before those corresponding to semitransparent objects when doing a depth-first traversal of the tree. However, the leaf nodes for the semitransparent objects occur in a specific order that is not related to the view direction of the camera. A rendering system needs to have the capability for accumulating a list of semitransparent objects and then sorting the list based on the current view direction. The sorted list is then drawn an object at a time. Given an automated system for sorting, there is no need to worry about where the semitransparent objects occur in the scene. The scene organization can be based on geometric information, the main premise for using a scene hierarchy in the first place. I will discuss the sorting issue in Section 4.2.4.

Game programmers are always willing to take a shortcut to obtain a faster system, or to avoid having to implement some complicated system, and hope that the

consequences are not visually distracting. In the context of correct sorting for scenes with semitransparency, the shortcut is to skip the sorting step. After all, what are the chances that someone will notice artifacts due to blending objects that are not sorted back to front? Alpha testing can help you with this shortcut. The scene is rendered twice, and on both passes, depth buffering is enabled in order to correctly sort the objects (on a per-pixel basis in screen space). Also on both passes, alpha testing is enabled. On the first pass, the test function is set to allow the blending for any colors with an alpha value equal to 1; that is, the opaque objects are drawn, but the semitransparent objects are not. On the second pass, the test function is set to allow the blending for any colors with an alpha value not equal to 1. This time the semitransparent objects are drawn, but the opaque objects are not.

As stated, this system is not quite right (ignoring the back-to-front sorting issue). Depth buffering is enabled, but recall that you have the capability to control whether reading or writing occurs. For the first pass through the scene, opaque objects are drawn. The depth buffering uses both reading and writing to guarantee that the final result is rendered correctly. Before drawing a pixel in the frame buffer, the depth buffer is read at the corresponding location. If the incoming depth passes the depth test, then the pixel is drawn in the frame buffer. Consequently, the depth buffer must be written to update the new depth for this pixel. If the incoming depth does not pass the test, the pixel is not drawn, and the depth buffer is not updated. For the second pass through the scene, semitransparent objects are drawn. These objects were not sorted from back to front. It is possible that two semitransparent objects are drawn front to back; that is, the first drawn object is closer to the observer than the second drawn object. You can see through the first drawn object because it is semitransparent, so you expect to see the second drawn object immediately behind it. To guarantee this happens, you have to disable depth buffer writes on the second pass. Consider if you did not do this. The first object is drawn, and the depth buffer is written with the depths corresponding to that object. When you try to draw the second object, its depths are larger than those of the first object, so the depth test fails and the second object is not drawn, even though it should be visible through the first. Disabling the depth buffer writing will prevent this error. Sample code to implement the process is

```
// in the application initialization phase
NodePtr m_spkScene = <the scene graph>;
Renderer* m_pkRenderer = <the renderer>;
AlphaState* pkAS = new AlphaState;
ZBufferState* pkZS = new ZBufferState;
m_spkScene->SetGlobalState(pkAS);
m_spkScene->SetGlobalState(pkZS);

pkAS->BlendEnabled = true;
pkAS->SrcBlend = AlphaState::SBF_SRC_ALPHA;
pkAS->DstBlend = AlphaState::DBF_ONE_MINUS_SRC_ALPHA;
```

```
pkAS->TestEnabled = true;
pkAS->Reference = 1.0f;

pkZS->Enabled = true;  // always readable
pkZS->Compare = ZBufferState::CF_LEQUAL;

// in the drawing phase (idle loop)
AlphaState* pkAS =
    m_spkScene->GetGlobalState(GlobalState::ALPHA);
ZBufferState* pkZS =
    m_spkScene->GetGlobalState(GlobalState::ZBUFFER);

// first pass
pkAS->Test = AlphaState::TF_EQUAL;
pkZS->Writable = true;
m_pkRenderer->DrawScene(m_spkScene);

// second pass
pkAS->Test = AlphaState::TF_NOTEQUAL;
pkZS->Writable = false;
m_pkRenderer->DrawScene(m_spkScene);
```

The alpha state and z-buffer state members that do not change in the drawing phase are all initialized once by the application. You could also store these states as members of the application object and avoid the GetGlobalState calls, but the lookups are not an expensive operation.

Another example of alpha testing is for drawing objects that have textures whose alpha values are either 0 or 1. The idea is that the texture in some sense defines what the object is. A classic example is for applying a decal to an object. The decal geometry is a rectangle that has a texture associated with it. The texture image has an artistically drawn object that does not cover all the image pixels. The pixels not covered are "see through"; that is, if the decal is drawn on top of another object, you see what the artist has drawn in the image, but you see the other object elsewhere. To accomplish this, the alpha values of the image are set to 1 wherever the artist has drawn, but to 0 everywhere else. Attach an AlphaState object to the decal geometry object (the rectangle). Set the reference value to be 0.5 (it just needs to be different from 0 and 1), and set the test function to be "greater than." When the decal texture is drawn on the object, only the portion is drawn with alpha values equal to 1 (greater than 0.5). The portion with alpha values equal to 0 (not greater than 0.5) is not drawn. Because they are not drawn, the depth buffer is not affected, so you do not have to use the two-pass technique discussed in the previous example.

Material

One of the simplest ways to color a geometric object is to provide it with a *material*. The material has various colors that affect how all the vertices of the object are colored. The class MaterialState represents the material and has the interface

```
class MaterialState : public GlobalState
{
public:
    virtual int GetGlobalStateType () const { return MATERIAL; }

    MaterialState ();
    virtual ~MaterialState ();

    ColorRGBA Emissive;   // default:  ColorRGBA(0,0,0,1)
    ColorRGBA Ambient;    // default:  ColorRGBA(0.2,0.2,0.2,1)
    ColorRGBA Diffuse;    // default:  ColorRGBA(0.8,0.8,0.8,1)
    ColorRGBA Specular;   // default:  ColorRGBA(0,0,0,1)
    float Shininess;      // default:  1
};
```

The data members are all public since no side effects are required when reading or writing them. If you want the geometric object to have the appearance that it is emitting light, you set the Emissive data member to the desired color. The member Ambient represents a portion of the object's color that is due to any ambient light in the scene. Other lights can shine on the object. How the object is lit depends on its material properties and on the normal vectors to the object's surface. For a matte appearance, set the Diffuse data member. Specular highlights are controlled by the Specular and Shininess parameters. Although all colors have an alpha channel, the only relevant one in the graphics API is the alpha channel in the diffuse color. Objects cannot really "emit" an alpha value. An alpha value for ambient lighting also does not make physical sense, and specular lighting says more about reflecting light relative to an observer. The diffuse color is more about the object itself, including having a material that is semitransparent.

In the standard graphics APIs, it is not enough to assign a material to an object. The material properties take effect only when lights are present. Moreover, diffuse and specular lighting require the object to have vertex normals. If you choose to attach a MaterialState to an object, you will need at least one light in the scene. Specifically, the light must occur on the path from the root node to the node containing the material. If the material is to show off its diffuse and specular lighting, any leaf node geometry objects in the subtree rooted at the node containing the material must have vertex normals. Later in this section I will discuss lights, and at that time I will present the formal equations for how lights, materials, and normal vectors interact.

Fog

The portions of a rendered scene at locations far from the observer can look a lot sharper than what your vision expects. To remedy this, you can add *fog* to the system, with the amount proportional to the distance an object is from the observer. The density of the fog (the amount of increase in fog per unit distance in the view frustum) can be controlled. The fog can be calculated on a per-vertex basis for the purposes of speed, but you may request that the fog be calculated on a per-pixel basis. The final color is a blended combination of a fog color and the vertex/pixel color. Fog is applied after transformations, lighting, and texturing are performed, so such objects are affected by the inclusion of fog.

The class that encapsulates fog is FogState. The interface is

```
class FogState : public GlobalState
{
public:
    virtual int GetGlobalStateType () const { return FOG; }

    FogState ();
    virtual ~FogState ();

    enum // DensityFunction
    {
        DF_LINEAR,
        DF_EXP,
        DF_EXPSQR,
        DF_QUANTITY
    };

    enum // ApplyFunction
    {
        AF_PER_VERTEX,
        AF_PER_PIXEL,
        AF_QUANTITY
    };

    bool Enabled;          // default: false
    float Start;           // default: 0
    float End;             // default: 1
    float Density;         // default: 1
    ColorRGBA Color;       // default: ColorRGB(0,0,0)
    int DensityFunction;   // default: DF_LINEAR
    int ApplyFunction;     // default: AF_PER_VERTEX
};
```

The data members are all in public scope since no side effects must occur when reading or writing them. The default values are listed as comments after each member. The Color member is the fog color that is used to blend with the vertex/pixel colors. A *fog factor* $f \in [0, 1]$ is used to blend the fog color and vertex/pixel color. If (r_0, g_0, b_0, a_0) is the fog color and (r_1, g_1, b_1, a_1) is the vertex/pixel color, then the blended color is

$$(r_2, g_2, b_2, a_2) = f(r_0, g_0, b_0, a_0) + (1 - f)(r_1, g_1, b_1, a_1),$$

where the operations on the right-hand side are performed componentwise. If the fog factor is 1, the vertex/pixel color is unaffected by the fog. If the fog factor is 0, only the fog color appears. The ApplyFunction member selects whether you want per-vertex fog calculations (faster) or per-pixel fog calculations (slower).

The DensityFunction controls how the fog is calculated. If the data member is set to DF_LINEAR, then the Start and End data members must be set and indicate the range of depths to which the fog is applied. The fog factor is

$$f = \frac{\text{End} - z}{\text{End - Start}},$$

where z is the depth measured from the camera position to the vertex or pixel location. In practice, you may choose the start and end values to be linear combinations of the near and far plane values. Linear fog does not use the Density data member, so its value is irrelevant.

If the DensityFunction value is set to DF_EXP, then the fog factor has exponential decay. The amount of decay is controlled by the nonnegative Density member function. The fog itself appears accumulated at locations far from the camera position. The fog factor is

$$f = \exp(-\text{Density} * z),$$

where z is once again measured from the camera position to the vertex or pixel location. You may also obtain a tighter accumulation of fog at large distances by using DF_EXPSQR. The fog factor is

$$f = \exp(-(\text{Density} * z)^2).$$

The exponential and squared exponential fog equations do not use the Start and End data members, so their values are irrelevant. The terrain sample application uses squared exponential fog as an attempt to hide the entry of new terrain pages through the far plane of the view frustum.

Culling

Consider a triangle mesh that is a convex polyhedron. Some of the triangles are visible to the observer. These are referred to as *front-facing* triangles. The triangles not visible to the observer are referred to as *back-facing* triangles. The two subsets are dependent, of course, on the observer's location. If the mesh is closed, the triangles can still be partitioned into two subsets, one for the front-facing triangles and one for the back-facing triangles. The back-facing triangles are not visible to the observer, so there is no reason why they should be drawn. The rendering system should eliminate these—a process called *triangle culling*.

In Section 3.3.3, I mentioned that the triangles in a mesh have their vertices ordered in a counterclockwise manner when viewed by the observer. This means that the vertices of a front-facing triangle are seen as counterclockwise ordered. The vertices of a back-facing triangle are clockwise ordered from the observer's perspective. The rendering system may use these facts to classify the two types of triangles. Let the observer's eye point be \mathbf{E} and let the observed triangle have counterclockwise-ordered vertices \mathbf{V}_0, \mathbf{V}_1, and \mathbf{V}_2. The vector $\mathbf{N} = (\mathbf{V}_1 - \mathbf{V}_0) \times (\mathbf{V}_2 - \mathbf{V}_0)$ is perpendicular to the plane of the triangle. The triangle is front facing if

$$\mathbf{N} \cdot (\mathbf{E} - \mathbf{V}_0) > 0,$$

and it is back facing if

$$\mathbf{N} \cdot (\mathbf{E} - \mathbf{V}_0) \leq 0.$$

If the dot product is zero, the triangle is seen edge on and is considered not to be visible.

A rendering system will select a convention for the vertex ordering for front-facing triangles. This is necessary so that the dot product tests can be coded accordingly. A modeling package also selects a convention for the vertex ordering, but the problem is that the conventions might not be consistent. If not, you can always export the models to a format your engine supports, then reorder the triangle vertices to meet the requirements of your rendering system. The burden of enforcing the ordering constraint is yours. Alternatively, the rendering system can allow you to specify the convention, making the system more flexible. The renderer will use the correct equations for the dot product tests to identify the back-facing triangles. In fact, the standard graphics APIs allow for this. I have encapsulated this in class CullState.

The interface for CullState is

```
class CullState : public GlobalState
{
public:
    virtual int GetGlobalStateType () const { return CULL; }
```

```
        CullState ();
        virtual ~CullState ();

        enum // FrontType
        {
            FT_CCW,  // front faces are counterclockwise ordered
            FT_CW,   // front faces are clockwise ordered
            FT_QUANTITY
        };

        enum // CullType
        {
            CT_FRONT,  // cull front-facing triangles
            CT_BACK,   // cull back-facing triangles
            CT_QUANTITY
        };

        bool Enabled;   // default: true
        int FrontFace;  // default: FT_CCW
        int CullFace;   // default: CT_BACK
    };
```

The data members are in public scope because no side effects must occur when
reading or writing them. The default value for Enabled is true, indicating that triangle
culling is enabled. The FrontFace member lets you specify the vertex ordering for the
triangles that you wish to use. The default value is counterclockwise. The CullFace
member lets you tell the renderer to cull front-facing or back-facing triangles. The
default is to cull back-facing triangles.

When triangle culling is enabled, the triangles are said to be *single sided*. If an
observer can see one side of the triangle, and if you were to place the observer on
the other side of the plane of the triangle, the observer would not see the triangle
from that location. If you are inside a model of a room, the triangles that form the
walls, floor, and ceiling may as well be single sided since the intent is to only see them
when you are inside the room. But if a wall separates the room from the outside
environment and you want the observer to see the wall from the outside (maybe it
is a stone wall in a castle), then the triangle culling system gets in your way when it is
enabled. In this scenario you want the triangles to be *double sided*—both sides visible
to an observer. This is accomplished by simply disabling triangle culling; set Enabled
to false.

Disabling triangle culling is also useful when a triangle mesh is not closed. For
example, you might have a model of a flag that flaps in the wind. The flag mesh is
initially a triangle mesh in a plane. During program execution, the triangle vertices
are dynamically modified to obtain the flapping. Because you want both sides of the

flag to be visible, you would attach a `CullState` object to the mesh and set `Enabled` to `false`.

Wireframe

A *wireframe* is a rendering of a triangle mesh where only the edges of the triangles are drawn. Although such an effect might be interesting in a game, wireframes are typically used for debugging purposes. For example, in wireframe mode you might be able to spot problems with a geometric model that was not properly constructed. I used wireframe mode when implementing and testing the portal system. Portions of a scene are culled by the portal system, but you do not see the culling occur when in regular drawing mode. However, in wireframe you can see the objects appear or disappear, giving you an idea whether or not the culling is taking place as planned.

The class to support wireframe mode is `WireframeState`. The interface is

```
class WireframeState : public GlobalState
{
public:
    virtual int GetGlobalStateType () const { return WIREFRAME; }

    WireframeState ();
    virtual ~WireframeState ();

    bool Enabled;  // default: false
};
```

Very simple, as you can see. You either enable or disable the mode. In practice, I tend to attach a `WireframeState` object to the root of my scene graph. I make the wireframe object an application member and then allow toggling of the `Enabled` member:

```
// initialization code
NodePtr m_spkScene = <the scene graph>;
WireframePtr m_spkWireframe = new WireframeState;
m_spkScene->SetGlobalState(m_spkWireframe);

// key press handler
if ( ucKey == 'w' )
    m_spkWireframe->Enabled = !m_spkWireframe->Enabled;
```

Dithering

On a graphics system with a limited number of colors, say, one supporting only a 256-color palette, a method for increasing the apparent number of colors is *dithering*.

As an example, suppose your system supports only two colors, black and white. If you were to draw an image with a checkerboard pattern—alternate drawing pixels in black and white—your eye will perceive the image as gray, even though your graphics system cannot draw a gray pixel. Consider that a black-ink printer is such a graphics system. Color printers may also use dithering to increase the apparent number of colors. How to do this effectively is the topic of color science. The dithering pattern can be much more complicated than a checkerboard. Suffice it to say that a graphics API might support dithering.

For the 32-bit color support that current graphics hardware has, dithering is probably not useful, but I have support for it anyway. The class is `DitherState` and the interface is

```
class DitherState : public GlobalState
{
public:
    virtual int GetGlobalStateType () const { return DITHER; }

    DitherState ();
    virtual ~DitherState ();

    bool Enabled;  // default: false
};
```

The dithering is either enabled or disabled.

Shading

Some graphics APIs provide the ability to select a *shading model*. *Flat shading* refers to drawing a primitive such as a line segment or a triangle with a single color. *Gouraud shading* refers to drawing the primitive by interpolating the colors at the vertices of the primitive to fill in those pixels corresponding to the interior of the primitive. In theory, Gouraud shading is more expensive to compute because of the interpolation. However, with current graphics hardware, the performance is not an issue, so you tend not to use flat shading. I have provided support anyway, via class `ShadeState`. Its interface is

```
class ShadeState : public GlobalState
{
public:
    virtual int GetGlobalStateType () const { return SHADE; }

    ShadeState ();
    virtual ~ShadeState ();
```

```
enum // ShadeMode
{
    SM_FLAT,
    SM_SMOOTH,
    SM_QUANTITY
};

int Shade;  // default: SM_SMOOTH
};
```

The shading mode is either flat or smooth; the latter refers to Gouraud shading (the default).

3.4.2 LIGHTS

Drawing objects using only textures results in renderings that lack the realism we are used to in the real world. Much of the richness our own visual systems provide is due to *lighting*. A graphics system must support the concept of lights, and of materials that the lights affect. The lighting models supported by standard graphics APIs are a simple approximation to true lighting, but are designed so that the lighting calculations can be performed quickly. More realistic lighting is found in systems that are almost never real time.

Materials were discussed earlier in this section. A material consists of various colors. The emissive color represents light that the material itself generates, which is usually none. *Ambient light* comes from light that has been scattered by the environment. A material reflects some of this light. The ambient color of the material indicates how much ambient light is reflected. Although referred to as a color, you may think of the ambient component as telling you the fraction of ambient light that is reflected. *Diffuse light* is light that strikes a surface. At each point on the surface the light arrives in some direction, but is then scattered equally in all directions at that point. A material also reflects some of this light. The diffuse color of the material indicates how much diffuse light is reflected. *Specular light* is also light that strikes a surface, but the reflected light has a preferred direction. The resulting appearance on the surface is referred to as *specular highlights*. A material reflects some of this light. The fractional amount is specified by the material's specular color.

The lights have physical attributes themselves, namely, colors (ambient, diffuse, specular), intensity, and attenuation (decrease in energy as the light travels over some distance). Lights also come in various types. I already mentioned ambient light due to scattering. The light has no single source and no specific direction. A source that provides light rays that are, for all practical purposes, parallel is referred to as a *directional light*. The motivation for this is sunlight. The Sun is far enough away from the Earth that the Sun's location is irrelevant. The sunlight is effectively unidirectional. A source that has a location, but emanates light in all directions is

called a *point light*. The motivation is an incandescent light bulb. The filament acts as the light source, and the bulb emits light in all directions. A light that has a source location but emits lights in a restricted set of directions (typically a cone of directions) is called a *spot light*. The motivation is a flashlight or airport beacon that has a lightbulb as the source and a reflector surface that concentrates the light to emanate in a fixed set of directions.

The types of lights and their attributes are sufficiently numerous that many engines provide multiple classes. Usually an engine will provide an abstract base class for lights and then derived classes such as an ambient light class, a directional light class, a point light class, and a spot light class. I did so in Wild Magic version 2, but decided that the way the renderer accessed a derived-class light's information was more complicated than it needed to be. Also in Wild Magic version 2, the Light class was derived from Object. A number of users were critical of this choice and insisted that Light be derived from Spatial. By doing so, a light automatically has a location (the local translation) and an orientation (the local rotation). One of the orientation vectors can assume the role of the direction for a directional light. I chose not to derive Light from Spatial because ambient lights have no location or direction and directional lights have no location. In this sense they are not very spatial! The consequence, though, was that I had to add a class, LightNode, that was derived from Node and that had a Light data member. This allows point and spot lights to change location and directional lights to change orientation and then have the geometric update system automatically process them. Even these classes presented some problems to users. One problem had to do with importing LightWave objects into the engine because LightWave uses left-handed coordinates for everything. The design of LightNode (and CameraNode) prevented a correct import of lights (and cameras) when they were to be attached as nodes in a scene.

In the end, I decided to satisfy the users. In Wild Magic version 3, I changed my design and created a single class called Light that is derived from Spatial. Not all data members make sense for each light type, but so be it. When you manipulate a directional light, realize that setting the location has no effect. Also be aware that by deriving from Spatial, some subsystems are available to Light that are irrelevant. For example, attaching to a light a global state such as a depth buffer has no meaning, but the engine semantics allow the attachment. In fact, you can even attach lights to lights. You can attach a light as a leaf node in the scene hierarchy. For example, you might have a representation of a headlight in an automobile. A node is built with two children: One child is the Geometry object that represents the headlight's model data, and the other child is a Light to represent the light source for the headlight. The geometric data is intended to be drawn to visualize the headlight, but the light object itself is not renderable. The virtual functions for global state updates and for drawing are stubbed out in the Light class, so incorrect use of the lights should not be a problem. So be warned that you can manipulate a Light as a Spatial object in ways that the engine was not designed to handle.

The Light Class

The Light class has a quite complicated interface. I will look at portions of it at a time. The class supports the standard light types: ambient, directional, point, and spot.

```
class Light : public Spatial
{
public:
    enum // Type
    {
        LT_AMBIENT,
        LT_DIRECTIONAL,
        LT_POINT,
        LT_SPOT,
        LT_QUANTITY
    };

    Light (int iType = LT_AMBIENT);
    virtual ~Light ();

    int Type;           // default: LT_AMBIENT
    ColorRGBA Ambient;  // default: ColorRGBA(0,0,0,1)
    ColorRGBA Diffuse;  // default: ColorRGBA(0,0,0,1)
    ColorRGBA Specular; // default: ColorRGBA(0,0,0,1)
    float Intensity;    // default: 1
    float Constant;     // default: 1
    float Linear;       // default: 0
    float Quadratic;    // default: 0
    bool Attenuate;     // default: false
    bool On;            // default: true

    // spot light parameters (valid only when Type = LT_SPOT)
    float Exponent;
    float Angle;
};
```

When you create a light, you specify the type you want. Each light has ambient, diffuse, and specular colors and an intensity factor that multiplies the colors. The member On is used to quickly turn a light on or off. This is preferred over attaching and detaching a light in the scene.

The data members Constant, Linear, Quadratic, and Attenuate are used for attenuation of point and spot lights over some distance. To allow attenuation, you set

`Attenuate` to `true`. The attenuation factor multiplies the light colors, just as the intensity factor does. The attenuation factor is

$$\alpha = \frac{1}{C + Ld + Qd^2}, \tag{3.8}$$

where C is the `Constant` value, L is the `Linear` value, and Q is the `Quadratic` value. The variable d is the distance from the light's position to a vertex on the geometric object to be lit.

The actual lighting model is somewhat complicated, but here is a summary of it. The assumption is that the object to be lit has a material with various colors. I will write these as vector-valued quantities (RGBA) for simplicity of the notation. Additions and multiplications are performed componentwise. The material emissive color is \mathbf{M}_{ems}, the ambient color is \mathbf{M}_{amb}, the diffuse color is \mathbf{M}_{dif}, and the specular color is \mathbf{M}_{spc}. The shininess is M_s, a nonnegative scalar quantity. A global ambient light is assumed (perhaps representing the Sun). This light is referred to by $\mathbf{L}^{(0)}$ and has subscripts for the colors just like the material colors use. In the engine, this light automatically exists, so you need not create one and attach it to the scene. The object to be lit may also be affected by n lights, indexed by $\mathbf{L}^{(i)}$ for $1 \le i \le n$. Once again these lights have subscripts for the colors. The ith light has a contribution to the rendering of

$$\alpha_i \sigma_i \left(\mathbf{A}^{(i)} + \mathbf{D}^{(i)} + \mathbf{S}^{(i)} \right).$$

The term α_i is the attenuation. It is calculated for point and spot lights using Equation (3.8). It is 1 for ambient and directional lights—neither of these is attenuated. The term σ_i is also an attenuator that is 1 for ambient, diffuse, and point lights, but potentially less than 1 for spot lights. The light has an ambient contribution,

$$\mathbf{A}^{(i)} = \mathbf{M}_{amb}\mathbf{L}^{(i)}_{amb},$$

a diffuse contribution,

$$\mathbf{D}^{(i)} = \mu^{(i)}_D \mathbf{M}_{dif}\mathbf{L}^{(i)}_{dif},$$

and a specular contribution,

$$\mathbf{S}^{(i)} = \mu^{(i)}_S \mathbf{M}_{spc}\mathbf{L}^{(i)}_{spc}.$$

The color assigned to a vertex on the object to be lit is

$$\mathbf{M}_{ems} + \mathbf{L}^{(0)}_{amb}\mathbf{M}_{amb} + \sum_{i=1}^{n} \alpha_i \sigma_i \left(\mathbf{A}^{(i)} + \mathbf{D}^{(i)} + \mathbf{S}^{(i)} \right). \tag{3.9}$$

The modulators $\mu_D^{(i)}$, $\mu_S^{(i)}$, and σ_i depend on the light type and geometry of the object. For an ambient light, the diffuse modulator is 1. For a directional light with unit-length world direction vector **U** and at a vertex with outer-pointing unit-length normal **N**,

$$\mu_D^{(i)} = \max\{-\mathbf{U} \cdot \mathbf{N}, 0\}.$$

The diffuse modulator is 1 when the light shines directly downward on the vertex. It is 0 when the light direction is tangent to the surface. For a point or spot light with position **P** and a vertex with position **V**, define the unit-length vector

$$\mathbf{U} = \frac{\mathbf{V} - \mathbf{P}}{|\mathbf{V} - \mathbf{P}|}. \tag{3.10}$$

This does assume the light is not located at the vertex itself. The diffuse modulator equation for a directional light also applies here, but with the vector **U** as defined.

The specular modulator is 1 for an ambient light. For the other light types, the specular modulator is computed based on the following quantities. Let **V** be the vertex location and **N** be a unit-length vertex normal. If the light is directional, let **U** be the unit-length direction. If the light is a point light or spot light, let **U** be the vector defined by Equation (3.10). The specular modulator is 0 if $-\mathbf{U} \cdot \mathbf{N} \leq 0$. Otherwise, define the unit-length vector[5]

$$\mathbf{H} = \frac{\mathbf{U} + (0, 0, -1)}{|\mathbf{U} + (0, 0, -1)|},$$

and the specular modulator is

$$\mu_S^{(i)} = (\max\{-\mathbf{H} \cdot \mathbf{N}, 0\})^{M_s}.$$

The spot light modulator σ_i is 1 for a light that is not a spot light. When the light is a spot light, the modulator is 0 if the vertex is not contained in the cone of the light. Otherwise, define **U** by Equation (3.10), where **P** is the spot light position. The modulator is

$$\sigma_i = (\max\{\mathbf{U} \cdot \mathbf{D}, 0\})^{e_i},$$

where **D** is the spot light direction vector (unit length) and e_i is the exponent associated with the spot light. The spot light angle $\theta_i \in [0, \pi)$ determines the cone of the light. The Light data members that correspond to these parameters are Exponent and Angle.

5. In OpenGL terminology, I do not use a local viewer for the light model. If you were to use a local viewer, then $(0, 0, -1)$ in the equation for **H** is replaced by $(\mathbf{P} - \mathbf{E})/|\mathbf{P} - \mathbf{E}|$, where **P** is the light position and **E** is the eye point (camera position).

The remaining portion of the Light interface is related to the class being derived from Spatial:

```
class Light : public Spatial
{
public:
    // light frame (local coordinates)
    //    default location  E = (0,0,0)
    //    default direction D = (0,0,-1)
    //    default up        U = (0,1,0)
    //    default right     R = (1,0,0)
    void SetFrame (const Vector3f& rkLocation,
        const Vector3f& rkDVector, const Vector3f& rkUVector,
        const Vector3f& rkRVector);
    void SetFrame (const Vector3f& rkLocation,
        const Matrix3f& rkAxes);
    void SetLocation (const Vector3f& rkLocation);
    void SetAxes (const Vector3f& rkDVector,
        const Vector3f& rkUVector, const Vector3f& rkRVector);
    void SetAxes (const Matrix3f& rkAxes);
    Vector3f GetLocation () const;   // Local.Translate
    Vector3f GetDVector () const;    // Local.Rotate column 0
    Vector3f GetUVector () const;    // Local.Rotate column 1
    Vector3f GetRVector () const;    // Local.Rotate column 2

    // For directional lights.  The direction vector must be
    // unit length.  The up vector and left vector are generated
    // automatically.
    void SetDirection (const Vector3f& rkDirection);

    // light frame (world coordinates)
    Vector3f GetWorldLocation () const;  // World.Translate
    Vector3f GetWorldDVector () const;   // World.Rotate column 0
    Vector3f GetWorldUVector () const;   // World.Rotate column 1
    Vector3f GetWorldRVector () const;   // World.Rotate column 2

private:
    // updates
    virtual void UpdateWorldBound ();
    void OnFrameChange ();

    // base class functions not supported
```

```
    virtual void UpdateState (TStack<GlobalState*>*,
        TStack<Light*>*) { /**/ }
    virtual void Draw (Renderer&, bool) { /**/ }

};
```

Normally, the local transformation variables (translation, rotation, scale) are for exactly that—transformation. In the Light class, the local translation is interpreted as the origin for a coordinate system of the light. The columns of the local rotation matrix are interpreted as the coordinate axis directions for the light's coordinate system. The choice for the default coordinate system is akin to the standard camera coordinate system relative to the screen: The center of the screen is the origin. The up vector is toward the top of the screen (the direction of the positive y-axis), the right vector is toward the right of the screen (the direction of the positive x-axis), and the z-axis points out of the screen. The light is positioned at the origin, has direction into the screen (the direction of the negative z-axis), has up vector to the top of the screen, and has right vector to the right of the screen. Because the light's coordinate system is stored in the local translation vector and local rotation matrix, you should use the interface provided and avoid setting the data member Local explicitly to something that is not consistent with the interpretation as a coordinate system.

The first block of code in the interface is for set/get of the coordinate system parameters. The SetDirection function is offset by itself just to draw attention to the fact that you are required to pass in a unit-length vector. As the comment indicates, the up and left vectors are automatically generated. Their values are irrelevant since the direction vector only pertains to a directional light, and the up and left vectors have no influence on the lighting model. The last block of code in the public interface allows you to retrieve the world coordinates for the light's (local) coordinate system.

The Light class has no model bound; however, the light's position acts as the center of a model bound of radius zero. The virtual function UpdateWorldBound computes the center of a world bound of radius zero. The function OnFrameChange is a simple wrapper around a call to UpdateGS and is executed whenever you set the coordinate system components. Therefore, you do not need to explicitly call UpdateGS whenever the coordinate system components are modified.

The two virtual functions in the private section are stubs to implement pure virtual functions in Spatial (as required by C++). None of these make sense for lights anyway, as I stated earlier, but they exist just so that Light inherits other properties of Spatial that are useful.

Support for Lights in Spatial and Geometry

The Spatial class stores a list of lights. If a light is added to this list, and the object really is of type Node, then my design choice is that the light illuminates all leaf

geometry in the subtree rooted at the node. The portion of the interface for `Spatial` relevant to adding and removing lights from the list is

```
class Spatial : public Object
{
public:
    void SetLight (Light* pkLight);
    int GetLightQuantity () const;
    Light* GetLight (int i) const;
    void RemoveLight (Light* pkLight);
    void RemoveAllLights ();

protected:
    TList<Pointer<Light> >* m_pkLightList;
};
```

The list is considered to be unordered since Equation (3.9) does not require the lights to be ordered. Notice that the list contains smart pointers to lights. I use `typedef` to create aliases for the smart pointers. For `Light` it is `LightPtr`. The `TList` declaration cannot use `LightPtr`. The `typedef` for `LightPtr` is contained in `Wm3Light.h`. Class `Light` is derived from `Spatial`, so `Wm3Light.h` includes `Wm3Spatial.h`. If we were to include `Wm3Light.h` in `Wm3Spatial.h` to access the definition of `LightPtr`, we would create a circular header dependency, in which case the compiler has a complaint. To avoid this, the class `Light` is forward-declared and the `typedef` is not used.

Function `SetLight` checks to see if the input light is already in the list. If so, no action is taken. If not, the light is added to the front of the list. The function `Get-LightQuantity` just iterates over the list, counts how many items it has, and returns that number. The function `GetLight` returns the ith light in the list. Together, `Get-LightQuantity` and `GetLight` allow you to access the list as if it were an array. This is convenient, especially in the renderer code. The function `RemoveLight` searches the list for the input light. If it exists, it is removed. The list is singly linked, so the search uses two pointers, one in front of the other, in order to facilitate the removal. The function `RemoveAllLights` destroys the list by removing the front item repeatedly until the list is empty.

The `Geometry` class stores an array of lights, which is separate from the list. It stores smart pointers to all the lights encountered in a traversal from the root node to the geometry leaf node. These lights are used by the renderer to light the geometric object. The render state update, discussed later in this section, shows how the lights are propagated to the leaf nodes.

3.4.3 TEXTURES

The `Texture` class is designed to encapsulate most of the information needed to set up a texture unit on a graphics card. Minimally, the class should store the texture image.

The texture coordinates assigned to vertices of geometry objects are not stored in Texture, which allows sharing of Texture objects across multiple geometry objects.

In Wild Magic version 2, the texture coordinates were stored in the Geometry object itself. Having support for multitexturing meant that Geometry needed to store as many texture coordinate arrays as there are textures attached to the object, which caused the interface to Geometry to become unruly. On the release of each new generation of graphics cards that supported more texture units than the previous generation, I had to modify Geometry to include more array pointers for the texture coordinates. Naturally, the streaming code for Geometry had to be modified to store the new data and to load old files knowing that they were saved using a smaller number of texture units. Most Geometry objects used only one or two arrays of texture coordinates, but the class had to be prepared for the worst case that all arrays were used. The class even had a separate array to handle textures associated with bump maps. The bulkiness of Geometry regarding texture coordinates and the fact that its code evolved on a somewhat regular basis made me realize I needed a different design.

Wild Magic version 3 introduces a new class, Effect. The class, discussed in detail later in this section, now encapsulates the textures and corresponding texture coordinates that are to be attached to a Geometry object. An increase in the number of texture units for the next-generation hardware requires *no changes* to either the Geometry class or the Effect class. The Geometry class is responsible now only for vertex positions and normals and the indices that pertain to connectivity of the vertices. During the development of advanced features for Wild Magic version 3, the redesign of Spatial, Geometry, TriMesh, and the introduction of Effect has paid off. The core classes are generic enough and isolated sufficiently well that changes to other parts of the engine have not forced rewrites of those classes. This is an important aspect of any large library design—make certain the core components are robust and modular, protecting them from the evolution of the rest of the library that is built on top of them.

Now back to the Texture class. The texture image is certainly at the heart of the class. The relevant interface items for images are

```
class Texture : public Object
{
public:
    Texture (Image* pkImage = NULL);
    virtual ~Texture ();

    void SetImage (ImagePtr spkImage);
    ImagePtr GetImage () const;

protected:
    ImagePtr m_spkImage;
};
```

The only constructor acts as the default constructor, but also allows you to specify the texture image immediately. The data member m_spkImage is a smart pointer to the texture image. You may set/get the image via the accessors SetImage and GetImage.

A graphics system provides a lot of control over how the image is drawn on an object. I will discuss a portion of the interface at a time.

Projection Type

The first control is over the type of projection used for drawing the image:

```
class Texture : public Object
{
public:
    enum // CorrectionMode
    {
        CM_AFFINE,
        CM_PERSPECTIVE,
        CM_QUANTITY
    };

    int Correction;  // default: CM_PERSPECTIVE
};
```

The two possibilities are affine or perspective. The standard is to use perspective-correct drawing. Affine drawing was a popular choice for software rendering because it is a lot faster than using perspective-correct drawing. However, affine drawing looks awful! I tried to generate some images to show the difference using the Wild Magic OpenGL renderer, but apparently the current-generation hardware and OpenGL drivers ignore the hint to use affine texturing, so I could only obtain perspective-correct drawing. The option should remain, though, because on less powerful platforms, affine texturing is quite possibly necessary for speed—especially if you plan on implementing a software renderer using the Wild Magic API.

Filtering within a Single Image

A texture image is mapped onto a triangle by assigning texture coordinates to the vertices of the triangle. Once the triangle is mapped to screen space, the pixels inside the triangle must be assigned colors. This is done by linearly interpolating the texture coordinates at the vertices to generate texture coordinates at the pixels. It is possible (and highly likely) that the interpolated texture coordinates do not correspond exactly to an image pixel. For example, suppose you have a 4×4 texture image and a triangle with texture coordinates (0, 0), (1, 0), and (0, 1) at its vertices. The pixel

(i, j) in the image, where $0 \le i < 4$ and $0 \le j < 4$, has the associated texture coordinates $(u, v) = (i/3, j/3)$. If a pixel's interpolated texture coordinates are $(0.2, 0.8)$, the real-valued image indices are $i' = 3(0.2) = 0.6$ and $j' = 3(0.8) = 2.4$. I used prime symbols to remind you that these are not integers. You have to decide how to create a color from this pair of numbers and the image. The portion of the Texture interface related to the creation is

```
class Texture : public Object
{
public:
    enum // FilterMode
    {
        FM_NEAREST,
        FM_LINEAR,
        FM_QUANTITY
    };

    int Filter;  // default: FM_LINEAR
};
```

Two choices are available. By setting Filter to FM_NEAREST, the texturing system rounds the real-valued indices to the nearest integers. In this case, $i = 1$ since $i' = 0.6$ is closer to 1 than it is to 0, and $j = 2$ since $j' = 2.4$ is closer to 2 than it is to 3. The image value at location $(i, j) = (1, 2)$ is chosen as the color for the pixel.

The second choice for Filter is FM_LINEAR. The color for the pixel is computed using bilinear interpolation. The real-valued indices (i', j') fall inside a square whose four corners are integer-valued indices. Let $\lfloor v \rfloor$ denote the floor of v, the largest integer smaller than or equal to v. Define $i_0 = \lfloor i' \rfloor$ and $j_0 = \lfloor j' \rfloor$. The four corners of the square are (i_0, j_0), $(i_0 + 1, j_0)$, $(i_0, j_0 + 1)$, and $(i_0 + 1, j_0 + 1)$. The bilinear interpolation formula generates a color C' from the image colors $C_{i,j}$ at the four corners:

$$C' = (1 - \Delta_i)(1 - \Delta_j)C_{i_0, j_0} + (1 - \Delta_i)\Delta_j C_{i_0, j_0+1} + \Delta_i(1 - \Delta_j)C_{i_0+1, j_0}$$

$$+ \Delta_i \Delta_j C_{i_0+1, j_0+1},$$

where $\Delta_i = i' - i_0$ and $\Delta_j = j' - j_0$. Some attention must be given when $i_0 = n - 1$ when the image has n columns. In this case, $i_0 + 1$ is outside the image domain. Special handling must also occur when the image has m rows and $j_0 = m - 1$.

Figure 3.10 shows a rectangle with a checkerboard texture. The object is drawn using nearest-neighbor interpolation. Notice the jagged edges separating gray and black squares.

Figure 3.11 shows the same rectangle and checkerboard texture. The edges are smoothed using bilinear interpolation. For reference later, notice that the edges near the top of the image still have a small amount of jaggedness.

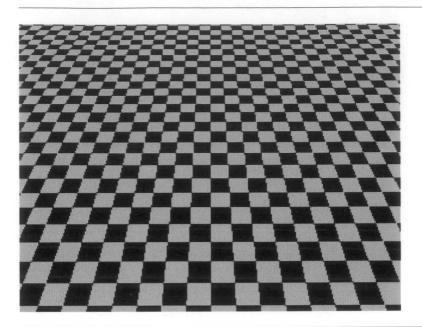

Figure 3.10 Illustration of nearest-neighbor interpolation using `Texture::FM_NEAREST`.

Mipmapping: Filtering within Multiple Images

Bilinear filtering produces better-quality texturing than choosing the nearest neighbor, but it comes at greater expense in computational time. Fortunately with graphics hardware support, this is not an issue. Even with bilinear filtering, texturing can still have some artifacts. When a textured object with bilinear interpolation is close to the eye point, most of the pixels obtain their colors from the interpolation. That is, the texture coordinates of the pixels are strictly inside the square formed by four texture image samples, so the pixel colors are always influenced by four samples. The texture image samples are referred to as *texels*.[6] For the close-up object, the texels are in a sense a lot larger than the pixels. This effect is sometimes referred to as *magnification*. The texture image is magnified to fill in the pixels.

When that same object is far from the eye point, aliasing artifacts show up. Two adjacent pixels in the close-up object tend to be in the same four-texel square. In the

6. The word *pixel* is an abbreviation of the words "picture element." Similarly, the word *texel* represents the words "texture element." The names people choose are always interesting! It certainly is easier to say pixel and texel than the original phrases.

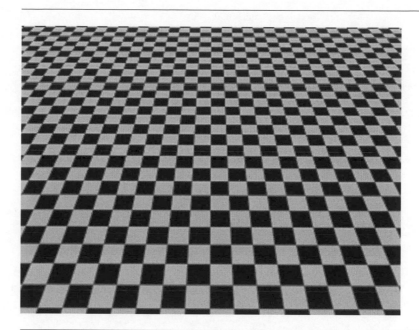

Figure 3.11 Illustration of bilinear interpolation using Texture::FM_LINEAR.

faraway object, two adjacent pixels tend to be in different four-texel squares. In this situation, the texels are in a sense a lot smaller than the pixels.

To eliminate the aliasing artifacts, an alternative is needed that is the reverse of magnification, *minification*. The idea is to generate a set of texture images from the original. A pixel in the new image is an average of a 2×2 block of pixels in the old image. Thus, each new image is half the size per dimension of the previous image. A full pyramid of images starts with the original, a $2^n \times 2^m$ image. The next image has dimensions $2^{n-1} \times 2^{m-1}$. The averaging process is repeated until one of the dimensions is 1. For a square image $n = m = 1$, the final image is 1×1 (a single texel). Pixels corresponding to a portion of the object close to the eye point are selected from the original image. For pixels corresponding to a portion of the object further away from the eye point, a selection must be made about which of the pyramid images to use. The alternatives are even more varied because you can choose to use nearest-neighbor interpolation or bilinear interpolation within a single image *and* you can choose to use the nearest image slice or linearly interpolate between slices. The process of texturing with a pyramid of images is called *mipmapping* [Wil83]. The prefix *mip* is an acronym for the Latin *multum in parvo*, which means "many things in a small place." The pyramid itself is referred to as the *mipmap*.

As mentioned, there are a few choices for how mipmapping is applied. The interface of Texture supporting these is

```
class Texture : public Object
{
public:
    enum // MipmapMode
    {
        MM_NEAREST,
        MM_LINEAR,
        MM_NEAREST_NEAREST,
        MM_NEAREST_LINEAR,
        MM_LINEAR_NEAREST,
        MM_LINEAR_LINEAR,
        MM_QUANTITY
    };

    int Mipmap;  // default: MM_LINEAR_LINEAR
};
```

The enumerated values that are assigned to the data member Mipmap refer to the following algorithms:

- MM_NEAREST: Only the original texture image is used, so the pyramid of images is not constructed. Nearest-neighbor interpolation is used to select the texel that is nearest to the target pixel.

- MM_LINEAR: Only the original texture image is used, so the pyramid of images is not constructed. Bilinear interpolation is used to generate the color for the target pixel.

The next four options do require building the mipmap. The graphics drivers provide some mechanism for selecting which image in the mipmap to use. That mechanism can vary with graphics API and/or manufacturer's graphics cards, so I do not discuss it here, but see [Ebe00] for details.

- MM_NEAREST_NEAREST: The mipmap image nearest to the pixel is selected. In that image, the texel nearest to the pixel is selected and assigned to the pixel.

- MM_NEAREST_LINEAR: The two mipmap images that bound the pixel are selected. In each image, the texel nearest to the pixel is selected. The two texels are linearly interpolated and assigned to the pixel.

- MM_LINEAR_NEAREST: The mipmap image nearest to the pixel is selected. In that image, bilinear interpolation of the texels is used to produce the pixel value.

- MM_LINEAR_LINEAR: The two mipmap images that bound the pixel are selected. In each image, bilinear interpolation of the texels is used to generate two colors. Those colors are linearly interpolated to produce the pixel value. This is sometimes call *trilinear interpolation*.

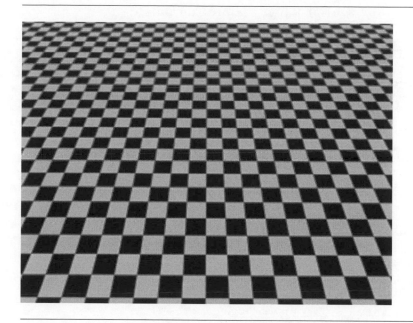

Figure 3.12 Illustration of trilinear interpolation using `Texture::MM_LINEAR_LINEAR`.

Note that for each enumerated value, the first name refers to the interpolation type within an image. The second name refers to the interpolation type across two images.

In theory, `MM_NEAREST` and `MM_LINEAR` use only the original texture image, so mipmaps need not (and should not) be built. In fact, the choices are equivalent to using single-image filtering along. The OpenGL renderer indeed does not generate the mipmaps; the result is that standard filtering is used (as specified by the `Filter` data member).[7]

Figure 3.12 shows the rectangle and checkerboard texture using trilinear interpolation for mipmapping. The slightly jagged edges that appear in the top half of Figure 3.11 do not appear in the top half of Figure 3.12.

7. That said, if you have had much experience with graphics drivers for different brands of graphics cards, you will find that the drivers do not always adhere to the theory. In a test program for `MM_LINEAR`, one of my graphics cards rendered an image that should have been identical to Figure 3.11, but instead rendered an image that showed a small, triangular shaped, bilinearly interpolated region near the bottom of the image. The remainder of the image showed that nearest- neighbor interpolation was used. A graphics card from a different manufacturer correctly rendered the image entirely using bilinear interpolation.

Out-of-Range Texture Coordinates

In the discussion of bilinear interpolation for texture image filtering, I mentioned that special attention must be paid to interpolation at texels that are on the boundary of the image. The natural inclination is to *clamp* values outside the domain of the image indices. If a texture coordinate is (0.7, 1.1), the clamped value is (0.7, 1.0). The texture coordinate $(-0.4, 0.2)$ is clamped to (0.0, 0.2). Other choices are possible. The coordinates may be *repeated* by using modular arithmetic. Any value larger than 1 has its integer part removed, and any value smaller than 0 has an integer added to it until the result is 0 or larger. For example, (0.7, 1.1) is wrapped to (0.7, 0.1), and $(-0.4, 0.2)$ is wrapped to (0.6, 0.2). In the latter example, we only needed to add 1 to -0.4 to obtain a number in the interval [0, 1]. The texture coordinate $(-7.3, 0.2)$ is wrapped to (0.7, 0.2). In this example, we had to add 8 to -7.3 to obtain a number in the interval [0, 1].

The handling of texture coordinates at the image boundaries is supported by the interface

```
class Texture : public Object
{
public:
    enum // CoordinateMode
    {
        WM_CLAMP,
        WM_REPEAT,
        WM_CLAMP_BORDER,
        WM_CLAMP_EDGE,
        WM_QUANTITY
    };

    ColorRGBA BorderColor;  // default: ColorRGBA(0,0,0,0)

    int CoordU;  // default: WM_CLAMP_EDGE
    int CoordV;  // default: WM_CLAMP_EDGE
};
```

Given a texture coordinate (u, v), each component can be clamped or repeated. Figure 3.13 illustrates the four possibilities.

Unfortunately, the WM_CLAMP mode has issues when the filter mode is not FM_NEAREST and/or the mipmap mode is not MM_NEAREST. When bilinear interpolation is used and the texture coordinates are on the image boundary, the interpolation uses the *border color*, which is stored in the data member Texture::BorderColor. The OpenGL renderer is set up to tell the graphics API about the border color only if that color is valid. When it is invalid, a black border color is used by default. Figure 3.14 shows the effect when two textures on two objects have a common boundary. In

Figure 3.13 A square with vertices $(-1, -1)$, $(1, -1)$, $(1, 1)$, and $(-1, 1)$ is drawn with a texture image. The texture coordinates at the square's corners are $(0, 0)$, $(2, 0)$, $(2, 2)$, and $(0, 2)$. (a) Clamp u and clamp v. (b) Clamp u and repeat v. (c) Repeat u and clamp v. (d) Repeat u and repeat v. (See also Color Plate 3.13.)

either case, if you have a tiled environment such as terrain, the clamping to the border color is not the effect you want.

Instead, use clamping to the edge of the texture. Figure 3.15 illustrates with the same squares and texture coordinates as in Figure 3.14. In Figure 3.15(a), notice that the dark line that appeared with border clamping no longer occurs. However, you will

(a) (b)

Figure 3.14 Two squares, one with vertices $(-1, -1)$, $(0, -1)$, $(0, 1)$, and $(-1, 1)$, and one with vertices $(0, -1)$, $(1, -1)$, $(1, 1)$, and $(0, 1)$, are drawn with texture images. The images were obtained by taking a 128×128 bitmap and splitting it into 64×128 images. The texture coordinates at the squares' corners are $(0, 0)$, $(1, 0)$, $(1, 1)$, and $(0, 1)$. (a) Clamp u and v to border, no border color assigned. (b) Clamp u and v to border, red border color assigned. (See also Color Plate 3.14).

notice in the middle of the image about one-third of the distance from the bottom a discontinuity in the image intensities. The bilinear interpolation and handling of texture coordinates is causing this. Figure 3.15(b) shows how to get around this problem. The discontinuity is much less noticeable. The left edge of the texture on the left duplicates the right edge of the texture on the right. When tiling terrain, you want to generate your textures to have color duplication on shared boundaries.

Automatic Generation of Texture Coordinates

Some rendering effects require the texture coordinates to change dynamically. Two of these are environment mapping, where an object is made to appear as if it is reflecting the environment around it, and projected textures, where an object has a texture applied to it as if the texture were projected from a light source. A graphics API can provide the services for updating the texture coordinates instead of requiring the application to explicitly do this. When creating textures of these types, you may use the following interface for Texture:

(a) (b)

Figure 3.15 (a) Clamp *u* and *v* to edge, border color is always ignored. (b) Clamp *u* and *v* to edge, but textures were created differently. (See also Color Plate 3.15.)

```
class Texture : public Object
{
public:
    enum // TexGenMode
    {
        TG_NONE,
        TG_ENVIRONMENT_MAP,
        TG_PROJECTED_TEXTURE,
        TG_QUANTITY
    };

    int Texgen;  // default: TG_NONE
};
```

I only support the two aforementioned effects, but if you add new ones, you will need to add more enumerated values to the class. You should add these after the TG_PROJECTED_TEXTURE item, but before the TG_QUANTITY item, to guarantee that the streaming system loads already saved files correctly. In other words, if you insert a new enumerated value elsewhere, you will cause a change in the implicit numbering of the values, thereby invalidating the numbers that were saved in previous streaming operations to disk.

The `Effect` system that I describe later already has derived classes to support environment mapping and projected textures, so there is no need for you to explicitly manipulate the `Texgen` data member. You can just provide the texture image to `EnvironmentMapEffect` and `ProjectedTextureEffect` and attach the effect to a node.

Application Mode

The `Texture` class has enumerated values that specify how a texture is to be applied to an object. This is called the *apply mode*:

```
class Texture : public Object
{
public:
    enum // ApplyMode
    {
        AM_REPLACE,
        AM_DECAL,
        AM_MODULATE,
        AM_BLEND,
        AM_ADD,
        AM_COMBINE,
        AM_QUANTITY
    };

    int Apply;  // default: AM_REPLACE
};
```

For a single texture, the mode you want is `AM_REPLACE`. This tells the graphics system to just draw the texture image on the object. Any colors that were drawn to the object pixels previously are *replaced* by those from the texture image.

The other enumerated values have to do with the blending of multiple textures onto an object, the topic of the next subsection.

3.4.4 MULTITEXTURING

The term *multitexturing* refers to drawing an object with two or more texture images. A classic application is light maps. A primary texture is drawn on the object, and a secondary texture representing variations in light intensity is then applied to the object. The colors from the primary and secondary texture images must be combined somehow, much like the blending that occurs with `AlphaBlending`.

The `Texture` class has a variable for storing an apply mode. The relevant interface is

Table 3.4 Blending equations for the apply mode values. The alpha channel is handled separately from the red, green, and blue channels.

Apply mode/ image type	RGB		RGBA	
AM_REPLACE	\mathbf{C}_t	A_f	\mathbf{C}_t	A_t
AM_DECAL	\mathbf{C}_t	A_f	$(1-A_t)\mathbf{C}_f + A_t\mathbf{C}_t$	A_f
AM_MODULATE	$\mathbf{C}_t\mathbf{C}_f$	A_f	$\mathbf{C}_t\mathbf{C}_f$	$A_t A_f$
AM_BLEND	$(\mathbf{1}-\mathbf{C}_t)\mathbf{C}_f + \mathbf{C}_t\mathbf{C}_c$	A_f	$(\mathbf{1}-\mathbf{C}_t)\mathbf{C}_f + \mathbf{C}_t\mathbf{C}_c$	$A_t A_f$
AM_ADD	$\mathbf{C}_t + \mathbf{C}_f$	A_f	$\mathbf{C}_t + \mathbf{C}_f$	$A_t A_f$

```
class Texture : public Object
{
public:
    enum // ApplyMode
    {
        AM_REPLACE,
        AM_DECAL,
        AM_MODULATE,
        AM_BLEND,
        AM_ADD,
        AM_COMBINE,
        AM_QUANTITY
    };

    ColorRGBA BlendColor;   // default: ColorRGBA(0,0,0,1)

    int Apply;  // default: AM_REPLACE
};
```

I already discussed that objects to be drawn with a single texture, and no vertex colors or material colors, should use AM_REPLACE. The remaining enumerated values have to do with blending the texture image colors with other quantities. Wild Magic supports 24-bit RGB and 32-bit RGBA images. The apply modes perform blending according to Table 3.4.

The vector arguments are RGB colors, $\mathbf{C}_s = (r_s, g_s, b_s)$ for source index $s \in \{t, c, f\}$. The arguments A_s are alpha values. The *texture color* (\mathbf{C}_t, A_t) comes from the RGBA image associated with the texture unit. The color itself may be filtered based on the mode assigned to the data member Texture::Filter. The *primary color*

(\mathbf{C}_f, A_f) comes from vertex colors or material colors (interpolated across the triangles, of course). The primary colors are computed before any texturing is applied. The *constant color* (\mathbf{C}_c, A_c) is the color assigned to Texture::BlendColor.

The mode that gives you full control over the blending is AM_COMBINE. When the renderer encounters a texture object, it passes its information along to the graphics API. If the combine mode is in effect, the graphics API must be told what the blending equation should be. The equations are not in themselves complicated, but the colors to be blended can come from a variety of sources. The Texture class has additional information that you must set in order to control the blending equation, the sources, and the operations among the sources. The relevant portion of the interface when Apply is set to Texture::AM_COMBINE is

```
class Texture : public Object
{
public:
    enum // ApplyCombineFunction
    {
        ACF_REPLACE,
        ACF_MODULATE,
        ACF_ADD,
        ACF_ADD_SIGNED,
        ACF_SUBTRACT,
        ACF_INTERPOLATE,
        ACF_DOT3_RGB,
        ACF_DOT3_RGBA,
        ACF_QUANTITY
    };

    enum // ApplyCombineSrc
    {
        ACS_TEXTURE,
        ACS_PRIMARY_COLOR,
        ACS_CONSTANT,
        ACS_PREVIOUS,
        ACS_QUANTITY
    };

    enum // ApplyCombineOperand
    {
        ACO_SRC_COLOR,
        ACO_ONE_MINUS_SRC_COLOR,
        ACO_SRC_ALPHA,
        ACO_ONE_MINUS_SRC_ALPHA,
        ACO_QUANTITY
    };
```

```
enum // ApplyCombineScale
{
    ACSC_ONE,
    ACSC_TWO,
    ACSC_FOUR,
    ACSC_QUANTITY
};

int CombineFuncRGB;       // default: ACF_REPLACE
int CombineFuncAlpha;     // default: ACF_REPLACE
int CombineSrc0RGB;       // default: ACS_TEXTURE
int CombineSrc1RGB;       // default: ACS_TEXTURE
int CombineSrc2RGB;       // default: ACS_TEXTURE
int CombineSrc0Alpha;     // default: ACS_TEXTURE
int CombineSrc1Alpha;     // default: ACS_TEXTURE
int CombineSrc2Alpha;     // default: ACS_TEXTURE
int CombineOp0RGB;        // default: ACO_SRC_COLOR
int CombineOp1RGB;        // default: ACO_SRC_COLOR
int CombineOp2RGB;        // default: ACO_SRC_COLOR
int CombineOp0Alpha;      // default: ACO_SRC_COLOR
int CombineOp1Alpha;      // default: ACO_SRC_COLOR
int CombineOp2Alpha;      // default: ACO_SRC_COLOR
int CombineScaleRGB;      // default: ACSC_ONE
int CombineScaleAlpha;    // default: ACSC_ONE
};
```

The parameters and names are quite daunting, but once you understand how these are used to generate a blending equation, you should find these useful for advanced multitexturing effects.

The parameter CombineFuncRGB lets you specify the blending of the red, green, and blue colors. The alpha channel is handled by a separate function specified by CombineFuncAlpha. Table 3.5 lists the possible blending equations based on the selection of CombineFuncRGB and CombineFuncAlpha. The table omits the entries ACF_DOT3_RGB and ACF_DOT3_RGBA; these are used for bump mapping, the topic of Section 5.1.6. The arguments can be scalars (alpha values) or 3-tuples (RGB values). Any operations between two 3-tuples are performed componentwise.

The CombineSrc[i] and CombineOp[i] parameters determine what the V_i values are for $i \in \{0, 1, 2\}$. Table 3.6 lists the possible V_i values. The vector arguments are RGB colors, $\mathbf{C}_s = (r_s, g_s, b_s)$ for source index $s \in \{t, c, f, p\}$. The arguments A_s are alpha values. The *texture color* (\mathbf{C}_t, A_t) comes from the RGBA image associated with the texture unit. The color itself may be filtered based on the mode assigned to the data member Texture::Filter. The *primary color* (\mathbf{C}_f, A_f) comes from vertex colors or material colors (interpolated across the triangles, of course). The primary colors are computed before any texturing is applied. The *constant color* (\mathbf{C}_c, A_c) is the color assigned to Texture::BlendColor. The *previous color* (\mathbf{C}_p, A_p) is the output from the

Table 3.5 Combine functions and their corresponding blending equations.

Combine function	Blending equation
ACF_REPLACE	V_0
ACF_MODULATE	$V_0 * V_1$
ACF_ADD	$V_0 + V_1$
ACF_ADD_SIGNED	$V_0 + V_1 - \frac{1}{2}$
ACF_SUBTRACT	$V_0 - V_1$
ACF_INTERPOLATE	$V_0 * V_2 + V_1 * (1 - V_2)$

Table 3.6 The pair `CombineSrc[i]` and `CombineOp[i]` determine the argument V_i.

Src/op	ACO_SRC_COLOR	ACO_ONE_MINUS_ SRC_COLOR	ACO_SRC_ALPHA	ACO_ONE_MINUS_ SRC_ALPHA
ACS_TEXTURE	\mathbf{C}_t	$1 - \mathbf{C}_t$	A_t	$1 - A_t$
ACS_PRIMARY_COLOR	\mathbf{C}_f	$1 - \mathbf{C}_f$	A_f	$1 - A_f$
ACS_CONSTANT	\mathbf{C}_c	$1 - \mathbf{C}_c$	A_c	$1 - A_c$
ACS_PREVIOUS	\mathbf{C}_p	$1 - \mathbf{C}_p$	A_p	$1 - A_p$

texture unit previous to the current one. If the current texture unit is unit 0, then the previous color is the same as the primary color; that is, the inputs to texture unit 0 are the vertex colors or material colors.

After the blending equation is computed, it is possible to magnify the resulting color by a scaling factor of 1 (keep the resulting color), 2, or 4. If any color channel of the scaled color is greater than 1, it is clamped to 1. You may select the scaling parameter by setting `CombineScaleRGB` and `CombineScaleAlpha`. The valid parameters to assign are `ACSC_ONE`, `ACSC_TWO`, or `ACSC_FOUR`.

As an example, consider Equation (3.7), which blends a light map with a base texture, but avoids the oversaturation that a simple addition tends to produce. That equation is rewritten as

$$V_0 * V_2 + V_1 * (1 - V_2) = 1 * \mathbf{C}_d + \mathbf{C}_s * (1 - \mathbf{C}_d),$$

where \mathbf{C}_d is a base texture color and \mathbf{C}_s is a light map color. The vector **1** represents the color white. The `Texture::ACF_INTERPOLATE` function is the one to use. The following

code block sets up the combine function, sources, and operands to obtain the desired effect:

```
Texture* pkBase = <goes in texture unit 0>;
Texture* pkLightMap = <goes in texture unit 1>;

// draw the base texture onto the triangle first
pkBase->Apply = Texture::AM_REPLACE;

// use the interpolate combine function
pkLightMap->Apply = Texture::AM_COMBINE;
pkLightMap->CombineFuncRGB = Texture::ACF_INTERPOLATE;

// V0 = (1,1,1)
pkLightMap->BlendColor = ColorRGBA::WHITE;
pkLightMap->CombineSrc0RGB = Texture::ACS_CONSTANT;
pkLightMap->CombineOp0RGB = Texture::ACO_SRC_COLOR;

// V1 = base texture (previous texture unit values)
pkLightMap->CombineSrc1RGB = Texture::ACS_PREVIOUS;
pkLightMap->CombineOp1RGB = Texture::ACO_SRC_COLOR;

// V2 = light map (current texture unit values)
pkLightMap->CombineSrc2RGB = Texture::ACS_TEXTURE;
pkLightMap->CombineOp2RGB = Texture::ACO_SRC_COLOR;
```

The simple addition $V_0 + V_1$ can be controlled by a combine function:

```
// draw the base texture onto the triangle first
pkBase->Apply = Texture::AM_REPLACE;

// use the add function
pkLightMap->Apply = Texture::AM_COMBINE;
pkLightMap->CombineFuncRGB = Texture::ACF_ADD;

// V0 = base texture
pkLightMap->CombineSrc0RGB = Texture::ACS_PREVIOUS;
pkLightMap->CombineOp0RGB = Texture::ACO_SRC_COLOR;

// V1 = light map
pkLightMap->CombineSrc1RGB = Texture::ACS_TEXTURE;
pkLightMap->CombineOp1RGB = Texture::ACO_SRC_COLOR;
```

However, the apply mode `AM_ADD` works as well:

```
// draw the base texture onto the triangle first
pkBase->Apply = Texture::AM_REPLACE;

// add the light map to the base texture
pkLightMap->Apply = Texture::AM_ADD;
```

As you can see, there are many ways you can obtain the same effect.

3.4.5 EFFECTS

The *effects system* in Wild Magic version 3 is a new invention to the engine. Wild Magic version 2 had a base class `RenderState` that encapsulated what I now call global states, lights, and texture information. In both versions of the engine, the `Texture` class stores information to configure the texture units on the graphics hardware and also stores a smart pointer to the texture image. In Wild Magic version 2, I had a class `TextureState` that stored an array of `Texture` objects, supporting multitexturing in a sense. A `TextureState` could be attached to a `Node`. All geometry leaf objects in the subtree rooted at the node used the `Texture` objects of the `TextureState`. On the other hand, the `Geometry` objects stored their own texture coordinates. To configure the texture units, the renderer needed to obtain the texture image and setup information from the `TextureState` object and texture coordinates from the `Geometry` object.

In a multitexturing situation, a further complication was that one `TextureState` could store the base texture in slot 0 of the array and be attached to one node in the scene hierarchy. Another `TextureState` could store the secondary texture and be attached to another node. The idea is that the accumulation of the texture states along a path from the root node to a leaf would lead to an array of `Texture` objects to be used in the multitexturing. The accumulation maintained an array whose slot 0 stored the `Texture` from slot 0 of any `TextureState` encountered along the path. In the current example, that means the `TextureState` storing the secondary texture cannot store it in slot 0; otherwise one of the texture objects hides the other. That means storing the secondary texture in, say, slot 1. The consequence of this design is that the application writer has to be very careful (and has the responsibility) about how to fill the slots in the `TextureState`. As some contractors added special effects to Wild Magic, the problems with my design became apparent.

In particular, projected textures were a problem. A projected texture is intended to be the last texture applied to a geometric object. Wild Magic version 2 has a `ProjectedTexture` class that is derived from `Node`. The class has a `TextureState` data member to store the `Texture` object corresponding to the projected texture. The intent was to create a specialized node to be an interior node of the scene hierarchy, and to have its texture be the projected texture for all geometry objects at the leafs of the

subtree of the node. The dilemma was which slot in the array of TextureState to place the projected texture. Not knowing the slots used for the textures for the geometry leaf nodes, the only reasonable slot was the last one so as not to hide the textures used by the geometry leaf nodes. But this choice led to yet another problem. If there were four slots, the projected texture was placed in slot 3 (zero-based indexing). Now if a geometry object has only a single texture, placed in slot 0, then the renderer is given an object to draw using two textures. The renderer implementation was set up in a very general manner to iterate through the final array of textures and configure each texture unit accordingly. The texture unit 0 (for the base texture in slot 0) is set up, but texture units 1 and 2 are not used. Texture unit 1 had to be told to pass the output from texture unit 0 without changing it. Similarly, texture unit 2 had to pass the output from texture unit 1 without changing it. Texture unit 3 used the output from texture unit 2 and blended it with the projected texture that was assigned to texture unit 3. Clearly, this is an inefficiency that resulted from a substandard design in the scene graph management front end.

To remedy this for Wild Magic version 3, I scrapped the idea of having lights managed by a LightState object and textures managed by a TextureState object. Regarding textured objects, the renderer should be provided with the geometric information (vertices, normals, indices, transformations), texture information (texture images and texture coordinates), color information (vertex colors), lighting information (lights and material), and any semantics on how to combine these. The scene graph management system has to decide how to package these quantities to send them to the renderer. The packaging should require as little work as possible from the application writer, yet allow the renderer to efficiently gather the information and configure the texture units. The semantics for the configuration should not be exposed to the application writer, as was the projected texture example in Wild Magic version 2 (i.e., having to decide in which array slots to place the texture objects).

The effort to achieve these goals led to a redesign of the core classes Spatial, Geometry, and Node, and to the creation of a base class Effect. Information such as texture objects (images and configuration information), texture coordinates, and vertex colors are stored in Effect. The initial design change was to allow global states to be applied at interior nodes of a scene hierarchy, but allow only "local effects" to be applied at the leaf nodes. The Effect should encapsulate all the relevant information and semantics for producing a desired visual result. Many of the special effects that were added to Wild Magic version 2 as Node-derived classes were replaced by Effect objects that apply only to the geometry objects to which they are attached. However, projected textures were still problematic with regard to the new system. The projected textures usually are applied to a collection of geometric objects in the scene, not just to one. Having a projected texture affect an entire subtree of a scene is still desirable. A small redesign midstream led to allowing "global effects" (such as projected textures, projected shadows, and planar reflections) to occur at interior nodes, yet still based on the premise of Effect encapsulating the drawing attributes, and still leading to a general but efficient renderer implementation.

The discussion of global effects is postponed until Section 3.5.6, at which time I will discuss *multipass* operations. Such operations involve traversing through portions of the scene multiple times. Be aware that *multitexturing* refers to the use of multiple textures on an object. Many of the rendering effects can use single-pass multitexturing. Multipass can involve a single texture, or it can involve multiple textures. In the remainder of this section, the mechanism for local effects is described.

The interface for class Effect is

```
class Effect : public Object
{
public:
    Effect ();
    virtual ~Effect ();

    // Create a clone of the effect.  Colors and textures are
    // shared.  Each derived class can override this behavior and
    // decide what is copied and what is shared.
    virtual Effect* Clone ();

    // data common to many effects
    ColorRGBArrayPtr ColorRGBs;
    ColorRGBAArrayPtr ColorRGBAs;
    TArray<TexturePtr> Textures;
    TArray<Vector2fArrayPtr> UVs;

// internal use
public:
    // function required to draw the effect
    Renderer::DrawFunction Draw;
};
```

The class has storage for vertex colors, either RGB or RGBA, but not both. If you happen to set both, the RGBA colors will be used. Storage for an array of Texture objects is provided. Storage for an array of corresponding texture coordinates is also provided. Usually the arrays should have the same quantity of elements, but that is not necessary if the graphics system is asked to automatically generate the texture coordinates that are associated with a texture object.

The class has a function pointer data member—a pointer to some drawing function in the class Renderer interface. Many of the standard drawing operations are handled by Renderer::DrawPrimitive, but others require special handling. For example, environment mapping is implemented in the Renderer function DrawEnvironmentMap. A derived class will implement its constructors to assign the correct function pointer. The application writer should not manipulate this member.

The base class is not abstract. This allows you to create an Effect object and set the colors and textures as desired. In particular, if you have a special effect that involves a fancy combination of textures, you can do this without having to derive a class from Effect to manage the new feature. However, if the desired effect requires specialized handling by the renderer via a new drawing function in the Renderer interface, then you will need to derive a class from Effect and implement the drawing function in the derived renderer classes.

The Spatial class provides the storage for the effect, including the ability to set/get one:

```
class Spatial : public Object
{
public:
    virtual void SetEffect (Effect* pkEffect);
    Effect* GetEffect () const;

protected:
    EffectPtr m_spkEffect;
};
```

Use of the set/get functions is clear. If you set an effect and the object already had one attached, the old one is removed in the sense that its reference count is decremented. If the count becomes zero, the object is automatically destroyed.

3.4.6 THE CORE CLASSES AND RENDER STATE UPDATES

The core classes Spatial, Geometry, and Node all have some form of support for storing render state and making sure that the renderer has the complete state for each object it draws. The class Geometry has the storage capabilities for the render state that affects it. My decision to do this in Wild Magic version 3 was to provide a single object type (Geometry) to the renderer. Wild Magic version 2 had an abstract rendering that required the object to be passed as the specific types they were, but the interface was cumbersome. The redesign for version 3 has made the rendering interface much more streamlined. The process of assembling the rendering information in the Geometry object is referred to as *updating the render state*.

The portions of the interfaces for classes Spatial, Node, and Geometry that are relevant to updating the render state are

```
class Spatial : public Object
{
public:
    virtual void UpdateRS (TStack<GlobalState*>* akGStack = NULL,
        TStack<Light*>* pkLStack = NULL);
```

```
protected:
    void PropagateStateFromRoot (TStack<GlobalState*>* akGStack,
        TStack<Light*>* pkLStack);
    void PushState (TStack<GlobalState*>* akGStack,
        TStack<Light*>* pkLStack);
    void PopState (TStack<GlobalState*>* akGStack,
        TStack<Light*>* pkLStack);
    virtual void UpdateState (TStack<GlobalState*>* akGStack,
        TStack<Light*>* pkLStack) = 0;
};

class Node : public Object
{
protected:
    virtual void UpdateState (TStack<GlobalState*>* akGStack,
        TStack<Light*>* pkLStack);
};

class Geometry : public Object
{
protected:
    virtual void UpdateState (TStack<GlobalState*>* akGStack,
        TStack<Light*>* pkLStack);
};
```

The entry point into the system is method UpdateRS ("update render state"). The input parameters are containers to assemble the global state and lights during a depth-first traversal of the scene hierarchy. The parameters have default values. The caller of UpdateRS should *not* set these and make a call: object.UpdateRS(). The containers are allocated and managed internally by the update system.

The protected member functions are helper functions for the depth-first traversal. The function PushState pushes any global state and lights that the Spatial object has attached to it onto stacks. The function PopState pops those stacks. The intent is that the stacks are used by all the nodes in the scene hierarhcy as they are visited. Function Node::UpdateState has the responsibility for propagating the update in a recursive traversal of the scene hierarchy. Function Geometry::UpdateState is called at leaf nodes of the hierarchy. It has the reponsibility for copying the contents of the stacks into its appropriate data members. The stacks store smart pointers to global states and lights, so the copy is really a smart pointer copy and the objects are shared.

The render state at a leaf node represents all the global states and lights that occur on the path from the root node to the leaf node. However, the UpdateRS call need only be called at a node whose subtree needs a render state update. Figure 3.16 illustrates a common situation.

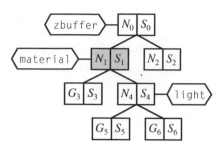

Figure 3.16 A common situation for updating render state.

The z-buffer state is already attached to node N_0, and the light is already attached to node N_4. A material state is attached to node N_1. The render state update is initiated at N_1. The result of the depth-first traversal of the subtree at N_1 is the following: G_3 has links to the z-buffer and material states; G_5 has links to the z-buffer state, the material state, and the light; and G_6 has links to the z-buffer state, the material state, and the light. The z-buffer state is, however, not in the subtree of N_1, so we in fact have to start collecting the states from the root node and along paths that lead to the leaf nodes that are in the subtree of N_1. The function `PropagateStateFromRoot` has the responsibility of starting the render state update at N_1 by first traversing to the root N_0, collecting the render state of the path from N_0 to N_1, and then passing this state to the leaf nodes of the subtree at N_1 together with any additional render state that is in that subtree. Pseudocode for the sequence of operations is listed next. The indentation denotes the level of the calling stack.

```
N1.UpdateRS();
N1: create global state stack GS;      // GS = {}
N1: create light stack LS;             // LS = {}
N1.PropagateStateFromRoot(GS,LS);
    N0.PropagateStateFromRoot(GS,LS);
        N0.PushState(GS,LS);           // GS = {zbuffer}, LS = {}
    N1.PushState(GS,LS);               // GS = {zbuffer,material},
                                       // LS = {}

N1.UpdateState(GS,LS);
    G3.UpdateRS(GS,LS);
        G3.PushState(GS,LS);           // GS = {zbuffer,material},
                                       // LS = {}

        G3.UpdateState(GS,LS);         // share: zbuffer,material
        G3.PopState(GS,LS);
    N4.UpdateRS(GS,LS);
        N4.PushState(GS,LS);           // GS = {zbuffer,material},
                                       // LS = {light}
```

```
       N4.UpdateState(GS,LS);
          G5.UpdateRS(GS,LS);
             G5.PushState(GS,LS);     // GS = {zbuffer,material},
                                      // LS = {light}
                G5.UpdateStore(GS,LS); // share: zbuffer,material,
                                      //        light
                G5.PopState(GS,LS);   // GS = {zbuffer,material},
                                      // LS = {light}
          G6.UpdateRS(GS,LS);
             G6.PushState(GS,LS);     // GS = {zbuffer,material},
                                      // LS = {light}
                G6.UpdateStore(GS,LS); // share: zbuffer,material,
                                      //        light
                G6.PopState(GS,LS);   // GS = {zbuffer,material},
                                      // LS = {light}
          N4.PopState(GS,LS);         // GS = {zbuffer,material},
                                      // LS = {}
N1: destroy global state stack GS;    // GS = {}
N1: destroy light stack LS;           // LS = {}
```

The pseudocode is slightly deceptive in that it indicates the global state stack is initially empty, but in fact it is not. After the stack is allocated, smart pointers to the default global state objects are pushed onto it. The copy of smart pointers from the global state stack to the local storage of Geometry results in a full set of global states to be used when drawing the geometry object, and the global states are the ones that are at the top of the stack. Nothing prevents you from having multiple states of the same type in a single path from root node to leaf node. For example, the root node can have a z-buffer state that enables depth buffering, but a subtree of objects at node N that can be correctly drawn without depth buffering enabled can also have a z-buffer state that disables depth buffering.

At first glance you might be tempted not to have PropagateStateFromRoot in the update system. Consider the current example. Before the material state was attached to node N_1, and assuming the scene hierarchy was current regarding render state, G_3 should have in its local storage the z-buffer. G_5 and G_6 should each have local storage containing the z-buffer and light. When you attach the material to node N_1 and call UpdateRS whose implementation does only the depth-first traversal, it appears the correct states will occur at the geometry leaf nodes. In my implementation this is not the case. The global state stack is initialized to contain all the default global states, including the default z-buffer state. The copy of smart pointers in the Geometry::UpdateState will overwrite the z-buffer state pointer of N_0 with the default z-buffer state pointer, thus changing the behavior at the leaf nodes.

Now you might consider changing the render state update semantics so that the global state stack is initially empty, accumulate only the render states visited in the depth-first traversal, and then have Geometry::UpdateState copy only those pointers

into its local storage. To throw a wrench into the works, suppose that the subtree at N_4 is detached from the scene and a new subtree added as the second child of N_1. The leaf nodes of the new subtree are unaware of the render state that N_1 and its predecessors have. A call to the depth-first-only UpdateRS at N_1 will propagate the render states from N_1 downward, but now the z-buffer state of N_0 is missing from the leaf nodes. To remedy this problem, you should have called UpdateRS at the root node N_0. The leaf nodes will get all the render state they deserve, but unfortunately other subtrees of the scene hierarchy are updated even though they have current render state information. My decision to include PropagateStateFromRoot is based on having as efficient a render state update as possible. In a situation such as the current example, the application writer does not have to call UpdateRS at N_0 when all that has changed is a subtree modification at N_4. In my update system, after the subtree is replaced by a new one, you only need to call UpdateRS at N_4.

The previous discussion does point out that there are various circumstances when you have to call UpdateRS. Clearly, if you attach a new global state or light to a node, you should call UpdateRS to propagate that information to the leaf nodes. Similarly, if you detach a global state or light from a node, the leaf nodes still have smart pointers to those. You must call UpdateRS to eliminate those smart pointers, replacing the global state pointers with ones to the default global states. The light pointers are just removed from the storage. A change in the topology of the scene, such as attaching new children or replacing children at a node N, also requires you to call UpdateRS. This is the only way to inform the leaf nodes of the new subtree about their render state.

If you change the data members in a global state object or in a light object, you do *not* have to call UpdateRS. The local storage of smart pointers in Geometry to the global states and lights guarantees that you are sharing those objects. The changes to the data members are immediately known to the Geometry object, so when the renderer goes to draw the object, it has access to the new values of the data members.

To finish up, here is a brief discussion of the implementations of the render state update functions. The entry point is

```
void Spatial::UpdateRS (TStack<GlobalState*>* akGStack,
    TStack<Light*>* pkLStack)
{
    bool bInitiator = (akGStack == NULL);

    if ( bInitiator )
    {
        // stack initialized to contain the default global states
        akGStack = new TStack<GlobalState*>[GlobalState::MAX_STATE];
        for (int i = 0; i < GlobalState::MAX_STATE; i++)
            akGStack[i].Push(GlobalState::Default[i]);
```

```
        // stack has no lights initially
        pkLStack = new TStack<Light*>;

        // traverse to root and push states from root to this node
        PropagateStateFromRoot(akGStack,pkLStack);
    }
    else
    {
        // push states at this node
        PushState(akGStack,pkLStack);
    }

    // propagate the new state to the subtree rooted here
    UpdateState(akGStack,pkLStack);

    if ( bInitiator )
    {
        delete[] akGStack;
        delete pkLStack;
    }
    else
    {
        // pop states at this node
        PopState(akGStack,pkLStack);
    }
}
```

The initiator of the update calls UpdateRS() with no parameters. The default parameters are null pointers. This lets the function determine that the initiator is the one who is responsible for allocating and deallocating the stacks. Notice that the global state "stack" is really an array of stacks, one stack per global state type. The initiator is also responsible for calling PropagateStateFromRoot. The UpdateState call propagates the update to child nodes for a Node object, but copies the smart pointers in the stacks to local storage for a Geometry object. For the noninitiators, the sequence of calls is effectively

```
PushState(akGStack,pkLStack);
UpdateState(akGStack,pkLStack);
PopState(akGStack,pkLStack);
```

In words: push my state onto the stacks, propagate it to my children, and then pop my state from the stacks.

The propagation of state from the root is

```
void Spatial::PropagateStateFromRoot (
    TStack<GlobalState*>* akGStack, TStack<Light*>* pkLStack)
{
    // traverse to root to allow downward state propagation
    if ( m_pkParent )
        m_pkParent->PropagateStateFromRoot(akGStack,pkLStack);

    // push states onto current render state stack
    PushState(akGStack,pkLStack);
}
```

This is a recursive call that traverses a linear list of nodes. The traversal takes you up the tree to the root, and then you push the states of the nodes as you return to the initiator.

The pushing and popping of state is straightforward:

```
void Spatial::PushState (TStack<GlobalState*>* akGStack,
    TStack<Light*>* pkLStack)
{
    TList<GlobalStatePtr>* pkGList = m_pkGlobalList;
    for (/**/; pkGList; pkGList = pkGList->Next())
    {
        int eType = pkGList->Item()->GetGlobalStateType();
        akGStack[eType].Push(pkGList->Item());
    }

    TList<LightPtr>* pkLList = m_pkLightList;
    for (/**/; pkLList; pkLList = pkLList->Next())
        pkLStack->Push(pkLList->Item());
}

void Spatial::PopState (TStack<GlobalState*>* akGStack,
    TStack<Light*>* pkLStack)
{
    TList<GlobalStatePtr>* pkGList = m_pkGlobalList;
    for (/**/; pkGList; pkGList = pkGList->Next())
    {
        int eType = pkGList->Item()->GetGlobalStateType();
        GlobalState* pkDummy;
        akGStack[eType].Pop(pkDummy);
    }
```

```
        TList<LightPtr>* pkLList = m_pkLightList;
        for (/**/; pkLList; pkLList = pkLList->Next())
        {
            Light* pkDummy;
            pkLStack->Pop(pkDummy);
        }
    }
```

The code iterates over a list of global states attached to the object and pushes them on the stack (pops them from the stack) corresponding to the type of the state. The code also iterates over a list of lights attached to the object and pushes them on the stack (pops them from the stack).

The propagation of the update down the tree is

```
void Node::UpdateState (TStack<GlobalState*>* akGStack,
    TStack<Light*>* pkLStack)
{
    for (int i = 0; i < m_kChild.GetQuantity(); i++)
    {
        Spatial* pkChild = m_kChild[i];
        if ( pkChild )
            pkChild->UpdateRS(akGStack,pkLStack);
    }
}
```

This, too, is a straightforward operation. Just as with the geometric update functions `UpdateGS` and `UpdateWorldData`, the pair `UpdateRS` and `UpdateState` form a recursive chain (A calls B, B calls A, etc.).

Finally, the copy of smart pointers from the stacks to local storage is

```
void Geometry::UpdateState (TStack<GlobalState*>* akGStack,
    TStack<Light*>* pkLStack)
{
    // update global state
    int i;
    for (i = 0; i < GlobalState::MAX_STATE; i++)
    {
        GlobalState* pkGState = NULL;
        akGStack[i].GetTop(pkGState);
        assert( pkGState );
        States[i] = pkGState;
    }
```

```
    // update lights
    Light* const* akLight = pkLStack->GetData();
    int iQuantity = pkLStack->GetQuantity();
    for (i = 0; i < iQuantity; i++)
        Lights.Append(akLight[i]);
}
```

No surprises here, either. The Geometry class has an array of smart pointers to GlobalState for global state storage, and it maintains a list of lights. Although the light list may be arbitrarily long, in practice the graphics APIs limit you to a fixed number, typically eight. The rendering system is designed to process only those lights up to the predetermined maximum.

3.5 Renderers and Cameras

This section describes the two basic objects that are necessary to draw a scene—renderers and cameras. A camera model is simpler to describe than a renderer, so I will discuss cameras first.

3.5.1 Camera Models

Only a portion of the world is displayed at any one time; this region is called the *view volume*. Objects outside the view volume are not visible and therefore not drawn. The process of determining which objects are not visible is called *culling*. Objects that intersect the boundaries of the view volume are only partially visible. The visible portion of an object is determined by intersecting it with the view volume, a process called *clipping*.

The display of visible data is accomplished by projecting it onto a *view plane*. Wild Magic uses perspective projection. Our assumption is that the view volume is a bounded region in space, so the projected data lies in a bounded region in the view plane. A rectangular region in the view plane that contains the projected data is called a *viewport*. The viewport is what is drawn on the rectangular computer screen. The standard view volume used is called the *view frustum*. It is constructed by selecting an eye point and forming an infinite pyramid with four planar sides. Each plane contains the eye point and an edge of the viewport. The infinite pyramid is truncated by two additional planes called the *near plane* and the *far plane*. Figure 3.17 shows a view frustum. The perspective projection is computed by intersecting a ray with the view plane. The ray has origin \mathbf{E}, the eye point, and passes through the world point \mathbf{X}. The intersection point is \mathbf{X}_p.

The combination of an eye point, a view plane, a viewport, and a view frustum is called a *camera model*. The model has a coordinate system associated with

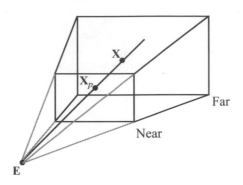

Figure 3.17 An eye point **E** and a view frustum. The point **X** in the view frustum is projected to the point \mathbf{X}_p in the viewport.

it. The *camera origin* is the eye point **E**. The *camera direction vector* (the view vector) is the unit-length vector **D** that is perpendicular to the view plane. The eye point is considered to be on the negative side of the plane. The *camera up vector* is the unit-length **U** vector chosen to be parallel to two opposing edges of the viewport. The *camera right vector*[8] is the unit-length vector **R** chosen to be perpendicular to the camera direction and camera up vector with $\mathbf{R} = \mathbf{D} \times \mathbf{U}$. The set of vectors $\{\mathbf{D}, \mathbf{U}, \mathbf{R}\}$ is a right-handed system and may be stored as columns of a rotation matrix $R = [\mathbf{D}\ \mathbf{U}\ \mathbf{R}]$. The right vector is parallel to two opposing edges of the viewport.

Figure 3.18 shows the camera model, including the camera coordinate system and the view frustum. The six frustum planes are labeled with their names: near, far, left, right, bottom, top. The camera location **E** and the camera axis directions **D**, **U**, and **R** are shown. The view frustum has eight vertices. The near plane vertices are $\mathbf{V}_{t\ell}$, $\mathbf{V}_{b\ell}$, \mathbf{V}_{tr}, and \mathbf{V}_{br}. Each subscript consists of two letters, the first letters of the frustum planes that share that vertex. The far plane vertices have the name **W** and use the same subscript convention. The equations for the vertices are

8. And there was much rejoicing! Wild Magic version 2 had a *left vector* $\mathbf{L} = \mathbf{U} \times \mathbf{D}$. My choice was based on storing the camera axis vectors in the local rotation matrices as $R = [\mathbf{L}\ \mathbf{U}\ \mathbf{D}]$; that is, the axis vectors are the columns of the matrix. The default values were chosen so that $R = I$, the identity matrix. This had been a source of so much confusion that I changed my default camera model to resemble the OpenGL default camera model.

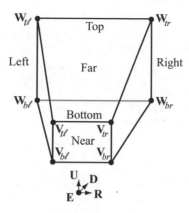

Figure 3.18 A camera model and view frustum.

$$\mathbf{V}_{b\ell} = \mathbf{E} + d_{\min}\mathbf{D} + u_{\min}\mathbf{U} + r_{\min}\mathbf{R}$$

$$\mathbf{V}_{t\ell} = \mathbf{E} + d_{\min}\mathbf{D} + u_{\max}\mathbf{U} + r_{\min}\mathbf{R}$$

$$\mathbf{V}_{br} = \mathbf{E} + d_{\min}\mathbf{D} + u_{\min}\mathbf{U} + r_{\max}\mathbf{R}$$

$$\mathbf{V}_{tr} = \mathbf{E} + d_{\min}\mathbf{D} + u_{\max}\mathbf{U} + r_{\max}\mathbf{R}$$

$$\mathbf{W}_{b\ell} = \mathbf{E} + \frac{d_{\max}}{d_{\min}}\left(d_{\min}\mathbf{D} + u_{\min}\mathbf{U} + r_{\min}\mathbf{R}\right)$$

$$\mathbf{W}_{t\ell} = \mathbf{E} + \frac{d_{\max}}{d_{\min}}\left(d_{\min}\mathbf{D} + u_{\max}\mathbf{U} + r_{\min}\mathbf{R}\right)$$

$$\mathbf{W}_{br} = \mathbf{E} + \frac{d_{\max}}{d_{\min}}\left(d_{\min}\mathbf{D} + u_{\min}\mathbf{U} + r_{\max}\mathbf{R}\right)$$

$$\mathbf{W}_{tr} = \mathbf{E} + \frac{d_{\max}}{d_{\min}}\left(d_{\min}\mathbf{D} + u_{\max}\mathbf{U} + r_{\max}\mathbf{R}\right). \tag{3.11}$$

The near plane is at a distance d_{\min} from the camera location and the far plane is at a distance d_{\max}. These distances are the extreme values in the \mathbf{D} direction. The extreme values in the \mathbf{U} direction are u_{\min} and u_{\max}. The extreme values in the \mathbf{R} direction are r_{\min} and r_{\max}.

Object culling is implemented to use plane-at-a-time culling. The frustum planes are assigned unit-length normals that point inside the frustum. A bounding volume is tested against each frustum plane. If the bounding volume is fully outside one of

the planes, the object is not visible and is culled from the display system. To support culling we need to know the equations of the six frustum planes.

The near plane has inner-pointing, unit-length normal \mathbf{D}. A point on the plane is $\mathbf{E} + d_{\min}\mathbf{D}$. An equation of the near plane is

$$\mathbf{D} \cdot \mathbf{X} = \mathbf{D} \cdot (\mathbf{E} + d_{\min}\mathbf{D}) = \mathbf{D} \cdot \mathbf{E} + d_{\min}. \tag{3.12}$$

The far plane has inner-pointing, unit-length normal $-\mathbf{D}$. A point on the plane is $\mathbf{E} + d_{\max}\mathbf{D}$. An equation of the far plane is

$$-\mathbf{D} \cdot \mathbf{X} = -\mathbf{D} \cdot (\mathbf{E} + d_{\max}\mathbf{D}) = -(\mathbf{D} \cdot \mathbf{E} + d_{\max}). \tag{3.13}$$

The left plane contains the three points \mathbf{E}, $\mathbf{V}_{t\ell}$, and $\mathbf{V}_{b\ell}$. A normal vector that points inside the frustum is

$$(\mathbf{V}_{b\ell} - \mathbf{E}) \times (\mathbf{V}_{t\ell} - \mathbf{E}) = (d_{\min}\mathbf{D} + u_{\min}\mathbf{U} + r_{\min}\mathbf{R}) \times (d_{\min}\mathbf{D} + u_{\max}\mathbf{U} + r_{\min}\mathbf{R})$$

$$= (d_{\min}\mathbf{D} + r_{\min}\mathbf{R}) \times (u_{\max}\mathbf{U}) + (u_{\min}\mathbf{U}) \times (d_{\min}\mathbf{D} + r_{\min}\mathbf{R})$$

$$= (d_{\min}\mathbf{D} + r_{\min}\mathbf{R}) \times ((u_{\max} - u_{\min})\mathbf{U})$$

$$= (u_{\max} - u_{\min})(d_{\min}\mathbf{D} \times \mathbf{U} + r_{\min}\mathbf{R} \times \mathbf{U})$$

$$= (u_{\max} - u_{\min})(d_{\min}\mathbf{R} - r_{\min}\mathbf{D}).$$

An inner-pointing, unit-length normal and the left plane are

$$\mathbf{N}_\ell = \frac{d_{\min}\mathbf{R} - r_{\min}\mathbf{D}}{\sqrt{d_{\min}^2 + r_{\min}^2}}, \quad \mathbf{N}_\ell \cdot (\mathbf{X} - \mathbf{E}) = 0. \tag{3.14}$$

An inner-pointing normal to the right plane is $(\mathbf{V}_{tr} - \mathbf{E}) \times (\mathbf{V}_{br} - \mathbf{E})$. A similar set of calculations as before will lead to an inner-pointing, unit-length normal and the right plane:

$$\mathbf{N}_r = \frac{-d_{\min}\mathbf{R} + r_{\max}\mathbf{D}}{\sqrt{d_{\min}^2 + r_{\max}^2}}, \quad \mathbf{N}_r \cdot (\mathbf{X} - \mathbf{E}) = 0. \tag{3.15}$$

Similarly, an inner-pointing, unit-length normal and the bottom plane are

$$\mathbf{N}_b = \frac{d_{\min}\mathbf{U} - u_{\min}\mathbf{D}}{\sqrt{d_{\min}^2 + u_{\min}^2}}, \quad \mathbf{N}_b \cdot (\mathbf{X} - \mathbf{E}) = 0. \tag{3.16}$$

An inner-pointing, unit-length normal and the top plane are

$$\mathbf{N}_t = \frac{-d_{\min}\mathbf{U} + u_{\max}\mathbf{D}}{\sqrt{d_{\min}^2 + u_{\max}^2}}, \quad \mathbf{N}_t \cdot (\mathbf{X} - \mathbf{E}) = 0. \tag{3.17}$$

The Camera Class

Time for a few comments about the Camera class, similar to those for the Light class. In Wild Magic version 2, the Camera class was derived from Object. I considered a Camera a special type of object that had some spatial information, but also a lot of other information that did not warrant it being derived from Spatial. A number of users were critical of this choice and insisted that Camera be derived from Spatial. For example, if you were to build a model of a room with a security camera mounted in a corner, the camera orientation could be modified using a controller (rotate camera back and forth for coverage of the area of the room). The camera itself can be used for rendering what it sees and then displaying that rendering on a television monitor that is also part of the room model. To support this, I added a class CameraNode that is derived from Node and that had a Camera data member. I had a similar class to encapsulate lights, namely, LightNode. But these classes presented some problems to users; one problem had to do with importing LightWave objects into the engine. Because LightWave uses left-handed coordinates for everything, the design of CameraNode and LightNode prevented a correct import of lights (and cameras) when they were to be attached as nodes in a scene.

In Wild Magic version 3, I changed my design and derived Camera from Spatial, thus eliminating the need for CameraNode. The warnings I issued about deriving Light from Spatial apply here as well. Some subsystems of Spatial are available to Camera that are irrelevant. For example, attaching to a camera a global state such as a depth buffer has no meaning, but the engine semantics allow the attachment. You can attach lights to cameras, but this makes no sense. The camera object itself is not renderable. The virtual functions for global state updates and for drawing are stubbed out in the Camera class, so incorrect use of the cameras should not be a problem. So be warned that you can manipulate a Camera as a Spatial object in ways that the engine was not designed to handle.

The portion of the interface for Camera that relates to the camera coordinate system is

```
class Camera : public Spatial
{
public:
    Camera ();

    // Camera frame (local coordinates)
    //    default location  E = (0,0,0)
    //    default direction D = (0,0,-1)
    //    default up        U = (0,1,0)
    //    default right     R = (1,0,0)
    // If a rotation matrix is used for the axis directions, the
    // columns of the matrix are [D U R].  That is, the view
    // direction is in column 0, the up direction is in column 1,
```

```
        // and the right direction is in column 2.
        void SetFrame (const Vector3f& rkLocation,
            const Vector3f& rkDVector, const Vector3f& rkUVector,
            const Vector3f& rkRVector);
        void SetFrame (const Vector3f& rkLocation,
            const Matrix3f& rkAxes);
        void SetLocation (const Vector3f& rkLocation);
        void SetAxes (const Vector3f& rkDVector,
            const Vector3f& rkUVector, const Vector3f& rkRVector);
        void SetAxes (const Matrix3f& rkAxes);
        Vector3f GetLocation () const;  // Local.Translate
        Vector3f GetDVector () const;   // Local.Rotate column 0
        Vector3f GetUVector () const;   // Local.Rotate column 1
        Vector3f GetRVector () const;   // Local.Rotate column 2

        // camera frame (world coordinates)
        Vector3f GetWorldLocation () const;  // World.Translate
        Vector3f GetWorldDVector () const;   // World.Rotate column 0
        Vector3f GetWorldUVector () const;   // World.Rotate column 1
        Vector3f GetWorldRVector () const;   // World.Rotate column 2

    protected:
        virtual void UpdateWorldBound ();
        void OnFrameChange ();
    };
```

Normally, the local transformation variables (translation, rotation, scale) are for exactly that—transformation. In the Camera class, the local translation is interpreted as the origin for a coordinate system of the camera; that is, the local translation is the eye point. The columns of the local rotation matrix are interpreted as the coordinate axis directions for the camera's coordinate system. Think of the camera's right and up vectors as the positive x- and positive y-axes for the display screen. The view direction is into the screen, the negative z-axis. The eye point is not the center of the screen, but is positioned in front of the screen. Because the camera's coordinate system is stored in the local translation vector and local rotation matrix, you should use the interface provided and avoid setting the data member Local explicitly to something that is not consistent with the interpretation as a coordinate system.

The first block of code in the interface is for set/get of the coordinate system parameters. The second block of code in the public interface allows you to retrieve the world coordinates for the camera's (local) coordinate system.

The Camera class has no model bound. However, the camera's position acts as the center of a model bound of radius zero. The virtual function UpdateWorldBound computes the center of a world bound of radius zero. The function OnFrameChange is a wrapper around a call to UpdateGS and is executed whenever you set the coordinate

system components. Therefore, you do not need to explicitly call UpdateGS whenever the coordinate system components are modified. Unlike the Light class, the Camera version of OnFrameChange has the job of computing the world coordinate representations for the frustum planes to be used for culling. It also has the job of informing the renderer associated with it that the camera coordinate system has changed. The renderer takes the appropriate action to update any of its state, such as making specific camera-related calls to the graphics API that it encapsulates.

The two virtual functions in the private section are stubs to implement pure virtual functions in Spatial (as required by C++). None of these make sense for cameras anyway. They exist just so that Camera inherits other properties of Spatial that are useful.

View Frustum Parameters

The view frustum parameters r_{\min} (left), r_{\max} (right), u_{\min} (bottom), u_{\max} (top), d_{\min} (near), and d_{\max} (far) are set/get by the following interface:

```
class Camera : public Spatial
{
public:
    void SetFrustum (float fRMin, float fRMax, float fUMin,
        float fUMax, float fDMin, float fDMax);

    void SetFrustum (float fUpFovDegrees, float fAspectRatio,
        float fDMin, float fDMax);

    void GetFrustum (float& rfRMin, float& rfRMax, float& rfUMin,
        float& rfUMax, float& rfDMin, float& rfDMax) const;

    float GetDMin () const;
    float GetDMax () const;
    float GetUMin () const;
    float GetUMax () const;
    float GetRMin () const;
    float GetRMax () const;

protected:
    void OnFrustumChange ();

    float m_fDMin, m_fDMax, m_fUMin, m_fUMax, m_fRMin, m_fRMax;

    // Values computed in OnFrustumChange that are needed in
    // OnFrameChange.
```

```
    float m_afCoeffL[2], m_afCoeffR[2];
    float m_afCoeffB[2], m_afCoeffT[2];
};
```

For those of you familiar with Wild Magic version 2, notice that the order of the parameters to the first SetFrustum method has changed. The new ordering is the same used by OpenGL's glFrustum function. The second SetFrustum method is equivalent to OpenGL's gluPerspective function. This method creates a symmetric view frustum ($u_{min} = -u_{max}$ and $r_{min} = -r_{max}$) using a field of view specified in the up direction and an aspect ratio corresponding to width divided by height. The field of view is an angle specified in degrees and must be in the interval (0, 180). The angle is that between the top and bottom view frustum planes. The typical aspect ratio is 4/3, but for wide-screen displays is 16/9.

The function OnFrustumChange is a callback that is executed whenever SetFrustum is called. The callback informs the renderer to which the camera is attached that the frustum has changed. The renderer makes the appropriate changes to its state (informing the graphics API of the new frustum parameters). The callback also computes some quantities related to culling—specifically, the coefficients of the coordinate axis vectors in Equations (3.14) through (3.17). The coefficients from Equation (3.14) are stored in m_afCoeffL. The coefficients from Equation (3.15) are stored in m_afCoeffR. The coefficients from Equation (3.16) are stored in m_afCoeffB. The coefficients from Equation (3.17) are stored in m_afCoeffT. The function OnFrameChange is called very frequently and uses these coefficients for computing the world representations of the frustum planes.

You will see in most of the applications that I set the frustum to a symmetric one with the first SetFrustum method. The typical call is

```
// order:  left, right, bottom, top, near, far
m_spkCamera->SetFrustum(-0.55f,0.55f,-0.4125f,0.4125f,1.0f,100.0f);
```

The ratio of right divided by top is 4/3. The near plane distance from the eye point is 1, and the far plane distance is 100. If you decide to modify the near plane distance in an application using this call to SetFrustum, you must modify the left, right, bottom, and top values accordingly. Specifically,

```
float fNear = <some positive value>;
float fFar = <whatever>;
float fLeft = -0.55f*fNear;
float fRight = 0.55f*fNear;
float fBottom = -0.4125f*fNear;
float fTop = 0.4125f*fNear;
m_spkCamera->SetFrustum(fLeft,fRight,fBottom,fTop,fNear,fFar);
```

The second SetFrustum method is probably more intuitive for the user.

A question that arises periodically on the Usenet computer graphics newsgroups is how to do *tiled rendering*. The idea is that you want to have a high-resolution drawing of an object, but the width and/or height of the final result is larger than your computer monitor can display. You can accomplish this by selecting various view frustum parameters and rendering the object as many times as it takes to generate the final image. For example, suppose your computer monitor can display at 1600×1200; that is, the monitor has 1200 scan lines, and each scan line has 1600 columns. To generate an image that is 3200×2400, you can render the scene four times, each rendering to a window that is 1600×1200. I have not yet described the renderer interface, but the use of it is clear in this example. The view frustum is symmetric in this example.

```
// initialization code
NodePtr m_spkScene = <the scene graph>;
Renderer* m_pkRenderer = <the renderer>;
CameraPtr m_spkCamera = <the camera assigned to the renderer>;
float m_fDMin = <near plane distance>;
float m_fDMax = <far plane distance>;
float m_fRMax = <some value>;
float m_fUMax = <some value>;
m_spkCamera->SetFrustum(-m_fRMax,m_fRMax,-m_fUMax,m_fUMax,
    m_fDMin,m_fDMax);

// keyboard handler code (ucKey is the input keystroke)
switch (ucKey)
{
case 0:  // draw all four quadrants
    m_spkCamera->SetFrustum(-m_fRMax,m_fRMax,-m_fUMax,m_fUMax,
        m_fDMin,m_fDMax);
    break;
case 1:  // upper-right quadrant
    m_spkCamera->SetFrustum(0.0f,m_fRMax,0.0f,m_fUMax,
        m_fDMin,m_fDMax);
    break;
case 2:  // upper-left quadrant
    m_spkCamera->SetFrustum(-m_fRMax,0.0f,0.0f,m_fUMax,
        m_fDMin,m_fDMax);
    break;
case 3:  // lower-left quadrant
    m_spkCamera->SetFrustum(-m_fRMax,0.0f,-m_fUMax,0.0f,
        m_fDMin,m_fDMax);
    break;
```

```
case 4:  // lower-right quadrant
    m_spkCamera->SetFrustum(0.0f,m_fRMax,-m_fUMax,0.0f,
        m_fDMin,m_fDMax);
    break;
}

// idle-loop callback or on-display callback
m_pkRenderer->DrawScene(m_spkScene);
```

I use the keyboard handler approach on a Microsoft Windows machine so that I can use ALT+PRINTSCREEN to capture the window contents, edit it in Windows Paint to keep only the contents of the client window, and then copy that into the appropriate quadrant in a bitmap file of size 3200 × 2400. You can certainly automate this task by rendering each tile one at a time, and then reading the frame buffer contents after each rendering and copying it to the appropriate location in a memory block that will eventually be saved as a bitmap file.

Viewport Parameters

The viewport parameters are used to represent the computer screen in normalized display coordinates $(\bar{x}, \bar{y}) \in [0, 1]^2$. The left edge of the screen is $\bar{x} = 0$, and the right edge is $\bar{x} = 1$. The bottom edge is $\bar{y} = 0$, and the top edge is $\bar{y} = 1$. The Camera interface is

```
class Camera : public Spatial
{
public:
    void SetViewPort (float fLeft, float fRight, float fTop,
        float fBottom);
    void GetViewPort (float& rfLeft, float& rfRight, float& rfTop,
        float& rfBottom);

protected:
    void OnViewPortChange ();

    float m_fPortL, m_fPortR, m_fPortT, m_fPortB;
};
```

The function OnViewPortChange is a callback that is executed whenever SetViewPort is called. The callback informs the renderer to which the camera is attached that the viewport has changed. The renderer makes the appropriate changes to its state (informing the graphics API of the new viewport parameters).

In most cases the viewport is chosen to be the entire screen. However, some applications might want to display an offset window with a rendering that is separate from what occurs in the main window. For example, you might have an application that draws a scene based on a camera at an arbitrary location and with an arbitrary orientation. A front view, top view, and side view might also be desired using fixed cameras. The four desired renderings may be placed in four quadrants of the screen. The sample code shows how to do this. Once again, I have not discussed the renderer interface, but the use of it is clear.

```
// initialization (all camera frames assumed to be set properly)
NodePtr m_spkScene = <the scene graph>;
Renderer* m_pkRenderer = <the renderer>;
CameraPtr m_spkACamera = <the camera for arbitrary drawing>;
CameraPtr m_spkFCamera = <the camera for front view>;
CameraPtr m_spkTCamera = <the camera for top view>;
CameraPtr m_spkSCamera = <the camera for side view>;
m_spkACamera->SetViewport(0.0f,0.5f,1.0f,0.5f);  // upper left
m_spkFCamera->SetViewport(0.5f,1.0f,1.0f,0.5f);  // upper right
m_spkTCamera->SetViewport(0.0f,0.5f,0.5f,0.0f);  // lower left
m_spkSCamera->SetViewport(0.5f,1.0f,0.5f,0.0f);  // lower right

// on-idle callback
m_pkRenderer->SetCamera(m_spkACamera);
m_pkRenderer->DrawScene(m_spkScene);
m_pkRenderer->SetCamera(m_spkFCamera);
m_pkRenderer->DrawScene(m_spkScene);
m_pkRenderer->SetCamera(m_spkTCamera);
m_pkRenderer->DrawScene(m_spkScene);
m_pkRenderer->SetCamera(m_spkSCamera);
m_pkRenderer->DrawScene(m_spkScene);
```

I used four separate cameras in this example. It is also possible to use a single camera, but change its position, orientation, and viewport before each rendering:

```
// initialization code
NodePtr m_spkScene = <the scene graph>;
Renderer* m_pkRenderer = <the renderer>;
CameraPtr m_spkCamera = <the camera assigned to the renderer>;
Vector3f kACLoc = <camera location for arbitrary view>;
Matrix3f kACAxes = <camera orientation for arbitrary view>;
Vector3f kFCLoc = <camera location for front view>;
Matrix3f kFCAxes = <camera orientation for front view>;
Vector3f kTCLoc = <camera location for top view>;
Matrix3f kTCAxes = <camera orientation for top view>;
```

```
Vector3f kSCLoc = <camera location for side view>;
Matrix3f kSCAxes = <camera orientation for side view>;

// on-idle callback
m_spkCamera->SetFrame(kACLoc,kACAxes);
m_spkCamera->SetViewport(0.0f,0.5f,1.0f,0.5f);
m_pkRenderer->DrawScene(m_spkScene);
m_spkCamera->SetFrame(kFCLoc,kFCAxes);
m_spkCamera->SetViewport(0.5f,1.0f,1.0f,0.5f);
m_pkRenderer->DrawScene(m_spkScene);
m_spkCamera->SetFrame(kTCLoc,kTCAxes);
m_spkCamera->SetViewport(0.0f,0.5f,0.5f,0.0f);
m_pkRenderer->DrawScene(m_spkScene);
m_spkCamera->SetFrame(kSCLoc,kSCAxes);
m_spkCamera->SetViewport(0.5f,1.0f,0.5f,0.0f);
m_pkRenderer->DrawScene(m_spkScene);
```

Object Culling

The object culling support in the Camera class is the most sophisticated subsystem for the camera. This system interacts with the Spatial class during the drawing pass of the scene graph. I will talk about the drawing pass later, but for now it suffices to say that the Spatial class has the following interface for drawing:

```
class Spatial : public Object
{
public:
    BoundingVolumePtr WorldBound;
    bool ForceCull;

// internal use
public:
    void OnDraw (Renderer& rkRenderer, bool bNoCull = false);
    virtual void Draw (Renderer& rkRenderer,
        bool bNoCull = false) = 0;
};
```

We have already seen the WorldBound data member. It is used for culling purposes. The Boolean flag ForceCull allows a user to force the object not to be drawn, which is especially convenient for a complicated system that partitions the world into cells. Each cell maintains two lists: One list is for the visible objects; the other for the invisible objects, whenever the camera is in the cell. At the moment the camera enters

the cell, the list of visible objects is traversed. Each object has its ForceCull flag set to false. The other list is traversed, and each object has its ForceCull flag set to true.

Notice that the second public block is flagged for internal use. An application should never call these functions. A call to the function OnDraw is a request that the object draw itself. The drawing itself is performed by Draw. If the input parameter bNoCull is set to true, if the object is not force-culled, then the culling tests that compare the world bound to the view frustum planes are skipped.

Before drawing itself, the object must check to see if it is potentially visible. If not, it culls itself; that is, it does not call the Draw function. The code for OnDraw is

```
void Spatial::OnDraw (Renderer& rkRenderer, bool bNoCull)
{
    if ( ForceCull )
        return;

    CameraPtr spkCamera = rkRenderer.GetCamera();
    unsigned int uiState = spkCamera->GetPlaneState();

    if ( bNoCull || !spkCamera->Culled(WorldBound) )
        Draw(rkRenderer,bNoCull);

    spkCamera->SetPlaneState(uiState);
}
```

If ForceCull is set to true, the request to be drawn is denied. Otherwise, the object gets access to the camera attached to the renderer. Before attempting the culling, some camera state information is saved (on the calling stack) in the local variable uiState. Before exiting OnDraw, that state is restored. More about this in a moment. Assuming the object allows the culling tests (bNoCull set to false), a call is made to Camera::Culled. This function compares the world bound to the view frustum planes (in world coordinates). If the world bound is outside any of the planes, the function returns true, indicating that the object is culled. If the object is not culled, finally the drawing occurs via the function Draw. As we will see, Node::Draw propagates the drawing request to its children, so OnDraw and Draw form a recursive chain.

Now about the camera state that is saved and restored. I mentioned earlier that in a scene hierarchy, if a bounding volume of a node is *inside* a view frustum plane, the object contained by the bounding volume is also inside the plane. The objects represented by child nodes must necessarily be inside the plane, so there is no reason to compare a child's bounding volume to this same frustum plane. The Camera class maintains a bit flag (as an unsigned int) where each bit corresponds to a frustum plane. A bit value of 1 says that the bounding volume should be compared to the plane corresponding to that bit, and a bit value of 0 says to skip the comparison. The bits in the flag are all initialized to 1 in the Camera constructor. A drawing pass will set and restore these bits, so at the end of a drawing pass, the bits are all 1 again. The

determination that a bounding volume is inside a frustum plane is made during the
`Camera::Culled` call. If the bounding volume is inside, the corresponding bit is set to
0. On a recursive call to Draw, the `Camera::Culled` function will be called for the child
nodes. When a zero bit is encountered, the camera knows not to compare the child's
bounding volume to the corresponding frustum plane because the parent's bounding
volume is already inside that plane. The goal of maintaining the bit flags is to reduce
the computational time spent in comparing bounding volumes to frustum planes—
particularly important when the comparison is an expensive calculation (convex hull
versus plane, for example).

The portion of the Camera interface relevant to the culling discussion to this point
is

```
class Camera : public Spatial
{
protected:
    unsigned int m_uiPlaneState;

    // world planes:
    //    left = 0, right = 1, bottom = 2,
    //    top = 3, near = 4, far = 5,
    //    extra culling planes >= 6
    enum
    {
        CAM_FRUSTUM_PLANES = 6,
        CAM_MAX_WORLD_PLANES = 32
    };
    int m_iPlaneQuantity;
    Plane3f m_akWPlane[CAM_MAX_WORLD_PLANES];

// internal use
public:
    // culling support in Spatial::OnDraw
    void SetPlaneState (unsigned int uiPlaneState);
    unsigned int GetPlaneState () const;
    bool Culled (const BoundingVolume* pkWBound);
};
```

The data member `m_uiPlaneState` is the set of bits corresponding to the frustum
planes. Bit 0 is for the left plane, bit 1 is for the right plane, bit 2 is for the bottom
plane, bit 3 is for the top plane, bit 4 is for the near plane, and bit 5 is for the far plane.
The data member `m_iPlaneQuantity` specifies how many planes are in the system. This
number is at least six, but can be larger! The world representations for the planes are
stored in `m_akWPlane`. We already saw in `Spatial::OnDraw` the use of `SetPlaneState` and
`GetPlaneState` for the bit flag management.

The final function to consider is `Culled`:

```
bool Camera::Culled (const BoundingVolume* pkWBound)
{
    // Start with last pushed plane (potentially the most
    // restrictive plane).
    int iP = m_iPlaneQuantity - 1;
    unsigned int uiMask = 1 << iP;

    for (int i = 0; i < m_iPlaneQuantity; i++, iP-, uiMask >>= 1)
    {
        if ( m_uiPlaneState & uiMask )
        {
            int iSide = pkWBound->WhichSide(m_akWPlane[iP]);

            if ( iSide < 0 )
            {
                // Object is on negative side.  Cull it.
                return true;
            }

            if ( iSide > 0 )
            {
                // Object is on positive side of plane.  There is
                // no need to compare subobjects against this
                // plane, so mark it as inactive.
                m_uiPlaneState &= ~uiMask;
            }
        }
    }

    return false;
}
```

The function iterates over the array of world planes. If a plane is active (its bit is 1), the world bounding volume of the object is compared to the plane. If the bounding volume is on the positive side, then the bit for the plane is set to 0 so that the bounding volumes of descendants are never compared to that plane. If the bounding volume is on the negative side, it is outside the plane and is culled. If the bounding volume straddles the plane (part of it inside, part of it outside), then the object is not culled and you cannot disable the plane from comparisons with descendants.

I had mentioned that the number of planes can be larger than six. The public interface for `Camera` also contains the following functions:

```
class Camera : public Spatial
{
public:
    int GetPlaneQuantity () const;
    const Plane3f* GetPlanes () const;
    void PushPlane (const Plane3f& rkPlane);
    void PopPlane ();
};
```

An application writer may tell the camera to use additional culling planes by calling PushPlane for each such plane. The manual addition is useful in environments where you have knowledge of the placement of objects and you can safely say that objects behind a particular plane are not visible. For example, an application that has a fixed camera position and orientation could have a building in view of the observer. Objects behind the building are not visible. The plane of the back side of the building can be added to the camera system for culling purposes. But you need to be careful in using this support. In the current example, if a character is behind the building, the culling works fine. But if the character moves to the side of the building and is visible to the observer, but is still behind the plane of the back side of the building, you would cull the character when in fact he is visible.

The ability to push and pop planes is also useful in an automatic portaling system. Indeed, Wild Magic has support for portals for indoor occlusion culling. That system, described later, pushes and pops planes as necessary depending on the camera location and nearby portals. The Camera class has a public function flagged for internal use:

```
bool Culled (int iVertexQuantity, const Vector3f* akVertex,
    bool bIgnoreNearPlane);
```

This function is designed specifically for the portal system and will be described later.

Whether planes are pushed manually or automatically, the data member m_uiPlaneState has 6 bits reserved for the frustum planes. The remaining bits are used for the additional culling planes. On a 32-bit system, this means you can push up to 26 additional culling planes. I suspect that 26 is more than enough for practical applications. You should also be aware the planes are only used for object culling. The objects are *not clipped* against any of these planes. On current graphics hardware, selecting additional clipping planes can have some interesting and surprising side effects. For example, if you select an additional clipping plane, you might lose the use of one of your texture units. My recommendation is not to worry about the clipping, only the culling.

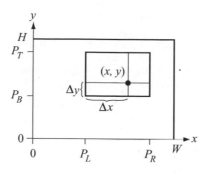

Figure 3.19 A pixel (x, y) selected in a viewport that is not the entire screen.

Picking

The engine supports *picking* operations. Generally these determine whether or not a linear component (line, ray, segment) intersects an object. The classical application is to select an object that is displayed on the screen. The user clicks on a screen pixel that is part of the object. A ray is generated in world coordinates: The origin of the ray is the camera location in world coordinates, and the direction of the ray is the vector from the camera location to the world point that corresponds to the screen pixel that was selected.

The construction of the world point is slightly complicated by having an active viewport that is not the full window. Figure 3.19 shows a window with a viewport and a selected pixel (x, y).

The current viewport settings are P_L (left), P_R (right), P_B (bottom), and P_T (top). Although these are placed at tick marks on the axes, all the numbers are normalized (in [0, 1]). The screen coordinates satisfy the conditions $0 \le x < W$ and $0 \le y < H$, where W is the width of the screen and H is the height of the screen. The screen coordinates must be converted to normalized coordinates:

$$x' = \frac{x}{W-1}, \quad y' = \frac{H-1-y}{H-1}.$$

The screen coordinates are left-handed: $y = 0$ is the top row, $y = H - 1$ is the bottom row, $x = 0$ is the left column, and $x = W - 1$ is the right column. The normalized coordinates (x', y') are right-handed due to the inversion of the y value. The relative distances within the viewport are

$$\Delta_x = \frac{x' - P_L}{P_R - P_L}, \quad \Delta_y = \frac{y' - P_B}{P_T - P_B}.$$

The picking ray is $\mathbf{E} + t\mathbf{U}$, where \mathbf{E} is the eye point in world coordinates and \mathbf{U} is a unit-length direction vector in world coordinates:

$$\mathbf{U} = d_{\min}\mathbf{D} + ((1 - \Delta_x)r_{\min} + \Delta_x r_{\max})\mathbf{R} + ((1 - \Delta_y)u_{\min} + \Delta_y u_{\max})\mathbf{U},$$

where \mathbf{D}, \mathbf{R}, and \mathbf{U} are the axis directions for the camera coordinate system in world coordinates. The equation is derived from the fact that the viewport contains the full extent of the rendering to the frustum rectangle $[r_{\min}, r_{\max}] \times [u_{\min}, u_{\max}]$.

The portion of the Camera interface to support construction of the pick ray is

```
class Camera : public Spatial
{
public:
    bool GetPickRay (int iX, int iY, int iWidth, int iHeight,
        Vector3f& rkOrigin, Vector3f& rkDirection) const;
};
```

The (x, y) input point is in left-handed screen coordinates. The function returns true if and only if the input point is located in the current viewport. When true, the origin and direction values are valid and are in world coordinates. The direction vector is unit length. If the returned function value is false, the origin and direction are invalid.

Some graphics APIs support picking in an alternate manner. In addition to the frame buffer and depth buffer values at a pixel (x, y) on the screen, the renderer maintains a buffer of names. The visible object that led to the frame buffer value at pixel (x, y) has its name stored in the name buffer. When the user clicks on the screen pixel (x, y), the graphics API returns the name of the corresponding object. The depth buffer value at the pixel may be used to gauge how far away the object is (at least how far away the world point is that generated the pixel). My concept of picking is more general. For example, if a character has a laser gun and shoots at another character, you have to determine if the target was hit. The laser beam itself is a ray whose origin is the gun and whose direction is determined by the gun barrel. A picking operation is initiated to determine if that ray intersects the target. In this case, the camera is not the originator of the picking ray.

3.5.2 Basic Architecture for Rendering

The class Renderer is an abstract class that defines an API that the scene graph management system uses for drawing. The intent is to provide a portable layer that hides platform-dependent constructs such as operating system calls, windowing systems, and graphics APIs. Derived classes that do handle the platform-dependent issues are built on top of Renderer. Wild Magic version 2 had a few derived classes. The class OpenGLRenderer encapsulated the OpenGL API. This class is itself portable to those

platforms that support OpenGL. However, window creation and memory allocation on the graphics card are dependent on the platform. I had constructed three classes derived from OpenGLRenderer. The class GlutRenderer encapsulates GLUT, which is itself intended to be a portable wrapper around OpenGL. The GlutRenderer runs on Microsoft Windows, on Macintosh OS X, and on PCs with Linux. Unfortunately, GLUT does not expose much in the way of creating subwindows, menus, and other controls. The class WglRenderer is derived from OpenGLRenderer, but makes no attempt to hide the fact that it runs on Microsoft Windows. A programmer may create a Windows-specific application with all the desired bells and whistles and then add to the application a WglRenderer. On the Macintosh, the class AglRenderer is derived from OpenGLRenderer and does not attempt to hide the fact that it runs using Apple's OpenGL.

For folks who prefer working only on Microsoft Windows using Direct3D, Wild Magic version 2 also had a class DxRenderer derived from Renderer. Naturally, applications using this are not portable to other platforms.

Wild Magic version 3 has the same philosophy about a portable rendering layer. As of the time of writing, I only have support for OpenGL. Hopefully by the time the book is in print, a Direct3D renderer will be posted at my Web site.

Regarding construction, destruction, and information relevant to the window in which the renderer will draw, the interface for Renderer is

```
class Renderer
{
public:
    // abstract base class
    virtual ~Renderer ();

    // window parameters
    int GetWidth () const;
    int GetHeight () const;

    // background color access
    virtual void SetBackgroundColor (const ColorRGB& rkColor);
    const ColorRGB& GetBackgroundColor () const;

    // text drawing
    virtual int LoadFont (const char* acFace, int iSize,
        bool bBold, bool bItalic) = 0;
    virtual void UnloadFont (int iFontID) = 0;
    virtual bool SelectFont (int iFontID) = 0;
    virtual void Draw (int iX, int iY, const ColorRGBA& rkColor,
        const char* acText) = 0;
```

```
protected:
    // abstract base class
    Renderer (int iWidth, int iHeight);

    // window parameters
    int m_iWidth, m_iHeight;
    ColorRGB m_kBackgroundColor;

    // current font for text drawing
    int m_iFontID;
};
```

First, notice that Renderer is *not* derived from Object. You only need one renderer in an application, so the sharing subsystem of Object is not necessary. Searching for a renderer by name or ID is also not necessary since there is only one. Derived-class renderers are dependent on platform, so you do not want to stream them. Renderers have nothing animated, and making copies is not an issue. Consequently, there is no reason to derive the class from Object.

A derived class must construct the base class through the protected constructor. The width and height of the window's client region to which the renderer must draw are provided to the base class. Notice that the window location is *not* given to the renderer. The application has the responsibility for window positioning and resizing, but the renderer only needs to know the dimensions of the drawing region. The background color for the window is stored in the renderer so that it can clear (if necessary) the window to that color before drawing.

The renderer API has pure virtual functions for drawing text on the screen and for font selection. The text drawing and font selection are usually done in a platform-specific manner, so implementations for the API must occur in the derived classes. The data member m_iFontID acts as a handle for the derived-class renderer. Multiple fonts can be loaded and managed by the application. The LoadFont member lets you create a font. The return value is a font ID that the application should store. The ID is passed to SelectFont to let the renderer know that text should be drawn using the corresponding font. The ID is also passed to UnloadFont when the font is to be destroyed. The actual text drawing occurs via the member function Draw. You specify where the text should occur on the screen and what its color should be. The color has an alpha channel, so the text may be drawn with some transparency. The environment mapping sample application illustrates font selection:

```
// select a font for text drawing
int iFontID = m_pkRenderer->LoadFont("Verdana",24,false,false);
m_pkRenderer->SelectFont(iFontID);
```

As you can see, it is simple enough to load a font and tell the renderer to use it.

A renderer must have a camera assigned to it in order to define the region of space that is rendered. The relevant interface is

```
class Renderer
{
public:
    void SetCamera (Camera* pkCamera);
    Camera* GetCamera () const;

protected:
    Camera* m_pkCamera;
};
```

The use of the interface is quite clear. To establish a two-way communication between the camera and the renderer, the Camera class has a data member m_pkRenderer that is set by Renderer during a call to SetCamera. The two-way communication is necessary: The renderer queries the camera for relevant information such as the view frustum parameters and coordinate frame, and, if the camera parameters are modified at run time, the camera must notify the renderer about the changes so that the renderer updates the graphics system (via graphics API calls).

Various resources are associated with a renderer, including a frame buffer (the front buffer) that stores the pixel colors, a back buffer for double-buffered drawing, a depth buffer for storing depths corresponding to the pixels, and a stencil buffer for advancing effects. The back buffer, depth buffer, and stencil buffer may need to be cleared before drawing a scene. The interface supporting these buffers is

```
class Renderer
{
public:
    // full window buffer operations
    virtual void ClearBackBuffer () = 0;
    virtual void ClearZBuffer () = 0;
    virtual void ClearStencilBuffer () = 0;
    virtual void ClearBuffers () = 0;
    virtual void DisplayBackBuffer () = 0;

    // clear the buffer in the specified subwindow
    virtual void ClearBackBuffer (int iXPos, int iYPos,
        int iWidth, int iHeight) = 0;
    virtual void ClearZBuffer (int iXPos, int iYPos,
        int iWidth, int iHeight) = 0;
    virtual void ClearStencilBuffer (int iXPos, int iYPos,
        int iWidth, int iHeight) = 0;
```

```
    virtual void ClearBuffers (int iXPos, int iYPos,
        int iWidth, int iHeight) = 0;
};
```

All the clearing functions are pure virtual, but the derived-class implementations are simple wrappers around standard graphics API calls. The function `DisplayBack-Buffer` is the request to the graphics system to copy the back buffer into the front buffer.

The graphics hardware also has a fixed number of texture units, and the graphics system supports at most a certain number of lights. You may query the renderer for these via

```
class Renderer
{
public:
    int GetMaxLights () const;
    int GetMaxTextures () const;

protected:
    int m_iMaxLights;
    int m_iMaxTextures;
};
```

The data members are initialized to zero in the Renderer constructor. The derived classes are required to set these to whatever limits exist for the user's environment. Wild Magic version 2 had a hard-coded number of texture units (4) and lights (8); both numbers were class-static data members. The number of texture units was chosen at a time when consumer graphics cards had just evolved to contain 4 texture units. Some engine users decided that it was safe to change that number. Unfortunately, the streaming system had a problem with this. If a scene graph was saved to disk when the texture units number was 4, all TextureState objects streamed exactly 4 TexturePtr smart pointers. When the texture units number is then changed to 6 or 8 and the disk copy of the scene is loaded, the loader attempts to read more than 4 TexturePtr links, leading to a serious error. The file pointer is out of synchronization with the file contents. Wild Magic version 3 fixes that because there is no more TextureState class. Generally, any resource limits are not saved during streaming. A scene graph may contain a Geometry object that has more textures attached to it than a graphics card can support. The rendering system makes sure that the additional textures just are not processed. But that does mean you must think about the target platform for your applications. If you use 8 texture units for a single object, you should put on the software packaging that the minimum requirement is a graphics card that has 8 texture units!

3.5.3 SINGLE-PASS DRAWING

In a sense, this system is the culmination of all the work you have done regarding scene management. At some point, you have set up your scene graph, and you want to draw the objects in it. The geometry leaf nodes of the scene have been properly updated, `Spatial::UpdateGS` for the geometric information and `Spatial::UpdateRS` for the render state. The leaf nodes contain everything needed to correctly draw the object. The interface support for the entry point into the drawing system is

```
class Renderer
{
public:
    // pre- and postdraw semantics
    virtual bool BeginScene ();
    virtual void EndScene ();

    // object drawing
    void DrawScene (Node* pkScene);

protected:
    Geometry* m_pkGeometry;
    Effect* m_pkLocalEffect;

// internal use
public:
    void Draw (Geometry* pkGeometry);

    typedef void (Renderer::*DrawFunction)();
    void DrawPrimitive ();
};
```

The pair of functions `BeginScene` and `EndScene` give the graphics system a chance to perform any operations before and after drawing. The `Renderer` class stubs these to do nothing. The OpenGL renderer has no need for pre- and postdraw semantics, but the Direct3D renderer does. The function `DrawScene` is the top-level entry point into the drawing system. Wild Magic version 2 users take note: The top-level call was named `Draw`, but I changed this to make it clear that it is the entry point and used the name `Draw` internally for multipass drawing. If you forget to change the top-level calls in your version 2 applications, I have a comment waiting for you in one of the Renderer functions!

The typical block of rendering code in the idle-loop callback is

```
NodePtr m_spkScene = <the scene graph>;
Renderer* m_pkRenderer = <the renderer>;
```

```
// in the on-idle callback
m_pkRenderer->ClearBuffers();
if ( m_pkRenderer->BeginScene() )
{
    m_pkRenderer->DrawScene(m_spkScene);
    m_pkRenderer->EndScene();
}
m_pkRenderer->DisplayBackBuffer();
```

The ClearBuffers call clears the frame buffer, the depth buffer, and the stencil buffer. Predraw semantics are performed by the call to BeginScene(). If they were successful, BeginScene returns true and the drawing commences with DrawScene. The drawing is to the back buffer. On completion of drawing, postdraw semantics are performed by the call to EndScene. Finally, the call to DisplayBackBuffer requests a copy of the back buffer to the front buffer.

The DrawScene starts a depth-first traversal of the scene hierarchy. Subtrees are culled, if possible. When the traversal reaches a Geometry object that is not culled, the object tells the renderer to draw it using Renderer::Draw(Geometry*). The core classes Spatial, Geometry, and Node all have support for the drawing pass. The relevant interfaces are

```
class Spatial : public Object
{
// internal use
public:
    void OnDraw (Renderer& rkRenderer, bool bNoCull = false);
    virtual void Draw (Renderer& rkRenderer,
        bool bNoCull = false) = 0;
};

class Node : public Spatial
{
// internal use
public:
    virtual void Draw (Renderer& rkRenderer, bool bNoCull = false);
};

class Geometry : public Spatial
{
protected:
    virtual void Draw (Renderer& rkRenderer, bool bNoCull = false);
};
```

The OnDraw and Draw functions form a recursive chain. The Draw function is pure virtual in Spatial, requiring derived classes to implement it. Node::Draw propagates the call through the scene, calling Spatial::OnDraw for each of its children. When a Geometry leaf node is encountered, Geometry::Draw is called; it is a simple wrapper for a call to Renderer::Draw(Geometry*).

The traversal for drawing is listed next. The function Renderer::DrawScene has some code for deferred drawing for the purposes of sorting, but I defer talking about this until Section 4.2.4.

```
void Renderer::DrawScene (Node* pkScene)
{
    if ( pkScene )
    {
        pkScene->OnDraw(*this);

        if ( DrawDeferred )
        {
            (this->*DrawDeferred)();
            m_iDeferredQuantity = 0;
        }
    }
}

void Node::Draw (Renderer& rkRenderer, bool bNoCull)
{
    if ( m_spkEffect == NULL )
    {
        for (int i = 0; i < m_kChild.GetQuantity(); i++)
        {
            Spatial* pkChild = m_kChild[i];
            if ( pkChild )
                pkChild->OnDraw(rkRenderer,bNoCull);
        }
    }
    else
    {
        // A "global" effect might require multipass rendering, so
        // the Node must be passed to the renderer for special
        // handling.
        rkRenderer.Draw(this);
    }
}
```

```
void Geometry::Draw (Renderer& rkRenderer, bool)
{
    rkRenderer.Draw(this);
}
```

We have already seen earlier that `Spatial::OnDraw` attempts to cull the object using its world bounding volume and the camera frustum. If the object is not culled, the `Draw` is called. In the `Node::Draw` function, the call is propagated to its children in the "then" clause. This is the typical behavior for single-pass drawing. Multipass drawing occurs when the node has a *global effect* attached to it. I discuss this later in Section 3.5.6.

This brings us to the question at hand: What does `Renderer::Draw` do with the `Geometry` object? The function is listed below. The code related to deferred drawing is discussed in Section 4.2.4.

```
void Renderer::Draw (Geometry* pkGeometry)
{
    if ( !DrawDeferred )
    {
        m_pkGeometry = pkGeometry;
        m_pkLocalEffect = pkGeometry->GetEffect();

        if ( m_pkLocalEffect )
            (this->*m_pkLocalEffect->Draw)();
        else
            DrawPrimitive();

        m_pkLocalEffect = NULL;
        m_pkGeometry = NULL;
    }
    else
    {
        m_kDeferredObject.SetElement(m_iDeferredQuantity,pkGeometry);
        m_kDeferredIsGeometry.SetElement(m_iDeferredQuantity,true);
        m_iDeferredQuantity++;
    }
}
```

The data members `m_pkGeometry` and `m_pkLocalEffect` are used to hang onto the geometric object and its effect object (if any) for use by the renderer when it does the actual drawing. Standard rendering effects use a `Renderer` function called `Draw-Primitive`. Some advanced effects require a specialized drawing function, a pointer to which the `Effect` object provides. I will discuss the advanced effects in Chapter 5.

3.5.4 THE DRAWPRIMITIVE FUNCTION

Single-pass rendering of objects is performed by `Renderer::DrawPrimitive`. This function is in the base class, so it necessarily hides any dependencies of the back-end graphics API by requiring a `Renderer`-derived class to implement a collection of pure virtual functions. At a high level, the order of operations is

- set global state
- enable lighting
- enable vertices
- enable vertex normals
- enable vertex colors
- enable texture units
- set the transformation matrix
- draw the object
- restore the transformation matrix
- disable texture units
- disable vertex colors
- disable vertex normals
- disable vertices
- disable lighting

Notice the symmetry. Each "enable" step has a corresponding "disable" step. The transformation is set and then restored. The only item without a counterpart is the setting of global state. Since each object sets *all* global state, there is no need to restore the previous global state as the last step. It is possible to create a pipeline in which the objects do not bother disabling features once the objects are drawn. The problem appears, however, if one object uses two texture units, but the next object uses only one texture unit. The first object enabled the second texture unit, so someone needs to disable that unit for the second object. Either the first object disables the unit (as shown previously) after it is drawn, or the second object disables the unit before it is drawn. In either case, the texture unit is disabled before the second object is drawn. I believe my proposed pipeline is the cleanest solution—let each object clean up after itself.

Wild Magic version 2 did not use this philosophy. A reported bug showed that vertex or material colors from one triangle mesh were causing a sibling triangle mesh to be tinted with those colors. To this day I still do not know where the problem is. Wild Magic version 3 appears not to have this bug. If a bug were to show up, I guarantee the current pipeline is easier to debug.

Portions of the actual `DrawPrimitive` code are shown next. The block for setting the global state is

```
if ( m_bAllowGlobalState )
    SetGlobalState(m_pkGeometry->States);
```

The default value for the Boolean data member `m_bAllowGlobalState` is true. It exists just to give advanced rendering features the ability not to set global state if they do not want it set. The `SetGlobalState` function is

```
void Renderer::SetGlobalState (
    GlobalStatePtr aspkState[GlobalState::MAX_STATE])
{
    GlobalState* pkState;

    if ( m_bAllowAlphaState )
    {
        pkState = aspkState[GlobalState::ALPHA];
        SetAlphaState((AlphaState*)pkState);
    }

    //... similar blocks for the other global states go here ...
}
```

Each global state has an associated Boolean data member that allows you to prevent that state from being set. This is useful in advanced rendering features that require multiple passes through a subtree of a scene hierarchy, because each pass tends to have different requirements about the global state. For example, the projected, planar shadow sample application needs control over the individual global states. The function `SetAlphaState` is pure virtual in `Renderer`, so the derived renderer classes need to implement it. Similar "set" functions exist for the other global state classes. The implementations of the "set" functions involve direct manipulation of the graphics API calls.

The blocks for enabling and disabling lighting are

```
if ( m_bAllowLighting )
    EnableLighting();

// ... other pipeline operations go here ...

if ( m_bAllowLighting )
    DisableLighting();
```

A Boolean data member also allows you to control whether or not lighting is enabled independent of whether there are lights in the scene that illuminate the

object. The default value for the data member is true. The base class implements EnableLighting and DisableLighting:

```
void Renderer::EnableLighting (int eEnable)
{
    int iQuantity = m_pkGeometry->Lights.GetQuantity();
    if ( iQuantity >= m_iMaxLights )
        iQuantity = m_iMaxLights;

    for (int i = 0; i < iQuantity; i++)
    {
        const Light* pkLight = m_pkGeometry->Lights[i];
        if ( pkLight->On )
            EnableLight(eEnable,i,pkLight);
    }
}

void Renderer::DisableLighting ()
{
    int iQuantity = m_pkGeometry->Lights.GetQuantity();
    if ( iQuantity >= m_iMaxLights )
        iQuantity = m_iMaxLights;

    for (int i = 0; i < iQuantity; i++)
    {
        const Light* pkLight = m_pkGeometry->Lights[i];
        if ( pkLight->On )
            DisableLight(i,pkLight);
    }
}
```

The first block of code in each function makes sure that the quantity of lights that illuminate the geometry object does not exceed the total quantity supported by the graphics API. The data member m_iMaxLights must be set during the construction of a derived-class renderer. In OpenGL, this number is eight. The second block of code iterates over the lights. If a light is on, it is enabled/disabled. The functions EnableLight and DisableLight are pure virtual in Renderer, so the derived renderer classes need to implement them. The implementations involve direct manipulation of the graphics API calls.

The blocks of code for handling the vertex positions for the geometry object are

```
EnableVertices();

// ... other pipeline operations go here ...

DisableVertices();
```

I assume that any geometry object has vertices. Otherwise, what would you draw? No Boolean member is provided to prevent the enabling of vertices. The functions `EnableVertices` and `DisableVertices` are pure virtual in Renderer, so the derived renderer classes need to implement them. The implementations involve direct manipulation of the graphics API calls. The OpenGL versions tell the graphics driver the vertex array to use. The engine supports caching of vertex data on the graphics card itself to avoid constantly sending vertices over an AGP bus. The enable/disable functions do all the graphics-API-specific work to make this happen.

The blocks of code for handling the vertex normals for the geometry object are

```
if ( m_bAllowNormals && m_pkGeometry->Normals )
    EnableNormals();

// ... other pipeline operations go here ...

if ( m_bAllowNormals && m_pkGeometry->Normals )
    DisableNormals();
```

The vertex normals are passed through the graphics API calls only if the geometry object has normals and the application has not prevented the enabling by setting `m_bAllowNormals` to `false`. The default value for the data member is `true`. The functions `EnableNormals` and `DisableNormals` are pure virtual in Renderer, so the derived renderer classes need to implement them. The implementations involve direct manipulation of the graphics API calls. The OpenGL versions tell the graphics driver the vertex normal array to use. The engine supports caching of vertex data on the graphics card itself to avoid constantly sending vertices over an AGP bus. The enable/disable functions do all the graphics-API-specific work to make this happen.

The blocks of code for handling the vertex colors for the geometry object are

```
if ( m_bAllowColors && m_pkLocalEffect )
{
    if ( m_pkLocalEffect->ColorRGBAs )
        EnableColorRGBAs();
    else if ( m_pkLocalEffect->ColorRGBs )
        EnableColorRGBs();
}

// ... other pipeline operations go here ...

if ( m_bAllowColors && m_pkLocalEffect )
{
    if ( m_pkLocalEffect->ColorRGBAs )
        DisableColorRGBAs();
    else if ( m_pkLocalEffect->ColorRGBs )
        DisableColorRGBs();
}
```

Once again, a Boolean data member controls whether or not the vertex color handling is allowed. The default value for m_bAllowColors is true. Vertex colors are not stored in the geometry object, but are considered to be one of the local effects that you can attach to an object. As such, the vertex colors are stored in the m_pkLocalEffect object that belongs to the m_pkGeometry object. Since Effect objects allow you to store RGB or RGBA colors, the renderer must decide which one to use. Only one set of colors is used, so setting both in the Effect object will lead to use of only the RGBA colors. The functions EnableColorRGBAs, EnableColorRGBs, DisableColorRGBAs, and DisableColorRGBs are pure virtual in Renderer, so the derived renderer classes need to implement them. The implementations involve direct manipulation of the graphics API calls. The OpenGL versions tell the graphics driver the vertex color array to use. The engine supports caching of vertex data on the graphics card itself to avoid constantly sending vertices over an AGP bus. The enable/disable functions do all the graphics-API-specific work to make this happen.

The texture units are enabled and disabled by the following code blocks:

```
if ( m_bAllowTextures )
    EnableTextures();

// ... other pipeline operations go here ...

if ( m_bAllowTextures )
    DisableTextures();
```

Again we have a Boolean data member, m_bAllowTextures, that gives advanced rendering features the chance to control whether or not the texture units are enabled. The default value is true. The base class implements EnableTextures and DisableTextures:

```
void Renderer::EnableTextures ()
{
    int iTMax, i;
    int iUnit = 0;

    // set the local-effect texture units
    if ( m_pkLocalEffect )
    {
        iTMax = m_pkLocalEffect->Textures.GetQuantity();
        if ( iTMax > m_iMaxTextures )
            iTMax = m_iMaxTextures;

        for (i = 0; i < iTMax; i++)
            EnableTexture(iUnit++,i,m_pkLocalEffect);
    }
```

```
    // set the global-effect texture units
    if ( m_pkGlobalEffect )
    {
        iTMax = m_pkGlobalEffect->Textures.GetQuantity();
        if ( iTMax > m_iMaxTextures )
            iTMax = m_iMaxTextures;

        for (i = 0; i < iTMax; i++)
            EnableTexture(iUnit++,i,m_pkGlobalEffect);
    }
}

void Renderer::DisableTextures ()
{
    int iTMax, i;
    int iUnit = 0;

    // disable the local-effect texture units
    if ( m_pkLocalEffect )
    {
        iTMax = m_pkLocalEffect->Textures.GetQuantity();
        if ( iTMax > m_iMaxTextures )
            iTMax = m_iMaxTextures;

        for (i = 0; i < iTMax; i++)
            DisableTexture(iUnit++,i,m_pkLocalEffect);
    }

    // disable the global-effect texture units
    if ( m_pkGlobalEffect )
    {
        iTMax = m_pkGlobalEffect->Textures.GetQuantity();
        if ( iTMax > m_iMaxTextures )
            iTMax = m_iMaxTextures;

        for (i = 0; i < iTMax; i++)
            DisableTexture(iUnit++,i,m_pkGlobalEffect);
    }
}
```

The first block of code in each function makes sure that the quantity of texture units that the geometry object requires does not exceed the total quantity supported by the graphics API and, in fact, by the graphics card. As you are aware, the more texture units the graphics card has, the more expensive it is. Since your clients will have cards with different numbers of texture units, you have to make sure you only

try to use what is there. The data member m_iMaxTextures must be set during the construction of a derived-class renderer. In OpenGL, the graphics card driver is queried for this information. The functions EnableTexture and DisableTexture are pure virtual in Renderer, so the derived renderer classes need to implement them. The implementations involve direct manipulation of the graphics API calls. The data member m_pkPostEffect is part of the multipass rendering system that is described later in this section.

As I noted earlier, Wild Magic version 2 had a design flaw regarding multitexturing. The flaw surfaced when trying to add a Node-derived class for projected texture. The assignment of textures to texture units was the programmer's responsibility, unintentionally so. To make sure the projected texture appears as the last texture and not have any texture units just pass the previous unit's data through it, the programmer needed to know for each geometry object in the subtree how many textures it used and what units they were assigned to, which is needlessly burdensome. In Wild Magic version 3, a projected texture shows up as a "post-effect." As you can see in the EnableTextures, the texture units are enabled as needed and in order.

The transformation handling is

```
if ( m_bAllowWorldTransform )
    SetWorldTransformation();
else
    SetScreenTransformation();

// ... the drawing call goes here ...

if ( m_bAllowWorldTransform )
    RestoreWorldTransformation();
else
    RestoreScreenTransformation();
```

The graphics system needs to know the model-to-world transformation for the geometry object. The transformation is set by the function SetWorldTransformation. The world translation, world rotation, and world scales are combined into a single homogeneous matrix and passed to the graphics API. The world transformation is restored by the function RestoreWorldTransformation.

The engine supports *screen space polygons*. The polygons are intended to be drawn either as part of the background of the window or as an overlay on top of all the other rendered data. As such, the vertices are two-dimensional and are already in screen space coordinates. The perspective viewing model does not apply. Instead we need an orthonormal projection. The function SetScreenTransformation must handle both the selection of projection type and setting of the transformation. The function RestoreScreenTransformation restores the projection type and transformation. All the transformation handlers are pure virtual in the base class. This allows hiding the matrix representation that each graphics API chooses.

The *z*-values (depth values) need to be provided for the polygon vertices. The *z*-values may depend on the graphics API, so the ScreenPolygon class requires you only to specify whether it is a foreground or a background polygon. ScreenPolygon derives from TriMesh, which allows you to attach render state and effects just like any other geometry object. A classical use for screen space polygons is to overlay the rendered scene with a fancy border, perhaps with simulated controls such as menu selection, buttons, sliders, and so on. An overlay can have an RGBA texture assigned to it. By setting selected image pixels to have an alpha of zero, you can make the overlay as fancy as you like, with curved components, for example.

The final piece of DrawPrimitive is the drawing call itself:

```
DrawElements();
```

This function tells the graphics system what type of geometric object is to be drawn (points, polyline, triangle mesh, etc.). In the case of an object that has an array of indices into the vertex array, the indices are passed to the graphics system.

3.5.5 CACHED TEXTURES AND VERTEX ATTRIBUTES

Consumer graphics hardware has become very powerful and allows a lot of computations to be off-loaded from the CPU to the GPU. For practical applications, the amount of data the GPU has to process will not cause the computational aspects to be the bottleneck in the graphics system. What has become the bottleneck now is the transfer of the data from the host machine to the graphics hardware. On a PC, this is the process of sending the vertex data and texture images across the AGP bus to the graphics card.

In Wild Magic version 2, vertex data is transferred to the graphics card each time a scene is rendered. However, the graphics APIs support caching on the graphics card for textures and their corresponding images, thus avoiding the transfer. When a texture is *bound* to the graphics card (i.e., cached on the card) the first time it is handed to the graphics API, you are given an identifier so that the next time the texture needs to be used in a drawing operation the graphics API knows it is already in VRAM and can access it directly. Support for this mechanism requires some communication between the Renderer and Texture classes.

I still use this mechanism in Wild Magic version 3. The relevant interface for the Texture class is

```
class Texture : public Object
{
protected:
    class BindInfo
    {
    public:
```

```
        BindInfo ();
        Renderer* User;
        char ID[8];
    };

    TArray<BindInfo> m_kBind;

// internal use
public:
    void Bind (Renderer* pkUser, int iSize, const void* pvID);
    void Unbind (Renderer* pkUser);
    void GetID (Renderer* pkUser, int iSize, void* pvID);
};
```

The nested class BindInfo is used by the graphics system to store the identifier to a texture. A pointer to the renderer to which the texture is bound is part of the binding information. The renderer is responsible for storing a unique identifier in the ID field of BindInfo. The array has 8 bytes to allow storage of the identifier on a 64-bit graphics system. Of course, if a graphics system requires more than 8 bytes for the identifier, this number must change. The number of bytes used is known only to the derived-class renderer and is irrelevant to the scene graph system. The size information is not saved in the BindInfo class for this reason. The ID array elements are all initialized to zero; a value of zero indicates the texture is not bound to any renderer. Public access to the binding system is labeled for internal use, so an application should not directly manipulate the functions.

When the renderer is told to use a texture, it calls GetID and checks the identifier. If it is zero, this is the first time the renderer has seen the texture. It then calls Bind and passes a pointer to itself, the size of the identifier in bytes, and a pointer to the identifier. Notice that a texture may be bound to multiple renderers; the class stores an array of BindInfo objects, one per renderer. The derived-class renderer does whatever is necessary to cache the data on the graphics card. The second time the renderer is told to use the texture, it calls the GetID function and discovers that the identifier is not zero. The derived-class renderer simply tells the graphics API that the texture is already in VRAM and should use it directly. All of the logic for this occurs through the function Renderer::EnableTexture. Recall that this is a pure virtual function that a derived class must implement.

At some point your application might no longer need a texture and deletes it from the scene. If that texture was bound to a renderer, you need to tell the renderer to unbind it in order to free up VRAM for other data. The smart pointer system makes the notification somewhat challenging. It is possible that the texture object was deleted automatically because its reference count went to zero. For example, this happens if a scene graph is deleted by assigning NULL to its smart pointer:

```
NodePtr m_spkScene = <a scene graph>;
// ... do some application stuff ...
m_spkScene = NULL;
// scene is deleted, including any Texture objects
```

If I had required you to search the scene graph for any Texture objects and somehow unbind them manually, that would have been a large burden to place on your shoulders. Instead, the destructor of the Texture class notifies the renderer that the texture is being deleted. To notify the renderer, you need to have access to it. Conveniently, the BindInfo nested class has a member User that is a pointer to the renderer to which the texture is bound. No coincidence. The destructor is

```
Texture::~Texture ()
{
    // Inform all renderers using this texture that it is being
    // destroyed.  This allows the renderer to free up any
    // associated resources.
    for (int i = 0; i < m_kBind.GetQuantity(); i++)
        m_kBind[i].User->ReleaseTexture(this);
}
```

The Texture object iterates over all its binding information and informs each renderer that it is being deleted. This gives the renderers a chance to unbind the texture, whereby it frees up the VRAM that the texture occupied. Once freed, the renderer in turn notifies the texture object that it is no longer bound to the renderer. The notification is via the member function Texture::Unbind.

Clearly, the Renderer class must have a function that the destructor calls to unbind the texture. This function is named ReleaseTexture and is a pure virtual function, so the derived class must implement it. The base class also has a function ReleaseTextures. This one is implemented to perform a depth-first traversal of a scene. Each time a Texture object is discovered, the renderer is told to release it. The texture objects are *not deleted*. If you were to redraw the scene, all the texture objects would be rebound to the renderer. Does this make the function useless? Not really. If you had a few scenes loaded into system memory, and you switch between them based on the current state of the game without deleting any of them, you certainly want to release the textures for one scene to make room for the next scene.

The graphics hardware does allow for you to cache vertex data on the card, as well as texture data. For meshes with a large number of vertices, this will also lead to a speedup in the frame rate because you do not spend all your time transferring data across a memory bus. Wild Magic version 2 did not support caching vertex data, but Wild Magic version 3 does. The vertex arrays (positions, normals, colors, indices, texture coordinates) are normally stored as shared arrays using the template class TSharedArray. The sharing is for the benefit of the scene graph management system. Each time a geometry object is to be drawn, its vertex arrays are given to the graphics

API for the purposes of drawing. The arrays are transferred across the memory bus on each drawing call.

To support caching, the graphics APIs need to provide a mechanism that is similar to what is used for textures, and they do. I chose to use *vertex buffer objects* for the caching. Just as the class Texture has the BindInfo nested class for storing binding information, the scene graph system needs to provide some place to store binding information for vertex data. I have done this by deriving a template class TCachedArray from TSharedArray. This class provides a system that is identical to the one in Texture. The texture binding occurs through the derived-class implementation of Renderer::EnableTexture. The vertex data caching occurs similarly through the derived-class implementations of EnableVertices, EnableNormals, EnableColorRGBAs, EnableColorRGBs, and EnableUVs. The derived-class implementations need only check the RTTI for the vertex arrays. If they are of type TCachedArray, the renderer binds the arrays and stores the identifiers in the BindInfo structures. If they are not of type TCachedArray, the renderer treats them normally and transfers the data across the memory bus on each draw operation.

The same issue arises as for textures. If the vertex data is to be deleted, and that data was bound to a renderer, the renderer needs to be notified that it should free up the VRAM used by that data. The texture objects notify the renderer through Renderer::ReleaseTexture. The vertex data objects notify the renderer through Renderer::ReleaseArray (there are five such functions—for positions, normals, color RGBs, color RGBAs, and texture coordinates). The notification occurs in the TCachedArray destructor. Finally, you may release all cached data by calling the function Renderer::ReleaseArrays. A depth-first traversal of the scene graph is made. Each cached vertex array is told to notify the renderer to free the corresponding resources and unbind the array.

3.5.6 GLOBAL EFFECTS AND MULTIPASS SUPPORT

The single-pass rendering of a scene graph was discussed in Section 3.5.3. This system essentially draws a Geometry object at the leaf node of a scene hierarchy using all the global state, lights, and effects that are stored by the object. Some effects, though, may be desired for all the geometry leaf nodes in a subtree. For example, a projected texture can apply to multiple triangle meshes, as can an environment map. A projected planar shadow may be rendered for an object made up of many triangle meshes. Planar reflections also apply to objects that have multiple components. It would be convenient to allow an Effect object to influence an entire subtree. Wild Magic version 2 supported this by creating Node-derived classes to represent the effects, but that design was clunky and complicated when it came to handling *reentrancy*. An effect such as a planar projected shadow requires multiple passes to be made over a subtree of the scene. Each pass has different requirements regarding render state. If the drawing is initiated on a first pass through the subtree, and the renderer must use a second

pass to complete the drawing, you have to be certain not to end up in an infinite recursion of the drawing function; that is, the drawing system must be reentrant.

The Effect class introduced in Wild Magic version 3 was initially designed to represent a *local effect;* that is, the Effect object stores the vertex colors, textures, and texture coordinates and implements any semantics necessary to correctly render the geometry object to which the effect is attached. A natural class to store the effect is the Geometry class. I still wanted to support *global effects* such as projected textures and projected planar shadows, but with a system that was better designed than the one requiring you to derive a class from Node and have it encapsulate the relevant render state. My choice was to store the Effect object in the Spatial class. In this way, a Node has an Effect object that can represent a global effect. A pleasant consequence is that a multipass drawing operation is cleanly implemented without much fuss in the scene graph management system.

A recapitulation of my previous discussion: The top-level call to drawing a scene is

```
void Renderer::DrawScene (Node* pkScene)
{
    if ( pkScene )
    {
        pkScene->OnDraw(*this);

        if ( DrawDeferred )
        {
            (this->*DrawDeferred)();
            m_iDeferredQuantity = 0;
        }
    }
}
```

The OnDraw function is implemented in Spatial and handles any culling of objects. If a Node object is not culled, the function Draw is called on all the children in order to propagate the drawing down the hierarchy. The Node class's version of Draw is

```
void Node::Draw (Renderer& rkRenderer, bool bNoCull)
{
    if ( m_spkEffect == NULL )
    {
        for (int i = 0; i < m_kChild.GetQuantity(); i++)
        {
            Spatial* pkChild = m_kChild[i];
            if ( pkChild )
                pkChild->OnDraw(rkRenderer,bNoCull);
        }
    }
```

```
        else
        {
            // A "global" effect might require multipass rendering,
            // so the Node must be passed to the renderer for special
            // handling.
            rkRenderer.Draw(this);
        }
    }
}
```

In the typical case, the node does not have an effect attached to it, in which case m_spkEffect is NULL, and the drawing operation is propagated to the node's children. If the node has an effect attached to it, then the renderer is immediately told to draw the subtree rooted at the node. From the scene graph management perspective, all you care about is that the renderer does the right thing and correctly draws the subtree. From the renderer's perspective, if multiple drawing passes must be made over the subtree, the Node::Draw function must be reentrant. The only natural solution is to require the renderer to keep a temporary handle to m_spkEffect, set m_spkEffect to NULL, draw the subtree with multiple passes (if necessary), and then restore m_spkEffect to its original value.

The function referenced by rkRenderer.Draw(this) in the previous displayed code block is listed next. The code for deferred drawing is discussed in Section 4.2.4.

```
void Renderer::Draw (Node* pkNode)
{
    if ( !DrawDeferred )
    {
        m_pkNode = pkNode;
        m_pkGlobalEffect = pkNode->GetEffect();

        assert( m_pkGlobalEffect );
        (this->*m_pkGlobalEffect->Draw)();

        m_pkNode = NULL;
        m_pkGlobalEffect = NULL;
    }
    else
    {
        m_kDeferredObject.SetElement(m_iDeferredQuantity,pkNode);
        m_kDeferredIsGeometry.SetElement(m_iDeferredQuantity,false);
        m_iDeferredQuantity++;
    }
}
```

The global effect has a Renderer function assigned to its Draw data member. The function encapsulates the semantics necessary to correctly draw the object. Pseudocode for the drawing function is

```
void DerivedRenderer::DrawGlobalFeature ()
{
    // Hang onto the effect with a smart pointer (prevent
    // destruction).
    EffectPtr spkSaveEffect = m_pkGlobalEffect;

    // Allow reentrancy to drawing at the node m_pkNode.  By
    // having a NULL effect, the node will just propagate the
    // drawing call to its children.
    m_pkNode->SetEffect(NULL);

    // do whatever, including calls to m_pkNode->Draw(*this,...)

    // Restore the effect.
    m_pkNode->SetEffect(spkSaveEffect);
}
```

Should you add a function such as the above to support a new effect, you must add a pure virtual function to the base class, Renderer::DrawGlobalFeature. Currently, the base class has

```
virtual void DrawBumpMap () = 0;
virtual void DrawEnvironmentMap () = 0;
virtual void DrawGlossMap () = 0;
virtual void DrawPlanarReflection () = 0;
virtual void DrawPlanarShadow () = 0;
virtual void DrawProjectedTexture () = 0;
```

Corresponding Effect-derived classes are in the scene graph management system. Each one sets its Draw data member to one of these function pointers.

CHAPTER 4

ADVANCED SCENE GRAPH TOPICS

4.1 LEVEL OF DETAIL

Level of detail (LOD) was a topic made popular when CPUs and GPUs were not so powerful. The idea is to use a coarser-level geometric representation of an object that has a similar appearance to the high-level representation, but requires less data to be processed by the CPU and GPU. The evolution of GPUs to handle large quantities of data has made level of detail less important in some situations. However, the concept will always be important when objects are in the distance. A character made up of 10,000 triangles looks really good when close to the observer. No doubt you will appreciate all the subtleties that the artist put into the texturing and lighting of the character. The attractiveness of the character is emphasized by the fact that a large number of pixels are colored due to the triangles in the object. When the character is in the distance, though, you will fail to recognize most details. Those 10,000 triangles are now covering only a small number of pixels, perhaps on the order of 10 to 100, and those pixels suffer a lot of overdraw. Even if the character was rendered to 100 pixels, that means each pixel on average is drawn to by 100 triangles. You must agree that this is a large waste of computational resources. Level of detail is designed to provide a large number of triangles for an object when close to the observer, but fewer triangles as the object moves away from the observer. The variation is an attempt to keep the number of triangles affecting a pixel as small as possible.

A few categories of level of detail have been used in graphics. *Sprites* or *billboards* are 2D representations of 3D objects that are used to reduce the complexity of the object. For example, trees typically are drawn as a pair of rectangles with alpha-blended textures, the pair intersecting in an *X* configuration. Another example is

299

a grandstand in an automobile race. The audience is typically drawn as rows of rectangular billboards that try to face the camera, but are constrained to rotate about the vertical axis. Wild Magic supports billboards of this type, but also allows for solid objects to be oriented to try to face an observer with a constraint to rotate about a vertical axis.

Discrete LOD is the notion of creating multiple representations of the same object. Each successive representation has less detail than the previous one, but the number of representations is a small number. A *switch node* is used to select which representation is drawn. Selection can be based on the distance of a *LOD center* from the eye point. The difference in the triangle counts between consecutive models is typically large. Artists have to manually generate each model—a process that takes time.

Continuous LOD is an attempt to automate the generation of different-resolution representations of an object. For triangle meshes, the generation amounts to removing a few triangles at a time while trying to preserve the shape of the object. The process is also known as *triangle mesh decimation*. In this context, continuous level of detail is really a discrete level of detail, but the difference in triangle count between models is small. The representations are usually generated procedurally offline. Generating a good set of texture coordinates and normals can be difficult.

Infinite LOD refers to the ability to generate an arbitrary number of triangles in a mesh that represents a smooth object. Given a surface representation of the object, a subdivision method is applied to tessellate the surface at run time, and as finely as you have the CPU time. Powerful processors on game consoles make surface representation a good choice, but creating surface models still appears to be in the realm of CAD/CAM and not game development.

I discuss each of these topics in this section.

4.1.1 BILLBOARDS

The class that supports billboards is `BillboardNode`. The interface is

```
class BillboardNode : public Node
{
public:
    // The model space of the billboard has an up vector of
    // (0,1,0) that is chosen to be the billboard's axis of
    // rotation.

    // construction
    BillboardNode (Camera* pkCamera = NULL, int iQuantity = 1,
        int iGrowBy = 1);

    // the camera to which the billboard is aligned
    void AlignTo (Camera* pkCamera);
```

```
protected:
    // geometric updates
    virtual void UpdateWorldData (double dAppTime);

    Pointer<Camera> m_spkCamera;
};
```

The billboard is constrained so that it can only rotate about its up vector in model space. The orientation is relative to a camera, so you either provide the camera to the constructor or defer the attachment until later through a call to AlignTo. The billboard alignment occurs during the UpdateGS pass. The BillboardNode class overrides the virtual function UpdateWorldData that is called in the Spatial version of UpdateGS. The implementation is

```
void BillboardNode::UpdateWorldData (double dAppTime)
{
    Spatial::UpdateWorldData(dAppTime);

    if ( m_spkCamera )
    {
        Vector3f kCLoc = World.ApplyInverse(
            m_spkCamera->GetWorldLocation());

        float fAngle = Mathf::ATan2(kCLoc.X(),kCLoc.Z());
        Matrix3f kOrient(Vector3f::UNIT_Y,fAngle);
        World.SetRotate(World.GetRotate()*kOrient);
    }

    for (int i = 0; i < m_kChild.GetQuantity(); i++)
    {
        Spatial* pkChild = m_kChild[i];
        if ( pkChild )
            pkChild->UpdateGS(dAppTime,false);
    }
}
```

The call to Spatial::UpdateWorldData computes the billboard's world transforms based on its parent's world transform and its local transforms. Notice that you should not call the function Node::UpdateWorldData since that function updates its children. The children of a BillboardNode cannot be updated until the billboard is aligned with the camera.

The eye point is inverse transformed to the model space of the billboard. The idea is to determine what local rotation must be applied to the billboard to orient it correctly in world space. To align the billboard, the projection of the camera to

the xz-plane of the billboard's model space determines the angle of rotation about the billboard's model y-axis. If the projected camera is on the model axis ($x = 0$ and $z = 0$), the ATan2 returns zero (rather than NaN), so there is no need to trap this degenerate case and handle it separately. The orientation matrix must be applied *first* to the billboard before applying the world rotation matrix. This is true simply because local transformations at a node are always applied before world transformations.

After the orientation about the y-axis, the geometric update can be propagated to the children of the billboard node.

Nothing in the algorithm requires the billboard to be a flat rectangle. The sample application in the folder

```
GeometricTools/WildMagic3/SampleGraphics/BillboardNodes
```

illustrates how to use BillboardNode. Two objects are displayed, one a flat rectangle and one a three-dimensional torus. As you move the camera through space using the arrow keys, notice that both objects always rotate about their up axes to attempt to face the camera.

4.1.2 DISPLAY OF PARTICLES

The Particles class was introduced in Section 3.3.4. Recall that a particle is a geometric primitive with a location in space and a size. The Particles class encapsulates a set of particles, called a particle system. The class interface for Particles is

```
class Particles : public TriMesh
{
public:
    // construction and destruction
    Particles (Vector3fArrayPtr spkLocations, FloatArrayPtr spkSizes,
        bool bWantNormals);
    virtual ~Particles ();

    // data members
    Vector3fArrayPtr Locations;
    FloatArrayPtr Sizes;
    float SizeAdjust;

    void SetActiveQuantity (int iActiveQuantity);
    int GetActiveQuantity () const;

    virtual void SetEffect (Effect* pkEffect);

    // If the Particles effect attributes are modified, the TriMesh
```

```
    // effect attributes need to be updated.
    void RefreshEffect ();

protected:
    Particles ();

    // Generate attributes for the triangle mesh from the
    // Particle effect.
    void GenerateColorRGBs ();
    void GenerateColorRGBAs ();
    void GenerateUVs ();

    // Drawing.  The particles are billboards that always face the
    // camera.
    void GenerateParticles (const Camera* pkCamera);
    virtual void Draw (Renderer& rkRenderer, bool bNoCull = false);

    // Allow application to specify fewer than the maximum number
    // of vertices to draw.
    int m_iActiveQuantity;

    // Store the effect that applies to the particle data.  The data
    // member Geometry::m_spkEffect will store the derived effect that
    // applies to the triangle mesh that represents the particles.
    EffectPtr m_spkParticleEffect;
};
```

The method `GenerateParticles` implements the construction of the billboard squares as pairs of triangles. The renderer's camera is an input because the squares must always face the camera in the world. The natural inclination is to forward-transform all the particle locations into the world coordinate system and build the squares in world space. However, that is inefficient in time, especially when the number of particles is large. Instead I inverse-transform the camera into the model space of the particles, compute the squares' vertices, and store them in the model space vertex array of the `TriMesh` base class. Figure 4.1 shows how the triangles are generated for a single particle.

The camera right, up, and view world direction vectors are \mathbf{R}, \mathbf{U}, and \mathbf{D}, respectively. The particles have world rotation matrix R. The scales and translations are not used when transforming the camera to the model space of the particles. The camera vectors in the particles' model space are $\mathbf{R}' = R^\mathrm{T}\mathbf{R}$, $\mathbf{U}' = R^\mathrm{T}\mathbf{U}$, and $\mathbf{D}' = R^\mathrm{T}\mathbf{D}$. The point \mathbf{C} is the particle location, which is the center of the square. The size of the particle is σ, and the size adjustment is α. The vertices shown in the figure are

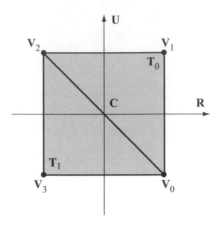

Figure 4.1 The billboard square for a single particle.

$$\mathbf{V}_0 = \mathbf{C} - \alpha\sigma\,(\mathbf{U}' - \mathbf{R}')$$

$$\mathbf{V}_1 = \mathbf{C} + \alpha\sigma\,(\mathbf{U}' + \mathbf{R}')$$

$$\mathbf{V}_2 = \mathbf{C} + \alpha\sigma\,(\mathbf{U}' - \mathbf{R}')$$

$$\mathbf{V}_3 = \mathbf{C} - \alpha\sigma\,(\mathbf{U}' + \mathbf{R}').$$

If normal vectors are required, the four vertices are assigned the same quantity,

$$\mathbf{N}_0 = \mathbf{N}_1 = \mathbf{N}_2 = \mathbf{N}_3 = -\mathbf{D}'.$$

The two triangle index triples are

$$T_0 = \langle 0, 1, 2\rangle, \qquad T_1\langle 0, 2, 3\rangle.$$

The indices are initialized once, in the constructor of `Particles`, since they do not change as the particles move about. The `GenerateParticles` call is made inside the `Draw` function.

When an `Effect` object is attached to a `Particles` object, some complications must be dealt with regarding rendering. Two inputs to the `Particles` constructor are the particle locations and sizes. For display purposes, the particles are rendered as billboards that have four times the number of vertices as particles. The rendering system expects vertex attributes to occur for all vertices, so the `Particles` class must create vertex attributes to correspond to the particle attributes. This is accomplished by the functions `GenerateColorRGBs`, `GenerateColorRGBAs`, and `GenerateUVs`, which are called by the `SetEffect` member function:

```
void Particles::SetEffect (Effect* pkEffect)
{
    m_spkParticleEffect = pkEffect;

    // Clone an effect for the triangle mesh representing the
    // particles.
    m_spkEffect = pkEffect->Clone();

    // quadruple the RGB colors
    if ( pkEffect->ColorRGBs )
        GenerateColorRGBs();

    // quadruple the RGBA colors
    if ( pkEffect->ColorRGBAs )
        GenerateColorRGBAs();

    // Generate textures and UVs for all active textures of
    // m_spkEffect.
    if ( pkEffect->Textures.GetQuantity() > 0 )
        GenerateUVs();
}
```

The effect that a user sets is intended to apply to the particles themselves. That effect is stored in the data member m_spkParticleEffect. The member m_spkEffect is what is passed to the renderer, so it must have attributes that correspond to all the vertices that are the corners of the billboards—four times the number of particles. A clone is made of the effect through an abstract cloning system; you have no idea what type the effect is, but Clone will give you the right thing. The color arrays and the texture coordinate arrays must be replaced with ones that correspond to the billboard corners. These arrays are created by the generate calls.

The implementation of the function GenerateColorRGBs is representative of the other functions, so I only show one here:

```
void Particles::GenerateColorRGBs ()
{
    int iLQuantity = Locations->GetQuantity();
    int iVQuantity = 4*iLQuantity;
    ColorRGB* akPColor = m_spkParticleEffect->ColorRGBs->GetData();
    ColorRGB* akMColor = new ColorRGB[iVQuantity];
    for (int i = 0, j = 0; i < iLQuantity; i++)
    {
        // get the particle color
        ColorRGB& rkColor = akPColor[i];
```

```
            // assign it as the quad color, applied to all four vertices
            akMColor[j++] = rkColor;
            akMColor[j++] = rkColor;
            akMColor[j++] = rkColor;
            akMColor[j++] = rkColor;
        }

        m_spkEffect->ColorRGBs = new ColorRGBArray(iVQuantity,akMColor);
    }
```

The number of allocated colors is iVQuantity, which is four times the number of particles iLQuantity. The particle colors are stored in akPColor. The mesh colors akMColor store four times the number of colors. Each particle color is copied into four mesh color slots, which correspond to the vertices used as the corners of the billboard that represents the particle. The last statement attaches the color array to the effect.

In the event that you change the particle attributes, only the member m_spkParticleEffect is changed. You have to force the regeneration of attributes for the mesh of billboard vertices. Do this by a call to RefreshEffect.

The sample application in the folder

```
GeometricTools/WildMagic3/SampleGraphics/ParticleSystems
```

illustrates how to use Particles. The particles look like fuzzy red spheres of various sizes that move randomly about the screen. I have used a texture with an alpha channel so that you cannot tell the billboards are rectangles. Try rotating the scene, either with the virtual track ball or with the F1 through F6 function keys. Even though the particles are displayed as billboards, the rotation seems to show that the particles really are spherical.

4.1.3 DISCRETE LEVEL OF DETAIL

Discrete level of detail refers to constructing a small set of models: a high-resolution one and many similar copies with decreasing numbers of triangles. According to some logic at display time, one of the models in the set is selected for drawing. A standard mechanism for selection is to use the distance between a LOD center, a point associated with the model, and the eye point. The smaller the distance, the higher the resolution model selected. Conversely, the larger the distance, the lower the resolution model selected.

Since we would like all the models to hang around waiting to be selected, it is convenient to have a node whose children are the models. But we do not want all the children to be processed during recursive traversals of the scene graph. A node that allows only one child at a time to be active is called a *switch node*. The class that implements this is SwitchNode and has the interface

```
class SwitchNode : public Node
{
public:
    SwitchNode (int iQuantity = 1, int iGrowBy = 1);

    enum { SN_INVALID_CHILD = -1 };

    void SetActiveChild (int iActiveChild);
    int GetActiveChild () const;
    void DisableAllChildren ();

    virtual void DoPick (const Vector3f& rkOrigin,
        const Vector3f& rkDirection, PickArray& rkResults);

protected:
    virtual void Draw (Renderer& rkRenderer, bool bNoCull = false);

    int m_iActiveChild;
};
```

The only data member is the index of the active child. If the active child index is set to SN_INVALID_CHILD, no children of the switch node are picked or drawn. Otherwise, only the active child is picked or drawn. Notice that I have not provided an override for geometric state updates or render state updates. This means that calls to UpdateGS and UpdateRS will propagate to all the children, even though only one is active. In my opinion, it makes sense to propagate the UpdateRS call to all the children since they are all representations of the same abstract object. The choice not to prevent propagation of UpdateGS requires some explanation.

Suppose that an UpdateGS call propagates down a scene hierarchy and reaches a switch node. If the switch node propagates the call only to the active child, then all other children have world transformations and world bounding volumes that are inconsistent with the rest of the scene. As long as those children remain inactive, this is not a problem. Now suppose that you decide to select a different child to be active. You most certainly want its geometric state to be current, so you need to call UpdateGS on that child. Immediately after the update you change the active child back to the previous one. At this time you do not know that the new active child *does not* need an update. Then again, if other operations occurred between the switching, you do not know if the active child *does* need an update. The conservative and safe thing to do is always call UpdateGS when you switch. Unfortunately, if the children are complicated objects with large subtrees representing them, you could be wasting a lot of cycles calling UpdateGS when it is not needed. To avoid this, I chose not to override UpdateGS and just let updates at predecessors take their course through the scene. If you are daring, modify SwitchNode to maintain an array of Boolean values

that indicate whether or not the children are up to date, and then override `UpdateGS` to use those so that on a switch to a new active child, you only update if needed.

Picking, on the other hand, is limited to the active child. This makes sense since the active child is presumably the only one you see displayed on the screen. If the picking had to do with firing a laser gun at the level-of-detail object, even if that object is not currently visible, it still makes sense to limit the picking to the active child.

My version of a switch node supports only one active child. You might want a more general variation that allows you to select a subset of children to be active. It is simple enough to add a new class to the engine, perhaps called `MultiswitchNode`, that allows you to specify which children are active. I leave the implementation details to you.

For an automated switching system, where the switching is based on some desired game logic, just derive a class from `SwitchNode` and add the automation. For example, Wild Magic has a derived class `DlodNode`. (The acronym DLOD stands for "discrete level of detail.") The class interface is

```
class DlodNode : public SwitchNode
{
public:
    // construction
    DlodNode (int iQuantity = 1, int iGrowBy = 1);

    // center for level of detail
    Vector3f& ModelCenter ();
    const Vector3f& GetModelCenter () const;
    const Vector3f& GetWorldCenter () const;

    // distance intervals for children
    void SetModelDistance (int i, float fMinDist, float fMaxDist);
    float GetModelMinDistance (int i) const;
    float GetModelMaxDistance (int i) const;
    float GetWorldMinDistance (int i) const;
    float GetWorldMaxDistance (int i) const;

protected:
    // Switch the child based on distance from world LOD center to
    // camera.
    void SelectLevelOfDetail (const Camera* pkCamera);

    // drawing
    virtual void Draw (Renderer& rkRenderer, bool bNoCull = false);

    // point whose distance to camera determines correct child
    Vector3f m_kModelLodCenter;
```

```
    // squared distances for each LOD interval
    TArray<float> m_kModelMinDist;
    TArray<float> m_kModelMaxDist;
    TArray<float> m_kWorldMinDist;
    TArray<float> m_kWorldMaxDist;
};
```

The parameters you may choose are a model center and ranges of distances for each child. The model center is, of course, specified relative to the coordinate system implied by a parent node (if any). The model distance ranges are intended to be disjoint intervals, but the system does work properly if they overlap slightly. The world center and world distance ranges are automatically computed by DlodNode. During the drawing pass, the distance is computed between the world center and the eye point. The world distance interval that contains the computed distance is located, and the corresponding child is made active. The distance calculations and the child selection are implemented in SelectLevelOfDetail, a function that is called by Draw.

The sample application in the folder

GeometricTools/WildMagic3/SampleGraphics/DlodNodes

illustrates how to use DlodNode. The objects are convex polyhedra. Polyhedra with a larger number of vertices are drawn when the abstract object is close to the eye point. Polyhedra with a smaller number of vertices are drawn when the object is far from the eye point. The switching is quite noticeable, but that is the intent of the sample application. In a game, you want your artists to construct models so that the switching is not that noticeable.

4.1.4 CONTINUOUS LEVEL OF DETAIL

The algorithm I discussed in [Ebe00] for continuous LOD regarding triangle meshes is from the articles [GH97, GH98]. The book discussion is shy on the details for implementation, but so are the papers (as is true with many research articles since page limits are usually imposed). I will take the opportunity to illustrate the basic concepts for triangle mesh decimation by using line mesh decimation in two dimensions.

The simplest example is reduction of vertices in a nonintersecting open polyline or a closed polyline that is a simple closed curve (not self-intersecting). The polyline has vertices $\{\mathbf{X}_i\}_{i=0}^n$. The algorithm removes one vertex at a time based on weights assigned to the vertices. A vertex weight is a measure of variation of the polyline at the specified vertex. A simple measure of weight w_i for vertex \mathbf{X}_i is based on the three consecutive vertices \mathbf{X}_{i-1}, \mathbf{X}_i, and \mathbf{X}_{i+1},

$$w_i = \frac{\text{Distance}^2(\mathbf{X}_i, \text{Segment}(\mathbf{X}_{i-1}, \mathbf{X}_{i+1}))}{\text{Length}^2(\text{Segment}(\mathbf{X}_{i-1}, \mathbf{X}_{i+1}))}, \tag{4.1}$$

where Segment(\mathbf{U}, \mathbf{V}) denotes the line segment from \mathbf{U} to \mathbf{V}. The vertex that is removed first is the one corresponding to the minimum weight. Observe that if the minimum weight is zero, then \mathbf{X}_i is already a point on Segment(\mathbf{X}_{i-1}, \mathbf{X}_{i+1}). Removing zero-weight points first is ideal for polyline reduction.

Special handling is required at the end points \mathbf{X}_0 and \mathbf{X}_N. The easiest thing to do is assign $w_0 = w_n = \infty$; that is, the end points are never removed. The polyline is reduced a vertex at a time until only two vertices remain, the end points. However, it is possible that $\mathbf{X}_n = \mathbf{X}_0$, in which case the polyline is closed. Assigning infinite weight to \mathbf{X}_0 leads to that point always occurring in a reduction. Instead, the weight formula can be applied to every vertex in a closed polyline with the understanding that the indices are selected modulo n.

Other definitions for vertex weights may be used. For example, a larger neighborhood of \mathbf{X}_i might be used. Or an interpolating polynomial curve could be used to assign the curvature of that curve to each vertex. The choices are many, but the algorithm for determining the order of removal of the vertices can be developed independently of the weight definition.

The algorithm considered here just removes vertices, one at a time. The vertices of the reduced polyline form a subset of the vertices of the original polyline. This is convenient, but not necessary. If \mathbf{X}_i provides the minimum weight of all vertices, it is possible to replace the triple $\langle \mathbf{X}_{i-1}, \mathbf{X}_i, \mathbf{X}_{i+1} \rangle$ by the pair $\langle \mathbf{Y}_{i-1}, \mathbf{Y}_{i+1} \rangle$, where \mathbf{Y}_{i-1} and \mathbf{Y}_{i+1} are quantities derived from the original triple, and possibly from other nearby vertices.

A Simple Algorithm

The simplest algorithm for reduction is a recursive one. Given a polyline $P = \{\mathbf{X}_i\}_{i=0}^n$, compute the weights $\{w_i\}_{i=0}^n$. Search the weights for the minimum weight w_k. Remove \mathbf{X}_k from P to obtain the polyline P' that has $n - 1$ vertices. Repeat the algorithm on P'. This is an $O(n^2)$ algorithm since the first pass processes n vertices, the second pass processes $n - 1$ vertices, and so on. The total number of processed vertices is $n + (n - 1) + \ldots + 3 = n(n + 1)/2 - 3$.

A Fast Algorithm

A faster algorithm is called for. All n weights are calculated on the first pass. When a vertex \mathbf{X}_i is removed from P, only the weights for \mathbf{X}_{i-1} and \mathbf{X}_{i+1} are affected. The calculation of all weights for the vertices of P' involves many redundant computations. Moreover, if only a couple of weights change, it is not necessary to search the entire sequence of weights for the minimum value. A heap data structure can be used that supports an $O(1)$ lookup. If the heap is implemented as a complete binary tree, the minimum occurs at the root of the tree. When the minimum is removed, an $O(\log n)$ update of the binary tree is required to convert it back to a heap. The initial construction of the heap requires a comparison sort of the weights, an $O(n \log n)$ operation.

The fast reduction requires an additional operation that is not part of the classic heap data structure. The heap is initially reconstructed in $O(n \log n)$ time. The minimum value is removed, and the binary tree is reorganized to form a heap in $O(\log n)$ time. The vertex removal causes a change in two weights in the heap. Once those weights are changed, the binary tree will no longer represent a heap. If we can remove the two old weights from the heap, we could then add the two new weights. Unfortunately, the classic heap data structure does not support removing an element from any location other than the root. As it turns out, if a weight is changed in the heap, the corresponding node in the binary tree can be propagated either toward the root of the tree or toward the leaves of the tree, depending on how the weight compares to the weights of its parent or child nodes. Since the propagation can be performed without changing the tree structure, this update operation is also $O(\log n)$. If the changed weight is smaller than its parent weight, the node is swapped with its parent node, thereby preserving the heap property. If the changed weight is larger than its children's weights, the node is swapped with the child node of largest weight, thereby preserving the heap property.

Now we encounter the next complication. If a weight at an internal heap node changes, we need to know *where* that node is located to perform the $O(\log n)$ update. If we had to search the binary tree for the changed node, that operation is $O(n)$, a linear search. The only property of a minimum heap is that the weights of the two children of a node are smaller or equal to the weight of the node itself. That is not enough information for a search query to decide which child should be visited during the tree traversal, a necessary piece of information to reduce the search to $O(\log n)$. The solution to this problem is to create a data structure for each vertex in the polyline. Assuming that the binary tree of the heap is stored in a contiguous array, the vertex data structure must store the index to the heap node that represents the vertex. That index is changed whenever a heap element is propagated to its parent or to a child.

An Illustration

An example is given here for a 16-sided polygon with vertices $\mathbf{X}_k = A_k(\cos(2\pi k/16), \sin(2\pi k/16))$ for $0 \leq k < 16$, where the amplitudes were randomly generated as $A_0 = 75.0626$, $A_1 = 103.1793$, $A_2 = 84.6652$, $A_3 = 115.4370$, $A_4 = 104.2505$, $A_5 = 98.9937$, $A_6 = 92.5146$, $A_7 = 119.7981$, $A_8 = 116.1420$, $A_9 = 112.3302$, $A_{10} = 83.7054$, $A_{11} = 117.9472$, $A_{12} = 110.5251$, $A_{13} = 100.6768$, $A_{14} = 90.1997$, and $A_{15} = 75.7492$. Figure 4.2 shows the polygon with labeled vertices.

The min heap is stored as an array of 16 records. Each record is of the form

```
HeapRecord
{
    int V;          // vertex index
    int H;          // heap index
    float W;        // weight (depends on neighboring vertices)
```

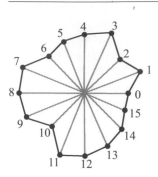

Figure 4.2 The initial 16-sided polygon to be reduced a vertex at a time.

```
        HeapRecord* L;  // points to record of left vertex neighbor
        HeapRecord* R;  // points to record of right vertex neighbor
}
```

The vertex index and doubly linked list structure represent the polyline itself. As vertices are removed, the list is updated to reflect the new topology. The weight is the numeric value on which the heap is sorted. As mentioned earlier, the heap index allows for an $O(1)$ lookup of the heap records whose weights change because of a vertex removal. Without this index, an $O(n)$ search on the vertex indices in the heap would be necessary to locate the heap records to change.

Initialization of the Heap

The heap records are initialized with the data from the original vertices. The vertex index and heap index are the same for this initialization. Figure 4.3 shows the heap array after initialization. The heap indices, the vertex indices, and the weights are shown. The weight of vertex \mathbf{X}_i is calculated using Equation (4.1), where the left neighbor is $\mathbf{X}_{(i-1) \bmod 16}$ and the right neighbor is $\mathbf{X}_{(i+1) \bmod 16}$.

To be a min heap, each node H_i in the binary tree must have a weight that is smaller or equal to the weights of its child nodes H_{2i+1} and H_{2i+2}. The heap array must be sorted so that the min heap property at each record is satisfied. This can be done in a nonrecursive manner by processing the parent nodes from the bottom of the tree toward the root of the tree. The first parent in the heap is located. In this example, H_7 is the first parent to process. Its only child, H_{15}, has a smaller value, so H_7 and H_{15} must be swapped. Figure 4.4 shows the state of the heap array after the swap.

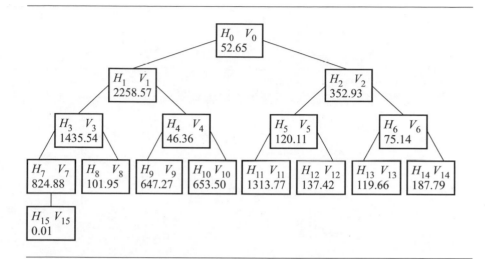

Figure 4.3 Initial values in the heap array.

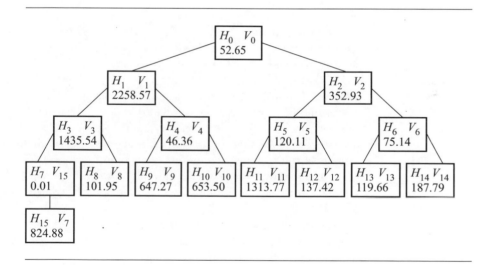

Figure 4.4 The heap array after swapping H_7 and H_{15} in Figure 4.3.

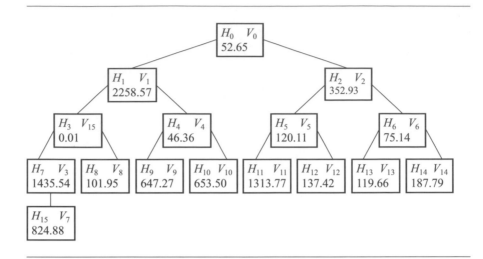

Figure 4.5 The heap array after swapping H_3 and H_7 in Figure 4.4.

The next parent to process is H_6. The weight at H_6 is smaller than the weights of its two children, so no swapping is necessary. The same is true for the parent nodes H_5 and H_4. Node H_3 has a weight that is larger than both its children's weights. A swap is performed with the child that has smallest weight; in this case H_3 and H_7 are swapped. Figure 4.5 shows the state of the heap array after the swap.

Before the swap, the subtree at the child is already guaranteed itself to be a min heap. After the swap, the worst case is that the weight needs to be propagated down a linear path in the subtree. Any further swaps are always with the child of minimum weight. In the example, an additional swap must occur, this time between H_7 and H_{15}. After the swap, the processing at H_3 is finished (for now), and the subtree at H_3 is itself a min heap. Figure 4.6 shows the state of the heap array after the swap of H_7 and H_{15}.

The next parent to process is H_2. The weight at H_2 is larger than the minimum weight occurring at child H_6, so these two nodes must be swapped. Figure 4.7 shows the state of the heap array after the swap.

Another swap must occur, now between H_6 and the minimum weight child H_{13}. Figure 4.8 shows the state of the heap array after the swap.

The next parent to process is H_1. The weight at H_1 is larger than the minimum weight occurring at child H_3, so these two nodes must be swapped. Figure 4.9 shows the state of the heap array after the swap.

Another swap must occur, now between H_3 and the minimum weight child H_8. Figure 4.10 shows the state of the heap array after the swap.

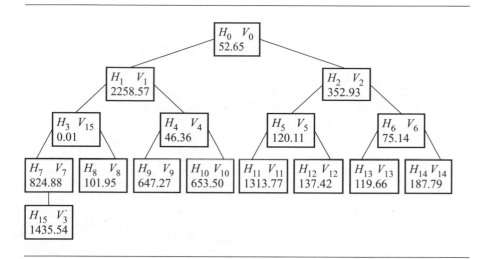

Figure 4.6 The heap array after swapping H_7 and H_{15} in Figure 4.5.

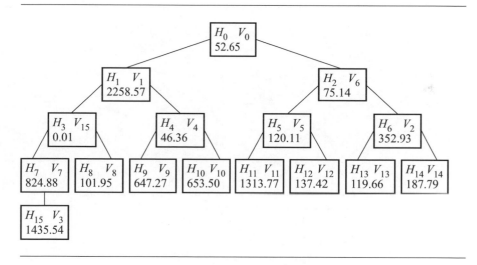

Figure 4.7 The heap array after swapping H_2 and H_6 in Figure 4.6.

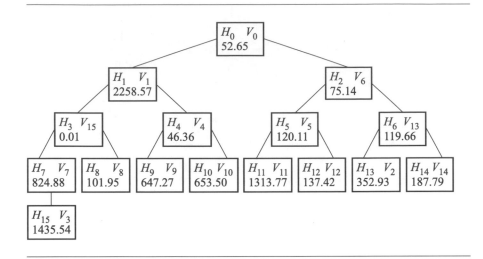

Figure 4.8 The heap array after swapping H_6 and H_{13} in Figure 4.7.

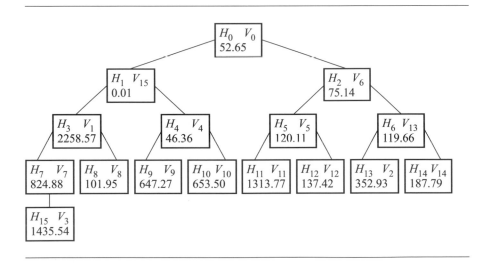

Figure 4.9 The heap array after swapping H_1 and H_3 in Figure 4.8.

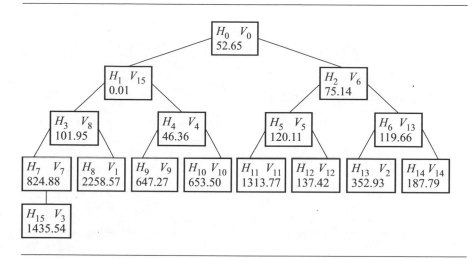

Figure 4.10 The heap array after swapping H_3 and H_8 in Figure 4.9.

The last parent to process is H_0. The weight at H_0 is larger than the minimum weight occurring at child H_1, so these two nodes must be swapped. Figure 4.11 shows the state of the heap array after the swap.

Another swap must occur, now between H_1 and the minimum weight child H_4, but no other swaps are necessary in that subtree. Figure 4.12 shows the state of the heap array after the swap. Now the heap array does represent a min heap since the children weights at each node are smaller or equal to the parent weights.

Remove and Update Operations

The vertex with minimum weight is the first to be removed from the polyline. The root of the heap corresponds to this vertex, so the root is removed from the heap. The vertex to be removed is V_{15}. To maintain a complete binary tree, the last item in the heap array is placed at the root location. Figure 4.13 shows the state of the heap array after moving the last record to the root position.

The array does not satisfy the min heap property since the root weight is larger than the minimum child weight. The root node H_0 must be swapped with H_1, the child of minimum weight. The swapping is repeated as long as the minimum weight child has smaller weight than the node under consideration. In this example, H_1 and H_4 are swapped, and then H_4 and H_9 are swapped. Figure 4.14 shows the state of the heap after the three swaps.

This is the typical operation for removing the minimum element from the heap. However, in the polyline application, there is more work to be done. The weights of

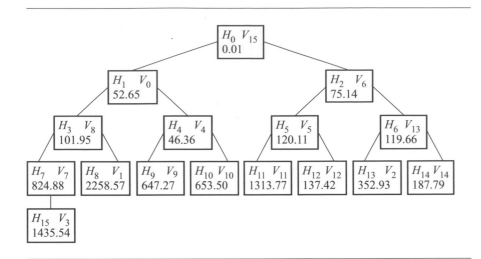

Figure 4.11 The heap array after swapping H_0 and H_1 in Figure 4.10.

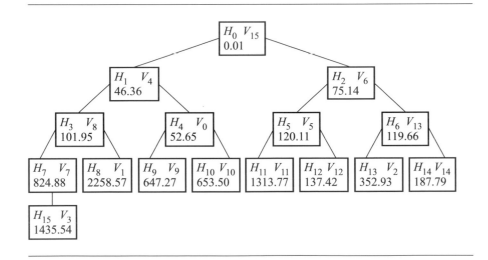

Figure 4.12 The heap array after swapping H_1 and H_4 in Figure 4.11.

vertices V_{14} and V_0 depended on V_{15}. The right neighbor of V_{14} was V_{15}, but is now V_0. The left neighbor of V_0 was V_{15}, but is now V_{14}. The weights of V_{14} and V_0 must be recalculated because of the change of neighbors. The old weight for V_{14} is 187.79, and the new weight is 164.52. The old weight for V_0 is 52.65, and the new weight is 52.77.

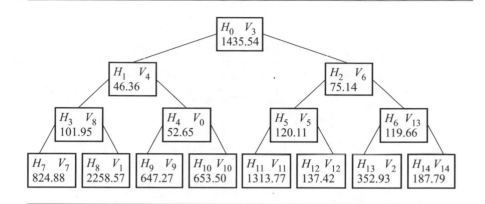

Figure 4.13 The heap array after removing the contents of H_0 and moving the contents of H_{15} to H_0.

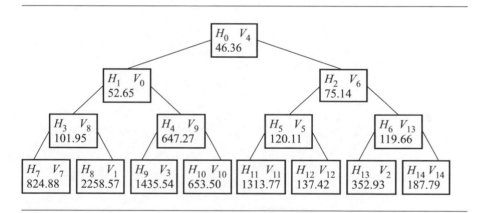

Figure 4.14 The heap after swapping H_0 with H_1, H_1 with H_4, and H_4 with H_9.

Neither change leads to an invalid heap, so no update of the heap array is necessary. Figure 4.15 shows the state of the heap after the two weight changes. Figure 4.16 shows the polygon of Figure 4.2 and the polygon with V_{15} removed.

The next vertex to be removed is V_4. The contents of the last heap node H_{14} are moved to the root, resulting in an invalid heap. Two swaps must occur, H_0 with H_1 and H_1 with H_3. Figure 4.17 shows the state of the heap after these changes.

The adjacent vertices whose weights must be updated are V_3 and V_5. For V_3, the old weight is 1435.54, and the new weight is 1492.74. This does not invalidate the heap at node H_9. For V_5, the old weight is 120.11, and the new weight is 157.11.

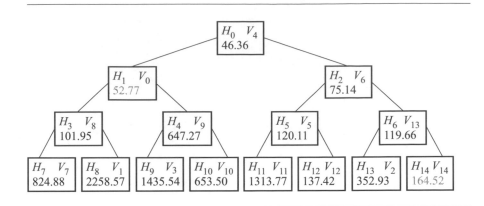

Figure 4.15 The heap after changing the weights on V_0 and V_{14}. The new weights are shown in gray.

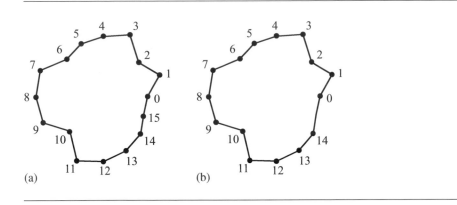

Figure 4.16 (a) The polygon of Figure 4.2 and (b) the polygon with V_{15} removed.

This change invalidates the heap at node H_5. Nodes H_5 and H_{12} must be swapped to restore the heap. Figure 4.18 shows the state of the heap after the two weight changes and the swap. Figure 4.19 shows the polygon of Figure 4.16(b) and the polygon with V_4 removed.

The next vertex to be removed is V_0. The contents of the last heap node H_{13} are moved to the root, resulting in an invalid heap. Two swaps must occur, H_0 with H_2 and H_2 with H_6. Figure 4.20 shows the state of the heap after these changes.

The adjacent vertices whose weights must be updated are V_1 and V_{14}. The left neighbor is processed first in the implementation. For V_{14}, the old weight is 164.52,

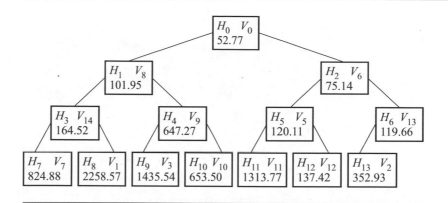

Figure 4.17 The heap after moving H_{14} to H_0 and then swapping H_0 with H_1 and H_1 with H_3.

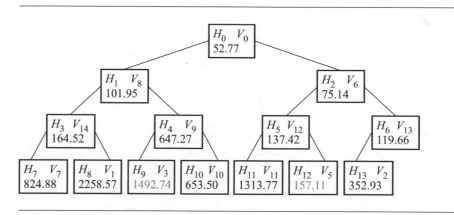

Figure 4.18 The heap after changing the weights on V_3 and V_5 and swapping H_5 and H_{12}. The new weights are shown in gray.

and the new weight is 65.80. The heap is invalid since the parent node H_1 has a weight that is larger than the weight at H_3. Two swaps must occur, H_3 with H_1 and H_1 with H_0. For V_1, the old weight is 2258.57, and the new weight is 791.10, but the heap is still valid. Figure 4.21 shows the state of the heap after the weight change and the swaps. Figure 4.22 shows the polygon of Figure 4.19(b) and the polygon with V_0 removed.

The process is similar for the remaining vertices, removed in the order V_{14}, V_6, V_5, V_8, V_{12}, V_2, V_{13}, V_{10}, V_9, and V_1. Vertices V_7, V_3, and V_{11} remain. Figure 4.23 shows the corresponding reduced polygons. Collapses occur from left to right, top to bottom.

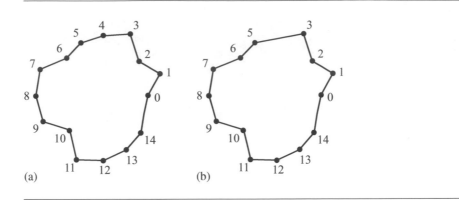

Figure 4.19 (a) The polygon of Figure 4.16(b) and (b) the polygon with V_4 removed.

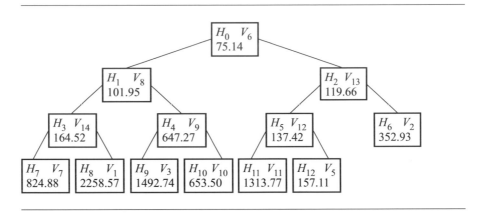

Figure 4.20 The heap after moving H_{13} to H_0, then swapping H_0 with H_2 and H_2 with H_6.

Dynamic Change in Level of Detail

The vertex collapses can be computed according to the algorithm presented previously. An application might want not only to decrease the level of detail by vertex collapses, but also increase it on demand. To support this, the edge connectivity must be stored with the polyline. The connectivity data structure will change based on the given addition or removal of a vertex.

An array of edge indices is used to represent the connectivity. The initial connectivity for an open polyline of n vertices is an array of $2n - 2$ indices grouped in pairs as $\langle 0, 1 \rangle$, $\langle 1, 2 \rangle$, ..., $\langle n - 2, n - 1 \rangle$. A closed polyline has one additional pair,

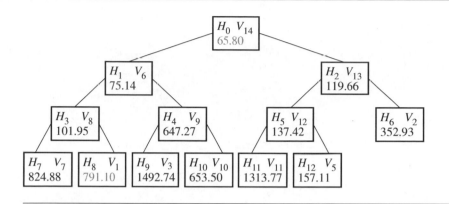

Figure 4.21 The heap after changing the weight on V_{14}, swapping H_3 with H_1 and H_1 with H_0, and then changing the weight on V_1. The new weights are shown in gray.

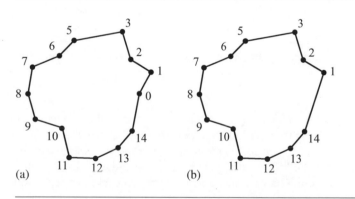

Figure 4.22 (a) The polygon of Figure 4.19(b) and (b) the polygon with V_0 removed.

$\langle n - 1, 0 \rangle$. If vertex V_i is removed, the pair of edges $\langle i - 1, i \rangle$ and $\langle i, i + 1 \rangle$ must be replaced by a single edge $\langle i - 1, i + 1 \rangle$. The change in level of detail amounts to inserting, removing, and modifying the elements of an array, but an array is not well suited for such operations.

Instead, the initial array of edge indices should be sorted so that the last edge in the array is the first one removed by a collapse operation. If the indices of the collapsed vertices are sorted as c_0, \ldots, c_{n-1} where the last vertex in the array is the first one removed by a collapse operation, then the initial edge array should be

$$\langle c_0, c_0 + 1 \rangle, \langle c_1, c_1 + 1 \rangle, \ldots, \langle c_{n-1}, c_{n-1} + 1 \rangle = \langle e_0, \ldots e_{2n-1} \rangle,$$

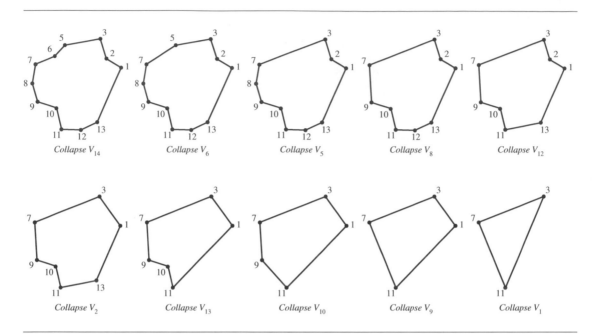

Figure 4.23 The remaining vertex collapses, occurring left to right, then top to bottom.

where the index sum $i + 1$ is computed modulo n to handle both open and closed polylines. To remove the vertex with index c_{n-1}, the last edge $\langle e_{2n-2}, e_{2n-1} \rangle$ is simply ignored. In an implementation, an index to the last edge in the array is maintained. When the level of detail decreases, that index is decremented. When the level increases, the index is incremented. The removal of the edge indicates that the vertex with index c_{n-1} is no longer in the polyline. That same index occurs earlier in the edge array and must be replaced by the second index of the edge. In the current example, $e_{2n-2} = c_{n-1}$ and $e_{2n-1} = c_{n-1} + 1$. A search is made in the edge array for the index $e_{m_{n-1}}$ that is also equal to c_{n-1}, then $e_{m_{n-1}} \leftarrow e_{2n-1}$. The mapping m_{n-1} should be stored in order to increase the level of detail by restoring the original value of $e_{m_{n-1}}$ to c_{n-1}.

The algorithm is iterative. To remove the vertex with index c_k, observe that $e_{2k} = c_k$ and $e_{2k+1} = c_k + 1$. The edge quantity is decreased by one. A search is made in $\langle e_0, \ldots, e_{2k-1} \rangle$ for the index e_{m_k} that is equal to c_k, then replacing $e_{m_k} \leftarrow e_{2k+1}$. Adding the vertex with index c_k back into the polyline is accomplished by replacing $e_{m_k} \leftarrow c_k$. The iteration stops when $k = 1$ for open polylines so that the final line segment is not collapsed to a single point. The iteration stops when $k = 5$ for closed polylines so that the smallest level of detail is a triangle that is never collapsed to a line segment.

Table 4.1 The vertex collapses for the 16-sided polygon in Figure 4.2.

Vertex	Map	Edges
15	25	$\langle 3, 4\rangle\langle 11, 12\rangle\langle 7, 8\rangle\langle 1, 2\rangle\langle 9, 10\rangle\langle 10, 11\rangle\langle 13, 14\rangle\langle 2, 3\rangle\langle 12, 13\rangle\langle 8, 9\rangle\langle 5, 6\rangle\langle 6, 7\rangle\langle 14, 0\rangle\langle 0, 1\rangle\langle 4, 5\rangle$
4	1	$\langle 3, 5\rangle\langle 11, 12\rangle\langle 7, 8\rangle\langle 1, 2\rangle\langle 9, 10\rangle\langle 10, 11\rangle\langle 13, 14\rangle\langle 2, 3\rangle\langle 12, 13\rangle\langle 8, 9\rangle\langle 5, 6\rangle\langle 6, 7\rangle\langle 14, 0\rangle\langle 0, 1\rangle$
0	25	$\langle 3, 5\rangle\langle 11, 12\rangle\langle 7, 8\rangle\langle 1, 2\rangle\langle 9, 10\rangle\langle 10, 11\rangle\langle 13, 14\rangle\langle 2, 3\rangle\langle 12, 13\rangle\langle 8, 9\rangle\langle 5, 6\rangle\langle 6, 7\rangle\langle 14, 1\rangle$
14	13	$\langle 3, 5\rangle\langle 11, 12\rangle\langle 7, 8\rangle\langle 1, 2\rangle\langle 9, 10\rangle\langle 10, 11\rangle\langle 13, 1\rangle\langle 2, 3\rangle\langle 12, 13\rangle\langle 8, 9\rangle\langle 5, 6\rangle\langle 6, 7\rangle$
6	21	$\langle 3, 5\rangle\langle 11, 12\rangle\langle 7, 8\rangle\langle 1, 2\rangle\langle 9, 10\rangle\langle 10, 11\rangle\langle 13, 1\rangle\langle 2, 3\rangle\langle 12, 13\rangle\langle 8, 9\rangle\langle 5, 7\rangle$
5	1	$\langle 3, 7\rangle\langle 11, 12\rangle\langle 7, 8\rangle\langle 1, 2\rangle\langle 9, 10\rangle\langle 10, 11\rangle\langle 13, 1\rangle\langle 2, 3\rangle\langle 12, 13\rangle\langle 8, 9\rangle$
8	5	$\langle 3, 7\rangle\langle 11, 12\rangle\langle 7, 9\rangle\langle 1, 2\rangle\langle 9, 10\rangle\langle 10, 11\rangle\langle 13, 1\rangle\langle 2, 3\rangle\langle 12, 13\rangle$
12	3	$\langle 3, 7\rangle\langle 11, 13\rangle\langle 7, 9\rangle\langle 1, 2\rangle\langle 9, 10\rangle\langle 10, 11\rangle\langle 13, 1\rangle\langle 2, 3\rangle$
2	7	$\langle 3, 7\rangle\langle 11, 13\rangle\langle 7, 9\rangle\langle 1, 3\rangle\langle 9, 10\rangle\langle 10, 11\rangle\langle 13, 1\rangle$
13	3	$\langle 3, 7\rangle\langle 11, 1\rangle\langle 7, 9\rangle\langle 1, 3\rangle\langle 9, 10\rangle\langle 10, 11\rangle$
10	9	$\langle 3, 7\rangle\langle 11, 1\rangle\langle 7, 9\rangle\langle 1, 3\rangle\langle 9, 11\rangle$
9	5	$\langle 3, 7\rangle\langle 11, 1\rangle\langle 7, 11\rangle\langle 1, 3\rangle$
1	3	$\langle 3, 7\rangle\langle 11, 3\rangle\langle 7, 11\rangle$

Consider the example shown previously that consisted of a 16-sided polygon. The vertex indices ordered from last removed to first removed are 3, 11, 7, 1, 9, 10, 13, 2, 12, 8, 5, 6, 14, 0, 4, 15. The initial edge array is

$$\langle 3, 4\rangle\langle 11, 12\rangle\langle 7, 8\rangle\langle 1, 2\rangle\langle 9, 10\rangle\langle 10, 11\rangle\langle 13, 14\rangle\langle 2, 3\rangle\langle 12, 13\rangle$$

$$\langle 8, 9\rangle\langle 5, 6\rangle\langle 6, 7\rangle\langle 14, 15\rangle\langle 0, 1\rangle\langle 4, 5\rangle\langle 15, 0\rangle,$$

and the edge quantity is $Q_e = 16$. The vertex quantity is $Q_v = 16$. The removal of V_{15} is accomplished by decrementing $Q_v = 15$ and $Q_e = 15$. The last edge $\langle 15, 0\rangle$ is ignored (iterations over the edges use Q_e as the upper bound for the loop index). A search is made in the first 15 edges for index 15 and is found at $e[25]$ (in the edge $\langle 14, 15\rangle$). That index is replaced by $e[25] = 0$, where 0 is the second index of the removed edge $\langle 15, 0\rangle$. The mapping index is $m_{15} = 25$. Table 4.1 lists the vertex collapses, the mapping indices, and the edge array (only through the valid number of edges).

Given the final triangle after all collapses, to restore vertex V_9 we need to increment Q_v to 4, increment Q_e to 4, and set $e[5] = 9$, where 5 is the mapping index associated with V_9.

Reordering Vertices

In an application that wants to rigidly transform the polyline, it might be useful to have the vertices at any level of detail stored as a packed array. This supports any optimized code for batch-transforming a contiguous block of vertices. The collapse indices $(c_0, c_1, \ldots, c_{n-1})$ represent a permutation of $(0, 1, \ldots, n - 1)$. The vertices themselves can be reordered using this permutation. Subsequently, the edge indices themselves must be converted properly. The reindexing requires the inverse permutation, $(d_0, d_1, \ldots, d_{n-1})$, where $d_{c_i} = i$. The mapping index does not change since the edge reindexing does not change the order of items in the edge array. If U_i are the reordered vertices, then $U_i = V_{c_i}$. If an edge is $E = \langle e_i, e_j \rangle$, then the reindexed edge is $F = \langle d_{e_i}, d_{e_j} \rangle$.

For example, the inverse permutation for

$$\vec{c} = (3, 11, 7, 1, 9, 10, 13, 2, 12, 8, 5, 6, 14, 0, 4, 15)$$

is

$$\vec{d} = (13, 3, 7, 0, 14, 10, 11, 2, 9, 4, 5, 1, 8, 6, 12, 15).$$

The initial edge array is

$$\langle 0, 14 \rangle \langle 1, 8 \rangle \langle 2, 9 \rangle \langle 3, 7 \rangle \langle 4, 5 \rangle \langle 5, 1 \rangle \langle 6, 12 \rangle \langle 7, 0 \rangle \langle 8, 6 \rangle \langle 9, 4 \rangle \langle 10, 11 \rangle \langle 11, 2 \rangle$$

$$\langle 12, 15 \rangle \langle 13, 3 \rangle \langle 14, 10 \rangle \langle 15, 13 \rangle.$$

The vertex collapse table from the last example is reindexed, as shown in Table 4.2.

Triangle Mesh Decimation

The ideas for line mesh decimation apply directly to triangle mesh decimation, but there are many more tedious details to take care of. A vertex collapse for a line mesh amounted to removing a vertex of minimum weight and then informing its right neighbor to connect itself to the left neighbor. For a triangle mesh, the equivalent concept is an *edge collapse*. An edge $\langle v_k, v_t \rangle$ of minimum weight is removed. The vertex v_k is the *keep* vertex and v_t is the *throw* vertex. The edge and v_t are removed from the mesh. All triangles sharing the edge are deleted. All remaining triangles sharing v_t have it replaced by v_k. A typical example is shown in Figure 4.24.

The first collapse is from the upper-left image to the upper-right image. The edge $\langle v_2, v_4 \rangle$ is removed. The keep vertex is v_2, and the throw vertex is v_4. The triangles $\langle v_2, v_0, v_4 \rangle$ and $\langle v_2, v_4, v_3 \rangle$ are removed. The remaining triangles that shared vertex v_4 now have that vertex replaced by v_2.

The second collapse is from the upper-right image to the lower-right image. The edge $\langle v_2, v_6 \rangle$ is removed. The keep vertex is v_2, and the throw vertex is v_6. The

Table 4.2 The vertex collapses for the previous example.

Vertex	Map	Edges
15	25	$\langle 0, 14 \rangle \langle 1, 8 \rangle \langle 2, 9 \rangle \langle 3, 7 \rangle \langle 4, 5 \rangle \langle 5, 1 \rangle \langle 6, 12 \rangle \langle 7, 0 \rangle \langle 8, 6 \rangle \langle 9, 4 \rangle \langle 10, 11 \rangle \langle 11, 2 \rangle \langle 12, 13 \rangle \langle 13, 3 \rangle \langle 14, 10 \rangle$
14	1	$\langle 0, 10 \rangle \langle 1, 8 \rangle \langle 2, 9 \rangle \langle 3, 7 \rangle \langle 4, 5 \rangle \langle 5, 1 \rangle \langle 6, 12 \rangle \langle 7, 0 \rangle \langle 8, 6 \rangle \langle 9, 4 \rangle \langle 10, 11 \rangle \langle 11, 2 \rangle \langle 12, 13 \rangle \langle 13, 3 \rangle$
13	25	$\langle 0, 10 \rangle \langle 1, 8 \rangle \langle 2, 9 \rangle \langle 3, 7 \rangle \langle 4, 5 \rangle \langle 5, 1 \rangle \langle 6, 12 \rangle \langle 7, 0 \rangle \langle 8, 6 \rangle \langle 9, 4 \rangle \langle 10, 11 \rangle \langle 11, 2 \rangle \langle 12, 3 \rangle$
12	13	$\langle 0, 10 \rangle \langle 1, 8 \rangle \langle 2, 9 \rangle \langle 3, 7 \rangle \langle 4, 5 \rangle \langle 5, 1 \rangle \langle 6, 3 \rangle \langle 7, 0 \rangle \langle 8, 6 \rangle \langle 9, 4 \rangle \langle 10, 11 \rangle \langle 11, 2 \rangle$
11	21	$\langle 0, 10 \rangle \langle 1, 8 \rangle \langle 2, 9 \rangle \langle 3, 7 \rangle \langle 4, 5 \rangle \langle 5, 1 \rangle \langle 6, 3 \rangle \langle 7, 0 \rangle \langle 8, 6 \rangle \langle 9, 4 \rangle \langle 10, 2 \rangle$
10	1	$\langle 0, 2 \rangle \langle 1, 8 \rangle \langle 2, 9 \rangle \langle 3, 7 \rangle \langle 4, 5 \rangle \langle 5, 1 \rangle \langle 6, 3 \rangle \langle 7, 0 \rangle \langle 8, 6 \rangle \langle 9, 4 \rangle$
9	5	$\langle 0, 2 \rangle \langle 1, 8 \rangle \langle 2, 4 \rangle \langle 3, 7 \rangle \langle 4, 5 \rangle \langle 5, 1 \rangle \langle 6, 3 \rangle \langle 7, 0 \rangle \langle 8, 6 \rangle$
8	3	$\langle 0, 2 \rangle \langle 1, 6 \rangle \langle 2, 4 \rangle \langle 3, 7 \rangle \langle 4, 5 \rangle \langle 5, 1 \rangle \langle 6, 3 \rangle \langle 7, 0 \rangle$
7	7	$\langle 0, 2 \rangle \langle 1, 6 \rangle \langle 2, 4 \rangle \langle 3, 0 \rangle \langle 4, 5 \rangle \langle 5, 1 \rangle \langle 6, 3 \rangle$
6	3	$\langle 0, 2 \rangle \langle 1, 3 \rangle \langle 2, 4 \rangle \langle 3, 0 \rangle \langle 4, 5 \rangle \langle 5, 1 \rangle$
5	9	$\langle 0, 2 \rangle \langle 1, 3 \rangle \langle 2, 4 \rangle \langle 3, 0 \rangle \langle 4, 1 \rangle$
4	5	$\langle 0, 2 \rangle \langle 1, 3 \rangle \langle 2, 1 \rangle \langle 3, 0 \rangle$
3	3	$\langle 0, 2 \rangle \langle 1, 0 \rangle \langle 2, 1 \rangle$

triangles $\langle v_2, v_6, v_3 \rangle$, $\langle v_2, v_6, v_7 \rangle$, and $\langle v_2, v_5, v_6 \rangle$ are removed. No other triangles shared v_6, so the remaining triangles need no adjusting.

The third collapse is from the lower-right image to the lower-left image. The edge $\langle v_2, v_1 \rangle$ is removed. The keep vertex is v_2, and the throw vertex is v_1. The triangles $\langle v_2, v_1, v_0 \rangle$ and $\langle v_2, v_3, v_1 \rangle$ are removed. No other triangles shared v_1, so the remaining triangles need no adjusting.

A not-so-typical example that illustrates how a mesh can fold over, independent of the geometry of the mesh, is shown in Figure 4.25. In Figure 4.25(a), the triangles are counterclockwise ordered as $\langle 0, 4, 3 \rangle$, $\langle 4, 1, 2 \rangle$, and $\langle 4, 2, 3 \rangle$. The collapse of vertex 4 to vertex 0 leads to deletion of $\langle 0, 4, 3 \rangle$ and modification of $\langle 4, 1, 2 \rangle$ to $\langle 0, 1, 2 \rangle$ and modification of $\langle 4, 2, 3 \rangle$ to $\langle 0, 2, 3 \rangle$. Both modified triangles are visible in the figure as counterclockwise.

In Figure 4.25(b), the modified triangle $\langle 0, 2, 3 \rangle$ is counterclockwise. This is by design; collapses always preserve this. But the triangle appears to be clockwise in the figure: upside down, it folded over. We can avoid the problem by doing a look-ahead on the collapse. If any potentially modified triangle causes a folding, we assign an infinite weight to the offending edge to prevent that edge from collapsing.

Another issue when collapsing edges in an open mesh is that the mesh can shrink. To avoid shrinking, we can also assign infinite weights to boundary edges of the original mesh. And finally, if we want to preserve the mesh topology, we can assign infinite weights to edges with three or more shared triangles.

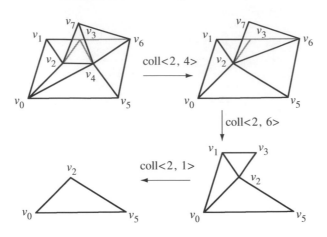

Figure 4.24 A sequence of three edge collapses in a triangle mesh.

A well-chosen set of data structures is needed to support edge collapse operations. It is sufficient to store the following information about the mesh:

```
Vertex =
{
    int V;              // index into vertex array
    EdgeSet E;          // edges sharing V
    TriangleSet T;      // triangles sharing vertex
}

Edge =
{
    int V0, V1;         // store with V0 = min(V0,V1)
    TriangleSet T;      // triangles sharing edge
    int H;              // index into heap array
    float W;            // weight of edge
}

Triangle =
{
    int V0, V1, V2;     // store with V0 = min(V0,V1,V2)
    int T;              // unique triangle index
}
```

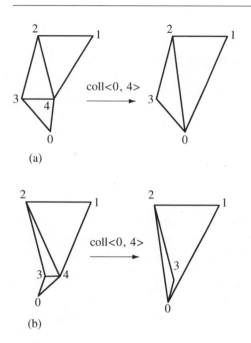

Figure 4.25 An edge collapse resulting in the mesh folding over on itself: (a) no folding and (b) folding.

An insert operation modifies the appropriate data structures and creates new components only when necessary. A remove operation also modifies the data structures and deletes components only when their reference counts decrease to zero.

The heap is implemented as an array of pointers to Edge objects. It is initialized just as for polylines. An iteration is made over the edges in the mesh, and the heap array values are filled in. An initial sort is made to force the array to represent a min heap. Some pseudocode for the edge collapse is

```
void EdgeCollapse (int VKeep, int VThrow)
{
    for each triangle T sharing edge <VKeep,VThrow> do
        RemoveTriangle(T);

    for each triangle T sharing VThrow do
    {
        RemoveTriangle(T);
        replace VThrow in T by VKeep;
```

```
        InsertTriangle(T);
    }

    // Set of potentially modified edges consists of all edges
    // shared by the triangles containing the VKeep.  Modify
    // the weights and update the heap.
    EdgeSet Modified;
    for each triangle T sharing VKeep do
        insert edges of T into Modified;

    for each edge E in Modified do
    {
        compute weight E.W;
        update the heap at index E.H;
    }
}
```

During the insertion and removal of triangles, edges are inserted and/or deleted in a *weak* sense. Multiple attempts are made to insert an edge shared by two modified triangles. Each time the attempt occurs, the offending triangle has changed, so the edge weight changes. To reduce the code complexity, we just allow the edge weight to be updated each time rather than trying to minimize the number of updates. Of course, if an edge is inserted the first time, its weight is newly added to the heap.

When an edge is deleted, it must be removed from the heap. However, the edge might not be at the root of the heap. You may artificially set the weight to be $-\infty$ and call the heap update to bubble the edge to the root of the heap, and then remove it.

Vertices are also deleted and sometimes inserted. Although the edge collapse makes it appear as if only the throw vertex is deleted, others can be. After each collapse, you can store the deleted vertex indices in an array that eventually represents the permutation for reordering vertices.

The function that removes triangles can be set up to store an array of the deleted triangle indices for use in reordering the triangle connectivity array.

After all edge collapses, you can build the collapse records using the pseudocode

```
CollapseRecord
{
    int VKeep, VThrow;   // the edge to collapse
    int VQuantity;       // vertices remaining after the collapse
    int TQuantity;       // triangles remaining after the collapse

    // connectivity indices in [0..TQ-1] that contain VThrow
    int IQuantity;
    int Index[];
}
```

Dynamic Change in Level of Detail

Each edge collapse in the triangle decimation generated a set of deleted vertices and a set of deleted triangles. This information is used to generate a sequence of records representing the collapses. The sequence can be used at run time to change the level of detail. Just as for polylines, sort the triangle index array so that the last triangles in the array are the first triangles deleted by an edge collapse. Sort the vertices so that the last vertices in the array are the first vertices deleted by an edge collapse. This requires permuting the indices in the triangle connectivity array—something done as a postprocessing step to the edge collapses.

To decrease the level of detail: Decrement the index array quantity by the amount stored in the corresponding record. Replace the appropriate indices in the first part of the array by the index of the deleted vertex.

To increase the level of detail: Increment the index array quantity by the amount stored in the corresponding record. Restore the appropriate indices in the first part of the array. This requires remembering where you changed the indices with each collapse. This mapping can be computed once, at decimation time, and then used during run time.

The vertex reordering supports batch transforming of contiguous blocks of vertices and avoids having to repack data for the renderer each time the level of detail changes.

Source Supporting Continuous Level of Detail

The source files that implement the scheme described here are in the Detail subfolder of the Source folder. In particular, look at the files with first names Wm3CreateClodMesh, Wm3CollapseRecord, and Wm3ClodMesh. The class for triangle mesh decimation is CreateClodMesh. The public portion of the interface is

```
class CreateClodMesh
{
public:
    CreateClodMesh (int iVQuantity, Vector3f* akVertex,
        int iTQuantity, int* aiTConnect, int& riCQuantity,
        CollapseRecord*& rakCRecord);

    ~CreateClodMesh ();

    template <class T> void Reorder (T*& ratVertexAttribute);
};
```

The creation of the collapse records and reordering of the vertex and index arrays in the Wild Magic version 3 implementation are nearly the same as what appeared in

Wild Magic version 2. One major difference, though, is in how vertex attributes are handled. In version 2, you had to pass the color, normal, and/or texture coordinate arrays to the CreateClodMesh constructor. The attributes were reordered using the same permutation applied to the array of vertex locations. In version 3, you reorder the vertex attributes after the construction of the collapse records. The template class member function Reorder does the work. The version 2 code could not handle additional attributes such as texture coordinates for multiple textures. The idea in version 3 is that you can reorder as many arrays of attributes as you like.

Also, the version 2 class was derived from a base class that provided the vertex-edge-triangle data structure to support dynamic insertion and removal of mesh items. The base class had a lot of operations not needed by triangle mesh decimation. In version 3, I have removed that base class and implemented the data structures directly in CreateClodMesh.

The source code for CreateClodMesh is about 1200 lines of tedious details. Such is the fate of dynamic manipulation of meshes. If you can follow the high-level description I provided previously, you should be able to trace your way through the source code to understand how it relates to the discussion.

The class ClodMesh is derived from TriMesh. The public interface is

```
class ClodMesh : public TriMesh
{
public:
    // Construction and destruction.  ClodMesh accepts
    // responsibility for deleting the input arrays.
    ClodMesh (Vector3fArrayPtr spkVertices, IntArrayPtr spkIndices,
        bool bGenerateNormals, int iRecordQuantity,
        CollapseRecord* akRecord);

    virtual ~ClodMesh ();

    // LOD selection is based on manual selection by the
    // application.  To use distance from camera or screen space
    // coverage, derive a class from WmlClodMesh and override
    // 'GetAutomatedTargetRecord'.
    int GetRecordQuantity () const;
    int& TargetRecord ();
    virtual int GetAutomatedTargetRecord ();

    // Geometric updates.  The Draw method will call this update
    // and adjust the TriMesh quantities according to the current
    // value of the target record.  You can call this manually in
    // an application that does not need to display the mesh.
    void SelectLevelOfDetail ();
};
```

You must create the collapse records using CreateClodMesh for the triangle meshes of interest and then pass these to the constructor of ClodMesh. As the source code comments indicate, you can manually set the *target record* in the sequence of collapse records. The next drawing operation will internally call the function SelectLevel-OfDetail, which updates the active vertex quantity and the active triangle quantity. To automate the selection of the target record, you need only derive a class from ClodMesh and override the GetAutomatedTargetRecord.

The sample application in the folder

GeometricTools/WildMagic3/SampleGraphics/ClodMeshes

illustrates how to use CreateClodMesh to decimate a TriMesh object that represents a face and then create a ClodMesh object. The selection of the target record is based on the distance from the eye point to the center of the world bounding sphere for the mesh. The farther away from the eye point the bounding sphere gets, the fewer triangles are used in the face. The following function controls the target record when the camera moves forward in the view direction:

```
void TestClodMesh::MoveForward ()
{
    Application::MoveForward();

    Vector3f kDiff = m_spkScene->WorldBound->Center
        - m_spkCamera->GetWorldLocation();
    float fDepth = kDiff.Dot(m_spkCamera->GetWorldDVector());
    if ( fDepth <= m_spkCamera->GetDMin() )
    {
        m_spkClod->TargetRecord() = 0;
    }
    else if ( fDepth >= m_spkCamera->GetDMax() )
    {
        m_spkClod->TargetRecord() =
            m_spkClod->GetRecordQuantity() - 1;
    }
    else
    {
        // Distance along camera direction controls triangle
        // quantity.
        float fN = m_spkCamera->GetDMin();
        float fF = m_spkCamera->GetDMax();
        float fRatio = (fDepth - fN)/(fF - fN);

        // allow nonlinear drop-off
        fRatio = Mathf::Pow(fRatio,0.5f);
```

```
        int iMaxIndex = m_spkClod->GetRecordQuantity() - 1;
        int iIndex = (int)(iMaxIndex*fRatio);
        m_spkClod->TargetRecord() = iIndex;
    }
}
```

The base class MoveForward is called first, so the camera is moved a small amount in the view direction. The vector difference between the eye point and the world bounding sphere is projected onto the view direction. The length of the projection is the fDepth variable in the code. If that depth is smaller than the near plane distance, the target record is set to the first one in the list of collapse records, resulting in all triangles in the mesh being displayed (at least those still in the view frustum). If the depth is larger than the far plane distance, the target record is set to the last collapse record, in which case the coarsest-resolution mesh is used for drawing the face. The face edges were assigned infinite weight, so the mesh becomes flat only but does not shrink. For depths between the near and far values, the target record index is chosen between the minimum and maximum indices using a fractional power of the same proportion that the depth has relative to the near and far distances of the view frustum. A linear proportion could be used, but I wanted the quantity of triangles drawn to drop off more rapidly as the face moves away from the eye point. I will save the screen shots of this for the discussion of sample applications in Section 8.2.5.

4.1.5 INFINITE LEVEL OF DETAIL

The classical way for obtaining infinite level of detail is to start with a functional definition of a surface,

$$\mathbf{P}(u, v) = (x(u, v), y(u, v), z(u, v))$$

for the parameters (u, v) either in a rectangle domain, usually $0 \le u \le 1$ and $0 \le v \le 1$, or in a triangular domain, usually $u \ge 0$, $v \ge 0$, and $u + v \le 1$. The parameter domain is subdivided into triangles and the corresponding vertices are on the 3D triangle mesh. For example, a rectangle domain can be subdivided a few steps as shown in Figure 4.26. A triangle domain can be subdivided a few steps as shown in Figure 4.27.

You have a lot of choices for surface functions to control the actual vertex locations associated with the input parameters. This topic is covered in more detail in Section 4.3.

Another possibility for infinite level of detail is *subdivision surfaces*. These surfaces are generated by starting with a triangle (or polygon) mesh. A refinement phase creates new vertices and reconnects them to create new (and usually smaller) triangles. A smoothing phase moves the vertices to new locations. These two phases are repeated alternately to any level of detail you prefer. Unlike parametric surfaces, subdivision surfaces do not have a closed-form expression for the vertex locations. However, such

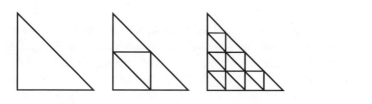

Figure 4.26 A few subdivisions of a rectangle domain into triangles.

Figure 4.27 A few subdivisions of a triangle domain into triangles.

expressions are not really necessary if your goal is to generate some shapes for display. Vertex normals can be computed from the mesh of triangles without relying on a parametric formula for the surface normals. Wild Magic version 3 does not implement subdivision surfaces, so I do not describe them in this book. For a well-written summary of the topic, see [AMH02].

4.2 SORTING

The classic reason for geometric sorting is for correct drawing of objects, both opaque and semitransparent. The opaque objects should be sorted from front to back, based on an observer's location, and the semitransparent objects should be sorted from back to front. The sorted opaque objects are drawn first, and the sorted semitransparent objects are drawn second.

Geometric sorting is not the only important reason for reorganizing your objects. In many situations, changes in the render state can cause the renderer to slow down. The most obvious case is when you have a limited amount of VRAM and more textures than can fit in it. Suppose you have a sequence of six objects to draw, S_1 through S_6, and each object has one of three texture images assigned to it. Let I_1, I_2, and I_3 be those images; assume they are of the same size and that VRAM is limited in that it can only store two of these at a time. Suppose the order of objects in the scene

leads to the images being presented to the renderer in the order I_1, I_2, I_3, I_1, I_2, I_3. To draw S_1, I_1 is loaded to VRAM and the object is drawn. Image I_2 is then loaded to VRAM and S_2 is drawn. To draw S_3, image I_3 must be loaded to VRAM. There is no room for it, so one of the images must be discarded from VRAM. Assuming a "least frequently used" algorithm, I_1 is discarded. At that point I_3 is loaded, in which case VRAM stores I_2 and I_3, and S_3 is drawn. S_4 requires I_1 to be loaded to VRAM. That image was just discarded, so it needs to be loaded again. Since I_2 is the least frequently used, it is discarded and I_1 is loaded. Now VRAM stores I_3 and I_1. S_4 may be drawn. S_5 requires I_2 to be in VRAM. Once again we have the undesirable situation of having to reload an image that was just discarded. When all six objects have been drawn, VRAM has performed four discard operations. Since sending large textures across the memory bus to the graphics card is expensive, the discards can really reduce the frame rate.

If we were instead to sort the objects by the images that they use, we would have S_1, S_4, S_2, S_5, S_3, and S_6. Image I_1 is loaded to VRAM, and S_1 is drawn. We can immediately draw S_4 since it also uses I_1 and that image is already in VRAM. Image I_2 is loaded to VRAM, and both S_2 and S_5 are drawn. In order to handle the last two objects, VRAM must discard I_1, load I_3, and then draw S_3 and S_6. In this drawing pass, only one discard has occurred. Clearly the sorting by texture image buys you something in this example.

In general, if your profiling indicates that a frequent change in a specific render state is a bottleneck, sorting the objects by that render state should be beneficial. You set the render state once and draw all the objects.

The first three topics in this section are about geometric sorting. The first is on sorting of spatial regions using binary space partitioning trees (BSP trees). The BSP trees are not used for partitioning triangle meshes. The second is about portals, an automatic method to cull nonvisible geometric objects. The third is on sorting the children at a node. Since a drawing pass uses a depth-first traversal, the order of the children is important. The last topic of the section is on deferred drawing to support sorting by render state.

4.2.1 Binary Space Partitioning Trees

As I have mentioned a few times, I use BSP trees to partition the world as a coarse-level sorting, not to partition the data in the world. The basic premise is illustrated in Figure 4.28.

A line partitions the plane into two half planes. The half plane to the side that the line normal points is gray. The other half plane is white. The view frustum overlaps both half planes. The eye point is in the white half plane. The region that the view frustum encloses is the only relevant region for drawing purposes. If you draw a ray from the eye point to any point inside the gray subregion of the frustum (a line of sight, so to speak), that ray will intersect any objects in the white subregion before it intersects any objects in the gray subregion. Consequently, no object in the

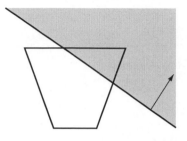

Figure 4.28 An illustration of BSP tree sorting in two dimensions.

gray subregion can occlude an object in the white subregion. If the objects in the gray subregion are drawn so that the depth buffer is correctly written with depth information, you can draw the objects in the white subregion with depth buffering set to write-only. It is not necessary to read the depth buffer for comparisons because you already know the objects in the white subregion occlude anything in the gray subregion.

A frequent use of BSP trees is where the separating planes are actual geometry in a level, most notably walls, floors, and ceilings. If a wall plane splits space into two half spaces, and if one half space is behind the wall and never visible to the observer, then you do not even need to draw the region behind the wall. In Wild Magic, disabling drawing a half space is accomplished by setting the Spatial::ForceCull flag to true.

The classical BSP node in a scene graph has a separating plane and two children. One child corresponds to the half space on one side of the plane; the other child corresponds to the other half space. The child subtrees represent those portions of the scene in their respective half spaces. My BSP node stores three children: two to represent the portions of the scene in the half spaces, and the third to represent any geometry associated with the separating plane. For example, in a level with walls, the wall geometry will be part of the scene represented by the third child. The class is BspNode and its interface is

```
class BspNode : public Node
{
public:
    BspNode ();
    BspNode (const Plane3f& rkModelPlane);
    virtual ~BspNode ();

    SpatialPtr AttachPositiveChild (Spatial* pkChild);
    SpatialPtr AttachCoplanarChild (Spatial* pkChild);
    SpatialPtr AttachNegativeChild (Spatial* pkChild);
```

```
        SpatialPtr DetachPositiveChild ();
        SpatialPtr DetachCoplanarChild ();
        SpatialPtr DetachNegativeChild ();
        SpatialPtr GetPositiveChild ();
        SpatialPtr GetCoplanarChild ();
        SpatialPtr GetNegativeChild ();

        Plane3f& ModelPlane ();
        const Plane3f& GetModelPlane () const;
        const Plane3f& GetWorldPlane () const;

        Spatial* GetContainingNode (const Vector3f& rkPoint);

protected:
        // geometric updates
        virtual void UpdateWorldData (double dAppTime);

        // drawing
        virtual void Draw (Renderer& rkRenderer, bool bNoCull = false);

        Plane3f m_kModelPlane;
        Plane3f m_kWorldPlane;
};
```

The class is derived from Node. The BspNode constructors must create the base class objects. They do so by requesting three children, but set the growth factor to zero; that is, the number of children is fixed at three. The child at index 0 is associated with the positive side of the separating plane; that is, the half space to which the plane normal points. The child at index 2 is associated with the negative side of the separating plane. The child at index 1 is where additional geometry may be attached such as the triangles that are coplanar with the separating plane. Rather than require you to remember the indexing scheme, the Attach*, Detach*, and Get* member functions are used to manipulate the children.

The separating plane is specified in model space coordinates for the node. The model-to-world transformations are used to transform that plane into one in world coordinates. This is done automatically by the geometric state update system via a call to UpdateGS, through the virtual function UpdateWorldData:

```
void BspNode::UpdateWorldData (double dAppTime)
{
    Node::UpdateWorldData(dAppTime);
    m_kWorldPlane = World.ApplyForward(m_kModelPlane);
}
```

The base class UpdateWorldData is called first in order to guarantee that the model-to-world transformation for BspNode is up to date.

The Transformation class has a member function for transforming a plane in model space to one in world space, namely, ApplyForward. Let \mathbf{X} be a point in model space and $\mathbf{Y} = RS\mathbf{X} + \mathbf{T}$ be the corresponding point in world space, where S is the diagonal matrix of world scales, R is the world rotation, and \mathbf{T} is the world translation. Let the model space plane be $\mathbf{N}_0 \cdot \mathbf{X} = c_0$, where \mathbf{N}_0 is a unit-length normal vector. The inverse transformation is $\mathbf{X} = S^{-1}R^T(\mathbf{Y} - \mathbf{T})$. Replacing this in the plane equation and applying some algebra leads to a world plane $\mathbf{N}_1 \cdot \mathbf{Y} = c_1$, where

$$\mathbf{N}_1 = RS^{-1}\mathbf{N}_0 \quad \text{and} \quad c_1 = c_0 + \mathbf{N}_1 \cdot \mathbf{T}.$$

If the scale matrix S is not the identity matrix, then \mathbf{N}_1 is not unit length. In this case it must be normalized and the constant adjusted,

$$\mathbf{N}_1' = \frac{\mathbf{N}_1}{|\mathbf{N}_1|} \quad \text{and} \quad c_1' = \frac{c_1}{|\mathbf{N}_1|},$$

resulting in the world plane $\mathbf{N}_1' \cdot \mathbf{Y} = c_1'$.

The virtual function Draw is implemented in BspNode. It is designed to draw according to the description I provided previously, the one associated with Figure 4.28. The source code is

```
void BspNode::Draw (Renderer& rkRenderer, bool bNoCull)
{
    // draw children in back-to-front order
    SpatialPtr spkPChild = GetPositiveChild();
    SpatialPtr spkCChild = GetCoplanarChild();
    SpatialPtr spkNChild = GetNegativeChild();

    CameraPtr spkCamera = rkRenderer.GetCamera();
    int iLocSide = m_kWorldPlane.WhichSide(
        spkCamera->GetWorldLocation());
    int iFruSide = spkCamera->WhichSide(m_kWorldPlane);

    if ( iLocSide > 0 )
    {
        // camera origin on positive side of plane

        if ( iFruSide <= 0 )
        {
            // The frustum is on the negative side of the plane or
            // straddles the plane.  In either case, the negative
            // child is potentially visible.
```

```
                if ( spkNChild )
                    spkNChild->Draw(rkRenderer,bNoCull);
            }

            if ( iFruSide == 0 )
            {
                // The frustum straddles the plane.  The coplanar child
                // is potentially visible.
                if ( spkCChild )
                    spkCChild->Draw(rkRenderer,bNoCull);
            }

            if ( iFruSide >= 0 )
            {
                // The frustum is on the positive side of the plane or
                // straddles the plane.  In either case, the positive
                // child is potentially visible.
                if ( spkPChild )
                    spkPChild->Draw(rkRenderer,bNoCull);
            }
        }
        else if ( iLocSide < 0 )
        {
            // camera origin on negative side of plane

            if ( iFruSide >= 0 )
            {
                // The frustum is on the positive side of the plane or
                // straddles the plane.  In either case, the positive
                // child is potentially visible.
                if ( spkPChild )
                    spkPChild->Draw(rkRenderer,bNoCull);
            }

            if ( iFruSide == 0 )
            {
                // The frustum straddles the plane.  The coplanar child
                // is potentially visible.
                if ( spkCChild )
                    spkCChild->Draw(rkRenderer,bNoCull);
            }
```

```
            if ( iFruSide <= 0 )
            {
                // The frustum is on the negative side of the plane or
                // straddles the plane.  In either case, the negative
                // child is potentially visible.
                if ( spkNChild )
                    spkNChild->Draw(rkRenderer,bNoCull);
            }
        }
        else
        {
            // Camera origin on plane itself.  Both sides of the plane
            // are potentially visible as well as the plane itself.
            // Select the first-to-be-drawn half space to be the one to
            // which the camera direction points.
            float fNdD = m_kWorldPlane.Normal.Dot(
                spkCamera->GetWorldDVector());
            if ( fNdD >= 0.0f )
            {
                if ( spkPChild )
                    spkPChild->Draw(rkRenderer,bNoCull);

                if ( spkCChild )
                    spkCChild->Draw(rkRenderer,bNoCull);

                if ( spkNChild )
                    spkNChild->Draw(rkRenderer,bNoCull);
            }
            else
            {
                if ( spkNChild )
                    spkNChild->Draw(rkRenderer,bNoCull);

                if ( spkCChild )
                    spkCChild->Draw(rkRenderer,bNoCull);

                if ( spkPChild )
                    spkPChild->Draw(rkRenderer,bNoCull);
            }
        }
    }
```

The three children must be drawn in back-to-front order. It is possible that any of the three children have empty subtrees, so the smart pointers for those children must be tested to see if they are not null before using them.

The first step, of course, is to determine on which side of the separating plane the eye point is located. This is the role of the code

```
CameraPtr spkCamera = rkRenderer.GetCamera();
int iLocSide = m_kWorldPlane.WhichSide(
    spkCamera->GetWorldLocation());
int iFruSide = spkCamera->WhichSide(m_kWorldPlane);
```

As Figure 4.28 indicates, we also need to know how the view frustum is positioned relative to the separating plane. The Plane class has a member function WhichSide that determines whether the input point is on the positive side of the plane (return value is positive), on the negative side of the plane (return value is negative), or on the plane (return value is zero). The Camera class has a member function WhichSide that tests the eight vertices of the view frustum to see on which side of the plane they lie. If all eight lie on the positive side of the plane, the return value is positive. If all eight lie on the negative side of the plane, the return value is negative. Otherwise, some of the eight lie on the positive side and some lie on the negative side, and the function returns zero.

Consider the block of code when the eye point is on the negative side of the plane. This is the configuration in Figure 4.28. If the view frustum is on the positive side of the plane or straddles the plane, the gray subregion must be drawn first. This is the positive child of the BSP node. As you can see in the code, that child is drawn first. If the frustum is fully on the positive side, then the separating plane does not cut through it, so any geometry associated with that plane need not be drawn. If the separating plane does intersect the frustum, then you should draw the geometry for the plane (if any). The code block that compares iFruSide to zero handles this. Naturally, when the frustum straddles the plane, you also need to draw the negative child. That is the last code block in the clause that handles the eye point on the negative side of the plane.

A technical complication appears to be what to do when the eye point is exactly on the separating plane. For an environment where you have walls as the separating planes, you would actually prevent this case, either by some metaknowledge about the structure of the environment and the eye point location or by a collision detection system. As it turns out, there is nothing to worry about here. Any ray emanating from the eye point through the frustum is either fully on one side of the plane, fully on the other side, or in the plane itself. In my code, though, I choose to order the drawing of the children based on the half space that contains the camera view direction.

In the code block when the eye point is on the negative side of the plane, the view frustum straddles the plane, and the BSP node has three children, all the children will be drawn. In the example of an environment where the plane of a wall is used as the separating plane, the child corresponding to the nonvisible half space does not need

to be drawn. You, the application writer, must arrange to set the ForceCull flag to true for that child so that the drawing pass is not propagated down the corresponding subtree. That said, it is possible that the camera moves along the wall to a doorway that does let you see into the space behind the wall. In this case you need to structure your application logic to set/unset the ForceCull flag according to the current location of the eye point. This is the stuff of occlusion culling in a game, essentially keeping a map of the world that helps you identify which objects are, or are not, visible from a given region in the world.

The leaf nodes of a BSP tree implicitly represent a region of space that is convex. The region is potentially unbounded. Many times it is useful to know which of these convex regions a point is in. The function

```
Spatial* GetContainingNode (const Vector3f& rkPoint);
```

is the query that locates the region. The return value is not necessarily of type BspNode. The leaf nodes of the BSP tree can be any Spatial-derived type you prefer.

A sample application in the folder demonstrates BSP trees used for spatial partitioning.

```
GeometricTools/WildMagic3/SampleGraphics/BspNodes
```

More details are provided in Section 8.2.2, but for now suffice it to say that the world is partitioned into five convex regions. Four regions contain one object each, and the fifth region contains two objects. Depth buffering is disabled at the root of the scene. Some of the one-object regions contain convex polyhedra. When the BSP tree drawing reaches those regions, the polyhedra are drawn with depth buffer reads disabled and depth buffer writes enabled. In the regions that have nonconvex objects (tori), depth buffer reads and writes are enabled to get correct drawing.

4.2.2 PORTALS

The portal system is designed for indoor environments where you have lots of regions separated by opaque geometry. The system is a form of occlusion culling and attempts to draw only what is visible to the observer. The regions form an abstract graph. Each region is a node of the graph. Two regions are adjacent in the graph if they are adjacent geometrically. A portal is a doorway that allows you to look from one region into another region adjacent to it. The portals are the arcs for the abstract graph. From a visibility perspective, a portal is bidirectional. If you are in one region and can see through a doorway into an adjacent room, then an observer in the adjacent region should be able to look through the same doorway into the original region. However, you can obtain more interesting effects in your environment by making portals unidirectional. The idea is one of teleportation. Imagine a region that exists in one "universe" and allows you to look through a portal into another "universe."

Once you step through the portal, you turn around and look back. The portal is not there! I am certain you have seen this effect in at least one science-fiction movie. The Wild Magic engine implements portals to be unidirectional.

The portal system is also a form of sorting in the following sense. The drawing pass starts in one region. The standard depth-first traversal of the subscene rooted at the region node is bypassed. Instead, the drawing call is propagated to regions that are adjacent to the current one and that are visible through portals. Effectively, the regions are sorted based on visibility. Suppose you have three regions (A, B, and C) arranged along a linear path, each having portals into the adjacent regions. If you are in region A and can see through a portal to B, and you can additionally see through a portal in B to the region C, then C is the farthest region you can see from your current position. Region C should be drawn first, followed by region B, and then your own region A. The drawing pass must be careful to prevent cycles in the graph. The system does have Boolean flags to tag regions whenever they have been visited. These flags prevent multiple attempts to draw the regions.

The Wild Magic portal system uses a BSP tree to decompose the indoor environment. The leaf nodes of the BSP tree are convex regions in space. The class ConvexRegion is derived from Node and is used to represent the leaf nodes. Any geometric representation for the region, including walls, floors, ceilings, furniture, or whatever, may be added as children of the convex region node. The root of the BSP tree is a special node that helps determine in which leaf region the eye point is. Another class is designed to support this, namely, ConvexRegionManager. It is derived from BspNode. The middle child of such a node is used to store the representation for the outside of the encapsulated region, just in case you should choose to let the player exit your indoor environment. Finally, the class Portal encapsulates the geometry of the portal and its behavior. The abstract graph of regions is a collection of ConvexRegion objects and Portal objects. Both types of objects have connections that support the graph arcs.

Figure 4.29 illustrates the basic graph connections between regions and portals. The outgoing portals for the convex region in the figure can, of course, be the incoming portals to another convex region, hence the abstract directed graph. Figure 4.30

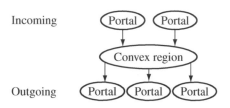

Figure 4.29 A ConvexRegion node. The portals with arrows to the node are the *incoming portals* to the region. The arrows from the node to the other portals are *outgoing portals*.

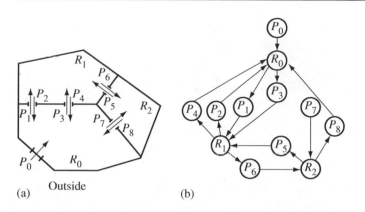

Figure 4.30 A configuration of three regions, nine portals, and an outside area. (a) The geometric layout for the regions and portals. (b) The directed graph associated with it.

shows a specific configuration of regions and portals, including the directed graph associated with it.

The portal P_0 is from the outside to inside the collection of regions. The portal is displayed as if the door is closed. Once a player-character stands in front of the door, a mouse click can open it. The character steps through, and the door closes behind him (never to open again). The other doorways each have two unidirectional portals, so no teleportation occurs in this configuration.

The occlusion culling comes into play as follows. Figure 4.31 shows two regions with a portal from one region to the other. Using the standard drawing with a frustum, the renderer will draw everything in the gray region shown in Figure 4.31(a), including the object shown as a small, black disk. That object is not visible to the observer, but the renderer did not know this until too late when the depth buffer comparisons showed that the wall is closer to the eye point and occludes the object.

The portal polygon, necessarily convex, is used to construct additional planes for the purposes of culling objects *in the adjacent region*. The polygon vertices must be counterclockwise ordered when viewed from the region that contains the eye point **E**. If \mathbf{V}_0 and \mathbf{V}_1 are consecutive polygon vertices, the plane containing **E**, \mathbf{V}_0, and \mathbf{V}_1 is constructed and passed to the camera to be used when drawing the adjacent region. The smaller frustum used for the adjacent region is shown as light gray in Figure 4.31. Keep in mind that the smaller frustum is only used for culling. The regular view frustum is still used for drawing, so the renderer may attempt to draw portions of the walls in the adjacent region, even though they are partially occluded. The idea is to eliminate occluded objects from the drawing pass. You could design the camera system to tell the graphics system to use the additional culling planes for clipping,

(a) (b)

Figure 4.31 Two regions with a portal from one to the other. (a) The gray region depicts the view frustum. (b) The trimmed version of the view frustum using planes formed by the eye point and edges of the portal polygon.

but that has the potential to take away resources from other objects.[1] The current consumer graphics hardware is powerful enough that you might as well just let it go ahead and draw the partially occluded object.

At the top level of the system, we have class ConvexRegionManager. Its interface is

```
class ConvexRegionManager : public BspNode
{
public:
    ConvexRegionManager ();

    SpatialPtr AttachOutside (Spatial* pkOutside);
    SpatialPtr DetachOutside ();
    SpatialPtr GetOutside ();

    ConvexRegion* GetContainingRegion (const Vector3f& rkPoint);

protected:
    virtual void Draw (Renderer& rkRenderer, bool bNoCull = false);
};
```

A convex region manager is a BSP tree whose leaf nodes are the ConvexRegion objects. A subscene representing the outside of the environment, if any, can be attached or

1. For example, each additional clipping plane could cause you to lose the services of a texture unit. For a portal with a rectangular doorway, you would lose four texture units. On a four-texture-unit card, your adjacent regions are going to be beautifully colored with vertex colors or material colors. Your artists are not going to be happy.

detached via the member functions AttachOutside and DetachOutside. The outside scene can be as complex as you like, especially so if you plan on an application that has both an outdoor and an indoor environment.

The main role of ConvexRegionManager is to locate the convex region that contains the eye point. The function GetContainingRegion supports this query. If the function returns NULL, the eye point is not in any of the convex regions and, for all practical purposes, is outside. The Draw function that uses the query is fairly simple:

```
void ConvexRegionManager::Draw (Renderer& rkRenderer, bool bNoCull)
{
    CameraPtr spkCamera = rkRenderer.GetCamera();
    ConvexRegion* pkRegion = GetContainingRegion(
        spkCamera->GetWorldLocation());

    if ( pkRegion )
    {
        // Inside the set of regions, start drawing with region of
        // camera.
        pkRegion->Draw(rkRenderer,bNoCull);
    }
    else
    {
        // Outside the set of regions, draw the outside scene (if
        // it exists).
        if ( GetOutside() )
            GetOutside()->Draw(rkRenderer,bNoCull);
    }
}
```

A situation you must guard against in your application is the one where the eye point is outside, but the near plane of the view frustum straddles a separating wall between inside and outside. The convex region manager determines that the eye point is outside, so the region traversal for drawing is never initiated. The outside is drawn, not correctly because the view frustum contains part of the inside environment that never gets drawn. To see the effect, I have added a conditionally compiled block of code to the TestPortal sample application. If you enable the block, the initial location for the camera and view frustum is such that the eye point is outside and the frustum straddles a wall between the outside and inside. When you move forward with the up-arrow key, you will see the inside pop into view (the eye point has moved into an inside region).

The only reason I have ConvexRegionManager in the engine is to provide an automatic method for locating the convex region containing the eye point. The containment query is called in each drawing pass, even if the eye point has not moved. Since the object is a BSP tree, presumably with a small height, the cost of the query should

not be an issue. However, if you were to keep track of the eye point and containing room through other means, say, by a map you have of the indoor environment, there is no need for the BSP tree. The graph of ConvexRegion and Portal objects works just fine without the manager.

The interfaces for the ConvexRegion and Portal classes are

```
class ConvexRegion : public Node
{
public:
    ConvexRegion (int iPQuantity, Portal** apkPortal);
    virtual ~ConvexRegion ();
    int GetPortalQuantity () const;
    Portal* GetPortal (int i) const;

protected:
    ConvexRegion ();
    virtual void UpdateWorldData (double dAppTime);
    int m_iPQuantity;
    Portal** m_apkPortal;
    bool m_bVisited;

// internal use
public:
    virtual void Draw (Renderer& rkRenderer, bool bNoCull = false);
};

class Portal : public Object
{
public:
    Portal (int iVQuantity, Vector3f* akModelVertex,
        ConvexRegion* pkAdjacentRegion, bool bOpen);
    virtual ~Portal ();
    ConvexRegion*& AdjacentRegion ();
    bool& Open ();

protected:
    Portal ();
    friend class ConvexRegion;
    void UpdateWorldData (const Transformation& rkWorld);
    void Draw (Renderer& rkRenderer);

    int m_iVQuantity;
    Vector3f* m_akModelVertex;
    Vector3f* m_akWorldVertex;
```

```
        ConvexRegion* m_pkAdjacentRegion;
        bool m_bOpen;
};
```

The `ConvexRegion` constructor is passed an array of outgoing portals associated with the convex region. The class will use the array pointer directly and will delete the array during destruction. Because the class takes over ownership of the portal array, it cannot be shared between convex regions.

The `Portal` constructor is passed an array of vertices that represent the portal geometry, a pointer to the adjacent region (so this portal is incoming for that region), and a Boolean flag indicating whether the portal is initially open or closed. The vertices must form a planar convex polygon, they must be counterclockwise ordered when looking through the portal to the adjacent region, and they must be in the model space coordinates for the region that contains the portal. All of these constraints support constructing the portal planes to be given to the camera for culling.

`ConvexRegion` overrides the `UpdateWorldData` virtual function in order to update the geometric state in its subtree in the normal manner that an `UpdateGS` processes the subtree. The outgoing portals themselves might need updating. Since `Portal` is not derived from `Spatial`, these objects are not visited by `UpdateGS` pass. The convex region must initiate the update of the portals. The source code is

```
void ConvexRegion::UpdateWorldData (double dAppTime)
{
    // update the region walls and contained objects
    Node::UpdateWorldData(dAppTime);

    // update the portal geometry
    for (int i = 0; i < m_iPQuantity; i++)
        m_apkPortal[i]->UpdateWorldData(World);
}
```

The portal objects must update their own data, and do so with a single batch update:

```
void Portal::UpdateWorldData (const Transformation& rkWorld)
{
    rkWorld.ApplyForward(m_iVQuantity,m_akModelVertex,
        m_akWorldVertex);
}
```

The drawing function in both classes is an implementation of the traversal of a directed graph. Because the graph most likely has cycles, the code needs to maintain Boolean flags indicating whether or not a region has already been visited to prevent an

infinite loop. The ConvexRegion class has a data member, m_bVisited, for this purpose. The drawing routine for a convex region is

```
void ConvexRegion::Draw (Renderer& rkRenderer, bool bNoCull)
{
    if ( !m_bVisited )
    {
        m_bVisited = true;

        // draw anything visible through open portals
        for (int i = 0; i < m_iPQuantity; i++)
            m_apkPortal[i]->Draw(rkRenderer);

        // draw the region walls and contained objects
        Node::Draw(rkRenderer,bNoCull);

        m_bVisited = false;
    }
}
```

The convex region manager starts the drawing pass in the region containing the eye point. On entry to the drawing function for this region, the visitation flag is false. The flag is then set to true to indicate that the region has been visited. The outgoing portals associated with the region are asked to propagate the drawing to their adjacent regions. During the propagation, if the current region is revisited, its visitation flag will prevent another recursive call (and avoid the infinite loop). In Figure 4.30, if the eye point is in region R_0, a cycle is formed by following portal P_1 into R_1, and then immediately returning to R_0 through portal P_2. A larger cycle occurs, this one by following P_1 into R_1, P_6 into R_2, and then P_8 into R_0. Once the graph of regions has been traversed, the recursive call comes back to the original region and the Node::Draw call is made. This call is what draws the interior of the region and all its contents. The visitation flag is reset to false to allow the next drawing call to the portal system.

You might have noticed that this process has the potential for being very slow. I mentioned that the graph of regions is entirely traversed. In a large indoor environment, there could be a substantial number of regions, most of them not visible. If the portal system visits all the nonvisible regions and attempts to draw them anyway, what is the point? Not to worry. As described earlier, the portals are used to generate additional culling planes for the camera to use. The planes are used to cull objects not visible to the observer, including portals themselves! Return once again to Figure 4.30. Suppose the observer is in region R_0 and standing directly in front of the doorway marked portal P_1. The observer then looks straight ahead into region R_1 through that portal. The portal planes generated by the observer's eye point and the edges of the portal polygon form a narrow frustum into region R_1. The portal marked P_6 is not visible to the observer. The portal drawing system will make sure that the region

traversal does not continue through P_6. In this manner, a carefully designed environment will have only a few potentially visible regions along a line of sight, so only a few regions will be processed by the renderer.

The portal drawing code is

```
void Portal::Draw (Renderer& rkRenderer)
{
    // only draw adjacent regions if portal is open
    if ( !m_bOpen )
        return;

    // only draw visible portals
    Camera* pkCamera = rkRenderer.GetCamera();
    if ( pkCamera->Culled(m_iVQuantity,m_akWorldVertex,true) )
        return;

    // push world planes formed by camera eye point and portal edges
    int i0 = 0, i1 = m_iVQuantity - 1;
    for (/**/; i0 < m_iVQuantity; i1 = i0++)
    {
        Plane3f rkPlane(pkCamera->GetLocation(),m_akWorldVertex[i0],
            m_akWorldVertex[i1]);

        pkCamera->PushPlane(rkPlane);
    }

    // draw the adjacent region and any nonculled objects in it
    m_pkAdjacentRegion->Draw(rkRenderer);

    // pop world planes
    for (i0 = 0; i0 < m_iVQuantity; i0++)
        pkCamera->PopPlane();
}
```

I mentioned that the Portal constructor takes a Boolean input that indicates whether or not the portal is "open." The intent is that if you can see through the portal, it is open. If not, it is closed. In a typical game, a character arrives at a closed door, preventing him from entering a region. A magical click of the mouse button causes the door to pop open, and the character steps into the region. The open flag is used to support this and controls whether or not a portal propagates the drawing call to the adjacent region. The first step that the Portal::Draw function takes is to check that Boolean flag.

The second step in the drawing is to check if this portal is visible to the observer. The Camera class has support for culling a portal by analyzing its geometry. I will talk

about this support a litte bit later. If the portal is (potentially) visible (not culled), the portal planes are constructed and pushed onto a stack of planes that the camera maintains. Naturally, the plane construction must occur before you attempt to draw the adjacent region so that those planes can be used for culling objects in that region. Once pushed, the adjacent region is told to draw itself. Thus, `ConvexRegion::Draw` and `Portal::Draw` form a recursive chain of functions. Once the region is drawn, the planes that were pushed onto the camera's stack are now popped because they have served their purpose.

If the portal is culled, then the drawing pass is not propagated. In my previous example using Figure 4.30, an observer in region R_0 standing in front of portal P_1 will cause the region traversal to start in R_0. When portal P_1 has its `Draw` function called, the portal is open and the portal itself is visible to the camera, so the portal planes are formed, pushed onto the camera's stack, and the adjacent region must be drawn. A traversal over its outgoing portals is made, and the portals are told to propagate the drawing call. We will find in `Portal::Draw` for P_6 that this portal is not visible to the observer; the planes for P_1 are on the camera's stack, but not yet those for P_6. The drawing call is not propagated to R_1 (through that path).

Now, about the `Camera` support for pushing and popping portal planes and for culling portals. The class has the following support interface:

```
class Camera
{
public:
    // access to stack of world culling planes
    int GetPlaneQuantity () const;
    const Plane3f* GetPlanes () const;
    void PushPlane (const Plane3f& rkPlane);
    void PopPlane ();

protected:
    // world planes:
    //    left = 0, right = 1, bottom = 2,
    //    top = 3, near = 4, far = 5,
    // extra culling planes >= 6
    enum
    {
        CAM_FRUSTUM_PLANES = 6,
        CAM_MAX_WORLD_PLANES = 32
    };
    int m_iPlaneQuantity;
    Plane3f m_akWPlane[CAM_MAX_WORLD_PLANES];
};
```

The standard frustum planes always are stored in the first six slots of the array m_akWPlane. The PushPlane call will append to that array the additional planes; thus the array is treated like a stack. The maximum number of planes is arbitrarily chosen to be 32. If you need more than this, you should first question your artists as to why they need such a complex environment before increasing the maximum. The PopPlane call removes the planes from the stack (not literally, only the stack top index is decremented). It does make sure that frustum planes are not popped.

The portal culling call is

```
bool Camera::Culled (int iVertexQuantity, const Vector3f* akVertex,
    bool bIgnoreNearPlane)
{
    // Start with last pushed plane (potentially the most
    // restrictive plane).
    int iP = m_iPlaneQuantity - 1;
    for (int i = 0; i < m_iPlaneQuantity; i++, iP-)
    {
        Plane3f& rkPlane = m_akWPlane[iP];
        if ( bIgnoreNearPlane && iP == 4 /* camera near plane */ )
            continue;

        int iV;
        for (iV = 0; iV < iVertexQuantity; iV++)
        {
            int iSide = rkPlane.WhichSide(akVertex[iV]);
            if ( iSide >= 0 )
            {
                // polygon is not totally outside this plane
                break;
            }
        }

        if ( iV == iVertexQuantity )
        {
            // polygon is totally outside this plane
            return true;
        }
    }

    return false;
}
```

The input vertices are iterated and tested against each of the culling planes. If all the vertices are outside the plane (the outside convention is used for the standard frustum

planes), then the portal is outside. The convexity of the portal polygon guarantees this is a correct object-culling test when processing only the vertices of the object.

This culling function can be applied to any geometry, but for portals in particular, the Boolean variable bIgnoreNearPlane should be set to true. This avoids the situation when the portal is in the view pyramid—all of the volume inside the planes including the space between the near plane and the eye point—but is between the eye point and the near plane. In such a situation you do not want the portal system to cull the portal. This situation typically occurs when the camera moves through the portal from the current region to the adjacent region.

A sample application in the folder demonstrates the portal system:

```
GeometricTools/WildMagic3/SampleGraphics/Portals
```

More details are provided in Section 8.2.8.

4.2.3 SORTING CHILDREN OF A NODE

One of the simplest, coarse-level sorting methods to be applied in a scene hierarchy is to sort the children of a node. How they are sorted depends on what your environment is and how the camera is positioned and oriented relative to the children of the node.

To demonstrate, consider the example of a node that has six TriMesh objects that are the faces of a cube. The faces are textured and are semitransparent, so you can see the back faces of the cube through the front faces. The global state is set as indicated:

- Back-face culling is disabled. Because each face is semitransparent, you must be able to see it from either the front or the back.

- Depth buffering is enabled for writing, but not reading. The faces will be depth sorted based on the location of the eye point and then drawn in the correct order. Reading the depth buffer to determine if a pixel should be drawn is not necessary. If the cube is the only object in the scene, it is not necessary to write to the depth buffer. If other objects are drawn in the same scene using depth buffering with reading enabled, you need to make certain that the depths are correct. That is why writing is enabled.

- Alpha blending is enabled at the node since the face textures have alpha values to obtain the semitransparency.

The cube is constructed in its model space to have center at the origin $(0, 0, 0)$. The faces perpendicular to the x-axis are positioned at $x = 1$ and $x = -1$. The faces perpendicular to the y-axis are positioned at $y = 1$ and $y = -1$. The faces perpendicular to the z-axis are positioned at $z = 1$ and $z = -1$. The camera is inverse-transformed from the world into the model space of the cube. The back faces and front faces are determined solely by analyzing the components of the camera view direction in the cube's model space. Let that direction be $\mathbf{D} = (d_0, d_1, d_2)$. Suppose that

the eye point is at $(2, 0, 0)$ and you are looking directly at the face at $x = 1$. The view direction is $(-1, 0, 0)$. The $x = 1$ face is front facing. Its outer normal is $(1, 0, 0)$. The angle between the view direction and the outer normal is 180 degrees, which is larger than 90 degrees, so the cosine of the angle is negative. The dot product of the view direction and outer normal is the cosine of the angle. In the current example, the dot product is $(-1, 0, 0) \cdot (1, 0, 0) = -1 < 0$. The $x = -1$ face is back facing. It has outer normal $(-1, 0, 0)$. The cosine of the angle between the view direction and the outer normal is $(-1, 0, 0) \cdot (-1, 0, 0) = 1 > 0$. Similar arguments apply to the other faces. The classification for back faces is summarized by the following:

- $d_0 > 0$: Face $x = 1$ is back facing.
- $d_0 < 0$: Face $x = -1$ is back facing.
- $d_1 > 0$: Face $y = 1$ is back facing.
- $d_1 < 0$: Face $y = -1$ is back facing.
- $d_2 > 0$: Face $z = 1$ is back facing.
- $d_2 < 0$: Face $z = -1$ is back facing.

A sorting algorithm for the faces will inverse-transform the camera's world view direction to the model space of the cube; the resulting direction is (d_0, d_1, d_2). The signs of the d_i are tested to determine the cube faces that are back facing. The six children of the node are reordered so that the back faces occur first and the front faces occur second. A sample application in the folder demonstrates this algorithm:

`GeometricTools/WildMagic3/SampleGraphics/SortFaces`

More details are provided in Section 8.2.11. Be ready for a couple of unexpected surprises if you implement this without looking at my version first. My original attempt at implementing this displayed a cube where the faces used the same texture (a water texture) whose alpha values were all $\frac{1}{2}$. As I rotated the cube, the rendering looked perfect *even without the sorting*. If you make the alpha values all 1, the rendering looks completely wrong (which it should)! I then added some black letters to the texture, the face names Xp, Xm, Yp, Ym, Zp, and Zm, and restored the alpha values to be $\frac{1}{2}$. My thought was that I could then detect that the rendering was incorrect. The images *still* looked correct. My final change was to make the alpha values 1 for texture pixels that were black. Now the black letters on a back face were solid black, but the black letters on a front face were somewhat gray due to blending. Now it is clear that the rendering is incorrect. Once I added the sorting, the demonstration worked as advertised.

The other surprise was that some of the faces were flickering depending on the cube orientation. It turns out that my original sorting scheme filled the beginning of an array with pointers to the back faces, starting from index 0, and filled the end of an array with pointers to the front faces, starting from the last array index with index decrementing. The decrementing caused the order of the front faces to change each frame, even though neither the cube nor the camera was moving. Apparently

the numerical round-off errors in the rendering showed up as flickering, probably due to the color channel values oscillating between two adjacent integer values.

4.2.4 DEFERRED DRAWING

In the introduction to this section, I mentioned some motivations for sorting based on render state. Wild Magic version 3 has support for sorting generally by providing a deferred drawing system. The idea is to accumulate a list of the objects to be drawn rather than drawing those objects at the time they are encountered in the drawing pass. When the list is complete, a deferred drawing function is called. This function includes any sorting by render state (or any other processing you care to do), followed by drawing of the objects (or anything else you care to do).

The Renderer class has the following interface to support deferred drawing:

```
class Renderer
{
public:
    typedef void (Renderer::*DrawFunction)();
    DrawFunction DrawDeferred;

    // no drawing (useful for profiling scene graph overhead)
    void DrawDeferredNoDraw ();

    // draw all objects without sorting
    void DrawDeferredNoSort ();

protected:
    int m_iDeferredQuantity;
    TArray<Spatial*> m_kDeferredObject;
    TArray<bool> m_kDeferredIsGeometry;
};
```

The function pointer DrawDeferred is initially NULL, indicating that deferred drawing is disabled. To enable deferred drawing, just assign to DrawDeferred a pointer to the function you want to be called when it is time to draw.

The three Renderer functions that manipulate the deferred data members are

```
void Renderer::DrawScene (Node* pkScene)
{
    if ( pkScene )
    {
        pkScene->OnDraw(*this);
        if ( DrawDeferred )
```

```
            {
                (this->*DrawDeferred)();
                m_iDeferredQuantity = 0;
            }
        }
}

void Renderer::Draw (Node* pkNode)
{
    if ( !DrawDeferred )
    {
        m_pkNode = pkNode;
        m_pkGlobalEffect = pkNode->GetEffect();

        assert( m_pkGlobalEffect );
        (this->*m_pkGlobalEffect->Draw)();

        m_pkNode = NULL;
        m_pkGlobalEffect = NULL;
    }
    else
    {
        m_kDeferredObject.SetElement(m_iDeferredQuantity,pkNode);
        m_kDeferredIsGeometry.SetElement(m_iDeferredQuantity,false);
        m_iDeferredQuantity++;
    }
}

void Renderer::Draw (Geometry* pkGeometry)
{
    if ( !DrawDeferred )
    {
        m_pkGeometry = pkGeometry;
        m_pkLocalEffect = pkGeometry->GetEffect();

        if ( m_pkLocalEffect )
            (this->*m_pkLocalEffect->Draw)();
        else
            DrawPrimitive();

        m_pkLocalEffect = NULL;
        m_pkGeometry = NULL;
    }
    else
```

```
        {
            m_kDeferredObject.SetElement(m_iDeferredQuantity,pkGeometry);
            m_kDeferredIsGeometry.SetElement(m_iDeferredQuantity,true);
            m_iDeferredQuantity++;
        }
    }
```

The invariant of DrawScene is that m_iDeferredQuantity is zero on entry. If a deferred drawing function has been assigned to DrawDeferred, the Renderer::Draw functions skip the immediate drawing and append the object pointer to the deferred object array. The array of Boolean values is used at draw time to quickly determine if the object is Geometry or Node. This avoids a more expensive run-time type identification via a dynamic cast of the object pointer. The two arrays in the system automatically grow when needed. When the scene traversal ends, control is returned to DrawScene and the deferred drawing function is called. Very simple scheme, is it not?

I have provided two choices for DrawDeferred. The first is DrawDeferredNoDraw that is stubbed out to do absolutely nothing! Nothing is drawn on the screen. This function is useful for profiling an application to see what overhead the scene graph management system generates. The other function is DrawDeferredNoSort and simply iterates over the array of accumulated objects and calls the appropriate drawing function:

```
void Renderer::DrawDeferredNoSort ()
{
    // disable deferred drawing
    DrawFunction oSave = DrawDeferred;
    DrawDeferred = NULL;

    for (int i = 0; i < m_iDeferredQuantity; i++)
    {
        if ( m_kDeferredIsGeometry[i] )
            Draw((Geometry*)m_kDeferredObject[i]);
        else
            Draw((Node*)m_kDeferredObject[i]);
    }

    // enable deferred drawing
    DrawDeferred = oSave;
}
```

You must disable deferred drawing before drawing the objects, otherwise you will be in an infinite loop due to the Draw call placing your object right back into the array. Of course, you must reenable the deferred drawing before exiting.

If you want to implement other deferred drawing functions, you should add a new member function to Renderer. For example, if you plan on sorting by texture state, you might add a function

```
class Renderer
{
public:
    virtual void DrawDeferredTextureSort ();
};

void Renderer::DrawDeferredTextureSort ()
{
    // disable deferred drawing
    DrawFunction oSave = DrawDeferred;
    DrawDeferred = NULL;

    SortByTexture();
    DrawPrimitivesTextureSort();

    // enable deferred drawing
    DrawDeferred = oSave;
}
```

The function Renderer::SortByTexture is an implementation of your own very special sorting function to reorder the objects by texture state. This function will sort m_kDeferredObject, but must simultaneously reorder in the same way the array m_kDeferredIsGeometry. The global effects that are applied to Node objects are complicated enough that you probably should draw them separately. The sorting can place all the Geometry objects first in the array, followed by the Node objects. Let us assume that we also added a data member to Renderer to store the number of Geometry objects, call it m_iDeferredGeometryQuantity, and that the SortByTexture function assigns the correct value to it. The drawing function will be a variation on Renderer::DrawPrimitive, perhaps something like

```
void Renderer::DrawPrimitivesTextureSort ()
{
    previousTextures = INVALID;
    int i;
    for (i = 0; i < m_iDeferredGeometryQuantity; i++)
    {
        m_pkGeometry = (Geometry*)m_akDeferredGeometry[i];
        m_pkLocalEffect = pkGeometry->GetEffect();

        set global state;
        enable lighting;
```

```
        enable vertices;
        enable normals;
        enable colors;

        if ( currentTextures != previousTextures )
        {
            enable textures;
            previousTextures = currentTextures;
        }

        set world transform;
        draw geometry object;
        restore world transform;

        if ( nextTextures != currentTextures )
            disable textures;

        disable colors;
        disable normals;
        disable vertices;
        disable lighting;
    }

    for (/**/; i < m_iDeferredQuantity; i++)
        Draw((Node*)m_kDeferredObject[i]);
}
```

A sample application that illustrates how the deferred drawing works is on the companion website in directory

```
GeometricTools/WildMagic3/SampleGraphics/DeferredDraw
```

The scene consists of an environment mapped model and a multitexture mapped model. The list of objects contains one Node (the environment map is a global effect) and four Geometry objects (the number of leaves in the multitexture mapped model). You can press keys to have normal drawing, deferred drawing with no sorting, or deferred drawing with no drawing.

4.3 CURVES AND SURFACES

Two geometric types supported by a graphics engine are polylines and triangle meshes (see Section 3.3). These objects are usually generated by artists and exported for use in an application. Modeling packages also support two analogous types,

curves and surfaces. Although these are more commonly used in CAD/CAM systems, they are useful in games. I will restrict attention to parametric curves and parametric surfaces, where the positional information is determined as a function of some parameters.

A graphics engine still requires lower-level primitives for rendering. A curve must be sampled to produce a polyline, and a surface must be sampled to produce a triangle mesh. In practice, the curves tend to be specified as a collection of *segments*, with each segment defined by a common curve type—for example, Bézier curves, B-spline curves, or NURBS curves. Similarly, surfaces tend to be specified as a collection of *patches*, with each patch defined by a common surface type—for example, Bézier patches, B-spline patches, or NURBS patches. The situation for surfaces is slightly more complicated than for curves. The patches come in many flavors; the two most important are *triangle patches* and *rectangle patches*. The polygon adjective refers to the shape of the parametric domain.

A curve may be defined as a collection of segments that are ordered end to end; that is, the end point of one segment becomes the starting point of the next segment. Each end point is shared by two segments, except possibly at the two end points of the curve. If the curve forms a closed loop, then all segment end points are shared by two segments. But nothing prevents you from having a more complicated topology. Each end point may be shared by as many segments as you like (think wireframe mode when drawing a triangle mesh). A collection of segments with a user-defined topology for connections is referred to as a *curve mesh*.

The analogy with surfaces is that a collection of patches is arranged so that at most two patches share a patch boundary curve. Such a mesh is called a *manifold mesh*.[2] As with curves, you can have more than two patches sharing a patch boundary curve. In general, a collection of patches with a user-defined topology for connections is referred to as a *surface mesh*.

In Wild Magic version 2, I had support for Bézier patches, with each patch having one of three types: triangle patch, rectangle patch, or cylinder patch. A Bézier mesh is a collection of such patches. To visualize the mesh, I had a system for subdividing the parametric domains of the patches and generating a triangle mesh that approximates the true surface. Unfortunately, the subdivision scheme was intertwined with the Bézier patch classes. If you wanted to support other surface types such as B-splines or NURBS, you would have to duplicate a lot of code that is already in the Bézier patch classes. Wild Magic version 3 does a lot better. The architecture is such that the patch definition and patch evaluation are cleanly separated from the subdivision scheme. All that the subdivision needs is the ability to query a patch for its surface position given a pair of parameter values. This allows you to add new surface patch types without having to rewrite any subdivision code.

2. The definition of a manifold mesh is more formal than I have presented. The intuition, though, is as I have described it here.

This section describes briefly the interfaces for parametric curves and surfaces. The emphasis is not on the mathematical aspects. Should you decide to add your own curve or surface types, you might very well need to understand some of the mathematics—implementing NURBS surfaces is not trivial, for example. The subdivision schemes are described in a lot of detail. The computer science and engineering aspects are, at times, complex.

4.3.1 PARAMETRIC CURVES

A *parametric curve* in three dimensions is a function $\mathbf{P}(u)$ that specifies a position as a function of the parameter $u \in [u_{\min}, u_{\max}]$. The first derivative is denoted $\mathbf{P}'(u)$. This is a vector that is tangent to the curve at the corresponding position $\mathbf{P}(u)$. The second derivative is denoted $\mathbf{P}''(u)$. If the curve represents the path of a particle with respect to time u, then the first derivative is the velocity of the particle and the second derivative is the acceleration of the particle.

I created an abstract class called CurveSegment that has pure virtual functions for computing the position and the first, second, and third derivatives. The class interface is

```
class CurveSegment : public Object
{
public:
    virtual ~CurveSegment ();

    float GetUMin () const;
    float GetUMax () const;

    virtual Vector3f P (float fU) const = 0;
    virtual Vector3f PU (float fU) const = 0;
    virtual Vector3f PUU (float fU) const = 0;
    virtual Vector3f PUUU (float fU) const = 0;

    Vector3f Tangent (float fU) const;
    Vector3f Normal (float fU) const;
    Vector3f Binormal (float fU) const;
    void GetFrame (float fU, Vector3f& rkPosition,
        Vector3f& rkTangent, Vector3f& rkNormal,
        Vector3f& rkBinormal) const;
    float Curvature (float fU) const;
    float Torsion (float fU) const;

protected:
```

```
    CurveSegment (float fUMin, float fUMax);
    CurveSegment ();

    float m_fUMin, m_fUMax;
};
```

The class stores the minimum and maximum u values for the curve, but derived classes must generate their values. The values may be retrieved through the member accessors GetUMin and GetUMax. The position, first derivative, second derivative, and third derivative are computed by the member functions P, PU, PUU, and PUUU, respectively. A derived class must implement these.

If a curve is used as the path for a camera, a common requirement is to specify an orientation for the camera that is related to the curve geometry. The natural vector to use for the camera view direction at a point on the curve is the tangent vector at that point. We need to specify an up vector. The right vector is the cross product of the view direction and the up vector. One choice for the orientation is the Frenet frame, of which the tangent vector is one of the members. The other two vectors are called the normal vector and the binormal vector. The rates of change of these vectors with respect to changes in arc length s are related by the Frenet-Serret equations:

$$\mathbf{T}'(s) = \kappa(s)\mathbf{N}(s)$$

$$\mathbf{N}'(s) = -\kappa(s)\mathbf{T}(s) + \tau(s)\mathbf{B}(s)$$

$$\mathbf{B}'(s) = -\tau(s)\mathbf{N}(s),$$

where $\kappa(s)$ is the curvature of the curve and $\tau(s)$ is the torsion of the curve. In terms of the curve parameter u, the tangent vector is

$$\mathbf{T} = \frac{\mathbf{P}'}{|\mathbf{P}'|},$$

the normal vector is

$$\mathbf{N} = \frac{(\mathbf{P}' \cdot \mathbf{P}')\mathbf{P}'' - (\mathbf{P}' \cdot \mathbf{P}'')\mathbf{P}'}{|\mathbf{P}'||\mathbf{P}' \times \mathbf{P}''|},$$

and the binormal vector is

$$\mathbf{B} = \mathbf{T} \times \mathbf{N}.$$

If you need to compute curvature or torsion, the formulas are

$$\kappa = \frac{|\mathbf{P}' \times \mathbf{P}''|}{|\mathbf{P}'|^3} \quad \text{and} \quad \tau = \frac{\mathbf{P}' \cdot \mathbf{P}'' \times \mathbf{P}'''}{|\mathbf{P}' \times \mathbf{P}''|^2}.$$

A problem with the Frenet frame that you need to be aware of is that the normal vectors are sometimes discontinuous as a function of u, and sometimes they are not uniquely defined. The classic example is a straight-line path. The tangent vectors are all the same, but any vector perpendicular to the line could serve as a normal vector. Regardless of the mathematical problems that might arise, class CurveSegment implements the construction of the Frenet frame via the member functions GetTangent, GetNormal, and GetBinormal. The implementations compute the formulas mentioned previously. Along with the position, all may be computed simultaneously with a call to GetFrame. Functions are provided for curvature and torsion calculations.

4.3.2 PARAMETRIC SURFACES

A *parametric surface* in three dimensions is a function $\mathbf{P}(u, v)$ that specifies a position as a function of the parameters u and v. The two types of domains that Wild Magic supports are *rectangular*, where $u \in [u_{\min}, u_{\max}]$ and $v \in [v_{\min}, v_{\max}]$, and *triangular*, where $u \in [u_{\min}, u_{\max}]$, $v \in [v_{\min}, v_{\max}]$, and $(v_{\max} - v_{\min})(u - u_{\min}) + (u_{\max} - u_{\min})(v - v_{\max}) \le 0$. The first-order partial derivatives are denoted \mathbf{P}_u and \mathbf{P}_v. Both vectors are tangent to the surface at the corresponding position. Unit-length tangents are

$$\mathbf{T}_0 = \frac{\mathbf{P}_u}{|\mathbf{P}_u|}, \qquad \mathbf{T}_1 = \frac{\mathbf{P}_v}{|\mathbf{P}_v|}.$$

As long as the two tangent vectors are linearly independent, a unit-length surface normal vector is

$$\mathbf{N} = \frac{\mathbf{T}_0 \times \mathbf{T}_1}{|\mathbf{T}_0 \times \mathbf{T}_1|}.$$

I created an abstract class called SurfacePatch that has pure virtual functions for computing the position and first and second derivatives. The curve class required a third derivative for computing torsion, but we have no need for third derivatives on surfaces. The class interface is

```
class SurfacePatch : public Object
{
public:
    virtual ~SurfacePatch ();

    float GetUMin () const;
    float GetUMax () const;
    float GetVMin () const;
    float GetVMax () const;
    bool IsRectangular () const;
```

```
    virtual Vector3f P (float fU, float fV) const = 0;
    virtual Vector3f PU (float fU, float fV) const = 0;
    virtual Vector3f PV (float fU, float fV) const = 0;
    virtual Vector3f PUU (float fU, float fV) const = 0;
    virtual Vector3f PUV (float fU, float fV) const = 0;
    virtual Vector3f PVV (float fU, float fV) const = 0;

    Vector3f Tangent0 (float fU, float fV) const;
    Vector3f Tangent1 (float fU, float fV) const;
    Vector3f Normal (float fU, float fV) const;
    void GetFrame (float fU, float fV, Vector3f& rkPosition,
        Vector3f& rkTangent0, Vector3f& rkTangent1,
        Vector3f& rkNormal) const;
    void ComputePrincipalCurvatureInfo (float fU, float fV,
        float& rfCurv0, float& rfCurv1, Vector3f& rkDir0,
        Vector3f& rkDir1);

protected:
    SurfacePatch (float fUMin, float fUMax, float fVMin,
        float fVMax, bool bRectangular);
    SurfacePatch ();

    float m_fUMin, m_fUMax, m_fVMin, m_fVMax;
    bool m_bRectangular;
};
```

The class stores the minimum and maximum *u* and *v* values for the surface, but derived classes must generate their values. Also, the derived class must specify if it uses a rectangular or triangular domain. The Boolean member m_bRectangular is used for this purpose. The values may be retrieved through the member accessors GetUMin, GetUMax, GetVMin, GetVMax, and IsRectangular. The position, first derivative, and second derivative are computed by the member functions P, PU, PV, PUU, PUV, and PVV. A derived class must implement these.

Analogous to choosing a coordinate frame for a point on a curve, we sometimes might want a coordinate frame for a point on a surface. To attempt a frame that smoothly varies as the point moves over the surface is in the realm of the differential geometry of surfaces, a mathematics-heavy topic. I discussed the concepts briefly in [Ebe00]. The quick summary is that at each point on the surface, if you were to move in a direction tangential to that point, the surface curves by some amount. There will be a tangential direction along which that curvature is maximum, and one along which that curvature is minimum. These directions are called *principal directions,* and the corresponding curvatures are called the *principal curvatures.* The member function ComputePrincipalCurvatureInfo computes the principal directions

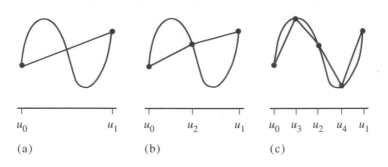

Figure 4.32 (a) A curve segment tessellated by a single line segment connecting its end points. (b) One subdivision step applied to the original tessellation. (c) Two subdivision steps applied to the original tessellation.

and curvatures. Frames using principal directions have their own mathematical difficulties. If a point has the property that the minimum and maximum curvatures are the same, then no matter what tangential direction you move along, the curvature is the same. Such a point is called an *umbilic* point. Locally, the surface appears to be a sphere. At such a point every direction is principal, so a frame varying as you move along the surface will have a discontinuity at an umbilic.

4.3.3 CURVE TESSELLATION BY SUBDIVISION

The subdivision scheme I use for tessellating a curve is simple. Let $\mathbf{P}(u)$ be the curve for $u \in [u_{\min}, u_{\max}]$. Given two points on the curve, say, $\mathbf{P}(u_0)$ and $\mathbf{P}(u_1)$ with $u_0 < u_1$, the parameter interval $[u_0, u_1]$ is subdivided into two halves $[u_0, u_m]$ and $[u_m, u_1]$, where $u_m = (u_0 + u_1)/2$. The new point in the tessellation is $\mathbf{P}(u_m)$. The process is repeated for the subintervals as many times as desired. Figure 4.32 illustrates a few levels of subdivision.

The first subdivision step does not produce a tessellation that resembles the curve, but the second subdivision step does. Naturally, more subdivision steps will produce a polyline that is a better approximation to the curve than the previous step produces.

If you have a collection of curve segments that produce a single curve by ordering the segments end to end, a subdivision scheme may be applied to all the segments simultaneously. Let the segments be $\mathbf{P}_i(u)$ with parameter intervals $[a_i, b_i]$, for $0 \le i < n$. It is not necessary that these intervals be the full domains of the segments. For a continuous curve, it is necessary that $\mathbf{P}_i(b_i) = \mathbf{P}_{i+1}(a_{i+1})$. My implementation of the subdivision scheme assumes continuity. If you have a collection of segments that are not ordered end to end, then apply separate subdivision schemes to the segments.

Assuming continuity, the initial tessellation is the set of vertices

$$\left\{ \mathbf{P}_0(a_0), \mathbf{P}_1(a_1), \ldots, \mathbf{P}_{n-1}(a_{n-1}), \mathbf{P}_{n-1}(b_{n-1}) \right\} \tag{4.2}$$

and represents a polyline that approximates the curve. All the first end points of the curve segments are in the tessellation. The last end point of the last curve is also included. The initial tessellation has $n + 1$ vertices. A subdivision step involves subdividing each parameter interval by calculating the midpoints, $c_i = (a_i + b_i)/2$, and inserting the vertices $\mathbf{P}_i(c_i)$ into the tessellation. The new tessellation is

$$\left\{ \mathbf{P}_0(a_0), \mathbf{P}_i(c_0), \mathbf{P}_1(a_1), \mathbf{P}_i(c_1), \ldots, \mathbf{P}_{n-1}(a_{n-1}), \mathbf{P}_i(c_{n-1}), \mathbf{P}_{n-1}(b_{n-1}) \right\}.$$

The process may be repeated on the subintervals $[a_i, c_i]$ and $[c_i, b_i]$, and then continuing yet again on the resulting subintervals. The class that implements this scheme is CurveMesh.[3]

A portion of the CurveMesh interface is

```
class CurveMesh : public Polyline
{
public:
    CurveMesh (int iSegmentQuantity, CurveSegmentPtr* aspkSegment,
        FloatArrayPtr spkParams, bool bAllowAttributes,
        bool bAllowDynamicChange);

    virtual ~CurveMesh ();

    void SetLevel (int iLevel);
    int GetLevel () const;

protected:
    int m_iSegmentQuantity;
    CurveSegmentPtr* m_aspkSegment;
    FloatArrayPtr m_spkOrigParams;
    int m_iLevel, m_iFullVQuantity;
};
```

A quantity and array of curve segments are passed to the constructor. They are assumed to be ordered to form a continuous curve. The class assumes responsibility for deleting the aspkSegment array, so it must be dynamically allocated. The array spkParams stores the parameter values for the curve segment end points. If there are

3. For now I only support a mesh of curve segments that are ordered end to end. It is possible to support a general mesh, as described earlier. This will require creating a new class PolylineMesh that represents a mesh of polylines.

N segments, this array must have $2(N-1)$ values. Curve segment P[i] has domain [spkParams[2*i],spkParams[2*i+1]]. Continuity requires that P[i](spkParams [2*i+1]) = P[i+1](spkParams[2*(i+1)]). The polyline produced by the subdivision is flagged as open. If you want a closed polyline, you should make certain that the first end point of P[0] matches the last end point of P[N-1].

The default level of subdivision is 0; that is, the polyline that approximates the curve is the sequence of points in Equation (4.2). To subdivide to a different level, call the member function SetLevel with an input that is nonnegative. The input is stored in m_iLevel. The subdivision is always computed from level 0, not incrementally from the previous level. The total number of vertices in the polyline is stored in m_iFull-VQuantity.

For display purposes, the polyline needs vertex attributes. Vertex colors are the most common for polylines, but nothing prevents you from using vertex normals for dynamic lighting or texture coordinates for texturing with a selected image. The CurveMesh object will have an Effect attached to it, since the effect stores the vertex attributes, but the subdivision code knows nothing about these. The problem is that the new vertices introduced by a subdivision call need to have vertex attributes calculated. The approach I used in Wild Magic version 2 was to subdivide the vertices and their attributes simultaneously. The disadvantage to this approach is that the programmer must decide which vertex attributes to pass to the constructor of the class.

In Wild Magic version 3 I decided that greater flexibility is provided to the programmer if the vertex attributes can be processed independently of the subdivision call. The same philosophy was used in the class CreateClodMesh regarding mesh decimation. The class stored enough information to allow you to assign vertex attributes to the CLOD mesh after the decimation was performed. Class CurveMesh also stores information for vertex attribute construction after subdivision, but you have to let the class know you plan on doing this. The Boolean parameter bAllowAttributes in the constructor should be set to true when you plan on using vertex attributes. A binary tree of vertex indices is maintained. A new vertex \mathbf{V}_i is inserted into the tessellation as a result of subdividing a parameter interval $[u_j, u_k]$ for some indices j and k. The binary tree node representing index i had two child nodes representing indices j and k. The curve points at the interval end points are \mathbf{V}_j and \mathbf{V}_k. If these end points have scalar attributes assigned to them, say, α_j and α_k, the scalar attribute assigned to \mathbf{V}_i is the average $\alpha_i = (\alpha_j + \alpha_k)/2$. The scalar attributes are the individual components of any vertex attributes—for example, a color channel (R, G, or B), a component of a texture coordinate, or a component of a normal vector. In the latter case, the normal components will be interpolated separately, so you need to normalize the results yourself.

The interface for the binary tree handling is

```
class CurveMesh : public Polyline
{
public:
    float* GetAttributes (int iSize, const float* afAttr) const;
```

```
protected:
    class VertexTree
    {
    public:
        VertexTree ();

        int V[2];
    };
    VertexTree* m_akVTree;
    bool m_bBuildVertexTree;
};
```

The internal structure is the simplest you can think of for a binary tree. The member function is designed so that you never have to reallocate attribute arrays in the Effect object attached to the CurveMesh object. An attribute array corresponding to the initial vertices in the tessellation is passed to GetAttributes. The number of float components is passed as the size. For example, if you have an array of ColorRGB, iSize is set to 3, and the pointer to the array is typecast as a float* and passed to the function. The return value is an array of the same type, ColorRGB in our example, and has the same number of elements as vertices in the current tessellation. You have the responsibility of replacing the old attribute array in the Effect object with the new one. Just a note on the implementation of GetAttributes. The function must traverse the binary tree of indices. A recursive call is not necessary, though, because the tree is stored as an array in an order that guarantees that a forward iteration over the array will generate new attributes from array slots with already valid attributes.

The way that you compute attributes is illustrated in the sample application that is on the companion website in the directory

GeometricTools/WildMagic3/SampleGraphics/SurfaceMeshes

A CurveMesh object is created with the Boolean flag set to true for building and managing the binary tree. An Effect object is attached that has vertex colors for the initial vertices of the tessellation. In the key handler of the application, when the plus key is pressed, the level of tessellation is increased. The vertex attributes are updated by

```
m_spkCurve->SetLevel(m_iLevel);
pkEffect = m_spkCurve->GetEffect();
iOrigQuantity = pkEffect->ColorRGBs->GetQuantity();
afOrigColors = (const float*)pkEffect->ColorRGBs->GetData();
akColor = (ColorRGB*) m_spkCurve->GetAttributes(3,afOrigColors);
iVQuantity = m_spkCurve->Vertices->GetQuantity();
pkEffect->ColorRGBs = new ColorRGBArray(iVQuantity,akColor);
```

The first line of code causes the curve to be subdivided to a specified level. The effect is accessed from the curve. The color array for the initial tessellation is fetched from the effect and then passed to the GetAttributes function so that a new color array can be computed with the aid of the binary tree of indices. The effect needs to be updated by giving it the new color array.

Another feature that is useful is to allow the curve itself to change, in which case all the vertices in the tessellation must be recomputed. For example, if your curve is a Bézier curve with control points, any change in the control points will require the curve mesh to be updated. If you want to allow dynamic changes of this type, you need to set the constructor input Boolean parameter bAllowDynamicChange to true. Support for dynamic updates is provided by the interface

```
class CurveMesh : public Polyline
{
public:
    void OnDynamicChange ();

protected:
    class CurveInfo
    {
    public:
        CurveInfo ();

        CurveSegmentPtr Segment;
        float Param;
    };
    void InitializeCurveInfo ();
    bool m_bAllowDynamicChange;
    CurveInfo* m_akCInfo;
};
```

Whenever your curve segments have been modified, you must call the method On-DynamicChange. The internal data structure associated with the updates, nested class CurveInfo, stores information for each vertex in the current tessellation. During the subdivision process, the parameters that generate the new vertices are temporarily stored until the subdivision terminates. At that time the temporary information is deleted, so the parameters associated with the vertices in the tessellation are discarded. The curve segments to which the parameters were associated are also temporarily stored during subdivision, and they, too, are discarded at the end of the process. A dynamic change requires us to remember the parameter values and curve segments, which is exactly what CurveInfo does.

A final feature is provided by the interface

```
class CurveMesh : public Polyline
{
public:
    void Lock ();
    bool IsLocked () const;
};
```

The ability to vary the level of subdivision and compute vertex attributes might be exercised during the development of an application. If you should decide that no more adjustments must be made to the CurveMesh object, it is recommended that you discard all the memory that is used internally to support these operations by calling Lock. This function deletes the array of curve segments and the parameter array that were passed to the constructor. If a binary tree of vertex indices was requested during construction, the array to store that is also deleted. However, the array to allow dynamic changes is retained so that you can morph the curves, if so desired. Once you call Lock, you cannot "unlock" and have the data restored. That can only be done by constructing another object from the same input data you originally used. Also, after a Lock call, any calls to SetLevel are ignored.

A few words are in order about the subdivision process itself. The class CurveMesh has two private functions that are called by SetLevel. The first one is Allocate. Its job is to compute the number of vertices required by the specified level for subdivision. A private, nested class called Edge is used to represent an edge connecting two vertices. This class simply stores the curve segment that is used to subdivide the edge, a pair of indices into the vertex array where the edge end points are stored, and a pair of parameters that generated those end points via the curve segment. The function Allocate creates arrays large enough to store both the vertices and edges. It computes the initial vertices that correspond to the parameters passed to the CurveMesh constructor. It also initializes the edges using the level 0 information—the parameters passed to the constructor and the indices to the vertices just computed. If the number of initial vertices is V_0, then the number of initial edges is $E_0 = V_0 - 1$. A subdivision produces V_1 vertices and E_1 edges, where

$$V_1 = V_0 + E_0, \qquad E_1 = 2E_0.$$

Each edge has a new vertex associated with it (the midpoint in parameter space), so E_0 new vertices are generated. Since the new vertex implies the edge is split into two edges, the number of edges doubles.

The second private function is Subdivide. Its job is to fill in the vertex and edge arrays with the new vertices and edges implied by the subdivision step. The algorithm process is straightforward, but the implementation has a subtle twist. Each old edge is split into two new edges. The new edges must be stored in the array created by Allocate, but should not overwrite any old edges not yet processed. In order for this to happen, you have to iterate backwards over the old edges in the array and write

the new edges to the correct locations. I also want this to happen in a manner that preserves the ordering of the vertices so that I can iterate over the final set of edges and generate the polyline.

For example, suppose that the old edges are E_0, E_1, and E_2. E_0 will be split into two edges E_0' and E_1', E_1 will be split into two edges E_2' and E_3', and E_2 will be split into two edges E_4' and E_5'. The array that Allocate creates has six slots, and the first three slots are filled with the old edges:

$$\left[\; E_0 \;\middle|\; E_1 \;\middle|\; E_2 \;\middle|\; \emptyset \;\middle|\; \emptyset \;\middle|\; \emptyset \;\right]$$

The symbol \emptyset indicates that the slots are empty. Clearly, if we were to compute E_0' and E_1' and store them in the slots currently occupied by E_0 and E_1, we would overwrite E_1 before it was processed, which is an error. Instead, split E_2 by computing E_4' and E_5' and storing them at the end of the array. The array becomes

$$\left[\; E_0 \;\middle|\; E_1 \;\middle|\; E_2 \;\middle|\; \emptyset \;\middle|\; E_4' \;\middle|\; E_5' \;\right]$$

Split E_1 by computing E_2' and E_3' and storing them in the next available slots at the end of the array. The array becomes

$$\left[\; E_0 \;\middle|\; E_1 \;\middle|\; E_2' \;\middle|\; E_3' \;\middle|\; E_4' \;\middle|\; E_5' \;\right]$$

Notice that E_2 has been overwritten, but since we already processed that edge, this is not a problem. Finally, split E_0 by computing E_0' and E_1' and storing them in the final available slots. The array becomes

$$\left[\; E_0' \;\middle|\; E_1' \;\middle|\; E_2' \;\middle|\; E_3' \;\middle|\; E_4' \;\middle|\; E_5' \;\right]$$

The edge E_0 will be overwritten by this process. It is essential to compute E_1' first and store it before you compute E_0' and overwrite E_0. The implementation of Subdivide does compute the new edges in the order E_{i+1}' followed by E_i', so there is no problem on the overwriting.

The uniform subdivision scheme described here does not take into account the shape of the curve. Adaptive subdivision schemes will choose to subdivide a subinterval depending on the variation between the curve and the line segment connecting to that subinterval. A few adaptive schemes are described in [Ebe00]. Should you choose to use one of them, you will need to either modify the CurveMesh source code or implement a new class.

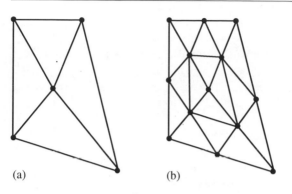

Figure 4.33 (a) A triangulated region in the parameter domain. (b) One subdivision step applied to the triangulated region.

4.3.4 SURFACE TESSELLATION BY SUBDIVISION

The subdivision scheme for surfaces is more complicated than that for curves. The surface tessellation is a triangle mesh, even if the surface patches are rectangles. Only a subset of the rectangle domain may be used to control the positions during the subdivision of a triangle. Consider a triangle in the parameter domain with vertices (u_0, v_0), (u_1, v_1), and (u_2, v_2). The surface has corresponding vertices $\mathbf{P}(u_i, v_i)$ for $0 \leq i \leq 2$. The triangle is subdivided into four smaller triangles by introducing new parameter points at the midpoints of the three edges. The process is repeated on the subtriangles as many times as desired. Figure 4.33 illustrates a level of subdivision. The more subdivision steps you take, the better the triangle mesh approximates the surface.

If the initial number of vertices is V_0, the initial number of edges is E_0, and the initial number of triangles is T_1, a subdivision step will produce new numbers of vertices, edges, and triangles according to

$$V_1 = V_0 + E_0, \qquad E_1 = 2E_0 + 3T_0, \qquad T_1 = 4T_0.$$

These equations are motivated by Figure 4.33. Each edge in the triangulation receives a new vertex, which corresponds to the midpoint of the edge in parameter space. Thus, the new number of vertices is E_0, increasing the total number to $V_0 + E_0$. An edge is split into two, adding $2E_0$ edges to the triangulation. Three additional edges are added per triangle to form the new interior triangle, a total of $3T_0$ edges for those interior triangles. The total number of edges is $2E_0 + 3T_0$. Clearly, one triangle is replaced by four, so the new number of triangles is $4T_0$.

The class that supports the surface subdivision, `SurfaceMesh`, closely resembles `CurveMesh`. A portion of the `SurfaceMesh` interface is

```
class SurfaceMesh : public TriMesh
{
public:
    SurfaceMesh (Vector3fArrayPtr spkVertices, IntArrayPtr spkIndices,
        bool bGenerateNormals, Vector2fArrayPtr spkParams,
        SurfacePatchPtr* aspkPatch, bool bAllowAttributes,
        bool bAllowDynamicChange);

    virtual ~SurfaceMesh ();

    void SetLevel (int iLevel);
    int GetLevel () const;

protected:
    Vector3fArrayPtr m_spkOrigVertices;
    IntArrayPtr m_spkOrigIndices;
    Vector2fArrayPtr m_spkOrigParams;
    SurfacePatchPtr* m_aspkPatch;
    int m_iLevel, m_iFullVQuantity, m_iPatchQuantity;
};
```

In the CurveMesh class, I automatically generated the vertices from the curve segments. That can also be done in the SurfaceMesh class, but I found it to be more convenient to provide those vertices to the constructor. If this is not done, and you do not even pass the number of vertices to the constructor, an iteration must be made through the index array to count the number of vertices. If the indices do not form a contiguous range of integers, special case code must be written to deal with this. So, I pass the vertex and index arrays for the initial tessellation, a TriMesh (the class from which SurfaceMesh is derived). The Boolean flag bGenerateNormals, if true, tells the TriMesh to generate vertex normals.

The index array has $3N$ elements and represents a collection of triangles that share the vertices. Each triangle has a surface patch associated with it. The array of surface patches is aspkPatch and must have N elements. Each triangle also has three parameter pairs assigned to its vertices; the parameters are in the domain of the surface patch associated with the triangle. The array of parameter pairs is spkParams and must have $3N$ elements. The evaluation of the surface patch at the three parameter pairs must reproduce the three input vertices for the triangle. The class SurfaceMesh assumes the responsibility for deleting the input array of patches, so this array should be dynamically allocated.

To subdivide, just call SetLevel with the desired level of subdivision. You should not make the value too large. Each additional level quadruples the number of triangles. It does not take too large a level to produce more triangles than a graphics driver is designed to handle.

The handling of vertex attributes is identical to what was used in CurveMesh. To support computation of vertex attributes after subdivision, the input Boolean

parameter bAllowAttributes to the constructor must be set to true. The relevant interface is

```
class SurfaceMesh : public TriMesh
{
public:
    float* GetAttributes (int iSize, const float* afAttr) const;

protected:
    class VertexTree
    {
    public:
        VertexTree ();

        int V[2];
    };
    VertexTree* m_akVTree;
    bool m_bAllowAttributes;
};
```

A binary tree of indices is used to assist in computing the attributes of a new vertex from those of the two old ones that contributed to it.

The dynamic changes to a surface are also handled in a manner identical to that used for curves. The relevant interface is

```
class SurfaceMesh : public TriMesh
{
public:
    void OnDynamicChange ();

protected:
    class SurfaceInfo
    {
    public:
        SurfaceInfo ();

        SurfacePatchPtr Patch;
        Vector2f Param;
    };
    void InitializeSurfaceInfo ();
    bool m_bAllowDynamicChange;
    SurfaceInfo* m_akSInfo;
};
```

When dynamic changes are enabled, the surface information array stores the surface patch and parameter value that correspond to each vertex in the tessellation. This allows a quick update of the vertices whenever the patch itself changes—for example, when a Bézier patch has its control points modified.

A locking mechanism for surfaces is in place, just like the one for curves. The interface is

```
class SurfaceMesh : public TriMesh
{
public:
    void Lock ();
    bool IsLocked () const;
};
```

When `Lock` is called, the original vertex array, index array, and patch array are all deleted. If vertex attributes were allowed, the binary tree of indices is also deleted. The surface information array is not deleted so that you can continue to morph the surface, if so desired. Once locked, you cannot unlock the surface, and any calls to `SetLevel` are ignored.

The subdivision process is supported by two functions, `Allocate` and `Subdivide`, that are analogous to the ones found in `CurveMesh`. They are much more complicated, though, because of the necessity to manage a vertex-edge-triangle table during the subdivision process. In the curve mesh code, the old edges were split into new edges and stored in the same array containing the old edges. Care was taken not to overwrite old edges before they were processed. The surface mesh code instead uses a hash set of edges to support the subdivision. The triangle mesh representation does not explicitly store edges, so to determine the unique edges in the mesh, you need to iterate over the index array and locate those edges. The hash set data structure stores only the unique edges and provides, effectively, a constant lookup time for edges.[4] During the iteration over the index array, an edge can be encountered multiple times—the number of times the edge is shared by triangles. To avoid splitting the same edge multiple times, the nested class `Edge` that represents an edge has a reference counter whose value is the number of times an edge is currently shared. After an old edge is split, the two new subedges are distinct objects. The old edge must be removed from the hash set. Since the old edge is visited multiple times, the reference count is decremented on each visit, and when the count becomes zero, the edge is removed from the hash set.

4. A hash set data structure is implemented in Wild Magic. If you choose to use the Standard Template Library (STL) set template, be aware that the lookup time is on the order of $O(\log n)$ for n elements. The set stores its elements according to an ordering imposed by the template parameter class. The lookup is a binary search. Wild Magic's structure uses a hash table and has a lookup time on the order of $O(1 + \alpha)$, where α is related to the number of hash collisions. See Section 2.1.1 for details about hash sets.

The sample application on the companion website in the directory

`GeometricTools/WildMagic3/SampleGraphics/SurfaceMeshes`

illustrates the use of both `CurveMesh` and `SurfaceMesh`.

4.4 TERRAIN

Outdoor games have a need for realistic-looking terrain. How you create the terrain data will depend on the type of game. For example, if you are writing a flight simulator, most of the terrain will be observed from a high altitude. The detail on the terrain is not as much of an issue as for games where the player-characters are close to the ground. The detail near the character is expected to be at high resolution. Terrain that is far away requires less detail, but if the triangle mesh used for the terrain close-up is the same one used for the faraway view, the graphics system can spend a lot of cycles drawing many triangles that affect only a handful of pixels. Recall that this concept has been visited already (see Section 4.1). A terrain system might very well be constructed to use level-of-detail algorithms. Whether a flight simulator or a game played on the ground, the potential is great for having a large amount of terrain. This is particularly an issue for game worlds that are designed to have new regions added to them. It is likely that not all the terrain data will fit into available memory on the PC or console, so it must be paged from disk to memory on demand, and hopefully in a manner that does not catch the player's attention. A terrain system in a game engine needs to manage the data efficiently, essentially requiring a virtual memory management system. This section discusses these concepts and how Wild Magic supports them.

4.4.1 DATA REPRESENTATIONS

You have a variety of choices to make regarding the representation of the terrain. A triangle mesh may be used for terrain. If the world up vector is in the direction $(0, 0, 1)$, and the reference height plane (perhaps sea level) is $z = 0$, each vertex (x, y, z) represents the height z above the reference plane at a location (x, y) in that plane. In this sense, the z-value is a function of (x, y), say, $z = f(x, y)$, and the terrain is referred to as a *height field*, the graph of the function f. Well, you could make the situation more complicated, and perhaps more interesting, by allowing the terrain to fold over—it is no longer the graph of a function. Most terrain algorithms are designed to manage large amounts of terrain and deal with level of detail, but are restricted to height fields, so I restrict my attention to height fields only in this discussion.

A triangle mesh gives an artist a chance to strut his stuff and design some really good-looking environments. I recall the artist-generated terrain in the three-dimensional version of Panzer General, produced by Mindscape some years ago. The geometry and the applied textures of the triangles were well designed to hide the sharp-edge artifacts that are inherent in low-polygon-count models. Generating a large amount of terrain in this manner can be time consuming. For larger worlds, automatic or semiautomatic height field generation is desirable. Even if some of the texture generation is automated, the final results still need an artist's expertise to touch up the images. Realizing that large chunks of terrain will be stitched together, height fields tend to be generated over rectangular grids in the xy-plane with uniform sampling in each dimension. The heights over a rectangular grid can be generated by creating gray-scale bitmaps whose intensities are proportional to the desired heights. This approach allows even engineers such as myself to quickly build a terrain system.[5] Height fields created in this manner lend themselves to some level-of-detail algorithms, all based on decimation schemes for regular triangulations of the spatial grid.

An alternative, one I suspect is not used regularly in the art pipeline, is to represent the terrain by surface patches. Patches with rectangular domains that are tiled in the xy-plane are equally viable for terrain modeling as are height fields generated by bitmap images. Should you choose to incorporate level of detail, you are not restricted to a triangulation imposed by a regular grid in the xy-plane. The tessellation of the surface to produce a triangle mesh for the renderer may be controlled by the shape of the surface itself. Regions of large curvature are given a high density of triangles; regions of low curvature are given many fewer triangles. Finally, surface patch representations even allow you to fit a height field on a regularly sampled grid, with the hope that you can replace a large amount of data (all the height samples) by a much smaller amount (for example, control points for the surface). This is an attractive proposition for game consoles that tend to have limited memory, a slow bus, but lots of processing power to tessellate on the fly.

4.4.2 LEVEL OF DETAIL

My discussion in [Ebe00] for level of detail regarding terrain is based on a SIGGRAPH paper [LKR+96]. At the time I wrote that book, CPUs were very slow compared to current processors, and the graphics cards had not yet evolved to use hardware texturing and lighting. The triangle throughputs were not phenomenal either. A continuous-level-of-detail terrain algorithm was quite attractive and was our choice at NDL to put into NetImmerse. A year after Lindstrom's paper appeared in SIGGRAPH, the ROAM algorithm appeared [DWS+97]. ROAM and its variants became

5. The lack of art skills shows up even more quickly when we engineers attempt to create our own bitmaps for texturing!

Figure 4.34 The mesh topology for a 3×3 block of vertices.

much more popular methods for terrain systems, but I never got around to implementing a version for Wild Magic. The second edition of *3D Game Engine Design* is scheduled to appear in print by the end of 2005. The terrain chapter will be replaced by a description of ROAM and its variations, and the engine that ships with that book will have an implementation.

That said, I will still talk briefly about the terrain implementation in Wild Magic. Terrain level of detail, whether Lindstrom's algorithm or the ROAM algorithm, involves modifying the triangle count in a mesh in a view-dependent manner. If you can understand the basic concepts, you will be able to roll your own system. Many of the figures here are from [Ebe00]; my apologies for the duplication.

Vertex Simplification

At the lowest level in the terrain system is a 3×3 block of vertices. The mesh topology for the block is shown in Figure 4.34. The mesh has eight triangles, all sharing the center vertex of the block. Vertices can be removed from the edges to form configurations with fewer triangles. Figure 4.35 shows the possibilities.

These are distinct modulo rotations and reflections of the blocks. For example, configuration 0 can be rotated 90 degrees to produce a two-triangle block where the diagonal edge connects the upper-left vertex to the lower-right vertex. The four corner vertices always exist in each configuration, and the other five vertices can be included or removed. The number associated with a configuration is the number of vertices from those five that the block contributes to the full triangle mesh.

The height field is defined on a grid of $(2^n + 1) \times (2^n + 1)$ locations in the xy-plane, where $n \geq 1$. The grid is considered to be a collection of adjacent 3×3 blocks, each one having the triangle configuration shown in Figure 4.34. A level-of-detail algorithm will decide when to add or remove vertices from these 3×3 blocks. The addition or removal is not done in the sense of allocating or deallocating memory. Instead, a data structure is used to represent a vertex and stores a Boolean flag indicating whether or not the vertex participates in the current tessellation of the height field. The class ClodTerrainVertex is my data structure for the vertex. The interface is

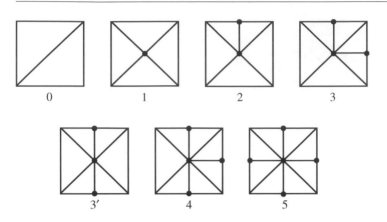

Figure 4.35 The seven distinct triangle configurations.

```
class ClodTerrainVertex
{
public:
    ClodTerrainVertex ();

    void SetDependent (int i, ClodTerrainVertex* pkDependent);
    ClodTerrainVertex* GetDependent (int i);
    bool GetEnabled () const;
    void Enable ();
    void Disable ();

protected:
    ClodTerrainVertex* m_akDependent[2];
    bool m_bEnabled;
};
```

The class is not derived from Object. Higher-level classes in the terrain system have the responsibility for managing the terrain vertices. The data member m_bEnabled stores whether or not the vertex participates in the tessellation. Access to the data member is through the functions GetEnabled, Enable, and Disable.

The ClodTerrainVertex also has an array of two pointers to ClodTerrainVertex objects. You should recognize this as a simple binary tree data structure. The tree exists because the enabling or disabling of a vertex can affect the status of other vertices in the height field. Figure 4.36 shows a simple situation of two adjacent 3×3 blocks. The dependency means that if \mathbf{V} occurs in the tessellation, so must \mathbf{V}_L and \mathbf{V}_R since they are shared by those triangles that also share \mathbf{V}.

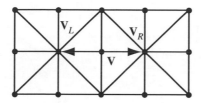

Figure 4.36 Two adjacent 3 × 3 blocks of vertices. The arrows indicate that the vertex **V** on the
shared edge has two dependent vertices, \mathbf{V}_L and \mathbf{V}_R.

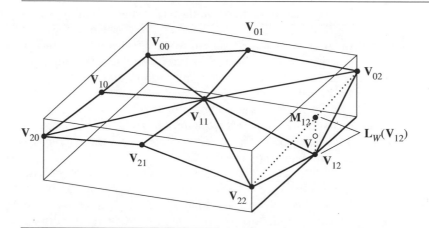

Figure 4.37 A single block with nine vertices labeled and all eight triangles drawn. The candidate
vertex for disabling is \mathbf{V}_{12}, and the candidate vertical line segment for screen space
height measurement is $\langle \mathbf{M}_{12}, \mathbf{V}_{12} \rangle$.

· The decision to disable a vertex is based on the screen space height between the
vertex and the edge that would occur if the vertex were disabled. Figure 4.37 shows a
three-dimensional view of the block.

The mathematics is a bit horrendous for computing the screen space height of
the vertical line segment. Section 3.3.5 of [Ebe00] has all the details. Despite the
complexity, the main idea is that if the screen space height of the vertical line segment
is smaller than a user-specified threshold, presumably a threshold that is a fraction of
a pixel, the vertex \mathbf{V}_{12} is disabled in the tessellation. The player will never notice the
collapse of two edges to one because the collapse occurs at a subpixel level. That's the
theory. The Lindstrom paper made an approximation to the screen space distance
that was valid when the eye point is far from the terrain. I called this the *distant*

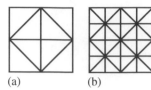

(a) (b)

Figure 4.38 Four adjacent 3 × 3 blocks. (a) All vertices disabled. (b) All vertices enabled.

terrain assumption. This is a reasonable assumption for a flight simulator, but not for a character walking on the ground. I provided an alternative approximation that is valid when you are close to the terrain and called it the *close terrain assumption.*

If all vertices that are allowed to be disabled in the 3 × 3 blocks are disabled, the triangle quantity has been reduced. What to do at that point? The decimation scheme may be applied at a higher level. First, two adjacent 3 × 3 blocks that are completely decimated have configuration 0 as shown in Figure 4.35, but with an additional constraint. The diagonal edge must be reflected between the two blocks. The block having the configuration 0 exactly as shown in the figure is said to be an *even block*. The adjacent block must be an *odd block*. Figure 4.38 shows four adjacent 3 × 3 blocks, one at minimum resolution (all vertices disabled) and one at maximum resolution (all vertices enabled).

The four blocks that were simplified as shown in the left of the figure combine to form a 3 × 3 block of the vertices *still enabled*. This block is a subset of a 5 × 5 block. However, as a 3 × 3 block at a higher level, there are again five vertices— all but the four corners—that may be considered for disabling. Each of them has two dependents, just as in the case of original resolution. This observation allows us to continue the triangle decimation to produce potentially larger blocks of 3 × 3 vertices that contain triangles of large area. These will occur when the blocks are in the distance. The result is that the renderer has to draw only a small number of triangles to cover a small number of pixels.

Block Simplification

The previous discussion led us to see that we can process blocks of vertices that are larger than the lowest-resolution 3 × 3 blocks in the height field. The class that represents the blocks is `ClodTerrainBlock`. The interface is

```
class ClodTerrainBlock
{
public:
    unsigned char GetX () const;
```

```
unsigned char GetY () const;
unsigned char GetStride () const;
float GetDelta (int i) const;
float GetDeltaMax () const;
float GetDeltaL () const;
float GetDeltaH () const;
const Vector3f& GetMin () const;
const Vector3f& GetMax () const;

void SetEven (bool bSet);
bool GetEven () const;
void SetProcessed (bool bSet);
bool GetProcessed () const;
void SetVisible (bool bSet);
bool GetVisible () const;
void SetVisibilityTested (bool bSet);
bool GetVisibilityTested () const;

bool BitsSet () const;
void ClearBits ();

// creation of the quadtree
void Initialize (ClodTerrainPage* pkPage,
    ClodTerrainBlock* pkBlock, unsigned short usBlock,
    unsigned char ucX, unsigned char ucY,
    unsigned char ucStride, bool bEven);

// allows for changing the height data during run time
void UpdateBoundingBox (ClodTerrainPage* pkPage,
    ClodTerrainBlock* pkBlock, unsigned short usBlock,
    unsigned char ucStride);

// test for intersection of page's bounding box and view frustum
void TestIntersectFrustum (const ClodTerrainPage* pkPage,
    const Camera* pkCamera);

// distant terrain assumption
void ComputeInterval (const Vector3f& rkModelEye,
    float fTolerance);

// close terrain assumption
void ComputeInterval (const Vector3f& rkModelDir,
    const Vector3f& rkModelEye, float fTolerance,
    Vector2f& rkLoc, float fSpacing);
```

```
    void SimplifyVertices (ClodTerrainPage* pkPage,
        const Vector3f& rkModelEye, const Vector3f& rkModelDir,
        float fTolerance, bool bCloseAssumption);

    void Disable (ClodTerrainPage* pkPage);

    // quadtree indexing
    static unsigned short GetParentIndex (unsigned short usChild);
    static unsigned short GetChildIndex (unsigned short usParent,
        unsigned short usIndex);
    static bool IsFirstChild (unsigned short usIndex);
    static bool IsSibling (unsigned short usIndex,
        unsigned short usTest);

protected:
    // bit flags for m_ucFlags
    enum
    {
        EVEN_PARITY       = 0x01,
        PROCESSED         = 0x02,
        VISIBLE           = 0x04,
        VISIBILITY_TESTED = 0x08,
        BITS_MASK         = 0x0E  // all but even parity bit
    };

    void GetVertex9 (unsigned short usSize,
        ClodTerrainVertex* pkVOrigin,
        ClodTerrainVertex* apkTVertex[9]);

    unsigned char m_ucX, m_ucY, m_ucStride, m_ucFlags;
    float m_fDelta[5], m_fDeltaMax;
    float m_fDeltaL, m_fDeltaH;
    Vector3f m_kMin, m_kMax;
};
```

This class is not derived from Object. Another class, called ClodTerrainPage, manages a collection of blocks by organizing them in a quadtree. The ClodTerrainBlock interface gives ClodTerrainPage all that it needs to manage the blocks. As you can see, the interface itself is quite complicated. The tedious and long details of what ClodTerrainBlock does are in Section 11.5 of [Ebe00], which I recommend you read to understand the actual code in Wild Magic. This code contains the essence of the algorithm in [LKR+96].

The class ClodTerrainPage represents a single tile, or *page*, in the height field. Its interface is

```
class ClodTerrainPage : public TriMesh
{
public:
    // size = 2^p + 1, p <= 7 (size = 3, 5, 9, 17, 33, 65, 129)
    ClodTerrainPage (unsigned short usSize,
        unsigned short* ausHeight, const Vector2f& rkOrigin,
        float fMinElevation, float fMaxElevation, float fSpacing,
        float fUVBias = 0.0f);

    virtual ~ClodTerrainPage ();

    // height field access
    unsigned short GetSize () const;
    const unsigned short* GetHeights () const;
    const Vector2f& GetOrigin () const;
    float GetMinElevation () const;
    float GetMaxElevation () const;
    float GetSpacing () const;

    // pixel tolerance on projected vertex height
    void SetPixelTolerance (const Renderer* pkRenderer,
        float fTolerance);
    float GetPixelTolerance () const;

    // Height field measurements.  If the location is not in the
    // page, the return value is Mathf::MAX_REAL.
    float GetHeight (float fX, float fY) const;

    // texture coordinates for the page
    Vector2fArrayPtr GetUVs () const;
    float& UVBias ();

protected:
    friend class ClodTerrainBlock;

    // streaming support
    ClodTerrainPage ();
    void InitializeDerivedData ();

    // queue handlers
    void AddToQueue (unsigned short usBlock);
    unsigned short RemoveFromQueue ();
    unsigned short ReadFromQueue (unsigned short usIndex);
```

```
    // page simplification
    bool IntersectFrustum (const Camera* pkCamera);

    // block simplification
    void SimplifyBlocks (const Camera* pCamera,
        const Vector3f& rkModelEye, const Vector3f& rkModelDir,
        bool bCloseAssumption);

    // vertex simplification
    void SimplifyVertices (const Vector3f& rkModelEye,
        const Vector3f& rkModelDir, bool bCloseTerrainAssumption);

    // simplification
    friend class ClodTerrain;
    void ResetBlocks ();
    void Simplify (const Renderer* pkRenderer,
        const Vector3f& rkModelEye, const Vector3f& rkModelDir,
        bool bCloseAssumption);

    // tessellation
    float GetX (unsigned char ucX) const;
    float GetY (unsigned char ucY) const;
    float GetHeight (unsigned short usIndex) const;
    float GetTextureCoordinate (unsigned char ucIndex) const;
    void Render (ClodTerrainBlock& rkBlock);
    void RenderTriangle (unsigned short usT, unsigned short usL,
        unsigned short usR);
    void RenderBlocks ();

    virtual void Draw (Renderer& rkRenderer, bool bNoCull = false);

    // height field
    unsigned short m_usSize, m_usSizeM1;
    unsigned short* m_ausHeight;
    Vector2f m_kOrigin;
    float m_fMinElevation, m_fMaxElevation, m_fSpacing;
    float m_fInvSpacing, m_fTextureSpacing, m_fMultiplier;

    // texture parameters
    float m_fUVBias;

    // simplification
    float m_fPixelTolerance, m_fWorldTolerance;
    bool m_bNeedsTessellation;
```

```
    unsigned short* m_ausLookup;
    int m_iConnectLength;

    // (2^p+1) by (2^p+1) array of vertices, row-major order
    ClodTerrainVertex* m_akTVertex;

    // (2^p+1) by (2^p_1) array of texture coordinates, row-major
    // order
    Vector2fArrayPtr m_spkUVs;

    // maximum quantities
    int m_iTotalVQuantity, m_iTotalTQuantity, m_iTotalIQuantity;

    // quadtree of blocks
    unsigned short m_usBlockQuantity;
    ClodTerrainBlock* m_akBlock;

    // circular queue of indices for active blocks
    unsigned short* m_ausQueue;
    unsigned short m_usQueueQuantity;
    unsigned short m_usFront, m_usRear;
    unsigned short m_usNumUnprocessed;
    unsigned short m_usItemsInQueue;

// for internal use (by ClodTerrain)
public:
    // stitch/unstitch (r,c) and (r,c+1)
    void StitchNextCol (ClodTerrainPage* pkNextCol);
    void UnstitchNextCol (ClodTerrainPage* pkNextCol);

    // stitch/unstitch (r,c) and (r+1,c)
    void StitchNextRow (ClodTerrainPage* pkNextRow);
    void UnstitchNextRow (ClodTerrainPage* pkNextRow);
};
```

This interface is also highly complex. The constructor takes as input a single, square height field. The heights are passed in as a one-dimensional array of unsigned short, but they represent a two-dimensional square array of size usSize. The size is limited to be of the form $2^n + 1$ for $1 \le n \le 7$. The form itself allows the block-based simplification as a quadtree. The upper bound on 7 is the largest integer for which the number of triangles in the full-resolution mesh representing the page is smaller than the maximum value of an unsigned short. That is, a 129×129 page has $2 \cdot 129 \cdot 129 = 33,282$ triangles. The maximum unsigned short (2 bytes) is 65,536. If you were to use a 257×257 page, there are 132,098 triangles, and a 4-byte integer

is needed to index the triangles. Terrain pages can use *a lot of memory*. Limiting the indices to 2-byte unsigned values reduces the memory usage by quite a significant amount. Moreover, by using 2-byte indices, the ClodTerrainBlock values m_ucX, m_ucY, and m_ucStride each can be 1-byte quantities. If a 4-byte index is used, the ClodTerrainBlock values would have to be 2-byte quantities. Once again, we are reducing memory usage significantly. The use of 2-byte integers for height is also designed to reduce memory usage.

The constructor also accepts parameters for the world origin of the terrain page, the minimum and maximum heights associated with the page, the world distance between adjacent spatial samples, and a bias number for the texture coordinates associated with a texture to be applied to the page. The unsigned short height values are mapped to the range of heights between the minimum and maximum elevation in order to produce the true world heights. More on the bias number later.

The tolerance on screen space height used to determine whether or not a vertex is disabled is controlled via the member function SetPixelTolerance. If your application is running on a computer with a slow CPU or a low-end graphics card, you can set the tolerance to a larger number. If large enough, noticeable popping occurs—but better that than running at only a few frames per second.

The member function GetHeight lets you query the terrain page for the height at a specified (x, y) on the page. If the (x, y) value does not occur exactly at a sample point in the height field, the triangle containing the point is located and a linear interpolation is used to compute the height. I chose this instead of bilinear interpolation in order that the (x, y, h) value be exactly on the triangle mesh surface. This is useful when picking is used to keep the camera a fixed height above the surface. Any smoothing of camera motion should occur as a postprocess to the picking operation.

The member functions GetUVs and UVBias will be discussed later. The simplification functions are buried in the protected section of ClodTerrainPage. The intent is that you have even a higher-level manager for the simplification, namely, the class ClodTerrain. This is the topic of the next section.

4.4.3 TERRAIN PAGES AND MEMORY MANAGEMENT

I had implemented Lindstrom's algorithm [LKR+96] in the version of Wild Magic that shipped with [Ebe00], but the source code illustrated the level-of-detail management only for a height field over a single rectangular domain. A high-level description of how to handle tiled terrain was presented in [Ebe00], and I even had some stitching code in place to support the tiling, but I suspect the book did not present enough information for someone to implement a system to handle it (judging by some of the technical support email I received about it). I will now discuss this topic *and* the implementation of it in the engine. The management applies to tiled terrain whether or not you incorporate level of detail. In the event you do, issues must be addressed regarding the stitching of adjacent tiles to avoid cracking in the combined mesh.

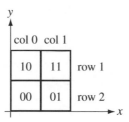

Figure 4.39 The page ordering for a 2 × 2 grid of terrain pages.

Page Stitching

The first issue to deal with is stitching of the pages when the pages are using a level-of-detail algorithm. If you have no level of detail, and the pages are at a fixed resolution, there is no stitching to do. The level of detail can cause vertices on the edge of its page to be disabled. The level of detail at an adjacent page can cause vertices on the equivalent edge to be disabled. But the sets of disabled vertices might not be the same. If they are not, cracking occurs along the shared edge. Two adjacent blocks on the same page do not have this problem because the vertices on the shared edge are exactly the same in memory. When the adjacent blocks are in different pages, each block has its vertices that it manages. The vertices on the shared edge are abstractly the same, but there are two copies of them that need to be handled in an identical manner.

What needs to happen is that the vertices on one page boundary need to be told who their dependents are on the other page. This dependency is slightly different than within a single block. Specifically, the dependent of a vertex on the other page is that vertex that is abstractly equivalent. If one of the copies is in the tessellation, so must be the other copy.

The pages in the terrain have to be numbered with row and column indices. This allows you to identify which pages have to be stitched together, including whether the stitching occurs along a row or along a column. The height fields are functions $z = h(x, y)$ with the xy-plane using right-handed coordinates. The column index increases with x, and the row index increases with y. For example, looking down the positive z-axis, a 2 × 2 grid of pages is labeled as shown in Figure 4.39. The pages are P_{rc}, where r is the row index and c is the column index.

Figure 4.40 shows how to set up the dependencies for two pages sharing a row edge. The symbol s in the figure is the page size. The last indexed row or column in a page is $s - 1$. The stitching code is

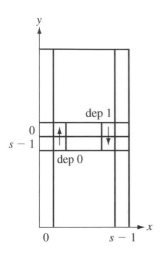

Figure 4.40 Vertex dependencies between two pages sharing a row edge.

```
void ClodTerrainPage::StitchNextRow (ClodTerrainPage* pkNextRow)
{
    // 'this' is page (r,c), 'pkNextRow' is page (r+1,c)
    int iSize = (int)m_usSize;
    int iMax = iSize - 2;
    int iYThis = iSize - 1;
    int iYNext = 0;
    for (int iX = 1; iX <= iMax; iX++)
    {
        int iIThis = iX + iSize*iYThis;
        int iINext = iX + iSize*iYNext;
        ClodTerrainVertex* pkVThis = &m_akTVertex[iIThis];
        ClodTerrainVertex* pkVNext = &pkNextRow->m_akTVertex[iINext];
        pkVNext->SetDependent(1,pkVThis);
        pkVThis->SetDependent(0,pkVNext);
    }
}
```

The vertex pkVThis refers to the one in the figure that has "dep 0" written below it. The vertex pkVNext refers to the one in the figure to which the arrow of "dep 0" points. The connection is also made in the other direction.

Figure 4.41 shows how to set up the dependencies for two pages sharing a column edge. The stitching code is

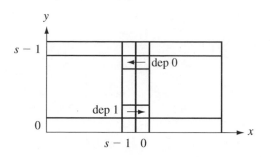

Figure 4.41 Vertex dependencies between two pages sharing a column edge.

```
void ClodTerrainPage::StitchNextCol (ClodTerrainPage* pkNextCol)
{
    // 'this' is page (r,c), 'pkNextCol' is page (r,c+1)
    int iSize = (int)m_usSize;
    int iMax = iSize - 2;
    int iXThis = iSize - 1;
    int iXNext = 0;
    for (int iY = 1; iY <= iMax; iY++)
    {
        int iIThis = iXThis + iSize*iY;
        int iINext = iXNext + iSize*iY;
        ClodTerrainVertex* pkVThis = &m_akTVertex[iIThis];
        ClodTerrainVertex* pkVNext = &pkNextCol->m_akTVertex[iINext];
        pkVNext->SetDependent(0,pkVThis);
        pkVThis->SetDependent(1,pkVNext);
    }
}
```

The vertex pkVThis refers to the one in the figure that has "dep 0" written to the right of it. The vertex pkVNext refers to the one in the figure to which the arrow of "dep 0" points. The connection is also made in the other direction. The stitching functions have counterparts that do the unstitching.

Terrain Page Management

The second issue to deal with is the management of pages in memory. Not all the pages for a large world will fit into physical memory. This requires having a rudimentary virtual memory management system in place. The class ClodTerrain provides

this system, as well as all of the initialization and simplification that goes with the continuous-level-of-detail terrain. The class interface is

```
class ClodTerrain : public Node
{
public:
    ClodTerrain (const char* acHeightPrefix,
        const char* acImagePrefix, Renderer* pkRenderer,
        float fUVBias = 0.0f, ColorRGBA* pkBorderColor = NULL);

    virtual ~ClodTerrain ();

    int GetRowQuantity () const;
    int GetColQuantity () const;
    unsigned short GetSize () const;
    float GetMinElevation () const;
    float GetMaxElevation () const;
    float GetSpacing () const;

    float GetHeight (float fX, float fY) const;

    ClodTerrainPage* GetPage (int iRow, int iCol);
    ClodTerrainPage* GetCurrentPage (float fX, float fY) const;
    ClodTerrainPagePtr ReplacePage (int iRow, int iCol,
        const char* acHeightPrefix, const char* acImagePrefix,
        const char* acHeightName, const char* acImageName);
    ClodTerrainPagePtr ReplacePage (int iRow, int iCol,
        ClodTerrainPage* pkNewPage);

    void Simplify ();

    void SetPixelTolerance (float fTolerance);
    float GetPixelTolerance () const;

    float& UVBias ();
    ColorRGBA& BorderColor ();

protected:
    ClodTerrain ();

    void LoadPage (const char* acHeightPrefix,
        const char* acImagePrefix, int iRow, int iCol);

    int m_iRows, m_iCols;
```

```
        unsigned short m_usSize;
        float m_fMinElevation, m_fMaxElevation, m_fSpacing;
        ClodTerrainPagePtr** m_aaspkPage;

        float m_fPixelTolerance;
        Renderer* m_pkRenderer;
        bool m_bCloseAssumption;

        int m_iCameraRow, m_iCameraCol;

        float m_fUVBias;
        ColorRGBA m_kBorderColor;
};
```

The first two parameters of the constructor are the paths to the directories that contain the height field data and the texture images *plus* the names of the files in those directories. The sample application

```
GeometricTools/WildMagic3/SampleGraphics/Terrains
```

has three different resolution height files stored in the directories

```
GeometricTools/WildMagic3/Data/Terrain/Height32
GeometricTools/WildMagic3/Data/Terrain/Height64
GeometricTools/WildMagic3/Data/Terrain/Height128
```

The number suffix refers to n in the page size $(2^n + 1) \times (2^n + 1)$. The corresponding texture images are in the directories

```
GeometricTools/WildMagic3/Data/Terrain/Image32
GeometricTools/WildMagic3/Data/Terrain/Image64
GeometricTools/WildMagic3/Data/Terrain/Image128
```

The height and image prefixcs passed to the ClodTerrain constructor are

```
"Height128/height"
"Image128/image"
```

The path is relative to the working directory of the application. Let us assume that we are working with the files with suffix 32. The loading code assumes that there exists a file

```
"Height32/height.wmhf"
```

The extension stands for Wild Magic Height File. The file is binary and contains the number of rows (4-byte signed integer), the number of columns (4-byte signed

integer), the size of the page (2-byte unsigned short, the value 32 in this example), the minimum elevation (4-byte float), the maximum elevation (4-byte float), and the spacing between samples (4-byte float). If there are R rows and C columns, the remaining files in the directory should be

```
''Height32/height.r.c.wmhf''
```

for $0 \le r < R$ and $0 \le c < C$. In the sample application, $R = C = 8$, so there are 64 height fields. The texture images have the same numbering scheme: files are of the form

```
''Image32/image.r.c.wmif''
```

where the extension stands for Wild Magic Image File.

All the height and image files are loaded. For each pair of a height and image file, a ClodTerrainPage is created and a pointer to it is stored in a two-dimensional array. The pages are stitched together using

```
// terrain has m_iRows by m_iCols pages
for (iRow = 0; iRow < m_iRows; iRow++)
{
    for (iCol = 0; iCol+1 < m_iCols; iCol++)
    {
        m_aaspkPage[iRow][iCol]->StitchNextCol(
            m_aaspkPage[iRow][iCol+1]);
    }
}

for (iCol = 0; iCol < m_iCols; iCol++)
{
    for (iRow = 0; iRow+1 < m_iRows; iRow++)
    {
        m_aaspkPage[iRow][iCol]->StitchNextRow(
            m_aaspkPage[iRow+1][iCol]);
    }
}
```

I have chosen to use a toroidal topology for the pages. For a large enough world, players will not notice that they are on a torus rather than a sphere. The wraparound is accomplished by

```
int iColsM1 = m_iCols-1;
for (iRow = 0; iRow < m_iRows; iRow++)
```

```
{
    m_aaspkPage[iRow][iColsM1]->StitchNextCol(
        m_aaspkPage[iRow][0]);
}

int iRowsM1 = m_iRows-1;
for (iCol = 0; iCol < m_iCols; iCol++)
{
    m_aaspkPage[iRowsM1][iCol]->StitchNextRow(
        m_aaspkPage[0][iCol]);
}
```

Even with this topology, you are not obligated to use only a fixed set of terrain pages. Once the stitching is in place, the pages are added as child nodes to the ClodTerrain object. At this point you should consider the collection of terrain pages as the *active set*. The active set can change over time. The old pages may be replaced by new ones as desired, with the decision to replace most likely based on the current camera location and the direction in which it is headed. The active set and the page replacement scheme are essentially a memory management system. More on replacing pages a bit later.

Simplification

After the terrain pages are attached to the ClodTerrain object, the terrain needs to be simplified using the block and vertex dependencies. This is accomplished through the member function ClodTerrain::Simplify. This function is the workhorse of the terrain system. Each time the camera moves, either positionally or rotationally, Simplify must be called. After all, the continuous-level-of-detail system is designed to be view dependent. Ignoring the issue with toroidal wraparound, the simplification would be

```
void ClodTerrain::Simplify ()
{
    // get camera location/direction in model space of terrain
    const Camera* pkCamera = m_pkRenderer->GetCamera();
    Vector3f kWorldEye = pkCamera->GetWorldLocation();
    Vector3f kWorldDir = pkCamera->GetWorldDVector();
    Vector3f kModelEye = World.ApplyInverse(kWorldEye);
    Vector3f kModelDir = kWorldDir*World.GetRotate();

    // ... page management goes here ...

    // Initialize the pages (setup for quadtree blocks to
```

```
// be simplified).
int iRow, iCol;
for (iRow = 0; iRow < m_iRows; iRow++)
{
    for (iCol = 0; iCol < m_iCols; iCol++)
        m_aaspkPage[iRow][iCol]->ResetBlocks();
}

// simplify only the potential visible pages
for (iRow = 0; iRow < m_iRows; iRow++)
{
    for (iCol = 0; iCol < m_iCols; iCol++)
    {
        ClodTerrainPage* pkPage = m_aaspkPage[iRow][iCol];
        if ( pkPage->IntersectFrustum(pkCamera) )
        {
            pkPage->Simplify(m_pkRenderer,kModelEye,kModelDir,
                m_bCloseAssumption);
        }
    }
}
```

First, the simplification algorithms assumes camera information in the coordinate system of the terrain, so the camera eye point and world direction are inverse transformed to the terrain model space. Second, the active blocks in the quadtree are reset via ResetBlocks. This sets the blocks' states so that the simplification step can decide where in the quadtree new blocks need to become active. Third, only the pages that are potentially visible are simplified. There is no reason to simplify a nonvisible page. Now it is possible that a nonvisible page will be modified if it is stitched to one that is visible.

I placed a comment in the previous code block that indicates the page management code must be placed at that location. Each terrain page has associated with it a model space origin. The origin was assigned to it when it was loaded by ClodTerrain, and it is based on the row and column indices for the page and on the sample spacing for the pages. In a toroidal topology, if you were to move the camera along a straight-line path, you would eventually return to the page you started at. The camera has a different eye point vector than it did the first time it was on the page, but the page model space origin is the same. This is a mismatch in coordinates. The page management code must update the model space origins for the pages in the active set to make them consistent with the camera eye point vector. The code block to handle this is

```
float fLength = m_fSpacing*(m_usSize-1);
```

```
float fInvLength = 1.0f/fLength;
int iNewCameraCol = (int)Mathf::Floor(kWorldEye.X()*fInvLength);
int iNewCameraRow = (int)Mathf::Floor(kWorldEye.Y()*fInvLength);
if (iNewCameraCol != m_iCameraCol || iNewCameraRow != m_iCameraRow)
{
    m_iCameraCol = iNewCameraCol;
    m_iCameraRow = iNewCameraRow;

    // translate page origins for toroidal wraparound
    int iCMinO = m_iCameraCol - m_iCols/2;
    int iCMinP = iCMinO % m_iCols;
        if ( iCMinP < 0 )
        iCMinP += m_iCols;

    int iRMinO = m_iCameraRow - m_iRows/2;
    int iRMinP = iRMinO % m_iRows;
        if ( iRMinP < 0 )
        iRMinP += m_iRows;

    int iRO = iRMinO, iRP = iRMinP;
    for (int iRow = 0; iRow < m_iRows; iRow++)
    {
        int iCO = iCMinO, iCP = iCMinP;
        for (int iCol = 0; iCol < m_iCols; iCol++)
        {
            ClodTerrainPage* pkPage = m_aaspkPage[iRP][iCP];
            Vector2f kOldOrigin = pkPage->GetOrigin();
            Vector2f kNewOrigin(iCO*fLength,iRO*fLength);
            Vector2f kTrn = kNewOrigin - kOldOrigin;
            pkPage->Local.Translate().X() = kTrn.X();
            pkPage->Local.Translate().Y() = kTrn.Y();

            iCO++;
            if ( ++iCP == m_iCols )
                iCP = 0;
        }

        iRO++;
        if ( ++iRP == m_iRows )
            iRP = 0;
    }
    UpdateGS();
}
```

The camera world coordinates are not confined by the toroidal topology. The camera can be anywhere in the xy-plane, and the terrain appears to be infinite to the observer. The array of pages P_{rc} is effectively infinite, where r and c are any integer values. The first four lines of code determine which page P_{rc} contains the camera world coordinates (x, y). The variable `iNewCameraRow` is r, and the variable `iNewCameraCol` is c. The previous page is stored in the member variables `m_iCameraRow` and `m_iCameraCol`. The new row and column indices are compared to the old ones. If they have not changed, the page origins are consistent with the camera coordinates. If the origins are changed, the final `UpdateGS` call makes sure all the world data is correct and consistent with the new origins.

Replacing Pages

The topology of the mesh of pages is toroidal, but this does not mean that you should think of the game world as the surface of a torus. Enough pages are stored in the system so that only a few intersect the view frustum at one time. The simplification algorithm is only applied to this subset of pages. The fact that other, invisible pages are toroidally stitched together does not affect the simplification of the visible pages. For all practical purposes, the pages in the view frustum can be part of a world built on an infinite plane or of a world built on a large sphere (that locally looks like an infinite plane).

As the camera moves about the terrain, the `ClodTerrain::Simplify` function updates the page origins to be consistent with world coordinates. An application can also monitor the current row and column associated with the camera. When the camera gets close enough to pages of interest, the current pages can be replaced by new ones loaded from disk. In this sense the world really can be built as if it were infinite. Two functions exist in `ClodTerrain` that allow you to replace a page in a specified row and column:

```
ClodTerrainPagePtr ReplacePage (int iRow, int iCol,
    const char* acHeightPrefix, const char* acImagePrefix,
    const char* acHeightName, const char* acImageName);

ClodTerrainPagePtr ReplacePage (int iRow, int iCol,
    ClodTerrainPage* pkNewPage);
```

The first function requires you to provide the same prefixes that were passed to the `ClodTerrain` constructor; the assumption is that the replacement pages are in the same location and use the same naming convention. You need to provide the actual page names for the files located in the prefix directories. The second function allows you to replace a page with one already stored in memory. The idea is that you might have just replaced a page with a new one, only to find out that the player quickly returned to a location that requires putting back the old page. You can keep a cache of

recently visited pages in memory for quick replacement. How big the cache is depends on the target platform and how much memory you are willing to expend in order to replace pages quickly.

Texturing Issues

When stitching pages together, a visual anomaly can occur. If the textures on two pages somehow are mismatched at a shared edge of a page, the game players will definitely notice. Even if artists have done their best to hide the mismatch, the graphics system itself can cause problems. The issue was already discussed in Section 3.4.3 and has to do with how texture coordinates are handled near the edges of the texture. For a terrain system, the only reasonable choice you have is to use the *clamp-to-edge* mechanism to make sure that bilinear filtering and mipmapping do not cause problems along shared edges.

An artist's assistance with the texture images will also help hide any artifacts at page boundaries, and the terrain design itself may be carefully chosen to help. For example, if you have terrain pages with flat spots, say, a river, and the page boundaries run down the middle of the river, that might be noticeable to a player. You might consider designing the pages so that boundaries occur in places of low probability that a character might see. For example, you could place them along ridges of a mountain, knowing that the character will not get close enough to notice any seams.

4.5 CONTROLLERS AND ANIMATION

Animation is supported in Wild Magic by the concept of a *controller*. A controller manages various quantities that are time varying. Character animation, for example, might be implemented by controlling the local transformations at each joint in the hierarchy representing the character. Motion is not the only quantity that can be controlled. For example, you might have a material attached to an object whose alpha value varies over time, and a controller can be built to vary the alpha value. You name it. If it varies with time, you can control it.

The base class for a controller is appropriately named `Controller`. The interface is

```
class Controller : public Object
{
public:
    virtual ~Controller ();

    Object* GetObject () const;

    virtual bool Update (double dAppTime);
```

```
        enum // RepeatType
        {
            RT_CLAMP,
            RT_WRAP,
            RT_CYCLE,
            RT_QUANTITY
        };

        int RepeatType;       // default = RT_CLAMP
        double MinTime;       // default = 0.0
        double MaxTime;       // default = 0.0
        double Phase;         // default = 0.0
        double Frequency;     // default = 1.0
        bool Active;          // default = true

    protected:
        Controller ();

        // the controlled object
        friend class Object;
        virtual void SetObject (Object* pkObject);

        // Conversion from application time units to controller time
        // units.  Derived classes may use this in their update
        // routines.
        double GetControlTime (double dAppTime);

        // Regular pointer used for controlled object to avoid
        // circular smart pointers between controller and object.
        Object* m_pkObject;

        double m_dLastAppTime;
    };
```

This is an abstract base class that provides the basic services for managing the time values that affect the controlled object. The SetObject function is used by the Object class when a controller is attached to it. The virtual function Update in the Controller class is the main entry point for modifying the managed object's state. The input value is the application time, a value of type double to guarantee a 64-bit value for time. The Active data member in the controller interface is just a switch to indicate whether or not the object is to be updated in the Update call. The update function is implemented in any class derived from Controller; the behavior, of course, is dependent on what that derived class is intended to modify over time. The application can be creative in

the ways that it calls the controller update functions. However, the main mechanism is an update function that applies to a scene graph hierarchy. The controller updates are called when various objects in the scene graph are visited during a depth-first recursion.

Sometimes the time scale of the controller is different than that of the application. For example, some modeling packages use units different than seconds for time-varying quantities. The exporter can preserve such units, but provide information on how that maps to seconds. This information is stored using the MinTime, MaxTime, Phase, and Frequency data members. The only allowable mappings to seconds are linear functions. That is, if t_a is the application time, f is the frequency, and p is the phase, then the controller time is

$$t_c = f * t_a + p.$$

The default frequency is $f = 1$, and the default phase is $p = 0$. Further modifications of the controller time t_c are allowed based on the value of the *repeat type* parameter. This parameter ties the controller time to the minimum and maximum times, both extreme times in the same units as the controller time. If the repeat type is *clamp*, the controller time is clamped to the interval bounded by the minimum t_{min} and maximum t_{max} times. That is,

```
// repeat type = CLAMP
tc = f*ta + p;
if ( tc < tmin )
    tc = tmin;
else if ( tc > tmax )
    tc = tmax;
```

This mode guarantees that the time-varying quantities change only on the specified interval.

If the repeat type is *wrap*, the time varies from t_{min} to t_{max}, then is wrapped around back to t_{min} and the animation starts anew. The code for computing the time is

```
// repeat type = WRAP
tc = f*ta + p;
mult = (tc - tmin)/(tmax - tmin);
integer_part = floor(mult);
fractional_part = mult - integer_part;
tc = tmin + fractional_part*(tmax - tmin);
```

If the repeat type is *clamp*, the time varies from t_{min} to t_{max}, then reverses direction to decrease back to t_{min}, and once again reverses direction, thus causing a cyclical behavior in time. The code for computing the time is

```
// repeat type = CYCLE
tc = f*ta + p;
mult = (tc - tmin)/(tmax - tmin);
integer_part = floor(mult);
fractional_part = mult - integer_part;
if ( integer_part is even )
{
    // forward in time
    tc = tmin + fractional_part*(tmax - tmin);
}
else
{
    // backward in time
    tc = tmax - fractional_part*(tmax - tmin);
}
```

The conversion from application time to controller time is implemented in the function `GetControlTime`. The derived class has the option of whether or not to call this in the `Update` function.

The remainder of this section is a discussion of the classes in the engine that are derived from `Controller`.

4.5.1 KEYFRAME ANIMATION

One of the most commonly used methods for animation is *keyframe animation*. Each node of a scene hierarchy has its local transformations computed by interpolating a small set of translations, rotations, and scales. An artist will generate the sets of transformations, and each transformation is assigned a time for the animation. The engine interpolates those transformations at all other times to generate smooth motion. The artist-generated transformations are called *keyframes*, a term from classical 2D animated cartoon production. Such cartoons are generated by having the main artists draw a sequence of important frames, and other artists, called in-betweeners, fill in the gaps between consecutive frames by drawing a lot more frames. The keyframe controller in the graphics engine is the equivalent of the in-betweeners.

The controller class supporting keyframe animation is `KeyframeController` and has the interface

```
class KeyframeController : public Controller
{
public:
    KeyframeController ();
    virtual ~KeyframeController ();
```

```
    FloatArrayPtr TranslationTimes;
    Vector3fArrayPtr TranslationData;

    FloatArrayPtr RotationTimes;
    QuaternionfArrayPtr RotationData;

    FloatArrayPtr ScaleTimes;
    FloatArrayPtr ScaleData;

    virtual bool Update (double dAppTime);

protected:
    static void GetKeyInfo (float fCtrlTime, int iQuantity,
        float* afTime, int& riLastIndex, float& rfNormTime,
        int& ri0, int& ri1);

    Vector3f GetTranslate (float fNormTime, int i0, int i1);
    Matrix3f GetRotate (float fNormTime, int i0, int i1);
    float GetScale (float fNormTime, int i0, int i1);

    int m_iTLastIndex;
    int m_iRLastIndex;
    int m_iSLastIndex;
};
```

The class manages three arrays of data, one for the translations, one for the rotations (stored as quaternions), and one for the *uniform* scales. Wild Magic version 3 just introduced the ability to have nonuniform scales at the Geometry leaf nodes, but I have not modified the keyframe controller class to handle nonuniformity. Each array of transformation data has an associated array of keyframe times. The times at which translation, rotation, and scale are specified do not have to be the same. The keyframe controller does allow them to be the same since the data members are smart pointers.

Most of the interface just exposes the data members so that you can set them. The Update function is the override of the one in the base class Controller. Its job is to determine the pair of keys (for each channel) whose times bound dAppTime. If you have a long animation sequence with n keys, ordered by time, of course, a linear search will be $O(n)$. Since the keys are ordered, you can instead use a binary search that is $O(\log n)$. For a real-time application, even this can use a lot of CPU cycles. The lookup occurs for each channel in each controller at rates such as 60 frames per second. A faster approach uses time coherency. The chances that the current pair of keys will be the same pair on the next call to Update is nearly 100 percent. If it is not, the chances are high that the next pair of keys bound the input time. Simply save the index of the first key of the bounding pair and start a linear search from that pair

on the next call. The asymptotic behavior is $O(1)$ with a very small constant. If you want to experiment, implement the linear search and profile it on a large animation sequence with a slowly varying time, and then profile the method as I implemented it. You will see significant differences.

The fast lookup is implemented in the method `GetKeyInfo`. The input `fCtrlTime` is the mapping of `dAppTime` by the base class `GetControlTime`. The array of times is passed by `iQuantity` and `afTime`. The index from the last search is `riLastIndex`. The values returned from the function call through passed parameters are `rfNormTime`, a value that normalizes time to the interval $[0, 1]$, and the indices `ri0` and `ri1` for the pair of keys that bound the input time. If t_0 and t_1 are the bounding times and t is the input time, the normalized time is $u = (t - t_0)/(t_1 - t_0)$. The normalized time is passed to `GetTranslate` for linear interpolation of two vectors, to `GetRotate` for spherical linear interpolation of two quaternions, and to `GetScale` for linear interpolation of two scalars. The transformations computed by the interpolations are for the local transformations of the `Spatial` object to which the controller is attached.

The sample application on the companion website,

```
GeometricTools/WildMagic3/SampleGraphics/SkinnedBiped
```

is designed to illustrate keyframe animation as well as skinning. The character is animated at most of its joints using keyframe controllers.

4.5.2 Morphing

The definitions of *morphing* are many. Most of them have the flavor of modifying one object in some well-defined manner to look like another object. The version of morphing that I have implemented as a controller involves a sequence of `Geometry` objects, called *targets*, all of the same class type and all having the same number of vertices. Given a vertex on one object, there is a corresponding vertex on each of the other objects. A weighted average of each collection of corresponding vertices is computed; the result is an object that is a weighted combination of the targets. Think of the weights as an array of numbers summing to 1. The array of weights is applied to *all* sets of corresponding vertices. A set of weight arrays is provided for the morphing, and each set is assigned a time. These act as keyframes: An artist has provided the weights to be used on the objects at a small number of snapshots in time, and a morphing controller does the in-betweening by interpolating the weight arrays and applying the resulting weight array to the set of targets to produce the in-between object.

The class `MorphController` implements this concept. Its interface is

```
class MorphController : public Controller
{
public:
    MorphController (int iVertexQuantity, int iTargetQuantity,
```

```
            int iKeyQuantity);
    virtual ~MorphController ();

    int GetVertexQuantity () const;
    int GetTargetQuantity () const;
    int GetKeyQuantity () const;

    void SetVertices (int i, Vector3fArray* pkVertices);
    Vector3fArray* GetVertices (int i) const;

    void SetTimes (FloatArray* pkTimes);
    FloatArray* GetTimes () const;
    void SetWeights (int i, FloatArray* pkWeights);
    FloatArray* GetWeights (int i) const;

    virtual bool Update (double dAppTime);

protected:
    MorphController ();

    void GetKeyInfo (float fCtrlTime, float& rfTime,
        float& rfOmTime, int& ri0, int& ri1);

    int m_iVertexQuantity;
    int m_iTargetQuantity;
    Vector3fArrayPtr* m_aspkVertices;

    int m_iKeyQuantity;
    FloatArrayPtr m_spkTimes;
    FloatArrayPtr* m_aspkWeights;

    int m_iLastIndex;
};
```

The constructor is passed the number of vertices in a target, the number of targets, and the number of keys for the weight arrays. The majority of the public interface is for setting and getting the vertex, target, and key data.

Suppose there are V vertices, T targets, and K keys. A weight array has elements w_i for $0 \le i \le T - 1$ with $w_i \ge 0$ and $\sum_{i=0}^{T-1} w_i = 1$. If \mathbf{X}_i is the set of corresponding vertices to be weighted, with \mathbf{X}_i from target i, then the output vertex is

$$\mathbf{X} = \sum_{i=0}^{T-1} w_i \mathbf{X}_i.$$

Observing that $w_0 = 1 - \sum_{i=1}^{T-1} w_i$, the expression is rewritten as

$$\mathbf{X} = \mathbf{X}_0 + \sum_{i=1}^{T-1} w_i (\mathbf{X}_i - \mathbf{X}_0).$$

If the differences $\mathbf{X}_i - \mathbf{X}_0$ are precomputed, then the new expression requires three fewer multiplications than the old one. The storage requirements are also slightly less: one floating-point value per array of weights since we do not need to store w_0. For a large amount of morphing data and a lot of keys, this small difference can add up to a large one, both in memory and speed.

An artist can generate all T targets, but an exporter from the modeling package or an importer can be written to precompute the vector differences. The MorphController class does assume the precomputing has happened. The data member m_aspkVertices is an array of T vertex arrays; each vertex array is the geometric data of the target and has V vertices. The vertex array m_aspkVertices[0] stores the original target. The vertices are the \mathbf{X}_0 in the weighted average equation. The remaining vertex arrays m_aspkVertices[i] for $i \geq 1$ store the vector differences $\mathbf{X}_i - \mathbf{X}_0$.

The data member m_aspkWeights is an array of K weight arrays. Each array represents weights w_1 through w_{T-1}, so each array stores $T - 1$ floating-point values. The weights w_0 are not stored. The keyframe times are stored in m_spkTimes, an array of K floating-point values.

The Update function takes the input application time dAppTime and must look up the pair of consecutive keys that bound that time. The process is identical to the one used in KeyframeController. Time coherency allows an $O(1)$ lookup by saving the index of the first key of the bounding pair found in the last update call and then using it as the starting point for a linear search in the current update call. That index is stored in m_iLastIndex. The fast lookup is implemented in the method GetKeyInfo. The input fCtrlTime is the mapping of dAppTime by the base class GetControlTime. The outputs are the normalized time, rfTime, and one minus that time, rfOmTime. The indices for the bounding pair of keyframe times are returned in ri0 and ri1. If t_0 and t_1 are the keyframe times and t is the control time, the normalized time is $u = (t - t_0)/(t_1 - t_0)$.

The sample application on the companion website,

GeometricTools/WildMagic3/SampleGraphics/MorphControllers

is designed to show morphing. There are five targets and six keys. The object is a face with 1330 vertices and 2576 triangles.

4.5.3 POINTS AND PARTICLES

A simple interface is provided for controlling a collection of points stored as a Polypoint geometric object. The class is PointController and has the interface

```
class PointController : public Controller
{
public:
    virtual ~PointController ();

    // The system motion, in local coordinates.
    float SystemLinearSpeed;
    float SystemAngularSpeed;
    Vector3f SystemLinearAxis;
    Vector3f SystemAngularAxis;

    // Point motion, in the model space of the system.
    float* PointLinearSpeed ();
    float* PointAngularSpeed ();
    Vector3f* PointLinearAxis ();
    Vector3f* PointAngularAxis ();

    virtual bool Update (double dAppTime);

protected:
    // streaming support
    PointController ();

    // for deferred allocation of the point motion arrays
    void Reallocate (int iVertexQuantity);
    virtual void SetObject (Object* pkObject);

    virtual void UpdateSystemMotion (float fCtrlTime);
    virtual void UpdatePointMotion (float fCtrlTime);

    // point motion (in model space of system)
    int m_iPQuantity;
    float* m_afPointLinearSpeed;
    float* m_afPointAngularSpeed;
    Vector3f* m_akPointLinearAxis;
    Vector3f* m_akPointAngularAxis;
};
```

The class is abstract since the default constructor is protected and no constructors exist. The intention is that you implement whatever physics you desire by deriving a class from this one.

The set of points is referred to as a *system*. That system, when viewed as a single entity, moves according to its linear velocity and rotates according to its angular velocity. In physics simulations where the points represent a rigid body, the origin of the

system is chosen to be the center of mass of the points, and the coordinate axes are chosen to be the principal directions of the inertia tensor. The class interface lets you set the linear velocity as a linear speed, SystemLinearSpeed, and the unit-length direction, SystemLinearAxis. The angular velocity is set by choosing the angular speed, SystemAngularSpeed, and the unit-length rotation axis, SystemAngularAxis.

In a nonrigid system, each point can have its own linear and angular velocity. These are set by the member functions that expose the arrays of quantities, PointLinearSpeed, PointLinearAxis, PointAngularSpeed, and PointAngularAxis. The arrays have the same number of elements as the Polypoint object the controller manages. To avoid accidentally reallocating any of the arrays with the wrong number of elements, the array pointers are not exposed in the public interface.

The important functions to override in a derived class are UpdateSystemMotion and UpdatePointMotion. The Update function of PointController computes the control time from the application time dAppTime and then calls the two motion updates with the control time. PointController does provide implementations. The system motion update changes the local translation by computing how far the system has moved in the direction of linear velocity and adding it to the current local translation. Similarly, the local rotation is updated by multiplying it by the incremental rotation implied by the angular speed and angular axis. The local translation of each point is updated using the distance traveled by the point in the direction of its linear velocity. The point does not have a size, so how does one interpret angular velocity? The point could be a summary statistic of an object that does have size. Each point may have a normal vector assigned to it (Polypoint objects can have vertex normal arrays). If normal vectors are attached to the points, those vectors are rotated by the new local rotation matrix.

The sample application on the companion website,

GeometricTools/WildMagic3/SampleGraphics/PointSystems

is designed to illustrate point controllers. The application creates a class called RandomController that is derived from PointController. The system linear and angular velocities are always zero, so the system motion update has no effect on the points. However, the point motion update is implemented to randomly move the points around in a cubic region of space.

Another controller, ParticleController, is used to manage the quantities in the Particles class. The interface is

```
class ParticleController : public Controller
{
public:
    virtual ~ParticleController ();

    // The system motion, in local coordinates.
```

```
            float SystemLinearSpeed;
            float SystemAngularSpeed;
            Vector3f SystemLinearAxis;
            Vector3f SystemAngularAxis;

            // Point motion, in the model space of the system.
            float* PointLinearSpeed ();
            Vector3f* PointLinearAxis ();

            float SystemSizeChange;
            float* PointSizeChange ();

            virtual bool Update (double dAppTime);

    protected:
            // streaming support
            ParticleController ();

            // for deferred allocation of the point motion arrays
            void Reallocate (int iVertexQuantity);
            virtual void SetObject (Object* pkObject);

            virtual void UpdateSystemMotion (float fCtrlTime);
            virtual void UpdatePointMotion (float fCtrlTime);

            // point motion (in model space of system)
            int m_iLQuantity;
            float* m_afPointLinearSpeed;
            Vector3f* m_akPointLinearAxis;

            // size change parameters
            float* m_afPointSizeChange;
    };
```

The structure of this controller is nearly identical to PointController with a couple of exceptions. First, the points are not allowed any angular velocity. This choice was made because the particles are displayed as billboards that always face the camera, and an attempt to reorient them physically would be inconsistent with their visual display. Second, the particles have sizes, and a size adjustment applies to all the particles. The size quantities themselves may vary over time. The function UpdateSystem-Motion has the responsibility for varying SystemSizeChange, and the function Update-PointMotion has the responsibility for varying the elements of m_afPointSizeChange.

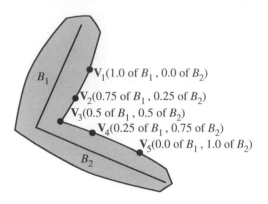

Figure 4.42 A skin-and-bones system consisting of two bones that influence five vertices. The vertex closest to the joint formed by the two bones is equally influenced by the bones. For each vertex farther from the joint, one bone influences it more than the other bone.

The sample application on the companion website,

```
GeometricTools/WildMagic3/SampleGraphics/ParticleSystems
```

is designed to illustrate particle controllers. The application creates a class called `BloodCellController` that is derived from `ParticleController`. The system linear and angular velocities are always zero, so the system motion update has no effect on the points. However, the point motion update is implemented to randomly move the particles around in a cubic region of space. The particles use a texture image with an alpha channel. They appear as if they are spherically shaped, red blobs. Well, to my imagination, they look like animated blood cells.

4.5.4 SKIN AND BONES

Skin-and-bones animation, or simply *skinning,* is the process of attaching a deformable mesh to a skeletal structure in order to smoothly deform the mesh as the bones move. The skeleton is represented by a hierarchy of *bones,* each bone positioned in the world by a translation and orientation. The *skin* is represented by a triangle mesh for which each vertex is assigned to one or more bones and is a weighted average of the world positions of the bones that influence it. As the bones move, the vertex positions are updated to provide a smooth animation. Figure 4.42 shows a simple configuration of two bones and five vertices.

The intuition of Figure 4.42 should be clear: Each vertex is constructed based on information relative to the bones that affect it. To be more precise, associate with bone B_i the uniform scale s_i, the translation vector \mathbf{T}_i, and the rotation matrix R_i. Let the vertex \mathbf{V}_j be influenced by n_j bones whose indices are k_1 through k_{n_j}. The vertex has two quantities associated with bone B_{k_i}: an offset from the bone, denoted $\boldsymbol{\Theta}_{jk_i}$ and measured in the model space of the bone, and a weight of influence, denoted w_{jk_i}. The world space contribution by B_{k_i} to the vertex offset is

$$s_{k_i} R_{k_i} \boldsymbol{\Theta}_{jk_i} + \mathbf{T}_{k_i}.$$

This quantity is the transformation of the offset from the bone's model space to world space. The world space location of the vertex is the weighted sum of all such contributions,

$$\mathbf{V}_j = \sum_{i=1}^{n_j} w_{jk_i} \left(s_{k_i} R_{k_i} \boldsymbol{\Theta}_{jk_i} + \mathbf{T}_{k_i} \right). \tag{4.3}$$

Skinning is supported in current graphics hardware. The skinning in Wild Magic was implemented originally to use the CPU to do all the algebraic calculations because, at the time, the hardware support was not always there. The CD-ROM that ships with [Ebe03a] has a shader program for handling skinning. Wild Magic version 3 has a software-based skin-and-bones controller, called SkinController. It should be easy enough to write one that uses the graphics APIs rather than using shaders, but the class will be Effect-derived since the renderer has to be given the responsibility to pass the bone matrices to the hardware through the graphics API interface.

The class interface for the software-based skinning is

```
class SkinController : public Controller
{
public:
    SkinController (int iVertexQuantity, int iBoneQuantity,
        Node** apkBones, float** aafWeight, Vector3f** aakOffset);
    virtual ~SkinController ();

    int GetVertexQuantity () const;
    int GetBoneQuantity () const;
    Node* GetBone (int iBone) const;
    float& Weight (int iVertex, int iBone);
    Vector3f& Offset (int iVertex, int iBone);

    virtual bool Update (double dAppTime);

protected:
    SkinController ();
```

```
    int m_iVertexQuantity;    // vq
    int m_iBoneQuantity;      // bq
    Node** m_apkBones;        // bones[bq]
    float** m_aafWeight;      // weight[vq][bq]
    Vector3f** m_aakOffset;   // offset[vq][bq]
};
```

The constructor is told how many vertices are in the skin (iVertexQuantity), how many bones affect the skin (iBoneQuantity), the array of (pointers to) bones themselves (apkBones), and the matrix of weights (aafWeight) and offsets (aakOffset) that determine how the skin vertices are constructed from the bones. The input arrays are the responsibility of the controller to delete, so they should be dynamically allocated. The weights and offsets must be allocated with the system template function Allocate that was discussed in Section 2.1.6. The controller is attached to a TriMesh object.

The relationship between the bones and the vertices can be thought of as a matrix of weights and offsets whose rows correspond to the vertices and whose columns correspond to the bones. For example, if there are three vertices and four bones, then the following array illustrates a possible relationship:

$$
\begin{bmatrix}
 & B_0 & B_1 & B_2 & B_3 \\
\mathbf{V}_0 & w_{00}, \mathbf{\Theta}_{00} & \emptyset & w_{02}, \mathbf{\Theta}_{02} & w_{03}, \mathbf{\Theta}_{03} \\
\mathbf{V}_1 & \emptyset & w_{11}, \mathbf{\Theta}_{11} & \emptyset & w_{13}, \mathbf{\Theta}_{13} \\
\mathbf{V}_2 & w_{20}, \mathbf{\Theta}_{20} & \emptyset & \emptyset & w_{23}, \mathbf{\Theta}_{23}
\end{bmatrix}
$$

An entry of \emptyset indicates that the bone does not influence the vertex. In this case the implied weight is 0. The indexing in the matrix is the same one referenced in Equation (4.3). The skin vertices are

$$\mathbf{V}_0 = w_{00}\left(s_0 R_0 \mathbf{\Theta}_{00} + \mathbf{T}_0\right) + w_{02}\left(s_2 R_2 \mathbf{\Theta}_{02} + \mathbf{T}_2\right) + w_{03}\left(s_3 R_3 \mathbf{\Theta}_{03} + \mathbf{T}_3\right)$$

$$\mathbf{V}_1 = w_{11}\left(s_1 R_1 \mathbf{\Theta}_{11} + \mathbf{T}_1\right) + w_{13}\left(s_3 R_3 \mathbf{\Theta}_{13} + \mathbf{T}_3\right)$$

$$\mathbf{V}_2 = w_{20}\left(s_2 R_2 \mathbf{\Theta}_{20} + \mathbf{T}_2\right) + w_{23}\left(s_3 R_3 \mathbf{\Theta}_{23} + \mathbf{T}_3\right).$$

The Update function is

```
bool SkinController::Update (double dAppTime)
{
    if ( !Controller::Update(dAppTime) )
        return false;

    // The skin vertices are calculated in the bone world
    // coordinate system, so the TriMesh world transform must be
    // the identity.
```

```
Geometry* pkGeom = StaticCast<Geometry>(m_pkObject);
pkGeom->World = Transformation::IDENTITY;
pkGeom->WorldIsCurrent = true;

// compute the skin vertex locations
assert( m_iVertexQuantity == pkGeom->Vertices->GetQuantity() );
Vector3f* akVertex = pkGeom->Vertices->GetData();
for (int i = 0; i < m_iVertexQuantity; i++)
{
    Vector3f kTmp = m_apkBones[0]->World.ApplyForward(
        m_aakOffset[i][0]);
    akVertex[i] = m_aafWeight[i][0]*kTmp;
    for (int j = 1; j < m_iBoneQuantity; j++)
    {
        kTmp = m_apkBones[j]->World.ApplyForward(
            m_aakOffset[i][j]);
        akVertex[i] += m_aafWeight[i][j]*kTmp;
    }
}

pkGeom->UpdateMS();
return true;
}
```

The assumption is that the world transformations of the bones are current. The bones affecting a skin are normally stored in a subtree of the scene hierarchy. This is particularly true when the skin is for a biped model, and the hierarchy represents the biped anatomy. In the depth-first traversal from an UpdateGS call, the bones must be visited first before its associated skin is visited. In [Ebe00] I said that the bone tree and skin should be siblings of the same parent. This is not necessary. In fact, frequently asked questions about the SkinnedBiped.mgc model (in Wild Magic version 2) were about how the biped was structured as a scene hierarchy and why was it that the skins were not stored as siblings of their bone trees. As it turns out, the biped model had its skins stored the way they were to minimize the render state changes associated with material state. The model is small enough that the material state changes are negligible. In Wild Magic version 3, I refactored the model so that the skins are siblings of their bone trees. But, of course, this is not necessary! All that matters is that the skin is visited after its bone tree in a depth-first traversal.

The skin vertices are constructed in the world coordinates of the bone tree. Any nonidentity local or world transformations stored at the TriMesh skin will cause it to be transformed out of that coordinate system, an error. The SkinController::Update function sets the skin's world transformation to be the identity. The automatic update that occurs in the Spatial class must be informed *not* to compute the world transformations. I talked about this in Section 3.2.3. The controller sets the WorldIsCurrent

Boolean flag as a message to the automatic system not to compute world transformations. Other `Controller`-derived classes might also have to pass this message.

The main task of the update routine is to compute the skin vertices for the current state of the bone tree. Equation (4.3) must be computed. You have a choice about which order to execute the double loop. Is the outside loop over the bones or over the vertices? I chose wrongly in Wild Magic version 2, not thinking about the performance issues. I had the bone loop on the outside. Some folks in the MIT Multimedia Lab, who were using Wild Magic version 2 for their Alpha Wolf AI demonstration, corrected my thinking and pointed out that my choice was thrashing the memory cache because of all the jumping around in memory the program had to do regarding vertex access. Wild Magic version 3 has the loops in the other order. If you look at the previously displayed source code, the intuition is clear. The vertex array `akVertex` has its elements accessed in order, so no jumping around in memory here. Each vertex is initialized using the bone at bone array index 0. In the inner loop, the weights and offsets are accessed repeatedly. Since the arrays are of the form `array[i][j]` and `j` is the index changing most rapidly, no jumping around in memory is occurring here either.

An optimization that I do not have in place, but that I am not in a rush to implement since a hardware-based skinning implementation should be next on the list, is to compute the forward transformation and vertex update inside the inner loop only when a weight is positive. When the weight is zero, the vertex update is the zero vector and does not affect the current vertex value.

The sample application on the companion website,

```
GeometricTools/WildMagic3/SampleGraphics/SkinnedBiped
```

illustrates the skin-and-bones controller. All the skin-and-bones data associated with the biped is stored as raw data, loaded by the application, and assembled to form the biped scene graph. The biped is also animated using keyframe controllers. This application gives you an idea of the intricacies and complexities of building an animated biped that looks good.

4.5.5 INVERSE KINEMATICS

Inverse kinematics (IK) is an intriguing topic, but a very difficult thing to implement when you have to reproduce what a modeling package produces. The algorithms that are used to determine transformations in a chain of nodes are varied, and folks really like to throw in their own hacks and variations to make the motion smooth and robust. If you have no idea what algorithm the modeling package uses, it is nearly impossible to reverse-engineer and match it. One of the main curses is the handling of joint angles by thinking of them as Euler angles. As long as there is only one degree of rotational freedom at a joint, not a problem. But when you have two or three degrees of rotational freedom at a joint, my intuition fails me on how to control the associated angles. The angles are typically specified in terms of rotations about the

coordinate axes. But once you apply that first rotation, the new coordinate axes are not the original ones. Naturally, you can choose the second angle to be relative to an axis in the new coordinate system, but if two modeling packages choose different conventions, you either have to map both somehow into your single IK controller class or you have to have multiple IK controller classes. I do not like either alternative. At any rate, I chose Wild Magic to have a single IK controller class. You make your choices, you live by the consequences.

The IK system represents a linear chain of Node objects. The system has three separate types of objects. *Joints* are represented by the class IKJoint. The class encapsulates how the transformations at a node are allowed to be updated, and it controls the updates themselves. There is a one-to-one correspondence between nodes in the chain and joints. That is, each node is viewed as a joint in the IK system. Certain nodes in the chain are required to reach one or more *goals*. These nodes are said to be *end effectors,* and the goals are *targets*. The class IKGoal encapsulates a pair consisting of an end effector and a target. The classical situation is that the root node of a chain is fixed (the shoulder of a character) and the node at the opposite end of the chain is the only end effector (the hand of a character). A goal might be for the character to grab a mug on a table. The IKGoal object pairs up the hand node (the end effector) and the mug node (the target). A node can have multiple goals: one is normally called the *primary goal*, and others are called *secondary goals*. For example, consider a chain of nodes: shoulder, elbow, hand. In attempting to have the hand grab a mug, you might notice the elbow moves in ways that appear unanatomical. A primary goal would be to attract the elbow away from the torso by requiring that node to remain close to a target positioned on the side of the elbow opposite the torso. A secondary goal might be to attract the elbow toward the floor using another target between the elbow and the floor. The final type of object is the IK controller itself, conveniently named IKController.

Figure 4.43 illustrates an IK system. Using the analogy of a biped's arm, the joint J_0 is the shoulder, the joint J_1 is the elbow, the joint J_2 is the wrist, and the joint J_3 is the hand. The goal for the hand is G_0, a target it must reach for. However, we do not want the elbow to bend backwards (a painful proposition for the character), so the goal for the elbow is G_1. The target associated with the goal is not necessarily stationary. It might be positioned based on the locations of joints J_0 and J_2 in an attempt to keep the V-shaped chain from J_0 through J_1 to J_2.

Goals

The simplest class to describe is IKGoal. Its interface is

```
class IKGoal : public Object
{
public:
    IKGoal (Spatial* pkTarget, Spatial* pkEffector, float fWeight);
```

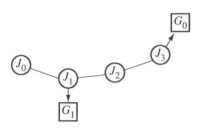

Figure 4.43 An IK system for a linear chain of four nodes.

```
    SpatialPtr GetTarget ();
    SpatialPtr GetEffector ();
    float Weight;

    Vector3f GetTargetPosition () const;
    Vector3f GetEffectorPosition () const;

protected:
    IKGoal ();

    SpatialPtr m_spkTarget;
    SpatialPtr m_spkEffector;
};
```

As mentioned previously, the class encapsulates a joint that is an end effector and a target that the end effector attempts to reach. In addition to the target and end effector, the constructor also takes a weight value that is positive. This value represents how much influence the goal should have when attempting to position the joints to reach all the targets. The function GetTargetPosition returns the world translation of the target, whereas GetEffectorPosition returns the world translation of the end effector.

Joints

The joint class is IKJoint and has the interface

```
class IKJoint : public Object
{
public:
    IKJoint (Spatial* pkObject, int iGoalQuantity, IKGoalPtr* aspkGoal);
```

```
    virtual ~IKJoint ();

    // index i is for the joint's parent's world axis[i]
    bool AllowTranslation[3];
    float MinTranslation[3];
    float MaxTranslation[3];
    bool AllowRotation[3];
    float MinRotation[3];
    float MaxRotation[3];

protected:
    // streaming
    IKJoint ();

    // support for the IK update
    friend class IKController;

    // the managed object
    Spatial* m_pkObject;

    // joint update
    Vector3f GetAxis (int i);
    void UpdateWorldSRT ();
    void UpdateWorldRT ();
    bool UpdateLocalT (int i);
    bool UpdateLocalR (int i);

    // the goals affected by this joint
    int m_iGoalQuantity;
    IKGoalPtr* m_aspkGoal;
};
```

The constructor takes as input the object whose transformations it will control. All but the last object in a chain must be Node-derived in order to have the chain links (parent-child links). The last object is not necessarily Node-derived. The clear choice for the input type is therefore Spatial. The other two input parameters form an array of goals that are affected by any translation or rotation of the joint. The update functions in IKJoint make calculations based on these goals.

Each object has up to six degrees of freedom, three for translation and three for rotation. The translational degrees of freedom are naturally the components of a translation vector,

$$\mathbf{T} = (T_x, T_y, T_z).$$

The rotational degrees of freedom are in Euler angles for rotations about the coordinate axes,

$$R = R_z(\theta_z) R_y(\theta_y) R_x(\theta_x).$$

The engine's convention is to multiply a matrix on the left of a vector, $R\mathbf{V}$, so the x-axis rotation is applied first, followed by the y-rotation, and then the z-rotation. The joints can be *constrained*. The translations are constrained by setting `MinTranslation` and `MaxTranslation` for each of the three components of translation, indexed by i with $0 \le i \le 2$. The index $i = 0$ is for T_x, the index $i = 1$ is for T_y, and the index $i = 2$ is for T_z. The default ranges are $(-\infty, +\infty)$, so any translation is allowed. The rotations are constrained by setting `MinRotation` and `MaxRotation` for each of the three angles of rotation. The index $i = 0$ is for θ_x, the index $i = 1$ is for θ_y, and the index $i = 2$ is for θ_z. The default ranges are $[-\pi, \pi]$, so any rotation is allowed. A joint need not use all its degrees of freedom. You may select which degrees of freedom you want by setting `AllowTranslation` or `AllowRotation` with the appropriate input indices.

The `IKController` that manages the joints is allowed access to the protected members by being a friend of the `IKJoint` class. This allows us not to expose the update functions in the public interface. All the control you have over a joint is through its parameters exposed via the public interface. The member function `UpdateWorldSRT` updates the world transformations for the object managed by `IKJoint`. This is the same update used in `UpdateGS` and multiplies the parent's world transformation with the object's local transformation. This particular member function is called for each joint in the IK chain (in order from parent to child, and so on) to make sure that any node used as an end effector has up-to-date world data. The member function `UpdateWorldRT` has a similar behavior, except that it does not take into account the scale. This function is called during iterations of the *cyclic coordinate descent* (CCD) algorithm that is applied to move the joints around to allow the end effectors to reach their goals. Before the update to the world translation and world rotation can be called, the local translation and rotation must be computed. This occurs through `UpdateLocalT` (local translation) and `UpdateLocalR` (local rotation), functions that are also called during the CCD algorithm. The two local transformations are at the heart of the updates. These are computed based on trying to minimize the distances between the end effectors and their targets.

In [Ebe00, Section 9.2.3, pages 352–354] I discuss list manipulators with one end effector. A joint may be rotated to meet one of three types of goals:

- Rotate to point. Rotate a joint to minimize the distance between the end effector and a point target.

- Rotate to line. Rotate a joint to minimize the distance between the end effector and a line target.

- Rotate to plane. Rotate a joint to minimize the distance between the end effector and a plane target.

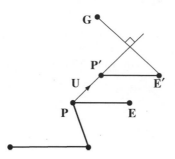

Figure 4.44 A four-node chain whose last node is the end effector **E**. The joint position **P** is to be translated in the unit-length direction **U** to minimize the distance from **E** to the goal's target **G**. The point **E**′ attains the minimum distance to the goal.

The only operation of these I support in the engine is rotate to point. A joint may be translated to meet one of three types of goals:

- Slide to point. Translate a joint to minimize the distance between the end effector and a point target.

- Slide to line. Translate a joint to minimize the distance between the end effector and a line target.

- Slide to plane. Translate a joint to minimize the distance between the end effector and a plane target.

All three of these imply that the connector between the joint and its parent joint must have varying length. Rather than thinking of physically stretching the material of the connector, think of a rod that has multiple segments that can be expanded—a radio antenna on an automobile, for example. The only operation of these I support in the engine is slide to point.

The function `UpdateLocalT` implements slide to point. A small amount of mathematics is in order to understand the source code of the function. Figure 4.44 illustrates the configuration that goes with the mathematics.

The translated joint is $\mathbf{P}' = \mathbf{P} + t\mathbf{U}$ for some t. The chain of nodes rooted at **P** is also translated by the same amount, so $\mathbf{E}' = \mathbf{E} + t\mathbf{U}$ for some t. Using the fact that $\mathbf{G} - \mathbf{E}'$ must be perpendicular to the line, we have

$$0 = \mathbf{U} \cdot (\mathbf{G} - \mathbf{E}') = \mathbf{U} \cdot (\mathbf{G} - \mathbf{E} - t\mathbf{U}) = \mathbf{U} \cdot (\mathbf{G} - \mathbf{E}) - t,$$

in which case

$$\mathbf{E}' = \mathbf{E} + (\mathbf{U} \cdot (\mathbf{G} - \mathbf{E}))\mathbf{U}.$$

For a single goal, an associated weight is irrelevant and may as well be chosen as $w = 1$.

If there are n goals, each goal having an end effector \mathbf{E}_i, a target \mathbf{G}_i, and a weight w_i, for $0 \le i < n$, the minimization of distances must occur jointly for all the goals. That is, the new positions for the end effectors, call them \mathbf{E}_i', must minimize the sum of the weighted squared distances

$$\sum_{i=0}^{n-1} w_i |\mathbf{G}_i - \mathbf{E}_i'|^2 .$$

The translation of \mathbf{P} to $\mathbf{P} + t\mathbf{U}$ is a rigid motion that can only cause the end effectors to be translated by the same amount, so $\mathbf{E}_i' = \mathbf{E}_i + t\mathbf{U}$. The sum of the weighted squared distances is a function of t,

$$F(t) = \sum_{i=0}^{n-1} w_i |\mathbf{G}_i - \mathbf{E}_i - t\mathbf{U}|^2 . \tag{4.4}$$

This is a quadratic function of t and must attain its minimum when the derivative $F'(t) = 0$. The derivative is

$$F'(t) = \sum_{i=0}^{n-1} 2w_i (\mathbf{G}_i - \mathbf{E}_i - t\mathbf{U}) \cdot (-\mathbf{U}) = 2 \left(\sum_{i=0}^{n-1} w_i \mathbf{U} \cdot (\mathbf{G}_i - \mathbf{E}_i) - t \sum_{i=0}^{n-1} w_i \right) .$$

Setting the derivative equal to zero and solving for t yields

$$t = \frac{\sum_{i=0}^{n-1} w_i \mathbf{U} \cdot (\mathbf{G}_i - \mathbf{E}_i)}{\sum_{i=0}^{n-1} w_i} . \tag{4.5}$$

The function `IKJoint::UpdateLocalT` is an implementation of the minimizer:

```
bool IKJoint::UpdateLocalT (int i)
{
    Vector3f kU = GetAxis(i);
    float fNumer = 0.0f;
    float fDenom = 0.0f;

    float fOldNorm = 0.0f;
    IKGoal* pkGoal;
    int iG;
    for (iG = 0; iG < m_iGoalQuantity; iG++)
    {
        pkGoal = m_aspkGoal[iG];
        Vector3f kGmE = pkGoal->GetTargetPosition() -
            pkGoal->GetEffectorPosition();
        fOldNorm += kGmE.SquaredLength();
```

```
        fNumer += pkGoal->Weight*kU.Dot(kGmE);
        fDenom += pkGoal->Weight;
    }

    if ( Mathf::FAbs(fDenom) <= Mathf::EPSILON )
    {
        // weights were too small, no translation
        return false;
    }

    // desired distance to translate along axis(i)
    float fT = fNumer/fDenom;

    // clamp to range
    Vector3f kTrn = m_pkObject->Local.GetTranslate();
    float fDesired = kTrn[i] + fT;
    if ( fDesired > MinTranslation[i] )
    {
        if ( fDesired < MaxTranslation[i] )
        {
            kTrn[i] = fDesired;
        }
        else
        {
            fT = MaxTranslation[i] - kTrn[i];
            kTrn[i] = MaxTranslation[i];
        }
    }
    else
    {
        fT = MinTranslation[i] - kTrn[i];
        kTrn[i] = MinTranslation[i];
    }

    // test if step should be taken
    float fNewNorm = 0.0f;
    Vector3f kStep = fT*kU;
    for (iG = 0; iG < m_iGoalQuantity; iG++)
    {
        pkGoal = m_aspkGoal[iG];
        Vector3f kNewE = pkGoal->GetEffectorPosition() + kStep;
        Vector3f kDiff = pkGoal->GetTargetPosition() - kNewE;
        fNewNorm += kDiff.SquaredLength();
    }
```

```
    if ( fNewNorm >= fOldNorm )
    {
        // translation does not get effector closer to goal
        return false;
    }

    // update the local translation
    m_pkObject->Local.SetTranslate(kTrn);
    return true;
}
```

The function `GetAxis(i)` gets the joint's parent's world axis direction for the specified index. The translations are always computed in the parent's world coordinate system, not the joint's world coordinate system, because we want to update the joint's *local transformations*. If the joint has no parent, it is the root of a scene graph. The coordinate system is the standard Euclidean one, so the axis retrieved by `GetAxis` is one of $(1, 0, 0)$, $(0, 1, 0)$, or $(0, 0, 1)$.

The first loop is over those goals that are affected by the joint's motion. This is an implementation of the formula in Equation (4.5). The sum of squared distances in Equation (4.4) is computed and stored in `fOldNorm`. After an unconstrained translation, the theory says that the sum of squared distances can only get smaller. However, a constrained translation might cause the sum to become larger. The new sum of squares is computed after the constrained translation. If larger than the old one, the translation is not allowed. If smaller, it is allowed and the local translation for the joint is modified. The `IKController` will do the work equivalent to an `UpdateGS` call to the remaining joints in the chain, thus guaranteeing that all world data is current for any future iterations of the CCD.

The function `UpdateLocalR` implements rotate to point. A small amount of mathematics is also in order to understand the source code of the function. Figure 4.45 illustrates the configuration that goes with the mathematics.

Using \mathbf{P} as the center of a rotation, the vector $\mathbf{E} - \mathbf{P}$ must be rotated by an angle θ to reach $\mathbf{E}' - \mathbf{P}$. Using a standard formula for rotation of a vector,

$$\mathbf{E}' - \mathbf{P} = (\mathbf{E} - \mathbf{P}) + (\sin\theta)\mathbf{U} \times (\mathbf{E} - \mathbf{P}) + (1 - \cos\theta)(\mathbf{U} \times (\mathbf{U} \times (\mathbf{E} - \mathbf{P}))).$$

Define $\mathbf{V} = \mathbf{U} \times (\mathbf{E} - \mathbf{P})$, $\mathbf{W} = \mathbf{U} \times \mathbf{V}$, $\sigma = \sin\theta$, and $\gamma = \cos\theta$. Then

$$\mathbf{E}' - \mathbf{P} = (\mathbf{E} - \mathbf{P}) + \sigma\mathbf{V} + \gamma\mathbf{W}.$$

We need to choose θ to minimize the squared distance between \mathbf{G} and \mathbf{E}'. The squared distance is

$$F(\theta) = |\mathbf{G} - \mathbf{E}'|^2.$$

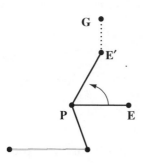

Figure 4.45 A four-node chain whose last node is the end effector **E**. The joint position **P** is to be rotated about an axis with unit-length direction **U** to minimize the distance from **E** to the goal's target **G**. For the sake of illustration, suppose that axis is out of the plane of the page. The point **E**′ attains the minimum distance to the goal.

The candidate angles to obtain the global minimum for the function occur when the first derivative is zero. The derivative is

$$F'(\theta) = -2(\mathbf{G} - \mathbf{E}') \cdot \frac{d\mathbf{E}'}{d\theta}.$$

Setting this to zero,

$$0 = (\mathbf{G} - \mathbf{E}') \cdot \frac{d\mathbf{E}'}{d\theta} = \big((\mathbf{G} - \mathbf{P}) - (\mathbf{E}' - \mathbf{P})\big) \cdot \frac{d(\mathbf{E}' - \mathbf{P})}{d\theta} = (\mathbf{G} - \mathbf{P}) \cdot \frac{d(\mathbf{E}' - \mathbf{P})}{d\theta}.$$

The last equality is true since the squared distance $|\mathbf{E}' - \mathbf{P}|^2$ is a constant for all angles θ; the vector difference represents the fixed-length connector that is rotated about **P**. The derivative of a constant is zero, so

$$0 = \frac{d}{d\theta} |\mathbf{E}' - \mathbf{P}|^2 = 2(\mathbf{E}' - \mathbf{P}) \cdot \frac{d(\mathbf{E}' - \mathbf{P})}{d\theta}.$$

Continuing the analysis of $F'(\theta) = 0$,

$$0 = (\mathbf{G} - \mathbf{P}) \cdot \frac{d(\mathbf{E}' - \mathbf{P})}{d\theta} = (\mathbf{G} - \mathbf{P}) \cdot (\gamma \mathbf{V} + \sigma \mathbf{W}) = \gamma \mathbf{V} \cdot (\mathbf{G} - \mathbf{P}) + \sigma \mathbf{W} \cdot (\mathbf{G} - \mathbf{P}).$$

This implies

$$(\sigma, \gamma) = \pm \frac{(\mathbf{V} \cdot (\mathbf{G} - \mathbf{P}), -\mathbf{W} \cdot (\mathbf{G} - \mathbf{P}))}{\sqrt{[\mathbf{V} \cdot (\mathbf{G} - \mathbf{P})]^2 + [\mathbf{W} \cdot (\mathbf{G} - \mathbf{P})]^2}}.$$

The angles whose sines and cosines satisfy this equation could produce maxima as well as minima. We have to choose whether the leading sign is positive or negative in order to obtain the minima. The second-derivative test is used for this purpose. The second derivative is

$$F''(\theta) = \sigma \left[2\mathbf{V} \cdot (\mathbf{G} - \mathbf{P}) \right] - \gamma \left[2\mathbf{W} \cdot (\mathbf{G} - \mathbf{P}) \right],$$

and we need this to be positive for a local minimum. The correct choice of sign, therefore, is positive, in which case

$$(\sigma, \gamma) = \frac{(\mathbf{V} \cdot (\mathbf{G} - \mathbf{P}), -\mathbf{W} \cdot (\mathbf{G} - \mathbf{P}))}{\sqrt{[\mathbf{V} \cdot (\mathbf{G} - \mathbf{P})]^2 + [\mathbf{W} \cdot (\mathbf{G} - \mathbf{P})]^2}},$$

and

$$F''(\theta) = 2\sqrt{[\mathbf{V} \cdot (\mathbf{G} - \mathbf{P})]^2 + [\mathbf{W} \cdot (\mathbf{G} - \mathbf{P})]^2} > 0.$$

An angle that minimizes $F(\theta)$ is

$$\theta = \operatorname{atan} 2((\mathbf{G} - \mathbf{P}) \cdot \mathbf{U} \times (\mathbf{E} - \mathbf{P}), -(\mathbf{G} - \mathbf{P}) \cdot \mathbf{U} \times (\mathbf{U} \times (\mathbf{E} - \mathbf{P}))),$$

where atan 2 is the standard mathematics library function for the inverse tangent, but returns an angle in the interval $[-\pi, \pi]$.

If there are n goals, each goal having an end effector \mathbf{E}_i, a target \mathbf{G}_i, and a weight w_i, for $0 \leq i < n$, the minimization of distances must occur jointly for all the goals. That is, the new positions for the end effectors, call them \mathbf{E}_i', satisfy the rotation conditions

$$\mathbf{E}_i' - \mathbf{P} = (\mathbf{E}_i - \mathbf{P}) + (\sin \theta)\mathbf{U} \times (\mathbf{E}_i - \mathbf{P}) + (1 - \cos \theta)(\mathbf{U} \times (\mathbf{U} \times (\mathbf{E}_i - \mathbf{P})))$$

and must minimize the sum of the weighted squared distances

$$F(\theta) = \sum_{i=0}^{n-1} w_i |\mathbf{G}_i - \mathbf{E}_i'|^2.$$

Only a single angle θ is involved since the rotation about \mathbf{P} is a rigid motion. Define $\mathbf{V}_i = \mathbf{U} \times (\mathbf{E}_i - \mathbf{P})$ and $\mathbf{W}_i = \mathbf{U} \times \mathbf{V}_i$. The definitions for σ and γ are as before. The derivative of F is computed similarly as in the case of one goal,

$$F'(\theta) = -2 \sum_{i=0}^{n-1} w_i (\mathbf{G}_i - \mathbf{P}) \cdot (\gamma \mathbf{V}_i + \sigma \mathbf{W}_i),$$

and the second derivative is

$$F''(\theta) = -2 \sum_{i=0}^{n-1} w_i (\mathbf{G}_i - \mathbf{P}) \cdot (\sigma \mathbf{V}_i - \gamma \mathbf{W}_i).$$

Setting $F'(\theta) = 0$ leads to

$$0 = \gamma \sum_{i=0}^{n-1} \mathbf{V}_i \cdot (\mathbf{G}_i - \mathbf{P}) + \sigma \sum_{i=0}^{n-1} \mathbf{W}_i \cdot (\mathbf{G}_i - \mathbf{P})$$

and has the minimizing solution

$$(\sigma, \gamma) = \frac{\left(\sum_{i=0}^{n-1} \mathbf{V}_i \cdot (\mathbf{G}_i - \mathbf{P}), -\sum_{i=0}^{n-1} \mathbf{W}_i \cdot (\mathbf{G}_i - \mathbf{P})\right)}{\sqrt{[\sum_{i=0}^{n-1} \mathbf{V}_i \cdot (\mathbf{G}_i - \mathbf{P})]^2 + [\sum_{i=0}^{n-1} \mathbf{W}_i \cdot (\mathbf{G}_i - \mathbf{P})]^2}}.$$

The choice of positive sign in front of the fraction guarantees that $F''(\theta) > 0$ so that indeed we have a minimum. An angle that minimizes F is

$$\theta = \operatorname{atan}2\left(\sum_{i=0}^{n-1}(\mathbf{G}_i - \mathbf{P}) \cdot \mathbf{U} \times (\mathbf{E}_i - \mathbf{P}), -\sum_{i=0}^{n-1}(\mathbf{G}_i - \mathbf{P}) \cdot \mathbf{U} \times (\mathbf{U} \times (\mathbf{E}_i - \mathbf{P}))\right).$$

$$(4.6)$$

The function `IKJoint::UpdateLocalR` is an implementation of the minimizer:

```
bool IKJoint::UpdateLocalR (int i)
{
    Vector3f kU = GetAxis(i);
    float fNumer = 0.0f;
    float fDenom = 0.0f;

    float fOldNorm = 0.0f;
    IKGoal* pkGoal;
    int iG;
    for (iG = 0; iG < m_iGoalQuantity; iG++)
    {
        pkGoal = m_aspkGoal[iG];
        Vector3f kEmP = pkGoal->GetEffectorPosition() -
            m_pkObject->World.GetTranslate();
        Vector3f kGmP = pkGoal->GetTargetPosition() -
            m_pkObject->World.GetTranslate();
        Vector3f kGmE = pkGoal->GetTargetPosition() -
            pkGoal->GetEffectorPosition();
        fOldNorm += kGmE.SquaredLength();
        Vector3f kUxEmP = kU.Cross(kEmP);
        Vector3f kUxUxEmP = kU.Cross(kUxEmP);
        fNumer += pkGoal->Weight*kGmP.Dot(kUxEmP);
        fDenom -= pkGoal->Weight*kGmP.Dot(kUxUxEmP);
    }
```

```
if ( fNumer*fNumer + fDenom*fDenom <= Mathf::EPSILON )
{
    // undefined atan2, no rotation
    return false;
}

// desired angle to rotate about axis(i)
float fTheta = Mathf::ATan2(fNumer,fDenom);

// factor local rotation into Euler angles
float afEuler[3];
m_pkObject->Local.Rotate().ToEulerAnglesZYX(afEuler[2],
    afEuler[1],afEuler[0]);

// clamp to range
float fDesired = afEuler[i] + fTheta;
if ( fDesired > MinRotation[i] )
{
    if ( fDesired < MaxRotation[i] )
    {
        afEuler[i] = fDesired;
    }
    else
    {
        fTheta = MaxRotation[i] - afEuler[i];
        afEuler[i] = MaxRotation[i];
    }
}
else
{
    fTheta = MinRotation[i] - afEuler[i];
    afEuler[i] = MinRotation[i];
}

// test if step should be taken
float fNewNorm = 0.0f;
Matrix3f kRot(kU,fTheta);
for (iG = 0; iG < m_iGoalQuantity; iG++)
{
    pkGoal = m_aspkGoal[iG];
    Vector3f kEmP = pkGoal->GetEffectorPosition() -
        m_pkObject->World.GetTranslate();
    Vector3f kNewE = m_pkObject->World.GetTranslate() +
        kRot*kEmP;
```

```
        Vector3f kGmE = pkGoal->GetTargetPosition() - kNewE;
        fNewNorm += kGmE.SquaredLength();
    }

    if ( fNewNorm >= fOldNorm )
    {
        // rotation does not get effector closer to goal
        return false;
    }

    // update the local rotation
    m_pkObject->Local.Rotate().FromEulerAnglesZYX(afEuler[2],
        afEuler[1],afEuler[0]);
    return true;
}
```

The structure is nearly identical to that of UpdateLocalT. The joint's parent's world coordinate system is used to select axes to rotate about. The first loop in the source code computes the arguments to the atan2 function in Equation (4.6). It is amazing, is it not, that a few lines of code are backed up by so much mathematics! The computation of fOldNorm is used to support constrained rotations. If the constraints cause an increase in the sum of squared distances (the new norm), then the rotation is rejected. Notice that the order of Euler angles in the composition of rotations is fixed. Should a modeling package do otherwise, most likely the IKJoint class should allow yet another parameter to its constructor that selects which order of composition should be used.

Controllers

The class IKController is a container for the IKJoints and IKGoals in the IK system. Its interface is

```
class IKController : public Controller
{
public:
    IKController (int iJointQuantity, IKJointPtr* aspkJoint,
        int iGoalQuantity, IKGoalPtr* aspkGoal);
    virtual ~IKController ();

    int Iterations;      // default = 128
    bool OrderEndToRoot; // default = true

    virtual bool Update (double dAppTime);
```

```
protected:
    IKController ();

    int m_iJointQuantity;
    IKJointPtr* m_aspkJoint;

    int m_iGoalQuantity;
    IKGoalPtr* m_aspkGoal;
};
```

The class assumes responsibility for the input arrays and will delete them. They should be dynamically allocated. The IKJoint objects will also have arrays of pointers to the IKGoals passed to IKController. Only those goals affected by the motion of a joint are assigned to that joint (by you in the application code).

The Update function is an implementation of the CCD algorithm. You have two ways to control the algorithm. You may choose the maximum number of iterations for a single call of Update by setting Iterations to whatever you like. The joints are processed one at a time in each iteration. You may also choose whether the joints are processed from the root joint to the end joint or in the opposite direction. The default is to work your way from the last joint toward the root, the idea being that if the last joint is an end effector and it is already near its goal (time coherency plays a role here), then most of the motion should occur near the end effector.

Before starting the CCD iterations, the Update call makes certain that all the joints' world data is up to date. This is done by

```
for (iJoint = 0; iJoint < m_iJointQuantity; iJoint++)
    m_aspkJoint[iJoint]->UpdateWorldSRT();
```

This is not your standard UpdateGS pass. One joint has a child node that is another joint, and the update applies only to that connection. The first joint might have other children, but they are not updated by UpdateWorldSRT. Is this an error? No. The IKController update is called in the Spatial::UpdateWorldData function, and all of the IKJoint objects are updated by this call. On return to the Node::UpdateWorldData that spawned the Spatial::UpdateWorldData call, any joints with other child subtrees will have those children updated.

The CCD loop for processing from end to root is

```
for (iIter = 0; iIter < Iterations; iIter++)
{
    for (iJoint = 0; iJoint < m_iJointQuantity; iJoint++)
    {
        int iRJoint = m_iJointQuantity - 1 - iJoint;
        pkJoint = m_aspkJoint[iRJoint];
```

```
for (i = 0; i < 3; i++)
{
    if ( pkJoint->AllowTranslation[i] )
    {
        if ( pkJoint->UpdateLocalT(i) )
        {
            for (j = iRJoint; j < m_iJointQuantity; j++)
                m_aspkJoint[j]->UpdateWorldRT();
        }
    }
}

for (i = 0; i < 3; i++)
{
    if ( pkJoint->AllowRotation[i] )
    {
        if ( pkJoint->UpdateLocalR(i) )
        {
            for (j = iRJoint; j < m_iJointQuantity; j++)
                m_aspkJoint[j]->UpdateWorldRT();
        }
    }
}
}
}
```

The logic is simple. For each joint, determine which translations are allowed. When one is allowed, call the minimizer function UpdateLocalT to translate the joint. If the translation does reduce the sum of squared distances between goals and end effectors, the return value of the update is true, indicating the translation was accepted. In this case, the local transformations of the joint have changed. Its successor joints in the IK chain must be notified that their world transformations need updating. This is performed by UpdateWorldRT. The same logic applies to the rotations. If a rotation is allowed and the minimizer is able to reduce the sum of squared distances, then the joint's local rotation is modified and the successors update their world transformations.

The sample application on the companion website,

GeometricTools/WildMagic3/SampleGraphics/InverseKinematics

has a simple IK system consisting of two joints, one with a single translational degree of freedom and one with a single rotational degree of freedom. Only one goal exists in the IK system.

ADVANCED RENDERING TOPICS

This chapter discusses obtaining visual effects that are considered more advanced than vertex coloring, lighting and materials, texturing, and multitexturing. The chapter consists of two sections. Section 5.1 elaborates on the Effect class that was introduced in Section 3.4.5. Wild Magic has a collection of derived classes that implement various effects obtainable through the *fixed-function pipeline*—through graphics API features that were available before the introduction of shader programming. The first section describes all these derived classes.

The topic of Section 5.2 is shader programming support in the scene graph management system. The emphasis is on the integration into the engine, not on actually writing shaders. For the latter, see [Eng02, Eng03, Fer04].

5.1 SPECIAL EFFECTS USING THE FIXED-FUNCTION PIPELINE

The effects system was introduced in Section 3.4.5 and is new to Wild Magic. The base class is Effect and has the interface

```
class Effect : public Object
{
public:
    Effect ();
    virtual ~Effect ();
```

431

```
    virtual Effect* Clone ();

    ColorRGBArrayPtr ColorRGBs;
    ColorRGBAArrayPtr ColorRGBAs;
    TArray<TexturePtr> Textures;
    TArray<Vector2fArrayPtr> UVs;

// internal use
public:
    // function required to draw the effect
    Renderer::DrawFunction Draw;
};
```

At its lowest level, this class is a container for vertex colors, whether RGB or RGBA, for texture images, and for texture coordinates. The class is not abstract, so you can create effects immediately. The renderer only allows you to have one set of colors. If you set `ColorRGBs` and `ColorRGBAs`, the renderer will use the latter set. You can have multiple textures and texture coordinates. The engine places no limit on the number, but the renderer will use only as many as the hardware supports. If your effect really does require 16 texture units, expect to be disappointed when you run your application on a card that has only 8 texture units. If you do supply multiple textures, the semantics of how the units combine together to produce a desired multitexture effect are up to you. Your control over this is through the combine mode of the `Texture` class (see Section 3.4.4).

The `Clone` function exists to create a new effect of the same class type, but shares vertex colors and textures. Each class derived from `Effect` can override this behavior and decide what is copied and what is shared. The reason for such a function originated with the `Particles` class. An `Effect`-derived object attached to a `Particles` object can only influence the particle's point locations. The rendering system displays particles by automatically generating four times the number of vertices as points and then quadruplicating the vertex attributes associated with the particles' points. A second `Effect` object had to be created and attached to the `TriMesh` that gets sent to the renderer for drawing. Since the effects are stored polymorphically through the `Effect` base class, I needed a virtual function in the `Effect` class to give me a copy of one effect, but of the same class type as the original effect. I can imagine other circumstances where you need similar cloning behavior.

Although you can manage your own `Effect` object, you will find it more convenient to derive a class that encapsulates the semantics you desire. Some advanced features require more than just combining vertex colors and texture images. For example, environment mapping, bump mapping, and projected texturing all have special needs that require explicit low-level rendering code to be written that is different than the `DrawPrimitive` call provides. If you derive from `Effect` and have to implement a `Renderer`-derived class drawing function to go with it, you can conveniently store a pointer to that function in the data member `Draw`. Some of the effects already

in the engine have no need for specialized drawing, so their `Draw` members are set to `DrawPrimitive`. In fact, the base class `Effect` sets its `Draw` member to `DrawPrimitive` by default.

This section contains a description of each of the `Effect`-derived classes that I have added to Wild Magic. This is by no means a comprehensive coverage of all the special effects you would ever need in an application, but it should suffice to show you how to write your own.

5.1.1 VERTEX COLORING

The simplest effect is one that just stores vertex colors. The class is `VertexColorEffect` and has the interface

```
class VertexColorEffect : public Effect
{
public:
    VertexColorEffect (ColorRGBArray* pkColorRGBs);
    VertexColorEffect (ColorRGBAArray* pkColorRGBAs);
    virtual ~VertexColorEffect ();

    virtual Effect* Clone ();

protected:
    VertexColorEffect ();
};
```

You can construct an effect using either an array of RGB colors or an array of RGBA colors. The `Clone` function creates an effect that shares the current object's vertex color array.

A sample use is

```
// create a tetrahedron
int iVQuantity = 4;
Vector3f* akVertex = new Vector3f[iVQuantity];
akVertex[0] = Vector3f(0.0f,0.0f,0.0f);
akVertex[1] = Vector3f(1.0f,0.0f,0.0f);
akVertex[2] = Vector3f(0.0f,1.0f,0.0f);
akVertex[3] = Vector3f(0.0f,0.0f,1.0f);
Vector3fArray* pkVertices = new Vector3fArray(iVQuantity,akVertex);

int iIQuantity = 12;  // 4 triangles
int* aiIndex = new int[iIQuantity];
aiIndex[ 0] = 0; aiIndex[ 1] = 1; aiIndex[ 2] = 3;
```

```
aiIndex[ 3] = 0; aiIndex[ 4] = 3; aiIndex[ 5] = 2;
aiIndex[ 6] = 0; aiIndex[ 7] = 2; aiIndex[ 8] = 1;
aiIndex[ 9] = 1; aiIndex[10] = 2; aiIndex[11] = 3;
IntArray* pkIndices = new IntArray(iIQuantity,aiIndex);

TriMesh* pkTetra = new TriMesh(pkVertices,pkIndices,false);

// create a vertex color effect
ColorRGB* akColor = new ColorRGB[iVQuantity];
akColor[0] = ColorRGB(0.0f,0.0f,1.0f);
akColor[1] = ColorRGB(0.0f,1.0f,0.0f);
akColor[2] = ColorRGB(1.0f,0.0f,0.0f);
akColor[3] = ColorRGB(0.0f,0.0f,0.0f);
ColorRGBArray* pkColors = new ColorRGBArray(iVQuantity,akColor);

VertexColorEffect* pkEffect = new VertexColorEffect(pkColors);
pkTetra->SetEffect(pkEffect);
```

The tetrahedron is built from scratch. The class StandardMesh hides the construction details for some types of objects. For example,

```
TriMesh* pkTetra = StandardMesh().Tetrahedron();
int iVQuantity = pkTetra->Vertices.GetQuantity();
ColorRGB* akColor = new ColorRGB[iVQuantity];
akColor[0] = ColorRGB(0.0f,0.0f,1.0f);
akColor[1] = ColorRGB(0.0f,1.0f,0.0f);
akColor[2] = ColorRGB(1.0f,0.0f,0.0f);
akColor[3] = ColorRGB(0.0f,0.0f,0.0f);
ColorRGBArray* pkColors = new ColorRGBArray(iVQuantity,akColor);
VertexColorEffect* pkEffect = new VertexColorEffect(pkColors);
pkTetra->SetEffect(pkEffect);
```

5.1.2 SINGLE TEXTURES

To attach a single texture to an object, use the class TextureEffect. Its interface is

```
class TextureEffect : public Effect
{
public:
    TextureEffect (Texture* pkTexture, Vector2fArray* pkUVs);
    virtual ~TextureEffect ();

    virtual Effect* Clone ();
```

```
protected:
    TextureEffect ();
};
```

The choice of parameters for the Texture object is up to you. The defaults give you replacement mode. You must also provide the texture coordinates. The number of elements of the array should match the number of vertices for the object to which the effect will be attached. The Clone member creates another TextureEffect that shares the texture object and texture coordinates of the original object.

A sample use is

```
// create a rectangle in the xy-plane
int iVQuantity = 4;
Vector3f* akVertex = new Vector3f[iVQuantity];
akVertex[0] = Vector3f(0.0f,0.0f,0.0f);
akVertex[1] = Vector3f(1.0f,0.0f,0.0f);
akVertex[2] = Vector3f(1.0f,1.0f,0.0f);
akVertex[3] = Vector3f(0.0f,1.0f,0.0f);
Vector3fArray* pkVertices = new Vector3fArray(iVQuantity,akVertex);

int iIQuantity = 6;  // 2 triangles
int* aiIndex = new int[iIQuantity];
aiIndex[ 0] = 0; aiIndex[ 1] = 1; aiIndex[ 2] = 2;
aiIndex[ 3] = 0; aiIndex[ 4] = 2; aiIndex[ 5] = 3;
IntArray* pkIndices = new IntArray(iIQuantity,aiIndex);

TriMesh* pkRect = new TriMesh(pkVertices,pkIndices,false);

// create texture coordinates
Vector2f* akUV = new Vector2f[iVQuantity];
akUV[0] = Vector2f(0.0f,0.0f);
akUV[1] = Vector2f(0.2f,0.0f);
akUV[2] = Vector2f(0.2f,0.2f);
akUV[3] = Vector2f(0.0f,0.2f);
Vector2fArray* pkUVs = new Vector2fArray(iVQuantity,akUV);

// create a texture, repeated pattern, trilinear mipmapping
Texture* pkTexture = new Texture;
pkTexture->CoordU = Texture::WM_REPEAT;
pkTexture->CoordV = Texture::WM_REPEAT;
pkTexture->Mipmap = Texture::MM_LINEAR_LINEAR;

// create a texture effect
TextureEffect* pkEffect = new TextureEffect(pkTexture,pkUVs);
pkRect->SetEffect(pkEffect);
```

5.1.3 DARK MAPS

A *dark map* is a multitexturing scheme whereby you draw a base texture and then modulate it by a texture that represents some lighting in the scene, giving the appearance that the object is affected by some lights. Why not call this a *light map*? The modulation is a multiplication of the two texture images. Since the normalized color channels are in the interval [0, 1], the product of two color channel values is a number smaller than both of the inputs (when neither input is 1). The result is that the final colors appear to be darker than the inputs.

The class representing the process is DarkMapEffect and has the interface

```
class DarkMapEffect : public Effect
{
public:
    DarkMapEffect (Texture* pkPrimaryTexture,
        Vector2fArray* pkPrimaryUVs, Texture* pkSecondaryTexture,
        Vector2fArray* pkSecondaryUVs);
    virtual ~DarkMapEffect ();

    virtual Effect* Clone ();

protected:
    DarkMapEffect ();
};
```

The constructor takes as input two texture objects and two sets of texture coordinates. The primary texture refers to the base texture. The secondary texture refers to the image that represents the (fake) lighting. The application mode for the primary texture is Texture::AM_REPLACE. This is automatic; you do not need to do this explicitly with the input pkPrimaryTexture. The application mode for the secondary texture is Texture::AM_MODULATE and is also set automatically for you. The two modes together tell the renderer to multiply the secondary colors with the primary colors to produce the final colors on the object to which the effect is attached. The Clone function creates a new dark map object that shares the textures and texture coordinates of the original object.

The use of this class is similar to TextureEffect, except that you have to create two texture objects and two sets of texture coordinates. A sample application showing off dark maps is on the companion website in the directory

```
GeometricTools/WildMagic3/SampleGraphics/Multitexture
```

The application shows the primary texture (a wooden door image), the secondary texture (a Gaussian blob), the dark map, and a light map (see the next section and Figure 5.1).

5.1.4 LIGHT MAPS

In the previous section on dark maps, I asked why they are not called "light maps." The answer had to do with the modulation of colors. A light map may be thought of instead as the combination of a primary texture and a secondary texture using addition of colors rather than multiplication. The sum of two color channels can only make the result brighter than the inputs.

The class encapsulating this concept is `LightMapEffect` and has the interface

```
class LightMapEffect : public Effect
{
public:
    LightMapEffect (Texture* pkPrimaryTexture,
        Vector2fArray* pkPrimaryUVs, Texture* pkSecondaryTexture,
        Vector2fArray* pkSecondaryUVs, bool bHardAdd = true);
    virtual ~LightMapEffect ();

    virtual Effect* Clone ();

protected:
    LightMapEffect ();
};
```

The structure of the class is nearly identical to that of `DarkMap`, but with two exceptions, one minor and one major. The minor exception is that the secondary texture has an application mode of `Texture::AM_ADD`. This tells the renderer to add the secondary texture to the primary one. In many cases, the addition causes a washed-out look, as if the lights are too bright. The constructor to `LightMap` has a Boolean parameter that allows you to use a different mode for light maps. The addition is referred to as *hard addition*. If you set the Boolean parameter to `false`, you get what is called *soft addition*. I already talked about obtaining this effect through alpha blending in Section 3.4.1 using the interpolation equation (3.7).

Figure 5.1 is a comparison of the two effects. You can see that the light map using hard addition has a washed-out effect at the center of the image. The light map using soft addition has a more subtle appearance.

5.1.5 GLOSS MAPS

A *gloss map* is a texture that is used to modulate the specular lighting on a surface. This gives the surface a shininess in some places, as if those places reflect more specular light than other places. The class that encapsulates this effect is `GlossMapEffect` and has the interface

Figure 5.1 Multitexturing to obtain dark maps and light maps. Upper left: Primary texture is a
wooden image. Upper right: Secondary texture to combine with the primary texture.
Lower left: A dark map. Lower middle: A light map using hard addition. Lower right:
A light map using soft addition. (See also Color Plate 5.1.)

```
class GlossMapEffect : public Effect
{
public:
    GlossMapEffect (Texture* pkTexture, Vector2fArray* pkUVs);
    virtual ~GlossMapEffect ();

    virtual Effect* Clone ();

protected:
    GlossMapEffect ();
};
```

The interface is not very interesting. The texture to be used for modulating the specular lighting is passed to the constructor. The texture coordinates are also passed. The Clone function creates a new object that shares the texture and texture coordinates of the old one.

So how do we actually get the effect of glossiness? This `Effect`-derived class is our first example for which a specific rendering function has been added to the system. The base class interface is

```
class Renderer
{
// internal use
public:
    virtual void DrawGlossMap () = 0;
};
```

The function is pure virtual, so any `Renderer`-derived class must implement it. The declaration is in a public section tagged for internal use only. This allows the `GlossMapEffect` class to assign the virtual function pointer to the `Draw` member of the base class `Effect`. The constructor of `GlossMapEffect` is

```
GlossMapEffect::GlossMapEffect (Texture* pkTexture,
    Vector2fArray* pkUVs)
{
    Draw = &Renderer::DrawGlossMap;
    pkTexture->Apply = Texture::AM_MODULATE;
    Textures.Append(pkTexture);
    UVs.Append(pkUVs);
}
```

The first line is the function pointer assignment. The second line shows that the application mode for the texture is modulation. This is the case because we will be modulating the specular lighting.

The effect is a local one, so you can only attach a `GlossMapEffect` object to a `Geometry`-derived object. Gloss mapping is implemented using a multipass process. The first pass involves drawing only material colors, but no textures. That means you need a `MaterialState` global state attached either to the `Geometry` object itself or to a predecessor in the scene. You also need a `Light` attached that will cause the material properties to be rendered. The renderer will only use specular lighting.

The second pass lights the object with ambient and diffuse colors, and the results are blended with the texture. Although you do not need to attach an `AlphaState` object to the scene, if you were required to do so, you would set the `SrcBlend` member to `AlphaState::SBF_ONE` and the `DstBlend` member to `AlphaState::SBF_SRC_ALPHA`. The blending equation is

$$(r_d, g_d, b_d, a_d) \leftarrow (r_s, g_s, b_s, a_s) + a_s(r_d, g_d, b_d, a_d).$$

That is, the current color in the frame buffer (the destination, the colors subscripted with d) is modulated by the alpha channel of the texture (the source, the colors subscripted with s) and then added to the texture colors. The idea is that any texture

image value with an alpha of one will appear to be specular, but texture image values of zero will not. The recommendation is that your alpha channel in the texture have only values of zero or one.

A sample application illustrating gloss maps is on the companion website in the directory

```
GeometricTools/WildMagic3/SampleGraphics/GlossMaps
```

The application has two squares that can be rotated simultaneously. A directional light and a material are attached to the scene, thus affecting both squares. One square has no effects attached to it and is only lit using the material colors. The other square has a gloss map attached to it. The texture image has all white RGB values, but the alpha values are zero in the background and one on the pixels that lie in a text string "Magic". As you rotate the squares, you see that the first square has a certain specular color to it. The second square has the same color but only in the region covered by the text string, giving it a glossy look. Figure 5.2 shows a couple of snapshots of the squares. The up axis has the direction $(0, 1, 0)$. The light is directional with direction $(0, -1, 0)$. When the squares are rotated to fully face the camera, both squares become completely black since the light no longer influences the visible surfaces.

5.1.6 BUMP MAPS

The classical lighting model for triangle meshes involves normal vectors specified only at the mesh vertices. The lights, materials, and vertex normals are combined to form colors at the vertices that are then interpolated across the triangle during rasterization. Unfortunately, this process does not allow for subtle variations in lighting within the triangle. To remedy this, you can use *bump mapping*. The idea is to simulate a surface patch by assigning to a mesh triangle a collection of surface normal vectors at points inside the triangle. Any lighting that can use these normals should give the planar triangle the appearance that it has variation like a surface. The problem, though, is you can only specify vertex normals.

Graphics APIs and hardware support this concept by allowing you to specify surface normals using a texture image, called the *normal map*. Normal vectors (n_x, n_y, n_z) have components in the interval $[-1, 1]$, which can be mapped to intervals $[0, 1]$. Once in this format, the three components are stored as the RGB channels in the texture image.

Given a surface position, a surface normal, and a light, we can compute the color due to lighting at the surface position using the same model of lighting that is applied to vertices in a triangle mesh. Just as the renderer has to interpolate vertex colors to fill in the pixel colors in the rasterized triangle, so must the renderer interpolate to fill in the pixel colors at points not exactly corresponding to a texel in the normal map. If all we have is a single light, we need to generate light vectors at those same surface

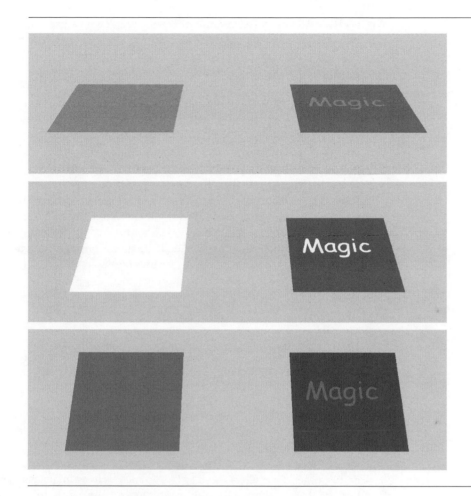

Figure 5.2 Three different rotations of the squares. The left square has lighting only via a material. The right square has a gloss map attached to it.

positions in order to compute the final color. The components of these light vectors may be mapped to the interval [0, 1], just as the normal components were. The graphics system will compute the dot product of surface normals and light directions as a multiplication of the RGB values corresponding to those vectors, producing what looks like diffuse lighting. The result of this can then be blended with the texture map that is assigned to the surface, thus giving you a finely detailed and lit surface. This process is referred to as *dot3 bump mapping*.

To generate a light vector at each point on the surface, we will generate a light vector at each triangle mesh vertex, map it to an RGB value and store it in a vertex color

array, and let the rasterizer interpolate the vertex colors in the usual manner. To have the light vector vary smoothly from vertex to vertex, we need to have a parameterization of the surface and transform the light vector into the coordinates relative to the parameterization. However, the triangle mesh was most certainly generated without such a coordinate system in mind. Well, maybe it was. The texture coordinates themselves may be thought of as inducing a parameterization of the surface. Each point (x, y, z) has a texture coordinate (u, v), so you may think of the surface parametrically as $(x(u, v), y(u, v), z(u, v))$. Now we do not actually know the functions for the components. All we know are sample values at the vertices. The application should provide vertex normals, either manually or through the automatic generation mechanism the engine provides. If we can estimate one tangent vector at the vertex, the other tangent vector is a cross product of the first tangent and the normal. Thus, the problem of generating a coordinate system reduces to estimating a tangent vector at a vertex, assuming that the surface is parameterized by the texture coordinates.

This brings us to a little more mathematics. Consider a triangle with vertices \mathbf{P}_0, \mathbf{P}_1, and \mathbf{P}_2 and with corresponding texture coordinates (u_0, v_0), (u_1, v_1), and (u_2, v_2). Any point on the triangle may be represented as

$$\mathbf{P}(s, t) = \mathbf{P}_0 + s(\mathbf{P}_1 - \mathbf{P}_0) + t(\mathbf{P}_2 - \mathbf{P}_0),$$

where $s \geq 0, t \geq 0$, and $s + t \leq 1$. The texture coordinate corresponding to this point is similarly represented as

$$(u, v) = (u_0, v_0) + s((u_1, v_1) - (u_0, v_0)) + t((u_2, v_2) - (u_0, v_0))$$

$$= (u_0, v_0) + s(u_1 - u_0, v_1 - v_0) + t(u_2 - u_0, v_2 - v_0).$$

Abstractly we have a surface defined by $\mathbf{P}(s, t)$, where s and t depend implicitly on two other parameters u and v. The problem is to estimate a tangent vector relative to u or v. We will estimate with respect to u, a process that involves computing the rate of change of \mathbf{P} as u varies, namely, the partial derivative $\partial \mathbf{P}/\partial u$. Using the chain rule from calculus,

$$\frac{\partial \mathbf{P}}{\partial u} = \frac{\partial \mathbf{P}}{\partial s}\frac{\partial s}{\partial u} + \frac{\partial \mathbf{P}}{\partial t}\frac{\partial t}{\partial u} = (\mathbf{P}_1 - \mathbf{P}_0)\frac{\partial s}{\partial u} + (\mathbf{P}_2 - \mathbf{P}_0)\frac{\partial t}{\partial u}.$$

Now we need to compute the partial derivatives of s and t with respect to u. The equation that relates s and t to u and v is written as a system of two linear equations in two unknowns:

$$\begin{bmatrix} u_1 - u_0 & u_2 - u_0 \\ v_1 - v_0 & v_2 - v_0 \end{bmatrix} \begin{bmatrix} s \\ t \end{bmatrix} = \begin{bmatrix} u - u_0 \\ v - v_0 \end{bmatrix}.$$

Inverting this leads to

$$\begin{bmatrix} s \\ t \end{bmatrix} = \frac{\begin{bmatrix} v_2 - v_0 & -(u_2 - u_0) \\ -(v_1 - v_0) & u_1 - u_0 \end{bmatrix} \begin{bmatrix} u - u_0 \\ v - v_0 \end{bmatrix}}{(u_1 - u_0)(v_2 - v_0) - (u_2 - u_0)(v_1 - v_0)}.$$

Computing the partial derivative with respect to u produces

$$\begin{bmatrix} \partial s / \partial u \\ \partial t / \partial u \end{bmatrix} = \frac{\begin{bmatrix} v_2 - v_0 & -(u_2 - u_0) \\ -(v_1 - v_0) & u_1 - u_0 \end{bmatrix} \begin{bmatrix} 1 \\ 0 \end{bmatrix}}{(u_1 - u_0)(v_2 - v_0) - (u_2 - u_0)(v_1 - v_0)}$$

$$= \frac{\begin{bmatrix} v_2 - v_0 \\ -(v_1 - v_0) \end{bmatrix}}{(u_1 - u_0)(v_2 - v_0) - (u_2 - u_0)(v_1 - v_0)}.$$

Combining this into the partial derivative for **P**, we have

$$\frac{\partial \mathbf{P}}{\partial u} = \frac{(v_2 - v_0)(\mathbf{P}_1 - \mathbf{P}_0) - (v_1 - v_0)(\mathbf{P}_2 - \mathbf{P}_0)}{(u_1 - u_0)(v_2 - v_0) - (u_2 - u_0)(v_1 - v_0)}$$

$$= \frac{(v_1 - v_0)(\mathbf{P}_2 - \mathbf{P}_0) - (v_2 - v_0)(\mathbf{P}_1 - \mathbf{P}_0)}{(v_1 - v_0)(u_2 - u_0) - (v_2 - v_0)(u_1 - u_0)}, \tag{5.1}$$

which is an estimate of a vertex tangent vector. If the vertex normal is named **N** and the normalized tangent in Equation (5.1) is named **T**, then the other tangent vector is named $\mathbf{B} = \mathbf{N} \times \mathbf{T}$. Unfortunately, the second tangent has been called the *binormal vector*. This term usually applies to curves (the Frenet frame), but the name is not generally used for surfaces (the Darboux frame).

Given a primary texture for the mesh, the surface normals in a normal map, and a light, we can compute the light vectors and store them in a vertex color array. All of this data is sent to the renderer and, assuming the graphics API has support for dot3 bump mapping, combined in the right way to obtain the special effect. The class that encapsulates this, BumpMapEffect, has the interface

```
class BumpMapEffect : public Effect
{
public:
    BumpMapEffect (Image* pkPrimary, Vector2fArray* pkPrimaryUVs,
        Image* pkNormalMap, Vector2fArray* pkNormalUVs,
        Light* pkLight);
    virtual ~BumpMapEffect ();

    virtual Effect* Clone ();
```

```
    Light* GetLight () const;

protected:
    BumpMapEffect ();

    LightPtr m_spkLight;

// internal use
public:
    void ComputeLightVectors (Geometry* pkMesh);
};
```

This effect represents another multipass process that has a specific renderer function associated with it, namely,

```
class Renderer
{
// internal use
public:
    virtual void DrawBumpMap () = 0;
};
```

The function is pure virtual, so any Renderer-derived class must implement it. The declaration is in a public section tagged for internal use only. This allows the BumpMapEffect class to assign the virtual function pointer to the Draw member of the base class Effect when constructing an object. As with GlossMapEffect, the BumpMapEffect may be attached only to a Geometry-derived object. The Clone function creates a new object that shares the light.

The image for the primary texture is passed to the constructor, along with the corresponding texture coordinates. The constructor creates the Texture object itself and sets the application mode to Texture::AM_REPLACE. The normal map and its corresponding texture coordinates are also passed to the constructor. The construction of the Texture object is

```
pkTexture = new Texture;
pkTexture->SetImage(pkNormalMap);
pkTexture->Apply = Texture::AM_COMBINE;
pkTexture->Filter = Texture::FM_LINEAR;
pkTexture->Mipmap = Texture::MM_LINEAR;
pkTexture->CombineFuncRGB = Texture::ACF_DOT3_RGB;
pkTexture->CombineSrc0RGB = Texture::ACS_TEXTURE;
pkTexture->CombineOp0RGB = Texture::ACO_SRC_COLOR;
pkTexture->CombineSrc1RGB = Texture::ACS_PRIMARY_COLOR;
pkTexture->CombineOp1RGB = Texture::ACO_SRC_COLOR;
```

The `Texture::AM_COMBINE` mode is used with a special combination function for dot3 bump mapping. The graphics API on the back end must support this function.

Finally, a light is passed to the constructor. Based on the light's position and orientation in the model space of the triangle mesh, the light vectors are computed at the mesh vertices using the vertex normals and the estimate of the vertex tangents. This work is done on the CPU, not the GPU, and is implemented in `ComputeLightVectors`. Notice that the input to this function is the actual `Geometry` object—something the effect knows nothing about. Not to worry. The renderer is given both the object and the effect, so the `DrawBumpMap` implementation will call `ComputeLightVectors` and pass it the mesh.

The implementation of `ComputeLightVectors` is long, but at a high level is not too complicated. I will not reproduce the code here in the text—you can find it on the companion website. The first part of the code computes a light vector for the light object. The light vector is the direction for a directional light. For a point or spot light, the light vector is the difference between the light position and the world translation vector for the triangle mesh, then used for *all* vertices. You could compute the light vector for each vertex by computing the world location for the vertex (the geometry object stores vertices in model space) and then subtracting it from the light's position. This can consume enough CPU cycles that the hack of using a single vector is probably justified for most settings. If it is not, feel free to modify the code. The light vector is then transformed to the model space of the triangle mesh.

The second part of the code iterates through the triangles of the mesh and attempts to compute the tangent **T** obtained from Equation (5.1). All three vertices of a triangle are processed, but the RGB representation of the light vector at the vertex is computed only once for a vertex. The color black is used as a flag to indicate that the vertex has not yet been visited, in which case its RGB value is computed. The code for tangent calculation is quite lengthy, but is designed to avoid numerical problems when triangles in the mesh are nearly degenerate (triangle slivers). The last chunk of code in the loop maps the light vector components to [0, 255] and stores them in the vertex color array.

A sample application illustrating bump maps is on the companion website in the directory

```
GeometricTools/WildMagic3/SampleGraphics/BumpMaps
```

The application has a single square with a sunfire texture and the text string "alpha". The normal map was computed using finite differences of a monochrome image of the text string. Figure 5.3 shows a snapshot of the square.

You can rotate the square in the application. If you rotate it so that the square is almost edge on to the view direction, you will see that the illusion of embossed text goes away.

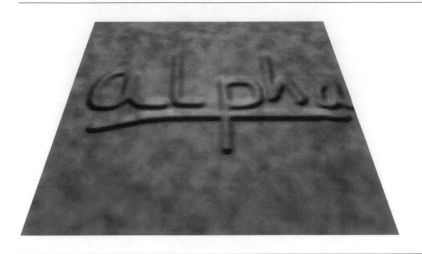

Figure 5.3 Illustration of dot3 bump mapping. (See also Color Plate 5.3.)

Figure 5.4 The mapping of a texture coordinate to a point on an object.

5.1.7 ENVIRONMENT MAPS

An *environment map* is a texture drawn on a surface that gives the appearance of the surface reflecting the environment around it. We need to assign texture coordinates to the geometric object to which the environment map is attached. These depend on the eye point's location and the object's location and orientation. Figure 5.4 illustrates how a texture coordinate is assigned to a point on the surface.

The point on the surface is **P**, the unit-length surface normal is **N**, the eye point is located at **E**, the direction of view to the point is **V**, the reflection of the view direction through the surface normal is **R**, and the texture coordinate assigned to the surface points is (u, v). The view direction is calculated as

$$\mathbf{V} = \frac{\mathbf{P} - \mathbf{E}}{|\mathbf{P} - \mathbf{E}|},$$

and the reflection vector is

$$\mathbf{R} = \mathbf{V} - 2(\mathbf{N} \cdot \mathbf{V})\mathbf{N}(R_x, R_y, R_z) = (\cos\theta\,\sin\phi,\ \sin\theta\,\sin\phi,\ \cos\phi),$$

where the last equation is the representation of the vector in spherical coordinates with $\theta \in [0, 2\pi)$ and $\phi \in [0, \pi]$. The texture coordinates are $u = \theta/(2\pi)$ and $v = \phi/\pi$, so

$$u = \begin{cases} \frac{1}{2\pi}\,\text{atan}\,2(R_y, R_x), & R_x \geq 0 \\ 1 + \frac{1}{2\pi}\,\text{atan}\,2(R_y, R_x), & R_x < 0 \end{cases} \quad \text{and} \quad v = \frac{1}{\pi}\,\text{acos}(R_z).$$

In practice, the texture coordinates are computed only for the vertices of a triangle mesh.

The mapping of a texture map, a planar entity, onto a curved surface can lead to distortion. Also, if the texture is required to wrap around a cylindrically or spherically shaped surface, the texture seams can be visible. Variations on environment mapping have been developed to circumvent these problems. The most popular one currently appears to be *cubic environment mapping*, where the target surface is a cube instead of a sphere. In Wild Magic, I currently only have support for *sphere mapping*, where the texture image itself is defined on a sphere and then mapped (with distortion) to a planar image.

The class that encapsulates spherical environment mapping is `EnvironmentMapEffect` and has the interface

```
class EnvironmentMapEffect : public Effect
{
public:
    EnvironmentMapEffect (Image* pkImage, int iApplyMode);
    virtual ~EnvironmentMapEffect ();

    virtual Effect* Clone ();

protected:
    EnvironmentMapEffect ();
};
```

The first input to the constructor is the texture image to be used as the environment map. Because the texture coordinates vary with the location of the eye point and the location and orientation of the surface, you are not required to pass to the constructor an array of texture coordinates. Most graphics APIs provide support for automatically calculating texture coordinates associated with sphere mapping, so I take advantage of this. The application mode is usually `Texture::AM_REPLACE`, but it can be other modes that allow you to include multitexturing with the environment map and other texture images. The `Clone` function creates a new object that shares the texture image and copies the application mode of the current object.

The constructor is

```
EnvironmentMapEffect::EnvironmentMapEffect (Image* pkImage,
    int iApplyMode)
{
    Draw = &Renderer::DrawEnvironmentMap;

    Texture* pkTexture = new Texture;
    pkTexture->SetImage(pkImage);
    pkTexture->Apply = iApplyMode;
    pkTexture->Filter = Texture::FM_LINEAR;
    pkTexture->Mipmap = Texture::MM_NEAREST;
    pkTexture->Texgen = Texture::TG_ENVIRONMENT_MAP;
    Textures.Append(pkTexture);
    UVs.Append(NULL);
}
```

The filtering mode is bilinear, and no mipmapping is enabled. You can change these, of course, after you construct an `EnvironmentMapEffect` object. This is the first example we have encountered where the `Texgen` data member of the `Texture` object is assigned a value. The value will tell the renderer that the texture is an environment map and needs to have its texture coordinates automatically generated. Consequently, we do not need to give the renderer an array of texture coordinates.

The effect is yet another that has a specially written renderer drawing function. In fact, this effect is the first one that is a *global effect*. Because you are not restricted to attaching the effect to a `Geometry` object, you can attach an `EnvironmentMapEffect` object to a `Node` object in the scene. The OpenGL version of the drawing function is

```
void OpenGLRenderer::DrawEnvironmentMap ()
{
    // Access the special effect.  Detach it from the node to
    // allow the effectless node drawing.
    assert( DynamicCast<EnvironmentMapEffect>(m_pkGlobalEffect) );
    EnvironmentMapEffectPtr spkEMEffect =
        (EnvironmentMapEffect*)m_pkGlobalEffect;
    m_pkNode->SetEffect(NULL);

    // Draw the Node tree.  Any Geometry objects with textures
    // will have the environment map as an additional one, drawn
    // after the others according to the apply mode stored by the
    // environment map.
    m_pkNode->Draw(*this);
```

```
    // reattach the effect
    m_pkNode->SetEffect(spkEMEffect);
}
```

The node at which the `EnvironmentMapEffect` object is attached generates the function call to `DrawEnvironmentMap`. The node's effect is temporarily stored, and then the node's effect pointer is set to `NULL`. This allows the node drawing code to be reentrant, not causing yet another call to `DrawEnvironmentMap`. See Section 3.5.6 for all the details of multipass operations at nodes. The node is told to draw itself. Once done, the `EnvironmentMapEffect` object is reattached to the node.

The setup of the graphics API to generate the texture coordinates is implemented in the virtual function `EnableTexture`. The specific details depend on the graphics API. For example, in the OpenGL renderer version, the enabling and disabling code is

```
// in EnableTexture(...)
glEnable(GL_TEXTURE_GEN_S);
glEnable(GL_TEXTURE_GEN_T);
glTexGeni(GL_S,GL_TEXTURE_GEN_MODE,GL_SPHERE_MAP);
glTexGeni(GL_T,GL_TEXTURE_GEN_MODE,GL_SPHERE_MAP);

// in DisableTexture(...)
glDisable(GL_TEXTURE_GEN_S);
glDisable(GL_TEXTURE_GEN_T);
```

Because the global effect occurs at an interior node, the `UpdateRS` call will place its texture object at the end of the array of the textures stored in the leaf geometry objects. Once the local effect textures are drawn on the geometry object, the global effect texture is blended with them. This is where the application mode passed to the constructor of `EnvironmentMapEffect` comes into play. If you set the mode to `Texture::AM_REPLACE`, any previous textures drawn to the geometry object are overwritten. More interesting effects occur when you use a different application mode. The sample application on the companion website in the directory

```
GeometricTools/WildMagic3/SampleGraphics/EnvironmentMaps
```

illustrates these effects. A mesh representing a face is loaded and has a sunfire texture attached to it as a `TextureEffect` object. The mesh is the child of a node in the scene. That node has an environment map attached to it as an `EnvironmentMapEffect` object. The face is initially displayed with replacement mode for the environment map, so you do not see the sunfire texture. You can press the plus key to toggle among various application modes. Figure 5.5 shows the results.

Figure 5.5 Screen shots from the environment map sample application. Top left: Replacement mode. Top right: Modulation mode. Bottom left: Blend mode. Bottom right: Add mode. (See also Color Plate 5.5.)

5.1.8 PROJECTED TEXTURES

A *projected texture* is a texture that is applied to an object as if it were projected from a light source onto the object. You may think of this as the model of a motion picture projection system that casts an image on a screen. Another realistic example is light passing through a stained-glass window and tinting the objects in a room. The class that encapsulates this effect is ProjectedTextureEffect.

The interface of ProjectedTextureEffect is

```
class ProjectedTextureEffect : public Effect
{
public:
    ProjectedTextureEffect (Image* pkImage, Camera* pkCamera,
        int iApplyMode);
    virtual ~ProjectedTextureEffect ();

    virtual Effect* Clone ();

    Camera* GetCamera () const;

protected:
    ProjectedTextureEffect ();

    CameraPtr m_spkCamera;
};
```

The first input to the constructor is the image for the projected texture. The second input is a camera whose eye point defines the projector location and whose frustum parameters determine how the image is projected onto objects. The application mode is the third parameter and specifies how the projected texture should be combined with any previous textures drawn on the object. The Clone function creates a new object and shares the image and camera of the current object.

The constructor is

```
ProjectedTextureEffect::ProjectedTextureEffect (Image* pkImage,
    Camera* pkCamera, int iApplyMode)
    :
    m_spkCamera(pkCamera)
{
    Draw = &Renderer::DrawProjectedTexture;

    Texture* pkTexture = new Texture;
    pkTexture->SetImage(pkImage);
    pkTexture->Apply = iApplyMode;
```

```
    pkTexture->Filter = Texture::FM_LINEAR;
    pkTexture->Mipmap = Texture::MM_LINEAR_LINEAR;
    pkTexture->Texgen = Texture::TG_PROJECTED_TEXTURE;
    Textures.Append(pkTexture);
    UVs.Append(NULL);
}
```

The filtering mode is bilinear and the mipmap mode is set for trilinear interpolation. Once again the Texgen parameter is assigned a value, in this case letting the renderer know that the texture coordinates are to be automatically generated for the object. These coordinates depend on the projector (the camera model) and the target of the projection (the triangle mesh).

A specialized renderer function exists for drawing projected textures, namely, Renderer::DrawProjectedTexture. The base class function is tagged as pure virtual, so all derived-class renderers must implement this function. The effect is global in that you can attach such an effect to a node in the scene, not just to geometry leaf objects. Just like environment maps, because the texture occurs at an interior node, the UpdateRS call will guarantee that the projected texture will be the last texture that is applied to the geometry objects. The specialized function is identical in structure to that of environment mapping:

```
void OpenGLRenderer::DrawProjectedTexture ()
{
    // Access the special effect.  Detach it from the node to
    // allow the effectless node drawing.
    assert( DynamicCast<ProjectedTextureEffect>(m_pkGlobalEffect) );
    ProjectedTextureEffectPtr spkPTEffect =
        (ProjectedTextureEffect*)m_pkGlobalEffect;
    m_pkNode->SetEffect(NULL);

    // Draw the Node tree.  Any Geometry objects with textures
    // will have the projected texture as an additional one, drawn
    // after the others according to the apply mode stored by the
    // projected texture.
    m_pkNode->Draw(*this);

    // reattach the effect
    m_pkNode->SetEffect(spkPTEffect);
}
```

The setup of the graphics API to generate the texture coordinates is implemented in the virtual function EnableTexture. The specific details depend on the graphics API. For example, in the OpenGL renderer version, the enabling code is

```
glEnable(GL_TEXTURE_GEN_S);
glEnable(GL_TEXTURE_GEN_T);
glEnable(GL_TEXTURE_GEN_R);
glEnable(GL_TEXTURE_GEN_Q);

// Select the camera coordinates of the model for the projected
// texture coordinates:  (s,t,r,q) = (x_cam,y_cam,z_cam,w_cam)
glTexGenfv(GL_S,GL_EYE_PLANE,(const float*)Vector4f::UNIT_X);
glTexGenfv(GL_T,GL_EYE_PLANE,(const float*)Vector4f::UNIT_Y);
glTexGenfv(GL_R,GL_EYE_PLANE,(const float*)Vector4f::UNIT_Z);
glTexGenfv(GL_Q,GL_EYE_PLANE,(const float*)Vector4f::UNIT_W);
glTexGeni(GL_S,GL_TEXTURE_GEN_MODE,GL_EYE_LINEAR);
glTexGeni(GL_T,GL_TEXTURE_GEN_MODE,GL_EYE_LINEAR);
glTexGeni(GL_R,GL_TEXTURE_GEN_MODE,GL_EYE_LINEAR);
glTexGeni(GL_Q,GL_TEXTURE_GEN_MODE,GL_EYE_LINEAR);

// Create the transformation to map (s,t,r,q) to the coordinate
// system of the projector camera.
glMatrixMode(GL_TEXTURE);
glPushMatrix();
glLoadIdentity();

// bias and scale the texture so it covers the near plane
glTranslatef(0.5f,0.5f,0.0f);
glScalef(0.5f,0.5f,1.0f);

// set the perspective projection for the projector camera
Camera* pkCamera = ((ProjectedTextureEffect*)pkEffect)->GetCamera();
float fL, fR, fB, fT, fN, fF;
pkCamera->GetFrustum(fL,fR,fB,fT,fN,fF);
glFrustum(fL,fR,fB,fT,fN,fF);

// set the model-view matrix for the projector camera
Vector3f kLoc = pkCamera->GetWorldLocation();
Vector3f kUVec = pkCamera->GetWorldUVector();
Vector3f kDVec = pkCamera->GetWorldDVector();
Vector3f kLookAt = kLoc + kDVec;
gluLookAt(kLoc.X(),kLoc.Y(),kLoc.Z(),kLookAt.X(),kLookAt.Y(),
    kLookAt.Z(),kUVec.X(),kUVec.Y(),kUVec.Z());
```

The comments in the source code make it clear what steps must be taken to get the graphics API to generate texture coordinates relative to the projector. The disabling code is

```
glMatrixMode(GL_TEXTURE);
glPopMatrix();
glMatrixMode(GL_MODELVIEW);

glDisable(GL_TEXTURE_GEN_S);
glDisable(GL_TEXTURE_GEN_T);
glDisable(GL_TEXTURE_GEN_R);
glDisable(GL_TEXTURE_GEN_Q);
```

A matrix was pushed onto the texture matrix stack in the enabling code, so it must be popped in the disabling code.

The sample application on the companion website in the directory

```
GeometricTools/WildMagic3/SampleGraphics/ProjectedTextures
```

illustrates the projected texture effect. A mesh representing a face is loaded and has no texture associated with it. A sunfire texture is projected onto the face. Figure 5.6 shows the face in a couple of orientations. Notice that the face moves relative to the observer, but the projected texture does not since the projector is fixed in space in this application.

5.1.9 PLANAR SHADOWS

The Wild Magic engine implements *projected planar shadows*. An object in the scene casts shadows onto one or more planes due to light sources; one light is associated with each plane (possibly the same light). The class that encapsulates this is Planar-ShadowEffect and has the interface

```
class PlanarShadowEffect : public Effect
{
public:
    PlanarShadowEffect (int iQuantity);
    virtual ~PlanarShadowEffect ();

    virtual Effect* Clone ();

    int GetQuantity () const;
    void SetPlane (int i, TriMeshPtr spkPlane);
    TriMeshPtr GetPlane (int i) const;
    void SetProjector (int i, LightPtr spkProjector);
    LightPtr GetProjector (int i) const;
    void SetShadowColor (int i, const ColorRGBA& rkShadowColor);
    const ColorRGBA& GetShadowColor (int i) const;
```

Figure 5.6 Illustration of projected textures. (See also Color Plate 5.6.)

```
protected:
    PlanarShadowEffect ();

    int m_iQuantity;
    TriMeshPtr* m_aspkPlane;
    LightPtr* m_aspkProjector;
    ColorRGBA* m_akShadowColor;
};
```

The constructor is passed the number of planes on which the object will cast a shadow. Each plane has an associated light source for projecting the shadow and a shadow color. The planes, projectors, and colors are all set by the member functions of the class.

This effect is a global effect. You may attach it to a Node object in the scene graph. A specialized drawing function is provided, namely, Renderer:DrawPlanarShadow. The base class function is pure virtual, so the derived-class renderers must implement them.

The OpenGL implementation uses a stencil buffer to guarantee that the shadow cast on the planar geometry is clipped against that geometry. The abstraction of the drawing routine is

```
draw the node subtree;
for each projection plane do
{
    enable depth buffering;
    enable stencil buffering;
    draw the plane;  // stencil keeps track of pixels drawn
    disable stencil buffering;
    disable depth buffering;

    compute the shadow projection matrix;
    push onto the model-view matrix stack;

    enable alpha blending;
    set current color to shadow color;
    enable stencil buffering;

    disallow global state changes;
    disallow lighting;
    disallow texturing;
    draw the node subtree;  // shadow only occurs where plane is
    allow texturing;
    allow lighting;
    allow global state changes;

    disable stencil buffering;
    restore current color;
    disable alpha blending;

    pop projection matrix from model-view matrix stack;
}
```

The shadow caster is drawn first. Each projection plane is processed one at a time. The plane is drawn with the stencil buffer enabled so that you keep track of those pixels affected by the plane. The shadow caster needs to be drawn into the plane from the perspective of the light projector. This involves computing a shadow projection matrix, which I will discuss in a moment. The matrix is pushed onto the model-view matrix stack so that the resulting transformation places the camera in the correct location and orientation to render the caster onto the projection plane, which acts as the view plane. The only colors we want for the rendering are the shadow colors, so the rendering system provides the ability for you to tell it not to allow various render

state changes. In this case we disallow just about everything except the current color.[1] The caster is rendered into the plane, but with stencil buffering enabled yet again, the only pixels blended with the shadow color are those that were drawn with the plane. The stencil buffer only allows those pixels to be touched. The remainder of the code is the restoration of rendering state to what it was before the function call was made.

The projection matrix construction requires a small amount of mathematics. The projection plane is implicit in the TriMesh representation of the plane. We need to know the equation of the plane in world coordinates. The TriMesh::GetWorldTriangle function call returns the three vertices of the first triangle in the mesh of the plane, and from these vertices we can construct the plane equation. The light source is either directional, in which case the projection is an oblique one, or positional, in which case the projection is a perspective one. The homogeneous matrices for these projections are computed by the Matrix4 class. The mathematical details are in Section 2.2.4, in particular in the subsection entitled "Operations Specific to 4D."

The sample application on the companion website in the directory

```
GeometricTools/WildMagic3/SampleGraphics/PlanarShadows
```

illustrates the projected, planar shadow effect. A biped model is loaded and drawn standing on a plane. Another plane perpendicular to the first is also drawn. The biped casts two shadows, one on the floor plane and one on the wall plane. Figure 5.7 shows a screen shot from the application. The light is a point source. You can move the location with the x, y, and z keys (both lowercase and uppercase). Press the G key to animate the biped and see the shadow change dynamically.

5.1.10 PLANAR REFLECTION

The Wild Magic engine implements *planar reflections*. An object in the scene casts reflections onto one or more planes. Thinking of the planes as mirrors, each plane has some amount of reflectance, say, a value in the interval $[0, 1]$. A reflectance of 0 means the plane does not reflect at all. A reflectance of 1 means the plane fully reflects the image. Values between 0 and 1 give varying degrees of reflectance. The reflectance value is used to blend the surface color and the reflection. The class that encapsulates this is PlanarReflectionEffect and has the interface

```
class PlanarReflectionEffect : public Effect
{
public:
    PlanarReflectionEffect (int iQuantity);
    virtual ~PlanarReflectionEffect ();
```

1. The Direct3D renderer does not have the concept of current color. An alternative method for blending the shadow into the plane is used.

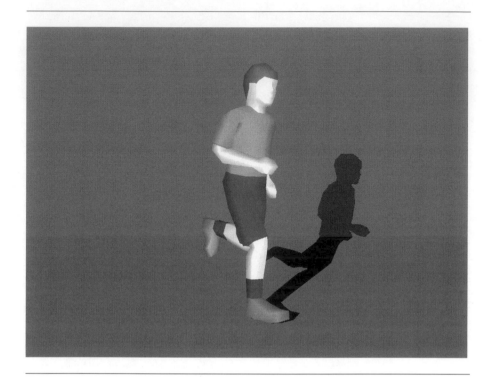

Figure 5.7 Illustration of projected, planar shadows. (See also Color Plate 5.7.)

```
virtual Effect* Clone ();

int GetQuantity () const;
void SetPlane (int i, TriMeshPtr spkPlane);
TriMeshPtr GetPlane (int i) const;
void SetReflectance (int i, float fReflectance);
float GetReflectance (int i) const;

protected:
    PlanarReflectionEffect ();

    int m_iQuantity;
    TriMeshPtr* m_aspkPlane;
    float* m_afReflectance;
};
```

The constructor is passed the number of planes on which the object will cast a reflection. Each plane has an associated reflectance value. The planes and reflectances are all set by the member functions of the class.

This effect is a global effect. You may attach it to a Node object in the scene graph. A specialized drawing function is provided, namely, Renderer:DrawPlanarReflection. The base class function is pure virtual, so the derived-class renderers must implement them.

The OpenGL implementation uses a stencil buffer for drawing the planes, just as it did for planar shadows. The abstraction of the drawing routine is

```
enable depth buffering;
enable stencil buffering;

for each reflecting plane do
{
    // see comment (1) after source code
    disable writing to depth buffer;
    disable writing to frame buffer;
    render plane into stencil buffer;

    // see comment (2) after source code
    enable writing to depth buffer;
    enable writing to frame buffer;
    render plane to write depth buffer to 'far';
    restore depth buffer state to normal;

    // see comment (3) after source code
    compute the reflection matrix;
    push onto the model-view matrix stack;

    // see comment (4) after source code
    enable extra clip plane for reflection plane;

    // see comment (5) after source code
    reverse the culling direction;

    // see comment (6) after source code
    draw node subtree with culling disabled;

    restore the cull direction;
    disable extra clip plane;
    pop the model-view matrix stack;
```

```
    // see comment (7) after source code
    enable alpha blending;
    set blending color to (r,g,b,a) = (0,0,0,reflectance);
    disallow alpha state changes;
    render the plane;
    allow alpha state changes;
    disable alpha blending;
}

disable stencil buffering;
disable depth buffering;
draw the node subtree;
```

The steps of the pseudocode are the following:

1. Render the reflecting plane into the stencil buffer. No pixels are written to the depth buffer or color buffer, but we use depth buffer testing so that the stencil buffer will not be written where the plane is behind something already in the depth buffer.

2. Render the reflecting plane again by only processing pixels where the stencil buffer contains the plane's assigned stencil value. This time there are no changes to the stencil buffer, and the depth buffer value is reset to the far clipping plane. This is done by setting the range of depth values in the viewport volume to be [1, 1]. Since the reflecting plane cannot also be semitransparent, it does not matter what is behind the reflecting plane in the depth buffer. We need to set the depth buffer values to the far plane value (essentially infinity) wherever the plane pixels are, so that when the reflected object is rendered, it can be depth-buffered correctly. Note that the rendering of the reflected object will cause depth values to be written, which will appear to be behind the mirror plane. Writes to the color buffer are now enabled. When the reflecting plane is rendered later and blended into the background, which should contain the reflected caster, we need to use the same blending function so that the pixels where the reflected object was not rendered will contain the reflecting plane's colors. In that case, the blending result will show that the reflecting plane is opaque when in reality it was blended with blending coefficients summing to one.

3. The reflection matrix is computed using a function in the class `Matrix4`. The mathematical details are in Section 2.2.4, in particular, in the subsection entitled "Operations Specific to 4D."

4. Enable a clip plane so that only objects above the mirror plane are reflected. We do not want objects below the clip plane to be reflected because we cannot see them.

5. Reverse the cull direction. This is necessary because of the use of the reflection matrix. The triangles in the meshes need to be treated as if their vertices are ordered in the opposite direction that they normally are in. In the actual implementation, a flag is set in the `Renderer` class telling the `CullState` processing code to treat back-facing triangles as front facing, and vice versa. This allows us not to assume that all models use back-facing triangles or all use front-facing triangles.

6. The rendering of the reflected object only draws where the stencil buffer contains the reflecting plane's stencil value. The node object is told to draw itself. The actual function call takes two arguments: The first is the renderer itself. The second argument is a Boolean flag indicating whether or not to allow culling by bounding volumes. In this case the culling is disabled to allow out-of-view objects to cast reflections.

7. The reflecting plane will be blended with what is already in the frame buffer, either the image of the reflected caster or the reflecting plane. All we want for the reflecting plane at this point is to force the alpha channel to always be the reflectance value for the reflecting plane. The reflecting plane is rendered wherever the stencil buffer is set to the plane's stencil value. The stencil buffer value for the plane will be cleared. The normal depth buffer testing and writing occurs. The frame buffer is written to, but this time the reflecting plane is blended with the values in the frame buffer based on the reflectance value. Note that where the stencil buffer is set, the frame buffer has color values from either the reflecting plane or the reflected object. Blending will use a source coefficient of $1 - \alpha$ for the reflecting plane and a destination coefficient of α for the reflecting plane or reflected object.

The sample application on the companion website in the directory

```
GeometricTools/WildMagic3/SampleGraphics/PlanarReflections
```

illustrates the planar reflection effect. A biped model is loaded and drawn standing on a plane. Another plane perpendicular to the first is also drawn. The biped casts two reflections, one on the floor plane and one on the wall plane. Figure 5.8 shows a screen shot from the application. The reflectance for the wall mirror is set to be larger than the reflectance of the floor. Press the *G* key to animate the biped and see the reflections change dynamically.

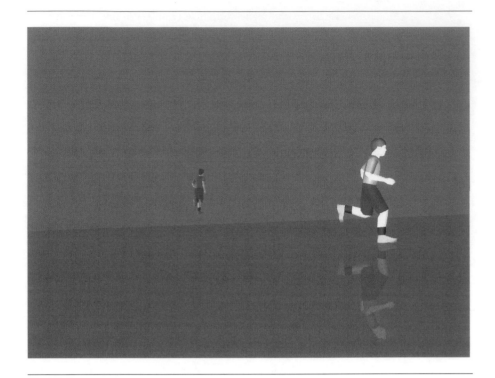

Figure 5.8 Illustration of planar reflections. (See also Color Plate 5.8.)

5.2 SPECIAL EFFECTS USING VERTEX AND PIXEL SHADERS

Current-generation consumer graphics hardware is programmable; the programs are called *shader programs*. The two categories of shader programs are *vertex shaders* and *pixel shaders*. Such programs give you more control over the rendering process than the fixed-function pipeline that restricts you to the standard graphics API calls. In fact, the fixed-function pipeline can be implemented with a collection of shader programs.

The prototypical vertex shader computes colors at the vertices of a triangle mesh by using vertex normals, material colors, lights, and the standard lighting equations. The prototypical pixel shader interpolates texture coordinates at the vertices and uses them as a lookup into a texture image in order to assign colors to pixels in the rasterized triangles. Having the ability to write your own vertex and pixel shaders allows you to be more creative with special effects—in most cases producing effects that cannot be done in the fixed-function pipeline.

As with any procedural programming language, a shader program may be thought of as a function that has inputs and outputs. At the lowest level, the function is implemented in an assembly-like language. The inputs to a vertex shader program include vertex positions (naturally), but also include other vertex attributes such as normals and colors. The inputs can also include user-defined constants that are managed at a higher level in the engine (or application). The outputs include vertex positions, possibly modifed from the input, and other attributes that are needed later in the pipeline—for example, in a pixel shader or by the fixed-function pipeline. The inputs to a pixel shader program include items such as the outputs from a vertex shader program, texture coordinates, texture unit information (to access the textures themselves), and user-defined constants.

The twist in all this is how the function is actually executed. Both OpenGL and Direct3D allow you to pass to them a text string representation of the function. You do not explicitly "call" the function, but you do provide all the inputs, directly or indirectly. Some of the inputs are made available through the mechanisms already provided in the fixed-function pipeline. For example, in OpenGL you give the graphics system pointers to the arrays of vertex locations, colors, normals, and texture coordinates, and you set up the texture units with the texture parameters and images. Other inputs are made available by passing render state information to the graphics system outside of the standard API for that system. For example, in OpenGL the parameters for a light are copied into arrays and passed to the graphics system via a special function that supports shaders. This happens outside the usual mechanism starting with `glEnable(GL_LIGHTING)`. User-defined constants must also be passed through the special function.

Implementing support for shaders in Wild Magic is partitioned into three separate topics. First, the shader program and its associated constants must be encapsulated in classes in the scene graph management system. This is discussed in Section 5.2.1. Second, the renderer API must be expanded to include management of shaders and to draw objects with shaders attached. Section 5.2.2 describes the evolution of the Renderer class to support shaders. Third, the path that takes you from writing a shader program to adding engine support for that shader is a long and tedious one. Using nVidia's Cg Toolkit, I built a tool that actually generates Wild Magic source code from a shader written in the Cg language. Similar tools for automatic source code generation can be built for other toolkits that assist you in building shaders. Section 5.2.3 discusses briefly the issues involved with source code generation.

5.2.1 SCENE GRAPH SUPPORT

To support shader programs in Wild Magic version 3, I needed to implement a subsystem in the scene graph management system that encapsulates both the shader programs and the constants that go with them. Wild Magic version 2 had a subsystem that was patched into the scene graph management system, but it was a bit awkward to use. That version included a lot of class member functions and data that turned

out not to be used. I have streamlined the system and made it more readable and understandable.

In Wild Magic version 2, the base class for shaders included enumerations that made it clear that the class was storing programs for both OpenGL and Direct3D. The shader programs themselves are part of the class data. Because the program formats are specific to the graphics API you choose, there has to be *some* dependency on the graphics API. A major goal of the scene graph management system is to be independent of the back-end rendering system, so the inclusion of shader support becomes problematic. My solution was to allow for the weakest dependency possible. The shader support in the engine proper has no indication that a graphics API exists on the back end. The abstract base class, Shader, has a pointer to the text string that represents the program and an array of constants, of class type ShaderConstant, associated with the program. The derived classes for Shader are VertexShader and PixelShader, both abstract. These also have no explicit dependencies on the graphics API.

A class derived from VertexShader or PixelShader introduces the dependency. That class stores a static array of text strings, one for OpenGL and one for Direct3D (more can be added for other graphics APIs). The constructor sets the Shader text string pointer to the appropriate static text string in the derived class. The selection is based on whatever renderer library was linked into the application. This required adding a static function to Renderer that acts as run-time type identification. Each Renderer-derived class implements this function, with the assumption that only one derived-class renderer may exist in an application. To the best of my knowledge, this assumption is safe to make! The interface for Renderer has added to it the following:

```
class Renderer
{
public:
    // Only one type of renderer can exist in an application.  The
    // active renderer type implements GetType() to return one of
    // the enumerations.
    enum
    {
        RT_OPENGL,
        RT_DIRECT3D,
        RT_QUANTITY
    };
    static int GetType ();
};
```

Class Renderer does not implement GetType; rather, each derived class does. The enumerations are indexed starting at 0 and are used as the indices into the static array of text strings that each shader class uses to store the shader programs. The correct

shader program is selected simply by the act of linking in the derived-class renderer library of your choice.

To motivate the architecture of the Shader class, let us work through a specific example of a shader-based effect from start to finish. The shader produces a charcoal effect when drawing an object. The application illustrating this is on the companion website in directory

```
GeometricTools/WildMagic3/SampleShaders/CharcoalEffects
```

It uses the algorithm and Cg vertex and pixel shader programs (with minor variations) in [MG02]. The Cg vertex shader program is

```
void vmain(
    in float4 i_f4Position : POSITION,
    in float3 i_f3Normal : NORMAL,
    in float2 i_f2TexCoord : TEXCOORD0,

    out float4 o_f4Position : POSITION,
    out float4 o_f4Color : COLOR,
    out float2 o_f2TexCon : TEXCOORD0,
    out float2 o_f2TexRan : TEXCOORD1,
    out float2 o_f2TexPap : TEXCOORD2,

    uniform float4x4 SCTransformMVP,
    uniform float4x4 SCTransformM,
    uniform float AmbientIntensity,
    uniform float ContrastExponent,
    uniform float3 SCLightDirection0,
    uniform float3 SCLightDirection1)
{
    // Transform the vertex by the model-view and the projection
    // matrix, concatenated as SCTransformMVP.
    float4 f4ProjectionPosition = mul(SCTransformMVP,i_f4Position);
    o_f4Position = f4ProjectionPosition;

    // Calculate the illumination at a vertex from two directional
    // lights and using only the ambient and diffuse contributions.
    // The normal is transformed by the model-to-world matrix
    // SCTransformM.  Only the intensity is computed so that the
    // output color is gray-scale.
    float3 f3Normal = mul((float3x3)SCTransformM,(float3)i_f3Normal);
    float fDiffuse1 = saturate(-dot(f3Normal,SCLightDirection0));
    float fDiffuse2 = saturate(-dot(f3Normal,SCLightDirection1));
    float fGray = saturate(fDiffuse1+fDiffuse2+AmbientIntensity);
```

```
    // enhance the contrast of the intensity
    float fEnhancedGray = pow(fGray,ContrastExponent);

    // create the gray-scale color (same value in all channels)
    o_f4Color = fEnhancedGray.xxxx;

    // The input texture coordinates are used as a lookup into a random
    // texture map.  The lookup value is used as the first component of
    // the texture coordinate for a contrast.texture.  The second
    // component is the enhanced gray-scale intensity.  The use of a
    // random texture map avoids banding artifacts that occur when the
    // input texture coordinates are used directly.
    o_f2TexRan.xy = i_f2TexCoord;
    o_f2TexCon.x = 0.0;
    o_f2TexCon.y = fEnhancedGray;

    // A paper texture is overlaid.  The texture coordinates for the
    // vertex are in screen space.  The components of the clip
    // coordinates are in [-1,1], so they must be mapped to [0,1] for
    // the final texture coordinates.
    float fProj = 1.0/f4ProjectionPosition.w;
    float2 f2ClipCoords = f4ProjectionPosition.xy*fProj;
    o_f2TexPap.xy = (f2ClipCoords+1.0)*0.5;
}
```

The OpenGL output from the Cg Toolkit is shown next with the comments removed for brevity. The Direct3D output is similarly structured, but not listed here. I added the C++ style comments in the book text to emphasize which of the local variables are associated with the vertex shader inputs.

```
!!ARBvp1.0
PARAM c12 = { 0, 1, 2, 0.5 };
TEMP R0, R1, R2;
ATTRIB v24 = vertex.texcoord[0];        // i_f2TexCoord
ATTRIB v18 = vertex.normal;             // i_f3Normal
ATTRIB v16 = vertex.position;           // i_f4Position
PARAM c9 = program.local[9];            // ContrastExponent
PARAM c8 = program.local[8];            // AmbientIntensity
PARAM c11 = program.local[11];          // SCLightDirection1
PARAM c10 = program.local[10];          // SCLightDirection0
PARAM c4[4] = { program.local[4..7] };  // SCTransformMVP
PARAM c0[4] = { program.local[0..3] };  // SCTransformM
```

```
    MOV result.texcoord[1].xy, v24;
    DP4 R0.x, c0[0], v16;
    DP4 R0.y, c0[1], v16;
    DP4 R0.z, c0[2], v16;
    DP4 R0.w, c0[3], v16;
    MOV result.position, R0;
    DP3 R2.x, c4[0].xyzx, v18.xyzx;
    DP3 R2.y, c4[1].xyzx, v18.xyzx;
    DP3 R2.z, c4[2].xyzx, v18.xyzx;
    DP3 R1.x, R2.xyzx, c10.xyzx;
    MIN R1.x, c12.y, -R1.x;
    MAX R1.y, c12.x, R1.x;
    DP3 R1.x, R2.xyzx, c11.xyzx;
    MIN R1.x, c12.y, -R1.x;
    MAX R1.x, c12.x, R1.x;
    ADD R1.x, R1.y, R1.x;
    ADD R1.x, R1.x, c8.x;
    MIN R1.x, c12.y, R1.x;
    MAX R1.xy, c12.x, R1.x;
    MOV R1.zw, c9.x;
    LIT R1.z, R1;
    MOV result.color.front.primary, R1.z;
    MOV result.texcoord[0].x, c12.x;
    MOV result.texcoord[0].y, R1.z;
    RCP R1.x, R0.w;
    MAD R0.xy, R0.xyxx, R1.x, c12.y;
    MUL result.texcoord[2].xy, R0.xyxx, c12.w;
END
```

The program, stored as a text string, is what you provide to the OpenGL API through a call to glProgramStringARB. The vertex positions, normals, and texture co-ordinates are managed by OpenGL. All you do is provide OpenGL with the arrays to these quantities. Management of the six other inputs is the engine's responsibility. These are called *shader constants*, each represented by an object from the class Shader-Constant. The four inputs with the SC prefix are *state constants* that you have to pass to the OpenGL API outside of its usual fixed-function pipeline. The other two inputs are *user-defined constants* and are specific to your shaders. The naming conventions in the Cg program for the state constants (prefixed by SC) and user-defined constant (no prefix) are designed to allow the automatic source code generator to create names for class data members and functions using my coding conventions for the engine. All six constants are passed to the OpenGL API through a call to glProgramLocalParameter4fvARB.

The interface for the ShaderConstant class is

```
class ShaderConstant : public Object
{
public:
    // state constants
    enum
    {
        SC_TRANSFORM_M,            // 4x4 modelworld matrix
        SC_TRANSFORM_P,            // 4x4 projection matrix
        SC_TRANSFORM_MV,           // 4x4 modelview matrix
        SC_TRANSFORM_MVP,          // 4x4 modelview*projection matrix
        SC_CAMERA_POSITION,        // (x,y,z,1)
        SC_CAMERA_DIRECTION,       // (x,y,z,0)
        SC_CAMERA_UP,              // (x,y,z,0)
        SC_CAMERA_RIGHT,           // (x,y,z,0)
        SC_FOG_COLOR,              // (r,g,b,a)
        SC_FOG_PARAMS,             // (start, end, density, enabled)
        SC_MATERIAL_EMISSIVE,      // (r,g,b,a)
        SC_MATERIAL_AMBIENT,       // (r,g,b,a)
        SC_MATERIAL_DIFFUSE,       // (r,g,b,a)
        SC_MATERIAL_SPECULAR,      // (r,g,b,a)
        SC_MATERIAL_SHININESS,     // (shiny, -, -, -)
        SC_LIGHT_POSITION,         // (r,g,b,a)
        SC_LIGHT_DIRECTION,        // (r,g,b,a)
        SC_LIGHT_AMBIENT,          // (r,g,b,a)
        SC_LIGHT_DIFFUSE,          // (r,g,b,a)
        SC_LIGHT_SPECULAR,         // (r,g,b,a)
        SC_LIGHT_SPOTCUTOFF,       // (angle, cos, sin, exponent)
        SC_LIGHT_ATTENPARAMS,      // (const, lin, quad, intensity)
        SC_NUMERICAL_CONSTANT,     // (f0,f1,f2,f3)
        SC_QUANTITY,
        SC_USER_DEFINED            // (f0,f1,f2,f3)
    };

    // state constant options
    enum
    {
        SCO_NONE = -1,
        SCO_MATRIX = 0,
        SCO_TRANSPOSE = 1,
        SCO_INVERSE = 2,
        SCO_INVERSE_TRANSPOSE = 3,
        SCO_LIGHT0 = 0,
```

```
        SCO_LIGHT1 = 1,
        SCO_LIGHT2 = 2,
        SCO_LIGHT3 = 3,
        SCO_LIGHT4 = 4,
        SCO_LIGHT5 = 5,
        SCO_LIGHT6 = 6,
        SCO_LIGHT7 = 7,
    };

    ShaderConstant (int iSCType, int iSCOption, int iRegister,
        int iRegisterQuantity);
    virtual ~ShaderConstant ();

    int GetSCType () const;
    int GetSCOption () const;
    int GetRegister () const;
    int GetRegisterQuantity () const;
    float* Data ();
    void SetRegisterData (int i, float fData0, float fData1 = 0.0f,
        float fData2 = 0.0f, float fData3 = 0.0f);

protected:
    ShaderConstant ();

    int m_iSCType;  // enum with SC_ prefix
    int m_iSCOption;  // enum with SCO_ prefix
    int m_iRegister;  // register to store data (1 reg = 4 floats)
    int m_iRegisterQuantity;  // registers needed for constant
    float* m_afData;  // the constant's data
};
```

Each constant is stored using multiples of four floats; each quadruple is referred to as a *register*, which is how the data is stored and manipulated on the graphics hardware—as 128-bit quantities. The number of the register associated with the constant is stored in m_iRegister. The number of registers required for the constant is stored in m_iRegisterQuantity. Constants do not have to use all four components of the register. The matrix constants use four registers for a total of 16 floating-point numbers (the matrices are stored as homogeneous transformations). The other constants use one register each. The actual data is stored in the m_afData array. The engine has the responsibility for assigning this data as needed.

The enumeration for state constants lists all the possibilities for shader inputs related to render state. If a constant is user defined, it is tagged with the SC_USER_ DEFINED value. The data member m_SCType stores this enumerated value.

Table 5.1 The `ShaderConstant` objects associated with the inputs to the example vertex shader program.

Input	m_iSCType	m_iSCOption	m_iRegister	m_iRegisterQuantity
SCTransformM	SC_TRANSFORM_M	SCO_NORMAL	0	4
SCTransformMVP	SC_TRANSFORM_MVP	SCO_NORMAL	4	4
AmbientIntensity	SC_USER_DEFINED	SCO_NONE	8	1
ContrastExponent	SC_USER_DEFINED	SCO_NONE	9	1
SCLightDirection0	SC_LIGHT_DIRECTION	SCO_LIGHT0	10	1
SCLightDirection1	SC_LIGHT_DIRECTION	SCO_LIGHT1	11	1
Register c12	SC_NUMERICAL_CONSTANT	SCO_NONE	12	1

The enumeration for state constant options lists additional interpretations of the shader inputs; the value is stored in `m_iSCOption`. Two categories exist for these. The first category has to do with the matrix constants. If a shader needs the transpose of the model-to-world transformation, the corresponding constant has type `SC_TRANSFORM_M` and option `SCO_TRANSPOSE`. The two labels tell the engine to store the transposed matrix in the data array of the shader constant. The second category has to do with the light constants. Most graphics systems support up to eight lights. The option `SCO_LIGHTi` for $0 \le i < 8$ is used whenever the type is one of the `SC_LIGHT*` enumerated values. The engine then knows from which light the data array should be assigned.

Our example vertex shader has *seven* shader constants with the assignments shown in Table 5.1. You might have thought there were six constants, but do not overlook register c12, which stores numerical constants used within the shader program itself.

Make sure you understand how the register numbers and register quantities are related to the quantities shown in the shader program. Notice that register c12 stores four numbers: $x = 0$, $y = 1$, $z = 2$, and $w = 0.5$. Only the x, y, and w fields are used in the program and correspond to the use of constants in the Cg program lines

```
o_f2TexCon.x = 0.0;  // use of c12.x
float fProj = 1.0/f4ProjectionPosition.w;  // use of c12.y
o_f2TexPap.xy = (f2ClipCoords+1.0)*0.5;    // use of c12.y, c12.w
```

The Cg pixel shader program for the charcoal rendering is

```
void pmain (
    in float4 i_f4Color : COLOR,
    in float2 i_f2TexCon : TEXCOORD0,
    in float2 i_f2TexRan : TEXCOORD1,
    in float2 i_f2TexPap : TEXCOORD2,
```

```
    out float4 o_f4Col : COLOR,
    uniform sampler2D ContrastTexture,
    uniform sampler2D RandomTexture,
    uniform sampler2D PaperTexture,
    uniform float4 Constants)
{

    // generate a random number in the range [0..1]
    float4 f4Random = tex2D(RandomTexture,i_f2TexRan);

    // get the paper texture color
    float4 f4PaperColor = tex2D(PaperTexture,i_f2TexPap);

    // user-defined parameter "smudge"
    // 0.5 = normal smudge
    // 0.0 = no lighting smudging
    // 1.0 = no contrast map, only diffuse lighting
    float fSmudge = Constants.x;

    // user-defined parameter "display paper"
    // 0.0 = display paper
    // 1.0 = no paper
    float fPaper = Constants.y;

    // perform a lookup into the contrast-enhanced texture map
    i_f2TexCon.x += f4Random.x;
    float4 f4Contrast = tex2D(ContrastTexture,i_f2TexCon);

    // Blend the contrast-enhanced texel with the contrast-enhanced
    // vertex color.
    float4 f4SmudgeColor = lerp(f4Contrast,i_f4Color,fSmudge);

    // If fPaper is large enough, it will saturate the paper color
    // to white, which will cancel out the alpha blending in the
    // next step.
    f4PaperColor = saturate(f4PaperColor+fPaper);

    // alpha blend with the background, drawn as a polygon
    o_f4Col = f4PaperColor*f4SmudgedColor;
}
```

The corresponding OpenGL output from the Cg Toolkit, minus the Cg comments, but with my comments added, is

```
// program.local[0] stores i_f4Color
// fragment.texcoord[0] stores i_f2TexCon
```

```
// fragment.texcoord[1] stores i_f2TexRan
// fragment.texcoord[2] stores i_f2TexPap
// texture unit 0 has the ContrastTexture
// texture unit 1 has the RandomTexture
// texture unit 2 has the PaperTexture
// register c[0] stores Constants (smudge,paper,-,-)

!!ARBfp1.0
PARAM u0 = program.local[0];
TEMP R0;
TEMP R1;
TEMP R2;
TEX R0.x, fragment.texcoord[1], texture[1], 2D;
TEX R1, fragment.texcoord[2], texture[2], 2D;
ADD R0.x, fragment.texcoord[0].x, R0.x;
ADD_SAT R1, R1, u0.y;
MOV R2.y, fragment.texcoord[0].y;
MOV R2.x, R0.x;
TEX R0, R2, texture[0], 2D;
ADD R2, fragment.color.primary, -R0;
MAD R0, u0.x, R2, R0;
MUL result.color, R1, R0;
END
```

A single `ShaderConstant` object is needed to manage the `Constants` input. The smudge and paper parameters are both contained in the same register, using only two of the floating-point components of the register. Table 5.2 is the pixel-shader equivalent of Table 5.1.

Table 5.2 The `ShaderConstant` object associated with the inputs to the example pixel shader program.

Input	m_iSCType	m_iSCOption	m_iRegister	m_iRegisterQuantity
Constants	SC_USER_DEFINED	SCO_NONE	0	1

The `Shader` class encapsulates the shader program and the array of `ShaderConstant` objects that are associated with the inputs to the shader program. The interface is

```
class Shader : public Object
{
public:
    virtual ~Shader ();
```

```
    enum  // ShaderType
    {
        ST_VERTEX_SHADER,
        ST_PIXEL_SHADER,
        ST_QUANTITY
    };
    virtual int GetShaderType () const = 0;

    void SetProgram (const char* acProgram);
    const char* GetProgram () const;
    int GetConstantQuantity () const;
    const ShaderConstantPtr GetConstant (int i) const;
    void AddConstant (ShaderConstant* pkConstant);

protected:
    Shader ();

    const char* m_acProgram;
    TArray<ShaderConstantPtr> m_kConstant;
};
```

The class is abstract since the only constructor is protected and the function GetShaderType is pure virtual. The only two derived classes will be VertexShader and PixelShader, each implementing GetShaderType in the obvious way. Their interfaces are solely designed to implement GetShaderType and provide no other functionality:

```
class VertexShader : public Shader
{
public:
    VertexShader () {}
    virtual ~VertexShader () {}
    virtual int GetShaderType () const { return ST_VERTEX_SHADER; }
};

class PixelShader : public Shader
{
public:
    PixelShader () {}
    virtual ~PixelShader () {}
    virtual int GetShaderType () const { return ST_PIXEL_SHADER; }
};
```

The constructors are public, so you can instantiate objects from either class.

The m_acProgram data member of Shader is a pointer to the actual text string that represents the shader program. Shader sets this to NULL. Classes derived from VertexShader and PixelShader must set this pointer to the appropriate string. As mentioned earlier, the selection mechanism is automatic based on which renderer library is linked into the application. The m_kConstant data member is an array that stores the shader constants.

The Shader interface is designed to allow you to set the pointer to the program text string and to set the shader constants. Even though VertexShader and PixelShader are instantiable, they do not set a program string or constants. You may construct executable shader programs solely with VertexShader and PixelShader objects—you do not have to derive classes—but it is your responsibility to handle the reading and writing of shader constants. This requires knowledge of the ordering of the constants in the m_kConstant array and how they relate to the shader program. Wild Magic version 2 included string names for the constants, but the memory usage might be an issue. More of an issue is that the constants were accessed by string name without a hash table to support fast searches. I found this to be cumbersome and chose instead to automatically generate source code with interfaces that access the constants by meaningful names. Not wanting to force a user to have to generate a class per shader, the VertexShader and PixelShader classes can be the only shader objects in an engine or application.

Back to the example at hand, the charcoal rendering effect. The sample application has a class, CharcoalVShader, that implements a vertex shader based on the vertex shader program mentioned earlier in this section. Its interface is

```
class CharcoalVShader : public VertexShader
{
public:
    CharcoalVShader ();
    virtual ~CharcoalVShader ();

    void SetAmbientIntensity (float fAmbientIntensity);
    float GetAmbientIntensity () const;
    void SetContrastExponent (float fContrastExponent);
    float GetContrastExponent () const;

private:
    static const char* ms_aacProgram[Renderer::RT_QUANTITY];
};
```

Recall that two user-defined constants appeared as inputs to the vertex shader program. The shader program inputs were named AmbientIntensity and Contrast-Exponent. The choice of member function names uses the shader program names. The static array of strings is used to store the shader programs. The value of Renderer::RT_QUANTITY is currently 2, indicating that a shader program exists for OpenGL (at in-

dex 0, the value of `Renderer::RT_OPENGL`) and for Direct3D (at index 1, the value of `Renderer::RT_DIRECT3D`).

The constructor for the class has an implementation that begins with

```
CharcoalVShader::CharcoalVShader ()
{
    // shader program (load the type of the current renderer)
    m_acProgram = ms_aacProgram[Renderer::GetType()];

    // ... other code goes here ...
}
```

The OpenGL renderer and the Direct3D renderer both implement the function `Renderer::GetType`, but only one renderer may be linked into the application. The correct array index is returned by `GetType` based on which renderer is linked. The static array occurs at the end of the file `Wm3CharcoalVShader.cpp` and stores directly in the file the shader program strings shown earlier in this section.

The constructor has seven blocks that create the shader constants to go with the shader program. A couple of those are

```
CharcoalVShader::CharcoalVShader ()
{
    // ... other code goes here ...

    // model-view projection matrix
    iType = ShaderConstant::SC_TRANSFORM_MVP;
    iOption = ShaderConstant::SCO_MATRIX;
    iReg = 0;
    iRegQuantity = 4;
    pkConst = new ShaderConstant(iType,iOption,iReg,iRegQuantity);
    m_kConstant.Append(pkConst);

    // ... other code goes here ...

    // ambient intensity
    iType = ShaderConstant::SC_USER_DEFINED;
    iOption = ShaderConstant::SCO_NONE;
    iReg = 8;
    iRegQuantity = 1;
    pkConst = new ShaderConstant(iType,iOption,iReg,iRegQuantity);
    pkConst->SetRegisterData(0,0.2f);
    m_kConstant.Append(pkConst);

    // ... other code goes here ...
}
```

The inputs to the `ShaderConstant` constructor are exactly those listed in Table 5.1. The set/get functions of the ambient intensity are implemented as

```
void CharcoalVShader::SetAmbientIntensity (float fAmbientIntensity)
{
    m_kConstant[2]->Data()[0] = fAmbientIntensity;
}

float CharcoalVShader::GetAmbientIntensity () const
{
    return m_kConstant[2]->Data()[0];
}
```

The set/get functions are convenient wrappers for an application to access the shader constant data. If you had chosen to create a `VertexShader` object to represent the charcoal vertex shader, you would have to remember that component 0 of register constant 2 stores the ambient intensity. You would also have to use `Shader::SetProgram` to set the pointer to the program text string and `Shader::AddConstant` to add the seven constants to the array of constants since you do not have access to the protected members of `Shader` or `VertexShader`.

The sample application also has a class `CharcoalPShader` that encapsulates the charcoal pixel shader. Its interface is

```
class CharcoalPShader : public PixelShader
{
public:
    CharcoalPShader ();
    virtual ~CharcoalPShader ();

    void SetSmudgeFactor (float fSmudgeFactor);
    float GetSmudgeFactor () const;
    void SetPaperFactor (float fPaperFactor);
    float GetPaperFactor () const;

private:
    static const char* ms_aacProgram[Renderer::RT_QUANTITY];
};
```

The static array stores the text strings that represent the pixel shader programs for OpenGL and Direct3D. The constructor is similar to that of `CharcoalVShader`:

```
CharcoalPShader::CharcoalPShader ()
{
    // shader program (load the type of the current renderer)
    m_acProgram = ms_aacProgram[Renderer::GetType()];
```

```
    // (smudge,paper,-,-)
    int iType = ShaderConstant::SC_USER_DEFINED;
    int iOption = ShaderConstant::SCO_NONE;
    int iReg = 0;
    int iRegQuantity = 1;
    ShaderConstant* pkConst = new ShaderConstant(iType,iOption,
        iReg,iRegQuantity);
    pkConst->SetRegisterData(0,0.0f,0.0f);
    m_kConstant.Append(pkConst);
}
```

The single shader constant manages both user-defined values. They are stored in the first two components of the register and are accessed by

```
void CharcoalPShader::SetSmudgeFactor (float fSmudgeFactor)
{
    m_kConstant[0]->Data()[0] = fSmudgeFactor;
}

float CharcoalPShader::GetSmudgeFactor () const
{
    return m_kConstant[0]->Data()[0];
}

void CharcoalPShader::SetPaperFactor (float fPaperFactor)
{
    m_kConstant[0]->Data()[1] = fPaperFactor;
}

float CharcoalPShader::GetPaperFactor () const
{
    return m_kConstant[0]->Data()[1];
}
```

Once again, the set/get member functions are convenient for accessing the constants by name rather than having to remember which array slots they are assigned to.

The two shaders need to be passed to the renderer. But keep in mind that they require other inputs such as vertex locations, textures, and texture coordinates. Moreover, the vertex shader needs two directional lights. Some more packaging of data is called for. My choice was to use the Effect mechanism to do this. The engine has a class ShaderEffect whose interface is

```
class ShaderEffect : public Effect
{
public:
```

```
    ShaderEffect ();
    virtual ~ShaderEffect ();

    virtual Effect* Clone ();

    VertexShaderPtr VShader;
    PixelShaderPtr PShader;

protected:
    virtual void DoCloning (Effect* pkEffect);
};
```

The class just adds two data members on top of those of Effect (color arrays, textures, and texture coordinates). The Clone function creates a new ShaderEffect that shares the shader objects. A ShaderEffect object is attached to a Geometry object as a local effect. The engine does not yet have support for global shader effects, but they are possible and will be implemented at a later date.

Since shaders are handled outside the fixed-function pipeline, the Renderer:: DrawPrimitive function does not apply to them. The constructor is

```
ShaderEffect::ShaderEffect ()
{
    Draw = &Renderer::DrawShader;
}
```

and chooses a drawing function that the renderer class has specifically for shaders.

The charcoal shader example has a derived class

```
class CharcoalEffect : public ShaderEffect
{
public:
    CharcoalEffect (Image* pkPaperImage);
    virtual ~CharcoalEffect ();

    virtual Effect* Clone ();

    void GenerateUVs (int iVQuantity);
    void SetSmudgeFactor (float fSmudgeFactor);
    void SetPaperFactor (float fPaperFactor);

protected:
    CharcoalEffect ();
    virtual void DoCloning (Effect* pkClone);
```

```
Image* GetContrastImage (int iWidth, int iHeight,
    float fNoiseDensity, float fContrastExponent);
Image* GetRandomImage (int iWidth, int iHeight);
};
```

The paper texture required by the shaders is passed to the constructor. The smudge and paper factors that are part of the pixel shader are exposed by Charcoal-Effect and passed along to the CharcoalPShader object. The shader constants for the CharcoalVShader object are chosen to be fixed numbers for the sample application, so they are not exposed through the CharcoalEffect interface. The protected member functions GetContrastImage and GetRandomImage generate the other two textures required by the pixel shader.

In the application, the skinned biped is loaded. A single instance of CharcoalEffect is stored in the application. The biped model is traversed, and each time a Geometry object is found, the CharcoalEffect object is cloned and is attached. Since the effect needs one set of texture coordinates (the others are generated by the shaders), the GenerateUVs call is made with an input equal to the number of vertices of the Geometry object. The texture coordinates are generated and stored in the cloned effect. Figure 5.9 shows four screen shots from the application.

5.2.2 RENDERER SUPPORT

Just as textures (and their images) and arrays can be bound to the renderer so that the data is cached in VRAM on the graphics card, so can shader programs. The binding mechanism used in Shader is the same one used in Texture and TCachedArray:

```
class Shader : public Object
{
// internal use
public:
    // Store renderer-specific information for binding and
    // unbinding shader programs.
    BindInfoArray BIArray;
};
```

Since the binding mechanism is used so often, I encapsulated the entire system in two classes, BindInfo and BindInfoArray. The first time a renderer sees a Shader object, it is bound to the renderer and a unique identifier is stored in the BIArray data member, together with a pointer to the renderer so that the shader resources can be freed up when a shader is destroyed. The destructor is

Figure 5.9 Four screen shots from the TestCharcoalEffect sample application. Top left: No smudge, display paper. Top right: No smudge, no display paper. Bottom left: Smudge, display paper. Bottom right: Smudge, no display paper. (See also Color Plate 5.9.)

```
Shader::~Shader ()
{
    // Inform all renderers using this shader that it is being
    // destroyed.  This allows the renderer to free up any
    // associated resources.
    const TArray<BindInfo>& rkArray = BIArray.GetArray();
    for (int i = 0; i < rkArray.GetQuantity(); i++)
        rkArray[i].User->ReleaseShader(this);
}
```

and is structured just like the destructors for Texture and TCachedArray.

The Renderer class itself provides interface calls to release the resources:

```
class Renderer
{
public:
    virtual void ReleaseShader (Shader* pkShader) = 0;
    void ReleaseShaders (Spatial* pkScene);
};
```

The derived classes must implement ReleaseShader since they must use specific knowledge of the graphics API to release the resources. The ReleaseShaders function implements a traversal of the input scene that calls ReleaseShader for the vertex and pixel shaders of any ShaderEffect object it finds.

The Renderer interface also provides enable and disable functions that are used by the drawing routines. These are similar to the enable and disable functions used for textures and cached arrays:

```
class Renderer
{
protected:
    virtual void EnableShader (VertexShader* pkVShader) = 0;
    virtual void EnableShader (PixelShader* pkPShader) = 0;
    virtual void DisableShader (VertexShader* pkVShader) = 0;
    virtual void DisableShader (PixelShader* pkPShader) = 0;
};
```

These are pure virtual functions that the derived classes must implement, once again because the details are specific to a graphics API.

The only drawing function currently that supports shaders is

```
class Renderer
{
public:
    void DrawShader ();
};
```

The implementation is similar to DrawPrimitive, except that fog, material, and light state handling by the fixed-function pipeline is bypassed, and the shaders provide these to the graphics API themselves. The DrawPrimitive function has the block

```
set world transformations;
draw the geometric object;
restore world transformations;
```

The DrawShader function inserts code for processing the shaders:

```
set world transformations;
enable vertex shader;
enable pixel shader;
draw the geometric object;
disable pixel shader;
disable vertex shader;
restore world transformations;
```

The enabling occurs after the setting of world transformations because the shaders might need to access the current matrices (model-to-world, model-view, or projection).

The enabling in OpenGL for a vertex shader is listed next. The pixel shader has nearly identical code.

```
void OpenGLRenderer::EnableShader (VertexShader* pkVShader)
{
    glEnable(GL_VERTEX_PROGRAM_ARB);

    GLuint uiID;
    pkVShader->BIArray.GetID(this,sizeof(GLuint),&uiID);
    if ( uiID != 0 )
    {
        // shader already exists in OpenGL, just bind it
        glBindProgramARB(GL_VERTEX_PROGRAM_ARB,uiID);
    }
    else
    {
        // shader seen first time, compile it
```

```
        glGenProgramsARB((GLsizei)1,&uiID);
        glBindProgramARB(GL_VERTEX_PROGRAM_ARB,uiID);

        const char* acProgram = pkVShader->GetProgram();
        glProgramStringARB(GL_VERTEX_PROGRAM_ARB,
            GL_PROGRAM_FORMAT_ASCII_ARB,(GLsizei)strlen(acProgram),
            acProgram);

        pkVShader->BIArray.Bind(this,sizeof(GLuint),&uiID);
    }

    int iCQuantity = pkVShader->GetConstantQuantity();
    for (int i = 0; i < iCQuantity; i++)
    {
        // get a constant
        ShaderConstantPtr spkConstant = pkVShader->GetConstant(i);
        int iSCType = spkConstant->GetSCType();

        // numerical constants are handled automatically by openGL
        if ( iSCType == ShaderConstant::SC_NUMERICAL_CONSTANT )
            continue;

        // constant is based on render state
        int iOption = spkConstant->GetSCOption();
        float* afData = spkConstant->Data();
        if ( iSCType != ShaderConstant::SC_USER_DEFINED )
            (this->*ms_aoSCFunction[iSCType])(iOption,afData);

        // constant is user defined
        int iRQuantity = spkConstant->GetRegisterQuantity();
        int iRegister = spkConstant->GetRegister();
        for (int j = 0; j < iRQuantity; j++)
        {
            glProgramLocalParameter4fvARB(GL_VERTEX_PROGRAM_ARB,
                iRegister+j,&afData[4*j]);
        }
    }
}
```

The first large block of code checks if the shader has been encountered for the first time. If so, the graphics API is given it to compile, and you get a unique identifier to be stored in the VertexShader object. If the shader is encountered again, the unique identifier tells OpenGL that the shader is already compiled and in VRAM, so there

is nothing to do except bind it. This is the same mechanism used for textures and cached arrays.

The second large block of code is the processing of shader constants. Numerical constants in the shader program are handled automatically by OpenGL, so nothing needs to be done with them. On the other hand, the Direct3D renderer must be told about the numerical constants, even though they are stored in the program itself. If the constant is user defined, the data array of the constant is passed to OpenGL via the function `glProgramLocalParameter4fvARB`.

If the constant is a state constant, the data array needs to be filled in with the current state information before it is passed to `glProgramLocalParameter4fvARB`. How the array gets filled depends on the type of the constant and the option (if any) as specified by the `m_iSCType` and `m_iSCOption` variables in `ShaderConstant`. There are a lot of types and options. Rather than have a large `switch` statement in the code, I chose to implement a set of functions, each one handling a type. The functions are stored in a static array of function pointers, `ms_aoSCFunction`, so that the function lookup is $O(1)$ time.[2] The interface for this mechanism is

```
class Renderer
{
protected:
    virtual void SetConstantTransformM (int, float*) = 0;
    virtual void SetConstantTransformP (int, float*) = 0;
    virtual void SetConstantTransformMV (int, float*) = 0;
    virtual void SetConstantTransformMVP (int, float*) = 0;
    void SetConstantCameraPosition (int, float*);
    void SetConstantCameraDirection (int, float*);
    void SetConstantCameraUp (int, float*);
    void SetConstantCameraRight (int, float*);
    void SetConstantFogColor (int, float*);
    void SetConstantFogParams (int, float*);
    void SetConstantMaterialEmissive (int, float*);
    void SetConstantMaterialAmbient (int, float*);
    void SetConstantMaterialDiffuse (int, float*);
    void SetConstantMaterialSpecular (int, float*);
    void SetConstantMaterialShininess (int, float*);
    void SetConstantLightPosition (int, float*);
    void SetConstantLightDirection (int, float*);
    void SetConstantLightAmbient (int, float*);
    void SetConstantLightDiffuse (int, float*);
    void SetConstantLightSpecular (int, float*);
```

2. If you had a `switch` statement with n cases, and each case is equally likely to occur, the time of locating the correct case is $O(n)$. You expect that, on average, you will use $n/2$ units of time searching through the cases.

```
    void SetConstantLightSpotCutoff (int, float*);
    void SetConstantLightAttenParams (int, float*);

    typedef void (Renderer::*SetConstantFunction)(int,float*);
    static SetConstantFunction
        ms_aoSCFunction[ShaderConstant::SC_QUANTITY];
};
```

The number of functions is exactly SC_QUANTITY, and the static array is assigned the function pointers in Wm3Renderer.cpp. The first input to the function is the option value. The second input is a pointer to the data array of the shader constant. The first four functions are pure virtual because access to the matrices of the graphics system is specific to the graphics API. The remaining functions have access to the appropriate state from Renderer (the camera member) and Geometry (global state and lights). A couple of typical functions are

```
void Renderer::SetConstantCameraPosition (int, float* afData)
{
    Vector3f kWLocation = m_pkCamera->GetWorldLocation();
    afData[0] = kWLocation.X();
    afData[1] = kWLocation.Y();
    afData[2] = kWLocation.Z();
    afData[3] = 1.0f;
}

void Renderer::SetConstantFogParams (int, float* afData)
{
    FogState* pkFog = StaticCast<FogState>(
        m_pkGeometry->States[GlobalState::FOG]);
    afData[0] = pkFog->Start;
    afData[1] = pkFog->End;
    afData[2] = pkFog->Density;
    afData[3] = ( pkFog->Enabled ? 1.0f : 0.0f );
}

void Renderer::SetConstantLightDiffuse (int iOption, float* afData)
{
    Light* pkLight = m_pkGeometry->Lights[iOption];
    assert( pkLight );

    if ( pkLight && pkLight->On )
    {
        afData[0] = pkLight->Diffuse.R();
        afData[1] = pkLight->Diffuse.G();
```

```
            afData[2] = pkLight->Diffuse.B();
            afData[3] = pkLight->Diffuse.A();
        }
        else
        {
            afData[0] = 0.0f;
            afData[1] = 0.0f;
            afData[2] = 0.0f;
            afData[3] = 1.0f;
        }
    }
}
```

The SetConstantTransform* functions in the OpenGL renderer access the model-to-world matrix directly from m_afWorldMatrix. This matrix is current because the EnableShader calls occur after the SetWorldTransformation call in DrawShader. The model-view and projection matrices are read from the OpenGL API via calls to glGet-Floatv using the appropriate input flags. It is important to remember that OpenGL represents matrices differently than Wild Magic. The SetConstantTransform* calls do the right thing in making sure the final matrices are in the format OpenGL expects.

5.2.3 AUTOMATIC SOURCE CODE GENERATION

Wild Magic version 2 used nVidia's Cg Toolkit to generate the low-level shader programs from those written in the Cg language. The toolkit produces output for both Direct3D and OpenGL. The engine came with a program called CgConverter that used the Cg Toolkit to process shader programs and write both renderers' outputs to a single file. The vertex shaders were written to files with extension wvs, and the pixel shaders were written to files with extension wps. The engine had code to load these files and allow you to access shader constants by string names.

I chose an alternate approach for Wild Magic version 3. A tool has been added, called CgToWm3, that automatically generates Wild Magic source code. The input is a vertex or pixel shader (or both) written in the Cg language. The output consists of classes for the shaders and a corresponding shader effect. For example, the TestCharcoalEffect sample application was automatically generated (except for the application files). The Cg file is charcoal.cg and contains both a vertex shader and a pixel shader; the code generation produces classes CharcoalVShader (derived from VertexShader), CharcoalPShader (derived from PixelShader), and CharcoalEffect (derived from ShaderEffect). As long as the shader constant naming conventions are adhered to, you will see class member data and functions named in the style that the rest of the engine uses.

Of course, you are not obligated to use Cg or generate source code automatically. The descriptions in previous sections are enough to show you how to write your own source from the assembly-like shader programs.

COLLISION DETECTION

The topic of collision detection is quite popular these days, especially regarding physics engines that attempt to simulate physically correct behavior of two colliding objects. The physics engine uses a *collision detection system* to determine the physical constraints and then uses a *collision response system* to change the motion of the colliding objects. The book [Ebe00] discusses only collision detection. In this chapter, I will talk about collision detection algorithms that are implemented in Wild Magic.

The black-box physics system that relies solely on the collision detection system to detect the constraints for solving the Newtonian equations of motion is what many practitioners think of as a physics engine. In fact, an engine can be based on a much broader foundation, including using known constraints to determine the Lagrangian equations of motion. Usually the reduction of dimensionality via known constraints leads to equations of motion that have better stability when solving numerically, especially in physical systems that model frictional forces. The book [Ebe03a] discusses the concepts you will find in any physical simulation. Chapter 7 discusses the support in Wild Magic for a small number of these ideas.

The nature of collision detection algorithms depends on the types of objects involved and what information is needed by the caller of a collision detection query. I choose to categorize collision detection algorithms according to the following broad categories:

1. *Stationary objects*. Both objects are not moving.

 (a) *Test-intersection queries*. Determine if the two objects are intersecting. The algorithms need only determine if the objects are intersecting, not what the set of intersection is.

(i) Use an intersection-based method?

(ii) Use a distance-based method?

(b) *Find-intersection queries.* Determine the intersection set of the objects. This set is the empty set when the objects are not intersecting.

(i) Use an intersection-based method?

(ii) Use a distance-based method?

2. *Moving objects.* One or both objects are moving. If both are moving, you may subtract the velocity of the first from the velocity of the second and handle the problem as if one object is stationary and the other is moving. Invariably, the application will limit the time interval over which the intersection query applies, say, $[0, t_{max}]$ for some user-specified $t_{max} > 0$. If the objects intersect during that time interval, they will intersect at a first time $t_{first} \in [0, t_{max}]$, called the *contact time*. The set of intersection at the first time is called the *contact set*.

(a) *Test-intersection queries.* Determine if the two objects will intersect during the time interval. The algorithms need only determine if the objects will intersect. The contact time might not be needed by the application. Since it is a natural consequence of the intersection algorithm, it is usually returned to the caller anyway. The query does not involve computing the contact set.

(i) Use an intersection-based method?

(ii) Use a distance-based method?

(b) *Find-intersection queries.* Determine the contact time and contact set of the objects. This set is the empty set when the objects do not intersect during the time interval.

(i) Use an intersection-based method?

(ii) Use a distance-based method?

As you can see, even a general categorization leads to a lot of possibilities that a collision detection system must handle.

At the lowest level you must decide whether to use an *intersection-based method* or a *distance-based method*. The intersection-based method amounts to choosing representations for the two objects, equating them, and then solving for various parameters. For example, consider finding the intersection between a line and a plane. The line is represented parameterically as $\mathbf{X} = \mathbf{P} + t\mathbf{D}$, where \mathbf{P} is a point on the line, \mathbf{D} is a unit-length direction, and t is any real number. The plane is represented algebraically as $\mathbf{N} \cdot (\mathbf{X} - \mathbf{Q}) = 0$, where \mathbf{N} is a unit-length normal vector and \mathbf{Q} is some point on the plane. For \mathbf{X} to be on both the line and the plane, we need

$$\mathbf{N} \cdot (\mathbf{P} + t\mathbf{D} - \mathbf{Q}) = 0.$$

Define $\mathbf{\Delta} = \mathbf{Q} - \mathbf{P}$. As long as $\mathbf{N} \cdot \mathbf{D} \neq 0$, we may solve for

$$\bar{t} = \frac{\mathbf{N} \cdot \mathbf{\Delta}}{\mathbf{N} \cdot \mathbf{D}}. \tag{6.1}$$

The point of intersection is computed by substituting \bar{t} into the t-value of the line equation. If $\mathbf{N} \cdot \mathbf{D} = 0$, the line is either fully on the plane when $\mathbf{N} \cdot \boldsymbol{\Delta} = 0$ or disjoint from the plane otherwise.

A distance-based method uses a parametric representation of the plane as well as one for a line. Let $X(t) = \mathbf{P} + t\mathbf{D}$ be the parameterized point on the line. If \mathbf{Q} is a point on the plane and \mathbf{U} and \mathbf{V} are unit-length and orthogonal vectors in the plane, then a point on the plane is $\mathbf{Y}(r, s) = \mathbf{Q} + r\mathbf{U} + s\mathbf{V}$ for real numbers r and s. The squared distance between a point on the plane and a point on the line is

$$
\begin{aligned}
F(r, s, t) &= |\mathbf{Y}(r, s) - \mathbf{X}(t)|^2 \\
&= |\mathbf{Q} + r\mathbf{U} + s\mathbf{V} - \mathbf{P} - t\mathbf{D}|^2 \\
&= r^2 + s^2 + t^2 - 2rt\mathbf{U} \cdot \mathbf{D} - 2st\mathbf{V} \cdot \mathbf{D} + 2r\mathbf{U} \cdot \boldsymbol{\Delta} + \\
&\quad\, 2s\mathbf{V} \cdot \boldsymbol{\Delta} - 2t\mathbf{D} \cdot \boldsymbol{\Delta} + |\boldsymbol{\Delta}|^2 ,
\end{aligned}
$$

where $\boldsymbol{\Delta} = \mathbf{Q} - \mathbf{P}$. The distance between the plane and the line is attained by a triple (r, s, t) that minimizes $F(r, s, t)$. From calculus, F is a quadratic function whose minimum occurs when the gradient $\nabla F = (0, 0, 0)$. That is,

$$
\begin{aligned}
(0, 0, 0) &= \nabla F \\
&= \left(\frac{\partial F}{\partial r}, \frac{\partial F}{\partial s}, \frac{\partial F}{\partial t} \right) \\
&= 2(r - t\mathbf{U} \cdot \mathbf{D} + \mathbf{U} \cdot \boldsymbol{\Delta}, \, s - t\mathbf{V} \cdot \mathbf{D} + \mathbf{V} \cdot \boldsymbol{\Delta}, \\
&\quad\, t - r\mathbf{U} \cdot \mathbf{D} - s\mathbf{V} \cdot \mathbf{D} - \mathbf{D} \cdot \boldsymbol{\Delta}).
\end{aligned}
\tag{6.2}
$$

This is a linear system of equations in three unknowns. We may solve for the t value by substituting the first two equations into the third:

$$
\begin{aligned}
0 &= t - r\mathbf{U} \cdot \mathbf{D} - s\mathbf{V} \cdot \mathbf{D} - \mathbf{D} \cdot \boldsymbol{\Delta} \\
&= t - (t\mathbf{U} \cdot \mathbf{D} - \mathbf{U} \cdot \boldsymbol{\Delta})\mathbf{U} \cdot \mathbf{D} - (t\mathbf{V} \cdot \mathbf{D} + \mathbf{V} \cdot \boldsymbol{\Delta})\mathbf{V} \cdot \mathbf{D} - \mathbf{D} \cdot \boldsymbol{\Delta} \\
&= t(1 - (\mathbf{U} \cdot \mathbf{D})^2 - (\mathbf{V} \cdot \mathbf{D})^2) + (\mathbf{U} \cdot \boldsymbol{\Delta})(\mathbf{U} \cdot \mathbf{D}) + (\mathbf{V} \cdot \boldsymbol{\Delta})(\mathbf{V} \cdot \mathbf{D}) - \mathbf{D} \cdot \boldsymbol{\Delta}.
\end{aligned}
\tag{6.3}
$$

The vectors \mathbf{U}, \mathbf{V}, and \mathbf{N} form an orthonormal set. They may be used as a coordinate system to represent the line direction,

$$
\mathbf{D} = (\mathbf{D} \cdot \mathbf{U})\mathbf{U} + (\mathbf{D} \cdot \mathbf{V})\mathbf{V} + (\mathbf{D} \cdot \mathbf{N})\mathbf{N}.
$$

It is easily shown that

$$
1 = |\mathbf{D}|^2 = (\mathbf{D} \cdot \mathbf{U})^2 + (\mathbf{D} \cdot \mathbf{V})^2 + (\mathbf{D} \cdot \mathbf{N})^2,
$$

in which case

$$
1 - (\mathbf{U} \cdot \mathbf{D})^2 - (\mathbf{V} \cdot \mathbf{D})^2 = (\mathbf{D} \cdot \mathbf{N})^2.
\tag{6.4}
$$

Also,

$$\mathbf{D} \cdot \mathbf{\Delta} = (\mathbf{D} \cdot \mathbf{U})(\mathbf{U} \cdot \mathbf{\Delta}) + (\mathbf{D} \cdot \mathbf{V})(\mathbf{V} \cdot \mathbf{\Delta}) + (\mathbf{D} \cdot \mathbf{N})(\mathbf{N} \cdot \mathbf{\Delta}),$$

in which case

$$(\mathbf{U} \cdot \mathbf{\Delta})(\mathbf{U} \cdot \mathbf{D}) + (\mathbf{V} \cdot \mathbf{\Delta})(\mathbf{V} \cdot \mathbf{D}) = \mathbf{D} \cdot \mathbf{\Delta} - (\mathbf{D} \cdot \mathbf{N})(\mathbf{N} \cdot \mathbf{\Delta}). \qquad (6.5)$$

Substituting Equations (6.4) and (6.5) into Equation (6.3) leads to

$$0 = (\mathbf{N} \cdot \mathbf{D})[t\mathbf{N} \cdot \mathbf{D} - \mathbf{N} \cdot \mathbf{\Delta}].$$

As long as $\mathbf{N} \cdot \mathbf{D} \neq 0$, the solution to the equation is \bar{t}, the same solution as in Equation (6.1). Of course, this is to be expected! To solve for r and s, you can substitute \bar{t} into the t-values of the first two equations of (6.2), with the results denoted \bar{r} and \bar{s}. In the event the line and the plane intersect, you may verify that $F(\bar{r}, \bar{s}, \bar{t}) = 0$. If the line and the plane do not intersect, $F(\bar{r}, \bar{s}, \bar{t}) > 0$, which is the squared distance between the line and the plane.

Clearly the intersection-based approach is simple to design and implement because it uses only basic algebra. The distance-based approach is quite a bit more complicated and uses calculus. Why would you ever consider using the distance-based approach? For a line and a plane—never. However, consider the added complexity of computing an intersection between a line segment and a planar rectangle in three dimensions. The intersection of the line containing the line segment and the plane containing the rectangle does not help you decide immediately if the segment and the rectangle intersect. More work must be done. In particular, the line-plane intersection point must be tested for containment in the rectangle.

The distance-based approach is nearly identical to what was shown earlier. Suppose the line segment is parameterized by $\mathbf{P} + t\mathbf{D}$ for $|t| \leq t_0$ for some $t_0 > 0$. The point \mathbf{P} is the center of the segment in this representation. Assuming the rectangle has center \mathbf{Q} and axis directions \mathbf{U} and \mathbf{V}, the parameterization is $\mathbf{Q} + r\mathbf{U} + s\mathbf{V}$ for $|r| \leq r_0$ and $|s| \leq s_0$ for some $r_0 > 0$ and $s_0 > 0$. The minimization of $F(r, s, t)$ now occurs on the domain $(r, s, t) \in [-r_0, r_0] \times [-s_0, s_0] \times [-t_0, t_0]$. This might still appear to be heavy-handed compared to the intersection-based approach, but the mathematics of computing the minimization leads to an efficient implementation. Moreover, the idea extends to many types of object-object intersection queries.

Do I still hear some skepticism about ever using a distance-based approach? Consider the case of moving objects for which you want to know the first time of contact. The design and implementation of intersection-based algorithms can be difficult, depending on the type of objects. Moreover, you might try a bisection algorithm on the time interval of interest, $[0, t_{\max}]$. If the objects are not intersecting at time 0, but they are intersecting at time t_{\max}, you may test for an intersection at time $t_{\max}/2$. If the objects are intersecting at this time, you repeat the test at time $t_{\max}/4$. If the objects are not intersecting at this time, you repeat the test at time $3t_{\max}/4$. The subdivision of the time interval is repeated until you reach a maximum number of subdivisions (provided by the application) or until the width of the current time subinterval is

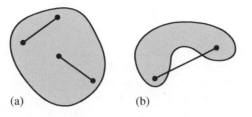

(a) (b)

Figure 6.1 (a) A convex object. No matter which two points you choose in the set, the line segment connecting them is in the set. (b) A nonconvex object. A pair of points in the set is shown for which the line segment connecting the points is not fully in the set.

small enough (threshold provided by the application). The fact that the subdivision is guided solely by the Boolean results at the time interval end points (intersecting or not intersecting) does not help you formulate a smarter search for the first contact time. A distance-based algorithm, on the other hand, gives you an idea of *how close* you are at any specified time, and this information supports a smarter search. This is the topic of Section 6.1. The general algorithm assumes only the existence of a distance calculator for each of the objects in the query, independent of the object type.

Intersection and distance algorithms for general objects can be extremely complicated. For that reason, practitioners restrict their attention to what are called *convex objects*. If S is a set of points representing the object, the set is said to be *convex* whenever the line segment connecting two points \mathbf{X} and \mathbf{Y} is contained in the set no matter which two points you choose. That is, if $\mathbf{X} \in S$ and $\mathbf{Y} \in S$, then $(1 - t)\mathbf{X} + t\mathbf{Y} \in S$ for all $t \in [0, 1]$. Figure 6.1 shows two planar objects, one convex and one not convex.

For objects that are not convex, a typical approach to computing intersection or distance is to decompose the object into a union of convex subobjects (not necessarily disjoint) and apply the intersection-based and/or distance-based queries to pairs of convex subobjects, with one subobject from each object in the intersection query.

Even with the restriction to convex objects, some object types are difficult to analyze in an intersection query. The algorithms tend to be easier to design and implement when one of the objects is a *linear component*—a line, a ray, or a line segment. Section 6.3 discusses line-object intersections. If both objects are not linear components, the algorithms can be much more complicated, both in design and in implementation. For example, computing the distance between two convex polyhedra is generally viewed as a difficult problem. The GJK algorithm is considered one of the best methods for solving this, but it is quite challenging to make it robust with floating-point arithmetic. A good book devoted to this topic is [vdB03]. Section 6.4 discusses object-object intersections, but the algorithms are limited to a small number of simple cases.

6.1 DISTANCE-BASED METHODS

The topic of this section is the computation of the contact time between two moving convex objects. The assumption is that you have a *distance calculator* for the pair of stationary objects, call it $d(A_0, A_1)$, where A_0 and A_1 are the objects and d is a function that computes *some measure of distance*. The natural measure is the true distance, but squared distance is acceptable as we will see. A *signed distance* is also allowed and provides strong information about the contact time. Whether or not you can obtain an accurate contact set, in addition to the contact time, depends on the object types. You might want only a subset of the contact set because the full set takes too many computational cycles to construct for a real-time application.

The motion itself can be complicated, making the analysis of $d(A_0, A_1)$ over time difficult. To simplify matters, I will assume that both A_0 and A_1 are rigid bodies moving with constant linear velocities \mathbf{V}_0 and \mathbf{V}_1, respectively. The notation $A_i(t) = A_i + t\mathbf{V}_i$ refers to the set of points that is initially the set A_i, but varies over time because of the velocity. For example, if A_i is the set of points for a line segment with center \mathbf{C}_i, unit-length direction \mathbf{U}_i, and extent $e_i > 0$, then

$$A_i = \{\mathbf{C}_i + s\mathbf{U}_i : |s| \le e_i\}.$$

The moving set is

$$A_i(t) = \{(\mathbf{C}_i + t\mathbf{V}_i) + s\mathbf{U}_i : |s| \le e_i\}.$$

The segment moves with constant linear velocity, but no angular velocity about its center. Generally, the time-varying distance function is

$$f(t) = d(A_0(t), A_1(t)) = d(A_0 + t\mathbf{V}_0, A_1 + t\mathbf{V}_1), \qquad t \in [0, t_{\max}]. \quad (6.6)$$

The contact time is the value $t_{\text{first}} \in [0, t_{\max}]$ for which $f(t_{\text{first}}) = 0$, but $f(t) > 0$ for $t \in [0, t_{\text{first}})$. It is possible that $t_{\text{first}} = 0$, in which case the objects are initially intersecting and the distance is zero. It is also possible that $f(t) > 0$ for all $t \in [0, t_{\max}]$, in which case the distance is always nonzero on the interval. The contact set C is the intersection of the two initial sets moved by their respective velocities to contact time:

$$C = (A_0 + t_{\text{first}}\mathbf{V}_0) \cap (A_1 + t_{\text{first}}\mathbf{V}_1). \quad (6.7)$$

Observe that we may reduce the problem to one stationary and one moving object by subtracting the velocity of the first object from the second. That is, let A_0 be stationary and use the velocity $\mathbf{V}_1 - \mathbf{V}_0$ for A_1. The distance function is

$$f(t) = d(A_0, A_1(t)) = d(A_0, A_1 + t(\mathbf{V}_1 - \mathbf{V}_0)). \quad (6.8)$$

The contact time in this situation will be the same as when both objects are moving, namely, t_{first}. However, if you compute the contact set, you must move the two initial

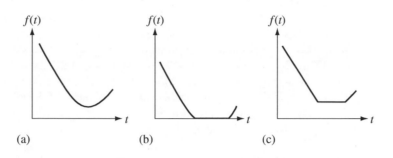

(a) (b) (c)

Figure 6.2 The graphs of $f(t)$ for three different point velocities. (a) The velocity is not parallel to any box axis, and the moving point does not intersect the box. (b) The velocity is not parallel to any box axis, and the moving point does intersect the box. (c) The velocity is parallel to a box axis, and the moving point does not intersect the box.

sets by their respective velocities, as mentioned previously. It is *not* the case that $C = A_0 \cap (A_1 + t_{\text{first}}(\mathbf{V}_1 - \mathbf{V}_0))$.

To illustrate the basic concepts, consider an example of a single point $A_0 = \{(x_0, y_0, z_0)\}$ with constant linear velocity $\mathbf{V} = (v_x, v_y, v_z)$ and a stationary axis-aligned box $A_1 = \{(x, y, z) : |x| \le e_x, |y| \le e_y, |z| \le e_z\}$. First, consider the squared-distance function for the point-box pair:

$$d^2(A_0, A_1) = d_x^2(A_0, A_1) + d_y^2(A_0, A_1) + d_z^2(A_0, A_1),$$

where

$$d_x^2 = \begin{cases} |x_0 - e_x|^2, & x_0 > e_x \\ 0, & |x_0| \le e_x \\ |x_0 + e_x|^2, & x_0 < -e_x \end{cases} \qquad d_y^2 = \begin{cases} |y_0 - e_y|^2, & y_0 > e_y \\ 0, & |y_0| \le e_y \\ |y_0 + e_y|^2, & y_0 < -e_y \end{cases}$$

$$d_z^2 = \begin{cases} |z_0 - e_z|^2, & z_0 > e_z \\ 0, & |z_0| \le e_z \\ |z_0 + e_z|^2, & z_0 < -e_z \end{cases}$$

The moving point has coordinates $\mathbf{P} + t\mathbf{V} = (x_0 + tv_x, y_0 + tv_y, z_0 + tv_z)$. These components replace those in the squared-distance equation to obtain a time-varying function $f(t)$. Figure 6.2 shows the graph of $f(t)$ for three different velocities of the point.

Figure 6.2(a) indicates that the minimum of $f(t)$ occurs at a single value of t. The path of the point is a straight line whose direction is not parallel to a box axis, so your imagination should make it clear why there is a single closest point on the line to the box. Figure 6.2(b) corresponds to the linear path passing directly through

the box. The squared-distance function $d^2(A_0, A_1)$ will report a distance of zero for any point on the segment of intersection between the linear path and the box. The horizontal section of the graph of $f(t)$ corresponds to the segment of intersection. Figure 6.2(c) corresponds to a linear path whose direction is parallel to a box axis, but the path does not intersect the box. Your imagination should convince you that the segment of intersection of the linear path and the box faces perpendicular to the path direction is a set of points *all equally close to the box*. The graph of $f(t)$ in Figure 6.2(c) has a horizontal section that corresponds to the segment of intersection.

A generic, numerical method that searches for the minimum of a function will be quite content with the graph in Figure 6.2(a). The same numerical method might be confused by the flatness of the other two graphs. In particular, if you are searching for a minimum distance of zero, the minimizer might very well locate one of the t-values that produces $f(t) = 0$, but that t-value is not t_{first}. Some numerical root finders will have similar problems with Figure 6.2(b). For example, a bisection routine could also locate a t-value where $f(t) = 0$, but it will not be the first such t-value. On the other hand, Newton's method with an initial guess of $t = 0$ should have no problems finding the first time of intersection because our restrictions that the objects be convex and the velocities be constant and linear cause $f(t)$ to be a *convex function*:

$$f((1-s)t_1 + st_2) \leq (1-s)f(t_1) + sf(t_2) \tag{6.9}$$

for $0 \leq s \leq 1$ and for any t_1 and t_2 in the domain of the function. Intuitively, the graph of f on the interval $[t_1, t_2]$ is always below the line segment connecting $(t_1, f(t_1))$ and $(t_2, f(t_2))$. If Newton's method is initiated at a value $t_0 < t_{\text{first}}$ for a convex function, the successive iterations t_i for $i \geq 1$ will also satisfy $t_i < t_{\text{first}}$. The flat spot to the right of t_{first} will not affect the iteration scheme.

Using the same example of a moving point and a box, suppose instead we have a measure of *signed distance*, or even a *pseudosigned distance*. The idea is that when the point is outside the box, the distance measurement is positive. When the point is inside the box, the distance measurement is negative. That measurement can be the negative of the distance from the point to a box face, or it can be a measurement that varies approximately like the distance. All that matters for contact time is that we can compute the time where distance is zero. The actual function value used for points inside the box do not have to actually be distances or signed distances. The signed-distance function is chosen to be the distance $d(A_0, A_1)$ whenever **P** is outside or on the box. If **P** is inside the box, the signed distance is

$$s(A_0, A_1) = -\min\{e_x - x_0, e_x + x_0, e_y - y_0, e_y + y_0, e_z - z_0, e_z + z_0\}.$$

Naturally, you may choose to use the signed, squared distances for $f(t)$. With signed distance, the root finding using something like bisection will be better behaved because the roots are isolated. However, the graph of $f(t)$ might still have flat spots, as illustrated in Figure 6.3. A flat spot can occur, for example, when the linear path of the point is parallel to a box axis and just intersects the box slightly inside one of the

Figure 6.3 Using signed distance, the function $f(t)$ has an isolated root at $t = t_{\text{first}}$, but still might have a flat spot.

nonperpendicular faces. The signed-distance function can *still* be zero on an entire interval of t-values, but this now happens when the linear path is coplanar with a box face. In situations like these, you should consider structuring your application to decide that the path does not intersect the box.[1]

6.1.1 A PLAN OF ATTACK

The issues discussed so far allow us to build a plan of attack for computing the distance between moving objects and for computing the contact time, if any. The three types of distancelike measurements we can use are distance, squared distance, or signed distance (or pseudosigned distance). I make use of the following information about our convex functions: They are piecewise differentiable, so the functions are not differentiable at only a few points. The minimum of such a function occurs either where its derivative is zero or where its derivative does not exist. In fact, there can be only one such point where either happens; call it t_c. For points $t < t_c$, either the derivative exists and is negative, $f'(t_c) < 0$, or the derivative does not exist. In the latter case, the one-sided derivatives are negative. Similarly, for $t > t_c$, either the derivative exists and is positive, $f'(t_c) > 0$, or the derivative does not exist. In the latter case, the one-sided derivatives are positive.

To compute the distance between moving objects, a numerical minimizer should be used. It does not matter which distancelike measurement you use. To compute the contact time, Newton's method is appropriate for any of the distancelike measurements as long as the initial guess is $t_0 = 0$. Because $f(t)$ is a convex function, the convergence is a sure thing. However, you need to have an implementation of the derivative function $f'(t)$, even if it is only defined piecewise. If you prefer to use

1. The distinction is between a *transverse intersection*, where the path direction takes the point strictly inside the box, and a *tangential* or *grazing intersection*, where the point never enters the interior of the box.

bisection for a guaranteed bounded number of iterations, you should use a signed-distance function. Bisection does not require derivative evaluations.

6.1.2 ROOT FINDING USING NEWTON'S METHOD

We are interested in computing the first time t_{first} for which $f(t_{\text{first}}) = 0$, but $f(t) > 0$ for $t \in [0, t_{\text{first}})$. Given an initial guess $t_0 = 0$, the iterates are

$$t_{i+1} = t_i - \frac{f(t_i)}{f'(t_i)}, \qquad i \ge 0,$$

where $f'(t)$ is the derivative of $f(t)$. I suggest iterating until one or more stopping conditions are met:

- The function value $f(t_i)$ is sufficiently close to zero. The threshold on zero is user defined.

- The domain value t_i has not changed much from t_{i-1}; that is, $|t_i - t_{i-1}|$ is sufficiently close to zero. The threshold on zero is user defined.

- A maximum number of iterations has been calculated. The maximum number is user defined.

Of course, if $f(t_0)$ is zero (within the threshold value), then the two objects are assumed to be initially intersecting. In this case, no iterates need to be generated and $t_{\text{first}} = 0$. If the process terminates because you have exceeded the maximum number of iterations, you should test the value of f at the last iterate to see how close it is to zero. If sufficiently larger than zero, the likelihood is that f does not have a zero on the original time interval, in which case the objects do not intersect during that interval.

6.1.3 ROOT FINDING USING BISECTION

A signed (or pseudosigned) distance function is assumed. Initially, set $t_0 = 0$ and $t_1 = t_{\text{max}}$. If $f(t_0) \le 0$ within the zero threshold value, then the objects are initially intersecting and $t_{\text{first}} = 0$. Otherwise, $f(t_0) > 0$ and the objects are not initially intersecting. If $f(t_1) < 0$, then there must be a contact time somewhere on the interval $[t_0, t_1]$. Compute $t_m = (t_0 + t_1)/2$ and evaluate $f(t_m)$. If $f(t_m) < 0$, the search continues by repeating the process on the subinterval $[t_0, t_m]$. If $f(t_m) > 0$, the search continues on the subinterval $[t_m, t_1]$. If $f(t_m) \le 0$ within the zero threshold, then t_m is labeled as the contact time. The number of subdivisions is user defined.

If $f(t_0) > 0$ and $f(t_1) > 0$, there is no guarantee that $f(t) = 0$ for some $t \in [t_0, t_1]$. Without any derivative information, I suggest that you repeat the bisection search on both subintervals $[t_0, t_m]$ and $[t_m, t_1]$. On any subintervals for which the function values at the end points multiply to a positive number, repeat the search on both

subintervals. If you ever find a subinterval $[t_0, t_1]$ where $f(t_0) > 0$ and $f(t_1) < 0$, only this subinterval should be searched further. If instead you find a subinterval where $f(t_0) < 0$ and $f(t_1) > 0$, then you should restrict your search for the contact time to subintervals with maximum value smaller than t_0—the current interval gives you a "last time of contact," when one object finally finishes passing through the other.

Your numerical method gets a big boost if you have derivative information. If you compute $f(t_0) > 0$ and $f(t_1) > 0$ and the one-sided derivatives at t_0 and t_1 are all positive, then it is not possible for the function to have a zero on $[t_0, t_1]$, so there is no reason to apply bisection and subdivide.

6.1.4 HYBRID ROOT FINDING

In order to obtain a robust algorithm for root finding, a blending of Newton's method and bisection is useful. The idea is simple. Starting on an interval $[t_{\min}, t_{\max}]$, let the initial value for Newton's method be $t_0 = t_{\min}$. Compute the next iterate, $t_1 = t_0 - f(t_0)/f'(t_0)$. If $t_1 \in [t_{\min}, t_{\max}]$, then accept the iterate and repeat the process. However, if $t_1 \notin [t_{\min}, t_{\max}]$, reject the iterate and apply a bisection step $t_1 = (t_{\min} + t_{\max})/2$. Determine which of the subintervals $[t_{\min}, t_1]$ or $[t_1, t_{\max}]$ bounds the root, and then repeat the process on that subinterval.

6.1.5 AN ABSTRACT INTERFACE FOR DISTANCE CALCULATIONS

Okay, I threatened not to include much mathematics in this book. The previous discussion is a motivation about the support I have added to Wild Magic for computing distance between moving objects and determining the contact time. The base class is an abstract interface for computing distance:

```
template <class Real>
class Distance
{
public:
    // abstract base class
    virtual ~Distance ();

    // Static distance queries.  The defaults return MAX_REAL.
    virtual Real Get ();          // distance
    virtual Real GetSquared ();   // squared distance
    virtual Real GetSigned ();    // signed distance

    // Dynamic distance queries.  The function computes the
    // smallest distance between the two objects over the time
    // interval [0,tmax].  If the Boolean input is 'true', the
    // contact time is computed when the distance
```

```
//    d <= ZeroThreshold, and is available via GetContactTime().
// The defaults return MAX_REAL.

virtual Real Get (Real fTMax,
    const Vector3<Real>& rkVelocity0,
    const Vector3<Real>& rkVelocity1,
    bool bComputeContactTime);

virtual Real GetSquared (Real fTMax,
    const Vector3<Real>& rkVelocity0,
    const Vector3<Real>& rkVelocity1,
    bool bComputeContactTime);

virtual Real GetSigned (Real fTMax,
    const Vector3<Real>& rkVelocity0,
    const Vector3<Real>& rkVelocity1,
    bool bComputeContactTime);

// Derivative calculations for dynamic distance queries.  The
// defaults use finite difference estimates
//    f'(t) = (f(t+h)-f(t-h))/(2*h)
// where h = DifferenceStep.  A derived class may override
// these and provide implementations of exact formulas that
// do not require h.

virtual Real GetDerivative (Real fT,
    const Vector3<Real>& rkVelocity0,
    const Vector3<Real>& rkVelocity1);

virtual Real GetDerivativeSquared (Real fT,
    const Vector3<Real>& rkVelocity0,
    const Vector3<Real>& rkVelocity1);

virtual Real GetDerivativeSigned (Real fT,
    const Vector3<Real>& rkVelocity0,
    const Vector3<Real>& rkVelocity1);

// numerical method for root finding
enum
{
    NM_NEWTONS,    // root finding for f(t) or f'(t)
    NM_BISECTION,  // root finding for f(t) or f'(t)
    NM_HYBRID,     // mixture of Newton's and bisection
};
```

```
    int RootFinder;       // default = NM_NEWTONS
    int MaximumIterations;  // default = 8
    Real ZeroThreshold;    // default = Math<Real>::ZERO_TOLERANCE
    Real DifferenceStep;   // default = 1e-03

    // The time at which minimum distance occurs for the dynamic
    // queries.
    Real GetContactTime () const;

    // Closest points on the two objects.  These are valid for
    // static or dynamic queries.  The set of closest points on a
    // single object need not be a single point.  In this case, the
    // Boolean member functions return 'true'.  A derived class
    // may support querying for the full contact set.
    const Vector3<Real>& GetClosestPoint0 () const;
    const Vector3<Real>& GetClosestPoint1 () const;
    bool HasMultipleClosestPoints0 () const;
    bool HasMultipleClosestPoints1 () const;

protected:
    Distance ();

    // root finders for f(t) = 0
    Real ComputeFRootNewtons (Real fTMax,
        const Vector3<Real>& rkVelocity0,
        const Vector3<Real>& rkVelocity1);

    Real ComputeFRootBisection (Real fTMax,
        const Vector3<Real>& rkVelocity0,
        const Vector3<Real>& rkVelocity1);

    Real ComputeFRootHybrid (Real fTMax,
        const Vector3<Real>& rkVelocity0,
        const Vector3<Real>& rkVelocity1);

    // root finders for f'(t) = 0
    Real ComputeDFRootNewtons (Real fTMax,
        const Vector3<Real>& rkVelocity0,
        const Vector3<Real>& rkVelocity1);

    Real ComputeDFRootBisection (Real fTMax,
        const Vector3<Real>& rkVelocity0,
        const Vector3<Real>& rkVelocity1);
```

```
Real ComputeDFRootHybrid (Real fTMax,
    const Vector3<Real>& rkVelocity0,
    const Vector3<Real>& rkVelocity1);

Real m_fContactTime;
Vector3<Real> m_kClosestPoint0;
Vector3<Real> m_kClosestPoint1;
bool m_bHasMultipleClosestPoints0;
bool m_bHasMultipleClosestPoints1;
};
```

The only constructor is protected, so the class is abstract. The function Get() computes the true distance between the objects. The function GetSquared() computes the squared distance between the objects. In most implementations, the squared distance is computed first, and the true distance obtained by a square root operation. The function GetSigned() computes the signed (or pseudosigned) distance between the objects. If this quantity is not well defined, as is the case for the distance from a point to a line, the true distance is returned.

The functions Get, GetSquared, and GetSigned that take the four inputs are used for dynamic distance queries. The maximum time for the interval is the first input. The velocities of the two objects are the second and third inputs. The minimum of $f(t)$ is computed by solving for $t_{\min} \in [0, t_{\max}]$, the time at which the one-sided derivatives of f' multiply to a nonpositive number. The root finder that you want to use is selected via the data member RootFinder (Newton's, bisection, or a hybrid).

The fourth input of these functions indicates whether or not you want the contact time computed. If you set this to true and the computed distancelike function is zero (within the zero threshold) or negative at some time $t_{\min} \in [0, t_{\max}]$, then the root finder of choice (Newton's, bisection, or a hybrid) is used to locate the contact time $t_{\text{first}} \in [0, t_{\min}]$, the smallest root for $f(t) = 0$. The contact time is returned via the member function GetContactTime. If the contact time does not exist on the specified time interval, GetContactTime returns Math<Real>::MAX_REAL.

The protected functions Compute* are the actual numerical methods for computing the roots of f and f'. The functions GetClosest* return a pair of closest points, one on each of the objects. If an object has a set of closest points containing more than one element, the Boolean function HasMultipleClosestPoints* returns true. The derived class may or may not implement an interface that allows you to access the entire contact set.

6.2 INTERSECTION-BASED METHODS

As noted previously, the intersection-based methods generally involve setting up some algebraic equations involving various parameters in the object representations and then solving those equations in closed form. The example I used was quite

simple, computing the intersection of a line and a plane. The line is parameterized by $\mathbf{X}(t) = \mathbf{P} + t\mathbf{D}$, and the plane is implicitly defined by $\mathbf{N} \cdot (\mathbf{X} - \mathbf{Q}) = 0$. Replacing the line equation into the plane equation, you may solve symbolically for $t = (\mathbf{N} \cdot \boldsymbol{\Delta})/(\mathbf{N} \cdot \mathbf{D})$, where $\boldsymbol{\Delta} = \mathbf{Q} - \mathbf{P}$, with care taken when the denominator is zero or close to zero.

A slightly more complicated example is to compute the intersection of a triangle with vertices \mathbf{P}_i, $0 \le i \le 2$, and a plane $\mathbf{N} \cdot (\mathbf{X} - \mathbf{Q}) = 0$. The algorithm involves determining where the vertices of the triangle are relative to the plane. If all three vertices are strictly on one side of the plane, there is no intersection. If \mathbf{P}_0 and \mathbf{P}_1 are on opposite sides of the plane, then the edge $\langle \mathbf{P}_0, \mathbf{P}_1 \rangle$ intersects the plane at a point \mathbf{I}_0. One of the other two triangle edges must also intersect the plane, say, at \mathbf{I}_1. The line segment $\langle \mathbf{I}_0, \mathbf{I}_1 \rangle$ is the set of intersection.

Yet more complicated is computing the intersection of two triangles. For the most popular algorithm, see [Möl97]. In a nutshell, when the two triangles are not parallel and not coplanar, the method computes the line segment of intersection of the first triangle with the plane of the second triangle. The line segment is trimmed to the subsegment that is contained in the second triangle.

The analysis is generally more complicated when the objects are moving. An extreme case is when you have two moving objects that are convex polyhedra. A find-intersection query must first determine the contact time. At that time the polyhedra are just touching, but without interpenetration. If you are to move the objects by their velocities using the contact time, you can construct the contact set. This set can be a single point, a line segment, or a convex polygon. The latter case occurs when the two polyhedra are in face-face contact. The two faces are convex and coplanar polygons. Within the common plane you need to compute the intersection of two convex polygons, an algorithm that is tractable but that takes some effort to implement in an efficient manner.

If you leave the realm of convex polyhedra, all bets are off regarding simplicity (or complexity), even if the objects are convex. For example, consider the difficulties of computing the set of intersection of two bounded cylinders. Even a test-intersection query is challenging. A discussion of this algorithm using the method of separating axes is in [SE02]. The worst case for separation is that you have to compute the roots of a fourth-degree polynomial. The test-intersection query for two ellipsoids requires computing the roots of a sixth-degree polynomial.

A collision detection library with support for many object types and both test- and find-intersection queries, whether the objects are stationary or moving, will be one very large chunk of source code! Not much in common can be factored out of the specific queries.

6.2.1 An Abstract Interface for Intersection Queries

The abstract interface that supports intersection queries is fairly small compared to that for distance. The class is `Intersector`:

```
template <class Real>
   class Intersector
   {
   public:
      // abstract base class
      virtual ~Intersector ();

      // Static intersection queries.  The default implementations
      // return 'false'.  The Find query produces a set of
      // intersection.  The derived class is responsible for
      // providing access to that set, since the nature of the set
      // is dependent on the object types.
      virtual bool Test ();
      virtual bool Find ();

      // Dynamic intersection queries.  The default implementations
      // return 'false'.  The Find query produces a set of first
      // contact.  The derived class is responsible for providing
      // access to that set, since the nature of the set is dependent
      // on the object types.  The first time of contact is managed
      // by this class.

      virtual bool Test (Real fTMax,
         const Vector3<Real>& rkVelocity0,
         const Vector3<Real>& rkVelocity1);

      virtual bool Find (Real fTMax,
         const Vector3<Real>& rkVelocity0,
         const Vector3<Real>& rkVelocity1);

      // The time at which two objects are in first contact for the
      // dynamic intersection queries.
      Real GetContactTime () const;

   protected:
      Intersector ();

      Real m_fContactTime;
   };
```

The interface supports the top-level queries. The method Test() supports the test-intersection query for stationary objects, and the method Find() supports the find-intersection query for stationary objects. The methods Test and Find whose inputs are the maximum time for the interval and the velocities of the objects support

the test- and find-intersection queries for moving objects. Many of the derived classes may very well implement the queries using distance-based methods. Unlike the interface `Distance`, there are no natural base-class functions that apply to all intersection cases. The majority of the work goes into the `Intersector`-derived classes.

6.3 LINE-OBJECT INTERSECTION

When one of the objects in an intersection query is a *linear component*, that is, either a line, a ray, or a line segment, the algorithm design tends to require a minimum of algebra and the implementation tends to be straightforward.

We have already seen the simplicity in computing the intersection of a line and a plane. If the line is $\mathbf{X}(t) = \mathbf{P} + t\mathbf{D}$ and the plane is $\mathbf{N} \cdot (\mathbf{X} - \mathbf{Q}) = 0$, and if the line is not parallel to the plane, then $t = (\mathbf{N} \cdot \mathbf{\Delta})/(\mathbf{N} \cdot \mathbf{D})$, where $\mathbf{\Delta} = \mathbf{Q} - \mathbf{P}$. Suppose now that all you had was a ray, where $t \geq 0$ is a constraint. The intersection algorithm still amounts to computing the t-value as shown, but you must test to see if $t \geq 0$. If it is, then the ray intersects the plane. If it is not, then no intersection occurs. Similarly, if you have a segment, where $t \in [t_0, t_1]$, then t is computed as shown, but you must test if it is in the specified interval. If it is, the segment intersects the plane. If not, there is no intersection.

A few objects of interest to intersect with a linear component are triangles, spheres, and oriented bounding boxes. Triangles are of interest because they are the basis for triangle meshes, of which most of the scene graph data is built from. Applications invariably have a need for computing the intersection of a linear component with a triangle mesh. I describe three such examples in this section: picking, terrain following, and collision avoidance.

If the triangle meshes are part of a scene hierarchy, it is possible to cull meshes from consideration if their bounding volumes are not intersected by the linear component. Hierarchical culling of this type can provide a significant increase in performance. The system requires test-intersection queries between linear components and bounding volumes and find-intersection queries between linear components and triangles. Both queries are discussed in this section.

6.3.1 INTERSECTIONS BETWEEN LINEAR COMPONENTS AND TRIANGLES

Let the linear component be represented parametrically by $\mathbf{X}(t) = \mathbf{P} + t\mathbf{D}$, where \mathbf{D} is a unit-length vector. There is no restriction for t if the component is a line, but $t \geq 0$ for a ray and $t \in [t_0, t_1]$ for a segment. The triangle has vertices \mathbf{V}_i for $0 \leq i \leq 2$. Points in the triangle are represented by barycentric coordinates,

$$b_0\mathbf{V}_0 + b_1\mathbf{V}_1 + b_2\mathbf{V}_2 = \mathbf{V}_0 + b_1\mathbf{E}_1 + b_2\mathbf{E}_2,$$

where $b_0 + b_1 + b_2 = 1$; $\mathbf{E}_1 = \mathbf{V}_1 - \mathbf{V}_0$, $\mathbf{E}_2 = \mathbf{V}_2 - \mathbf{V}_0$; and $0 \leq b_1$, $0 \leq b_2$, and $b_1 + b_2 \leq 1$. Equating the two representations, and defining $\mathbf{Q} = \mathbf{P} - \mathbf{V}_0$, we have

$$\mathbf{Q} + t\mathbf{D} = b_1\mathbf{E}_1 + b_2\mathbf{E}_2. \tag{6.10}$$

This is a system of three equations in the three unknowns t, b_1, and b_2. Although we could set up the matrices for the system and solve it using a standard numerical solver for linear systems, let us solve it instead using vector algebra. Define $\mathbf{N} = \mathbf{E}_1 \times \mathbf{E}_2$. Apply the cross product of \mathbf{E}_2 to Equation (6.10) to obtain

$$\mathbf{Q} \times \mathbf{E}_2 + t\mathbf{D} \times \mathbf{E}_2 = b_1\mathbf{E}_1 \times \mathbf{E}_2 + b_2\mathbf{E}_2 \times \mathbf{E}_2.$$

This reduces to

$$\mathbf{Q} \times \mathbf{E}_2 + t\mathbf{D} \times \mathbf{E}_2 = b_1\mathbf{N}.$$

Dot this equation with \mathbf{D} to obtain

$$\mathbf{D} \cdot \mathbf{Q} \times \mathbf{E}_2 + t\mathbf{D} \cdot \mathbf{D} \times \mathbf{E}_2 = b_1\mathbf{D} \cdot \mathbf{N}.$$

This reduces to

$$\mathbf{D} \cdot \mathbf{Q} \times \mathbf{E}_2 = b_1\mathbf{D} \cdot \mathbf{N}.$$

Assuming the triangle and line are not parallel, $\mathbf{D} \cdot \mathbf{N} \neq 0$ and

$$b_1 = \frac{\mathbf{D} \cdot \mathbf{Q} \times \mathbf{E}_2}{\mathbf{D} \cdot \mathbf{N}}. \tag{6.11}$$

Similarly, apply the cross product with \mathbf{E}_1 on the left of the terms in Equation (6.10), and then dot the result with \mathbf{D} to obtain

$$b_2 = \frac{\mathbf{D} \cdot \mathbf{E}_1 \times \mathbf{Q}}{\mathbf{D} \cdot \mathbf{N}}. \tag{6.12}$$

Finally, apply a dot product with \mathbf{N} to Equation (6.10) and solve for

$$t = \frac{-\mathbf{Q} \cdot \mathbf{N}}{\mathbf{D} \cdot \mathbf{N}}. \tag{6.13}$$

Equations (6.11), (6.12), and (6.13) are the parameters for the point of intersection of a line with the triangle. If the linear component is a ray, then you must test if $t \geq 0$. If it is, then the ray intersects the triangle in the same point that the line does. If it is not, there is no intersection. If the linear component is a segment, then you must test if $t \in [t_0, t_1]$. If it is, then the segment intersects the triangle in the same point that the line does. If it is not, there is no intersection.

When the line and triangle are coplanar, I choose to label the configuration as no intersection. The implementations are architected to minimize the operations that are performed. In particular, if some of the partial results allow you to conclude that the point of intersection is outside the triangle, there is no reason to complete the computations. The intersection query can directly report that there is no intersection. The test-intersection query avoids any divisions. The find-intersection query defers the divisions by $\mathbf{D} \cdot \mathbf{N}$ until they are absolutely needed. The test-intersection query for a line and a triangle is

```
template <class Real>
bool IntrLine3Triangle3<Real>::Test ()
{
    // compute the offset origin, edges, and normal
    Vector3<Real> kDiff = m_rkLine.Origin - m_rkTriangle.V0;
    Vector3<Real> kEdge1 = m_rkTriangle.V1 - m_rkTriangle.V0;
    Vector3<Real> kEdge2 = m_rkTriangle.V2 - m_rkTriangle.V0;
    Vector3<Real> kNormal = kEdge1.Cross(kEdge2);

    // Solve Q + t*D = b1*E1 + b2*E2 (Q = kDiff, D = line direction,
    // E1 = kEdge1, E2 = kEdge2, N = Cross(E1,E2)) by
    //   |Dot(D,N)|*b1 = sign(Dot(D,N))*Dot(D,Cross(Q,E2))
    //   |Dot(D,N)|*b2 = sign(Dot(D,N))*Dot(D,Cross(E1,Q))
    //   |Dot(D,N)|*t = -sign(Dot(D,N))*Dot(Q,N)
    Real fDdN = m_rkLine.Direction.Dot(kNormal);
    Real fSign;
    if ( fDdN > Math<Real>::ZERO_TOLERANCE )
    {
        fSign = (Real)1.0;
    }
    else if ( fDdN < -Math<Real>::ZERO_TOLERANCE )
    {
        fSign = (Real)-1.0;
        fDdN = -fDdN;
    }
    else
    {
        // Line and triangle are parallel, call it a "no
        // intersection" even if the line does intersect.
        return false;
    }

    Real fDdQxE2 = fSign*m_rkLine.Direction.Dot(
        kDiff.Cross(kEdge2));
```

```
        if ( fDdQxE2 >= (Real)0.0 )
        {
            Real fDdE1xQ = fSign*m_rkLine.Direction.Dot(
                kEdge1.Cross(kDiff));
            if ( fDdE1xQ >= (Real)0.0 )
            {
                if ( fDdQxE2 + fDdE1xQ <= fDdN )
                {
                    // line intersects triangle
                    return true;
                }
                // else: b1+b2 > 1, no intersection
            }
            // else: b2 < 0, no intersection
        }
        // else: b1 < 0, no intersection

        return false;
}
```

To avoid the divisions, observe that the tests $b_1 \geq 0$, $b_2 \geq 0$, and $b_1 + b_2 \leq 1$ are replaced by $|\mathbf{D} \cdot \mathbf{N}|b_1 \geq 0$, $|\mathbf{D} \cdot \mathbf{N}|b_2 \geq 0$, and $|\mathbf{D} \cdot \mathbf{N}|(b_1 + b_2) \leq |\mathbf{D} \cdot \mathbf{N}|$. The find-intersection query is similar in structure, but computes the point of intersection if there is one.

```
template <class Real>
bool IntrLine3Triangle3<Real>::Find ()
{
    Vector3<Real> kDiff = m_rkLine.Origin - m_rkTriangle.V0;
    Vector3<Real> kEdge1 = m_rkTriangle.V1 - m_rkTriangle.V0;
    Vector3<Real> kEdge2 = m_rkTriangle.V2 - m_rkTriangle.V0;
    Vector3<Real> kNormal = kEdge1.Cross(kEdge2);

    Real fDdN = m_rkLine.Direction.Dot(kNormal);
    Real fSign;
    if ( fDdN > Math<Real>::ZERO_TOLERANCE )
    {
        fSign = (Real)1.0;
    }
    else if ( fDdN < -Math<Real>::ZERO_TOLERANCE )
    {
        fSign = (Real)-1.0;
        fDdN = -fDdN;
    }
```

```
        else
        {
            return false;
        }

    Real fDdQxE2 = fSign*m_rkLine.Direction.Dot(
        kDiff.Cross(kEdge2));
    if ( fDdQxE2 >= (Real)0.0 )
    {
        Real fDdE1xQ = fSign*m_rkLine.Direction.Dot(
            kEdge1.Cross(kDiff));
        if ( fDdE1xQ >= (Real)0.0 )
        {
            if ( fDdQxE2 + fDdE1xQ <= fDdN )
            {
                // line intersects triangle
                Real fQdN = -fSign*kDiff.Dot(kNormal);
                Real fInv = ((Real)1.0)/fDdN;
                m_fLineT = fQdN*fInv;
                m_fTriB1 = fDdQxE2*fInv;
                m_fTriB2 = fDdE1xQ*fInv;
                m_fTriB0 = (Real)1.0 - m_fTriB1 - m_fTriB2;
                return true;
            }
            // else: b1+b2 > 1, no intersection
        }
        // else: b2 < 0, no intersection
    }
    // else: b1 < 0, no intersection

    return false;
}
```

The division by $\mathbf{D} \cdot \mathbf{N}$ is deferred until you know that the line does intersect the triangle. The two functions are methods of a class `IntrLine3Triangle3` that is derived from the abstract interface `Intersector`. The derived class stores the line t-value and the triangle (b_0, b_1, b_2) values for access by the application. These may be used to compute the point of intersection. The class for ray-triangle intersection is `IntrRay3Triangle3`, and the class for segment-triangle intersection is `IntrSegment3Triangle3`. Both classes have similar `Test` and `Find` member functions, but with the extra tests on the computed t-value to see if it meets the constraints for a ray or for a segment.

6.3.2 INTERSECTIONS BETWEEN LINEAR COMPONENTS AND BOUNDING VOLUMES

The two main bounding volumes used in the engine are spheres and oriented bounding boxes. In this section I will discuss the test-intersection and find-intersection queries for both types of bounding volumes.

Spheres

The usual parameterization is used for a linear component, $\mathbf{X}(t) = \mathbf{P} + t\mathbf{D}$ for a unit-length vector \mathbf{D}. The sphere has center \mathbf{C}, radius r, and is defined implicitly by $|\mathbf{X} - \mathbf{C}| = r$.

To compute the points of intersection, if any, between a line and a sphere, replace the parametric line equation into the squared-sphere equation to obtain

$$0 = |\mathbf{X} - \mathbf{C}|^2 - r^2 = |t\mathbf{D} + \mathbf{P} - \mathbf{C}|^2 - r^2 = |t\mathbf{D} + \mathbf{\Delta}|^2 - r^2$$

$$= t^2 + 2\mathbf{D} \cdot \mathbf{\Delta}t + |\mathbf{\Delta}|^2 - r^2. \tag{6.14}$$

The formal solutions are

$$t = -\mathbf{D} \cdot \mathbf{\Delta} \pm \sqrt{(\mathbf{D} \cdot \mathbf{\Delta})^2 - (|\mathbf{\Delta}|^2 - r^2)}.$$

The discriminant of the equation is $\delta = (\mathbf{D} \cdot \mathbf{\Delta})^2 - (|\mathbf{\Delta}|^2 - r^2)$. If $\delta > 0$, the quadratic equation has two distinct, real-valued roots. The line intersects the sphere in two points. If $\delta = 0$, the quadratic equation has a single repeated, real-valued root. The line intersects the sphere in one point. If $\delta < 0$, the quadratic equation has no real-valued roots, and the line and sphere do not intersect. The find-intersection query is an implementation of this algorithm. Only if $\delta > 0$ do you compute the relatively expensive square root. The test-intersection query is simply a test on δ. If $\delta \geq 0$, the line and sphere intersect. Otherwise, they do not intersect. The test for $\delta \geq 0$ is equivalent to showing that the distance from the sphere center to the line is smaller or equal to the sphere radius.

The line-sphere intersection is handled by the class `IntrLine3Sphere3` that is derived from `Intersector`. The test-intersection query is

```
template <class Real>
bool IntrLine3Sphere3<Real>::Test ()
{
    Vector3<Real> kDiff = m_rkLine.Origin - m_rkSphere.Center;
    Real fA0 = kDiff.Dot(kDiff) -
        m_rkSphere.Radius*m_rkSphere.Radius;
    Real fA1 = m_rkLine.Direction.Dot(kDiff);
```

```
    Real fDiscr = fA1*fA1 - fA0;
    return fDiscr >= (Real)0.0;
}
```

and the line-sphere find-intersection query is

```
template <class Real>
bool IntrLine3Sphere3<Real>::Find ()
{
    Vector3<Real> kDiff = m_rkLine.Origin - m_rkSphere.Center;
    Real fA0 = kDiff.Dot(kDiff) -
        m_rkSphere.Radius*m_rkSphere.Radius;
    Real fA1 = m_rkLine.Direction.Dot(kDiff);
    Real fDiscr = fA1*fA1 - fA0;

    if ( fDiscr < (Real)0.0 )
    {
        m_iQuantity = 0;
    }
    else if ( fDiscr >= ZeroThreshold )
    {
        Real fRoot = Math<Real>::Sqrt(fDiscr);
        m_afLineT[0] = -fA1 - fRoot;
        m_afLineT[1] = -fA1 + fRoot;
        m_akPoint[0] = m_rkLine.Origin +
            m_afLineT[0]*m_rkLine.Direction;
        m_akPoint[1] = m_rkLine.Origin +
            m_afLineT[1]*m_rkLine.Direction;
        m_iQuantity = 2;
    }
    else
    {
        m_afLineT[0] = -fA1;
        m_akPoint[0] = m_rkLine.Origin +
            m_afLineT[0]*m_rkLine.Direction;
        m_iQuantity = 1;
    }

    return m_iQuantity > 0;
}
```

The find-intersection query computes the square root only when it is needed.

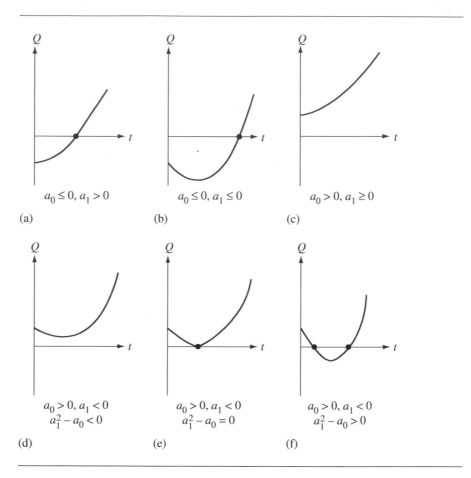

$a_0 \le 0, a_1 > 0$
(a)

$a_0 \le 0, a_1 \le 0$
(b)

$a_0 > 0, a_1 \ge 0$
(c)

$a_0 > 0, a_1 < 0$
$a_1^2 - a_0 < 0$
(d)

$a_0 > 0, a_1 < 0$
$a_1^2 - a_0 = 0$
(e)

$a_0 > 0, a_1 < 0$
$a_1^2 - a_0 > 0$
(f)

Figure 6.4 Possible graph configurations for a quadratic polynomial $Q(t)$ for $t \ge 0$.

For the ray-sphere test-intersection query, we could find the points of intersection for a line and sphere and then decide if either of the t-values are nonnegative. This involves computing a square root, an operation that can be avoided in the following way. Consider a quadratic equation $Q(t) = t^2 + 2a_1t + a_0$, the format of Equation (6.14). The ray intersects the sphere if $Q(t) = 0$ has one or two roots for $t \ge 0$. If $Q(0) \le 0$, the ray origin **P** is inside the sphere and the ray must intersect the sphere once. Accordingly, the graph of $Q(t)$ is a parabola that opens upwards. For large t, $Q(t)$ must be positive, so there is a root somewhere on the interval $(0, \infty)$. If $Q(0) > 0$, the ray origin is outside the sphere. If the graph of $Q(t)$ touches or crosses the horizontal axis, then $Q(t)$ has one root or two roots; otherwise, it has no roots. Figure 6.4 illustrates the possibilities.

Notice that $a_0 = Q(0)$ is the height of the graph at time zero and $2a_1 = Q'(0)$ is the slope of the graph at time zero. In Figure 6.4(a) and 6.4(b), $a_0 \leq 0$. The origin of the ray is inside (or on) the sphere when $a_0 \leq 0$. Regardless of the sign of a_1, the graph must intersect the t-axis in a single point. Geometrically, if the ray starts inside the sphere, it can only intersect the sphere once. The other cases $a_0 > 0$ correspond to the ray origin being outside the sphere. Figure 6.4(c) shows the case $a_0 > 0$ with $a_1 > 0$. It is not possible for the graph to intersect the axis, so there are no roots. The ray does not intersect the sphere. Figure 6.4(d), (e), and (f) is for the case $a_0 > 0$ and $a_1 < 0$. The quadratic function decreases initially, reaches a minimum, and then increases forever. The question is only whether the function decreases enough so that the graph either touches the axis or passes through the axis. The graph does not reach the axis when $a_1^2 - a_0 < 0$. The discriminant of the quadratic equation is negative, so the only roots are complex valued; the ray cannot intersect the sphere. The graph touches the axis at a single point when $a_1^2 - a_0 = 0$; in this case, the ray is tangent to the sphere. Finally, if $a_1^2 - a_0 > 0$, the quadratic equation has two positive roots, and the ray must intersect the sphere in two points.

The ray-sphere intersection is handled by the class `IntrRay3Sphere3`, which is derived from `Intersector`. The test-intersection query is very similar to that of line-sphere, but checks for $a_1 \geq 0$ as a quick no-intersection result:

```
template <class Real>
bool IntrRay3Sphere3<Real>::Test ()
{
    Vector3<Real> kDiff = m_rkRay.Origin - m_rkSphere.Center;
    Real fA0 = kDiff.Dot(kDiff) -
        m_rkSphere.Radius*m_rkSphere.Radius;
    if ( fA0 <= (Real)0.0 )
    {
        // P is inside the sphere
        return true;
    }
    // else: P is outside the sphere

    Real fA1 = m_rkRay.Direction.Dot(kDiff);
    if ( fA1 >= (Real)0.0 )
        return false;

    // quadratic has a real root if discriminant is nonnegative
    return fA1*fA1 >= fA0;
}
```

The find-intersection query for the ray and sphere uses the logic in `Test`, but replaces the return statements with root-finding code:

```
template <class Real>
bool IntrRay3Sphere3<Real>::Find ()
{
    Vector3<Real> kDiff = m_rkRay.Origin - m_rkSphere.Center;
    Real fA0 = kDiff.Dot(kDiff) -
        m_rkSphere.Radius*m_rkSphere.Radius;
    Real fA1, fDiscr, fRoot;
    if ( fA0 <= (Real)0.0 )
    {
        // P is inside the sphere
        fA1 = m_rkRay.Direction.Dot(kDiff);
        fDiscr = fA1*fA1 - fA0;
        fRoot = Math<Real>::Sqrt(fDiscr);
        m_afRayT[0] = -fA1 + fRoot;
        m_akPoint[0] = m_rkRay.Origin +
            m_afRayT[0]*m_rkRay.Direction;
        return true;
    }
    // else: P is outside the sphere

    fA1 = m_rkRay.Direction.Dot(kDiff);
    if ( fA1 >= (Real)0.0 )
    {
        m_iQuantity = 0;
        return false;
    }

    fDiscr = fA1*fA1 - fA0;
    if ( fDiscr < (Real)0.0 )
    {
        m_iQuantity = 0;
    }
    else if ( fDiscr >= ZeroThreshold )
    {
        fRoot = Math<Real>::Sqrt(fDiscr);
        m_afRayT[0] = -fA1 - fRoot;
        m_afRayT[1] = -fA1 + fRoot;
        m_akPoint[0] = m_rkRay.Origin +
            m_afRayT[0]*m_rkRay.Direction;
        m_akPoint[1] = m_rkRay.Origin +
            m_afRayT[1]*m_rkRay.Direction;
        m_iQuantity = 2;
    }
    else
```

```
    {
        m_afRayT[0] = -fA1;
        m_akPoint[0] = m_rkRay.Origin +
            m_afRayT[0]*m_rkRay.Direction;
        m_iQuantity = 1;
    }

    return m_iQuantity > 0;
}
```

Consider now a line segment $\mathbf{P} + t\mathbf{D}$ for $|t| \le e$ with $e > 0$. Further analysis of the graph of $Q(t) = t^2 + 2a_1 t + a_0$ may be applied for the segment-sphere test-intersection query. We need to determine the relationships among a_0, a_1, and the segment parameters that cause $Q(t)$ to have roots in the interval $[-e, e]$. The logic I use is slightly different than that for rays. Figure 6.5 shows the nine possible configurations for the graph of $Q(t)$:

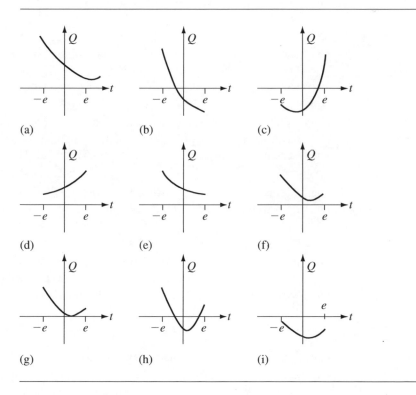

Figure 6.5 Possible graph configurations for a quadratic polynomial $Q(t)$ for $|t| \le e$.

(a) The quadratic function has no roots when $a_1^2 - a_0 < 0$. The segment is outside the sphere and does not intersect the sphere.

(b) The quadratic function has opposite signs at the end points, $Q(-e)Q(e) \leq 0$, with $Q(-e) > 0$. The smaller of the two quadratic roots is in $[-e, e]$, namely,

$$t = -a_1 - \sqrt{a_1^2 - a_0}.$$

The end point $\mathbf{P} - e\mathbf{D}$ is outside the sphere, and the end point $\mathbf{P} + e\mathbf{D}$ is inside the sphere. The segment intersects the sphere in a single point.

(c) The quadratic function has opposite signs at the end points, $Q(-e)Q(e) \leq 0$, with $Q(-e) < 0$. The larger of the two quadratic roots is in $[-e, e]$, namely,

$$t = -a_1 + \sqrt{a_1^2 - a_0}.$$

The end point $\mathbf{P} - e\mathbf{D}$ is inside the sphere, and the end point $\mathbf{P} + e\mathbf{D}$ is outside the sphere. The segment intersects the sphere in a single point.

(d) The quadratic function is positive at the end points, $Q(-e) > 0$ and $Q(e) > 0$. The derivative at the left end point is $Q'(-e) \geq 0$. The function is monotonic increasing on $[-e, e]$, so there are no roots. The segment does not intersect the sphere.

(e) The quadratic function is positive at the end points, $Q(-e) > 0$ and $Q(e) > 0$. The derivative at the right end point is $Q'(e) \leq 0$. The function is monotonic increasing on $[-e, e]$, so there are no roots. The segment does not intersect the sphere.

(f) The quadratic function is positive at the end points, $Q(-e) > 0$ and $Q(e) > 0$. The derivatives at the end points are of opposite sign, $Q'(-e) < 0$ and $Q'(e) > 0$. The discriminant is negative, $a_1^2 - a_0 < 0$, but we already handled this condition in case (a).

(g) The quadratic function is positive at the end points, $Q(-e) > 0$ and $Q(e) > 0$. The derivatives at the end points are of opposite sign, $Q'(-e) < 0$ and $Q'(e) > 0$. The discriminant is zero, $a_1^2 - a_0 = 0$. The function has a single repeated root at $t = -a_1$. The segment is tangent to the sphere.

(h) The quadratic function is positive at the end points, $Q(-e) > 0$ and $Q(e) > 0$. The derivatives at the end points are of opposite sign, $Q'(-e) < 0$ and $Q'(e) > 0$. The discriminant is positive, $a_1^2 - a_0 > 0$. The function has two roots at

$$t = -a_1 \pm \sqrt{a_1^2 - a_0}.$$

The segment intersects the sphere in two points.

(i) The quadratic function is negative at the end points, $Q(-e) < 0$ and $Q(e) < 0$. The function has no roots on $[-e, e]$. The segment is inside the sphere, but does not intersect the sphere.

Regarding the test-intersection query, case (a) is easily checked. Cases (b) and (c) are tested by $Q(-e)Q(e) \leq 0$. Cases (d) and (e) are combined into $2(a_1 - e) = Q'(-e) \geq 0$ or $2(a_1 + e) = Q'(e) \leq 0$. A single mathematical statement that represents the Boolean expressions is $|a_1| \geq e$. It is also necessary to make certain that $Q(-e) > 0$ (or $Q(e) > 0$). Case (f) is included in case (a). Cases (g) and (h) are known to produce roots when $Q(-e)Q(e) > 0$; assuming we have already tested cases (b) and (c), nothing needs to be done here. Finally, case (i) also occurs when $Q(-e)Q(e) > 0$, but $Q(-e) < 0$ (or $Q(e) < 0$). The class for segment-sphere intersection is IntrSegment3Sphere3 and is derived from Intersector. Its Test member function implements the logic discussed here. I have slightly changed the coding from the actual source to emphasize which cases are handled by the code.

```
template <class Real>
bool IntrSegment3Sphere3<Real>::Test ()
{
    Vector3<Real> kDiff = m_rkSegment.Origin - m_rkSphere.Center;
    Real fA0 = kDiff.Dot(kDiff) -
        m_rkSphere.Radius*m_rkSphere.Radius;
    Real fA1 = m_rkSegment.Direction.Dot(kDiff);
    Real fDiscr = fA1*fA1 - fA0;
    if ( fDiscr < (Real)0.0 )
        return false;  // cases (a) and (f)

    Real fTmp0 = m_rkSegment.Extent*m_rkSegment.Extent + fA0;
    Real fTmp1 = ((Real)2.0)*fA1*m_rkSegment.Extent;
    Real fQM = fTmp0 - fTmp1;
    Real fQP = fTmp0 + fTmp1;
    if ( fQM*fQP <= (Real)0.0 )
        return true;  // cases (b) and (c)

    // ... actual code ...
    // return fQM > (Real)0.0
    //     && Math<Real>::FAbs(fA1) < m_rkSegment.Extent;

    if ( fQM < (Real)0.0 )
        return false;  // case (i)

    if ( fA1 >= m_rkSegment.Extent )
        return false;  // case (d)

    if ( fA1 <= -m_rkSegment.Extent )
        return false;  // case (e)

    return true;  // cases (g) and (h)
}
```

The find-intersection query for the segment and sphere uses the logic in Test, but replaces the return statements with root-finding code:

```
template <class Real>
bool IntrSegment3Sphere3<Real>::Find ()
{
    Vector3<Real> kDiff = m_rkSegment.Origin - m_rkSphere.Center;
    Real fA0 = kDiff.Dot(kDiff) -
        m_rkSphere.Radius*m_rkSphere.Radius;
    Real fA1 = m_rkSegment.Direction.Dot(kDiff);
    Real fDiscr = fA1*fA1 - fA0;
    if ( fDiscr < (Real)0.0 )
    {
        m_iQuantity = 0;
        return false;
    }

    Real fTmp0 = m_rkSegment.Extent*m_rkSegment.Extent + fA0;
    Real fTmp1 = ((Real)2.0)*fA1*m_rkSegment.Extent;
    Real fQM = fTmp0 - fTmp1;
    Real fQP = fTmp0 + fTmp1;
    Real fRoot;
    if ( fQM*fQP <= (Real)0.0 )
    {
        fRoot = Math<Real>::Sqrt(fDiscr);
        m_afSegmentT[0] =
            ( fQM > (Real)0.0 ? -fA1 - fRoot : -fA1 + fRoot );
        m_akPoint[0] = m_rkSegment.Origin + m_afSegmentT[0] *
            m_rkSegment.Direction;
        m_iQuantity = 1;
        return true;
    }

    if ( fQM > (Real)0.0
    &&   Math<Real>::FAbs(fA1) < m_rkSegment.Extent )
    {
        if ( fDiscr >= ZeroThreshold )
        {
            fRoot = Math<Real>::Sqrt(fDiscr);
            m_afSegmentT[0] = -fA1 - fRoot;
            m_afSegmentT[1] = -fA1 + fRoot;
            m_akPoint[0] = m_rkSegment.Origin +
                m_afSegmentT[0]*m_rkSegment.Direction;
            m_akPoint[1] = m_rkSegment.Origin +
```

```
            m_afSegmentT[1]*m_rkSegment.Direction;
        m_iQuantity = 2;
    }
    else
    {
        m_afSegmentT[0] = -fA1;
        m_akPoint[0] = m_rkSegment.Origin +
            m_afSegmentT[0]*m_rkSegment.Direction;
        m_iQuantity = 1;
    }
}
else
{
    m_iQuantity = 0;
}

return m_iQuantity > 0;
}
```

As with ray-sphere intersection finding, the square roots in the segment-sphere intersection finding are computed only when they are needed.

Oriented Bounding Boxes

The find-intersection queries for linear components and oriented bounding boxes (OBBs) are implemented using clipping methods. The linear component is clipped against one OBB face at a time. If the entire linear component is clipped, the linear component and the OBB do not intersect; otherwise, they do intersect and the clipped linear component contains the points of intersection. The clipped component is either a segment, yielding two points of intersection, or a singleton point, yielding one point of intersection.

To simplify the clipping algorithm, the linear component is transformed into the coordinate system of the OBB. Let the component have origin \mathbf{P} and unit-length direction \mathbf{D}. Let the OBB have center \mathbf{C}, axis directions \mathbf{U}_i, and extents e_i for $0 \leq i \leq 2$. The component origin in OBB coordinates is $\mathbf{P}' = (x_0, x_1, x_2)$, where

$$\mathbf{P} = \mathbf{C} + \sum_{i=0}^{2} x_i \mathbf{U}_i$$

and $x_i = \mathbf{U}_i \cdot (\mathbf{P} - \mathbf{C})$. The component direction in OBB coordinates is $\mathbf{D}' = (x_0, x_1, x_2)$, where

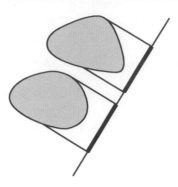

Figure 6.6 Two planar, convex objects that are not intersecting. A line is shown with the intervals of projection of the objects. The intervals are disjoint.

$$\mathbf{D} = \sum_{i=0}^{2} x_i \mathbf{U}_i$$

and $x_i = \mathbf{U}_i \cdot \mathbf{D}$. In the OBB coordinates (x_0, x_1, x_2), the clipping occurs against the six planes $x_i = \pm e_i$. Liang-Barsky clipping is used; the details are not interesting and are not shown here. See the Find methods in the classes IntrLine3Box3, IntrRay3Box3, and IntrSegment3Box3. All of these are Intersector-derived classes.

The test-intersection queries use the method of separating axes, described in great detail in [Ebe00] and [SE02]. The application to linear components and OBBs is also described in [Ebe00]. The idea of the method is that given two convex objects whose intervals of projection onto a line are disjoint, then the convex objects are not intersecting. Figure 6.6 shows two such objects in the plane.

A line for which the projections are disjoint is called a *separating axis*. Construction of a separating axis can be very complex when the objects themselves are complex. However, in the case of convex polyhedra, convex polygons, and linear components, the set of *potential* separating axes is a finite set.

The following construction provides a lot of intuition about separation. Given two sets A and B, the *Minkowski sum* of the sets is

$$A + B = \{a + b : a \in A, \ b \in B\}.$$

Each element of $A + B$ is the sum of two points, one in each of the sets. The *Minkowski difference* of the sets is

$$A - B = \{a - b : a \in A, \ b \in B\}.$$

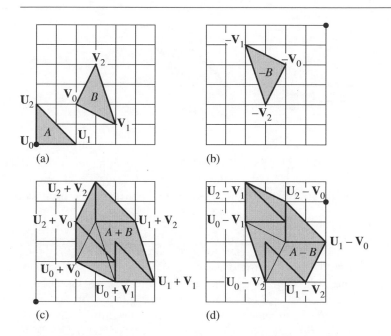

Figure 6.7 (a) Triangles A and B; (b) set $-B$; (c) set $A + B$; (d) set $A - B$. The origin is drawn as a small, black dot so that you can understand where the sets are located in the plane.

Each element of $A - B$ is the difference of two points, one in each of the sets.[2] Figure 6.7 shows a Minkowski sum and a Minkowski difference of two triangles.

The sum and difference sets are drawn to show the origin and the sets B and $-B$ with the set A placed at each of the vertices. Notice that the areas of $A + B$ *and* $A - B$ are larger than the areas of the input triangles. The sum and difference are, in fact, dilation operations.

2. Do not confuse the Minkowski difference $A - B$ with *set difference* $A \setminus B = \{x : x \in A, \ x \notin B\}$. Jay Stelly, of Valve Software, points out that the term Minkowski difference might be confused with *Minkowski subtraction*. *Minkowski addition* of a set A and a singleton set $\{b\}$ is defined by $A + \{b\} = \{a + b : a \in A\}$. Minkowski addition of two sets A and B is $A \oplus B = \cup_{b \in B}(A + \{b\})$, a union of sets. This operation is used for *dilation* of a set A by a set B. *Minkowski subtraction* of two sets A and B is defined by $A \ominus B = \cap_{b \in B}(A + \{b\})$, an intersection of sets. This operation is used for *erosion* of a set A by a set B. As long as B contains the origin, it is easily shown that $A \ominus B \subseteq A \subseteq A \oplus B$. The Minkowski sum $A + B$ and the Minkowski addition $A \oplus B$ are the same set. On the other hand, the Minkowski difference $A - B$ and the Minkowski subtraction $A \ominus B$ are *not the same set*. In fact, if we define the set $-B = \{x : -x \in B\}$, then $A - B = A + (-B)$, in which case $A - B$ is a dilation of the set A by the set $-B$.

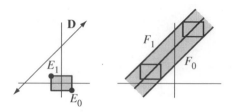

Figure 6.8 An OBB and a line. The OBB is extruded along the line in the direction **D**. The illustration is based on the OBB having its center at the origin. If the center were not at the origin, the extruded object would be translated from its current location.

How does this relate to separation of convex sets? Suppose A and B are convex sets, whether in the plane or in space (or in higher-dimensional spaces). If they intersect, then there exists a point $\mathbf{X} \in A \cap B$. This point causes the Minkowski difference $A - B$ to contain the origin $\mathbf{0}$. If they do not intersect, then $A \cap B = \emptyset$ and $A - B$ *cannot contain the origin*. Determining if two convex sets intersect is equivalent to determining if the Minkowski difference contains the origin.

In three dimensions, when A and B are convex polyhedra, convex polygons, or linear components, the Minkowski difference is itself a convex polyhedron, convex polygon, or linear component. The test for whether or not the difference set contains the origin is straightforward. If the difference set is a convex polyhedron, the origin is against each face to see if it is outside the face—and outside the polyhedron—or inside the face. If it is inside all faces, it is in the polyhedron. If the difference set is a convex polygon, then we must restrict our attention to the plane of the polygon. If that plane does not contain the origin, then A and B are separated. If the plane does contain the origin, we must test for containment in the convex polygon. If the origin is outside an edge, it is outside the polygon. If it is inside all edges, it is in the polygon. If the difference set is a linear component, we need only test if the origin is a point on that component.

Lines and OBBs

The application of the method of separating axes to a line and an OBB is described here. The Minkowski difference of the OBB and the line is an infinite convex polyhedron obtained by extruding the OBB along the line and placing it appropriately in space. Figure 6.8 illustrates this process in two dimensions.

Eight of the OBB edges are perpendicular to the plane of the page. Two of those edges are highlighted with points and labeled as E_0 and E_1. The edge E_0 is extruded along the line direction **D**. The resulting face, labeled F_0, is an infinite planar strip

with a normal vector $\mathbf{U}_0 \times \mathbf{D}$, where \mathbf{U}_0 is the unit-length normal of the face of the OBB that is coplanar with the page. The edge E_1 is extruded along the line direction to produce face F_1. Because edges E_0 and E_1 are parallel, face F_1 also has a normal vector \mathbf{U}_0. The maximum number of faces that the infinite polyhedron can have is six (project the OBB onto a plane with normal \mathbf{D} and obtain a hexagon), one for each of the independent OBB edge directions. These directions are the same as the OBB face normal directions, so the six faces are partitioned into three pairs of parallel faces with normal vectors $\mathbf{U}_i \times \mathbf{D}$.

Now that we have the potential separating axis directions, the separation tests are

$$|\mathbf{U}_0 \cdot \mathbf{D} \times \boldsymbol{\Delta}| > e_1 |\mathbf{D} \cdot \mathbf{U}_2| + e_2 |\mathbf{D} \cdot \mathbf{U}_1|$$

$$|\mathbf{U}_1 \cdot \mathbf{D} \times \boldsymbol{\Delta}| > e_0 |\mathbf{D} \cdot \mathbf{U}_2| + e_2 |\mathbf{D} \cdot \mathbf{U}_0|$$

$$|\mathbf{U}_2 \cdot \mathbf{D} \times \boldsymbol{\Delta}| > e_0 |\mathbf{D} \cdot \mathbf{U}_1| + e_1 |\mathbf{D} \cdot \mathbf{U}_0|$$

where $\boldsymbol{\Delta} = \mathbf{P} - \mathbf{C}$. The term $\mathbf{U}_i \cdot \mathbf{D} \times \boldsymbol{\Delta}$ is used instead of the mathematically equivalent $\mathbf{U}_i \times \mathbf{D} \cdot \boldsymbol{\Delta}$ in order for the implementation to compute $\mathbf{D} \times \boldsymbol{\Delta}$ once, leading to a reduced operation count for all three separation tests. The implementation of IntrLine3Box3::Test using this method is straightforward:

```
template <class Real>
bool IntrLine3Box3<Real>::Test ()
{
    Real fAWdU[3], fAWxDdU[3], fRhs;

    Vector3<Real> kDiff = m_rkLine.Origin - m_rkBox.Center;
    Vector3<Real> kWxD = m_rkLine.Direction.Cross(kDiff);

    fAWdU[1] = Math<Real>::FAbs(
        m_rkLine.Direction.Dot(m_rkBox.Axis[1]));
    fAWdU[2] = Math<Real>::FAbs(
        m_rkLine.Direction.Dot(m_rkBox.Axis[2]));
    fAWxDdU[0] = Math<Real>::FAbs(kWxD.Dot(m_rkBox.Axis[0]));
    fRhs = m_rkBox.Extent[1]*fAWdU[2] + m_rkBox.Extent[2]*fAWdU[1];
    if ( fAWxDdU[0] > fRhs )
        return false;

    fAWdU[0] = Math<Real>::FAbs(
        m_rkLine.Direction.Dot(m_rkBox.Axis[0]));
    fAWxDdU[1] = Math<Real>::FAbs(kWxD.Dot(m_rkBox.Axis[1]));
    fRhs = m_rkBox.Extent[0]*fAWdU[2] + m_rkBox.Extent[2]*fAWdU[0];
    if ( fAWxDdU[1] > fRhs )
        return false;
```

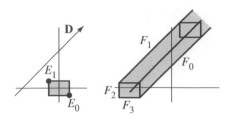

Figure 6.9 An OBB and a ray. The OBB is extruded along the ray in the direction **D**. The faces F_0 and F_1 are generated by OBB edges and **D**. The faces F_2 and F_3 are contributed from the OBB.

```
fAWxDdU[2] = Math<Real>::FAbs(kWxD.Dot(m_rkBox.Axis[2]));
fRhs = m_rkBox.Extent[0]*fAWdU[1] + m_rkBox.Extent[1]*fAWdU[0];
if ( fAWxDdU[2] > fRhs )
    return false;

return true;
}
```

Rays and OBBs

The infinite convex polyhedron that corresponds to the Minkowski difference of a line and an OBB becomes a semi-infinite object in the case of a ray and an OBB. Figure 6.9 illustrates in two dimensions.

The semi-infinite convex polyhedron has the same three pairs of parallel faces as for the line, but the polyhedron has the OBB as an end cap. The OBB contributes three additional faces and corresponding normal vectors. Thus, we have six potential separating axes. The separation tests are

$$|\mathbf{U}_0 \cdot \mathbf{D} \times \mathbf{\Delta}| > e_1|\mathbf{D} \cdot \mathbf{U}_2| + e_2|\mathbf{D} \cdot \mathbf{U}_1|$$

$$|\mathbf{U}_1 \cdot \mathbf{D} \times \mathbf{\Delta}| > e_0|\mathbf{D} \cdot \mathbf{U}_2| + e_2|\mathbf{D} \cdot \mathbf{U}_0|$$

$$|\mathbf{U}_2 \cdot \mathbf{D} \times \mathbf{\Delta}| > e_0|\mathbf{D} \cdot \mathbf{U}_1| + e_1|\mathbf{D} \cdot \mathbf{U}_0|$$

$$|\mathbf{U}_0 \cdot \mathbf{\Delta}| > e_0, \qquad (\mathbf{U}_0 \cdot \mathbf{\Delta})(\mathbf{U}_0 \cdot \mathbf{D}) \geq 0$$

$$|\mathbf{U}_1 \cdot \mathbf{\Delta}| > e_1, \qquad (\mathbf{U}_1 \cdot \mathbf{\Delta})(\mathbf{U}_1 \cdot \mathbf{D}) \geq 0$$

$$|\mathbf{U}_2 \cdot \mathbf{\Delta}| > e_2, \qquad (\mathbf{U}_2 \cdot \mathbf{\Delta})(\mathbf{U}_2 \cdot \mathbf{D}) \geq 0$$

The first three are the same as for a line. The last three use the OBB face normals for the separation tests. To illustrate these tests, see Figure 6.10.

Figure 6.10 Projections of an OBB and a ray onto the line with direction \mathbf{U}_i (a normal to an OBB face). The OBB center \mathbf{C} is subtracted from the OBB as well as the ray origin \mathbf{P}. The translated OBB projects to the interval $[-e_i, e_i]$, where e_i is the OBB extent associated with \mathbf{U}_i. The translated ray is $\boldsymbol{\Delta} + t\mathbf{D}$, where $\boldsymbol{\Delta} = \mathbf{P} - \mathbf{C}$, and projects to $\mathbf{U}_i \cdot \boldsymbol{\Delta} + t\mathbf{U}_i \cdot \mathbf{D}$.

The projected OBB is the finite interval $[-e_i, e_i]$. The projected ray is a semi-infinite interval on the t-axis. The origin is $\boldsymbol{\Delta} \cdot \mathbf{U}_i$, and the direction (a signed scalar) is $\mathbf{D} \cdot \mathbf{U}_i$. The top portion of the figure shows a positive signed direction and an origin that satisfies $\boldsymbol{\Delta} \cdot \mathbf{U}_i > e_i$. The finite interval and the semi-infinite interval are disjoint, in which case the original OBB and ray are separated. If instead the projected ray direction is negative, $\mathbf{D} \cdot \mathbf{U}_i < 0$, the semi-infinite interval overlaps the finite interval. The original OBB and ray are not separated by the axis with direction \mathbf{U}_i. Two similar configurations exist when $\boldsymbol{\Delta} \cdot \mathbf{U}_i < -e_i$. The condition $|\mathbf{U}_i \cdot \boldsymbol{\Delta}| > e_i$ says that the projected ray origin is further away from zero than the projected box extents. The condition $(\mathbf{U}_i \cdot \boldsymbol{\Delta})(\mathbf{U}_i \cdot \mathbf{D}) > 0$ guarantees that the projected ray points away from the projected OBB.

The implementation of the test-intersection query is

```
template <class Real>
bool IntrRay3Box3<Real>::Test ()
{
    Real fWdU[3], fAWdU[3], fDdU[3], fADdU[3], fAWxDdU[3], fRhs;

    Vector3<Real> kDiff = m_rkRay.Origin - m_rkBox.Center;

    fWdU[0] = m_rkRay.Direction.Dot(m_rkBox.Axis[0]);
    fAWdU[0] = Math<Real>::FAbs(fWdU[0]);
    fDdU[0] = kDiff.Dot(m_rkBox.Axis[0]);
    fADdU[0] = Math<Real>::FAbs(fDdU[0]);
    if ( fADdU[0] > m_rkBox.Extent[0]
    &&   fDdU[0]*fWdU[0] >= (Real)0.0 )
        return false;
```

```
    fWdU[1] = m_rkRay.Direction.Dot(m_rkBox.Axis[1]);
    fAWdU[1] = Math<Real>::FAbs(fWdU[1]);
    fDdU[1] = kDiff.Dot(m_rkBox.Axis[1]);
    fADdU[1] = Math<Real>::FAbs(fDdU[1]);
    if ( fADdU[1] > m_rkBox.Extent[1]
    &&   fDdU[1]*fWdU[1] >= (Real)0.0 )
        return false;

    fWdU[2] = m_rkRay.Direction.Dot(m_rkBox.Axis[2]);
    fAWdU[2] = Math<Real>::FAbs(fWdU[2]);
    fDdU[2] = kDiff.Dot(m_rkBox.Axis[2]);
    fADdU[2] = Math<Real>::FAbs(fDdU[2]);
    if ( fADdU[2] > m_rkBox.Extent[2]
    &&   fDdU[2]*fWdU[2] >= (Real)0.0 )
        return false;

    Vector3<Real> kWxD = m_rkRay.Direction.Cross(kDiff);

    fAWxDdU[0] = Math<Real>::FAbs(kWxD.Dot(m_rkBox.Axis[0]));
    fRhs = m_rkBox.Extent[1]*fAWdU[2] + m_rkBox.Extent[2]*fAWdU[1];
    if ( fAWxDdU[0] > fRhs )
        return false;

    fAWxDdU[1] = Math<Real>::FAbs(kWxD.Dot(m_rkBox.Axis[1]));
    fRhs = m_rkBox.Extent[0]*fAWdU[2] + m_rkBox.Extent[2]*fAWdU[0];
    if ( fAWxDdU[1] > fRhs )
        return false;

    fAWxDdU[2] = Math<Real>::FAbs(kWxD.Dot(m_rkBox.Axis[2]));
    fRhs = m_rkBox.Extent[0]*fAWdU[1] + m_rkBox.Extent[1]*fAWdU[0];
    if ( fAWxDdU[2] > fRhs )
        return false;

    return true;
}
```

Segments and OBBs

The semi-infinite convex polyhedron that corresponds to the Minkowski difference of a ray and an OBB becomes a finite object in the case of a segment and an OBB. Figure 6.11 illustrates in two dimensions.

The infinite convex polyhedron has the same three pairs of parallel faces as for the ray and line, but the polyhedron has the OBB as an end cap on both ends of the segment. The OBB contributes three additional faces and corresponding normal

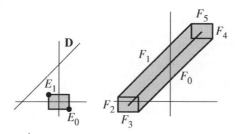

Figure 6.11 An OBB and a segment. The OBB is extruded along the segment in the direction
D. The faces F_0 and F_1 are generated by OBB edges and **D**. The faces F_2 and F_3 are
contributed from the OBB at one end point; the faces F_4 and F_5 are contributed from
the OBB at the other end point.

Figure 6.12 Projections of an OBB and a segment onto a line with direction **W**. The OBB center
C is subtracted from the OBB as well as the segment origin **P**. The translated OBB
projects to an interval $[-r, r]$. The translated segmet is $\mathbf{\Delta} + t\mathbf{D}$, where $\mathbf{\Delta} = \mathbf{P} - \mathbf{C}$,
and projects to $\mathbf{W} \cdot \mathbf{\Delta} + t\mathbf{W} \cdot \mathbf{D}$.

vectors, a total of six potential separating axes. The separation tests are

$$|\mathbf{U}_0 \cdot \mathbf{D} \times \mathbf{\Delta}| > e_1|\mathbf{D} \cdot \mathbf{U}_2| + e_2|\mathbf{D} \cdot \mathbf{U}_1|$$

$$|\mathbf{U}_1 \cdot \mathbf{D} \times \mathbf{\Delta}| > e_0|\mathbf{D} \cdot \mathbf{U}_2| + e_2|\mathbf{D} \cdot \mathbf{U}_0|$$

$$|\mathbf{U}_2 \cdot \mathbf{D} \times \mathbf{\Delta}| > e_0|\mathbf{D} \cdot \mathbf{U}_1| + e_1|\mathbf{D} \cdot \mathbf{U}_0|$$

$$|\mathbf{U}_0 \cdot \mathbf{\Delta}| > e_0 + e|\mathbf{U}_0 \cdot \mathbf{D}|$$

$$|\mathbf{U}_1 \cdot \mathbf{\Delta}| > e_1 + e|\mathbf{U}_1 \cdot \mathbf{D}|$$

$$|\mathbf{U}_2 \cdot \mathbf{\Delta}| > e_2 + e|\mathbf{U}_1 \cdot \mathbf{D}|,$$

where e is the extent of the segment. Figure 6.12 shows a typical separation of the
projections on some separating axis. The intervals are separated when $\mathbf{W} \cdot \mathbf{\Delta} - e|\mathbf{W} \cdot \mathbf{D}| > r$ or when $\mathbf{W} \cdot \mathbf{\Delta} + e|\mathbf{W} \cdot \mathbf{D}| < -r$. These may be combined into a joint state-
ment: $|\mathbf{W} \cdot \mathbf{\Delta}| > r + e|\mathbf{W} \cdot \mathbf{D}|$.

The implementation of the test-intersection query is

```
template <class Real>
bool IntrSegment3Box3<Real>::Test ()
{
    Real fAWdU[3], fADdU[3], fAWxDdU[3], fRhs;

    Vector3<Real> kDiff = m_rkSegment.Origin - m_rkBox.Center;

    fAWdU[0] = Math<Real>::FAbs(m_rkSegment.Direction.Dot(
        m_rkBox.Axis[0]));
    fADdU[0] = Math<Real>::FAbs(kDiff.Dot(m_rkBox.Axis[0]));
    fRhs = m_rkBox.Extent[0] + m_rkSegment.Extent*fAWdU[0];
    if ( fADdU[0] > fRhs )
        return false;

    fAWdU[1] = Math<Real>::FAbs(m_rkSegment.Direction.Dot(
        m_rkBox.Axis[1]));
    fADdU[1] = Math<Real>::FAbs(kDiff.Dot(m_rkBox.Axis[1]));
    fRhs = m_rkBox.Extent[1] + m_rkSegment.Extent*fAWdU[1];
    if ( fADdU[1] > fRhs )
        return false;

    fAWdU[2] = Math<Real>::FAbs(m_rkSegment.Direction.Dot(
        m_rkBox.Axis[2]));
    fADdU[2] = Math<Real>::FAbs(kDiff.Dot(m_rkBox.Axis[2]));
    fRhs = m_rkBox.Extent[2] + m_rkSegment.Extent*fAWdU[2];
    if ( fADdU[2] > fRhs )
        return false;

    Vector3<Real> kWxD = m_rkSegment.Direction.Cross(kDiff);

    fAWxDdU[0] = Math<Real>::FAbs(kWxD.Dot(m_rkBox.Axis[0]));
    fRhs = m_rkBox.Extent[1]*fAWdU[2] + m_rkBox.Extent[2]*fAWdU[1];
    if ( fAWxDdU[0] > fRhs )
        return false;

    fAWxDdU[1] = Math<Real>::FAbs(kWxD.Dot(m_rkBox.Axis[1]));
    fRhs = m_rkBox.Extent[0]*fAWdU[2] + m_rkBox.Extent[2]*fAWdU[0];
    if ( fAWxDdU[1] > fRhs )
        return false;

    fAWxDdU[2] = Math<Real>::FAbs(kWxD.Dot(m_rkBox.Axis[2]));
    fRhs = m_rkBox.Extent[0]*fAWdU[1] + m_rkBox.Extent[1]*fAWdU[0];
```

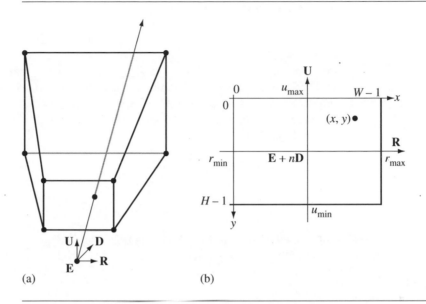

Figure 6.13 (a) A view frustum with a point selected on the near plane. The pick ray has an origin that is the eye point **E**, in world coordinates, and a direction that is from the eye point to the selected point. (b) The viewport on the near plane with screen coordinates (x, y) listed for the selected point.

```
    if ( fAWxDdU[2] > fRhs )
        return false;

    return true;
}
```

6.3.3 PICKING

A classical application for line-object intersection is *picking*—selecting an object drawn on the screen by clicking a pixel in that object using the mouse. Figure 6.13 illustrates a *pick ray* associated with a screen pixel, where the screen is associated with the near plane of a view frustum.

The eye point **E**, in world coordinates, is used for the origin of the pick ray. We need to compute a unit-length direction **W**, in world coordinates. The pick ray is then $\mathbf{E} + t\mathbf{W}$ for $t \geq 0$.

Constructing a Pick Ray

The screen has a width of W pixels and a height of H pixels, and the screen coordinates are left-handed (x to the right, y down). The selected point (x, y) is in screen coordinates, where $0 \leq x \leq W - 1$ and $0 \leq y \leq H - 1$. This point must be converted to world coordinates for points on the near plane. Specifically, we need a corresponding point $\mathbf{Q} = \mathbf{E} + n\mathbf{D} + x_v\mathbf{R} + y_v\mathbf{U}$, where $r_{min} \leq x_v \leq r_{max}$ and $u_{min} \leq y_v \leq u_{max}$, and where n is the distance from the eye point to the near plane. This is a matter of some simple algebra:

$$(x_p, y_p) = \left(\frac{x}{W - 1}, 1 - \frac{y}{H - 1} \right)$$

$$(x_v, y_v) = ((1 - x_p)r_{min} + x_p r_{max}, (1 - y_p)u_{min} + y_p u_{max}).$$

The first equation lists the *normalized viewport coordinates*, (x_p, y_p), that live in the set $[0, 1]^2$. Observe that the left-handed screen coordinates are converted to right-handed normalized viewport coordinates by reflecting the y-value. The pick ray direction is

$$\mathbf{W} = \frac{\mathbf{Q} - \mathbf{E}}{|\mathbf{Q} - \mathbf{E}|} = \frac{n\mathbf{D} + x_v\mathbf{R} + y_v\mathbf{U}}{\sqrt{n^2 + x_v^2 + y_v^2}}.$$

The pick ray may now be used for intersection testing with objects in the world to identify which one has been selected.

The construction is accurate as long as the *entire viewport* is used for drawing the scene. The Camera class, however, allows you to select a subrectangle on the screen in which the scene is drawn, via member function SetViewPort. Let x_{pmin}, x_{pmax}, y_{pmin}, and y_{pmax} be the viewport settings in the camera class. The default minimum values are 0, and the default maximum values are 1. If they are changed from the defaults, the pick ray construction must be modified. Figure 6.14 shows the screen with a viewport that is not the size of the screen.

The new construction for (x_v, y_v) is

$$(x_p, y_p) = \left(\frac{x}{W - 1}, 1 - \frac{y}{H - 1} \right)$$

$$(x_w, y_w) = \left(\frac{x_p - x_{pmin}}{x_{pmax} - x_{pmin}}, \frac{y_p - y_{pmin}}{y_{pmax} - y_{pmin}} \right)$$

$$(x_v, y_v) = ((1 - x_w)r_{min} + x_w r_{max}, (1 - y_w)u_{min} + y_w u_{max}).$$

The conversion is as if the smaller viewport really did fill the entire screen. This makes sense in that the world coordinate pick ray should be the same for a scene regardless of whether you draw the scene in the full screen or in a subrectangle of the screen. The Camera implementation for constructing the pick ray is

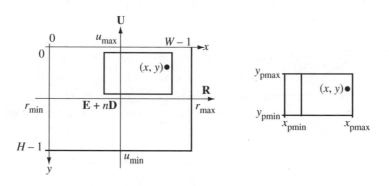

Figure 6.14 The viewport on the near plane with screen coordinates (x, y) listed for the selected point. The viewport is not the entire screen.

```
bool Camera::GetPickRay (int iX, int iY, int iWidth, int iHeight,
    Vector3f& rkOrigin, Vector3f& rkDirection) const
{
    float fPortX = ((float)iX)/(float)(iWidth-1);
    if ( fPortX < m_fPortL || fPortX > m_fPortR )
        return false;

    float fPortY = ((float)(iHeight-1-iY))/(float)(iHeight-1);
    if ( fPortY < m_fPortB || fPortY > m_fPortT )
        return false;

    float fXWeight = (fPortX - m_fPortL)/(m_fPortR - m_fPortL);
    float fViewX = (1.0f-fXWeight)*m_fRMin + fXWeight*m_fRMax;
    float fYWeight = (fPortY - m_fPortB)/(m_fPortT - m_fPortB);
    float fViewY = (1.0f-fYWeight)*m_fUMin + fYWeight*m_fUMax;

    rkOrigin = GetWorldLocation();
    rkDirection =
        m_fDMin*GetWorldDVector() +
        fViewX*GetWorldRVector() +
        fViewY*GetWorldUVector();
    rkDirection.Normalize();
    return true;
}
```

Since the Camera class does not store the width and height of the screen, those values must be passed to the function. The reason not to store them is that the screen dimensions are allowed to change (via resizing of the application window, for

example), but the camera model is not dependent on those changes. The Renderer class does store the screen dimensions.

Scene Graph Support

Now that we know how to construct a pick ray, we actually have to do the intersection testing with the scene. Wild Magic supports this in a hierarchical manner, using the bounding volumes attached to the nodes in a scene hierarchy. Starting with the root node, a test-intersection query is made between the pick ray and the world bounding volume of the node. If the ray does not intersect the bounding volume, then it cannot intersect the scene contained in the bounding volume—no intersection occurs. If the pick ray does intersect the world bounding volume, then the test-intersection query is propagated to all the children of the node (in the usual depth-first manner). The propagation continues recursively along a path to a leaf node as long as the ray and bounding volumes along that path intersect. If the ray and leaf node bounding volume intersect, then a find-intersection query between the ray and whatever the leaf node represents must be made. The query depends on the actual class type of the leaf; the information reported by the query is also dependent on the class type.

The subsystem for hierarchical picking is based in class Spatial. The relevant interface is

```
class Spatial
{
public:
    class PickRecord
    {
    public:
        virtual ~PickRecord ();

        Pointer<Spatial> IObject;  // the intersected leaf object
        float T;  // the pick ray parameter (t >= 0)

    protected:
        PickRecord (Spatial* pkIObject, float fT);
    };

    typedef TArray<PickRecord*> PickArray;

    virtual void DoPick (const Vector3f& rkOrigin,
        const Vector3f& rkDirection, PickArray& rkResults);

    static PickRecord* GetClosest (PickArray& rkResults);
};
```

The nested class `PickRecord` represents the minimal amount of information that a find-intersection query computes, the parameter t for which the pick ray $\mathbf{P} + t\mathbf{D}$ intersects an object. Each `Spatial`-derived class derives its own pick record class from `PickRecord` and adds whatever information it wants to return from a successful find-intersection query, instigated by a call to `DoPick`. The ray parameter can be used to sort the intersection points after a call to `DoPick`.

Notice that the `PickRecord` does not have the capability for run-time type information (RTTI). However, RTTI is obtained by using the `Object`-based RTTI for the `PickRecord` data member `IObject`. Once that member's type is known, the `PickRecord` can be cast to the appropriate `PickRecord`-derived class.

A find-intersection query can produce a lot of intersection results. Thus, a container class for pick records is needed to store the results. I have chosen a dynamic array, named `PickArray`, that stores an array of pointers to `PickRecord` objects. The entry point to the query is the function `DoPick`. The inputs are the origin and direction for the pick ray, in world coordinates, and an array to store the pick records. On return, the caller is responsible for iterating over the array and deleting all the `PickRecord` objects.

In most cases, the picked object is the one closest to the origin of the ray. The function `GetClosest` implements a simple search of the array for the pick record with the minimum t-value.

The `Node` class is responsible for the test-intersection query between the pick ray and world bounding volume and for propagating the call to its children if necessary. The `DoPick` function is

```
void Node::DoPick (const Vector3f& rkOrigin,
    const Vector3f& rkDirection, PickArray& rkResults)
{
    if ( WorldBound->TestIntersection(rkOrigin,rkDirection) )
    {
        for (int i = 0; i < m_kChild.GetQuantity(); i++)
        {
            Spatial* pkChild = m_kChild[i];
            if ( pkChild )
                pkChild->DoPick(rkOrigin,rkDirection,rkResults);
        }
    }
}
```

The implementation is straightforward. The `BoundingVolume` class has support for the test-intersection query with a ray. If the ray intersects the bounding volume, an iteration is made over the children and the call is propagated. The `SwitchNode` class has a similar implementation, but it only propagates the call to the active child.

The most relevant behavior of `DoPick` is in the class `TriMesh`, which represents a mesh of triangles. The class introduces its own `PickRecord` type:

```
class TriMesh
{
public:
    class PickRecord : public Geometry::PickRecord
    {
    public:
        PickRecord (TriMesh* pkIObject, float fT, int iTriangle,
            float fBary0, float fBary1, float fBary2);

        // Index of the triangle that is intersected by the ray.
        int Triangle;

        // Barycentric coordinates of the point of intersection.
        // If b0, b1, and b2 are the values, then all are in [0,1]
        // and b0+b1+b2=1.
        float Bary0, Bary1, Bary2;
    };
};
```

The pick record stores the index of any triangle intersected by the ray. It stores the barycentric coordinates of the intersection point with respect to the triangle. This allows the application to compute interpolated vertex attributes as well as the actual point of intersection. The base class for the pick record is `Geometry::PickRecord`, but in fact `Geometry` has no such definition. The compiler resorts to checking further down the line and finds `Spatial::PickRecord` as the base class.

The implementation of `DoPick` is

```
void TriMesh::DoPick (const Vector3f& rkOrigin,
    const Vector3f& rkDirection, PickArray& rkResults)
{
    if ( WorldBound->TestIntersection(rkOrigin,rkDirection) )
    {
        // convert the ray to model space coordinates
        Ray3f kRay(World.ApplyInverse(rkOrigin),
            World.InvertVector(rkDirection));

        // compute intersections with the model space triangles
        const Vector3f* akVertex = Vertices->GetData();
        int iTQuantity = Indices->GetQuantity()/3;
        const int* piConnect = Indices->GetData();
        for (int i = 0; i < iTQuantity; i++)
        {
            int iV0 = *piConnect++;
            int iV1 = *piConnect++;
```

```
            int iV2 = *piConnect++;

            Triangle3f kTriangle(akVertex[iV0],akVertex[iV1],akVertex[iV2]);
            IntrRay3Triangle3f kIntr(kRay,kTriangle);
            if ( kIntr.Find() )
            {
                rkResults.Append(new PickRecord(this,kIntr.GetRayT(),i,
                    kIntr.GetTriB0(),kIntr.GetTriB1(),kIntr.GetTriB2()));
            }
        }
    }
}
```

A test-intersection query is made between the pick ray and the world bounding volume. If the ray intersects the bounding volume, a switch is made to a find-intersection query to determine which triangles are intersected by the ray, and where. The triangle vertex data is in model coordinates, whereas the pick ray is in world coordinates. We certainly could transform each model triangle to world space and call the find-intersection query, but that involves potentially a large number of vertex transformations—an expense you do not want to incur. Instead, the pick ray is inverse-transformed to the model space of the triangle mesh, and the find-intersection queries are executed. This is a much cheaper alternative! For each triangle, a ray-triangle find-intersection query is made. If an intersection occurs, a pick record is created and inserted into the array of pick records.

One potential inefficiency is that the triangles are processed in a linear traversal. If the mesh has a very large number of triangles and the ray intersects only a very small number, a lot of computational time will be spent finding out that many triangles are not intersected by the ray. This is a fundamental problem in ray-tracing applications. One of the solutions is to use a hierarchical bounding volume tree that fits the triangle mesh. The idea is to localize in the mesh where intersections might occur by culling out large portions of the bounding volume tree, using fast rejection algorithms for ray-object pairs. Well, this is exactly what we have done at a coarse level, where the nodes of the tree are the Node objects in the scene. I have not provided a fine-level decomposition at the triangle mesh level *for the purposes of picking*, but it certainly can be added if needed. That said, I have bounding volume hierarchy support for object-object intersections (see Section 6.4.2).

A couple of the sample applications use picking. The application

GeometricTools/WildMagic3/SampleGraphics/Castle

allows you to pick objects in the scene. If you pick using the left mouse button, the name of the selected geometry object is displayed in the lower-right portion of the screen. If you pick using the right mouse button, the selected geometry object is

displayed as a wireframe object. This allows you to see what is behind the scenes (pun intended).

Another application using picking is

```
GeometricTools/WildMagic3/SampleGraphics/MorphControllers
```

This application displays a morphing face in the lower portion of the screen. A reduced viewport is used for the display. The upper portion of the screen displays the five targets of the morph controller. Each target is displayed in its own small viewport. The picking system reports which target you have selected, or if you selected the morphing face, or if nothing has been selected. The application illustrates that the pick ray must be chosen using the camera's viewport settings and cannot always assume the viewport is the entire screen.

6.3.4 STAYING ON TOP OF THINGS

Given a 3D environment in which characters can roam around, an important feature is to make certain that the characters stay on the ground and not fall through! If the ground is a single plane, you may use this knowledge to keep the camera (the character's eye point, so to speak) at a fixed height about the plane. However, if the ground is terrain, or a set of steps or floors in an indoor level, or a ramp, or any other nonplanar geometry, the manual management of the camera's height above the current ground location becomes more burdensome than you might like.

The picking system can help you by eliminating a lot of the management. The idea is to call the picking system each time the camera moves. The pick ray has origin **E** (the camera eye point) and direction $-\mathbf{U}$ (the downward direction for the environment). Do not use the camera's up vector for **U**. If you were to pitch forward to look at the ground, the up vector rotates with you. The environment up vector is always fixed. The smallest t-value from the picking tells you the distance from the eye point to the closest object below you. You can then update the height of the camera using the t-value to make certain you stay at a fixed height.

The application

```
GeometricTools/WildMagic3/SampleGraphics/Castle
```

implements such a system. The relevant application function is

```
void TestCastle::AdjustVerticalDistance ()
{
    // retain vertical distance above "ground"
    Spatial::PickArray kResults;
    m_spkScene->DoPick(m_spkCamera->GetLocation(),
        Vector3f(0.0f,0.0f,-1.0f), kResults);
```

```
    if ( kResults.GetQuantity() > 0 )
    {
        Spatial::PickRecord* pkRecord =
            Spatial::GetClosest(kResults);
        assert( pkRecord );
        TriMesh* pkMesh = DynamicCast<TriMesh>(pkRecord->IObject);
        assert( pkMesh );
        TriMesh::PickRecord* pkTMRecord =
            (TriMesh::PickRecord*)pkRecord;

        Vector3f kV0, kV1, kV2;
        pkMesh->GetWorldTriangle(pkTMRecord->Triangle,kV0,kV1,kV2);
        Vector3f kClosest =
            pkTMRecord->Bary0*kV0 +
            pkTMRecord->Bary1*kV1 +
            pkTMRecord->Bary2*kV2;

        kClosest.Z() += m_fVerticalDistance;
        m_spkCamera->SetLocation(kClosest);

        for (int i = 0; i < kResults.GetQuantity(); i++)
            delete kResults[i];
    }
}

void TestCastle::MoveForward ()
{
    Application::MoveForward();
    AdjustVerticalDistance();
}
```

The MoveForward function is called when the up arrow is pressed. The base class MoveForward translates the camera's eye point by a small amount in the direction of view. The AdjustVerticalDistance adjusts that translation in the environment up direction to maintain a constant height above the ground or other objects. As you wander around the castle environment, you will notice that you always stay on top of things, including the ground, stairs, and ramps.

6.3.5 STAYING OUT OF THINGS

We have seen how to stay on top of things by using the picking system. In the same 3D environment, it is also important not to let the characters walk through walls or other objects. *Collision avoidance*, as it is called, is a broad topic. Typically, the avoidance is

based on a test-intersection query of the bounding volume of the character against the various objects in the environment. This is complicated to get right, and potentially expensive if the object-object intersection algorithm is complicated.

An alternative that is not exact, but just a heuristic, is to cast a small number of pick rays from the eye point out into the scene. Consider this a form of *probing* (sometimes called *stabbing*, in the occlusion culling literature) to see what objects might be in the way. The more dense the set of rays, the less likely you will accidentally allow the character to pass through an object. However, the more dense the set, the more expensive the picking computations become. The balance between number of pick rays and speed of the testing will, of course, depend on your environments.

The application

```
GeometricTools/WildMagic3/SampleGraphics/Castle
```

supports collision avoidance via picking in addition to maintaining a constant height above the ground.

6.4 OBJECT-OBJECT INTERSECTION

The test-intersection and find-intersection queries for a pair of objects, neither one a linear component, can be anywhere from simple to nearly intractable, especially when the objects are in motion. Having a fully featured collision detection library that handles almost every type of query you can imagine is a commercial endeavor. I certainly have not provided full support for every possible type of collision, but I have provided a couple of simple systems to illustrate some of the concepts. This section talks about those systems.

6.4.1 COLLISION GROUPS

In an environment with n objects that can potentially collide with each other, your first instinct to compute intersections is to do a pairwise comparison. Choosing two objects at a time, and realizing that you should not compare an object against itself, there are $n(n-1)/2$ combinations. For large n, you can spend a lot of time making the comparisons when, in fact, not many objects collide.

At a high level, you can try to reduce n by partitioning the objects into *collision groups*. Each group represents a small number of potentially colliding objects, but two groups are deemed not to interact with each other. For example, you might have an indoor level with two rooms separated by a doorway. The objects in one room form a collision group; the objects in the other room form another collision group. As long as the objects stay in their respective rooms, you can test for collisions in each group independently of the other group. In the event, though, that one object passes through the doorway from one room into another, then you will need to update

the collision groups accordingly. It would be good to structure your environment so that two objects from the different groups cannot simultaneously pass through the doorway!

To convince you the grouping actually buys you some performance, consider when you have 10 objects. If all are in a single group, you have $10 \cdot 9/2 = 45$ pairs of objects to test. If the objects are in two disjoint groups, say, 5 objects per group, then each group has $5 \cdot 4/2 = 10$ pairs of objects to test. The total number of pairs to test for the two groups is 20.

The class I have chosen for grouping objects is called CollisionGroup. I will discuss the actual interface in Section 6.4.2. For the time being, I want to provide motivation for how you might structure such a class.

For a group of objects, an intersection query is structured according to the following pseudocode. The group is organized as an array of objects for simplicity of indexing.

```
for (i0 = 0; i0 < group.size; i0++)
{
    for (i1 = i0+1; i1 < group.size; i1++)
    {
        DoIntersectionQuery(group[i0],group[i1]);
    }
}
```

The first thing that should catch your attention is that the code does not appear to show you how any intersections are handled. It is possible for the DoIntersection-Query function to accumulate information related to the intersections and return that information for processing. For example,

```
for (i0 = 0; i0 < group.size; i0++)
{
    for (i1 = i0+1; i1 < group.size; i1++)
    {
        results = DoIntersectionQuery(group[i0],group[i1]);
        DoProcessQuery(results);
    }
}
```

The results minimally will include the intersection set for stationary objects and the contact time and contact set for moving objects.

The pseudocode also does not show how physical parameters are introduced to the system, such as the maximum time for a query and object velocities. The maximum time is independent of the objects, so it may be passed as a single parameter. Implementing a robust collision for deformable objects is a difficult task, so the restriction is made here that the objects are rigid and move with constant linear velocity

during the time interval. The velocity may change from time interval to time interval, thus implying a piecewise linear path of motion for an object. The pseudocode becomes

```
for (i0 = 0; i0 < group.size; i0++)
{
    for (i1 = i0+1; i1 < group.size; i1++)
    {
        QueryResults results = DoIntersectionQuery(maxTime,
            group[i0],velocity[i0],group[i1],velocity[i1]);
        DoProcessQuery(results);
    }
}
```

Another issue. I placed the DoProcessQuery function call inside the inner loop. This implies that the objects are manipulated *during the group intersection query itself*. Alternatively, you can accumulate the results of all the queries and process outside the loops:

```
QueryResults allResults;
for (i0 = 0; i0 < group.size; i0++)
{
    for (i1 = i0+1; i1 < group.size; i1++)
    {
        QueryResults results = DoIntersectionQuery(maxTime,
            group[i0],velocity[i0],group[i1],velocity[i1]);
        allResults.Append(results);
    }
}
DoProcessQuery(allResults);
```

The results of a query are different if you process all intersections using the current state of the objects than if you change an object's state in the middle of a query. For example, if you have three objects $A(t_0)$, $B(t_0)$, and $C(t_0)$, where t_0 indicates the time for the current state, then the decision to postpone processing intersections to outside the loop results in the following queries:

```
results0 = DoIntersectionQuery(t1,A(t0),B(t0));
results1 = DoIntersectionQuery(t1,A(t0),C(t0));
results2 = DoIntersectionQuery(t1,B(t0),C(t0));
allResults = results0 + results1 + results2;
DoProcessQuery(allResults);  // new states A(t1), B(t1), C(t1)
```

A change in an object's state during the query leads to different semantics:

```
results = DoIntersectionQuery(t1,A(t0),B(t0));
DoProcessQuery(results);  // new states A'(t0), B'(t0)
results = DoIntersectionQuery(t1,A'(t0),C(t0));
DoProcessQuery(results);  // new states A(t1), C'(t0)
results = DoIntersectionQuery(t1,B'(t0),C'(t0));
DoProcessQuery(results);  // new states B(t1), C(t1)
```

In the latter case, state $A(t_0)$ was modified to $A'(t_0)$ and then modified to $A(t_1)$. The final state is not necessarily (and usually not) the final state obtained by the former case.

My choice is not to process the results incrementally. I prefer to accumulate the query results and process all at the same time. One benefit, for example, is that you may sort the queries for the pairs of objects based on the contact time. Each object can be moved a distance corresponding to the minimum contact time, at which time the objects are known not to be interpenetrating.[3]

In the pseudocode, the processing is postulated to happen explicitly after all queries are made for the pairs of objects. How you process the queries is most definitely specific to your application. Rather than providing a virtual function DoProcessQuery in the CollisionGroup class and requiring you to derive a class from CollisionGroup to override the behavior of the virtual function, I chose a *callback mechanism* that is designed to report the results of a query via a user-supplied callback function. An element of the collsion group must encapsulate an object, the object's velocity, a callback function to be executed when the object collides with another object, and any other information relevant to perform an intersection query. The class I designed for the encapsulation is called CollisionRecord. The specifics of the class are described in Section 6.4.2. The collision group intersection query is

```
for (i0 = 0; i0 < group.size; i0++)
{
    CollisionRecord record0 = group[i0];
    for (i1 = i0+1; i1 < group.size; i1++)
    {
        CollisionRecord record1 = group[i1];
        record0.DoIntersectionQuery(record1);
    }
}
```

3. More correct is to say that the objects are not *abstractly* interpenetrating. In the presence of exact arithmetic, no objects are interpenetrating. When using floating-point arithmetic, numerical round-off errors can lead to situations where the objects are slightly interpenetrating.

The geometric nature of the intersection query can be as complicated as the objects are. At the lowest level, the query should resolve to intersections between primitive objects, in our case triangles that make up the objects (at least those represented by triangle meshes). When a triangle-triangle intersection query is performed, and an intersection occurs, the callbacks associated with each collision record are executed and passed all the relevant information associated with the intersection, including which high-level objects own the triangles. Your application has implemented the callbacks and is free to do with the information as it will—process the intersection immediately or accumulate the results for processing after the collision group query terminates. In this manner, I have given you the power to do whatever you want to with the low-level results. As is always the case, with great power comes great responsibility. My callback scheme provides mechanism, but not policy. You have the responsibility for deciding how to process the data.

6.4.2 HIERARCHICAL COLLISION DETECTION

There are many ways to implement a collision detection system. Wild Magic does not have a fully featured system that handles every possible situation you can imagine, and it does not have a fully featured physics system. As many programmers have discovered, these systems are nontrivial to build and difficult to make robust. What I discuss here is just one collision detection subsystem that would occur in a fully featured system.

The method involves a hiearchical decomposition of a triangle mesh using a *bounding volume tree*. The root node of the tree represents the entire mesh. An interior node represents a submesh. In particular, I use a binary tree representation, so the two children of an interior node represent submeshes whose union is the mesh at the interior node. A leaf node represents one or more triangles in the original mesh (the default is one). Each node has associated with it a bounding volume that bounds the mesh associated with the node. The premise of such a data structure is simple—localize the query to subsets of triangles that potentially intersect by using the bounding volumes for culling large portions of the mesh that cannot intersect.

If you have two triangle meshes to be involved in a collision query, the naive approach to handle the query is to test each pair of triangles, one triangle from each mesh, for intersection. This is an expensive proposition when the meshes have large numbers of triangles. Consider the worst case when the two meshes do not intersect. You would process all pairs of triangles only to find out that no pair has an intersection. Using a bounding volume tree, the bounding volumes of the two root nodes are tested for intersection. If the bounding volumes do not intersect, then the meshes do not intersect. The bounding volume test is a *quick rejection test* and is akin to culling of objects in the rendering system.

How does the localization work? If the bounding volumes at the roots of the trees do intersect, the meshes might or might not intersect. More work must be done to decide which is the case. The trees are descended recursively, comparing

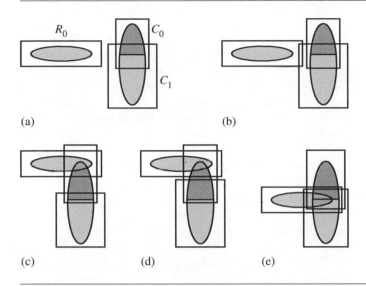

Figure 6.15 (a) Neither C_0 nor C_1 intersects R_0. The triangle meshes do not intersect. (b) C_1 intersects R_0, but C_0 does not. The submesh associated with C_0 cannot intersect the mesh associated with R_0. The subtree of C_1 must be traversed to find intersections, but the subtree of C_0 must not. In this example, the mesh of C_1 does not intersect the mesh of R_0. (c) C_0 intersects R_0, but C_1 does not. The submesh associated with C_1 cannot intersect the mesh associated with R_0. The subtree of C_0 must be traversed to find intersections, but the subtree of C_1 must not. In this example, the mesh of C_0 does intersect the mesh of R_0. (d) Both C_0 and C_1 intersect R_0. The subtrees rooted at the children must be traversed to obtain more information about the nature of intersections, if any. In this example, the mesh of C_0 intersects the mesh of R_0, but the mesh of C_1 does not. (e) Both C_0 and C_1 intersect R_0. The subtrees rooted at the children must be traversed to obtain more information about the nature of intersections, if any. In this example, both child meshes intersect the mesh of R_0.

bounding volumes along the way. I choose to use a depth-first search on one tree for a comparison of the bounding volumes against that of a fixed node in the other tree. Breadth-first searches are also possible. Let R_0 be the bounding volume of the root of the first tree and R_1 be the bounding volume of the root of the second tree. Given that R_0 and R_1 intersect, the child bounding volumes of the root of the second tree, call them C_0 and C_1, are compared to R_0. The possibilities are shown in Figure 6.15.

The ideal, optimal case is when the two objects intersect at a single pair of triangles. A single path of bounding volumes is processed in each tree to narrow down the possible intersections to a pair of leaf nodes of the tree. This eliminates a lot of

calculations. On the other hand, if the trees are very deep, the large number of intersection tests for pairs of triangles are replaced by a large number of intersection tests for bounding volumes, in which case the localization costs more than if you had simply dealt only with triangle-triangle pairs. The break-even point for the number of triangles in a mesh versus the depth of the tree is something you should determine based on your own data and target platform. For current CPUs running at 2 to 3 GHz, my rule of thumb is that once the tree depth becomes 8 or 9, the tree approach is no longer cost-effective. If depth 0 corresponds to a single root node, and depth 1 corresponds to a root and two children, then depth n corresponds to a complete binary tree with $2^{n+1} - 1$ nodes, of which 2^n are leaf nodes. A tree of depth 9 has 512 leaf nodes, so the largest triangle mesh involved in the collision query is limited to 512 triangles. Should you choose to include objects in a collision query with thousands of triangles, you might want to consider something more practical such as using a *collision proxy*, a triangle mesh that has many fewer triangles, but approximately the same shape as your object. The proxy is not displayable geometry and is only used as a coarse-resolution approximation solely for collision queries.

The concept of a bounding volume was already discussed in Section 3.2.2, but in the context of culling objects from the rendering system. The abstract base class is BoundingVolume and provides an interface to support visual culling. That same interface also has functions to support collision culling using bounding volume trees. Two of the derived bounding volume classes are SphereBV (bounding spheres) and BoxBV (oriented bounding boxes). The bounding volume trees may use any bounding volume type that the engine implements. The use of SphereBV is the essence of *sphere trees*, as discussed in [Hub96]. The use of BoxBV is the essence of the popular *OBB trees* (in RAPID), as discussed in [GLM96].

The hierarchical collision system must support constructing the trees as well as the collision queries themselves. The abstract class BoundingVolumeTree has all this support. The construction code is detailed, much of it independent of the bounding volume type. The base class contains the factored code that supports all types. A few functions that are specific to the bounding volume type are implemented in derived classes, namely, SphereBVTree and BoxBVTree.

Class BoundingVolumeTree

The interface for BoundingVolumeTree is

```
class BoundingVolumeTree
{
public:
    virtual ~BoundingVolumeTree ();

    // tree topology
    BoundingVolumeTree* GetLChild ();
```

```
            BoundingVolumeTree* GetRChild ();
            bool IsInteriorNode () const;
            bool IsLeafNode () const;

            // member access
            const TriMesh* GetMesh () const;
            const BoundingVolume* GetWorldBound () const;
            int GetTriangleQuantity () const;
            int GetTriangle (int i) const;
            const int* GetTriangles () const;

            void UpdateWorldBound ();

        protected:
            BoundingVolumeTree (const TriMesh* pkMesh);
            BoundingVolumeTree (int eBVType, const TriMesh* pkMesh,
                int iMaxTrisPerLeaf = 1, bool bStoreInteriorTris = false);

            void BuildTree (int eBVType, int iMaxTrisPerLeaf,
                bool bStoreInteriorTris, const Vector3f* akCentroid,
                int i0, int i1, int* aiISplit, int* aiOSplit);

            static void SplitTriangles (const Vector3f* akCentroid,
                int i0, int i1, int* aiISplit, int& rj0, int& rj1,
                int* aiOSplit, const Line3f& rkLine);

            // for quick-sort of centroid projections on axes
            class ProjectionInfo
            {
            public:
                int m_iTriangle;
                float m_fProjection;
            };
            static int Compare (const void* pvElement0,
                const void* pvElement1);

            // model bounding volume factory
            typedef BoundingVolume* (*CreatorM)(
                const TriMesh*,int,int,int*,Line3f&);
            static CreatorM ms_aoCreateModelBound[
                BoundingVolume::BV_QUANTITY];

            // world bounding volume factory
            typedef BoundingVolume* (*CreatorW)(void);
```

```
        static CreatorW ms_aoCreateWorldBound[
            BoundingVolume::BV_QUANTITY];

        // mesh and bounds
        const TriMesh* m_pkMesh;
        BoundingVolumePtr m_spkModelBound;
        BoundingVolumePtr m_spkWorldBound;

        // binary tree representation
        BoundingVolumeTree* m_pkLChild;
        BoundingVolumeTree* m_pkRChild;

        int m_iTriangleQuantity;
        int* m_aiTriangle;
};
```

The constructor BoundingVolumeTree(int, const TriMesh*, int, bool) is the entry point to construction of the tree. The first parameter is the type of the bounding volume to use and is provided by the derived-class constructors. The mesh subdivision is based on projecting the triangle centroids onto some line and then splitting by the median of the centroids. All triangles whose centroids are on one side of the median become one submesh, and the remaining triangles form the other submesh. The idea is to produce a balanced tree to minimize the tree depth. The constructor computes the triangle centroids and then passes control to the function BuildTree to do the subdivision.

The BuildTree function partitions the triangles and stores the indices in an array, grouped by which submesh the triangles are in. The algorithm is memory efficient in that it uses two index arrays whose sizes are the number of triangles. The indices in the first array are partitioned and stored in the second array. On the next subdivision the indices in the second array are partitioned and stored in the first array. The arrays reverse roles on each subdivision step.

The first thing BuildTree does is compute a model bounding volume for the current mesh. The same function uses geometric information from this bounding volume to determine the line that the centroids of the triangles of the current mesh will be projected onto in order to split the mesh into two submeshes. The second step in BuildTree is to create a world bounding volume. This volume is computed from the model bounding volume and the mesh transformations on each intersection query. The code in BuildTree for these steps is

```
Line3f kLine;
m_spkModelBound = ms_aoCreateModelBound[eBVType](m_pkMesh,i0,i1,
    aiISplit,kLine);
m_spkWorldBound = ms_aoCreateWorldBound[eBVType]();
```

Notice the use of static arrays that store function pointers. These create bounding volumes of the specific type indicated by eBVType. Your first instinct might be to use virtual functions for model and world bounding volume creation; the base class would declare the virtual functions as pure, and the derived classes would implement them. For example,

```
Line3f kLine;
m_spkModelBound = CreateModelBound(m_pkMesh,i0,i1,aiISplit,kLine);
m_spkWorldBound = CreateWorldBound();
```

The class SphereBVTree overrides the two virtual functions to create SphereBV objects. Likewise, the class BoxBVTree overrides the two virtual functions to create BoxBV objects. But this does not work! The problem is that BuildTree is called in the constructor for BoundingVolumeTree. That means CreateModelBound and CreateWorld-Bound are indirectly called during the base class construction. The C++ language insists that direct or indirect calls to virtual functions during a base class construc-tor call can only be resolved to be calls to the implementation of those functions in the base class. In the current situation, CreateModelBound resolves to BoundingVol-umeTree::CreateModelBound, not to a derived class CreateModelBound. This is an error since the virtual function in the base class is pure.[4]

I really do want the correct derived-class functions to be called. Since C++ does not support this, I had to hack a bit. My choice was to store static arrays of the creation functions in the base class, and then each derived class fills in the array elements during pre-main construction. For example, SphereBVTree uses the pre-main initialization macros and implements

```
void SphereBVTree::Initialize ()
{
    ms_aoCreateModelBound[BoundingVolume::BV_SPHERE] =
        &SphereBVTree::CreateModelBound;

    ms_aoCreateWorldBound[BoundingVolume::BV_SPHERE] =
        &SphereBVTree::CreateWorldBound;
}
```

The size of the array is the current number of bounding volume types; this information is stored in class BoundingVolume:

```
// run-time type information
enum // BVType
```

4. Some compilers trap this error when in debug mode. For example, Microsoft Visual Studio will generate an exception and report an attempt to call a pure virtual function.

```
{
    BV_SPHERE,
    BV_BOX,
    BV_QUANTITY
};
virtual int GetBVType () const = 0;
```

Effectively, this is a user-managed virtual function table lookup, but with semantics different than what C++ supports.[5]

The creation of model bounding volumes is specific to the type of bounding volume. The SphereBV bounding volume uses the average of the mesh vertices as the sphere center. The smallest radius is computed for the sphere centered at the average to contain all the mesh vertices. The line used for splitting the mesh is chosen to be the best line of fit to the vertices using orthogonal least squares. The direction of the line is the eigenvector of the covariance matrix of the vertices that corresponds to the largest eigenvalue. The BoxBV bounding volume is computed to have a center that is the average of the vertices. The covariance matrix associated with this center is computed, and the eigenvectors are extracted from it. The eigenvectors are used as the box axis directions. The extents of the vertices in these directions are computed. The box obtained from these axes and extents is the model bound. Notice that the center of this box is not necessarily the one used to generate the covariance matrix.

BuildTree uses the line returned from the model bounding volume construction and passes it to the SplitTriangles function. This function projects the centroids of the current triangle mesh onto the line, computes the median, and partitions the triangle indices. A bounding volume tree is computed for each submesh in a recursive manner by twice calling the BuildTree function.

The default number of triangles per leaf node of the tree is 1. When a recursive call is made to BuildTree for a mesh of one triangle, the triangle index is stored at the leaf node. The member variable m_iTriangleQuantity is set to 1, and the array m_aiTriangle is allocated to contain a single element, the triangle index. The constructor for BoundingVolumeTree actually allows you to specify more than one triangle per leaf node via input iMaxTrisPerLeaf. At some point the call to BuildTree is for a submesh whose number of triangles is smaller or equal to iMaxTrisPerLeaf. In this case, a leaf node is created, and m_iTriangle is set to the number of triangles in the submesh. The array m_aiTriangle is allocated to store all the triangle indices for the submesh. Another parameter to the constructor is bStoreInteriorTris. If this Boolean flag is set to true, the interior nodes of the bounding volume tree also allocate m_aiTriangle and store the indices for the submesh represented by the node.

5. Wild Magic version 2 had a similar scheme, but the bounding volume creation functions were implemented in the BoundingVolume-derived classes. Wild Magic version 3 implements the creation functions in the BoundingVolumeTree to better encapsulate the hierarchical collision solely within the bounding volume tree system.

This information might be useful in some applications, but not others, so I leave it to you to decide whether or not you want the information stored.

Class CollisionRecord

The collision group is a collection of collision records. Each record encapsulates the triangle mesh, its bounding volume tree, the object linear velocity (the object is rigid), a callback to be executed if an intersection occurs between this object and another, and callback data that can be passed to the callback function. The class interface is

```
class CollisionRecord
{
public:
    typedef void (*Callback) (CollisionRecord& rkRecord0, int iT0,
        CollisionRecord& rkRecord1, int iT1, void* pvIntersectionData);

    // Construction and destruction.  CollisionRecord assumes
    // responsibility for deleting pkTree, so it should be
    // dynamically allocated.
    CollisionRecord (TriMesh* pkMesh, BoundingVolumeTree* pkTree,
        Vector3f* pkVelocity, Callback oCallback, void* pvCallbackData);

    ~CollisionRecord ();

    // member access
    TriMesh* GetMesh ();
    Vector3f* GetVelocity ();
    void* GetCallbackData ();

    // intersection queries
    void TestIntersection (CollisionRecord& rkRecord);
    void FindIntersection (CollisionRecord& rkRecord);
    void TestIntersection (float fTMax, CollisionRecord& rkRecord);
    void FindIntersection (float fTMax ,CollisionRecord& rkRecord);

protected:
    TriMesh* m_pkMesh;
    BoundingVolumeTree* m_pkTree;
    Vector3f* m_pkVelocity;
    Callback m_oCallback;
    void* m_pvCallbackData;
};
```

The `TestIntersection` query is for static objects; that is, the velocity vectors are ignored (assumed to be zero velocity). The implementation is

```
void CollisionRecord::TestIntersection (CollisionRecord& rkRecord)
{
    // convenience variables
    BoundingVolumeTree* pkTree0 = m_pkTree;
    BoundingVolumeTree* pkTree1 = rkRecord.m_pkTree;
    const TriMesh* pkMesh0 = m_pkTree->GetMesh();
    const TriMesh* pkMesh1 = rkRecord.m_pkTree->GetMesh();

    pkTree0->UpdateWorldBound();
    pkTree1->UpdateWorldBound();

    const BoundingVolume* pkWorldBV0 = pkTree0->GetWorldBound();
    const BoundingVolume* pkWorldBV1 = pkTree1->GetWorldBound();
    if ( pkWorldBV0->TestIntersection(pkWorldBV1) )
    {
        BoundingVolumeTree* pkRoot;

        if ( pkTree0->IsInteriorNode() )
        {
            pkRoot = m_pkTree;

            // compare Tree0.L to Tree1
            m_pkTree = pkRoot->GetLChild();
            TestIntersection(rkRecord);

            // compare Tree0.R to Tree1
            m_pkTree = pkRoot->GetRChild();
            TestIntersection(rkRecord);

            m_pkTree = pkRoot;
        }
        else if ( pkTree1->IsInteriorNode() )
        {
            pkRoot = rkRecord.m_pkTree;

            // compare Tree0 to Tree1.L
            rkRecord.m_pkTree = pkRoot->GetLChild();
            TestIntersection(rkRecord);

            // compare Tree0 to Tree1.R
            rkRecord.m_pkTree = pkRoot->GetRChild();
            TestIntersection(rkRecord);
```

```
            rkRecord.m_pkTree = pkRoot;
        }
        else
        {
            // at a leaf in each tree
            int iMax0 = pkTree0->GetTriangleQuantity();
            for (int i0 = 0; i0 < iMax0; i0++)
            {
                int iT0 = pkTree0->GetTriangle(i0);

                // get world space triangle
                Triangle3f kTri0;
                pkMesh0->GetWorldTriangle(iT0,kTri0);

                int iMax1 = pkTree1->GetTriangleQuantity();
                for (int i1 = 0; i1 < iMax1; i1++)
                {
                    int iT1 = pkTree1->GetTriangle(i1);

                    // get world space triangle
                    Triangle3f kTri1;
                    pkMesh1->GetWorldTriangle(iT1,kTri1);

                    IntrTriangle3Triangle3<float> kIntersector(
                        kTri0,kTri1);
                    if ( kIntersector.Test() )
                    {
                        if ( m_oCallback )
                        {
                            m_oCallback(*this,iT0,rkRecord,iT1,
                                &kIntersector);
                        }

                        if ( rkRecord.m_oCallback )
                        {
                            rkRecord.m_oCallback(rkRecord,iT1,
                                *this,iT0,&kIntersector);
                        }
                    }
                }
            }
        }
    }
}
```

The function first tells the bounding volume tree nodes to compute their world bounding volumes from their model bounding volumes and the triangle mesh model-to-world transformation. The world bounding volumes are tested for (static) intersection. If the test fails, the meshes represented by the tree nodes cannot intersect and the function returns. If the test succeeds, the `CollisionRecord::TestIntersection` function is called recursively on the children of the first tree's node and compared to the second tree's current node. If the first tree's node is a leaf node, the second tree is recursively processed to compare its bounding volumes against the leaf node bounding volume of the first tree. It is possible that eventually a leaf node of one tree is compared to a leaf node of another tree. At that time we are ready to test for intersection between the triangles at the leaf nodes. An all-pairs comparison is made, but now the assumption is that each leaf node has only one (or only a few) triangles, so efficiency is not a question anymore—the localization of the intersection has occurred.

For each triangle-triangle pair, a test-intersection query is made. If it succeeds, the callback functions are called. The intersector is passed to the callback so that the intersection set may be accessed, if necessary, to process the triangles.

The `FindIntersection(CollisionRecord&)` implementation is nearly identical, except that the triangle-triangle static test-intersection query is replaced by a static find-intersection query. The `TestIntersection` and `FindIntersection` queries that take the maximum time are designed for moving objects. The world bounding volume static test-intersection is replaced by a dynamic test-intersection. The triangle-triangle static test- or find-intersection queries are replaced by triangle-triangle dynamic test- or find-intersection queries.

Triangle-Triangle Intersection Queries

The triangle-triangle intersection queries are implemented in the class `IntrTriangle3Triangle3` class, which is derived from `Intersector`.

The static test-intersection query uses the method of separating axes to decide whether or not the triangles are intersecting.

The static find-intersection query uses a straightforward geometric construction. If the planes of the triangles are not parallel, the line of intersection of the planes is computed. The intersection of the first triangle with this line is computed and produces a line segment. The intersection of the second triangle with the line is computed, producing another line segment. The intersection of the two line segments is the intersection set of the triangles.

The dynamic test-intersection query also uses the method of separating axes, but with an extension that handles objects moving with constant linear velocity. The extension is discussed in [Ebe00] and [SE02]. The dynamic find-intersection query also uses the method of separating axes when the triangles are not initially

intersecting. The extension to handle moving objects also is designed to compute the contact time and contact set.

Class CollisionGroup

The interface for CollisionGroup is

```
class CollisionGroup
{
public:
    CollisionGroup ();
    ~CollisionGroup ();

    // CollisionGroup assumes responsibility for deleting the
    // collision records, so the input records should be
    // dynamically allocated.
    bool Add (CollisionRecord* pkRecord);
    bool Remove (CollisionRecord* pkRecord);

    // Intersection queries.  If two objects in the group collide,
    // the corresponding records process the information
    // accordingly.

    // The objects are assumed to be stationary (velocities are
    // ignored) and all pairs of objects are compared.
    void TestIntersection ();
    void FindIntersection ();

    // The objects are assumed to be moving.  Objects are compared
    // when at least one of them has a velocity vector associated
    // with it (that vector is allowed to be the zero vector).
    void TestIntersection (float fTMax);
    void FindIntersection (float fTMax);

protected:
    TArray<CollisionRecord*> m_kRecord;
};
```

This is a simple wrapper to encapsulate an array of collision records. You may add and remove collision records as desired. The first two functions TestIntersection and FindIntersection have the obvious implementations.

```
void CollisionGroup::TestIntersection ()
{
    // objects are assumed to be stationary, compare all pairs
    for (int i0 = 0; i0 < m_kRecord.GetQuantity(); i0++)
    {
        CollisionRecord* pkRecord0 = m_kRecord[i0];
        for (int i1 = i0+1; i1 < m_kRecord.GetQuantity(); i1++)
        {
            CollisionRecord* pkRecord1 = m_kRecord[i1];
            pkRecord0->TestIntersection(*pkRecord1);
        }
    }
}

void CollisionGroup::FindIntersection ()
{
    // objects are assumed to be stationary, compare all pairs
    for (int i0 = 0; i0 < m_kRecord.GetQuantity(); i0++)
    {
        CollisionRecord* pkRecord0 = m_kRecord[i0];
        for (int i1 = i0+1; i1 < m_kRecord.GetQuantity(); i1++)
        {
            CollisionRecord* pkRecord1 = m_kRecord[i1];
            pkRecord0->FindIntersection(*pkRecord1);
        }
    }
}
```

The second two functions are for moving objects and provide a slight increase in performance because two objects without velocities specified are assumed to be stationary and not intersecting. Such pairs are not processed by the system. This is useful, for example, when you have moving objects in a room. The objects may collide with each other and with the walls of the room. However, two walls are not moving and cannot intersect, so there is no point in initiating a collision query for two walls.

```
void CollisionGroup::TestIntersection (float fTMax)
{
    // objects are assumed to be moving, compare all pairs
    for (int i0 = 0; i0 < m_kRecord.GetQuantity(); i0++)
    {
        CollisionRecord* pkRecord0 = m_kRecord[i0];
        for (int i1 = i0+1; i1 < m_kRecord.GetQuantity(); i1++)
        {
            CollisionRecord* pkRecord1 = m_kRecord[i1];
```

```
                       if ( pkRecord0->GetVelocity()
                       ||  pkRecord1->GetVelocity() )
                       {
                           pkRecord0->TestIntersection(fTMax,*pkRecord1);
                       }
                   }
               }
           }

       void CollisionGroup::FindIntersection (float fTMax)
       {
           // objects are assumed to be moving, compare all pairs
           for (int i0 = 0; i0 < m_kRecord.GetQuantity(); i0++)
           {
               CollisionRecord* pkRecord0 = m_kRecord[i0];
               for (int i1 = i0+1; i1 < m_kRecord.GetQuantity(); i1++)
               {
                   CollisionRecord* pkRecord1 = m_kRecord[i1];
                   if ( pkRecord0->GetVelocity()
                   ||  pkRecord1->GetVelocity() )
                   {
                       pkRecord0->FindIntersection(fTMax,*pkRecord1);
                   }
               }
           }
       }
```

An application illustrating the hierarchical collision system is on the companion website,

```
GeometricTools/WildMagic3/SampleGraphics/Collisions
```

The application creates two finite cylinders, each with a single color. Wherever the cylinders intersect, the triangle colors are modified to highlight those involved in the intersection. Figure 6.16 shows a couple of screen shots. The cylinders are red and blue. The intersecting triangles on the red cylinder are colored in yellow. Those on the blue cylinder are colored in cyan.

6.4.3 SPATIAL AND TEMPORAL COHERENCE

The CollisionGroup intersection queries for moving objects just iterate over all pairs of objects and execute a query per pair. A smarter system will take advantage of spatial and temporal coherence. If two objects are far away at one instance of time and do not intersect, the chances are they are still far away at the next instance of time. It is

Figure 6.16 A couple of screen shots showing the triangles of intersection between two cylinders. (See also Color Plate 6.16.)

useful to have a system that knows not to even initiate an intersection query for this situation.

An effective system is described in [Bar01] and performs well in practice. I discussed this system in [Ebe03a]. Rather than try to rewrite that material, I just repeat it here (not quite verbatim), but with a discussion of the actual implementation.

To each object, we associate an axis-aligned bounding box (AABB). If two AABBs do not intersect, then the objects contained by them do not intersect. If the AABBs do intersect, we then test if the enclosed objects intersect. Each time step the objects move and their AABBs must be updated. Once the AABBs are updated for all the objects, we expect that the intersection status of pairs of objects/AABBs has changed—old intersections might no longer exist, new intersections might now occur. Spatial and temporal coherence will be used to make sure the update of status is efficient.

Intersecting Intervals

The idea of determining intersection between AABBs is based on sorting and update of intervals on the real line, a one-dimensional problem that we will analyze first. Consider a collection of n intervals $I_i = [b_i, e_i]$ for $1 \le i \le n$. The problem is to efficiently determine all pairs of intersecting intervals. The condition for a single pair I_i and I_j to intersect is $b_j \le e_i$ and $b_i \le e_j$. The naive algorithm for the full set of intervals just compares all possible pairs, an $O(n^2)$ algorithm.

A more efficient approach uses a *sweep algorithm*, a concept that has been used successfully in many computational geometry algorithms. First, the interval end points are sorted into ascending order. An iteration is made over the sorted list (the sweep) and a set of *active intervals* is maintained, initially empty. When a beginning value b_i is encountered, all active intervals are reported as intersecting with interval I_i, and I_i is added to the set of active intervals. When an ending value e_i is encountered, interval I_i is removed from the set of active intervals. The sorting phase is $O(n \log n)$. The sweep phase is $O(n)$ to iterate over the sorted list—clearly asymptotically faster than $O(n \log n)$. The intersecting reporting phase is $O(m)$ to report the m intersecting intervals. The total order is written as $O(n \log n + m)$. The worst-case behavior is when all intervals overlap, in which case $m = O(n^2)$, but for our applications we expect m to be relatively small. Figure 6.17 illustrates the sweep phase of the algorithm.

The sorted interval end points are shown on the horizontal axis of the figure. The set of active intervals is initially empty, $A = \emptyset$. The first five sweep steps are enumerated as follows:

1. b_3 encountered. No intersections reported since A is empty. Update $A = \{I_3\}$.

2. b_1 encountered. Intersection $I_3 \cap I_1$ is reported. Update $A = \{I_3, I_1\}$.

3. b_2 encountered. Intersections $I_3 \cap I_2$ and $I_1 \cap I_2$ reported.
 Update $A = \{I_3, I_1, I_2\}$.

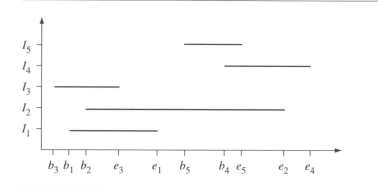

Figure 6.17 The sweep phase of the algorithm.

4. e_3 encountered. Update $A = \{I_1, I_2\}$.

5. e_1 encountered. Update $A = \{I_2\}$.

The remaining steps are easily stated and are left as an exercise.

A warning is in order here: The sorting of the interval end points must be handled carefully when equality occurs. For example, suppose that two intervals $[b_i, e_i]$ and $[b_j, e_j]$ intersect in a single point, $e_i = b_j$. If the sorting algorithm lists e_i before b_j, when e_i is encountered in the sweep we remove I_i from the set of active intervals. Next, b_j is encountered, and intersections of I_j with the active intervals are reported. The interval I_i was removed from the active set on the previous step, so $I_j \cap I_i$ is *not reported*. In the sort, suppose instead that b_j is listed before e_i by the sorting algorithm. Since b_i was encountered earlier in the sweep, the set of active intervals contains I_i. When b_j is encountered $I_j \cap I_i$ *is reported* as an intersection. Clearly, the order of equal values in the sort is important. Our application will require that we report just-touching intersections, so the interval end points cannot be sorted just as a set of floating-point numbers. Tags need to be associated with each end point indicating whether it is a beginning point or an ending point. The sorting must take the tag into account to make sure that equal end point values are sorted so that values with a "begin" tag occur before values with an "end" tag. The tags are not a burden since, in fact, we need them anyway to decide during the sweep what type of end point we have encountered. Pseudocode for the sort and sweep is

```
struct EndPoint
{
    enum Type { BEGIN = 0, END = 1 };
    Type type;
    double value;
    int interval;  // index of interval containing this end point
```

```
        // EndPoint E1, E2;
        // E1 < E2 when
        //    E1.value < E2.value, or
        //    E1.value == E2.value AND E1.type < E2.type
}

struct Interval
{
    EndPoint P[2];
};

void SortAndSweep (int n, Interval I[])
{
    // use O(n log n) sort
    array<EndPoint> L = Sort(n,I);

    // active set of intervals (stored by index in array)
    set<int> A = empty;

    // (i,j) in S means I[i] and I[j] overlap
    set<int,int> S = empty;

    for (i = 0; i < L.size(); i++)
    {
        if ( L[i].type == EndPoint::BEGIN )
        {
            for (each j in A) do
                S.Insert(j,L[i].interval);
            A.Insert(L[i].interval);
        }
        else  // L[i].type == EndPoint::END
        {
            A.Remove(I[L[i].interval]);
        }
    }
}
```

Once the sort-and-sweep has occurred, the intervals are allowed to move about, thus invalidating the order of the end points in the sorted list. We can re-sort the values and apply another sweep, an $O(n \log n + m)$ process. However, we can do better than that. The sort itself may be viewed as a way to know the spatial coherence of the intervals. If the intervals move only a small distance, we expect that not many of the end points will swap order with their neighbors. The modified list is *nearly sorted*, so we should re-sort using an algorithm that is fast for nearly sorted inputs. Taking

advantage of the small number of swaps is our way of using temporal coherence to reduce our workload. The insertion sort is a fast algorithm for sorting nearly sorted lists. For general input it is $O(n^2)$, but for nearly sorted data it is $O(n + e)$, where e is the number of exchanges used by the algorithm. Pseudocode for the insertion sort is

```
// input:  A[0] through A[n-1]
// output: array sorted in place
void InsertionSort (int n, type A[])
{
    for (j = 1; j < n; j++)
    {
        key = A[j];
        i = j-1;
        while ( i >= 0 and A[i] > key )
        {
            Swap(A[i],A[i+1]);
            i-;
        }
        A[i+1] = key;
    }
}
```

The situation so far is that we applied the sort-and-sweep algorithm to our collection of intervals, a once-only step that requires $O(n \log n + m)$ time. The output is a set S of pairs (i, j) that correspond to overlapping intervals, $I_i \cap I_j$. Some intervals are now moved, and the list of end points is re-sorted in $O(n + e)$ time. The set S might have changed, and two overlapping intervals might not overlap now. Instead, two nonoverlapping intervals might now overlap. To update S we can simply apply the sweep algorithm from scratch, an $O(n + m)$ algorithm, and build S anew. Better, though, is to mix the update with the insertion sort. An exchange of two "begin" points with two "end" points does not change the intersection status of the intervals. If a pair of "begin" and "end" points is swapped, then we have either gained a pair of overlapping intervals or lost a pair. By temporal coherence, we expect the number of changes in status to be small. If c is the number of changes of overlapping status, we know that $c \le e$, where e is the number of exchanges in the insertion sort. The value e is expected to be much smaller than m, the number of currently overlapping intervals. Thus, we would like to avoid the full sweep that takes $O(n + m)$ time and update during the insertion sort that takes smaller time $O(n + e)$.

Figure 6.18 illustrates the update phase of the algorithm applied to the intervals shown in Figure 6.17. At the initial time the sorted end points are $\{b_3, b_1, b_2, e_3, e_1, b_5, b_4, e_5, e_2, e_4\}$. The pairs of indices for the overlapping intervals are $S = \{(1, 2), (1, 3), (2, 3), (2, 4), (2, 5), (4, 5)\}$. Now I_1 moves to the right and I_5 moves to the left. The new end points are denoted $\bar{b}_1, \bar{e}_1, \bar{b}_5,$ and \bar{e}_5. The list of end points that was

Figure 6.18 The update phase of the algorithm when intervals have moved.

sorted but now has had values changed is $\{b_3, \bar{b}_1, b_2, e_3, \bar{e}_1, \bar{b}_5, b_4, e_5, e_2, e_4\}$. The insertion sort is applied to this set of values. The steps follow:

1. Initialize the sorted list to be $L = \{b_3\}$.

2. Insert \bar{b}_1, $L = \{b_3, \bar{b}_1\}$.

3. Insert b_2, $L = \{b_3, \bar{b}_1, b_2\}$.

 (a) Exchange \bar{b}_1 and b_2, $L = \{b_3, b_2, \bar{b}_1\}$. No change to S.

4. Insert e_3, $L = \{b_3, b_2, \bar{b}_1, e_3\}$.

5. Insert \bar{e}_1, $L = \{b_3, b_2, \bar{b}_1, e_3, \bar{e}_1\}$.

6. Insert \bar{b}_5, $L = \{b_3, b_2, \bar{b}_1, e_3, \bar{e}_1, \bar{b}_5\}$.

 (a) Exchange \bar{e}_1 and \bar{b}_5, $L = \{b_3, b_2, \bar{b}_1, e_3, \bar{b}_5, \bar{e}_1\}$. This exchange causes I_1 and I_5 to overlap, so insert $(1, 5)$ into the set $S = \{(1, 2), (1, 3), (1, 5), (2, 3), (2, 4), (2, 5), (4, 5)\}$.

7. Insert b_4, $L = \{b_3, b_2, \bar{b}_1, e_3, \bar{b}_5, \bar{e}_1, b_4\}$.

8. Insert \bar{e}_5, $L = \{b_3, b_2, \bar{b}_1, e_3, \bar{b}_5, \bar{e}_1, b_4, \bar{e}_5\}$.

 (a) Exchange b_4 and \bar{e}_5, $L = \{b_3, b_2, \bar{b}_1, e_3, \bar{b}_5, \bar{e}_1, \bar{e}_5, b_4\}$. This exchange causes I_4 and I_5 to no longer overlap, so remove $(4, 5)$ from the set $S = \{(1, 2), (1, 3), (1, 5), (2, 3), (2, 4), (2, 5)\}$.

9. Insert e_2, $L = \{b_3, b_2, \bar{b}_1, e_3, \bar{b}_5, \bar{e}_1, \bar{e}_5, b_4, e_2\}$.

10. Insert e_4, $L = \{b_3, b_2, \bar{b}_1, e_3, \bar{b}_5, \bar{e}_1, \bar{e}_5, b_4, e_2, e_4\}$.

11. The new list is sorted and the set of overlaps is current.

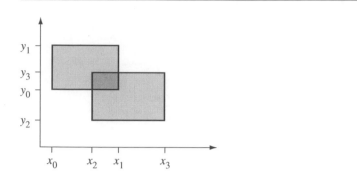

Figure 6.19 Axis-aligned rectangles overlap when both their x-intervals and y-intervals overlap.

Intersecting Rectangles

The algorithm for computing all pairs of intersecting axis-aligned rectangles is a simple extension of the algorithm for intervals. An axis-aligned rectangle is of the form $[x_{\min}, x_{\max}] \times [y_{\min}, y_{\max}]$. Two such rectangles intersect if there is overlap between both their x-intervals and their y-intervals, as shown in Figure 6.19. The rectangles are $[x_0, x_1] \times [y_0, y_1]$ and $[x_2, x_3] \times [y_2, y_3]$. The rectangles overlap because $[x_0, x_1] \cap [x_2, x_3] \neq \emptyset$ and $[y_0, y_1] \cap [y_2, y_3] \neq \emptyset$.

In the two-dimensional setting, we maintain two sorted lists, one for the end points of the x-intervals and one for the end points of the y-intervals. The initial step of the algorithm sorts the two lists. The sweep portion is only slightly more complicated than for one dimension. The condition for overlap is that the x-intervals *and* y-intervals overlap. If we were to sweep the sorted x-list first and determine that two x-intervals overlap, that is not sufficient to say that the rectangles of those x-intervals overlap. We could devise some fancy scheme to sweep both x- and y-lists at the same time, but it is simpler just to do a little extra work. If two x-intervals overlap, we will test for overlap of the corresponding rectangles in both dimensions and update the set of overlapping rectangles as needed.

Once we have the sorted lists and a set of overlapping rectangles, we will move the rectangles and must update the lists and set. The process will use an insertion sort to take advantage of spatial and temporal coherence. The x-list is processed first. If an exchange occurs so that two previously overlapping intervals no longer overlap, the corresponding rectangles no longer overlap, so we can remove that pair from the set of overlaps. If an exchange occurs so that two previously nonoverlapping intervals now overlap, the corresponding rectangles may or may not overlap. Just as we did for the initialization phase, we will simply test the corresponding rectangles for overlap in both dimensions and adjust the set of overlaps accordingly.

Intersecting Boxes

You should see clearly that the algorithm for axis-aligned rectangles in two dimensions extends easily to axis-aligned boxes in three dimensions. The collision system itself has the following outline:

1. Generate AABBs for the objects of the system.

2. Using the sort-and-sweep method, compute the set S of all pairs of intersecting AABBs.

3. Determine which AABBs intersect using the fast insertion sort update.

4. For each pair of intersecting AABBs, call the intersection query between the corresponding collision records.

5. When all intersecting pairs are processed, move the objects according to your collision response system.

6. Recompute the AABBs for the objects.

7. Repeat step 3.

The implementation of the system for intersecting boxes is in the class Intersect-ingBoxes:

```
template <class Real>
class IntersectingBoxes
{
public:
    typedef typename int BoxPair[2];

    IntersectingBoxes (TArray<AxisAlignedBox3<Real>>& rkBoxes);
    ~IntersectingBoxes ();

    void Initialize ();

    void SetBox (int i, const AxisAlignedBox3<Real>& rkRect);
    void GetBox (int i, AxisAlignedBox3<Real>& rkRect) const;

    void Update ();

    const TSet<BoxPair>& GetOverlap () const;

private:
    class EndPoint
    {
    public:
```

```
            Real Value;
            int Type;   // '0' if interval min, '1' if interval max
            int Index;  // index of interval containing this end point

            // support for sorting of end points
            bool operator< (const EndPoint& rkEP) const
            {
                if ( Value < rkEP.Value )
                    return true;
                if ( Value > rkEP.Value )
                    return false;
                return Type < rkEP.Type;
            }
        };

        void InsertionSort (TArray<EndPoint>& rkEndPoint,
            TArray<int>& rkLookup);

        TArray<AxisAlignedBox3<Real> >& m_rkBoxes;
        TArray<EndPoint> m_kXEndPoint, m_kYEndPoint, m_kZEndPoint;
        TSet<BoxPair> m_kOverlap;

        TArray<int> m_kXLookup, m_kYLookup, m_kZLookup;
};
```

The function Initialize is called by the constructor and does the sort-and-sweep to initialize the update system. However, if you add or remove items from the array of boxes after the constructor call, you will need to call this function once before you start the multiple calls of the update function.

After the system is initialized, you can move the boxes using the function SetBox. It is not enough to modify the input array of boxes since the end point values stored internally by this class must also change. You can also retrieve the current box information using GetBox. When you are finished moving boxes, call the Update function to determine the overlapping boxes. An incremental update is applied to determine the new set of overlapping boxes. If (i, j) is in the overlap set, then box i and box j are overlapping. The indices are those for the input array. The set elements (i, j) are stored so that $i < j$.

The members m_kXLookup, m_kYLookup, and m_kZLookup are used for the following purposes. The intervals are indexed $0 \le i < n$. The end point array has $2n$ entries. The original $2n$ interval values are ordered as b[0], e[0], b[1], e[1], . . . , b[n-1], and e[n-1]. When the end point array is sorted, the mapping between interval values and end points is lost. In order to modify interval values that are stored in the end point array, we need to maintain the mapping. This is done by the lookup tables of

$2n$ entries. The value m_kLookup[2*i] is the index of b[i] in the end point array. The value m_kLookup[2*i+1] is the index of e[i] in the end point array.

The sample application on the companion website that illustrates this is

```
GeometricTools/WildMagic3/SamplePhysics/IntersectingBoxes
```

The application shows a collection of boxes that are moving. Whenever two boxes overlap, the box colors are changed.

CHAPTER 7

PHYSICS

7.1 NUMERICAL METHODS FOR SOLVING DIFFERENTIAL EQUATIONS

The equations of motion for a physical simulation can always be written as a system of nonlinear equations of the form

$$\frac{d\mathbf{X}}{dt} = \mathbf{F}(t, \mathbf{X}), \qquad t \geq 0, \qquad \mathbf{X}(0) = \mathbf{X}_0. \tag{7.1}$$

The vector \mathbf{X} represents the physical states of the simulation, typically including position, linear velocity, orientation, and angular velocity. The system is an initial-value problem since the state vector is specified at the initial time $t \geq 0$.

The differential equations are almost never solvable in closed form, so numerical methods must be used for approximating the solution. The simplest is *Euler's method*. The idea is to replace the first derivative of Equation (7.1) by a forward difference approximation:

$$\frac{\mathbf{X}(t + h) - \mathbf{X}(t)}{h} = \mathbf{F}(t, \mathbf{X}(t)).$$

The value $h > 0$ is the *step size* of the solver. Generally, the smaller the value of h, the less error you make in the approximation. This is solved for the term involving $t + h$:

$$\mathbf{X}(t + h) = \mathbf{X}(t) + h\mathbf{F}(t, \mathbf{X}(t)). \tag{7.2}$$

At time step t, if the state $\mathbf{X}(t)$ is known, then Euler's method gives you an approximation of the state at time $t + h$, namely, $\mathbf{X}(t + h)$.

Euler's method is the prototype for a numerical solver for ordinary differential equations. The function **F** is a given. Knowing the input time t, a step size h, and an input state $\mathbf{X}(t)$, the method produces an output time $t + h$ and a corresponding state $\mathbf{X}(t + h)$. The general concept is encapsulated by an abstract base class, OdeSolver, with the following interface:

```
template <class Real>
class WM3_ITEM OdeSolver
{
public:
    // abstract base class
    virtual ~OdeSolver ();

    // The system is dx/dt = F(t,x).  The dimension of x is passed
    // to the constructor of OdeSolver.
    typedef void (*Function)(
        Real,          // t
        const Real*,   // x
        void*,         // user-specified data
        Real*);        // F(t,x)

    virtual void Update (Real fTIn, Real* afXIn, Real& rfTOut,
        Real* afXOut) = 0;

    virtual void SetStepSize (Real fStep) = 0;
    Real GetStepSize () const;

    void SetData (void* pvData);
    void* GetData () const;

protected:
    OdeSolver (int iDim, Real fStep, Function oFunction,
        void* pvData = NULL);

    int m_iDim;
    Real m_fStep;
    Function m_oFunction;
    void* m_pvData;
    Real* m_afFValue;
};
```

The only constructor is protected. Its first input iDim is the number of states, the *dimension* of the system. The second input fStep is the step size $h > 0$ of the system.

The general mathematical function to evaluate is $\mathbf{F}(t, \mathbf{X})$. The function type used for the solver, type Function, is of a slightly different format. It takes t and \mathbf{X} as its first two parameters. It also allows you to pass data through a void* parameter. Various physical quantities might be associated with \mathbf{F}, but are not known to the Function representation until run time. These may be passed as the user-specified data. If you were to return the output as an array pointer, you would have to dynamically allocate memory on each call. To avoid the dynamic allocation, an array for the output components is passed to the Function for you to fill in. In most cases, this means you only need a single array for output that is used for each call to the function. The base class provides this storage in member m_afFValue.

OdeSolver allows you to modify the step size by SetStepSize. This is a pure virtual function, so every derived class must implement it. Minimally, the function assigns fStep to the member data m_fStep, but many solvers have related quantities that should be computed once and cached for reasons of efficiency in the iterations of the solver. The current step size is read by GetStepSize.

The user-specified data is stored in the OdeSolver object. It is passed to the Function object on each call. You can set and get the user-specified data via member functions SetData and GetData.

The calculation of the output time and state from the input time and state is the role of Update. It is clear which function parameters are inputs and which are outputs.

7.1.1 EULER'S METHOD

The class OdeEuler is an implementation of Euler's method. The interface is

```
template <class Real>
class OdeEuler : public OdeSolver<Real>
{
public:
    OdeEuler (int iDim, Real fStep,
        typename OdeSolver<Real>::Function oFunction,
        void* pvData = NULL);

    virtual ~OdeEuler ();

    virtual void Update (Real fTIn, Real* afXIn, Real& rfTOut,
        Real* afXOut);

    virtual void SetStepSize (Real fStep);
};
```

The update function is

```
template <class Real>
void OdeEuler<Real>::Update (Real fTIn, Real* afXIn, Real& rfTOut,
    Real* afXOut)
{
    m_oFunction(fTIn,afXIn,m_pvData,m_afFValue);
    for (int i = 0; i < m_iDim; i++)
        afXOut[i] = afXIn[i] + m_fStep*m_afFValue[i];

    rfTOut = fTIn + m_fStep;
}
```

The first line of the function evaluates $\mathbf{F}(t_0, \mathbf{X}_0)$, where t_0 is the input time and \mathbf{X}_0 is the input state. The loop computes the components of the output state $\mathbf{X}_1 = \mathbf{X}_0 + h\mathbf{F}(t_0, \mathbf{X}_0)$. The last line of code computes the output time $t_1 = t_0 + h$.

A sample illustration of OdeEuler numerically solves the system of differential equations

$$\frac{dx}{dt} = t - ay, \qquad \frac{dy}{dt} = bx, \qquad (x(0), y(0)) = (1, 2),$$

where a and b are some physical parameters.

```
void F (float fT, const float* afX, void* pvData, float* afFValue)
{
    float* afData = (float*)pvData;
    afFValue[0] = fT - afData[0]*afX[1];  // t - a*y
    afFValue[1] = afData[1]*afX[0];       // b*x
}

int iDim = 2;
float fStep = 0.001f;
float fA = <some physical parameter>;
float fB = <some physical parameter>;
float afData[2] = { fA, fB };
OdeEuler kSolver(iDim,fStep,F,afData);

float fT = 0.0f;
float afState[2] = { 1.0, 2.0f };  // (x(0),y(0))

int iNumSteps = <desired number of steps to take>;
for (int i = 1; i <= iNumSteps; i++)
```

```
{
    // new time and state replaces old time and state
    kSolver.Update(fT,afState,fT,afState);

    // ... process output fT and afState here ...
}
```

7.1.2 MIDPOINT METHOD

Euler's method is simple to implement, but it is neither accurate enough nor stable enough to apply to most differential equations. A family of methods that are better for applications are the *Runge-Kutta methods*. These are discussed in standard textbooks on numerical methods (for example, [BF01]). The *midpoint method* is one of the methods in this family. The mathematical formulation is

$$t_0, \mathbf{X}_0 \qquad\qquad \text{initial time and state}$$

$$\mathbf{Y} = \mathbf{X}_0 + (h/2)\mathbf{F}(t_0, \mathbf{X}_0) \qquad \text{first step}$$

$$\mathbf{X}_1 = \mathbf{X}_0 + h\mathbf{F}(t_0 + h/2, \mathbf{Y}) \quad \text{second step}$$

$$t_1 = t_0 + h.$$

Notice that the output state is obtained by a composition

$$\mathbf{X}_1 = \mathbf{X}_0 + h\mathbf{F}(t_0 + h/2, \mathbf{X}_0 + (h/2)\mathbf{F}(t_0, \mathbf{X}_0)).$$

The Runge-Kutta methods all have this flavor. The midpoint method is a second-order method: \mathbf{F} is evaluated twice in the algorithm.

The class interface for the midpoint method is

```
template <class Real>
class OdeMidpoint : public OdeSolver<Real>
{
public:
    OdeMidpoint (int iDim, Real fStep,
        typename OdeSolver<Real>::Function oFunction,
        void* pvData = NULL);

    virtual ~OdeMidpoint ();

    virtual void Update (Real fTIn, Real* afXIn, Real& rfTOut,
        Real* afXOut);
```

```
    virtual void SetStepSize (Real fStep);

protected:
    Real m_fHalfStep;
    Real* m_afXTemp;
};
```

The update method is

```
template <class Real>
void OdeMidpoint<Real>::Update (Real fTIn, Real* afXIn,
    Real& rfTOut, Real* afXOut)
{
    int i;

    // first step
    m_oFunction(fTIn,afXIn,m_pvData,m_afFValue);
    for (i = 0; i < m_iDim; i++)
        m_afXTemp[i] = afXIn[i] + m_fHalfStep*m_afFValue[i];

    // second step
    Real fHalfT = fTIn + m_fHalfStep;
    m_oFunction(fHalfT,m_afXTemp,m_pvData,m_afFValue);
    for (i = 0; i < m_iDim; i++)
        afXOut[i] = afXIn[i] + m_fStep*m_afFValue[i];

    rfTOut = fTIn + m_fStep;
}
```

The previous example that illustrated the use of OdeEuler is easily modified to use OdeMidpoint. The line of code

```
OdeEuler kSolver(iDim,fStep,F,afData);
```

is replaced by

```
OdeEuler OdeMidpoint(iDim,fStep,F,afData);
```

The differential equation numerical solvers in Wild Magic were designed to make it this easy to change the type of the solver in an application.

7.1.3 RUNGE-KUTTA FOURTH-ORDER METHOD

The most common Runge-Kutta method used in applications is one that is fourth order. The mathematical formulation is listed next and has the same flavor as the midpoint method—a nested composition of **F**:

$$t_0, \mathbf{X}_0 \qquad\qquad\qquad \text{initial time and state}$$

$$\mathbf{K}_1 = h\mathbf{F}(t_0, \mathbf{X}_0) \qquad\qquad \text{no nesting}$$

$$\mathbf{K}_2 = h\mathbf{F}\left(t_0 + \frac{h}{2}, \mathbf{X}_0 + \frac{\mathbf{K}_1}{2}\right) \qquad \text{singly nested}$$

$$\mathbf{K}_3 = h\mathbf{F}\left(t_0 + \frac{h}{2}, \mathbf{X}_0 + \frac{\mathbf{K}_2}{2}\right) \qquad \text{doubly nested}$$

$$\mathbf{K} = h\mathbf{F}(t_0 + h, \mathbf{X}_0 + \mathbf{K}_3) \qquad \text{triply nested}$$

$$\mathbf{X}_1 = \mathbf{X}_0 + \frac{1}{6}(\mathbf{K}_1 + 2\mathbf{K}_2 + 2\mathbf{K}_3 + \mathbf{K}_4)$$

$$t_1 = t_0 + h$$

The class interface for the Runge-Kutta fourth-order method is

```
template <class Real>
class WM3_ITEM OdeRungeKutta4 : public OdeSolver<Real>
{
public:
    OdeRungeKutta4 (int iDim, Real fStep,
        typename OdeSolver<Real>::Function oFunction,
        void* pvData = NULL);

    virtual ~OdeRungeKutta4 ();

    virtual void Update (Real fTIn, Real* afXIn, Real& rfTOut,
        Real* afXOut);

    virtual void SetStepSize (Real fStep);

protected:
    Real m_fHalfStep, m_fSixthStep;
    Real* m_afTemp1;
    Real* m_afTemp2;
    Real* m_afTemp3;
```

```
        Real* m_afTemp4;
        Real* m_afXTemp;
};
```

The temporary arrays are used to store the \mathbf{K}_i during the construction of the output state. The convenience variables m_fHalfStep and m_fSixthStep store $h/2$ and $h/6$, respectively.

The update function is

```
template <class Real>
void OdeRungeKutta4<Real>::Update (Real fTIn, Real* afXIn,
    Real& rfTOut, Real* afXOut)
{
    int i;

    // first step
    m_oFunction(fTIn,afXIn,m_pvData,m_afTemp1);
    for (i = 0; i < m_iDim; i++)
        m_afXTemp[i] = afXIn[i] + m_fHalfStep*m_afTemp1[i];

    // second step
    Real fHalfT = fTIn + m_fHalfStep;
    m_oFunction(fHalfT,m_afXTemp,m_pvData,m_afTemp2);
    for (i = 0; i < m_iDim; i++)
        m_afXTemp[i] = afXIn[i] + m_fHalfStep*m_afTemp2[i];

    // third step
    m_oFunction(fHalfT,m_afXTemp,m_pvData,m_afTemp3);
    for (i = 0; i < m_iDim; i++)
        m_afXTemp[i] = afXIn[i] + m_fStep*m_afTemp3[i];

    // fourth step
    rfTOut = fTIn + m_fStep;
    m_oFunction(rfTOut,m_afXTemp,m_pvData,m_afTemp4);
    for (i = 0; i < m_iDim; i++)
    {
        afXOut[i] = afXIn[i] + m_fSixthStep*(m_afTemp1[i] +
            ((Real)2.0)*(m_afTemp2[i] + m_afTemp3[i]) +
            m_afTemp4[i]);
    }
}
```

Once again, the sample using OdeEuler is easily modified to use OdeRungeKutta4 by replacing the constructor call.

7.1.4 IMPLICIT EQUATIONS AND METHODS

Equation (7.1) defines the derivative of the state explicitly in terms of the time and the state of the system. Some physical models might have the derivative defined by an *implicit equation*:

$$\mathbf{F}(t, \mathbf{X}(t), d\mathbf{X}(t)/dt) = \mathbf{0}. \tag{7.3}$$

If an algebraic manipulation allows you to solve for the derivative explicitly in terms of the other variables, then explicit numerical methods can be applied to the problem. If it is not possible to solve for the derivative explicitly, an additional level of processing must occur to solve the system. Specifically, think of Equation (7.3) as

$$\mathbf{G}(t, \mathbf{X}(t), \mathbf{Y}) = \mathbf{0},$$

where t and $\mathbf{X}(t)$ are known values, but \mathbf{Y} is an unknown quantity. A root-finding method such as Newton's method can be used to construct the root \mathbf{Y} of \mathbf{G}. A forward finite difference for the derivative is then used to compute the next state, namely,

$$\frac{\mathbf{X}(t + h) - \mathbf{X}(t)}{h} = \mathbf{Y}$$

or

$$\mathbf{X}(t + h) = \mathbf{X}(t) + h\mathbf{Y}.$$

The occurrence of implicit equations for the output state can occur, even if the differential equation is an explicit one. For example, Euler's method used a forward finite difference to approximate the derivative:

$$\mathbf{F}(t, \mathbf{X}(t)) = \frac{d\mathbf{X}(t)}{dt} \doteq \frac{\mathbf{X}(t + h) - \mathbf{X}(t)}{h}.$$

Solving for $\mathbf{X}(t + h)$ yields Equation (7.2). If we were instead to use a *backward* finite difference, we obtain

$$\mathbf{F}(t, \mathbf{X}(t)) = \frac{d\mathbf{X}(t)}{dt} \doteq \frac{\mathbf{X}(t) - \mathbf{X}(t - h)}{h}$$

or

$$\mathbf{X}(t) = \mathbf{X}(t - h) + h\mathbf{F}(t, \mathbf{X}(t)).$$

To put this into the format of Equation (7.2), replace t by $t + h$:

$$\mathbf{X}(t + h) = \mathbf{X}(t) + h\mathbf{F}(t + h, \mathbf{X}(t + h)). \tag{7.4}$$

The technical problem here is that the output state $\mathbf{X}(t + h)$ occurs on both the left-hand and right-hand sides of the equation. Rewrite this to the standard form of an implicit equation:

$$\mathbf{0} = \mathbf{G}(t, \mathbf{X}(t), \mathbf{X}(t + h)) = \mathbf{X}(t) + h\mathbf{F}(t + h, \mathbf{X}(t + h)) - \mathbf{X}(t + h).$$

Thinking of \mathbf{G} as a function of its last component \mathbf{Y},

$$\mathbf{G}(t, \mathbf{X}(t), \mathbf{Y}) = \mathbf{0},$$

we may use a root finder to compute \mathbf{Y}. The output state is $\mathbf{X}(t + h) = \mathbf{Y}$.

Since we are making approximations at various stages of the algorithm, rather than using multiple iterations in a root finder for \mathbf{G}, we can use a single iteration to define a numerical method for the differential equation. Let $\mathbf{Y}_0 = \mathbf{X}(t)$ be the initial guess for the output state. One interation of Newton's method is

$$\mathbf{Y}_1 = \mathbf{Y}_0 - D\mathbf{G}(t, \mathbf{X}(t), \mathbf{Y}_0)^{-1}\mathbf{G}(t, \mathbf{X}(t), \mathbf{Y}_0),$$

where $D\mathbf{G}$ is the matrix of first-order partial derivatives of the components of \mathbf{G} with respect to the components of \mathbf{Y}. This is the multidimensional generalization of Newton's method for a function of one variable, $y_{i+1} = y_i - F(y_i)/F'(y_i)$. In one dimension, you divide by the derivative of F. In multiple dimensions, you "divide" by the derivatives in the sense of matrix inversion. The value \mathbf{Y}_1 is used as the output state. In terms of the original state vector, the method is

$$\mathbf{X}(t + h) = \mathbf{X}(t) + h \left(I - hD\mathbf{F}(t, \mathbf{X}(t))\right)^{-1} \mathbf{F}(t, \mathbf{X}(t)). \tag{7.5}$$

The class that implements Equation (7.5) is `OdeImplicitEuler`. The interface is

```
template <class Real>
class OdeImplicitEuler : public OdeSolver<Real>
{
public:
    // The function F(t,x) has input t, a scalar, and input x,
    // an n-vector.  The first derivative matrix with respect to
    // x is DF(t,x), an n-by-n matrix.  Entry DF[r][c] is the
    // derivative of F[r] with respect to x[c].
    typedef void (*DerivativeFunction)(
        Real,             // t
        const Real*,      // x
        void*,            // user-specified data
        GMatrix<Real>&);  // DF(t,x)

    OdeImplicitEuler (int iDim, Real fStep, Function oFunction,
        DerivativeFunction oDFunction, void* pvData = NULL);
```

```
    virtual ~OdeImplicitEuler ();

    virtual void Update (Real fTIn, Real* afXIn, Real& rfTOut,
        Real* afXOut);

    virtual void SetStepSize (Real fStep);

protected:
    DerivativeFunction m_oDFunction;
    GMatrix<Real> m_kDF;
    GVector<Real> m_kF;
    GMatrix<Real> m_kIdentity;
};
```

The update function is

```
template <class Real>
void OdeImplicitEuler<Real>::Update (Real fTIn, Real* afXIn,
    Real& rfTOut, Real* afXOut)
{
    m_oFunction(fTIn,afXIn,m_pvData,m_kF);
    m_oDFunction(fTIn,afXIn,m_pvData,m_kDF);
    GMatrix<Real> kDG = m_kIdentity - m_fStep*m_kDF;
    GMatrix<Real> kDGInverse(m_iDim,m_iDim);
    bool bInvertible = kDG.GetInverse(kDGInverse);

    if ( bInvertible )
    {
        m_kF = kDGInverse*m_kF;
        for (int i = 0; i < m_iDim; i++)
            afXOut[i] = afXIn[i] + m_fStep*m_kF[i];
    }
    else
    {
        memcpy(afXOut,afXIn,m_iDim*sizeof(Real));
    }

    rfTOut = fTIn + m_fStep;
}
```

The first five lines of code compute the inverse derivative matrix DG^{-1}. If the matrix is indeed invertible, the output state is computed according to Equation (7.5). If it is not invertible, the output state is set to the input state, but the output time is $t + h$.

7.2 PARTICLE PHYSICS

The engine supports physical simulation of particle systems. The n particles are point sources with positions \mathbf{X}_i, masses m_i, and velocities \mathbf{V}_i, for $0 \le i < n$. Forces $\mathbf{F}_i = m_i \mathbf{A}_i$ are applied to the particles, where \mathbf{A}_i is the acceleration of the particle. The simulation is modeling using Newton's equations of motion:

$$\ddot{\mathbf{X}}_i = \mathbf{F}_i(t, \mathbf{X}_i, \dot{\mathbf{X}}_i)/m_i, \qquad 0 \le i < n.$$

This is a second-order system of ordinary differential equations and is converted to a system of first-order equations:

$$\begin{bmatrix} \dot{\mathbf{X}}_i \\ \dot{\mathbf{V}}_i \end{bmatrix} = \begin{bmatrix} \mathbf{V}_i \\ \mathbf{F}_i(t, \mathbf{X}_i, \mathbf{V}_i)/m_i \end{bmatrix}. \tag{7.6}$$

The system is solved using the Runge-Kutta fourth-order method.

The class that encapsulates the particle system is `ParticleSystem`. Its interface is listed next. The template parameters include `Real` for the floating-point type and `TVector`, which is either `Vector2` or `Vector3` to support 2D or 3D systems.

```
template <class Real, class TVector>
class ParticleSystem
{
public:
    ParticleSystem (int iNumParticles, Real fStep);
    virtual ~ParticleSystem ();

    int GetNumParticles () const;
    void SetMass (int i, Real fMass);
    Real GetMass (int i) const;
    TVector* Positions () const;
    TVector& Position (int i);
    TVector* Velocities () const;
    TVector& Velocity (int i);
    void SetStep (Real fStep);
    Real GetStep () const;

    virtual TVector Acceleration (int i, Real fTime,
        const TVector* akPosition,  const TVector* akVelocity) = 0;

    virtual void Update (Real fTime);

protected:
    int m_iNumParticles;
    Real* m_afMass;
```

```
    Real* m_afInvMass;
    TVector* m_akPosition;
    TVector* m_akVelocity;
    Real m_fStep, m_fHalfStep, m_fSixthStep;

    // temporary storage for solver
    typedef TVector* TVectorPtr;
    TVectorPtr m_akPTmp, m_akDPTmp1, m_akDPTmp2;
    TVectorPtr m_akDPTmp3, m_akDPTmp4;
    TVectorPtr m_akVTmp, m_akDVTmp1, m_akDVTmp2;
    TVectorPtr m_akDVTmp3, m_akDVTmp4;
};
```

Many of the class member functions are accessors. The simulation is supported by the virtual functions Acceleration and Update. The right-hand side of Equation (7.6) has the force divided by mass, which is the acceleration of the particle. The member function Acceleration is what a derived class implements to represent \mathbf{F}_i/m_i for each particle. The acceleration depends on the time t, the current particle position \mathbf{X}_i, and the current particle velocity \mathbf{V}_i.

The update function is the call into the Runge-Kutta solver. A particle is immovable if it has infinite mass. Equivalently, the inverse of the mass is zero. Only particles with finite mass are affected by the applied forces.

```
template <class Real, class TVector>
void ParticleSystem<Real,TVector>::Update (Real fTime)
{
    // Runge-Kutta fourth-order solver
    Real fHalfTime = fTime + m_fHalfStep;
    Real fFullTime = fTime + m_fStep;

    // first step
    int i;
    for (i = 0; i < m_iNumParticles; i++)
    {
        if ( m_afInvMass[i] > (Real)0.0 )
        {
            m_akDPTmp1[i] = m_akVelocity[i];
            m_akDVTmp1[i] = Acceleration(i,fTime,m_akPosition,
                m_akVelocity);
        }
    }
    for (i = 0; i < m_iNumParticles; i++)
    {
        if ( m_afInvMass[i] > (Real)0.0 )
```

```
        {
            m_akPTmp[i] = m_akPosition[i] +
                m_fHalfStep*m_akDPTmp1[i];
            m_akVTmp[i] = m_akVelocity[i] +
                m_fHalfStep*m_akDVTmp1[i];
        }
        else
        {
            m_akPTmp[i] = m_akPosition[i];
            m_akVTmp[i] = TVector::ZERO;
        }
    }

    // second step
    for (i = 0; i < m_iNumParticles; i++)
    {
        if ( m_afInvMass[i] > (Real)0.0 )
        {
            m_akDPTmp2[i] = m_akVTmp[i];
            m_akDVTmp2[i] = Acceleration(i,fHalfTime,m_akPTmp,
                m_akVTmp);
        }
    }
    for (i = 0; i < m_iNumParticles; i++)
    {
        if ( m_afInvMass[i] > (Real)0.0 )
        {
            m_akPTmp[i] = m_akPosition[i] +
                m_fHalfStep*m_akDPTmp2[i];
            m_akVTmp[i] = m_akVelocity[i] +
                m_fHalfStep*m_akDVTmp2[i];
        }
        else
        {
            m_akPTmp[i] = m_akPosition[i];
            m_akVTmp[i] = TVector::ZERO;
        }
    }

    // third step
    for (i = 0; i < m_iNumParticles; i++)
    {
        if ( m_afInvMass[i] > (Real)0.0 )
        {
```

```
                    m_akDPTmp3[i] = m_akVTmp[i];
                    m_akDVTmp3[i] = Acceleration(i,fHalfTime,m_akPTmp,
                        m_akVTmp);
                }
            }
            for (i = 0; i < m_iNumParticles; i++)
            {
                if ( m_afInvMass[i] > (Real)0.0 )
                {
                    m_akPTmp[i] = m_akPosition[i] +
                        m_fStep*m_akDPTmp3[i];
                    m_akVTmp[i] = m_akVelocity[i] +
                        m_fStep*m_akDVTmp3[i];
                }
                else
                {
                    m_akPTmp[i] = m_akPosition[i];
                    m_akVTmp[i] = TVector::ZERO;
                }
            }

            // fourth step
            for (i = 0; i < m_iNumParticles; i++)
            {
                if ( m_afInvMass[i] > (Real)0.0 )
                {
                    m_akDPTmp4[i] = m_akVTmp[i];
                    m_akDVTmp4[i] = Acceleration(i,fFullTime,m_akPTmp,
                        m_akVTmp);
                }
            }
            for (i = 0; i < m_iNumParticles; i++)
            {
                if ( m_afInvMass[i] > (Real)0.0 )
                {
                    m_akPosition[i] += m_fSixthStep*(m_akDPTmp1[i] +
                        ((Real)2.0)*(m_akDPTmp2[i] + m_akDPTmp3[i]) +
                        m_akDPTmp4[i]);
                    m_akVelocity[i] += m_fSixthStep*(m_akDVTmp1[i] +
                        ((Real)2.0)*(m_akDVTmp2[i] + m_akDVTmp3[i]) +
                        m_akDVTmp4[i]);
                }
            }
        }
```

Compare this to the Runge-Kutta solver that is implemented in class `OdeRunge-Kutta4`. The current solver iterates over the particles, applying the Runge-Kutta algorithm to each one, but ignoring those particles with infinite mass. Notice that each step involves updating two arrays named `m_akDPTmp*` and `m_akDVTmp*`. The first type of array corresponds to $\dot{\mathbf{X}}_i = \mathbf{V}_i$ in Equation (7.6), and the second type of array corresponds to $\dot{\mathbf{V}}_i = \mathbf{F}_i(t, \mathbf{X}_i, \mathbf{V}_i)/m_i$ in Equation (7.6).

You may derive classes from `ParticleSystem` to build your own customized particle systems. The next section describes a few such classes that represent mass-spring systems.

7.3 Mass-Spring Systems

A popular choice for modeling deformable bodies is mass-spring systems, which I discussed in detail in [Ebe03a]. This section contains a brief summary of the ideas, of which two are important for implementation purposes. First, the springs connecting the masses are modeled using Hooke's law and lead to the equations of motion. I solve these numerically using Runge-Kutta fourth-order methods. Second, the topology of the connections of the masses by springs must be handled by an implementation. Curve masses are modeled as a one-dimensional array of particles (e.g., hair or rope), surface masses as two-dimensional arrays (e.g., cloth or water surface), and volume masses as three-dimensional arrays (e.g., gelatinous blob or viscous material).

7.3.1 Curve Masses

A curve mass is represented as a polyline of vertices, open with two end points or closed with no end points. Each vertex of the polyline represents a mass. Each edge represents a spring connecting the two masses at the end points of the edge. Figure 7.1 shows two such configurations.

The equations of motion for an open linear chain are as follows. The masses m_i are located at positions \mathbf{X}_i for $1 \leq i \leq p$. The system has $p - 1$ springs connecting the masses; spring i connects m_i and m_{i+1}. At an interior point i, two spring forces are applied, one from the spring shared with point $i - 1$ and one from the spring shared with point $i + 1$. The spring connecting masses m_i and m_{i+1} has spring constant c_i and rest length L_i. The differential equation for particle i is

$$
\begin{aligned}
m_i \ddot{\mathbf{x}}_i = {} & c_{i-1} \left(|\mathbf{x}_{i-1} - \mathbf{x}_i| - L_{i-1} \right) \frac{\mathbf{x}_{i-1} - \mathbf{x}_i}{|\mathbf{x}_{i-1} - \mathbf{x}_i|} \\
& + c_i \left(|\mathbf{x}_{i+1} - \mathbf{x}_i| - L_i \right) \frac{\mathbf{x}_{i+1} - \mathbf{x}_i}{|\mathbf{x}_{i+1} - \mathbf{x}_i|} + \mathbf{F}_i,
\end{aligned} \tag{7.7}
$$

Figure 7.1 Two curve mass objects represented as mass-spring systems.

where \mathbf{F}_i represents other forces acting on particle i, such as gravitational or wind forces. With the proper definitions at the two boundary particles of c_0, c_p, L_0, L_p, \mathbf{X}_0, and \mathbf{X}_{p+1}, Equation (7.7) also handles fixed boundary points and closed loops.

The class that implements a deformable curve mass is MassSpringCurve and is derived from ParticleSystem. The interface is

```
template <class Real, class TVector>
class MassSpringCurve : public ParticleSystem<Real,TVector>
{
public:
    MassSpringCurve (int iNumParticles, Real fStep);
    virtual ~MassSpringCurve ();

    int GetNumSprings () const;
    Real& Constant (int i);  // spring constant
    Real& Length (int i);  // spring resting length

    virtual TVector Acceleration (int i, Real fTime,
        const TVector* akPosition, const TVector* akVelocity);

    virtual TVector ExternalAcceleration (int i, Real fTime,
        const TVector* akPosition, const TVector* akVelocity);

protected:
    int m_iNumSprings;
    Real* m_afConstant;
    Real* m_afLength;
};
```

The number of particles in the mass-spring system is passed to the constructor. The second parameter, fStep, is the step size used in the Runge-Kutta numerical solver. After construction, you must set the spring constants and spring resting lengths via the appropriate member functions.

The Acceleration function is an override of the base class virtual function and is what is called by the Runge-Kutta numerical solver. This function handles the internal forces that the springs exert on the masses. The implementation is

```
template <class Real, class TVector>
TVector MassSpringCurve<Real,TVector>::Acceleration (int i, Real fTime,
    const TVector* akPosition, const TVector* akVelocity)
{
    TVector kAcceleration = ExternalAcceleration(i,fTime,
        akPosition,akVelocity);

    TVector kDiff, kForce;
    Real fRatio;

    if ( i > 0 )
    {
        int iM1 = i-1;
        kDiff = akPosition[iM1] - akPosition[i];
        fRatio = m_afLength[iM1]/kDiff.Length();
        kForce = m_afConstant[iM1]*(((Real)1.0)-fRatio)*kDiff;
        kAcceleration += m_afInvMass[i]*kForce;
    }

    int iP1 = i+1;
    if ( iP1 < m_iNumParticles )
    {
        kDiff = akPosition[iP1] - akPosition[i];
        fRatio = m_afLength[i]/kDiff.Length();
        kForce = m_afConstant[i]*(((Real)1.0)-fRatio)*kDiff;
        kAcceleration += m_afInvMass[i]*kForce;
    }

    return kAcceleration;
}
```

This is a straightforward implementation of the right-hand side of Equation (7.7). The end points of the curve of masses are handled separately since each has only one spring attached to it.

We must also allow for external forces such as gravity, wind, and friction. The function ExternalAcceleration supports these. Just as in the ParticleSystem class, the function represents the acceleration \mathbf{F}_i/m_i for a force \mathbf{F}_i exerted on the particle i.

Figure 7.2 A surface mass represented as a mass-spring system with the masses organized as a two-dimensional array.

Derived classes override this function, but the default implementation is for a zero external force.

The sample application on the companion website that illustrates the use of `MassSpringCurve` is

`GeometricTools/WildMagic3/SamplePhysics/Rope`

The application models a rope as a deformable curve mass.

7.3.2 SURFACE MASSES

A surface mass is represented as a collection of particles arranged as a two-dimensional array. An interior particle has four neighbors as shown in Figure 7.2.

The masses are m_{i_0, i_1} and are located at \mathbf{X}_{i_0, i_1} for $0 \leq i_0 < n_0$ and $0 \leq i_1 < n_1$. The spring to the right of a particle has spring constant

$$c_{i_0, i_1}^{(0)} \text{ and resting length } L_{i_0, i_1}^{(0)}.$$

The spring below a particle has spring constant

$$c_{i_0, i_1}^{(1)} \text{ and resting length } L_{i_0, i_1}^{(1)}.$$

The understanding is that the spring constants and resting lengths are zero if the particle has no such spring in the specified direction.

The equation of motion for particle (i_0, i_1) has four force terms due to Hooke's law, one for each neighboring particle:

$$m_{i_0,i_1}\ddot{\mathbf{X}}_{i_0,i_1} = c_{i_0-1,i_1}\left(|\mathbf{X}_{i_0-1,i_1} - \mathbf{X}_{i_0,i_1}| - L_{i_0-1,i_1}\right)\frac{\mathbf{X}_{i_0-1,i_1} - \mathbf{X}_{i_0,i_1}}{|\mathbf{X}_{i_0-1,i_1} - \mathbf{X}_{i_0,i_1}|}$$

$$+ c_{i_0+1,i_1}\left(|\mathbf{X}_{i_0+1,i_1} - \mathbf{X}_{i_0,i_1}| - L_{i_0+1,i_1}\right)\frac{\mathbf{X}_{i_0+1,i_1} - \mathbf{X}_{i_0,i_1}}{|\mathbf{X}_{i_0+1,i_1} - \mathbf{X}_{i_0,i_1}|}$$

$$+ c_{i_0,i_1-1}\left(|\mathbf{X}_{i_0,i_1-1} - \mathbf{X}_{i_0,i_1}| - L_{i_0,i_1-1}\right)\frac{\mathbf{X}_{i_0,i_1-1} - \mathbf{X}_{i_0,i_1}}{|\mathbf{X}_{i_0,i_1-1} - \mathbf{X}_{i_0,i_1}|}$$

$$+ c_{i_0,i_1+1}\left(|\mathbf{X}_{i_0,i_1+1} - \mathbf{X}_{i_0,i_1}| - L_{i_0,i_1+1}\right)\frac{\mathbf{X}_{i_0,i_1+1} - \mathbf{X}_{i_0,i_1}}{|\mathbf{X}_{i_0,i_1+1} - \mathbf{X}_{i_0,i_1}|}$$

$$+ \mathbf{F}_{i_0,i_1}. \tag{7.8}$$

As in the case of linear chains, with the proper definition of the spring constants and resting lengths at the boundary points of the mesh, Equation (7.8) applies to the boundary points as well as the interior points.

The class that implements a deformable surface mass is `MassSpringSurface` and is derived from `ParticleSystem`. The interface is

```
template <class Real, class TVector>
class MassSpringSurface : public ParticleSystem<Real,TVector>
{
public:
    MassSpringSurface (int iRows, int iCols, Real fStep);
    virtual ~MassSpringSurface ();

    int GetRows () const;
    int GetCols () const;
    void SetMass (int iRow, int iCol, Real fMass);
    Real GetMass (int iRow, int iCol) const;
    TVector** Positions2D () const;
    TVector& Position (int iRow, int iCol);
    TVector** Velocities2D () const;
    TVector& Velocity (int iRow, int iCol);

    Real& ConstantR (int iRow, int iCol);  // spring to (r+1,c)
    Real& LengthR (int iRow, int iCol);     // spring to (r+1,c)
    Real& ConstantC (int iRow, int iCol);  // spring to (r,c+1)
    Real& LengthC (int iRow, int iCol);     // spring to (r,c+1)

    virtual TVector Acceleration (int i, Real fTime,
        const TVector* akPosition, const TVector* akVelocity);
```

```
        virtual TVector ExternalAcceleration (int i, Real fTime,
            const TVector* akPosition, const TVector* akVelocity);

protected:
    int GetIndex (int iRow, int iCol) const;
    void GetCoordinates (int i, int& riRow, int& riCol) const;

    int m_iRows;              // R
    int m_iCols;              // C
    TVector** m_aakPosition;  // R-by-C
    TVector** m_aakVelocity;  // R-by-C

    int m_iRowsM1;            // R-1
    int m_iColsM1;            // C-1
    Real** m_aafConstantR;    // (R-1)-by-C
    Real** m_aafLengthR;      // (R-1)-by-C
    Real** m_aafConstantC;    // R-by-(C-1)
    Real** m_aafLengthC;      // R-by-(C-1)
};
```

This class represents an $R \times C$ array of masses lying on a surface and connected by an array of springs. The masses are indexed by $m_{r,c}$ for $0 \le r < R$ and $0 \le c < C$ and are stored in row-major order. The other arrays are also stored in linear memory in row-major order. The mass at interior position $\mathbf{X}_{r,c}$ is connected by springs to the masses at positions $\mathbf{X}_{r-1,c}, \mathbf{X}_{r+1,c}, \mathbf{X}_{r,c-1}$, and $\mathbf{X}_{r,c+1}$. Boundary masses have springs connecting them to the obvious neighbors: an "edge" mass has three neighbors, and a "corner" mass has two neighbors.

The base class has support for accessing the masses, positions, and velocities stored in a linear array. Rather than force you to use the one-dimensional index i for the two-dimensional pair (r, c), I have provided member functions for accessing the masses, positions, and velocities using the (r, c) pair. To avoid name conflict, Positions is used to access the one-dimensional array of particles. In the derived class, Positions2D is the accessor for the same array, but as a two-dimensional array. Simultaneous representations of the arrays require the class to use System::Allocate and System::Deallocate for dynamic creation and destruction of the array. The protected functions GetIndex and GetCoordinates implement the mapping between one- and two-dimensional indices.

The spring constants and spring resting lengths must be set after a class object is constructed. The interior mass at (r, c) has springs to the left, right, bottom, and top. Edge masses have only three neighbors, and corner masses have only two neighbors. The mass at (r, c) provides access to the springs connecting to locations $(r, c + 1)$ and $(r + 1, c)$. Edge and corner masses provide access to only a subset of these. The caller is responsible for ensuring the validity of the (r, c) inputs.

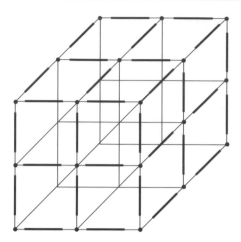

Figure 7.3 A volume mass represented as a mass-spring system with the masses organized as a three-dimensional array. Only the masses and springs on the three visible faces are shown. The other connections are shown, but without their springs.

The virtual functions `Acceleration` and `ExternalAcceleration` are similar to the ones in class `MassSpringCurve`. The sample application on the companion website that illustrates the use of `MassSpringSurface` is

`GeometricTools/WildMagic3/SamplePhysics/Cloth`

The application models a cloth as a deformable surface mass.

7.3.3 VOLUME MASSES

A volume mass is represented as a collection of particles arranged as a three-dimensional array. An interior particle has six neighbors as shown in Figure 7.3.

The masses are m_{i_0,i_1,i_2} and are located at \mathbf{X}_{i_0,i_1,i_2} for $0 \le i_j < n_j$, $j = 0$, 1, 2. In the direction of positive increase of index i_j, the spring has a spring constant

$$c^{(j)}_{i_0,i_1,i_2} \text{ and resting length } L^{(j)}_{i_0,i_1,i_2}$$

for $j = 0$, 1, 2. The understanding is that the spring constants and resting lengths are zero if the particle has no such spring in the specified direction.

The equation of motion for particle (i_0, i_1, i_2) has six force terms due to Hooke's law, one for each neighboring particle:

$$m_{i_0,i_1,i_2}\ddot{\mathbf{X}}_{i_0,i_1,i_2} =$$

$$c_{i_0-1,i_1,i_2}\left(|\mathbf{X}_{i_0-1,i_1,i_2} - \mathbf{X}_{i_0,i_1,i_2}| - L_{i_0-1,i_1,i_2}\right)\frac{\mathbf{X}_{i_0-1,i_1,i_2} - \mathbf{X}_{i_0,i_1,i_2}}{|\mathbf{X}_{i_0-1,i_1,i_2} - \mathbf{X}_{i_0,i_1,i_2}|}$$

$$+\, c_{i_0+1,i_1,i_2}\left(|\mathbf{X}_{i_0+1,i_1,i_2} - \mathbf{X}_{i_0,i_1,i_2}| - L_{i_0+1,i_1,i_2}\right)\frac{\mathbf{X}_{i_0+1,i_1,i_2} - \mathbf{X}_{i_0,i_1,i_2}}{|\mathbf{X}_{i_0+1,i_1,i_2} - \mathbf{X}_{i_0,i_1,i_2}|}$$

$$+\, c_{i_0,i_1-1,i_2}\left(|\mathbf{X}_{i_0,i_1-1,i_2} - \mathbf{X}_{i_0,i_1,i_2}| - L_{i_0,i_1-1,i_2}\right)\frac{\mathbf{X}_{i_0,i_1-1,i_2} - \mathbf{X}_{i_0,i_1,i_2}}{|\mathbf{X}_{i_0,i_1-1,i_2} - \mathbf{X}_{i_0,i_1,i_2}|}$$

$$+\, c_{i_0,i_1+1,i_2}\left(|\mathbf{X}_{i_0,i_1+1,i_2} - \mathbf{X}_{i_0,i_1,i_2}| - L_{i_0,i_1+1,i_2}\right)\frac{\mathbf{X}_{i_0,i_1+1,i_2} - \mathbf{X}_{i_0,i_1,i_2}}{|\mathbf{X}_{i_0,i_1+1,i_2} - \mathbf{X}_{i_0,i_1,i_2}|}$$

$$+\, c_{i_0,i_1,i_2-1}\left(|\mathbf{X}_{i_0,i_1,i_2-1} - \mathbf{X}_{i_0,i_1,i_2}| - L_{i_0,i_1,i_2-1}\right)\frac{\mathbf{X}_{i_0,i_1,i_2-1} - \mathbf{X}_{i_0,i_1,i_2}}{|\mathbf{X}_{i_0,i_1,i_2-1} - \mathbf{X}_{i_0,i_1,i_2}|}$$

$$+\, c_{i_0,i_1,i_2+1}\left(|\mathbf{X}_{i_0,i_1,i_2+1} - \mathbf{X}_{i_0,i_1,i_2}| - L_{i_0,i_1,i_2+1}\right)\frac{\mathbf{X}_{i_0,i_1,i_2+1} - \mathbf{X}_{i_0,i_1,i_2}}{|\mathbf{X}_{i_0,i_1,i_2+1} - \mathbf{X}_{i_0,i_1,i_2}|}$$

$$+\, \mathbf{F}_{i_0,i_1,i_2}. \tag{7.9}$$

With the proper definition of the spring constants and resting lengths at the boundary points of the mesh, Equation (7.9) applies to the boundary points as well as the interior points.

The class that implements a deformable volume mass is `MassSpringVolume` and is derived from `ParticleSystem`. The interface is

```
template <class Real, class TVector>
class WM3_ITEM MassSpringVolume : public ParticleSystem<Real,TVector>
{
public:
    MassSpringVolume (int iSlices, int iRows, int iCols, Real fStep);
    virtual ~MassSpringVolume ();

    int GetSlices () const;
    int GetRows () const;
    int GetCols () const;
    void SetMass (int iSlice, int iRow, int iCol, Real fMass);
    Real GetMass (int iSlice, int iRow, int iCol) const;
    TVector*** Positions3D () const;
    TVector& Position (int iSlice, int iRow, int iCol);
    TVector*** Velocities3D () const;
    TVector& Velocity (int iSlice, int iRow, int iCol);
```

```
        Real& ConstantS (int iS, int iR, int iC);   // to (s+1,r,c)
        Real& LengthS (int iS, int iR, int iC);     // to (s+1,r,c)
        Real& ConstantR (int iS, int iR, int iC);   // to (s,r+1,c)
        Real& LengthR (int iS, int iR, int iC);     // to (s,r+1,c)
        Real& ConstantC (int iS, int iR, int iC);   // to (s,r,c+1)
        Real& LengthC (int iS, int iR, int iC);     // to (s,r,c+1)

        virtual TVector Acceleration (int i, Real fTime,
            const TVector* akPosition, const TVector* akVelocity);

        virtual TVector ExternalAcceleration (int i, Real fTime,
            const TVector* akPosition, const TVector* akVelocity);

    protected:
        int GetIndex (int iSlice, int iRow, int iCol) const;
        void GetCoordinates (int i, int& riSlice, int& riRow,
            int& riCol) const;

        int m_iSlices;              // S
        int m_iRows;                // R
        int m_iCols;                // C
        int m_iSliceQuantity;       // R*C
        TVector*** m_aaakPosition;  // S-by-R-by-C
        TVector*** m_aaakVelocity;  // S-by-R-by-C

        int m_iSlicesM1;            // S-1
        int m_iRowsM1;              // R-1
        int m_iColsM1;              // C-1
        Real*** m_aaafConstantS;    // (S-1)-by-R-by-C
        Real*** m_aaafLengthS;      // (S-1)-by-R-by-C
        Real*** m_aaafConstantR;    // S-by-(R-1)-by-C
        Real*** m_aaafLengthR;      // S-by-(R-1)-by-C
        Real*** m_aaafConstantC;    // S-by-R-by-(C-1)
        Real*** m_aaafLengthC;      // S-by-R-by-(C-1)
    };
```

This class represents an $S \times R \times C$ array of masses lying in a volume and connected by an array of springs. The masses are indexed by $m(s, r, c)$ for $0 \le s < S$, $0 \le r < R$, and $0 \le c < C$ and are stored in lexicographical order. That is, the index for the one-dimensional array of memory is $i = c + C(r + Rs)$. The other arrays are also stored in linear memory in lexicographical order. The mass at interior position $\mathbf{X}_{s,r,c}$ is connected by springs to the masses at positions $\mathbf{X}_{s-1,r,c}$, $\mathbf{X}_{s+1,r,c}$, $\mathbf{X}_{s,r-1,c}$, $\mathbf{X}_{s,r+1,c}$, $\mathbf{X}_{s,r,c-1}$, and $\mathbf{X}_{s,r,c+1}$. Boundary masses have springs connecting

them to the obvious neighbors: a "face" mass has five neighbors, an "edge" mass has four neighbors, and a "corner" mass has three neighbors.

The base class has support for accessing the masses, positions, and velocities stored in a linear array. Rather than force you to use the one-dimensional index i for the three-dimensional triple (s, r, c), I have provided member functions for accessing the masses, positions, and velocities using the (s, r, c) triple. To avoid name conflict, Positions is used to access the one-dimensional array of particles. In the derived class, Positions3D is the accessor for the same array, but as a three-dimensional array. Simultaneous representations of the arrays require the class to use System::Allocate and System::Deallocate for dynamic creation and destruction of the array. The protected functions GetIndex and GetCoordinates implement the mapping between one- and three-dimensional indices.

The spring constants and spring resting lengths must be set after a class object is constructed. The interior mass at (s, r, c) has springs attaching it to six neighbors. Face masses have only five neighbors, edge masses have only four neighbors, and corner masses have only three neighbors. The mass at (s, r, c) provides access to the springs connecting to locations $(s + 1, r, c)$, $(s, r + 1, c)$, and $(s, r, c + 1)$. Face, edge, and corner masses provide access to only a subset of these. The caller is responsible for ensuring the validity of the (s, r, c) inputs.

The virtual functions Acceleration and ExternalAcceleration are similar to the ones in classes MassSpringCurve and MassSpringSurface.

The sample application on the companion website that illustrates the use of MassSpringVolume is

GeometricTools/WildMagic3/SamplePhysics/GelatinCube

The application models a gelatinous cube as a deformable volume mass.

7.3.4 ARBITRARY CONFIGURATIONS

In general you can set up an arbitrary configuration for a mass-spring system of p particles with masses m_i and location \mathbf{x}_i. Each spring added to the system connects two masses, say, m_i and m_j. The spring constant is $c_{ij} > 0$, and the resting length is L_{ij}.

Let \mathcal{A}_i denote the set of indices j such that m_j is connected to m_i by a spring—the set of *adjacent indices,* so to speak. The equation of motion for particle i is

$$m_i \ddot{\mathbf{X}}_i = \sum_{j \in \mathcal{A}_i} c_{ij} \left(|\mathbf{X}_j - \mathbf{X}_i| - L_{ij} \right) \frac{\mathbf{X}_j - \mathbf{X}_i}{|\mathbf{X}_j - \mathbf{X}_i|} + \mathbf{F}_i. \tag{7.10}$$

The technical difficulty in building a differential equation solver for an arbitrary graph is encapsulated solely by a vertex-edge table that stores the graph. Whenever the numerical solver must process particle i via Equation (7.10), it must be able to iterate over the adjacent indices to evaluate the Hooke's law terms.

The class that implements a mass-spring system with an arbitrary configuration of masses and springs is MassSpringArbitrary and is derived from ParticleSystem. The interface is

```
template <class Real, class TVector>
class MassSpringArbitrary : public ParticleSystem<Real,TVector>
{
public:
    MassSpringArbitrary (int iNumParticles, int iNumSprings,
        Real fStep);
    virtual ~MassSpringArbitrary ();

    int GetNumSprings () const;
    void SetSpring (int iSpring, int iParticle0, int iParticle1,
        Real fConstant, Real fLength);
    void GetSpring (int iSpring, int& riParticle0,
        int& riParticle1, Real& rfConstant, Real& rfLength) const;

    Real& Constant (int iSpring);
    Real& Length (int iSpring);

    virtual TVector Acceleration (int i, Real fTime,
        const TVector* akPosition, const TVector* akVelocity);

    virtual TVector ExternalAcceleration (int i, Real fTime,
        const TVector* akPosition, const TVector* akVelocity);

protected:
    class Spring
    {
    public:
        int Particle0, Particle1;
        Real Constant, Length;
    };

    int m_iNumSprings;
    Spring* m_akSpring;

    // Each particle has an associated array of spring indices for those
    // springs adjacent to the particle.  The set elements are spring
    // indices, not indices of adjacent particles.
    TSet<int>* m_akAdjacent;
};
```

The constructor requires you to specify the number of particles and the number of springs in the system. The parameter fStep is the step size used in the Runge-Kutta numerical solver. After construction, you must call SetSpring for each spring that you want in the system. If spring i connects particles p_1 and p_2, the order of the parameters in the function call is irrelevant. It is possible to have two springs that connect the same pair of particles, but I suggest just using at most one spring per pair.

The array member, m_akAdjacent, is an array of sets of integers. The set m_akAdjacent[i] represents \mathcal{A}_i and contains those integers j for which a spring connects particle i to particle j.

The virtual functions Acceleration and ExternalAcceleration are similar to the ones in classes MassSpringCurve, MassSpringSurface, and MassSpringVolume.

The sample application on the companion website that illustrates the use of MassSpringArbitrary is

GeometricTools/WildMagic3/SamplePhysics/GelatinBlob

The application models a gelatinous blob as a deformable volume mass. The blob has the topology of an icosahedron.

7.4 Deformable Bodies

There are many ways to model deformable bodies in a physics simulation. A model that is designed to conform to the physical principles of deformation will most likely be expensive to compute in a real-time application. Instead, you should consider less expensive alternatives. I will mention a few possibilities here.

The SurfaceMesh class, described in Section 4.3, supports dynamic updating of the mesh vertices, which makes it a good candidate for representing a deformable body. You must provide the physics simulation that modifies the mesh vertices during run time. A pitfall of simulations is allowing arbitrary motion of vertices, which leads to self-intersections of the mesh. A collision detection system can help you determine—and prevent—self-intersections, but by doing so, you add an additional layer of expense to the computations. Once physics hardware becomes available on consumer machines, the expense will be negligible.

The MorphController class similarly allows you to dynamically deform a mesh. Whereas the deformations of SurfaceMesh-derived objects are controlled by changing the surface parameters of the derived class, the deformations of objects with a MorphController attached are controlled by a set of keyframes. The keyframes themselves may be dynamically modified.

Yet more classes in the engine that support deformable objects are PointController and ParticleController. Their interfaces allow you to specify the positions and velocities whenever your choose. A physical simulation will set these quantities accordingly.

The possibilities are endless. The `IKController` and `SkinController` classes may also be used for deformation. Animation via controllers directly supports the concept of deformation: It is just a matter of animating the data that directly, or indirectly, affects the vertices of a mesh. The popular rag doll physics is an excellent example of how to blend together deformable objects and collision detection and response.

7.5 RIGID BODIES

The last topic of the chapter is *rigid bodies*. Creating a general physics engine that handles interacting bodies is quite difficult. However, an engine will contain the foundations for computing unconstrained motion using Newton's equations of motion. The collision detection system computes the physical constraints that occur during run time. A careful separation of the collision detection subsystem and the collision response subsystem is called for. The two subsystems must interact, but the separation allows you to more easily diagnose problems and identify which subsystem is causing problems when your simulation shows that some objects are not conforming to the physical principles you had in mind.

A particle can be thought of as a rigid body without size or orientation; it has a position, velocity, and applied forces. Many objects in a physical simulation, though, are not particles and have size and orientation. The standard representation for a rigid body in a real-time application is a polyhedron. A coordinate system is chosen for the body for the purposes of positioning and orienting the object in space. For physical and mathematical reasons, the center of mass is chosen to be the body origin, and the body coordinate axes are chosen to be the principal directions of inertia. The direction vectors turn out to be eigenvectors of the inertia tensor for the body. The choice of coordinate system allows us to decompose the motion calculations into translation of the center of mass (position, linear velocity, and linear acceleration) and rotation of the body (orientation, angular velocity, and angular acceleration). Yet another simplifying assumption is that the mass of the rigid body is uniformly distributed within the body.

Here is a very brief summary of the material in [Ebe03a] regarding unconstrained motion of a rigid body. Let $\mathbf{X}(t)$ and $\mathbf{V}(t)$ denote the position and velocity, respectively, of the center of mass of the rigid body. The linear momentum of the body is

$$\mathbf{P}(t) = m\mathbf{V}(t). \tag{7.11}$$

Newton's second law of motion states that the rate of change of linear momentum is equal to the applied force,

$$\dot{\mathbf{P}}(t) = \mathbf{F}(t), \tag{7.12}$$

where m is the mass of the body, $\ddot{\mathbf{X}}(t)$ is the linear acceleration of the body, and $\mathbf{F}(t)$ is the applied force on the object. The equations of motion pertaining to position and linear momentum are

$$\dot{\mathbf{X}} = m^{-1}\mathbf{P}, \qquad \dot{\mathbf{P}} = \mathbf{F}. \tag{7.13}$$

Similar equations of motion can be derived for the orientation matrix $R(t)$ of the body. In the coordinate system of the rigid body, let \mathbf{b} denote the time-independent position of a point relative to the origin (the center of mass). The world coordinate of the point is

$$\mathbf{Y}(t) = \mathbf{X}(t) + R(t)\mathbf{b}.$$

The inertia tensor in body coordinates is the 3×3 symmetric matrix,

$$J_{\text{body}} = \int_B \left(|\mathbf{b}|^2 I - \mathbf{b}\mathbf{b}^{\text{T}} \right) dm, \tag{7.14}$$

where B is the set of points making up the body, I is the identity matrix, and dm is the infinitesimal measure of mass in the body. For a body of constant density δ, $dm = \delta\, dV$, where dV is the infinitesimal measure of volume in the body. As we will see later in this section, the integration in Equation (7.14) can be computed exactly for a constant-density, rigid body that is represented by a polyhedron. The resulting formula is an algebraic expression that is easily computed.

The inertia tensor in world coordinates is

$$J(t) = \int_B \left(|\mathbf{r}|^2 I - \mathbf{r}\mathbf{r}^{\text{T}} \right) dm = R(t) J_{\text{body}} R(t)^{\text{T}}, \tag{7.15}$$

where $\mathbf{r}(t) = \mathbf{Y}(t) - \mathbf{X}(t) = R(t)\mathbf{b}$. The inertia tensor is sometimes referred to as the *mass matrix*.

The rate of change of the orientation matrix, $R(t)$, is related to the angular velocity vector, $\mathbf{W}(t) = (w_0, w_1, w_2)$, by

$$\dot{R}(t) = \text{Skew}(\mathbf{W}(t))R(t), \tag{7.16}$$

where $S = \text{Skew}(\mathbf{W})$ is the skew-symmetric matrix whose entries are $S_{00} = S_{11} = S_{22} = 0$, $S_{01} = -w_2$, $S_{10} = w_2$, $S_{02} = w_1$, $S_{20} = -w_1$, $S_{12} = -w_0$, and $S_{21} = w_0$.

The angular momentum, $\mathbf{L}(t)$, and angular velocity, $\mathbf{W}(t)$, are related by

$$\mathbf{L}(t) = J(t)\mathbf{W}(t), \tag{7.17}$$

where $J(t)$ is the inertia tensor defined by Equation (7.15). Notice the similarity of Equation (7.17) to Equation (7.11). The linear momentum is defined as *mass times*

linear velocity, and the angular momentum is defined as *mass matrix times angular velocity*.

The equivalent of Newton's second law of motion, which relates linear acceleration and force, is the following, which states that the rate of change of angular momentum is equal to the applied torque:

$$\dot{\mathbf{L}}(t) = \boldsymbol{\tau}(t), \tag{7.18}$$

where $\boldsymbol{\tau}(t)$ is the torque applied to the rigid body. The equations of motion pertaining to orientation and angular momentum are

$$\dot{R} = \mathrm{Skew}(\mathbf{W})R, \qquad \dot{\mathbf{L}} = \boldsymbol{\tau}. \tag{7.19}$$

The angular velocity is dependent on other known quantities, namely,

$$\mathbf{W}(t) = J^{-1}\mathbf{L} = RJ_{\mathrm{body}}^{-1}R^{T}\mathbf{L}. \tag{7.20}$$

Equations (7.13), (7.19), and (7.20) can be combined into a single system of differential equations that model the unconstrained motion of the rigid body. The state vector is $\mathbf{S} = (\mathbf{X}, \mathbf{P}, R, \mathbf{L})$, and the system of equations is

$$\frac{d\mathbf{S}}{dt} = \frac{d}{dt}\begin{bmatrix} \mathbf{X} \\ R \\ \mathbf{P} \\ \mathbf{L} \end{bmatrix} = \begin{bmatrix} \dot{\mathbf{X}} \\ \dot{R} \\ \dot{\mathbf{P}} \\ \dot{\mathbf{L}} \end{bmatrix} = \begin{bmatrix} m^{-1}\mathbf{P} \\ \mathrm{Skew}(RJ_{\mathrm{body}}^{-1}R^{T}\mathbf{L})R \\ \mathbf{F} \\ \boldsymbol{\tau} \end{bmatrix} = \mathbf{G}(t, \mathbf{S}). \tag{7.21}$$

This system is first-order, so it may be solved numerically using your favorite differential equation solver. My choice is the Runge-Kutta fourth-order method. The input parameters are the mass m and body inertia tensor J_{body}, both constants during the physical simulation. The force \mathbf{F} and torque $\boldsymbol{\tau}$ are vector-valued functions that your application must present to the simulator. The initial state, $\mathbf{S}(0)$, is also specified by your application. Once all these quantities are known, the numerical solver is ready to be iterated.

Although Equation (7.21) is ready to solve numerically, most practitioners choose to use quaternions to represent the orientation matrices. If $R(t)$ is the orientation matrix, a corresponding quaternion is denoted $q(t)$. The equivalent of Equation (7.16) for quaternions is

$$\dot{q}(t) = \omega(t)q(t)/2, \tag{7.22}$$

where $\omega = W_0 i + W_1 j + W_2 k$ is the quaternion representation of the angular velocity $\mathbf{W} = (W_0, W_1, W_2)$. The system of equations that I really implement is

$$\begin{bmatrix} \dot{\mathbf{X}} \\ \dot{q} \\ \dot{\mathbf{P}} \\ \dot{\mathbf{L}} \end{bmatrix} = \begin{bmatrix} m^{-1}\mathbf{P} \\ \omega q/2 \\ \mathbf{F} \\ \tau \end{bmatrix}. \tag{7.23}$$

After each iteration of the numerical solver, the application must transform the rigid body to its new world coordinates. The use of quaternions will require us to convert between quaternions and rotation matrices. The classes `Matrix3` and `Quaternion` support these conversions.

7.5.1 THE RIGID BODY CLASS

The class that encapsulates a rigid body is `RigidBody` and has the interface

```
template <class Real>
class RigidBody
{
public:
    RigidBody ();
    virtual ~RigidBody ();

    // set/get position
    Vector3<Real>& Position ();

    // set rigid body state
    void SetMass (float fMass);
    void SetBodyInertia (const Matrix3<Real>& rkInertia);
    void SetPosition (const Vector3<Real>& rkPos);
    void SetQOrientation (const Quaternion<Real>& rkQOrient);
    void SetLinearMomentum (const Vector3<Real>& rkLinMom);
    void SetAngularMomentum (const Vector3<Real>& rkAngMom);
    void SetROrientation (const Matrix3<Real>& rkROrient);
    void SetLinearVelocity (const Vector3<Real>& rkLinVel);
    void SetAngularVelocity (const Vector3<Real>& rkAngVel);

    // get rigid body state
    Real GetMass () const;
    Real GetInverseMass () const;
    const Matrix3<Real>& GetBodyInertia () const;
    const Matrix3<Real>& GetBodyInverseInertia () const;
    Matrix3<Real> GetWorldInertia () const;
    Matrix3<Real> GetWorldInverseInertia () const;
    const Vector3<Real>& GetPosition () const;
```

```
        const Quaternion<Real>& GetQOrientation () const;
        const Vector3<Real>& GetLinearMomentum () const;
        const Vector3<Real>& GetAngularMomentum () const;
        const Matrix3<Real>& GetROrientation () const;
        const Vector3<Real>& GetLinearVelocity () const;
        const Vector3<Real>& GetAngularVelocity () const;

        // force/torque function format
        typedef Vector3<Real> (*Function)
        (
            Real,                       // time of application
            Real,                       // mass
            const Vector3<Real>&,       // position
            const Quaternion<Real>&,    // orientation
            const Vector3<Real>&,       // linear momentum
            const Vector3<Real>&,       // angular momentum
            const Matrix3<Real>&,       // orientation
            const Vector3<Real>&,       // linear velocity
            const Vector3<Real>&        // angular velocity
        );

        // force and torque functions
        Function Force;
        Function Torque;

        // Runge-Kutta fourth-order differential equation solver
        void Update (Real fT, Real fDT);

protected:
        // constant quantities (matrices in body coordinates)
        Real m_fMass, m_fInvMass;
        Matrix3<Real> m_kInertia, m_kInvInertia;

        // state variables
        Vector3<Real> m_kPos;           // position
        Quaternion<Real> m_kQOrient;    // orientation
        Vector3<Real> m_kLinMom;        // linear momentum
        Vector3<Real> m_kAngMom;        // angular momentum

        // derived state variables
        Matrix3<Real> m_kROrient;       // orientation matrix
        Vector3<Real> m_kLinVel;        // linear velocity
        Vector3<Real> m_kAngVel;        // angular velocity
};
```

The constructor creates an uninitialized rigid body. The rigid body state must be initialized using the Set functions before starting the physical simulation. The Get functions allow you access to the current state of the rigid body.

The constant quantities for the rigid body are the mass and inertia tensor in body coordinates. Because the differential equation solver must divide by mass and use the inverse of the inertia tensor, these are computed once and stored. If you want a rigid body to be immovable, set its *inverse* mass to zero and its *inverse* inertia tensor to the zero matrix. In effect, the body mass is infinite, and the body is too heavy to rotate.

The state variable in Equation (7.23) includes position, orientation (represented as a quaternion), linear momentum, and angular momentum. These values are stored by the class. The other quantities of interest are derived from the state variables: the orientation matrix (derived from the quaternion orientation), the linear velocity (derived from the linear momentum and mass), and the angular velocity (derived from the angular momentum, the inertia tensor, and the orientation matrix). The derived variables are guaranteed to be synchronized with the state variables.

The class defines a function type, called RigidBody::Function. The force \mathbf{F} and torque τ in Equation (7.23) possibly depend on many variables, including the current time and state of the system. If you think of the equations of motion as $\dot{\mathbf{S}} = \mathbf{G}(t, \mathbf{S})$, then the function type RigidBody::Function represents the function on the right-hand side, $\mathbf{G}(t, \mathbf{S})$. The class has two data members that are in public scope, Force and Torque, which are set by your application.

The member function Update is a single iteration of the Runge-Kutta fourth-order solver. The implementation is

```
template <class Real>
void RigidBody<Real>::Update (Real fT, Real fDT)
{
    Real fHalfDT = ((Real)0.5)*fDT;
    Real fSixthDT = fDT/((Real)6.0);
    Real fTpHalfDT = fT + fHalfDT;
    Real fTpDT = fT + fDT;

    Vector3<Real> kNewPos, kNewLinMom, kNewAngMom, kNewLinVel;
    Vector3<Real> kNewAngVel;
    Quaternion<Real> kNewQOrient;
    Matrix3<Real> kNewROrient;

    // A1 = G(T,S0), B1 = S0 + (DT/2)*A1
    Vector3<Real> kA1DXDT = m_kLinVel;
    Quaternion<Real> kW = Quaternion<Real>((Real)0.0,m_kAngVel.X(),
        m_kAngVel.Y(),m_kAngVel.Z());
    Quaternion<Real> kA1DQDT = ((Real)0.5)*kW*m_kQOrient;
    Vector3<Real> kA1DPDT = Force(fT,m_fMass,m_kPos,m_kQOrient,
        m_kLinMom,m_kAngMom,m_kROrient,m_kLinVel,m_kAngVel);
```

```
Vector3<Real> kA1DLDT = Torque(fT,m_fMass,m_kPos,m_kQOrient,
    m_kLinMom,m_kAngMom,m_kROrient,m_kLinVel,m_kAngVel);
kNewPos = m_kPos + fHalfDT*kA1DXDT;
kNewQOrient = m_kQOrient + fHalfDT*kA1DQDT;
kNewLinMom = m_kLinMom + fHalfDT*kA1DPDT;
kNewAngMom = m_kAngMom + fHalfDT*kA1DLDT;
kNewQOrient.ToRotationMatrix(kNewROrient);
kNewLinVel = m_fInvMass*kNewLinMom;
kNewAngVel = kNewROrient*m_kInvInertia*kNewROrient.Transpose()
    *kNewAngMom;

// A2 = G(T+DT/2,B1), B2 = S0 + (DT/2)*A2
Vector3<Real> kA2DXDT = kNewLinVel;
kW = Quaternion<Real>((Real)0.0,kNewAngVel.X(),kNewAngVel.Y(),
    kNewAngVel.Z());
Quaternion<Real> kA2DQDT = ((Real)0.5)*kW*kNewQOrient;
Vector3<Real> kA2DPDT = Force(fTpHalfDT,m_fMass,kNewPos,
    kNewQOrient,kNewLinMom,kNewAngMom,kNewROrient,kNewLinVel,
    kNewAngVel);
Vector3<Real> kA2DLDT = Torque(fTpHalfDT,m_fMass,kNewPos,
    kNewQOrient,kNewLinMom,kNewAngMom,kNewROrient,kNewLinVel,
    kNewAngVel);
kNewPos = m_kPos + fHalfDT*kA2DXDT;
kNewQOrient = m_kQOrient + fHalfDT*kA2DQDT;
kNewLinMom = m_kLinMom + fHalfDT*kA2DPDT;
kNewAngMom = m_kAngMom + fHalfDT*kA2DLDT;
kNewQOrient.ToRotationMatrix(kNewROrient);
kNewLinVel = m_fInvMass*kNewLinMom;
kNewAngVel = kNewROrient*m_kInvInertia*kNewROrient.Transpose()
    *kNewAngMom;

// A3 = G(T+DT/2,B2), B3 = S0 + DT*A3
Vector3<Real> kA3DXDT = kNewLinVel;
kW = Quaternion<Real>((Real)0.0,kNewAngVel.X(),kNewAngVel.Y(),
    kNewAngVel.Z());
Quaternion<Real> kA3DQDT = ((Real)0.5)*kW*kNewQOrient;
Vector3<Real> kA3DPDT = Force(fTpHalfDT,m_fMass,kNewPos,
    kNewQOrient,kNewLinMom,kNewAngMom,kNewROrient,kNewLinVel,
    kNewAngVel);
Vector3<Real> kA3DLDT = Torque(fTpHalfDT,m_fMass,kNewPos,
    kNewQOrient,kNewLinMom,kNewAngMom,kNewROrient,kNewLinVel,
    kNewAngVel);
kNewPos = m_kPos + fDT*kA3DXDT;
```

```
kNewQOrient = m_kQOrient + fDT*kA3DQDT;
kNewLinMom = m_kLinMom + fDT*kA3DPDT;
kNewAngMom = m_kAngMom + fDT*kA3DLDT;
kNewQOrient.ToRotationMatrix(kNewROrient);
kNewLinVel = m_fInvMass*kNewLinMom;
kNewAngVel = kNewROrient*m_kInvInertia*kNewROrient.Transpose()
    *kNewAngMom;

// A4 = G(T+DT,B3), S1 = S0 + (DT/6)*(A1+2*(A2+A3)+A4)
Vector3<Real> kA4DXDT = kNewLinVel;
kW = Quaternion<Real>((Real)0.0,kNewAngVel.X(),kNewAngVel.Y(),
    kNewAngVel.Z());
Quaternion<Real> kA4DQDT = ((Real)0.5)*kW*kNewQOrient;
Vector3<Real> kA4DPDT = Force(fTpDT,m_fMass,kNewPos,
    kNewQOrient,kNewLinMom,kNewAngMom,kNewROrient,kNewLinVel,
    kNewAngVel);
Vector3<Real> kA4DLDT = Torque(fTpDT,m_fMass,kNewPos,
    kNewQOrient,kNewLinMom,kNewAngMom,kNewROrient,kNewLinVel,
    kNewAngVel);
m_kPos = m_kPos + fSixthDT*(kA1DXDT + ((Real)2.0)*(kA2DXDT +
    kA3DXDT) + kA4DXDT);
m_kQOrient = m_kQOrient + fSixthDT*(kA1DQDT +
    ((Real)2.0)*(kA2DQDT + kA3DQDT) + kA4DQDT);
m_kLinMom = m_kLinMom + fSixthDT*(kA1DPDT +
    ((Real)2.0)*(kA2DPDT + kA3DPDT) + kA4DPDT);
m_kAngMom = m_kAngMom + fSixthDT*(kA1DLDT +
    ((Real)2.0)*(kA2DLDT + kA3DLDT) + kA4DLDT);
m_kQOrient.ToRotationMatrix(m_kROrient);
m_kLinVel = m_fInvMass*m_kLinMom;
m_kAngVel = m_kROrient*m_kInvInertia*m_kROrient.Transpose()
    *m_kAngMom;
}
```

Its structure is similar to the previous implementations we have seen for the Runge-Kutta solvers. The exception is that after each of the four steps in the solver, the derived variables must be computed. The orientation matrix is computed from the orientation quaternion, the linear velocity is computed from the linear momentum and inverse mass, and the angular velocity is computed from the orientation matrix, the inverse inertia tensor, and the angular momentum.

Two applications illustrating the use of RigidBody are on the companion website:

```
GeometricTools/WildMagic3/SamplePhysics/BouncingBalls
GeometricTools/WildMagic3/SamplePhysics/BouncingTetrahedra
```

The first application is fairly simple from the point of view of collision detection—it is easy to compute the contact time and contact point between two spheres. The second application is more complicated: it sets up the collision detection as a linear complementarity problem (LCP) and uses a numerical solver for the LCP. LCPs and their numerical solution are a complicated topic that I will not discuss here. See [Ebe03a] for details and references to the literature.

7.5.2 Computing the Inertia Tensor

The `RigidBody` class requires you to initialize the body by specifying its mass and body inertia tensor. Generally, the inertia tensor is a complicated, mathematical beast. For constant-density bodies that are represented by polyhedra, the tensor can be computed in closed form. The document [Ebe03b] is about deriving the equations for the inertia tensor. The paper [Mir96] is what practitioners had been using for the equations, but is less efficient regarding the calculations, and the equations are more detailed and tedious to implement. A discussion of [Ebe03b] is also in [Ebe03a].

The essence of the algorithm is that the entries of the inertia tensor are triple integrals evaluated over the region of space occupied by the body. Each integral has an integrand that is a quadratic polynomial. The divergence theorem from calculus allows you to convert the volume integrals to surface integrals. Because the object is a polyhedron, the surface integrals are reduced to a sum of integrals over the polyhedron faces. Each of these integrals is easily computed in closed form.

A single function is provided for computing the mass, center of mass, and the inertia tensor for a rigid body with constant density and represented by a polyhedron:

```
template <class Real>
void ComputeMassProperties (const Vector3<Real>* akVertex,
    int iTQuantity, const int* aiIndex, bool bBodyCoords,
    Real& rfMass, Vector3<Real>& rkCenter,
    Matrix3<Real>& rkInertia);
```

The polyhedron must be represented by a closed triangle mesh. Each edge of the mesh is shared by exactly two triangles. The first parameter of the function is the array of vertices for the mesh. The second parameter is the number of triangles in the mesh. The third parameter is the index array, which has $3T$ indices for T triangles. Each triple of indices represents a triangle in the mesh, and the indices are for lookups in the vertex array.

The parameter `bBodyCoords` is set to `true` when you want the inertia tensor in body coordinates. For the purposes of the class `RigidBody`, this is what you want. If you want the inertia tensor in world coordinates, set the Boolean parameter to `false`.

The last three parameters (the mass of the body, the center of mass, and the inertia tensor) are the output of the function.

CHAPTER 8

APPLICATIONS

The last topic of this book is about creating applications. The example in Section 1.1 showed you how much source code must be written to simply create and display a window. The WinMain function is about 135 lines of code. Its duties are

- create the application window
- create a renderer whose output is displayed in the application window
- set up the camera model for the renderer
- display the window
- start the message pump so that the window can receive and process events (mouse, keyboard, termination)
- draw the triangle during idle time
- exit the message pump, destroy the renderer, and destroy the window

The event-processing function is WndProc, and it is about 250 lines of code. A switch statement is used to determine the type of event that has occurred. In this particular application, the pressing of character keys is trapped in order to translate and rotate the triangle. The pressing of arrow keys, paging keys, and home or end keys is trapped in order to translate and rotate the camera. The only other event trapped is the signal to terminate the application. Conceptually, the event handler code is simple, but its size is large.

601

The drawing function is DrawIt and is purely specific to the OpenGL renderer. Such drawing will be customized for a particular application.

The WinMain and WndProc functions have a lot of code that you should expect to be common to all applications. Object-oriented principles dictate that you should make every attempt to factor out the common code for reuse.

Many programmers are accustomed to developing on a single platform. Even with code factoring for reuse on their preferred platforms, in most cases the resulting system will not work for other platforms. The WinMain and WndProc are specific to the Microsoft Windows platform. A Unix or Linux platform will use the standard entry point, main, and, most likely, an X-Windows base layer for window creation and event handling. The Macintosh OS X platform is Unix based and also uses main as the entry point. However, the Macintosh has no native concept of command line parameters, unless you execute programs from a terminal window. Even if you intend your applications to be run from a terminal, getting keyboard and mouse events hooked up to an application is a nontrivial process—one that is quite specific to the Macintosh.

Clearly, this discussion should be the motivation for writing an interface for an application layer. The first goal of the interface is to hide the extensive code for the application setup and to avoid the drudgery of creating repeatedly the base code for each of your applications. Write it once; use it often. Should you choose to have portable software, the second goal of the interface is to hide the platform-specific details of the application.

8.1 ABSTRACTION OF THE APPLICATION

The Wild Magic version 3 engine has an application subsystem whose features include the following:

- The initialization and termination of objects via registered functions. This mechanism was described in detail in Section 2.3.8.

- A console application layer for those applications requiring neither a window nor a renderer. For example, the ScenePrinter tool is an application on the companion website that traverses a scene graph and creates an ASCII file of information about it.

- A window application layer that supports both 2D and 3D applications. Derived classes are provided for the 2D and 3D window applications. The 2D layer has only a renderer for drawing to a bitmap that is later sent to the graphics card to be used as the entire screen. The 3D layer has a camera, as well as a renderer, and is the basis for nearly all the sample applications that are on the companion website.

- An application library that supports both console and windowed applications, so you need only link in one library for any application, regardless of its type. In contrast, for Wild Magic version 2, you had to create either a console application

with no linking of any application library, or a 3D application with linking of a 3D application library, or a 2D application that was derived from the 3D application layer as a quick hack to support such applications.

The application types in Wild Magic version 3 are `ConsoleApplication`, `Window-Application2`, and `WindowApplication3`. Your application will be a derived class from one of these. The application library is designed so that your applications are portable across all platforms that have implemented a few required functions in the application layer. My libraries hide operating system dependencies, the initialization and termination subsystem, the creation of windows and renderers, and the handling of events such as key presses and mouse clicks. The abstract interface is by no means complete, but suffices for most applications. You certainly can add to the application layer as needed.

8.1.1 PROCESSING COMMAND LINE PARAMETERS

The standard entry point into an application is the function

```
int main (int iQuantity, char** apcArgument)
{
    // iQuantity >= 1 is always true
    // apcArgument[0] is the name of the executing module

    // ... process command line arguments here ...

    return 0;
}
```

The first parameter is the number of strings that occur in the second parameter, an array of pointers to character strings. The input parameters are optional, so it is okay to call `main()` or `main(int)`. The compiler will correctly parse the statement in all cases. The function actually has a third optional parameter, which is used for passing the environment variables, but I do not deal with those in Wild Magic. Clearly, anyone writing an application that accepts inputs to `main` must be prepared to parse the array of strings.

The age-old approach to processing command line parameters is represented by Henry Spencer's *getopt* routines. The *getopt* routines are limited in that the option names have to be a single letter. Also, the main routine must contain a loop and a switch statement (of options), which repeatedly fetches an argument and decides which option it is and which action to take. I wrote my own command line parser, which allows option names of length greater than 1, and which allows one to get an argument anywhere in the main routine. This tends to keep the parameter processing and actions together in a related block of code.

The class is `Command` and has the following interface:

```
class Command
{
public:
    Command (int iQuantity, char** apcArgument);
    Command (char* acCmdline);
    ~Command ();

    int ExcessArguments ();

    Command& Min (double dValue);
    Command& Max (double dValue);
    Command& Inf (double dValue);
    Command& Sup (double dValue);

    int Boolean (char* acName);   // returns existence of option
    int Boolean (char* acName, bool& rbValue);
    int Integer (char* acName, int& riValue);
    int Float (char* acName, float& rfValue);
    int Double (char* acName, double& rdValue);
    int String (char* acName, char*& racValue);
    int Filename (char*& racName);

    const char* GetLastError ();

protected:
    // constructor support
    void Initialize ();

    // command line information
    int m_iQuantity;         // number of arguments
    char** m_apcArgument;    // argument list (array)
    char* m_acCmdline;       // argument list (single)
    bool* m_abUsed;          // arguments already processed

    // parameters for bounds checking
    double m_dSmall;    // bound for argument (min or inf)
    double m_dLarge;    // bound for argument (max or sup)
    bool m_bMinSet;     // if true, compare:  small <= arg
    bool m_bMaxSet;     // if true, compare:  arg <= large
    bool m_bInfSet;     // if true, compare:  small < arg
    bool m_bSupSet;     // if true, compare:  arg < large

    // last error strings
    const char* m_acLastError;
```

```
    static char ms_acOptionNotFound[];
    static char ms_acArgumentRequired[];
    static char ms_acArgumentOutOfRange[];
    static char ms_acFilenameNotFound[];
};
```

The constructor Command(int,char**) takes as input the arguments to routine main. In a Microsoft Windows application, the constructor Command(char*) takes as input the command line string to WinMain. I have designed the Wild Magic version 3 application layer to use only main, so you have no need for the second form of the constructor.

After all arguments are processed, the method ExcessArguments may be called to check for extraneous information on the command line that does not match what was expected by the program. If extra or unknown arguments appear, then the return value is the index within the command line string of the first such argument.

When parsing options whose arguments are numerical values, it is possible that upper and lower bounds are required on the input. The bounds for input X are set via calls to Min (min $\leq X$), Max ($X \leq$ max), Inf (inf $< X$), or Sup ($X <$ sup). These methods return *this so that a Command object can set bounds and acquire input within the same statement. Some examples are shown later in this section.

The supported option types are *Booleans* (the option takes no arguments), *integers*, *reals*, *strings*, or *filenames*. Each type has an associated method whose first char* parameter is the option name and whose second parameter will be the option argument, if present. The exceptions are the first Boolean method (an option with no argument) and filenames (an argument with no option). The return value of each method is the index within the command line string, or zero if the option did not occur on the command line.

The function GetLastError returns information about problems with reading command line parameters. The errors are "option not found", "option requires an argument", "argument out of range", and "filename not found". The user has the responsibility for calling GetLastError.

A simple example of command line parsing is the following. Suppose that you have a program for integrating a function $f(x)$ whose domain is the half-open interval $[a, b)$. The function will be specified as a string, and the end points of the interval will be specified as real numbers. Let's assume that we want $0 \leq a < b < 1$. Your program will use samples of the function to produce an approximate value for the integral, so you also want to input the number of partition points as an integer. Finally, your program will write information about the integration to a file.

```
#include "Wm3Command.h"
using namespace Wm3;

// usage:
// "integrate [options] outputfile" with options listed below:
```

```
// "  -a (float)    :  left endpoint (a >= 0, default=0.0)"
// "  -b (float)    :  right endpoint (a < b < 1, default=0.5)"
// "  -num (int)    :  number of partitions (default=1)"
// "  -func (string):  expression for f(x)"
// "  -debug        :  debug information (default=none)"
// "  outputfile    :  name of file for output information"

int main (int iQuantity, char** apcArgument)
{
    Command kCmd(iQuantity,apcArgument);

    // get left end point (0 <= a is required)
    double dA = 0.0f;
    kCmd.Min(0.0).Double("a",dA);
    if ( kCmd.GetLastError() )
    {
        cout << "0 <= a required" << endl;
        return 1;
    }

    // get right end point (a < b < 1 is required)
    double dB = 0.5;
    kCmd.Inf(dA).Sup(1.0).Double("b",dB);
    if ( kCmd.GetLastError() )
    {
        cout << "a < b < 1 required" << endl;
        return 2;
    }

    // get number of partition points (1 or larger)
    int iPoints = 1;
    kCmd.Min(1).Integer("num",iPoints);
    if ( kCmd.GetLastError() )
    {
        cout << "num parameter must be 1 or larger" << endl;
        return 3;
    }

    // get function expression (must be supplied)
    char acFunction[128];
    if ( !kCmd.String("func",acFunction) )
    {
        cout << "function must be specified" << endl;
        return 4;
    }
```

```
// get output filename
char acOutfile[128];
if ( !kCmd.Filename(acOutfile) )
{
    cout << "output file must be specified" << endl;
    return 5;
}

// want debug information?
bool bDebug = false;
kCmd.Boolean("debug",bDebug);

// check for extraneous or unknown options
if ( kCmd.ExcessArguments() )
{
    cout << "command line has excess arguments" << endl;
    return 6;
}

// your program code goes here
return 0;
}
```

8.1.2 THE APPLICATION CLASS

The base class of the entire application library is quite simple. It is called Application and has the following interface:

```
class Application
{
    WM3_DECLARE_TERMINATE;

public:
    virtual ~Application ();

    static Application* TheApplication;
    static Command* TheCommand;

    typedef int (*EntryPoint)(int, char**);
    static EntryPoint Run;

protected:
    Application ();
};
```

```
WM3_REGISTER_TERMINATE(Application);
#include "Wm3Application.mcr"
```

The class is abstract since its only constructor is protected. This class contains the minimum support for all the application types: console, 2D windowed, and 3D windowed. The engine is designed to handle a single application; that is, the existence of multiple instances of the same application is unknown to the engine. Because only a single instance of an application is assumed, a pointer to the unique application object is stored in the base class and is named TheApplication. The event handlers of the windowed applications are C-style functions that are not member functions in the Application class hierarchy. The handlers must be able to pass along events to the application object. They do so through the TheApplication pointer. The base class also stores a unique object for the command line parameters. The uniqueness is clear: you cannot pass two command lines to the same executable module.

The entry point to the application is through the static data member Run. The int parameter is the number of command line arguments. The char** parameter is the array of argument strings. The final derived classes (your applications) must set this function pointer to an appropriately designed function. The mechanism is described later in this section. A function pointer is used rather than a member function to allow all application types to coexist in the library. If a member function were to be used instead, each application type would have to implement that function, leading to multiply defined functions in the library—an error that the linker will report to you.

In Section 2.3.8, I mentioned a small code block for the main function. The actual source code is in the file Wm3Application.cpp. Since main is what the compiler expects as the entry point, the function cannot be a class member. The code is

```
int main (int iQuantity, char** apcArgument)
{
    Main::Initialize();

    int iExitCode = 0;
    if ( Application::Run )
    {
        Application::TheCommand = new Command(iQuantity,apcArgument);
        iExitCode = Application::Run(iQuantity,apcArgument);
        delete Application::TheCommand;
    }
    else
    {
        iExitCode = INT_MAX;
    }

    Main::Terminate();
```

```
    delete Application::TheApplication;
    return iExitCode;
}
```

The actual code is slightly different than what was discussed in Section 2.3.8.

As discussed previously, all registered initialization functions are executed before the application is run. The application itself is created during the initialization phase—more on this a little bit later. If the application Run function pointer has not been set, the application cannot run. This error will occur if you forget to use the initialization system properly when creating your application classes.

Assuming the application's Run function is set, the command line object is created for use by the application, and then the Run function is executed. On completion, the command line object is destroyed. All registered termination functions are then executed. The goal is to trap object leaks that the application might have.

The deletion of the application object is delayed until the very end of the main function, which forces you to correctly clean up any objects in your application when a termination callback is executed. I made this choice so that the graphics system has a chance to release any resources that are associated with the application: textures, shader programs, cached arrays, and anything else you might have cached in VRAM on the graphics card. If you have not freed all your objects, Main::Terminate will complain loudly that you forgot to clean up!

8.1.3 THE CONSOLEAPPLICATION CLASS

Console applications do not require a window for displaying results. In a straightforward C or C++ program, you would implement such an application using main directly. My application layer supports console applications, but they require more setup than just implementing a single function—a natural consequence of the design of main in the Application class.

The ConsoleApplication class has the interface

```
class ConsoleApplication : public Application
{
public:
    ConsoleApplication ();
    virtual ~ConsoleApplication ();

    virtual int Main (int iQuantity, char** apcArgument) = 0;

protected:
    static int Run (int iQuantity, char** apcArgument);
};
```

The class is abstract because of the presence of the pure virtual function `Main`. This is not to be confused with the class `Main`. I choose to use the name because, effectively, the function is the entry point into an application that resembles the standard application entry point `int main(int,char**)`. Your applications must implement `Main`.

The `Run` function is

```
int ConsoleApplication::Run (int iQuantity, char** apcArgument)
{
    ConsoleApplication* pkTheApp =
        (ConsoleApplication*)TheApplication;
    return pkTheApp->Main(iQuantity,apcArgument);
}
```

A console application will set the function pointer `Application::Run` to its own `Run` function pointer. When `Application::Run` is executed by the `main` function in class `Application`, the `ConsoleApplication::Run` will be executed. All that it does is pass on the command line parameters to the derived class's implementation of `Main`. This is technically not required since `Application::TheCommand` was already constructed in `main`, and the derived class has access to it. However, I did not want to force you to use the command line object; you can parse the parameters yourself, if you so choose.

The final piece of the puzzle is to derive a class from `ConsoleApplication` and hook up the `Run` function by using the initialization mechanism. An additional macro is provided, in the file `WmlApplication.mcr`, to implement the initialization and create the application object, both without having to type in the code yourself. The macro is `WM3_CONSOLE_APPLICATION` and is defined by

```
#define WM3_CONSOLE_APPLICATION(classname) \
WM3_IMPLEMENT_INITIALIZE(classname); \
\
void classname::Initialize () \
{ \
    Application::Run = &ConsoleApplication::Run; \
    TheApplication = new classname; \
}
```

The initialization function sets the `Application::Run` function pointer so, indeed, your application will be run when you click the "go" button. The second line of code in the initialization function acts as a factory to create an object from your specific application class.

The following example illustrates what you must do for a hypothetical class My-ConsoleApplication:

```
// in MyConsoleApplication.h

#include "Wm3ConsoleApplication.h"
using namespace Wm3;

class MyConsoleApplication : public ConsoleApplication
{
    WM3_DECLARE_INITIALIZE;
public:
    MyConsoleApplication ();
    virtual ~MyConsoleApplication ();
    virtual int Main (int iQuantity, char** apcArgument);
protected:
    // ... whatever else you need goes here ...
};

WM3_REGISTER_INITIALIZE(MyConsoleApplication);
```

The declaration macro for initialization is used to indicate your intention to have an `Initialize` function called by `Main::Initialize`. The registration macro generates the code to force the registration of `Initialize` with class `Main`.

The source file has

```
// in MyConsoleApplication.cpp

#include "MyConsoleApplication.h"
using namespace Wm3;

WM3_CONSOLE_APPLICATION(MyConsoleApplication);

int MyConsoleApplication::Main (int iQuantity, char** apcArgument)
{
    // ... do your thing here ...
    return 0;
}
```

The order of events is

1. The `MyConsoleApplication::Initialize` function is registered pre-main, that is, before `int main(int,char**)` executes.

2. `int main(int,char**)` is executed.

3. `Main::Initialize` is called.

4. `MyConsoleApplication::Initialize` is called. The function pointer `ConsoleApplication::Run` is assigned to `Application::Run`. A `MyConsoleApplication` object is dynamically created, and its pointer is assigned to `Application::TheApplication`.

5. `Application::TheCommand` is dynamically created, using the `int` and `char**` parameters that were passed to `int main(int,char**)`.

6. The function that `Application::Run` points to is executed. In this case, it is `ConsoleApplication::Run`, which, in turn, calls the function `MyConsoleApplication::Main` for your application object.

For the most part, all these details are hidden from you. All you should care about are creating the skeleton class, as shown, and implementing the `Main` function for your particular needs.

8.1.4 THE WINDOWAPPLICATION CLASS

The mechanism for working with windowed applications is similar to that for console applications. The base class for such applications is `WindowApplication` and is the common framework that occurs in 2D and 3D applications. The portion of the interface similar to the console interface is

```
class WindowApplication : public Application
{
public:
    WindowApplication (const char* acWindowTitle, int iXPosition,
        int iYPosition, int iWidth, int iHeight,
        const ColorRGB& rkBackgroundColor);
    virtual ~WindowApplication ();

    virtual int Main (int iQuantity, char** apcArgument);

protected:
    static int Run (int iQuantity, char** apcArgument);
};
```

The Run function is

```
int WindowApplication::Run (int iQuantity, char** apcArgument)
{
    WindowApplication* pkTheApp = (WindowApplication*)TheApplication;
    return pkTheApp->Main(iQuantity,apcArgument);
}
```

and has exactly the same purpose as that of `ConsoleApplication::Run`.

The mechanism to hook up your application to be run is supported by the macro

```
#define WM3_WINDOW_APPLICATION(classname) \
WM3_IMPLEMENT_INITIALIZE(classname); \
\
void classname::Initialize () \
{ \
    Application::Run = &WindowApplication::Run; \
    TheApplication = new classname; \
}
```

The macro is structured exactly the same as the WM3_CONSOLE_APPLICATION macro. Unlike the console applications, an additional layer occurs between your application and the WindowApplication class. The derived class WindowApplication2 supports 2D applications; the derived class WindowApplication3 supports 3D applications.

An example to illustrate setting up a 3D application uses a hypothetical class MyWindowApplication:

```
// in MyWindowApplication.h

#include "Wm3WindowApplication3.h"
using namespace Wm3;

class MyWindowApplication : public WindowApplication3
{
    WM3_DECLARE_INITIALIZE;
public:
    MyWindowApplication ();
    virtual ~MyWindowApplication ();

    // ... other interface functions go here ...
protected:
    // ... whatever else you need goes here ...
};

WM3_REGISTER_INITIALIZE(MyWindowApplication);
```

The source file has

```
// in MyWindowApplication.cpp

#include "MyWindowApplication.h"
using namespace Wm3;
```

```
WM3_WINDOW_APPLICATION(MyWindowApplication);

MyWindowApplication::MyWindowApplication ()
    :
    WindowApplication3("MyWindowApplication",0,0,640,480,
        ColorRGBA::WHITE)
{
    // ... initializations go here ...
}

// ... your class implementation goes here ...
```

The `WindowApplication::Main` is implemented by `WindowApplication`, in comparison to `ConsoleApplication::Main`, which required the override to occur in the final application class. The implementations of `WindowApplication::Main` are platform specific because the windowing systems and event handling are platform specific. More about this later.

Construction

The `WindowApplication` class and its derivations all have a constructor of the form

```
class WindowApplication : public Application
{
public:
    WindowApplication (const char* acWindowTitle, int iXPosition,
        int iYPosition, int iWidth, int iHeight,
        const ColorRGB& rkBackgroundColor);
};
```

The window title is intended to be displayed on the title bar of the window. The position parameters are the location on the screen of the upper-left corner of the window, the width and height are the size of the window, and the input color is used for clearing the background by setting all pixels to that color. The final application class always declares the default constructor whose implementation calls the base class constructor with the appropriate parameters.

A portion of the `WindowApplication` is devoted to the access of the members set by the constructor

```
class WindowApplication : public Application
{
public:
    const char* GetWindowTitle () const;
```

```
    int GetXPosition () const;
    int GetYPosition () const;
    int GetWidth () const;
    int GetHeight () const;
    void SetRenderer (Renderer* pkRenderer);
    void SetWindowID (int iWindowID);
    int GetWindowID () const;

protected:
    const char* m_acWindowTitle;
    int m_iXPosition, m_iYPosition, m_iWidth, m_iHeight;
    ColorRGB m_kBackgroundColor;
    int m_iWindowID;
    Renderer* m_pkRenderer;
};
```

The Get routines have the obvious behavior. A typical windowing system will assign
a unique identifier (a window handle) to each window it creates. During the window
creation, that identifier must be stored by the window for identification purposes
throughout the program run time. The data member m_iWindowID stores that value
and is assigned by a call to SetWindowID. The renderer creation is dependent on the op-
erating system, the windowing system, and the graphics API (OpenGL or Direct3D,
for example). The platform-specific source code will create a renderer and then pass
it to the WindowApplication object by calling the function SetRenderer. Notice that
the renderer is stored polymorphically through the abstract base class Renderer—a
requirement for the WindowApplication interface to be platform independent.

Event Handling

All windowing systems have mechanisms for handling events such as key presses,
mouse clicks and motion, and repositioning and resizing of windows. They also have
mechanisms for repainting the screen when necessary and for idle-time processing
when the event queue is empty. The class WindowApplication has a collection of *event
callbacks*—functions that are called by the platform-specific implementations of the
event handlers and dispatchers. These callbacks are

```
class WindowApplication : public Application
{
public:
    virtual bool OnPrecreate ();
    virtual bool OnInitialize ();
    virtual void OnTerminate ();
    virtual void OnMove (int iX, int iY);
```

```
    virtual void OnResize (int iWidth, int iHeight);
    virtual void OnDisplay ();
    virtual void OnIdle ();
    virtual bool OnKeyDown (unsigned char ucKey, int iX, int iY);
    virtual bool OnKeyUp (unsigned char ucKey, int iX, int iY);
    virtual bool OnSpecialKeyDown (int iKey, int iX, int iY);
    virtual bool OnSpecialKeyUp (int iKey, int iX, int iY);
    virtual bool OnMouseClick (int iButton, int iState, int iX,
        int iY, unsigned int uiModifiers);
    virtual bool OnMotion (int iButton, int iX, int iY);
    virtual bool OnPassiveMotion (int iX, int iY);

    void RequestTermination ();
};
```

The typical structure of the main function in a windowing system is the following pseudocode:

```
int WindowApplication::Main (...)
{
    (1) do work if necessary before window creation;
    (2) create the window;
    (3) create the renderer;
    (4) initialize the application;
    (5) display the window;
    do_forever
    {
        if ( message pending )
        {
            (6) if message is to quit, break out of loop;
            (7) dispatch the message;
        }
        else
        {
            (8) do idle processing;
        }
    }
    (9) terminate the application;
}
```

Naturally, this function runs forever until a message is sent for the application to quit. The event callbacks are executed directly, or indirectly, during this function call. The callback OnPrecreate is called during stage (1). The window creation (2) is specific to the windowing system used by the operating system. The renderer creation (3) is specific to the graphics API. Stage (4) is managed by the callback OnInitialize. The

window display (5) is part of the windowing API and is not part of my application library. The message pump is the do_forever loop. If the quit message is received, the loop is exited and the application terminates.

The application is given a chance to clean up at stage (9) via the callback OnTerminate. The decision for an application to terminate can be implicit in the architecture (for example, when a user clicks on the window "close" button) or explicit (for example, when a user presses a specified key). In my applications, the default key is ESC. The function RequestTermination is called within my application library code and generates a quit message. The implementation is platform specific. For example, the Microsoft Windows API function PostMessage is called to post a WM_DESTROY message to the message queue.

Stage (7) is where the events are dispatched to an event handler. In my application architecture, the handler accesses the application object through the Application::TheApplication pointer, determines the type of the event that has occurred, and then tells the application object to execute its corresponding callback. Window translation generates an event that causes OnMove to be called. Window resizing generates an event that causes OnResize to be called. If a window is partially covered or minimized, and then uncovered or maximized, the window must be repainted (in part or in full). This type of event causes OnDisplay to be called.

Key presses are events that cause the functions OnKeyDown, OnKeyUp, OnSpecialKeyDown, and OnSpecialKeyUp to be called. The special keys are the arrow keys; the insert, delete, home, end, page up, and page down keys; and the function keys, F1 through F12. The callback OnSpecialKeyDown is executed when one of these keys is pressed. The callback OnSpecialKeyUp is executed when the key is released. The remaining keys on the keyboard are handled similarly by OnKeyDown and OnKeyUp.

The key identifiers tend to be constants provided by the platform's windowing system, and their values are not consistent across platforms—another source of nonportability. WindowApplication has a collection of const data members that are assigned the key identifiers in each platform-dependent implementation. These data members provide a consistent naming convention for your applications so that they may remain portable. For example, a few of these data members are

```
class WindowApplication : public Application
{
public:
    // keyboard identifiers
    static const int KEY_ESCAPE;
    static const int KEY_LEFT_ARROW;
    // ... other const data members ...

    // keyboard modifiers
    static const int KEY_SHIFT;
    static const int KEY_CONTROL;
    // ... other const data members ...
};
```

Mouse events include pressing a mouse button and moving the mouse, which generate calls to OnMouseClick, OnMotion, and OnPassiveMotion. If your development platform is Microsoft Windows or X-Windows, you might have been tempted to have more mouse callbacks such as OnLeftMouseDown and OnMiddleMouseUp, which is reasonable for hardware and operating systems that support multiple-button mice. However, a Macintosh mouse has only a single button, so I refrained from having anything other than OnMouseClick. I do pass in the button type (iButton), a button state (iState), and button modifiers (uiModifiers). The platform-independent names I use for these are

```
class WindowApplication : public Application
{
public:
    // mouse buttons
    static const int MOUSE_LEFT_BUTTON;
    static const int MOUSE_MIDDLE_BUTTON;
    static const int MOUSE_RIGHT_BUTTON;

    // mouse state
    static const int MOUSE_UP;
    static const int MOUSE_DOWN;

    // mouse modifiers
    static const int MOD_LBUTTON;
    static const int MOD_MBUTTON;
    static const int MOD_RBUTTON;
};
```

So in fact, you can write application code that works fine under Microsoft Windows and X-Windows, but not on the Macintosh. My advice is to use only the left mouse button MOUSE_LEFT_BUTTON for applications you intend to be portable. Alternatively, you can rewrite the Macintosh application code in a manner that maps combinations of the mouse button and modifiers to simulate a three-button mouse.

Mouse motion is handled in one of two ways. For mouse dragging, the idea is to detect that the mouse is moving while one of the mouse buttons is pressed. The callback that is executed in this situation is OnMotion. For processing mouse motion when no mouse buttons are pressed, the callback OnPassiveMotion is executed.

The OnPrecreate and OnInitialization callbacks return a Boolean value. In normal situations, the returned value is true, indicating that the calls were successful and the application may continue. If an abnormal condition occurs, the returned value is false. The application terminates early on such a condition. For example, if your OnInitialize function attempts to load a scene graph file, but fails to find that file, the function returns false and the application should terminate. Naturally, you should

structure your applications to be successful. But if an abnormal condition occurs, exit gracefully!

The key and mouse callbacks also return Boolean values. If the value is true, the callback has processed the event itself. For example, if your application implements OnKeyDown to process the X key, and the X key is actually pressed, your callback will detect that key and do something, after which it returns true. If the callback does not do anything when Y is pressed, and the callback receives the Y key and ignores it, the return value is false. This mechanism gives a final application the ability to determine if my base class key handlers processed the keys, and then choose to ignore that key itself. That said, nothing forces you to call the base class functions. The value you return is ignored by the platform-specific event handlers.

The idle processing is handled by the callback OnIdle. The 3D applications make extensive use of this callback in order to achieve real-time frame rates. You might be tempted to use a *system timer* to control the frame rate. The problem, though, is that many system timers have a limited resolution. For example, the WM_TIMER event in the Microsoft Windows environment occurs at an approximate rate of 18 times per second. Clearly, this will not support real-time applications.

Finally, a few interface functions in WindowApplication support font handling. Recall that the Renderer class can be told to use fonts other than the default ones used by the graphics API. If your application will overlay the rendered scene with text, you most likely will need to know font metrics in order to properly position the text. Simple metrics are provided by

```
class WindowApplication : public Application
{
public:
    int GetStringWidth (const char* acText) const;
    int GetCharWidth (const char cCharacter) const;
    int GetFontHeight () const;
};
```

The implementations are dependent on the windowing system, so they occur in the source files containing the platform-specific code.

The Microsoft Windows platform-specific code that implements a portion of the WindowApplication interface is in the file Wm3MsWindowApplication.cpp. The file includes the definitions of the const data member keyboard bindings and mouse bindings; RequestTermination; the implementations of the font metrics GetStringWidth, GetCharWidth, and GetFontHeight; an event handler (named MsWindowEventHandler); and the WindowApplication::Main function. The Main function is the same for 2D and 3D applications.

The renderer creation in Main produces either an OpenGL renderer or a Direct3D renderer. An external function, MsCreateRenderer, is called. If you choose

to use OpenGL, the stub file Wm3WglApplication.cpp is compiled into the application library. This stub contains an implementation of MsCreateRenderer that generates an OpenGL-based renderer. If you choose to use Direct3D, the stub file Wm3DxApplication.cpp is compiled into the application library, and it includes an implementation of MsCreateRenderer that generates a Direct3D-based renderer. Of course, this makes it impossible to compile an application library that supports both OpenGL and Direct3D simultaneously. But, after all, why would you want to do that?

8.1.5 THE WINDOWAPPLICATION3 CLASS

The class that supports the 3D applications is WindowApplication3 and is derived from WindowApplication. Its interface is a bit lengthy:

```
class WM3_ITEM WindowApplication3 : public WindowApplication
{
public:
    WindowApplication3 (const char* acWindowTitle, int iXPosition,
        int iYPosition, int iXSize, int iYSize,
        const ColorRGB& rkBackgroundColor);
    virtual ~WindowApplication3 ();

    virtual bool OnInitialize ();
    virtual void OnTerminate ();
    virtual void OnDisplay ();
    virtual bool OnKeyDown (unsigned char ucKey, int iX, int iY);
    virtual bool OnSpecialKeyDown (int iKey, int iX, int iY);
    virtual bool OnSpecialKeyUp (int iKey, int iX, int iY);
    virtual bool OnMouseClick (int iButton, int iState, int iX, int iY,
        unsigned int uiModifiers);
    virtual bool OnMotion (int iButton, int iX, int iY);

protected:
    // camera motion
    void InitializeCameraMotion (float fTrnSpeed, float fRotSpeed,
        float fTrnSpeedFactor = 2.0f, float fRotSpeedFactor = 2.0f);
    virtual bool MoveCamera ();
    virtual void MoveForward ();
    virtual void MoveBackward ();
    virtual void MoveUp ();
    virtual void MoveDown ();
    virtual void TurnLeft ();
    virtual void TurnRight ();
```

```
        virtual void LookUp ();
        virtual void LookDown ();
        CameraPtr m_spkCamera;
        Vector3f m_akWorldAxis[3];
        float m_fTrnSpeed, m_fTrnSpeedFactor;
        float m_fRotSpeed, m_fRotSpeedFactor;
        bool m_bUArrowPressed, m_bDArrowPressed, m_bLArrowPressed;
        bool m_bRArrowPressed, m_bPgUpPressed, m_bPgDnPressed;
        bool m_bHomePressed, m_bEndPressed, m_bCameraMoveable;

        // object motion
        void InitializeObjectMotion (Spatial* pkMotionObject);
        bool MoveObject ();
        void RotateTrackBall (float fX0, float fY0, float fX1,
            float fY1);
        SpatialPtr m_spkMotionObject;
        int m_iDoRoll, m_iDoYaw, m_iDoPitch;
        float m_fXTrack0, m_fYTrack0, m_fXTrack1, m_fYTrack1;
        Matrix3f m_kSaveRotate;
        bool m_bUseTrackBall, m_bTrackBallDown;
        bool m_bObjectMoveable;

        // performance measurements
        void ResetTime ();
        void MeasureTime ();
        void UpdateFrameCount ();
        void DrawFrameRate (int iX, int iY, const ColorRGBA& rkColor);
        double m_dLastTime, m_dAccumulatedTime, m_dFrameRate;
        int m_iFrameCount, m_iTimer, m_iMaxTimer;
};
```

Most of the event callbacks are stubbed out in the base class `WindowApplication` to do nothing. The event callbacks in the derived class that have some work to do are listed in the public section of the interface.

The protected section of the interface is decomposed into three subsections. The first subsection contains the declaration of the camera, `m_spkCamera`, to be used by the renderer. Naturally, you can create your own cameras, but the one provided by this class is the one that gets hooked up to various events in order to translate and rotate it. The remaining data members in the subsection are all related to handling camera motion. The camera can be moved via the arrow keys and other special keys.

The second subsection is related to object motion; the object is specified by your application—typically the entire scene graph. Only rotations are supported by the application library. Objects can be rotated in two ways. First, you can rotate the object

using the function keys F1 through F6. Second, the class has a *virtual trackball* that surrounds the scene. Dragging the mouse with the left button depressed allows you to rotate the trackball.

The third subsection is for performance measurements—specifically for measuring the frame rate of your application.

The following subsections discuss each of these topics.

Camera Motion

Given a camera with eye point **E**, view direction **D**, up direction **U**, and right direction **R**, all in world coordinates, the tendency is to update the position of the eye point and the orientation of the camera *relative to the camera coordinate frame itself*. The operations are summarized here. The new coordinate frame quantities are denoted with prime symbols: **E′**, **D′**, **U′**, and **R′**.

Let $s > 0$ be the speed of translation. The translation in the view direction causes only the eye point location to change:

$$\mathbf{E}' = \mathbf{E} \pm s\mathbf{D}.$$

The translation in the up direction is

$$\mathbf{E}' = \mathbf{E} \pm s\mathbf{U},$$

and the translation in the right direction is

$$\mathbf{E}' = \mathbf{E} \pm s\mathbf{R}.$$

Let $\theta > 0$ be an angle of rotation. The corresponding rotations are counterclockwise in the plane perpendicular to the rotation axis, looking down the axis at the plane; the direction you look in is the negative of the axis direction. The eye point is never changed by the rotations. The rotation about the view direction preserves that direction itself, but changes the other two:

$$\begin{bmatrix} \mathbf{U}' \\ \mathbf{R}' \end{bmatrix} = \begin{bmatrix} \cos\theta & -\sin\theta \\ \sin\theta & \cos\theta \end{bmatrix} \begin{bmatrix} \mathbf{U} \\ \mathbf{R} \end{bmatrix}. \tag{8.1}$$

In the implementation, after the rotation you need to assign the results back to the storage of the vectors; that is, $\mathbf{U} \leftarrow \mathbf{U}'$ and $\mathbf{R} \leftarrow \mathbf{R}'$. The rotation about the up vector is

$$\begin{bmatrix} \mathbf{R}' \\ \mathbf{D}' \end{bmatrix} = \begin{bmatrix} \cos\theta & -\sin\theta \\ \sin\theta & \cos\theta \end{bmatrix} \begin{bmatrix} \mathbf{R} \\ \mathbf{D} \end{bmatrix}, \tag{8.2}$$

and the rotation about the right vector is

$$\begin{bmatrix} \mathbf{D}' \\ \mathbf{U}' \end{bmatrix} = \begin{bmatrix} \cos\theta & -\sin\theta \\ \sin\theta & \cos\theta \end{bmatrix} \begin{bmatrix} \mathbf{D} \\ \mathbf{U} \end{bmatrix}. \tag{8.3}$$

As I mentioned, the tendency is for you to want to update the camera frame in this manner. The problem in an application, though, is that you usually have a world coordinate system that has a preferred up direction that remains fixed throughout the application's lifetime. The up vector for the camera changes on a roll about the view direction and on a pitch about the right vector. After a roll, a translation in the camera up direction is not a translation in the world up direction. After a pitch, a translation in the camera view direction is not a translation perpendicular to the world up direction. Consider the situation where the camera represents the viewing system of a character player. If the character walks along a horizontal floor and his view direction is parallel to the floor, any translation of his eye point should keep him on that floor. Now imagine that the character looks down at the floor. His view direction is no longer parallel to the floor. If you were to translate the eye point in the view direction, the character would walk toward the floor (and directly through it). Preferable would be to have the character walk parallel to the floor, even though he is looking down. This requires using the world coordinate frame for the incremental translations and rotations and applying the transformations to the camera frame.

The array m_akWorldAxis stores the world coordinate frame for the purposes of camera motion. The translation speed is m_fTrnSpeed, and the rotation speed is m_fRotSpeed. The other two float data members in the camera motion section, m_fTrnSpeedFactor and m_fRotSpeedFactor, are multiplicative (or division) factors for adjusting the current speeds. The member function InitializeCameraMotion initializes the speeds and factors. It also uses the camera's *local coordinate axes* at the time of the call to initialize m_akWorldAxis. The camera local axes are presumably set in the application's OnInitialize call to place the camera in the world coordinate frame of the scene graph. The entry 0 of the world axis array may be thought of as the view direction in the world. The entry 1 is thought of as the up vector, and the entry 2 is thought of as the right vector. The Boolean member m_bCameraMoveable indicates whether or not the camera is set up for motion. By default, the value is false. The value is set to true when InitializeCameraMotion is called.

The member functions MoveForward and MoveBackward translate the camera frame in the world view direction:

```
void WindowApplication3::MoveForward ()
{
    Vector3f kLoc = m_spkCamera->GetLocation();
    kLoc += m_fTrnSpeed*m_akWorldAxis[0];
    m_spkCamera->SetLocation(kLoc);
}
```

```
void WindowApplication3::MoveBackward ()
{
    Vector3f kLoc = m_spkCamera->GetLocation();
    kLoc -= m_fTrnSpeed*m_akWorldAxis[0];
    m_spkCamera->SetLocation(kLoc);
}
```

The translation keeps the camera parallel to the plane perpendicular to the world up vector, even if the observer is looking down at that plane. Similarly, the member functions MoveUp and MoveDown translate the camera frame in the world up direction:

```
void WindowApplication3::MoveUp ()
{
    Vector3f kLoc = m_spkCamera->GetLocation();
    kLoc += m_fTrnSpeed*m_akWorldAxis[1];
    m_spkCamera->SetLocation(kLoc);
}

void WindowApplication3::MoveBackward ()
{
    Vector3f kLoc = m_spkCamera->GetLocation();
    kLoc -= m_fTrnSpeed*m_akWorldAxis[1];
    m_spkCamera->SetLocation(kLoc);
}
```

Note that in the four functions the translations change neither the camera axis directions nor the world axis directions. I do not provide implementations for translating left or right.

The member functions TurnLeft and TurnRight are rotations about the world up vector:

```
void WindowApplication3::TurnLeft ()
{
    Matrix3f kIncr(m_akWorldAxis[1],m_fRotSpeed);
    m_akWorldAxis[0] = kIncr*m_akWorldAxis[0];
    m_akWorldAxis[2] = kIncr*m_akWorldAxis[2];

    Vector3f kDVector = kIncr*m_spkCamera->GetDVector();
    Vector3f kUVector = kIncr*m_spkCamera->GetUVector();
    Vector3f kRVector = kIncr*m_spkCamera->GetRVector();
    m_spkCamera->SetAxes(kDVector,kUVector,kRVector);
}
```

```
void WindowApplication3::TurnRight ()
{
    Matrix3f kIncr(m_akWorldAxis[1],-m_fRotSpeed);
    m_akWorldAxis[0] = kIncr*m_akWorldAxis[0];
    m_akWorldAxis[2] = kIncr*m_akWorldAxis[2];

    Vector3f kDVector = kIncr*m_spkCamera->GetDVector();
    Vector3f kUVector = kIncr*m_spkCamera->GetUVector();
    Vector3f kRVector = kIncr*m_spkCamera->GetRVector();
    m_spkCamera->SetAxes(kDVector,kUVector,kRVector);
}
```

The first blocks of code in the functions perform the rotations in Equation (8.2). You might think that only the camera view direction and right vectors need to be updated, but that is only the case when the camera up vector is in the same direction as the world up vector. If the observer is looking down at the floor, a rotation about the world up vector will change *all* the camera axis directions. Thus, the second blocks of code in the functions apply the rotation to all the camera axis directions.

The member functions LookUp and LookDown are pitch rotations about the world's right vector:

```
void WindowApplication3::LookUp ()
{
    Matrix3f kIncr(m_akWorldAxis[2],-m_fRotSpeed);

    Vector3f kDVector = kIncr*m_spkCamera->GetDVector();
    Vector3f kUVector = kIncr*m_spkCamera->GetUVector();
    Vector3f kRVector = kIncr*m_spkCamera->GetRVector();
    m_spkCamera->SetAxes(kDVector,kUVector,kRVector);
}

void WindowApplication3::LookDown ()
{
    Matrix3f kIncr(m_akWorldAxis[2],m_fRotSpeed);

    Vector3f kDVector = kIncr*m_spkCamera->GetDVector();
    Vector3f kUVector = kIncr*m_spkCamera->GetUVector();
    Vector3f kRVector = kIncr*m_spkCamera->GetRVector();
    m_spkCamera->SetAxes(kDVector,kUVector,kRVector);
}
```

Notice that the incremental rotations are calculated about the world's right vector. The other two world axis directions must not change! The incremental rotation is

designed to rotate only the camera coordinate frame. I do not provide implementations for roll rotations about the world direction vector.

The member function `MoveCamera` ties the camera motion functions to key press events:

```
bool WindowApplication3::MoveCamera ()
{
    if ( !m_bCameraMoveable ) return false;
    bool bMoved = false;
    if ( m_bUArrowPressed ) { MoveForward();  bMoved = true; }
    if ( m_bDArrowPressed ) { MoveBackward(); bMoved = true; }
    if ( m_bHomePressed   ) { MoveUp();       bMoved = true; }
    if ( m_bEndPressed    ) { MoveDown();     bMoved = true; }
    if ( m_bLArrowPressed ) { TurnLeft();     bMoved = true; }
    if ( m_bRArrowPressed ) { TurnRight();    bMoved = true; }
    if ( m_bPgUpPressed   ) { LookUp();       bMoved = true; }
    if ( m_bPgDnPressed   ) { LookDown();     bMoved = true; }
    return bMoved;
}
```

The up and down arrow keys control forward and backward translation. The home and end keys control up and down translation. The left and right arrow keys control rotation about the up vector. The page up and page down keys control rotation about the right vector.

You will notice the use of the remaining eight Boolean data members: `m_bUArrow-Pressed`, `m_bDArrowPressed`, `m_bLArrowPressed`, `m_bRArrowPressed`, `m_bPgUpPressed`, `m_bPgDnPressed`, `m_bHomePressed`, and `m_bEndPressed`. These exist solely to avoid a classic problem in a real-time application when the operating system and event system are inherently not real time: The keyboard events are not processed in real time. If you implement `OnSpecialKeyDown` to include calls to the actual transformation function such as `MoveForward`, you will find that the camera motion is not smooth and appears to occur in spurts. The problem is the speed at which the windowing system processes the events and dispatches them to the event handler. The workaround is to use the `OnSpecialKeyDown` and `OnSpecialKeyUp` only to detect the state of the special keys: down or up, pressed or not pressed. The function call `MoveCamera` is made *inside the idle loop*. When the up arrow key is pressed, the variable `m_bUArrowPressed` is set to true. As long as the key is pressed, that variable is constantly set to true at the frequency the events are processed. However, from the idle loop's perspective, the value is a constant `true`. The `MoveForward` function is called at the frequency the idle loop is called—a rate that is much larger than that of the event system. The result is that the camera motion is smooth. When the up arrow key is released, the variable `m_bUArrowPressed` is set to `false`, and the calls to `MoveCamera` in the idle loop no longer translate the camera.

The translation and rotation speeds are adjustable at run time. My default implementation of `OnKeyDown` is

```
bool WindowApplication3::OnKeyDown (unsigned char ucKey,
    int iX, int iY)
{
    if ( WindowApplication::OnKeyDown(ucKey,iX,iY) )
        return true;

    // standard keys
    switch ( ucKey )
    {
    case 't':  // slower camera translation
        if ( m_bCameraMoveable )
            m_fTrnSpeed /= m_fTrnSpeedFactor;
        return true;
    case 'T':  // faster camera translation
        if ( m_bCameraMoveable )
            m_fTrnSpeed *= m_fTrnSpeedFactor;
        return true;
    case 'r':  // slower camera rotation
        if ( m_bCameraMoveable )
            m_fRotSpeed /= m_fRotSpeedFactor;
        return true;
    case 'R':  // faster camera rotation
        if ( m_bCameraMoveable )
            m_fRotSpeed *= m_fRotSpeedFactor;
        return true;
    case '?':  // reset the timer
        ResetTime();
        return true;
    };

    return false;
}
```

The call to WindowApplication::OnKeyDown is to detect if the ESC key has been pressed, in which case the application will terminate. The camera translation speeds are controlled by keys t and T; the camera rotation speeds are controlled by keys r and R.

Object Motion

An object in the scene can be rotated using keyboard or mouse events. Usually, the object is the entire scene. To allow object motion, call the function InitializeObject-Motion and pass the object itself. The data member m_spkMotionObject points to that object. The Boolean data member m_bObjectMoveable, whose default value is false, is set to true by the function call.

We must decide first what the semantics of the rotation are. If the object has a parent (i.e., it is not the root of the scene), then the coordinate system of the object is that of its parent. The columns of the parent's world rotation matrix are the coordinate axis directions. To be consistent with the choice made for classes Camera and Light, whenever a rotation matrix represents coordinate axes, column 0 is the *direction* vector, column 1 is the *up* vector, and column 2 is the *right* vector. *Roll* is a rotation about the direction vector, *yaw* is rotation about the up vector, and *pitch* is rotation about the right vector. Let Q be the rotation matrix about one of these axes by a predetermined angle. If R is the object's local rotation matrix, then the update of the local rotation matrix is $R \leftarrow QR$. If the object is the root of the scene, the world rotation matrix is the identity matrix. Column 0 is $(1, 0, 0)$ and is the direction vector, column 1 is $(0, 1, 0)$ and is the up vector, and column 2 is $(0, 0, 1)$ and is the right vector. The incremental rotation matrix Q is computed using these axes and the predetermined angle.

To rotate the object via keyboard events, a mechanism similar to camera motion is used. The data members m_iDoRoll, m_iDoYaw, and m_iDoPitch are state variables that keep track of the pressed states of various keys. Roll is controlled by the F1 and F2 keys. If neither key is pressed, the default state for m_iDoRoll is zero. If F1 is pressed, m_iDoRoll is set to -1. If F2 is pressed, m_iDoRoll is set to $+1$. The signed values indicate the direction of rotation about the axis of rotation: -1 for clockwise rotation, 0 for no rotation, and $+1$ for counterclockwise rotation. Similarly, yaw is controlled by the F3 key (m_iDoYaw is set to -1) and the F4 key (m_iDoYaw is set to $+1$), and pitch is controlled by the F5 key (m_iDoPitch is set to -1) and the F6 key (m_iDoPitch is set to $+1$). The state of the keys is detected in OnSpecialKeyDown and OnSpecialKeyUp, just as was the case for camera motion via arrow keys and other special keys. The state tracking mechanism guarantees that the rotations occur in the idle loop and are not limited by the slower event handler.

The function MoveObject, called in the OnIdle callback, is used to update the local rotation of the object whenever one of the six function keys is pressed. Its implementation is

```
bool WindowApplication3::MoveObject ()
{
    if ( !m_bCameraMoveable || !m_spkMotionObject )
        return false;

    Spatial* pkParent = m_spkMotionObject->GetParent();
    Vector3f kAxis;
    Matrix3f kRot, kIncr;

    if ( m_iDoRoll )
    {
        kRot = m_spkMotionObject->Local.GetRotate();
        fAngle = m_iDoRoll*m_fRotSpeed;
        if ( pkParent )
```

```
            kAxis = pkParent->World.GetRotate().GetColumn(0);
        else
            kAxis = Vector3f::UNIT_X;
        kIncr.FromAxisAngle(kAxis,fAngle);
        m_spkMotionObject->Local.SetRotate(kIncr*kRot);
        return true;
    }

    // ... similar blocks for yaw and pitch go here ...

    return false;
}
```

The rotation axis is computed according to my earlier description. The rotation angle is either plus or minus the rotation speed parameter; the choice of sign depends on which function key was pressed.

The `WindowApplication3::OnKeyDown` implementation allows you to adjust the object rotation speed when the function keys are pressed. This is accomplished by the r key (decrease the rotation speed) and the R key (increase the rotation speed).

The application class has some data members and functions to support rotating an object by the mouse. The rotation is accomplished via a virtual trackball that is manipulated by the callbacks `OnMouseClick` and `OnMotion`. In order to rotate, the virtual trackball must be enabled (`m_bUseTrackBall` is set to `true`), there must be a motion object (`m_spkMotionObject` is not null), and the left mouse button must generate the events (input `iButton` must be `MOUSE_LEFT_BUTTON`).

The virtual trackball is assumed to be a sphere in the world whose projection onto the screen is a circle. The circle center is $(W/2, H/2)$, where W is the width of the screen and H is the height of the screen. The circle radius is $r = \min\{W/2, H/2\}$. Figure 8.1 shows a typical projection.

The trackball uses a right-handed, normalized coordinate system whose origin is the center of the circle and whose axis directions are parallel to the screen coordinate axes: x right and y up. Scaling occurs so that in this coordinate system the square is defined by $|x| \le 1$ and $|y| \le 1$. The circle itself is defined by $x^2 + y^2 = 1$. The starting point of a mouse drag operation is shown in Figure 8.1 and is labeled (x_0, y_0). The ending point of the mouse drag is denoted (x_1', y_1'). Any point that is outside the circle is projected onto the circle. The actual ending point used by the trackball is labeled (x_1, y_1) in the figure.

Imagine the starting and ending points being located on the sphere itself. Since the circle is $x^2 + y^2 = 1$, the sphere is $x^2 + y^2 + z^2 = 1$. The z-axis is defined to be into the screen, so the hemisphere on which you select points satisfies $z \le 0$. The (x, y, z) coordinate system is shown in Figure 8.1. The points (x_i, y_i) are mapped to the sphere points

$$\mathbf{V}_i = (x_i, y_i, -\sqrt{1 - x_i^2 - y_i^2}).$$

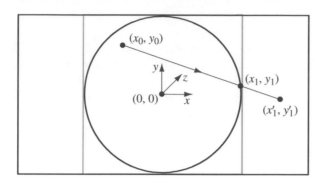

Figure 8.1 The projection of a virtual trackball onto the screen. The circle of projection is positioned at the center of the screen. The bounding square of the circle is shown.

The rotation of the trackball implied by the mouse drag has a rotation axis that is perpendicular to the plane containing the sphere center and the two sphere points. The rotation needs to be computed in world coordinates, so be aware that the cross product $\mathbf{V}_0 \times \mathbf{V}_1$ is in the normalized coordinate system, not in the world. A vector (x_i, y_i, z_i) in the normalized coordinate system corresponds to the world vector

$$\mathbf{W}_i = x_i \mathbf{R} + y_i \mathbf{U} + z_i \mathbf{D},$$

where \mathbf{R}, \mathbf{U}, and \mathbf{D} are the camera's right, up, and direction vectors, respectively, in world coordinates. The cross product of the two vectors is

$$\mathbf{W}_0 \times \mathbf{W}_1 = (x_0 \mathbf{R} + y_0 \mathbf{U} + z_0 \mathbf{D}) \times (x_1 \mathbf{R} + y_1 \mathbf{U} + z_1 \mathbf{D})$$

$$= (y_1 z_0 - y_0 z_1)\mathbf{R} + (x_0 z_1 - x_1 z_0)\mathbf{U} + (x_1 y_0 - x_0 y_1)\mathbf{D}.$$

The world coordinates $(y_1 z_0 - y_0 z_1, x_0 z_1 - x_1 z_0, x_1 y_0 - x_0 y_1)$ are *not* generated by $(x_0, y_0, z_0) \times (x_1, y_1, z_1)$. They are generated by $(z_0, y_0, x_0) \times (z_1, y_1, x_1)$. This has to do with the camera axis ordering $(\mathbf{D}, \mathbf{U}, \mathbf{R})$, which corresponds to a tuple (z, y, x).

The rotation axis in world coordinates is $\mathbf{W}_0 \times \mathbf{W}_1$. The angle of rotation is the angle between the two vectors, $\theta = \cos^{-1}(\mathbf{W}_0 \cdot \mathbf{W}_1)$. The member function `Rotate-TrackBall` computes the axis, angle, and the corresponding rotation matrix, call it Q. If the object is the root of the scene, the local rotation matrix R is updated just as we did for the keyboard-driven rotation: $R \leftarrow QR$.

If the object has a parent, the update is more complicated. The object has a model-to-world transformation that positions and orients the object in the world. If \mathbf{X} is a model space point, the corresponding world space point is

$$\mathbf{Y} = R_w S \mathbf{X} + \mathbf{T}_w,$$

where R_w is the world rotation, S is the diagonal scaling matrix, and \mathbf{T}_w is the world translation. In all my sample applications, I arrange for the object's world translation to be the origin so that the rotation is about the origin. The process of doing so is sometimes referred to as a *center-and-fit* operation. After this operation, the world translation is $\mathbf{T}_w = \mathbf{0}$, so

$$\mathbf{Y} = R_w S \mathbf{X}.$$

The world rotation is constructed from the object's parent's world rotation and from its local rotation. The relationship is

$$R_w = R_p R_\ell,$$

where R_p is the parent's world rotation and R_ℓ is the object's local rotation. The world point is therefore

$$\mathbf{Y} = R_p R_\ell S \mathbf{X}.$$

The trackball motion applies a world-to-world rotation matrix, which we called Q. The transformation of the world point \mathbf{Y} to the rotated point \mathbf{Z} is

$$\mathbf{Z} = Q\mathbf{Y} = (Q R_p R_\ell) S \mathbf{X}.$$

We do not want to modify the parent's rotation matrix by multiplying on the left by Q. Instead, we wish to adjust the local rotation R_ℓ while preserving the parent rotation. If R'_ℓ is the adjusted local rotation, we need

$$R_p R'_\ell = Q R_p R_\ell.$$

Solving for the adjusted local rotation,

$$R'_\ell = (R_p^{\mathrm{T}} Q R_p) R_\ell.$$

The expression $R_p^{\mathrm{T}} Q R_p$ is a *similarity transformation* and is viewed as the representation of the rotation Q in the coordinate system of the object. The matrix Q by itself represents the rotation in the parent's coordinate system.

The source code for `RotateTrackBall` is lengthy, but a straightforward implementation of the ideas is discussed here:

```
void WindowApplication3::RotateTrackBall (float fX0, float fY0,
    float fX1, float fY1)
{
    if ( (fX0 == fX1 && fY0 == fY1) || !m_spkCamera )
    {
        // nothing to rotate
        return;
    }
```

```
// get first vector on sphere
float fLength = Mathf::Sqrt(fX0*fX0+fY0*fY0);
float fInvLength, fZ0, fZ1;
if ( fLength > 1.0f )
{
    // outside unit disk, project onto it
    fInvLength = 1.0f/fLength;
    fX0 *= fInvLength;
    fY0 *= fInvLength;
    fZ0 = 0.0f;
}
else
{
    // compute point (x0,y0,z0) on negative unit hemisphere
    fZ0 = 1.0f - fX0*fX0 - fY0*fY0;
    fZ0 = ( fZ0 <= 0.0f ? 0.0f : Mathf::Sqrt(fZ0) );
}
fZ0 *= -1.0f;

// use camera world coordinates, order is (D,U,R),
// so point is (z,y,x)
Vector3f kVec0(fZ0,fY0,fX0);

// get second vector on sphere
fLength = Mathf::Sqrt(fX1*fX1+fY1*fY1);
if ( fLength > 1.0f )
{
    // outside unit disk, project onto it
    fInvLength = 1.0f/fLength;
    fX1 *= fInvLength;
    fY1 *= fInvLength;
    fZ1 = 0.0f;
}
else
{
    // compute point (x1,y1,z1) on negative unit hemisphere
    fZ1 = 1.0f - fX1*fX1 - fY1*fY1;
    fZ1 = ( fZ1 <= 0.0f ? 0.0f : Mathf::Sqrt(fZ1) );
}
fZ1 *= -1.0f;

// use camera world coordinates, order is (D,U,R),
// so point is (z,y,x)
Vector3f kVec1(fZ1,fY1,fX1);
```

```
// create axis and angle for the rotation
Vector3f kAxis = kVec0.Cross(kVec1);
float fDot = kVec0.Dot(kVec1);
float fAngle;
if ( kAxis.Normalize() > Mathf::ZERO_TOLERANCE )
{
    fAngle = Mathf::ACos(kVec0.Dot(kVec1));
}
else  // vectors are parallel
{
    if ( fDot < 0.0f )
    {
        // rotated pi radians
        fInvLength = Mathf::InvSqrt(fX0*fX0+fY0*fY0);
        kAxis.X() = fY0*fInvLength;
        kAxis.Y() = -fX0*fInvLength;
        kAxis.Z() = 0.0f;
        fAngle = Mathf::PI;
    }
    else
    {
        // rotation by zero radians
        kAxis = Vector3f::UNIT_X;
        fAngle = 0.0f;
    }
}

Vector3f kWorldAxis =
    kAxis.X()*m_spkCamera->GetWorldDVector() +
    kAxis.Y()*m_spkCamera->GetWorldUVector() +
    kAxis.Z()*m_spkCamera->GetWorldRVector();

Matrix3f kTrackRotate(kWorldAxis,fAngle);

const Spatial* pkParent = m_spkMotionObject->GetParent();
if ( pkParent )
{
    const Matrix3f& rkPRotate = pkParent->World.GetRotate();
    m_spkMotionObject->Local.SetRotate(
        rkPRotate.TransposeTimes(kTrackRotate)*rkPRotate *
        m_kSaveRotate);
}
else
```

```
        {
            m_spkMotionObject->Local.SetRotate(kTrackRotate *
                m_kSaveRotate);
        }

        m_spkMotionObject->UpdateGS();
}
```

The first part of the code computes the world axis of rotation and the angle of rotation, just as I described here. The last part of the code updates the object's local rotation based on the trackball motion. The incremental update matrix is Q if the object has no parent, but $R_p^{\mathrm{T}} Q R_p$ if the object has a parent.

You should notice that the update uses a data member named m_kSaveRotate. The trackball rotation is always anchored to the starting point. When that point is selected, the object's current local rotation is saved. The trackball rotation is always applied to the original local rotation.

The mouse event callbacks are simple enough:

```
bool WindowApplication3::OnMouseClick (int iButton, int iState,
    int iX, int iY, unsigned int)
{
    if ( !m_bUseTrackBall
    ||   iButton != MOUSE_LEFT_BUTTON
    ||   !m_spkMotionObject )
    {
        return false;
    }

    float fMult =
        1.0f/(m_iWidth >= m_iHeight ? m_iHeight : m_iWidth);

    if ( iState == MOUSE_DOWN )
    {
        // get the starting point
        m_bTrackBallDown = true;
        m_kSaveRotate = m_spkMotionObject->Local.GetRotate();
        m_fXTrack0 = (2*iX-m_iWidth)*fMult;
        m_fYTrack0 = (2*(m_iHeight-1-iY)-m_iHeight)*fMult;
    }
    else
    {
        m_bTrackBallDown = false;
    }
```

```
    return true;
}

bool WindowApplication3::OnMotion (int iButton, int iX, int iY)
{
    if ( !m_bUseTrackBall
    ||    iButton != MOUSE_LEFT_BUTTON
    ||    !m_bTrackBallDown
    ||    !m_spkMotionObject )
    {
        return false;
    }

    // get the ending point
    float fMult =
        1.0f/(m_iWidth >= m_iHeight ? m_iHeight : m_iWidth);
    m_fXTrack1 = (2*iX-m_iWidth)*fMult;
    m_fYTrack1 = (2*(m_iHeight-1-iY)-m_iHeight)*fMult;

    // update the object's local rotation
    RotateTrackBall(m_fXTrack0,m_fYTrack0,m_fXTrack1,m_fYTrack1);
    return true;
}
```

When the left mouse button is pressed, the callback OnMouseClick is executed. The trackball is set to its down state, the object's local rotation R is saved, and the starting point is calculated from the screen coordinates of the mouse click. As the mouse is dragged, the callback OnMotion is continually called. It computes the ending point and then calls the trackball rotation function to compute the incremental rotation Q and update the object's local rotation to QR.

Performance Measurements

Nearly all my sample applications include measuring the frame rate using function calls in the OnIdle callback. The rate is stored in the data member m_dFrameRate. The data member m_dAccumulatedTime stores the accumulated time used by the application. The function MeasureTime updates the accumulated time with the time difference between the last time the function was called, a value stored in m_dLastTime, and the current time as read by System::GetTime. The data member m_iFrameCount stores the number of times OnIdle has been called and is the number of frames displayed. The frame rate is the ratio of the number of the frame count and the accumulated time.

Because the application can run quite rapidly, the resolution of the System:: GetTime call might be too coarse to use on a frame-by-frame basis. If you have concerns about the resolution, I provided a miniature timer that is designed to have the accumulated time updated less frequently than each frame. The data member m_ iTimer is the clock counter. The starting value for the counter is stored in the data member m_iMaxTimer. My libraries use a default of 30, but you are certainly welcome to set it a different value in the constructor of your application. The idea is that m_iTimer is decremented on each frame. Once it reaches zero, System::Time is read, the accumulated time is updated, and m_iTimer is reset to m_iMaxTimer. The Measure-Time implementation is

```
void WindowApplication3::MeasureTime ()
{
    // start performance measurements
    if ( m_dLastTime == -1.0 )
    {
        m_dLastTime = System::GetTime();
        m_dAccumulatedTime = 0.0;
        m_dFrameRate = 0.0;
        m_iFrameCount = 0;
        m_iTimer = m_iMaxTimer;
    }

    // accumulate the time only when the miniature time allows it
    if ( --m_iTimer == 0 )
    {
        double dCurrentTime = System::GetTime();
        double dDelta = dCurrentTime - m_dLastTime;
        m_dLastTime = dCurrentTime;
        m_dAccumulatedTime += dDelta;
        m_iTimer = m_iMaxTimer;
    }
}
```

The initial value of m_dLastTime is −1, indicating that the frame rate measuring system is uninitialized. You may reset the measuring system via ResetTimer, which just sets the last time to the invalid −1. A convenience function for displaying the frame rate in the lower-left corner of the screen is DrawFrameRate.

A convenience key is provided for the ResetTimer call, namely, the question mark (?) key.

8.2 SAMPLE APPLICATIONS

A large number of sample applications are located on the companion website in the directory

MagicSoftware/WildMagic3/Test

Most of them are implemented in the same manner that I will describe here. Some of the samples are described briefly, some in more detail. My goal is to emphasize the highlights of the applications and not to cover every minute detail.

A typical application ships with only a single header file and a single source file. Naturally, a game application will have a large number of files, but the samples here are just for illustration of the engine features and for testing, as the directory name Test already hints at, so there is no need for many files.

The skeleton application code includes the header file and is of the form

```
#ifndef TESTAPPLICATION_H
#define TESTAPPLICATION_H

#include "Wm3WindowApplication3.h"
using namespace Wm3;

class TestApplication : public WindowApplication3
{
    WM3_DECLARE_INITIALIZE;

public:
    TestApplication ();

    // the most common overrides
    virtual bool OnInitialize ();
    virtual void OnTerminate ();
    virtual void OnIdle ();
    virtual bool OnKeyDown (unsigned char ucKey, int iX, int iY);

protected:
    // some helper functions go here

    // the root of the scene
    NodePtr m_spkScene;

    // other data as needed goes here

private:
```

```
        // for testing streaming of classes
        void TestStream ();
};

WM3_REGISTER_INITIALIZE(TestApplication);

#endif
```

The skeleton source file is of the form

```
#include "TestApplication.h"
WM3_WINDOW_APPLICATION(TestApplication);

TestApplication::TestApplication ()
    :
    WindowApplication3("TestApplication",0,0,640,480,
        ColorRGB(1.0f,1.0f,1.0f))
{
    // initialize some data here, if needed
}

bool TestApplication::OnInitialize ()
{
    if ( !WindowApplication3::OnInitialize() )
        return false;

    // set up the camera
    m_spkCamera->SetFrustum(...);
    Vector3f kCLoc(...);
    Vector3f kCDir(...);
    Vector3f kCUp(...);
    Vector3f kCRight = kCDir.Cross(kCUp);
    m_spkCamera->SetFrame(kCLoc,kCDir,kCUp,kCRight);

    // create the scene
    m_spkScene = new Node(...);
    // set up scene here

    // initial update of objects
    m_spkScene->UpdateGS();
    m_spkScene->UpdateRS();

    // use this if you want to move the camera
    InitializeCameraMotion(...);
```

```
    // use this if you want to rotate the scene
    InitializeObjectMotion(m_spkScene);
    return true;
}

void TestApplication::OnTerminate ()
{
    m_spkScene = NULL;
    // other smart pointers set to NULL here
    // other cleanup goes here
    WindowApplication3::OnTerminate();
}

void TestApplication::OnIdle ()
{
    // accumulate time for frame rate measurement
    MeasureTime();

    if ( MoveCamera() )
    {
        // do any necessary work here
    }

    if ( MoveObject() )
    {
        // do any necessary work here, minimally...
        m_spkScene->UpdateGS(...);
    }

    // do the drawing
    m_pkRenderer->ClearBuffers();
    if ( m_pkRenderer->BeginScene() )
    {
        m_pkRenderer->DrawScene(m_spkScene);
        DrawFrameRate(8,GetHeight()-8,ColorRGBA::WHITE);
        m_pkRenderer->EndScene();
    }
    m_pkRenderer->DisplayBackBuffer();

    // count number of times OnIdle called
    UpdateFrameCount();
}
```

```
bool TestApplication::OnKeyDown (unsigned char ucKey,
    int iX, int iY)
{
    // give application chance to exit on ESC key press
    if ( WindowApplication3::OnKeyDown(ucKey,iX,iY) )
        return true;

    switch ( ucKey )
    {
    // other cases here as needed

    case 's':
    case 'S':
        TestStream();
        return true;
    }

    return false;
}

void TestApplication::TestStream ()
{
    Stream kOStream;
    kOStream.Insert(m_spkScene);
    kOStream.Save("TestApplication.wmof");

    Stream kIStream;
    kIStream.Load("TestApplication.wmof");
    NodePtr spkScene = (Node*)kIStream.GetObjectAt(0);
}
```

An alternative `OnInitialize` is used when a center-and-fit operation is required to center the scene graph in the view frustum. The skeleton is

```
bool TestApplication::OnInitialize ()
{
    if ( !WindowApplication3::OnInitialize() )
        return false;

    // create the scene
    m_spkScene = new Node(...);
    Node* spkTrnNode = new Node;
    m_spkScene->AttachChild(spkTrnNode);
    // set up scene here, attach to spkTrnNode
```

```
    // set up camera for center-and-fit
    m_spkScene->UpdateGS();
    spkTrnNode->Local.Translate() =
        -m_spkScene->WorldBound->GetCenter();
    m_spkCamera->SetFrustum(...);
    Vector3f kCDir(...);
    Vector3f kCUp(...);
    Vector3f kCRight = kCDir.Cross(kCUp);
    Vector3f kCLoc =
        -3.0f*m_spkScene->WorldBound->GetRadius()*kCDir;
    m_spkCamera->SetFrame(kCLoc,kCDir,kCUp,kCRight);

    // initial update of objects
    m_spkScene->UpdateGS();
    m_spkScene->UpdateRS();

    // use this if you want to move the camera
    InitializeCameraMotion(...);

    // use this if you want to rotate the scene
    InitializeObjectMotion(m_spkScene);
    return true;
}
```

The idea is to create the scene and add a child node. The actual scene graph is attached to the child. The world bounding volume of the scene is computed by the UpdateGS call. The child node is translated by the center of the world bounding volume. When the next UpdateGS call occurs, the scene will have a world bounding center at the origin. Thus, rotations applied to the scene are about the origin. This process is the "center" portion of the center-and-fit operation. The "fit" portion is to position the camera sufficiently far from the scene so that you can see the entire scene in the view frustum. As a default, I choose to use three times the radius of the world bounding volume. If the camera eye point is located at \mathbf{E}, the camera view direction is \mathbf{D}, and the world bounding radius is r, then $\mathbf{E} = \mathbf{0} - 3r\mathbf{D}$. I included the origin $\mathbf{0}$ to stress the fact that we have translated the scene so that its center is at the origin, and the eye point is looking at the origin, but moved away $3r$ units along the line of sight.

The remainder of this section covers the scene graph structures and highlights of some of the sample applications. The subsection names are the application names without the Test prefix. The scene hierarchy for an application is listed as an Explorer-like control. A node name is listed on one line, and the children are listed on the next lines, but indented to imply they are indeed children of the node at the previous level of indentation. Global state, lights, and effects attached to the nodes are listed in angle brackets after the node name.

8.2.1 BILLBOARDNODE SAMPLE

The `TestBillboardNode` sample illustrates the use of the class `BillboardNode`. Two objects are managed as billboards: a rectangle, a two-dimensional object, and a torus, a three-dimensional object. Both objects automatically rotate to face the camera. The rotation is about the model space up vectors of the objects. In this case, those vectors are perpendicular to a displayed ground plane. The scene graph is

```
Scene(Node) <Wireframe>
    Ground(TriMesh) <Texture>
    Billboard0(BillboardNode)
        Rectangle(TriMesh) <Texture
    Billboard1(BillboardNode)
        Torus(TriMesh) <Texture>
```

To cause the automatic updates, the `OnIdle` function has the block of code

```
if ( MoveCamera() )
{
    m_spkBillboard0->UpdateGS();
    m_spkBillboard1->UpdateGS();
}
```

Whenever the camera has moved, `MoveCamera` returns `true`. Camera motion requires updating the billboards, which is what the `UpdateGS` calls do.

Figure 8.2 shows screen shots based on two different camera positions. See Section 4.1.1 for a discussion about billboards.

8.2.2 BSPNODE SAMPLE

The `TestBspNode` sample illustrates the use of the class `BspNode`. The world is partitioned by four BSP planes, as illustrated in Figure 8.3. The vertices in the figure are $V_0 = (-1, 1)$, $V_1 = (1, -1)$, $V_2 = (-1/4, 1/4)$, $V_3 = (-1, -1)$, $V_4 = (0, 0)$, $V_5 = (1, 1/2)$, $V_6 = (-3/4, -3/4)$, $V_7 = (-3/4, 3/4)$, and $V_8 = (1, 1)$. The four binary separating planes are labeled. The normal vector for each plane is shown, and it points to the positive side of the plane. That side of the plane corresponds to the positive child for the BSP node representing the plane.

The regions R_0 through R_4 are what the five BSP leaf nodes represent. The sample application places a triangle mesh in each region. Region R_0 contains a torus, region R_1 contains a sphere, region R_2 contains a tetrahedron, region R_3 contains a cube, and region R_4 contains an octahedron. The torus is the only nonconvex object in the scene.

The scene graph of the application is

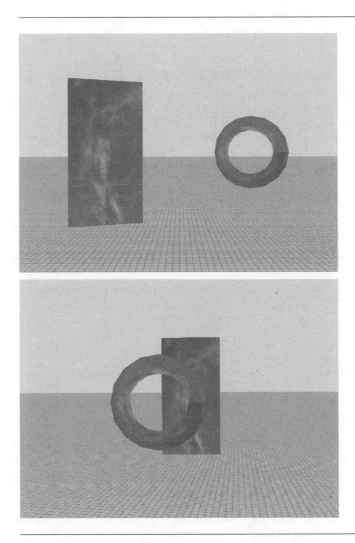

Figure 8.2 Two screen shots from the `TestBillboard` application. (See also Color Plate 8.2.)

```
Scene(Node) <Wireframe, ZBuffer>
    Ground(TriMesh) <Texture>
    Bsp0(BspNode)
        Bsp1(BspNode)
            Bsp3(BspNode)
                Torus(TriMesh) <ZBuffer, Texture>
                Plane3(TriMesh) <Wireframe, Cull, VertexColor>
```

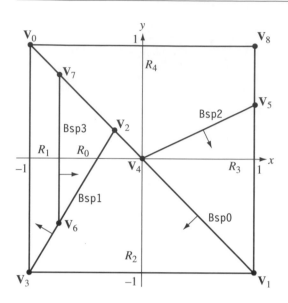

Figure 8.3 The partitioning of the world by four BSP planes. Only the square region defined by $|x| \le 1$ and $|y| \le 1$ is shown.

```
        Sphere(TriMesh) <Texture>
      Plane1(TriMesh) <Wireframe, Cull, VertexColor>
      Tetrahedron(TriMesh) <Texture>
    Plane0(TriMesh) <Wireframe, Cull, VertexColor>
    Bsp2(BspNode)
        Cube(TriMesh) <Texture>
        Plane2(TriMesh) <Wireframe, Cull, VertexColor>
        Octahedron(TriMesh) <Texture>
```

A screen shot from the application is shown in Figure 8.4. The four separating planes are visually represented by four rectangles drawn in wireframe mode. The WireframeState object is shared by all four planes, and the planes also share a Cull-State object. The culling state is disabled so that you can see the wireframe no matter which side of a plane you are on. Each plane has its own VertexColorEffect object so that the plane colors are distinct.

As you navigate through the scene, what you will find is somewhat boring. Clearly, no artist was harmed in the making of this demonstration! The point of the demonstration is the sorting of objects so you do not need to use depth buffering. Nothing about this process is visible to you, unless I were to get the sorting wrong, of course. A ZBufferState object is attached to the root node of the scene graph and

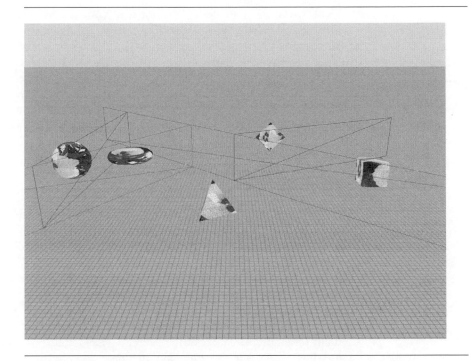

Figure 8.4 A view of the scene for the BSP sample application. Compare the view with the partitioning shown in Figure 8.3. (See also Color Plate 8.4.)

completely disables the depth buffer—no reading, no writing. The torus is not convex, so for completely correct drawing of only the torus, a depth buffer is needed. A ZBufferState object is attached to the torus mesh and enables reading and writing of the buffer. The other objects are convex and, by themselves, do not need depth buffering. The objects are drawn in the correct order because of the BSP tree. See Section 4.2.1 for a discussion about BSP trees.

8.2.3 CACHEDARRAY SAMPLE

Section 3.5.5 talked about caching vertex arrays on the graphics card. The Test-CachedArray sample application is very simple and has the scene graph structure

```
Scene(Node)
    Switch(SwitchNode)
        SphereNotCached(TriMesh) <Texture>
        SphereCached(TriMesh) <Texture>
```

The screen shots are not enlightening, so none are provided. A sphere mesh is created that is not told to cache itself on the graphics card, but an identical sphere mesh is told to cache itself. A sphere has 16,256 vertices and 32,256 triangles. The sample allows you to toggle between which sphere is drawn; the *c* key does the toggling. The important aspect of the demonstration is the difference in frame rates. On my ATI Radeon 9800 Pro graphics card, the uncached sphere draws at about 120 frames per second. The cached sphere draws at about 1200 frames per second, a 10-fold increase in speed.

8.2.4 CASTLE SAMPLE

The TestCastle sample application is a walk-through of a very large data set that I had an artist build.[1] You may navigate through the data set, both outside and inside the castle. The picking system is used to keep the camera a fixed height above whatever you are walking over (see Section 6.3.4). A ray is cast from the camera eye point vertically downward. The picking system calculates the closest point along the ray to the eye point, computes the distance to that point, and then adjusts the location of the eye point using the distance to remain a constant height above what is below you.

The picking system is also used to keep you from walking through objects, walls, and any other obstacles (see Section 6.3.5). A small number of rays are cast within a cone whose vertex is the eye point and that opens downward. The cone height is the distance from the eye point above the ground. If any nonground objects are within the cone, as detected by the picking, the camera is not allowed to move. This is not an aggressive test, and the density of pick rays might not be sufficiently large to detect very small objects entering the cone of interest.

The picking system is overloaded to handle a few more things. If you point at an object and click with the left mouse button, the name of the object is displayed in the lower portion of the screen—useful when building a level. If you notice an object that is not correctly built, you can easily determine its name and report it to the artist in charge. In fact, I used this system to figure out why one of the castle rooms appeared to have clockwise triangles when they should have been counterclockwise. It turned out that the artist had used a reflection matrix, but Wild Magic supports only rotations. Another system that picking supports is to selectively turn wireframe on for an object. You may do this with a click of the right mouse button (or CTRL plus button click on the Macintosh).

1. The artist is Chris Moak, and the artwork was done in 2001. The model was built in 3D Studio Max, but at the time I had only a minimal exporter. In fact, I still only have a minimal exporter. Trying to get data out of the modeling package and converted to Wild Magic objects is like pulling teeth. The Max model has multitextures and lighting, but the exporter at the time did not handle multitextures, and the lighting is not correctly converted. You can visit Chris's site and see some of his other work at *http://home.nc.rr.com/krynshaw/index.html*.

(a)

(b)

Figure 8.5 Two screen shots from outside the castle. (a) The solid view of the scene. (b) The same view, but in wireframe mode. (See also Color Plate 8.5.)

Figure 8.5 shows screen shots from the first screen that appears when the application runs. As you can see in Figure 8.5(b), the data set is enormous! The disk size of the scene is about 12 MB. Two versions of the data set are provided: one for uncached data and one for cached data. The data set is not portalized, but someday I will do

that. Unfortunately, the model needs a lot of reorganizing to support portals. Figure 8.6 shows screen shots from a location inside the castle.

8.2.5 CLODMESH SAMPLE

The TestClodMesh sample was discussed in Section 4.1.4, but with regard to the algorithm used for continuous level of detail. The scene graph structure is

```
Scene(Node) <Wireframe, Material, DirectionalLight>
    CenterAndFitTranslation(Node)
        Face(ClodMesh)
```

The material and light are used for coloring the face. The application shows how to adjust the level of detail from the collapse records based on the distance the face is from the eye point. The up and down arrow keys are used to move the camera forward and backward, respectively. As the camera moves away from the face, the resolution of the face triangle mesh is reduced. The number of triangles in the mesh is displayed at the bottom of the screen.

You can also press the c key to show the face at a lower resolution than the original. The collapse record number is 500, and the number of triangles in the mesh at that resolution is 1576. The original number of triangles is 2576.

Figure 8.7 shows some screen shots from the application. Observe that the face in the distance is a convincing rendering of the face that you saw close-up. The reduced-resolution face drawn close-up makes it clear that the mesh is significantly distorted from the original, but that the distortion makes no difference when the face is distant.

8.2.6 COLLISION SAMPLE

In Section 6.4, I discussed hierarchical collision detection using bounding volume hierarchies. The application that illustrates this system is TestCollision. The scene graph structure is very simple:

```
Scene(Node) <Wireframe>
    Cylinder0(TriMesh) <Texture>
    Cylinder1(TriMesh) <Texture>
```

The TextureEffect objects are distinct because the cylinders use different texture coordinates, but they both use the same Texture object. The image of the Texture object is quite small—a 2×2 array. The four texels have different colors: blue, cyan, red, and yellow. Cylinder 0 is short, wide, and initially colored blue by assigning all vertices the same texture coordinate that corresponds to the blue texel. Cylinder 1 is tall, narrow, and initially colored red by assigning all vertices the same texture coordinate that corresponds to the red texel.

(a)

fronthall_mesh0

(b)

Figure 8.6 Two screen shots from inside the castle. (a) The solid view of the scene. (b) The same
view, but with the distance wall clicked to place it in wireframe mode. You can see
the water and sky outside the castle. The name of the clicked mesh is also displayed
at the bottom of the screen. (See also Color Plate 8.6.)

triangles: 2576 triangles: 1576 triangles: 1576
(a) (b) (c)

Figure 8.7 (a) The face drawn with the original resolution, (b) the face at the reduced resolution but at the same distance from the camera, and (c) the face at the reduced resolution but far away from the camera.

Initially, the cylinders have the same center and axes, so the two are intersecting. Wherever the cylinders intersect, the triangle colors are modified to highlight those involved in the intersection. Figure 6.16 shows a couple of screen shots. The intersecting triangles on the red cylinder are colored in yellow, and those on the blue cylinder are colored in cyan. The color changes for those triangles occur in the collision callback function, TestCollision::Response.

You can reorient the scene graph by using the virtual trackball. The cylinders move in unison when you drag with the left mouse button down. Additionally, you can move the red cylinder by using the keyboard. The x and X keys translate the cylinder in the direction of the world's x-axis. The lowercase key causes a translation in the negative direction; the uppercase key causes a translation in the positive direction. The cylinder is similarly translated in either the world's y-axis by using the y and Y keys or in the world's z-axis by using the z and Z keys. The cylinder may be rotated about its center. The rotations are also about the world's coordinate axes. The r and R keys cause a rotation about the x-axis, the a and A keys cause a rotation about the y-axis, and the p and P keys cause a rotation about the z-axis.

Notice that the use of the r and R keys conflicts with the default behavior of the application library—to use those keys for adjusting the rotation speed. To circumvent the default behavior, the OnKeyDown function has the following implementation:

```
bool TestCollision::OnKeyDown (unsigned char ucKey, int iX, int iY)
{
    if ( WindowApplication::OnKeyDown(ucKey,iX,iY) ) return true;
    if ( Transform(ucKey) ) return true;
    switch ( ucKey )
    {
    case 'w':
    case 'W':
        m_spkWireframe->Enabled = !m_spkWireframe->Enabled;
        return true;
    }
    return false;
}
```

In most of the applications, the derived-class virtual function calls the same function in its immediate base class. The call you would see is

```
if ( WindowApplication3::OnKeyDown(ucKey,iX,iY) ) return true;
```

since WindowApplication3 is the base class. The base class virtual function implements key handlers for r and R, as well as for some other keys. To avoid the handlers, I instead call the virtual function for the class of WindowApplication, which is what WindowApplication3 derives from. That class's virtual function just checks to see if the ESC key is pressed—an indication that the application wants to terminate. The Transform function is defined in TestCollision and implements the handlers for the keys mentioned earlier that control translation and rotation of cylinder 1.

In other applications, you might want to avoid only some of the key handlers in the base class. For example, you might want to avoid r and R handling, but keep the behavior for t and T. The derived class OnKeyDown function could be implemented by

```
bool DerivedClass::OnKeyDown (unsigned char ucKey, int iX, int iY)
{
    switch ( ucKey )
    {
    case 'r':  // handler for r
        return true;
    case 'R':  // handler for R
        return true;
    }
    return WindowApplication3::OnKeyDown(ucKey,iX,iY);
}
```

Because your handlers for r and R occur first, the base class handlers are skipped. Alternatively, you can completely skip the base class handlers and process all the key presses yourself.

The collision group management and hierarchical collision detection are handled in the following manner: The scene graph is constructed in the member function CreateScene. The last part of that function contains the block of code

```
CollisionRecord* pkRec0 = new CollisionRecord(m_spkCyln0,
    new BoxBVTree(m_spkCyln0,1,false),NULL,Response,this);

CollisionRecord* pkRec1 = new CollisionRecord(m_spkCyln1,
    new BoxBVTree(m_spkCyln1,1,false),NULL,NULL,NULL);
```

The CollisionRecord constructor has the form

```
CollisionRecord (TriMesh* pkMesh, BoundingVolumeTree* pkTree,
    Vector3f* pkVelocity, Callback oCallback,
    void* pvCallbackData);
```

The data members m_spkCyln0 and m_spkCyln1 are smart pointers to the cylinder TriMesh objects and passed as the first parameters to the constructors. The second parameters are the bounding volume hierarchies that correspond to the objects. In this sample, I chose to use oriented bounding box volumes. You can replace BoxBVTree by SphereBVTree to see that the application still behaves as expected. The cylinder objects are both considered to be stationary, so the pointers to the velocity vectors are NULL, indicating that the objects have zero velocity.

The Callback parameter is a function pointer. The callback has the form

```
void (*Callback) (CollisionRecord& rkRecord0, int iT0,
    CollisionRecord& rkRecord1, int iT1,
    Intersector<float>* pkIntersector);
```

The two collision records of the objects involved in the collision are passed to the callback, as well as the indices of the two triangles involved in a collision. The last parameter is the triangle-triangle intersector that was used to determine that a collision has occurred (or will occur). You need to typecast the object to the appropriate class based on the type of intersection query you initiated (test/find, stationary/moving). The application implements a single callback, called Response. Since the callback must be a C-style function, the application member function is static.[2] Notice that the constructor for the collision record pkRec0 is passed the function Response, but the constructor for pkRec1 is passed NULL. In the sample application, the collision response is handled by only one of the objects—no double processing here. In other applications, you might very well pass callback functions to all the collision records.

2. A nonstatic member function in the C++ language has an implicit first parameter, a pointer to the calling object. You are accustomed to the pointer being named this. For example, a nonstatic member function void MyClass::F (int i) implicitly has the signature void F (MyClass* this, int i).

The last parameter to the constructor is a void* pointer that allows you to store object-specific data to be used in the callbacks. The callbacks themselves access the data through the collision records passed to them. This application does not have a need for object-specific data, but other applications might pass, for instance, physical parameters that are needed to correctly modify the physical behavior of the colliding objects.

The callback in this application is

```
void TestCollision::Response (CollisionRecord& rkRecord0, int iT0,
    CollisionRecord& rkRecord1, int iT1, Intersector<float>*)
{
    TriMesh* pkMesh;
    const int* aiIndex;
    Vector2f* akUV;
    int i0, i1, i2;

    // mesh0 triangles that are intersecting,
    // change from blue to cyan
    pkMesh = rkRecord0.GetMesh();
    aiIndex = pkMesh->Indices->GetData();
    i0 = aiIndex[3*iT0];
    i1 = aiIndex[3*iT0+1];
    i2 = aiIndex[3*iT0+2];
    akUV = pkMesh->GetEffect()->UVs[0]->GetData();
    akUV[i0] = ms_kCyanUV;
    akUV[i1] = ms_kCyanUV;
    akUV[i2] = ms_kCyanUV;

    // mesh1 triangles that are intersecting,
    // change from red to yellow
    pkMesh = rkRecord1.GetMesh();
    aiIndex = pkMesh->Indices->GetData();
    i0 = aiIndex[3*iT1];
    i1 = aiIndex[3*iT1+1];
    i2 = aiIndex[3*iT1+2];
    akUV = pkMesh->GetEffect()->UVs[0]->GetData();
    akUV[i0] = ms_kYellowUV;
    akUV[i1] = ms_kYellowUV;
    akUV[i2] = ms_kYellowUV;
}
```

No physical response is implemented here. Only the texture coordinates of the intersecting triangles are changed to cause a color change. A triangle on cylinder 0 is changed from blue to cyan, and a triangle on cylinder 1 is changed from red to yellow.

Also part of `CreateScene` is

```
m_pkGroup = new CollisionGroup;
m_pkGroup->Add(pkRec0);
m_pkGroup->Add(pkRec1);
m_pkGroup->TestIntersection();
```

A collision group is created to manage the two cylinders. The collision records for the cylinders are inserted into the group. The final call is the entry point into the collision detection system, a test-intersection query for stationary objects. During this call, the `Response` function will be called, which involves intersections of triangles on the circular ends of cylinder 0 and the sides of cylinder 1.

The `OnKeyDown` handler processes the keys that move cylinder 1. After the cylinder's local transformation is updated, in `Transform`, the following block of code is executed:

```
m_spkCyln1->UpdateGS(0.0f);
ResetColors();
m_pkGroup->TestIntersection();
```

The change in local transformation requires you to update the cylinder, both for display purposes and for collision detection purposes. The function `ResetColors` resets the texture coordinates of the two cylinders so that they are drawn in their original colors. The final call starts the collision detection system, once again causing the callback `Response` to be called.

8.2.7 INVERSEKINEMATICS SAMPLE

The `TestInverseKinematics` sample application is a simple illustration of inverse kinematics (IK). The IK system consists of a variable-length rod that is attached to the ground at one end point. The end point is visualized by drawing a cube centered at that location. The other end point is the end effector and is also visualized by drawing a cube centered at the location. It is allowed to translate in the vertical direction, which happens to be the z-axis. The rod can also rotate about the z-axis. Another cube is in the scene, has only translational degrees of freedom, and acts as the goal for the end effector. The application allows you to reposition and reorient the goal using key presses. The IK system responds accordingly to try to reach the goal.

The scene graph structure is

```
Scene(Node) <Wireframe>
    Ground(TriMesh) <VertexColor>
    IKSystem(Node)
        Goal(Node)
```

```
        GoalCube(TriMesh) <VertexColor>
Joint0(Node) <IKController>
        OriginCube(TriMesh) <VertexColor>
        Rod(Polyline) <VertexColor>
        Joint1(Node)
            EndCube(TriMesh) <VertexColor>
```

The IK system is encapsulated by a subtree of the scene. The system includes the goal and a linear chain of two nodes. As you translate the goal, the end effector tries to reach it. The rod changes length during the motion. The polyline representing the rod is a child of joint 0. The origin of the rod is the local translation value of joint 0, so it is reasonable to make the polyline a child of joint 0. The end point of the rod is the local translation value of joint 1. The end point is a duplicate of that translation, so in order to properly display the polyline representing the rod, the application must update the polyline end point *after* the UpdateGS call that has occurred at the IKSystem node. It is only after the update that the new joint 1 translation is known. The change to the end point requires an UpdateMS and an UpdateGS call to be applied to the Rod object.

The polyline end point update is encapsulated in the member function UpdateRod. It must be called after any UpdateGS call visits the IKSystem node. This happens in the Transform function that is called during an OnKeyDown event. Also, the trackball is hooked up to the application. Because the trackball rotates the scene, and the UpdateGS call for the scene is called indirectly through the OnMotion callback in the application library, the TestInverseKinematics application must implement OnMotion to trap the event, allow the trackball to rotate the scene, and then call UpdateRod afterward. The implementation is

```
bool TestInverseKinematics::OnMotion (int iButton, int iX, int iY)
{
    bool bMoved = WindowApplication3::OnMotion(iButton,iX,iY);
    if ( bMoved )
        UpdateRod();
    return bMoved;
}
```

Figure 8.8 shows a screen shot from the sample application. Initially, the goal is sitting on the ground plane at one unit of distance away from the origin of the IK system. The screen shot shows a configuration where the goal was moved vertically upward and then translated parallel to the plane by a small distance. The end effector moved upward to match the goal's vertical translation and then rotated about the vertical axis to match the goal's horizontal translation.

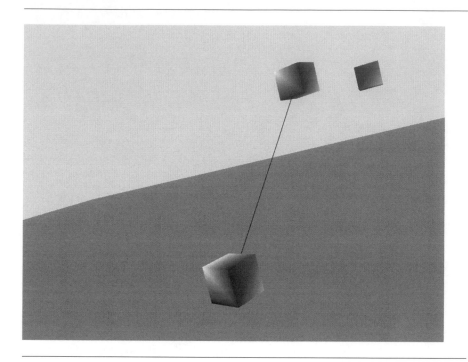

Figure 8.8 A screen shot from `TestInverseKinematics`.

8.2.8 PORTALS SAMPLE

Portals, convex regions, and convex region managers were discussed in Section 4.2.2, and the BSP trees that support the system were discussed in Section 4.2.1. The Test-Portals sample application illustrates the ideas of those sections, but has a quite lengthy implementation—a consequence of my hand-building the indoor environment for the convex region manager. Such an environment would be built in a real game using a modeling package. The exporting tools should be built to have the ability to automatically portalize the environment. For this process to succeed, the artists must be given careful instructions on how to order the rooms and construct the scene graph in the modeling package. The discussion here is about the construction of the environment without support from a modeling package or automatic portalizing tool. If you walk away with anything from this sample, it should be that any tools that automate difficult tasks are really good to have!

The indoor environment is a region bounded between the planes $z = 0$ and $z = 2$. A cross section in the xy-plane is shown in Figure 8.9. The environment has nine square and four diagonal rooms. The square rooms are named C_{xy}. The subscript refers to the location of the center point of the room. For example, C_{20} is the room

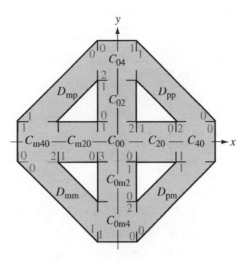

Figure 8.9 A cross section of the environment for the TestPortals sample.

whose center point is at $(x, y) = (2, 0)$, and C_{0m4} is the room whose center point is at $(x, y) = (0, -4)$ (the m stands for "minus"). The diagonal rooms are named D_{xy}. The subscript refers to the signs of x and y for the quadrant containing the room. For example, D_{pp} is the room in the quadrant for which both x and y are positive, and D_{mp} is the room in the quadrant for which $x < 0$ and $y > 0$ (the m stands for "minus," the p stands for "plus").

Each room has a floor located on the plane $z = 0$ and a ceiling located on the plane $z = 2$. Each room is bounded by four other planes. Table 8.1 lists the rooms and bounding planes.

The plane equations are written in the form in which they are used in the BSP tree construction. The coefficients on the left-hand side tell you the normal vector for the plane. For example, $-x + y = 4$ has a normal vector $(-1, 1, 0)$.

A BSP tree that implements the partitioning of the environment using an Explorer-like representation is

```
CRM (-z = 0)
    [+] outside
    [-] BSP:R (z = 2)
        [+] outside
        [-] BSP:RR (x = 1)
            [+] BSP:RRL (y = 1)
                [+] BSP:RRLL (x + y = 4)
                    [+] BSP:RRLLL (x + y = 6)
```

Table 8.1 The bounding planes for the rooms in the indoor environment.

Room	Bounding planes
C_{00}	$x = 1, -x = 1, y = 1, -y = 1$
C_{20}	$x = 1, x = 3, y = 1, -y = 1$
C_{40}	$x = 3, x = 5, y = 1, -y = 1$
C_{m20}	$-x = 1, -x = 3, y = 1, -y = 1$
C_{m40}	$-x = 3, -x = 5, y = 1, -y = 1$
C_{02}	$x = 1, -x = 1, y = 1, y = 3$
C_{04}	$x = 1, -x = 1, y = 3, y = 5$
C_{0m2}	$x = 1, -x = 1, -y = 1, -y = 3$
C_{0m4}	$x = 1, -x = 1, -y = 3, -y = 5$
D_{pp}	$x + y = 6, x + y = 4, x = 1, y = 1$
D_{pm}	$x - y = 6, x - y = 4, x = 1, -y = 1$
D_{mp}	$-x + y = 6, -x + y = 4, -x = 1, y = 1$
D_{mm}	$-x - y = 6, -x - y = 4, -x = 1, -y = 1$

```
                         [+] outside
                         [-] Dpp
                     [-] outside
                 [-] BSP:RRLR (-y = 1)
                     [+] BSP:RRLRL (x - y = 4)
                         [+] BSP:RRLRLL (x - y = 6)
                             [+] outside
                             [-] Dpm
                         [-] outside
                     [-] BSP:RRLRR (x = 3)
                         [+] BSP:RRLRRL (x = 5)
                             [+] outside
                             [-] C40
                         [-] C20
             [-] BSP:RRR (-x = 1)
                 [+] BSP:RRRL (y = 1)
                     [+] BSP:RRRLL (-x + y = 4)
                         [+] BSP:RRRLLL (-x + y = 6)
                             [+] outside
                             [-] Dmp
                         [-] outside
```

```
[-] BSP:RRRLR (-y = 1)
    [+] BSP:RRRLRL (-x - y = 4)
        [+] BSP:RRRLRLL (-x - y = 6)
            [+] outside
            [-] Dmm
        [-] outside
    [-] BSP:RRRLRR (-x = 3)
        [+] BSP:RRRLRRL (-x = 5)
            [+] outside
            [-] Cm40
        [-] Cm20
[-] BSP:RRRR (y = 1)
    [+] BSP:RRRRL (y = 3)
        [+] BSP:RRRRLL (y = 5)
            [+] outside
            [-] C04
        [-] C02
    [-] BSP:RRRRR (-y = 1)
        [+] BSP:RRRRRL (-y = 3)
            [+] BSP:RRRRRLL (-y = 5)
                [+] outside
                [-] C0m4
            [-] C0m2
        [-] C00
```

The tree is implemented in the scene graph as a tree of BspNode objects. The root of the tree is a ConvexRegionManager object, labeled CRM. The other nodes are labeled BSP and show their corresponding planes. The notation after the BSP lists the path to the node. If you were to sketch the tree so that the positive child branches to the left of the parent node and the negative child branches to the right, a path RRLRL indicates to go right twice, go left once, go right once, then left once. The path names are used in the source code.

The BSP tree construction is in the application member function CreateBspTree. The function is significantly long, so I will not reproduce it here. You can follow along by reading the source code. The first large block of source code creates the ConvexRegionManager object and all the BspNode objects. The splitting planes are the ones mentioned in the previous display of the BSP tree. The objects are assigned names by calling SetName; the node's path name is used.

The second large block of source code creates the cube and diagonal rooms as ConvexRegion objects. The functions used for creation are CreateCenterCube for C_{00}; CreateAxisConnector for C_{20}, C_{02}, C_{m20}, and C_{0m2}; CreateEndCube for C_{40}, C_{04}, C_{m40}, and C_{0m4}; and CreateDiagonalConnector for D_{pp}, D_{pm}, D_{mp}, and D_{mm}. The names assigned to those nodes are the room names, as defined earlier. Each room has two,

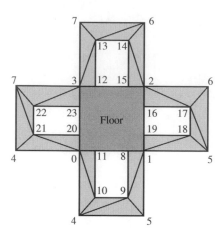

Figure 8.10 The vertex and index assignments for the room C_{00}. The view is of the room with the ceiling removed and the walls folded outward. The floor is dark gray, the walls are light gray, and the portal cutouts are white.

three, or four portals. The arrays of `Portal` objects are created within the four `Create*` functions.

The third large block of source code has the responsibility for setting up the adjacency graph of the convex regions. The indices into the portal arrays are shown in Figure 8.9. The opening between adjacent rooms is represented by a portal in each array of portals for the rooms. The index is immediately next to the opening. For example, room C_{40} has three outgoing portals. The opening at $y = 1$ has the index 0 immediately to its right, but inside C_{40}. The corresponding `Portal` object occurs in slot 0 of the array. The opening at $y = -1$ is represented by the `Portal` object in slot 1 of the array. Finally, the opening at $x = 3$ is represented by the `Portal` object in slot 2 of the array.

The fourth, and final, block of source code has the responsibility for setting the parent-child links in the BSP tree.

The construction of the triangle meshes for the rooms is also accomplished by a large amount of source code, which mainly sets vertex and index values. Room C_{00} is constructed according to Figure 8.10. The walls contain a total of 24 triangles, 4 per wall. The floor and ceiling are constructed as separate objects to allow for textures that are different than what is used on the walls. This room also contains four rectangular objects that are used to verify that the culling planes generated by the portals are actually doing their job.

The end rooms with three portals each are constructed according to Figure 8.11, and the four cube rooms adjacent to the center room and the four diagonal rooms are constructed according to Figure 8.12.

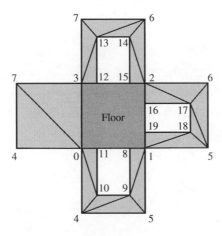

Figure 8.11 The vertex and index assignments for the end rooms. The view is of the room with the ceiling removed and the walls folded outward. The floor is dark gray, the walls are light gray, and the portal cutouts are white.

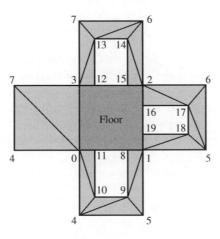

Figure 8.12 The vertex and index assignments for the connector rooms. The view is of the room with the ceiling removed and the walls folded outward. The floor is dark gray, the walls are light gray, and the portal cutouts are white.

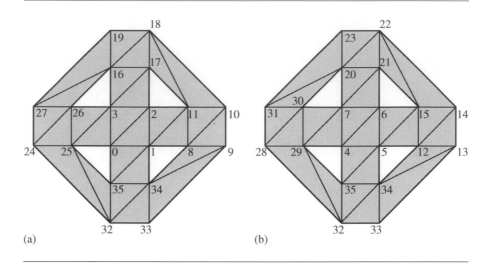

Figure 8.13 The vertex and index assignments for the outside. Two views are presented: (a) the top viewed from the top and (b) the bottom viewed from the top. Additional triangles occur on the walls that connect the top with the bottom.

The outside geometry is a separate object. It is constructed by the function `CreateOutside` and is only vertex colored. Figure 8.13 shows the vertex and index assignments.

The sample application allows you to verify that the portal system is working in two ways: First, you want to make certain that rooms are culled. Second, you want to make certain that objects in rooms are culled if their bounding volumes are not visible through the portal. Figure 8.14 shows screen shots from the application. The same views are shown in wireframe mode in Figure 8.15. Notice that in Figure 8.15(b) the wireframe for the rooms that are left- and right-adjacent to the center room show up, so in the distant view, those rooms were culled.

Figure 8.16 shows two views of the scene: one with just a sliver of the water-textured rectangle showing and one with that rectangle hidden. Figure 8.17 shows the same views in wireframe mode. Notice that in Figure 8.17(b) the wireframe of the water-texture rectangle is missing. This means the object has been culled. In particular, the plane formed by the eye point and right edge of the doorway is what culls the object.

8.2.9 SCREENPOLYGON SAMPLE

The `TestScreenPolygon` sample application shows how to use screen space polygons for both the background and foreground of an application. The screen space polygons

(a)

(b)

Figure 8.14 Screen shots from the TestPortals application. (a) A view of the scene when the eye
point is at some distance from the center room. (b) A view of the scene when the eye
point is closer to the center room. (See also Color Plate 8.14.)

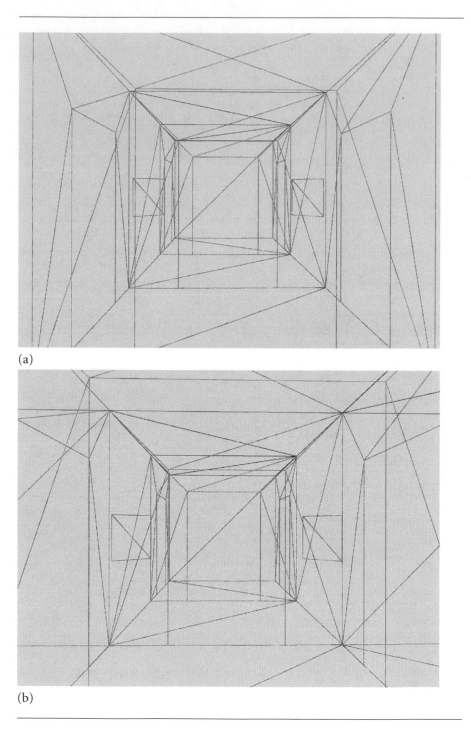

(a)

(b)

Figure 8.15 Wireframe views corresponding to Figure 8.14. (See also Color Plate 8.15.)

(a)

(b)

Figure 8.16 Screen shots from the TestPortals application. (a) A view of the scene where a sliver of the water-texture rectangle is showing. (b) A view of the scene when the eye point is closer to the right wall, and the rectangle is hidden. (See also Color Plate 8.16.)

(a)

(b)

Figure 8.17 Wireframe views corresponding to Figure 8.16. (See also Color Plate 8.17.)

Figure 8.18 A screen shot from the TestScreenPolygon application. (See also Color Plate 8.18.)

are not part of the scene graph, since they are not three-dimensional geometry that requires the formal update system to adjust world bounding volumes and world transformations. You must manage the objects separately. The application has two screen space polygons: The background polygon covers the entire screen and has a TextureEffect attached to it; the foreground polygon is a convex pentagon with a TextureEffect attached to it. The texture has an alpha channel with values that make the texture semitransparent. An AlphaState object is also attached to the foreground polygon so that it is blended into whatever is displayed on the screen. The skinned biped model is part of the application. The order of drawing is background polygon, skinned biped, foreground polygon (with blending). Figure 8.18 is a screen shot from the sample.

You may animate the biped and notice that the rendering of it is always between the foreground and background polygons. Also notice that the frame rate is displayed on top of the foreground polygon, yet another layer in the system.

The OnIdle loop is structured slightly differently than other applications:

```
void TestScreenPolygon::OnIdle ()
{
    MeasureTime();

    MoveCamera();
    if ( MoveObject() )
        m_spkScene->UpdateGS();
```

```
m_pkRenderer->ClearZBuffer();
if ( m_pkRenderer->BeginScene() )
{
    // draw background polygon first
    m_pkRenderer->Draw(m_spkBackPoly);

    m_pkRenderer->DrawScene(m_spkScene);

    // draw foreground polygon last
    m_pkRenderer->Draw(m_spkForePoly);

    // text goes on top of foreground polygon
    DrawFrameRate(8,GetHeight()-8,ColorRGBA::WHITE);

    m_pkRenderer->EndScene();
}
m_pkRenderer->DisplayBackBuffer();

UpdateFrameCount();
}
```

Usually the applications call `ClearBuffers` to clear the frame buffer as well as the depth buffer. However, we know that the background screen polygon fills the entire screen, so there is no reason to spend time clearing the frame buffer; thus, only `ClearZBuffer` is called.

After the `BeginScene` call, the renderer is told to draw the background polygon, followed by the scene, and then followed by the foreground polygon. The last drawing call displays the frame rate on top of everything else.

8.2.10 SKINNED BIPED SAMPLE

Wild Magic version 2 used the skinned biped model as a demonstration of skin-and-bones animation. The model also has keyframe controllers for animating the joints of the biped. The sample application loaded the already created model and simply displayed it on the screen. The animation was controlled manually by pressing keys. One of the most frequent questions about that sample was "How did you build the biped?"

The model was built in 3D Studio Max by an artist and then exported to the engine format. In particular, the skin of the model occurred in six triangle meshes, but the meshes were not stored as siblings of the bone trees that affected them. Each mesh had the same material applied to it, so the artist apparently wanted to have the drawing sorted by render state. The meshes are small enough that the sorting is not an issue for real-time display. In Wild Magic version 3, I manually decomposed

the old model and saved the parts to files of raw data. The TestSkinnedBiped sample application shows how the parts are reassembled so that the skins are siblings of the bone trees that affect them. In fact, I decomposed the skins even further into single anatomical pieces. One of the original skins contained vertices for the face, arms, and legs because a skin-color material was used for all those parts. This skin has been decomposed into separate skins for the face, left arm, right arm, left leg, and right leg. The other decomposed skins consist of a left shoe, a right shoe, a left ankle, a right ankle, hair, a shirt, and pants.

The scene graph structure is shown in the member function LoadModel. The source code lines are indented to show you the hierarchy. Two functions are called when building the scene, GetNode and GetMesh. The GetNode function loads up the raw data for interior nodes, including the keyframe controller data. The GetMesh function loads up the raw data for leaf nodes, including the triangle meshes and the skin controller data.

You have seen an inordinate number of screen shots with the skinned biped, so no point showing you yet another one!

8.2.11 SORTFACES SAMPLE

I discussed sorted drawing in Section 4.2.3. The TestSortFaces sample application is an implementation of the ideas. In the sample, I created a Node-derived class called SortedCube. The scene graph of the application is just an instance of this new class:

```
Scene(SortedCube) <Cull, ZBuffer, Alpha>
    XpFace(TriMesh) <Texture>
    XmFace(TriMesh) <Texture>
    YpFace(TriMesh) <Texture>
    YmFace(TriMesh) <Texture>
    ZpFace(TriMesh) <Texture>
    ZmFace(TriMesh) <Texture>
```

The cube consists of six TriMesh objects, each with an RGBA texture applied to it. The texture images have the names of the six faces: Xp, Xm, Yp, Ym, Zp, and Zm. The names are in black, and the texels have alpha values of 1, so the names are opaque. The background of the images is a water texture whose alpha values are 0.5, making it semitransparent. The AlphaState object is attached to the SortedCube to allow for alpha blending.

Since we want to see the back sides of the back-facing polygons when viewing them through the front faces, we need to disable back-face culling. The CullState object is attached for this purpose.

Finally, since the SortedCube is designed to sort the faces to obtain a correctly rendered scene, we do not want to rely on the depth buffer to sort on a per-pixel basis. A ZBufferState object is attached to the SortedCube object. Reading of the depth

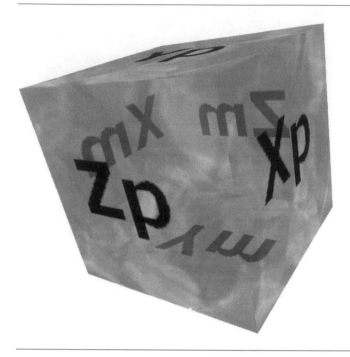

Figure 8.19 A screen shot from the `TestSortedFaces` application. (See also Color Plate 8.19.)

buffer is disabled, since the sorted faces preclude our having to compare depths. However, writing of the depth buffer is enabled. This does not matter in the current sample, but if you were to add other objects to the scene, the depth buffer values from semitransparent objects must be set in order to guarantee the other objects are correctly drawn (presumably most of them will use depth buffering). Figure 8.19 shows a screen shot from the sample.

8.2.12 TERRAIN SAMPLE

The `TestTerrain` sample application is a straightforward use of the `ClodTerrain` class. A `ClodTerrain` object is created. The default height and texture data are the highest resolution available: the pages are 129×129, and the texture images are 128×128. A `FogState` object is attached to the terrain in order to hide the rendering artifacts when terrain pages enter the view frustum through the far plane.

A sky dome is also loaded. This is the same object used in the `TestCastle` data set. To give the appearance of the sky being infinitely far away from the camera, whenever

the camera moves, the sky dome moves with it. These updates occur in the `OnIdle` callback:

```
if ( MoveCamera() )
{
    // The sky dome moves with the camera so that it is always in view.
    m_spkSkyDome->Local.Translate() = m_spkCamera->GetLocation();
    m_spkSkyDome->Local.Translate().Z() = 0.0f;
    m_spkSkyDome->UpdateGS();
}
```

The center point of the hemispherical dome is tied to exactly the eye point.

As you move about the terrain, the simplification system automatically adjusts the triangle mesh resolution. If the application runs slowly on your machine, try a less aggressive tolerance by pressing the minus key. For a more aggressive tolerance, press the plus key. You can also speed up the system by using the coarser-resolution height fields and/or texture images.

The *c* and *C* keys let you toggle between the *close assumption* and the *distant* assumption that were discussed in Section 4.4. Also, at any time you can force a simplification with the *m* or *M* keys.

As mentioned in Section 4.4, all of the camera motion virtual functions are overridden by `TestTerrain`. Once the camera has moved, the terrain simplification must occur. For example,

```
void TestTerrain::MoveForward ()
{
    WindowApplication3::MoveForward();

    Vector3f kLoc = m_spkCamera->GetLocation();
    float fHeight = m_spkTerrain->GetHeight(kLoc.X(),kLoc.Y());
    kLoc.Z() = fHeight + m_fHeightAboveTerrain;
    m_spkCamera->SetLocation(kLoc);
    m_spkCamera->UpdateGS();
    m_spkTerrain->Simplify();
}
```

The base class function is called to determine the new camera location. The camera has moved along its view direction, but the height above the terrain is required to be a constant. The five lines of code after the base class call adjust the camera eye point to have that constant height. The last line of code causes the simplification of the terrain to occur. Figure 8.20 shows a couple of screen shots from the sample application.

Figure 8.20 Screen shots from the TestTerrain application. (See also Color Plate 8.20.)

8.3 SAMPLE TOOLS

This section describes briefly a few tools that appear on the companion website. Tools for importing and exporting are the most difficult to write and maintain. One problem is that the modeling packages have their own scene management systems that do not easily map onto that of Wild Magic. Another problem is that finding adequate documentation that describes how to export from a package is nearly impossible. Maintenance of the exporters is a challenge because the companies that produce modeling packages release updates on a frequent enough basis that forces you to update your exporters to go with the new versions.

8.3.1 3DSTOWMOF IMPORTER

This is a simple tool that reads in files based on the old 3D Studio Max file format. The files have extension *.3ds. The importer is very basic: it imports geometry, textures, and some keyframe animation data. The file format does not support skin-and-bones. Wild Magic version 2 has an exporter for 3D Studio Max version 4 that I am currently upgrading to use Wild Magic version 3 in conjunction with 3D Studio Max version 6. The exporter supports keyframe animation and skin-and-bones in addition to the standard features such as lighting, material, and textures. If the exporter is not finished by the time the book is in print, you will be able to download it from the Wild Magic Web site.

8.3.2 MAYA AND MAX EXPORTERS

Also on the companion website are exporters for Maya version 6 and Max versions 4, 6, and 7. These exporters have a good number of features and do support keyframe animation and skin-and-bones. The Maya scene graph structures are sufficiently similar to those of Wild Magic, which reduces some of the pain of writing an exporter for that package.

8.3.3 BMPTOWMIF CONVERTER

The Wild Magic Image Format (WMIF) is a simple format. The class Image encapsulates the image reading and writing system. Since the format is for my engine, standard tools for converting file formats are not available. The BmpToWmif converter takes a 24-bit RGB Microsoft Windows bitmap and converts it to an RGB WMIF. A command line option allows you to specify an alpha value that is applied to all the texels, so you can create RGBA WMIF files with semitransparent texels.

8.3.4 WMIFTOBMP CONVERTER

After converting bitmap images to WMIF images, sometimes those original bitmaps get lost. It is handy to convert the WMIF images back to 24-bit RGB Microsoft Windows bitmaps, and the WmifToBmp converter does this. The alpha channel of the WMIF image is written to disk as a separate bitmap.

8.3.5 SCENEPRINTER TOOL

For a human-readable printout of a scene graph, use the ScenePrinter tool. The tool uses the StringTree class in the scene graph streaming system to produce ASCII output for the data members of each object in the scene. The program is a simple console application that loads the scene in a Stream object and then calls the SaveText member function of the Stream object.

8.3.6 SCENETREE TOOL

The SceneTree tool is a Microsoft Windows application that uses a Windows tree control to display a scene. If I ever get enough spare time, I will port this to the Linux and Macintosh platforms.

I find this tool quite useful for quickly examining the contents of a scene and to see what effects and controllers are attached. In fact, the heart of the tool is encapsulated by the files TreeControl.h and TreeControl.cpp. You can include these in your application code and create a tree control window from directly in your application. This window provides a more descriptive view of your data than do the "watch" windows in Visual Studio, since the watch windows know nothing about the high-level aspects of your data.

Figure 8.21 shows a screen shot of the SceneTree tool applied to the Skinned-Biped.wmof model.

8.3.7 SCENEVIEWER TOOL

The SceneViewer tool is a simple viewer that does a center-and-fit operation on the loaded scene graph. You can rotate the scene using the virtual trackball or using the function keys F1 through F6. All the usual camera navigation is enabled via the arrow keys, home, end, page up, and page down. Nothing fancy, but enough to quickly view a scene that was saved to the Wild Magic Object Format (WMOF).

Figure 8.21 A screen shot of the SceneTree tool.

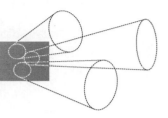

APPENDIX

CODING CONVENTIONS

I have various programming conventions I follow to make my code consistent and readable. Code consistency is, in my opinion, not a debatable concept; however, what is readable to one programmer might not be readable to another. Many programmers take a strong philosophical stance about code formatting and are not willing to compromise in the least. I am no different in that I feel strongly about my choices. This appendix describes my conventions and, in some cases, why I have selected them.

A.1 FILE NAMING AND ORGANIZATION

My source code libraries have files of various types, each type identified by its file extension. Wild Magic version 3 filenames all have the prefix Wm3. The prefix for Wild Magic version 2 filenames is Wml. I changed the prefix to allow an application to include both versions of the library. This allows you to use version 2 functions that are not yet ported to version 3, and it supports any conversions you might have to make to scene graphs that were created in version 2 of the product.

The files have various extensions. Header files have the extension h and contain class and function declarations. Source files have the extension cpp for C++ code.[1]

C++ allows you to have inlined source. For example, in a hypothetical header file MyClass.h, the class declaration contains

1. The OpenGL renderer uses GLEW for extension handling, a system with a C source file of extension c. I do not write C code in my own source.

```
class MyClass
{
public:
    void SetMyVariable (int i) { m_iMyVariable = i; }
    int GetMyVariable () const { return m_iMyVariable; }
private:
    int m_iMyVariable;
};
```

You may optionally use the `inline` keyword to prefix these statements. Unfortunately, including the body of a function in the class declaration is only considered a *suggestion* to the compiler. Whether or not the code is inlined depends on which compiler you are using. Some compilers provide a language extension to force the compiler to inline code, but the extensions are not portable, so I avoid them. I prefer to make the class declaration as readable as possible. The inline code distracts me from reading what the interface is. I place all the inline bodies in a separate file, what I call an "inline file." The file extension is `inl`. My version of the previous example is

```
// ... contents of MyClass.h ...
class MyClass
{
public:
    void SetMyVariable (int i);
    int GetMyVariable () const;
private:
    int m_iMyVariable;
};

#include "MyClass.inl"

// ... contents of MyClass.inl ...
inline void MyClass::SetMyVariable (int i)
{
    m_iMyVariable = i;
}

inline int MyClass::GetMyVariable () const
{
    return m_iMyVariable;
}
```

In summary, my organization of the header file is designed for you to quickly identify the public interface that is available to you, not for you to see implementation details of functions.

I use macros in the Object system of the library to support subsystems that require you to use similar code blocks in each class you define in the system. I place macros in files with an extension mcr. If you are using Microsoft's Visual Studio on a Windows platform, it is convenient for readability to have macro files processed by the syntax highlighting system. You can edit the Windows registry to make this happen. For Visual C++ 6 you need to modify the key

```
HKEY_CURRENT_USER
    Software
        Microsoft
            DevStudio
                6.0
                    Text Editor
                        Tabs/Language Settings
                            C/C++
```

This key has an item "File Extensions" of type REG_SZ. Right-click on this name, select the "Modify" option, and append to the string ";mcr". Files with the extensions in this list are syntax colored by the same editor scheme, in this case the one for cpp files. For Visual C++ 7 (any version), add a new entry with the extension .mcr to the registry path as shown:

```
HKEY_LOCAL_MACHINE
    SOFTWARE
        MICROSOFT
            VisualStudio
                7.0
                    Languages
                        File Extensions
                            .mcr
```

The "Name" field of the new entry is (Default) and the "Type" field is REG_SZ. The "Data" field needs to be the same one that shows up in the registry key .cpp. You can make a copy of that field by selecting the entry .cpp, right-clicking on the "Name" field, and selecting the "Modify" option. An edit control appears and shows the "Data" field highlighted. Press CTRL-C to copy the contents. Cancel out of that menu. Now select the registry key .mcr, right-click on "Name", and select the "Modify" option. Select the edit control and press CTRL-V to paste the contents from the previous copy.

A.2 COMMENT PREAMBLE AND SEPARATORS

All of the library files begin with the comment block

```
// Magic Software, Inc.
// http://www.magic-software.com
// http://www.wild-magic.com
// Copyright (c) 2004.  All Rights Reserved
//
// The Wild Magic Library (WM3) source code is supplied under the terms of
// the license agreement http://www.wild-magic.com/License/WildMagic3.pdf and
// may not be copied or disclosed except in accordance with the terms of that
// agreement.
```

I change the copyright notice annually. The license agreement is occasionally modified, but the conditions of the agreement can only become less restrictive over time.

The cpp files make use of *comment separators* between the functions. I find that comment separators make it easier for me to locate function blocks during scrolling than by having only blank line separators. Part of this ease might be related to the coloring provided by syntax highlighting in my editor of choice, the Visual Studio editor. Because each comment separator starts with two forward slashes and is completed with 76 hyphens, the cursor, when at the end of one of these lines, is highlighting column 79. I tend to display a source file fully maximized in the editor window. My editor window is set up so that column 79 is at the right edge of the window, a visual warning when typing to help me avoid typing past that point. The reason for 78 columns of text is that the standard printer settings allow 80 columns of text before a carriage return is automatically inserted. I structure my source files so that when printed, no automatic carriage returns are inserted that would corrupt the formatting of the source page. Of course, this is not a problem if your printer is set up to use more columns per page, but to be on the safe side, I assume the worst case for users of the code.

For example, in Wm3Geometry.cpp, the first two functions are constructor calls. The first comment separator is used to separate global declarations from the functions. The remaining comment separators are used to separate the functions.

```
#include "Wm3Geometry.h"
#include "Wm3Light.h"
#include "Wm3Texture.h"
using namespace Wm3;

WM3_IMPLEMENT_RTTI(Wm3,Geometry,Spatial);
WM3_IMPLEMENT_ABSTRACT_STREAM(Geometry);
```

```
//------------------------------------------------------------------
Geometry::Geometry ()
    :
    Lights(8,8)
{
    memset(States,0,GlobalState::MAX_STATE*sizeof(GlobalState*));
}
//------------------------------------------------------------------
Geometry::Geometry (Vector3fArrayPtr spkVertices)
    :
    ModelBound(BoundingVolume::Create()),
    Lights(8,8),
    Vertices(spkVertices)
{
    memset(States,0,GlobalState::MAX_STATE*sizeof(GlobalState*));
    UpdateModelBound();
}
//------------------------------------------------------------------
```

The number of hyphens here is smaller than in the source code so that the comment separator fits within the bounds of this book!

A.3 WHITE SPACE

The adequate use of white space is one of the least agreed upon topics regarding coding conventions. Different programmers invariably have different guidelines for spacing. This section describes my choices, for good or for bad.

A.3.1 INDENTATION

I use a level of indentation of four for each code block. I never use hard-coded tabs to obtain this indentation for two reasons. First, when viewing the code, a reader might have his editor set up to map a tab to a different number of spaces than I do. Second, a printer might also be set up to use a different number of spaces for a tab than I use. All white space in my source files occurs as a result of blank characters or blank lines. For example,

```
void SomeFunction (int i)
{
    // This comment indented 4 spaces from previous brace.
    if ( i > 0 )
```

```
    {
        // This comment indented 4 spaces from previous brace.
        printf("positive i = %d\n",i);
    }
    else
    {
        // This comment indented 4 spaces from previous brace.
        printf("nonpositive i = %d\n",i);
    }
}
```

A.3.2 BLANK LINES

I have no predefined rules for when (or when not) to use blank lines as white space. I try to use a blank line between code blocks when those blocks are not closely related. Usually, I have a comment at the beginning of a block to describe its purpose.

A.3.3 FUNCTION DECLARATORS

Function definitions, whether C-style or C++ member functions, occur in header files. The corresponding function bodies are either in a source file (extension cpp) or in an inline file (extension inl). Whether a definition or declaration, the declarator consists of a list of variables, possibly empty. Each item in the list contains a type name and an identifier name. Following the ANSI standard, if an identifier is not used in the function, the name is omitted. The type name–identifier pairs are separated by a comma and a blank. For example, a constructor for Vector2 is

```
template <class Real>
Vector2<Real>::Vector2 (Real fX, Real fY)
{
    m_afTuple[0] = fX;
    m_afTuple[1] = fY;
}
```

The declarator consists of two type name–identifier pairs, Real fX and Real fY. These are separated by a comma-blank pair. If the declarator is longer than 78 characters, the list is split at the last comma occurring before the 78 characters and continued on the next line with an indentation level of 4. For example,

```
void Camera::SetFrame (const Vector3f& rkLocation,
    const Vector3f& rkDVector, const Vector3f& rkUVector,
    const Vector3f& rkRVector)
```

```
{
    Local.SetTranslate(rkLocation);
    Local.SetRotate(Matrix3f(rkDVector,rkUVector,rkRVector,true));
    OnFrameChange();
}
```

If the list must be split multiple times, the second and all later lines are all indented to the same level. For a function that is const, sometimes the list does fit on a single line, but the const does not. I split the line so that const occurs on the next line, indented to a level of 4.

A.3.4 Constructor Initializers

The initialization of class members before the constructor body is called is accomplished by a comma-delimited list that follows a colon after the function declarator. I always place the colon on a separate line after the declarator, indented by one level. The list of initializations is on the next line at the same level. If the list does not fit on one line, it is split after the last comma that fits in the 78-character line. Some examples are

```
TriMesh::TriMesh (Vector3fArrayPtr spkVertices,
    IntArrayPtr spkIndices, bool bGenerateNormals)
    :
    Geometry(spkVertices)
{
    GeometryType = GT_TRIMESH;
    Indices = spkIndices;
    if ( bGenerateNormals )
        GenerateNormals();
}

BoxBVTree::BoxBVTree (const TriMesh* pkMesh, int iMaxTrisPerLeaf,
    bool bStoreInteriorTris)
    :
    BoundingVolumeTree(BoundingVolume::BV_BOX,pkMesh,
        iMaxTrisPerLeaf,bStoreInteriorTris)
{
}
```

Although you can initialize all members in the constructor initializer list, I usually only initialize members that are themselves class objects. Native-type members are initialized in the body of the constructor.

A.3.5 FUNCTION CALLS

Function calls are formatted with no white space between arguments. If the argument list does not fit on one line, it is split at the last comma that fits on the line. The remainder of the list on the next line is indented one level. For example,

```
SubdivideByVariation(m_fTMin,kPMin,m_fTMax,kPMax,fMinVariation,
    iMaxLevel,riNumPoints,pkList->m_kNext);
```

If the list is split multiple times, the second and later lines containing the list are indented to the same level.

A.3.6 CONDITIONALS

The formatting I use for if, while, and for statements is

```
if ( some_condition )
{
}

while ( some_condition )
{
}

for (initializers; terminate_conditions; updaters)
{
}
```

I use spaces to separate the Boolean conditions from the parentheses in the if and while statements, but not in the for statements. I do not recall a particular reason for these choices, and perhaps someday I will make these consistent regarding use of white space.

If some_condition is a compound Boolean expression that is too long to fit within the 78-character bound, I split the expression at a Boolean operator. The Boolean operator is left justified with the if or while keywords, and the remainder of that line is vertically justified with the previous line. For example,

```
bool Controller::Update (double dAppTime)
{
    if ( Active
    &&   (dAppTime == -Mathd::MAX_REAL
```

```
   ||    dAppTime != m_dLastAppTime) )
   {
       m_dLastAppTime = dAppTime;
       return true;
   }
   return false;
}
```

If the expression to be evaluated when the Boolean conditional is true is a single line of code, I do not use braces:

```
if ( some_condition )
   evaluate_expression;
```

If the Boolean condition is split, I do include braces for readability:

```
if ( some_condition
&&   some_other_condition )
{
   evaluate_expression;
}
```

I do not like splitting the for statement. For example, in Spatial:: UpdateWorldData, you will see a block of code

```
TList<GlobalStatePtr>* pkGList;
for (pkGList = m_pkGlobalList; pkGList; pkGList = pkGList->Next())
   pkGList->Item()->UpdateControllers(dAppTime);
```

I prefer this block over the following one:

```
for (TList<GlobalStatePtr>* pkGList = m_pkGlobalList;
   pkGList; pkGList = pkGList->Next())
{
   pkGList->Item()->UpdateControllers(dAppTime);
}
```

A.4 BRACES

As you may have already noticed, my braces for a single code block are aligned in the same column:

```
if ( i > 0 )
{
    // The starting and ending brace for this block are aligned.
}
```

Some people prefer Berkeley-style braces, but I do not:

```
if ( i > 0 ) {
    // I do not use this style of braces.
}
```

A.5 POINTER TYPES

This topic is one I have found to be quite philosophical among programmers. In the C language, you can declare pointer types and dereference them as illustrated next:

```
// declare piValue0 and piValue1 to be pointers to integers
int *piValue0, *piValue1;

// Assign 17 to the memory location pointed to by piValue0.
// The * is used to dereference the pointer.
*piValue0 = 17;

// Assign the value in the memory location pointed to by piValue0
// to the memory location pointed to by piValue1.  The * are used
// to dereference the pointers.
*piValue1 = *piValue0;

// After this assigment, piValue0 and piValue1 refer to the same
// memory location.
piValue1 = piValue0;
```

I am a firm believer in the object-oriented stance that pointers are objects and that a pointer type is representable as a class. This is supported by C++ in that you can overload the dereferencing operators operator*() and operator->(). A natural consequence of accepting pointers as objects leads to my choice of formatting:

```
int* piValue0;  // declaration, int* is the pointer type
*piValue0 = 17;  // dereference of the pointer type
```

In declarations, the asterisk immediately follows the type because type* denotes a pointer type. In assignments, the asterisk is used to dereference the pointer.

The fact that the C language allows declaration of multiple variables on the same line is, in my opinion, not a valid argument for separating the asterisk from the type

name. The C language was partly designed to allow compact statements. Having to use the verbose

```
int* piValue0;
int* piValue1;
```

instead of the compactly written

```
int *piValue0, *piValue1;
```

was, no doubt, viewed as wasteful by proponents of the latter form. However, whether C or C++, you can use

```
typedef int* IntPtr;  // or (gasp!): typedef int *IntPtr;
IntPtr piValue0, piValue1;
```

In fact, the type definition really does emphasize the fact that you are dealing with a pointer type.

The problems of integer types and pointer types are deeper than this. The C and C++ languages have constraints on how the sizes of different integer types compare, but these constraints allow for variability between platforms and CPUs. For example, it is guaranteed that

```
sizeof(short) <= sizeof(int) <= sizeof(long)
```

but sometimes you have to be careful about writing code whose behavior might change (for the worse) between the cases where equality or strict inequality occurs. To avoid such problems, developers tend to provide wrapper types to indicate exactly what the size of the type is. Pointers to the various types are also specified. For example,

```
// System meets the constraints:
//     sizeof(char) = sizeof(unsigned char) = 1, 'char' is signed
//     sizeof(short) = sizeof(unsigned short) = 2
//     sizeof(int) = sizeof(unsigned int) = 4
typedef char Int8;
typedef char* Int8Ptr;
typedef unsigned char UInt8;
typedef unsigned char* UInt8Ptr;
typedef short Int16;
typedef unsigned short UInt16;
typedef short* Int16Ptr;
typedef unsigned short* UInt16Ptr;
typedef int Int32;
```

```
typedef unsigned int UInt32;
typedef int* Int32Ptr;
typedef unsigned int* UInt32Ptr;

// if system has 64-bit signed integers declared as __int64 ...
typedef __int64 Int64;
typedef __int64* Int64Ptr;

// ... or if system has 64-bit 'long'
typedef long Int64;
typedef long* Int64Ptr;
```

With such a system in place to avoid integer-size dependencies, the declaration issue of "where do you place the asterisk" goes away. I do not currently have such wrappers in place. If you were to add the wrappers, the main problem will be to avoid name clashes if other libraries provide wrappers with the same names.

A.6 IDENTIFIER NAMES

The coding conventions for choosing identifier names are presented in this section.

A.6.1 VARIABLES

I have a rigid naming system for variables. The style is similar to Microsoft's Hungarian notation, but a bit more extensive. Class data members in private or protected scope are prefixed as follows: A nonstatic member is prefixed with m_, but a static class data member is prefixed with ms_. Class data members in public scope do not have a prefix. Their names start with a capital letter, and all complete words in the name have their first letter capitalized. For example,

```
class MyClass
{
public:
    int MyIntegerValue;

    void SetMyFloatValue (float fMyFloatValue);
    float GetMyFloatValue () const;
protected:
    float m_fMyFloatValue;
    static short ms_sMyStaticShortValue;
};
```

Table A.1 Prefixes used to identify the type of an identifier.

Prefix	Type	Prefix	Type
c	char	e	enumerated value
uc	unsigned char	k	class object
s	short	p	pointer
us	unsigned short	r	reference
i, j	int	a	array
ui	unsigned int	o	function pointer
l	long	v	void
ul	unsigned long	t	template variable
f	float	h	handle (Microsoft Windows)
d	double	q	interface (Microsoft COM)
b	bool		

Any data members in public scope do not have side effects when you read or write them. If you need side effects, you should provide public member accessors. In the example, these are SetMyFloatValue and GetMyFloatValue. Static public members also are not prefixed. For example, Vector2 has static public members ZERO (the zero vector), UNIT_X (the vector (1, 0)), and UNIT_Y (the vector (0, 1)).

Sometimes variables are defined in file scope but are not members of a class. These global variables are either publicly accessible in another file, through an extern declaration, or private to the file containing them by adding a static modifier. A publicly accessible global variable is prefixed with g_. A private global variable is prefixed with gs_. I try to avoid publicly accessible global variables; if they need to be accessible, I place them in class scope and either make them public in the class or provide accessor functions in the class. Private global class objects occur regularly when a class needs help with pre-main initialization and post-main termination. For example, see the macros in the file Wm3Main.mcr that use global, static variables.

Variables that are local to a code block have no prefix. Names for local variables and names for other variables minus the prefixes consist of lowercase letters that specify the type of the variable. After those letters are alphanumeric characters. Multiple words within a single identifier are capitalized for readability. I do not use underscores in identifier names except for the prefixing or for enumerations. The letters used for type are listed in Table A.1.

Based on user input, I made a few exceptions to the rules. Integer-valued loop indices may use single-letter names, typically i, j, or k. I also allow j as a prefix for an int variable.

A.6.2 CLASSES AND FUNCTIONS

Class names and function names are identifiers and are also alphanumeric. Multiple words within a single identifier are capitalized for readability. The mathematics-based classes that use templates with a parameter Real have names following the conventions here. Template classes that are not mathematics based use a prefix of T before the class name. For example, the container classes are of this type, such as TArray and TSet.

A.6.3 ENUMERATIONS

To avoid potential portability problems with enumerated types, specifically that the type might use different numbers of bytes on different platforms, I declare an enumeration, but store the values in an int variable. For example,

```
class FogState
{
public:
    enum // DensityFunction
    {
        DF_LINEAR,
        DF_EXP,
        DF_EXPSQR,
        DF_QUANTITY
    };

    int DensityFunction;  // default: DF_LINEAR
};
```

This is in contrast to using

```
class FogState
{
public:
    enum DensityFunctionType
    {
        DF_LINEAR,
        DF_EXP,
        DF_EXPSQR,
        DF_QUANTITY
    };

    DensityFunctionType DensityFunction;  // default: DF_LINEAR
};
```

This might no longer be an issue on current platforms with current operating systems, but previously, the Macintosh used to choose the smallest integer type that would store all the enumerations (but allowed you to reconfigure the system to make the value larger). In the current example, a char could be used since there are only four enumerations with implicitly assigned values 0 through 3. Not wanting to take chances with my streaming system, I avoid supplying a name for the enumerated type and store the values as an int.

I also use some manner of prefix on the enumerations, the prefix suggestive of the type. This practice avoids global name clashes, especially with the file windows.h, when the scope containing an enumerated value is ambiguous.

A.7 C++ EXCEPTIONS

I am not a fan of C++ exceptions (or of Java exceptions). Call me a dinosaur, but I prefer to use assertions to trap unexpected conditions during testing in the development environment. In fact, I use the assert macro generously.

In situations where I believe an unexpected condition can occur at run time in the actual consumer product (for example, trying to load a file from a specific location only to find out the file does not exist), I use what I call the *assert-recover* paradigm. The assert exists in case you can trap the problem during development time in a debug build of the product. However, if the unexpected condition occurs at run time, you would like the program to recover gracefully—certainly it should not crash. Code is added after the assert that is designed to gracefully exit the code block containing the assertion.

For example, in an application's OnInitialize callback:

```
bool MyApplication::OnInitialize ()
{
    if ( !WindowApplication3::OnInitialize() )
        return false;

    Stream kStream;
    bool bLoaded = kStream.Load("MyScene.wmof");
    assert( bLoaded );
    if ( !bLoaded )
        return false;

    // ... finish initializing ...
    return true;
}
```

The developer expected the scene graph file to occur in a certain directory. If someone deletes that file, or if the file is located in another directory, the stream load will

fail. The assert exists for you to trap the problem, if possible, at development time. But the test of bLoaded and the return of an error code is the recovery phase. The application will terminate gracefully.

In quite a few places, I have only assert statements. The intent is that the only way this can fail is if I completely overlooked something during the initial development, and I want to catch the problem later before I ship the code. That said, if your test programs do not yield full coverage of the source code, a development error might lead to a run-time error in the consumer product. For a bullet-proof system, you would always use the assert-recover paradigm. My recommendation at development time is to use some type of code coverage tool to let you know what portions of your code have *not* been visited. You can then add test programs to your testing matrix to force those code blocks to be exercised.

A.8 HEADER FILE ORGANIZATION

One of the topics least paid attention to is *header file organization*. A header file has a few roles; the main one is to expose a programming interface to a user. The header file also declares the classes and their data members and functions so that the compiler knows how to process the symbols in the source files. A class is generally not independent of the world around it. For example, the Matrix2 class encapsulates 2×2 matrices, but relies on knowledge about the Vector2 class. The header file for Vector2 must be included in either the header file or source file for Matrix2. Generally, the dependencies between classes in the library imply a hierarchical organization of the header files. I am about to tell you my two favorite stories regarding header file organization. Each of the stories has a lesson to learn.

A.8.1 INCLUDE GUARDS AND NESTED HEADER FILES

The first story on header file organization is about making life easy for your fellow programmers and clients of your source code. I worked for a short time at a local North Carolina company as a developer in statistical graphics. My development depended on libraries produced by other programmers in our group, as well as on libraries produced by other groups in the company. The initial source code samples that I had to learn from contained on the order of one to two dozen #include statements for various header files from the libraries. Much of the source code itself was not lengthy, so it was unclear to me why so many header files were being included. I started removing all but those header files I believed to have the interfaces needed to compile the source code file at hand, only to discover that the compiler generated a massive number of error statements about undefined symbols.

The problem? Most of the header files themselves did not include header files for subsystems that their corresponding source files required. Moreover, the header files were not using *include guards* to prevent multiple compilation. The implication is that

whenever I decided to include a particular header file to access the services exposed by that header file, I had to figure out all the other header files that were required by the one of interest and include them first, and in the correct order! Needless to say, this was very inconvenient. I mentioned this to my manager, including a suggestion that the system should be modified. He was also a developer in the group, quite proud of what he built, and he took offense, telling me that the use of include guards and nesting of header files was not a *general* solution. For as large and old a company as this was, I was quite surprised at the design decision not to use include guards and not to nest headers in the natural order.

The lesson for me in this was to beware of programmers with a lot of experience and pride who start justifying what they do based on authority instead of justifying what they do based on analytical reasoning. The lesson for you is "Use include guards and nest those headers."

For example, the file Wm3Line3.h contains

```
#ifndef WM3LINE3_H
#define WM3LINE3_H

#include "Wm3Vector3.h"

namespace Wm3
{

template <class Real>
class WM3_ITEM Line3
{
    // ... declarations go here ...
};

}

#endif
```

The Line3 class uses the interface of the Vector3 class, so the header for the math class is included. If I had not included the header, you would have to do the following in your source:

```
#include "Wm3Vector3.h"
#include "Wm3Line3.h"
using namespace Wm3;

Line3f MyFunction ()
{
    return Line3f(Vector3f::ZERO,Vector3f::UNIT_X);
}
```

The order of the header files is important. If you include Wm3Line3.h first, the compiler complains because it does not recognize Vector3 that occurs in that header file. There is no reason to force your users to figure out the includes and ordering; if your header file requires the interface, your header file includes the header for the interface.

The include guards prevent multiple compilation of header files that are indirectly included by other header files. For example, if you have an application that uses Wm3Matrix3.h as well as Wm3Line3.h, your source file would have

```
#include "Wm3Line3.h"
#include "Wm3Matrix3.h"
```

Both of these header files indirectly include Wm3Vector3.h. The first time the compiler encounters Wm3Vector3.h is in Wm3Line3.h. The portion of the compiler symbol table is built for that occurrence of the header. The compiler encounters Wm3Vector3.h a second time when it processes Wm3Matrix3.h. If we were to allow the second compilation to take place, the compiler would generate errors about multiply defined symbols. Fortunately, the include guard prevents this. The include guard for Wm3Vector3.h is WM3VECTOR3_H. The first time Wm3Vector3.h is visited, the compiler discovers that WM3VECTOR3_H is not defined. The next line of code in the header file defines WM3VECTOR3_H. The second time Wm3Vector3.h is visited, the compiler notices that WM3VECTOR3_H is defined, and will simply skip over the contents of the header file (until it reaches the #endif statement). Thus, in a single source file, a header file is only ever processed once.

If you have two source files, each including Wm3Vector3.h, the compiler *will* process the file twice. The conditional compilation of include guards is in effect on a per-source-file basis. Most compilers provide what is called a *precompiled header* system. This system is designed to deal with the multiple-source-file problem. With precompiled headers enabled, Wm3Vector3.h is only ever processed once by the compiler, even if it shows up in multiple source files.

The include guards avoid multiple compilation, and they support safely nesting include files so that your users do not have to guess about header file dependencies. So how do you know if you have organized the files properly? What I do is have a dummy source file that includes a single header file. For example,

```
// contents of dummy.cpp
#include Wm3TriMesh.h"
```

Press the compile button. If you have not properly nested header files that are needed by the TriMesh system, you will get compiler errors. Do this test for *each* file in your library. Tedious? Yes, it is. Do you want to provide quality source code and libraries to your customer? Then you will find that tedious tasks abound—we like to call it *quality assurance* and *quality control*.

A.8.2 MINIMIZING COMPILATION TIME

The second story on header file organization is about spending less time compiling and more time developing. My short stay at the company doing statistical graphics is much less known than my longer stay at a North Carolina game engine company. When I started at this company, the development machines had Intel Pentium 133 MHz CPUs and Microsoft Windows 95 as the operating system. The compiler was Microsoft Visual C++ version 4. The game engine source was of moderate size, not nearly as large as the Wild Magic code is now. The time it took to compile the entire engine was about 20 minutes. Needless to say, you cringe when you have a need to make changes to header files that most of the engine is dependent on. The flip side is that a 20-minute compile does give you time to work with pencil and paper or anything else that does not tie you to your computer.

Given the number of source files, I thought 20 minutes was excessive. Some investigation showed that a single header file included *all* of the header files in the engine, and this single header file was included in each and every source file, presumably for the convenience of the programmers not having to think about what to include. This is the exact opposite stance of the programmers at the other company!

The problem? A compiler spends a very large portion of its time processing the symbol table. If every source file includes every header file, the compiler is *really* busy processing all those symbols over and over. A single header file containing all other header files is not much of an issue with a couple of source files, but when you have a large library with a lot of source files, clearly another solution is needed. Yes, more tedious tasks to attend to. The source files should attempt to include *only what they need* and no more. This goal, and a proper and efficient nesting of header files, will lead to reduced compilation time and reduced headaches for clients of your code. At the aforementioned company, I took charge of the source files one weekend and rewrote all the source files to include only what they needed and modified headers to include only what they needed. The compile time for the entire engine was reduced from 20 minutes to 3 minutes. This is a significant reduction, I must say.

The guidelines I use for header file organization are the following: A header file for class A should include a header file for class B if the header file for class A makes use of objects from class B. If class A only has pointers or references to objects from class B, use a forward declaration. For example,

```
#ifndef CLASSA_H
#define CLASSA_H

#include "ClassB.h"
class C;

class A
{
public:
```

```
    A (const B& rkBObject, C* pkCObject);

protected:
    BObject m_kBObject;
    C* m_pkCObject;
};

#endif
```

Class A has a data member that is an object from class B. This counts as using an object from class C, so you need to include ClassB.h. However, class A has a pointer to an object of class C. A forward declaration is sufficient for this header file to compile when it is a single include in a dummy source file.

This is my *strong version* of header file organization. A weaker version allows you to include a header file, even if the compiler does not require it. In the previous example, this version of the rule allows

```
#ifndef CLASSA_H
#define CLASSA_H

#include "ClassB.h"
#include "ClassC.h";

class A
{
public:
    A (const B& rkBObject, C* pkCObject);

protected:
    BObject m_kBObject;
    C* m_pkCObject;
};

#endif
```

The idea is that if class C is commonly used whenever class A is used, there is no reason for users to have to keep including both ClassA.h and ClassC.h. The compromise is to include it for them. Do not be tempted to make *everything* easy; otherwise you will end up with a single header file that includes all other header files!

Sometimes forward declarations are necessary, particularly when header files have circular dependencies. One such example in Wild Magic pertains to the Spatial and Light classes. The Spatial class maintains a list of pointers to Light objects that illuminate it. However, Light is derived from Spatial. The following will not compile:

```
#ifndef WM3SPATIAL_H
#define WM3SPATIAL_H
#include "Wm3Light.h"
class Spatial
{
    TList<Light*>* m_pkLightList;
};
#endif

#ifndef WM3LIGHT_H
#define WM3LIGHT_H
#include "Wm3Spatial.h"
class Light : public Spatial
{
};
#endif
```

One of the header files must forward-declare the other class. Since Light is derived from Spatial, it needs Wm3Spatial.h to be included, so the only choice to break the circular dependency is

```
#ifndef WM3SPATIAL_H
#define WM3SPATIAL_H
class Light;
class Spatial
{
    TList<Light*>* m_pkLightList;
};
#endif

#ifndef WM3LIGHT_H
#define WM3LIGHT_H
#include "Spatial.h"
class Light : public Spatial
{
};
#endif
```

The circularity shows up when you use smart pointers. In Spatial, the actual light list contains smart pointers:

```
#ifndef WM3SPATIAL_H
#define WM3SPATIAL_H
class Light;
```

```
class Spatial
{
    TList<LightPtr>* m_pkLightList;
};
#endif
```

As it turns out, this code will not compile. The LightPtr symbol is a typedef in Wm3Light.h. You cannot access the definition unless you include Wm3Light.h. However, the inclusion fails because of the circular dependency. The solution is not to use the typedef:

```
#ifndef WM3SPATIAL_H
#define WM3SPATIAL_H
class Light;
class Spatial
{
    TList<Pointer<Light> >* m_pkLightList;
};
#endif
```

This compiles, but do not be tempted to remove the blank space between the two closing angle brackets. Compilers have an awful time trying to distinguish between >> as two closing angle brackets and >> used as operator>>. If you have used the Standard Template Library (STL), you probably have already encountered this issue.

BIBLIOGRAPHY

[AMH02] Tomas Akenine-Möller and Eric Haines. *Real-Time Rendering*, second edition. A.K. Peters, Natick, MA, 2002.

[AS65] Milton Abramowitz and Irene A. Stegun. *Handbook of Mathematical Functions with Formulas, Graphs, and Mathematical Tables*. Dover Publications, New York, 1965.

[Bar01] David Baraff. Physically based modeling: Rigid body simulation. *www.pixar.com/companyinfo/research/pbm2001/notesg.pdf*. 2001.

[BF01] Richard L. Burden and J. Douglas Faires. *Numerical Analysis*, seventh edition. Brooks/Cole, Belmont, CA, 2001.

[CLR90] Thomas H. Cormen, Charles E. Leiserson, and Ronald L. Rivest. *Introduction to Algorithms*. MIT Press, Cambridge, MA, 1990.

[DWS+97] Mark A. Duchaineau, Murray Wolinsky, David E. Sigeti, Mark C. Miller, Charles Aldrich, and Mark B. Mineev-Weinstein. ROAMing terrain: Real-time optimally adaptive meshes. In *IEEE Visualization 1997*, pages 81–88, 1997.

[Ebe00] David Eberly. *3D Game Engine Design*. Morgan Kaufmann Publishers, San Francisco, 2000.

[Ebe02] David Eberly. Fast inverse square root. *www.magic-software.com/Documentation/FastInvSqrt.pdf*. 2002.

[Ebe03a] David Eberly. *Game Physics*. Morgan Kaufmann Publishers, San Francisco, 2003.

[Ebe03b] David Eberly. Polyhedral mass properties (revisited). *www.magic-software.com/Documentation/PolyhedralMassProperties.pdf*. 2003.

[Eng02] Wolfgang F. Engel. *ShaderX: Vertex and Pixel Shader Tips and Tricks*. Wordware, Plano, TX, 2002.

[Eng03] Wolfgang F. Engel. *ShaderX2: Shader Programming Tips & Tricks with DirectX 9*. Wordware, Plano, TX, 2003.

[Fer04] Randima Fernando, editor. *GPU Gems*. Addison-Wesley, Boston, 2004.

[FG03] Kaspar Fischer and Bernd Gärtner. The smallest enclosing ball of balls: Combinatorial structure and algorithms. In *Annual Symposium on Computational Geometry: Proceedings of the Nineteenth Conference on Computational Geometry*, pages 292–301, 2003.

[GH97] Michael Garland and Paul Heckbert. Surface simplification using quadric error metrics. In *Proceedings of SIGGRAPH 1997*, pages 209–216, 1997.

[GH98] Michael Garland and Paul Heckbert. Simplifying surfaces with color and texture using quadric error metrics. In *IEEE Visualization 1998*, pages 263–269, 1998.

[GLM96] Stefan Gottschalk, Ming Lin, and Dinesh Manocha. OBBTree: A hierarchical structure for rapid interference detection. In *Proceedings of SIGGRAPH 1996*, pages 171–180, 1996.

[Hec94] Paul S. Heckbert, editor. *Graphics Gems IV*. Academic Press, San Diego, 1994.

[Hub96] P. M. Hubbard. Approximating polyhedra with spheres for time-critical collision detection. *ACM Transactions on Graphics*, 15(3):179–210, 1996.

[IM04] Milan Ikits and Marcelo Magallon. The OpenGL Extension Wrangler Library. *glew.sourceforge.net*. 2004.

[Kir92] David Kirk, editor. *Graphics Gems III*. Academic Press, San Diego, 1992.

[Knu73] Donald E. Knuth. *The Art of Computer Programming, Volumes 1, 2, 3*. Addison-Wesley, Boston, 1973.

[LKR^{+}96] Peter Lindstrom, David Koller, William Ribarsky, Larry F. Hodges, Nick Faust, and Gregory A. Turner. Real-time, continuous level of detail rendering of height fields. In *Proceedings of SIGGRAPH 1996*, pages 109–118, 1996.

[Lom03] Chris Lomont. Fast inverse square root. *www.math.purdue.edu/~clomont/ Math/Papers/2003/InvSqrt.pdf*. 2003.

[Mey88] Bertrand Meyer. *Object-Oriented Software Construction*. Prentice Hall International, Hertfordshire, UK, 1988.

[MG02] Aditi Majumder and M. Gopi. Non-photorealistic animation and rendering. In *Proceedings of the 2nd International Symposium on Non-Photorealistic Animation and Rendering*, pages 59–66, 2002.

[Mir96] Brian Mirtich. Fast and accurate computation of polyhedral mass properties. *Journal of Graphics Tools*, 1(2):31–50, 1996.

[Möl97] Tomas Möller. A fast triangle–triangle intersection test. *Journal of Graphics Tools*, 2(2):25–30, 1997.

[Pea85] Carl E. Pearson, editor. *Handbook of Applied Mathematics: Selected Results and Methods*, second edition. Van Nostrand Reinhold, New York, 1985.

[Ros04] Randi J. Rost. *OpenGL Shading Language*. Addison-Wesley, Boston, 2004.

[SE02] Philip J. Schneider and David Eberly. *Geometric Tools for Computer Graphics*. Morgan Kaufmann Publishers, San Francisco, 2002.

[Sho87] Ken Shoemake. Animating rotation with quaternion calculus. In *ACM SIG-GRAPH Course Notes 10: Computer Animation: 3-D Motion, Specification, and Control*, 1987.

[vdB03] Gino van den Bergen. *Collision Detection in Interactive 3D Environments*. Morgan Kaufmann Publishers, San Francisco, 2003.

[Wil83] Lance Williams. Pyramidial parametrics. *Computer Graphics*, 7(3):1–11, 1983.

INDEX

About the Website

THE PROPRIETARY MATERIAL, AND SPECIFICALLY DISCLAIM ANY WARRANTY OF MERCHANTABILITY OR FITNESS FOR A PARTICULAR PURPOSE.

IN NO EVENT WILL ELSEVIER, ITS AFFILIATES, LICENSORS, SUPPLIERS OR AGENTS, BE LIABLE TO YOU FOR ANY DAMAGES, INCLUDING, WITHOUT LIMITATION, ANY LOST PROFITS, LOST SAVINGS OR OTHER INCIDENTAL OR CONSEQUENTIAL DAMAGES, ARISING OUT OF YOUR USE OR INABILITY TO USE THE PRODUCT REGARDLESS OF WHETHER SUCH DAMAGES ARE FORESEEABLE OR WHETHER SUCH DAMAGES ARE DEEMED TO RESULT FROM THE FAILURE OR INADEQUACY OF ANY EXCLUSIVE OR OTHER REMEDY.

SOFTWARE LICENSE AGREEMENT

This Software License Agreement is a legal agreement between Geometric Tools, Inc., a North Carolina corporation, and any person or legal entity using or accepting any Software governed by this Agreement. The Software includes computer source code, the associated media, any printed materials, and any online or electronic documentation. The Software and any updates are available online from the Web site *www.geometrictools.com*.

By installing, copying, or otherwise using The Software, you agree to be bound by the terms of this Agreement. If you do not agree to the terms of this Agreement, you may not use The Software, and you should remove the Software from your computer. The Software is protected by copyright laws and international copyright treaties, as well as other intellectual property laws and treaties. The Software is licensed, not sold.

This Agreement shall be effective on the first day you use or accept The Software governed by this Agreement, whichever is earlier.

The parties agree as follows:

1. *Grant of License.* We grant you a nonexclusive license to use The Software subject to the terms and conditions of the Agreement:

 (a) There is no charge to you for this license.

 (b) The Software may be used, edited, modified, copied, and distributed by you for noncommercial products.

 (c) The Software may be used, edited, modified, copied, and distributed by you for commercial products provided that such products are not intended to wrap The Software solely for the purposes of selling it as if it were your own product. The intent of this clause is that you use The Software, in part or in whole, to assist you in building your own original products. An example of acceptable use is to incorporate the graphics portion of The Software in a game or game engine to be sold to an end user. An example that violates this clause is to compile a library from only The Software, bundle it with the headers files as a Software Development Kit (SDK), then sell that SDK to others.

If there is any doubt about whether you can use The Software for a commercial product, contact us and explain what portions you intend to use. We will consider creating a separate legal document that grants you permission to use those portions of The Software in your commercial product.

2. *Disclaimer of Warranty.* We make no warranties at all. The Software is transferred to you on an "as is" basis. You use The Software at your own peril. You assume all risk of loss for all claims or controversies, now existing or hereafter, arising out of use of The Software. We shall have no liability based on a claim that your use or combination of The Software with products or data not supplied by us infringes any patent, copyright, or proprietary right. All other warranties, expressed or implied, including, without limitation, any warranty of merchantability or fitness for a particular purpose are hereby excluded.

3. *Limitation of Liability.* We will have no liability for special, incidental or consequential damages even if advised of the possibility of such damages. We will not be liable for any other damages or loss in any way connected with The Software.

4. *Entire Agreement, Amendments.* This Agreement represents the complete and exclusive statement of the Agreements between the parties relating to the licensing of The Software and maintenance of The Software and supersedes all prior Agreements and representations between them relating to such licensing. Modifications to this Agreement shall not be effective unless in writing and signed by the party against whom enforcement is sought. The terms of this Agreement shall not be amended or changed by any purchase order or acknowledgment even if we have signed such documents.

5. *North Carolina Law, Severability.* This Agreement will be governed by North Carolina law. If any provision of this Agreement shall be unlawful, void, or for any reason unenforceable, it shall be deemed severable from and shall in no way affect the validity or enforceability of the remaining provisions of this Agreement.

INSTALLING AND COMPILING THE SOURCE CODE

The Wild Magic engine is portable and runs on PCs with Microsoft Windows 2000/XP operating systems or Linux operating systems. The engine also runs on Apple computers with the Macintosh OS X operating system (version 10.2.3 or higher). OpenGL renderers are provided for all the platforms. Project files are provided for Microsoft Visual Studio .NET 2003 on Microsoft Windows. Make files are provided for Linux. Xcode project files are provided for the Macintosh.

Copy the files from the companion website to your hard drive. The directions for installing and compiling are found in the file `WildMagic3p4ReleaseNotes.pdf`. *Please read the release notes carefully before attempting to compile.* Various modifications must be made to your development environment and some tools must be installed in order to have full access to all the features of Wild Magic.

UPDATES AND BUG FIXES

The Web site for version 3 of the Wild Magic engine is *www.geometrictools.com*. Updates and bug fixes will be posted, and a history of changes is maintained at the site.

Printed and bound by CPI Group (UK) Ltd, Croydon, CR0 4YY

23/10/2024

01778270-0001